The Photography Reader

The Photography Reader is a comprehensive collection of twentieth-century writings on photography – its production, its uses and effects. Encompassing essays by photographers including Edward Weston and László Moholy-Nagy, and key thinkers from Walter Benjamin to Roland Barthes and Susan Sontag, the Reader traces the development of ideas about photography, exploring issues such as identity, consumption, the gaze, and digital technology. Each themed section features an editor's introduction setting ideas and debates in their historical and theoretical context.

Sections include: Reflections on Photography; Photographic Seeing; Codes and Rhetoric; Photography and the Postmodern; Photo-digital; Documentary and Photojournalism; The Photographic Gaze; Image and Identity; Institutions and Contexts.

Includes essays by: Jan Avgikos, David A. Bailey, Roland Barthes, Geoffrey Batchen, David Bate, Karin E. Becker, Walter Benjamin, John Berger, Ossip Brik, Victor Burgin, Jane Collins, Douglas Crimp, Hubert Damisch, Edmundo Desnoes, Umberto Eco, Steve Edwards, Andy Grundberg, Stuart Hall, Lisa Henderson, bell hooks, Angela Kelly, Sarah Kember, Annette Kuhn, Lucy R. Lippard, Martin Lister, Catherine Lutz, Roberta McGrath, Lev Manovich, Rosy Martin, Christian Metz, W. J. T. Mitchell, László Moholy-Nagy, Wright Morris, Marjorie Perloff, Martha Rosler, Allan Sekula, Abigail Solomon-Godeau, Susan Sontag, Jo Spence, John Szarkowski, John Tagg, Liz Wells, Edward Weston, Peter Wollen.

Liz Wells, curator and writer, teaches Media Arts in the Faculty of Arts, University of Plymouth. She is the editor of *Viewfindings: Women Photographers, Landscape and Environment* (1994) and *Photography: A Critical Introduction* (third edition, Routledge 2004), and co-editor of *Shifting Horizons: Women's Landscape Photography Now* (2000).

The

Photography

Reader

Edited by

Liz Wells

 Routledge
Taylor & Francis Group

LONDON AND NEW YORK

First published 2003
by Routledge
2 Park Square, Milton Park, Abingdon, Oxon OX14 4RN

Simultaneously published in the USA and Canada
by Routledge
270 Madison Avenue, New York, NY 10016

Reprinted 2003, 2004 (twice), 2006 (three times), 2007 (twice),

2008 (three times), 2009 (twice)

Routledge is an imprint of the Taylor & Francis Group, an informa business

Typeset in Perpetua and Bell Gothic by
Florence Production Ltd, Stoodleigh, Devon
Printed and bound in Great Britain by
TJ International Ltd, Padstow, Cornwall

British Library Cataloguing in Publication Data
A catalogue record for this book is available from the British Library

Library of Congress Cataloging in Publication Data
has been applied for

ISBN10: 0–415–24660–1 (hbk)
ISBN10: 0–415–24661–X (pbk)

ISBN13: 978–0–415–24660–6 (hbk)
ISBN13: 978–0–415–24661–3 (pbk)

Contents

Illustrations

Contributors

Jan Avgikos is an adjunct Assistant Professor at Columbia University.

David A. Bailey, photographer, critic and curator, is Director of the African and Asian Visual Artist Archive, University of East London.

Roland Barthes (1915–1980) essayist and semiologist, taught at the Ecole des Hautes Etudes en Sciences Sociales, Paris. His critical writings ranged widely; key writings on photographs include *Mythologies* (1957/1972 English), 'The Photographic Message' and 'The Rhetoric of the Image' in *Image, Music, Text* (1977), *Camera Lucida* (1981/1984 English).

Geoffrey Batchen is the author of *Burning with Desire: The Conception of Photography* (1997) and *Each Wild Idea: Writing, Photography, History* (2001). He teaches the history of photography at the University of New Mexico, Albuquerque, USA.

David Bate, artist and writer, is currently course leader, MA Photographic Studies at the University of Westminster, UK. Publications include *Photography and Surrealism: Sexuality, Colonialism and Social Dissent* (2002), and contributions to *Afterimage, Camera Austria, Portfolio, Third Text*.

Karin E. Becker is Professor of Visual Culture Studies at the College of Art, Crafts and Design in Stockholm, Sweden, and is on the Journalism, Media and Communication Faculty, Stockholm University. Her research focuses on visual media and ethnography.

Walter Benjamin (1892–1940), Marxist cultural critic, was associated with 'Frankfurt School' theorists including Adorno and Marcuse, and with the playwright Bertolt Brecht. His essays encompass a range of issues, from history and criticism to literature, theatre and photography; from collecting and connoisseurship to authorship.

John Berger, novelist and critic, has written extensively on photography and visual arts, including, *Ways of Seeing* (1972), *About Looking* (1980), *Another Way of Telling* (1982). Recent work includes 'The Spectre of Hope' with Sebastaio Salgado, BBC (2001).

Ossip Brik (1888–1945), Soviet activist and theorist, contributed to *Lef* and *Novy Lef*, journals which carried debates about the revolutionary potential of the arts.

Victor Burgin is Millard Professor of Fine Art, Goldsmiths College, University of London, UK, since 2001, having recently returned from the University of California, Santa Cruz. He has published and exhibited widely; books include *Thinking Photography* (1982), *The End of Art Theory: Criticism and Postmodernity* (1986) and *In/Different Spaces* (1996).

Jane Collins is Professor of Rural Sociology and Women's Studies at the University of Wisconsin at Madison. She is co-author with Catherine Lutz of *Reading National Geographic* (1993).

Douglas Crimp is Professor of Visual and Cultural Studies at the University of Rochester, author of *On the Museum's Ruins* (1993) and *Melancholia and Moralism: Essays on AIDS and Queer Politics* (2002). He is currently writing a book on the films of Andy Warhol.

Hubert Damisch is on the faculty of the Ecole des Hautes Etudes in Sciences Sociales in Paris. His many publications include *The Origin of Perspective* (1994, Eng. trans.) and *Skyline: The Narcissistic City* (2001).

Edmundo Desnoes, born in Havana in 1930, is the author of *Memories of Underdevelopment*. He lives and writes in New York City and teaches at the Interactive Telecommunications Program (ITP), New York University.

Umberto Eco is known for his novels, *The Name of the Rose* (1983) and *Foucault's Pendulum* (1989) as well as his academic publications. He is Professor of Semiotics at the University of Bologna, Italy.

Steve Edwards is research lecturer in art history at The Open University, UK. He has published widely on photography; edited *Art and Its Histories: a Reader* (1999). His historical critique, *Allegories of Labour: the Making of English Photography*, is due for publication in 2002.

Andy Grundberg, critic, curator and teacher organised the travelling exhibition 'In Response to Place: Photographs from The Nature Conservancy's Last Great Places' (2001). His writings are collected in *The Crisis of the Real* (1999 – expanded edition).

Stuart Hall is Emeritus Professor of Sociology, The Open University, UK. His published contributions include many of the early texts of British cultural studies, work on 'Thatcherism' and, more recently, on race, ethnicity and cultural identity.

Lisa Henderson is Associate Professor of Communication at the University of Massachusetts, Amherst (USA), where she works on cultural production and sexual representation.

bell hooks' many publications include *Black Looks: Race and Representation* (1992), *Outlaw Culture: Resisting Representations* (1994), and *Reel to Real: Race Sex and Class at the Movies* (1996). She is Distinguished Professor of English at City College, New York.

Angela Kelly is a photographic artist, educator and exhibition organiser; her photographic art work is included in international collections world wide. Originally from Belfast N. Ireland, she is Associate Professor at the Rochester Institute of Technology in Rochester, NY.

Sarah Kember is the author of *Virtual Anxiety: Photography, New Technologies and Subjectivity* (1998) and *Cyberfeminism and Artificial Life* (2002). She teaches at Goldsmiths College, University of London, UK.

Annette Kuhn is Professor of Film Studies, Lancaster University, UK, and an editor of *Screen*. Her publications include *Alien Zone II* (editor, 1999) and *Family Secrets* (1995). Her new book on cinema and cultural memory will be published in 2002.

Lucy R. Lippard is a writer, curator, activist, and author of twenty books on contemporary art and critical studies, most recently – *On The Beaten Track: Tourism, Art and Place* (1999).

Martin Lister is Head of the School of Cultural Studies at the University of the West of England. He has lectured and published widely on visual culture and the digital image. He is editor of *The Photographic Image in Digital Culture* (1995), and co-author of *New Media: A Critical Introduction* (2002).

Catherine Lutz is Professor of Anthropology at the University of North Carolina, Chapel Hill, and author of *Unnatural Emotions* (1988), *Homefront: A Military City* (2001) and *The American Twentieth Century*, and co-author with Jane Collins of *Reading National Geographic* (1993).

Lev Manovich writes on new media. Publications include *The Language of New Media* (2001). He lectures in the Visual Arts Department at the University of California, San Diego.

Roberta McGrath's publications include *Seeing her Sex: Medical Archives* and *The Female Body* (2002). She lectures on photography theory and criticism at Napier University, Edinburgh.

Rosy Martin is an artist-photographer, therapist, lecturer, workshop leader and writer. She has exhibited and published widely since 1985, including essays in *Stolen Glances* (1991), *Family Snaps* (1991), *What can a Woman do with a Camera* (1995) and *Gender Issues in Art Therapy* (2002).

Christian Metz (1931–1993) contributed founding work on cinesemiotics and psychoanalytic film theory. Publications included *Film Language* (1974) and *The Imaginary Signifier* (1982). He was a director of research at the Ecole des Hautes Etudes en Science Sociales, Paris.

W. J. T. Mitchell has been editor of *Critical Inquiry* since 1978 and is the author of numerous articles and books on the visual arts, literature and media, including *Iconology* (1986), *Picture Theory* (1994) and *The Last Dinosaur Book* (1998). He teaches literature and art history at the University of Chicago.

László Moholy-Nagy (1895–1946), Hungarian artist, designer, photographer, film-maker, and broadcaster, was a central figure in the German Bauhaus design movement of the 1920s, (later exiled to become the Chicago Institute of Design).

Wright Morris (1910–1998) author and photographer, documented middle America on film and in his many novels and short stories. He was for many years Professor of English at San Francisco State College.

Marjorie Perloff's most recent books are *Wittgenstein's Ladder: Poetic Language and the Strangeness of the Ordinary* (1996), *Poetry On Off the Page* (1998) and *Twenty First Century Modernism* (2001). She is Sadie D. Patek Professor of Humanities Emerita at Stanford University.

Martha Rosler is an artist who works with video, photography and installation. A book of her essays is forthcoming from MIT Press.

Allan Sekula, photographer, writer and critic has published and exhibited widely including *Photography Against the Grain* (1984), *Fish Story* (1995), *Geography Lesson: Canadian Notes* (1997). He teaches at CalArts, Los Angeles.

Abigail Solomon-Godeau has written widely on postmodernism, feminist theory and nineteenth-century and contemporary art. She is the author of *Photography at the Dock: Essays on Photographic History, Institutions and Practices* (1991) and *Male Trouble: A Crisis in Representation* (1997). She is Professor of Art History, University of California, Santa Barbara.

Susan Sontag is author of a number of collections, including *On Photography* (1973), *Against Interpretation and Other Essays* (1987). She wrote the introductions to a selection of writings by Roland Barthes, published in the USA as *The Barthes Reader* (1982) and in Britain as *Barthes: Selected Writings* (1983), and to *One Way Street and Other Writings by Walter Benjamin* (1979).

Jo Spence (1934–1992), photographer and cultural activist, was a founder member of the Half Moon Workshop, later Camerawork, in East London. Publications include *Putting Myself in the Picture* (1986) and *Family Snaps* (1991) which she co-edited with Patricia Holland.

John Szarkowski was director of the Department of Photography at the New York Museum of Modern Art, late 1960s to 1991 and organised several exhibitions and publications on American photography.

John Tagg is Professor and Chair of Art History at Binghamton University, State University of New York. His books include *The Burden of Representation* (1988, 1992) and *Grounds of Dispute* (1992). He is currently working on a new study titled, *The Disciplinary Frame*.

Edward Weston (1886–1958) painter turned photographer, was a founder member of the f.64 West Coast group (which included Imogen Cunningham and Ansel Adams); he worked in Mexico and California.

Peter Wollen, Professor of Film Studies at the University of California, Los Angeles, has published extensively on photography, modern art, Godard and on the semiotics of cinema.

Acknowledgements

Permission given by the following copyright holders and authors is gratefully acknowledged. The following were reproduced with kind permission. While every effort has been made to trace copyright holders and obtain permission, this has not been possible in all cases. Any omissions brought to our attention will be remedied in future editions.

Jan Avgikos, 'Cindy Sherman: Burning down the house' in *Artforum*, January 1993. © *Artforum*.

David A. Bailey and Stuart Hall, 'The Vertigo of Displacement' in *Ten.8*, Vol 2/3 (1990).

Roland Barthes, extracts from *Camera Lucida: Reflections on Photography*, translated by Richard Howard. Translation copyright © 1981 by Farrar, Straus & Giroux, Inc. Reprinted by permission of Hill & Wang, a division of Farrar, Straus & Giroux, LLC and The Random House Group Limited.

Geoffrey Batchen, 'Photogenics' in *History of Photography*, 22/1 (1998) pp. 18–26. Reprinted by permission of Taylor & Francis Ltd. http://www.tandf.co.uk

David Bate, 'Art, Education, Photography' in *Hyperfoto* (1997).

Karin E. Becker, 'Photojournalism and the tabloid press' in P. Dahlgren and C. Sparks, *Journalism and Popular Culture* (London, Sage, 1992). Reprinted by permission of Sage Publishing Ltd.

Walter Benjamin, from 'The Work of Art in the Age of Mechanical Reproduction' in H. Arendt (ed.) *Illuminations* (1973).

John Berger, 'Photographs of Agony' in *About Looking* (London, Writers and Readers, 1980).

Ossip Brik, 'What the Eye does not see' in Christopher Phillips, *Photography in the Modern Era* (New York, Metropolitan Museum of Art and Aperture, 1989). Reprinted by permission of the Metropolitan Museum of Art, New York.

Victor Burgin, 'Looking at Photographs', first published in *Screen Education*, No. 24 (1977), pp. 17–24. Rights on *Screen Education* are administered by *Screen*.

Douglas Crimp, 'The Museum's Old, the Library's New Subject' in *On the Museum's Ruins* (Cambridge, MIT Press, 1993). Reprinted by permission of MIT Press.

Hubert Damisch, 'Five Notes for a Phenomenology of the Photographic Image' in *October 5*.

Edmundo Desnoes, 'Cuba Made me So' in Marshall Blonsky (ed.) *On Signs* (Oxford, Basil Blackwell, 1985). Reprinted by permission of the author.

Umberto Eco, 'A Photography' from *Faith in Fakes* (London, Secker & Warburg, 1986). Used by permission of The Random House Group Ltd.

Steve Edwards, 'Snapshooters of History: passages on the postmodern argument' in *Ten.8*, No. 32 (1989). Reprinted by permission of the author.

Andy Grundberg, 'The Crisis of the Real: Photography and Postmodernism' in Daniel P. Younger, *Multiple Views* (Albuquerque, University of New Mexico, 1991). Reprinted by permission of the University of New Mexico Press.

Lisa Henderson, 'Access and Consent in Public Photography' in Larry Gross, John Stuart Katz and Jay Ruby (eds) *Image Ethics: The Moral Rights of Subjects in Photographs* (New York and Oxford, Oxford University Press, 1988). Used by permission of Oxford University Press Inc.

bell hooks, 'In Our Glory: Photography and Black Life'. Copyright © 1995 *Art on My Mind* by bell hooks. Reprinted by permission of The New Press. www.thenewpress.com

Angela Kelly, 'Self Image: Personal is Political' in *Camerawork*, 12 (January 1979). Reprinted by permission of the author.

Sarah Kember, from 'The Shadow of the Object: photography and realism' in *Textual Practice*, 10/1 (1996) pp. 145–63. Reprinted by permission of Taylor & Francis Ltd. http://www.tandf.co.uk

Annette Kuhn, 'Remembrance' in Jo Spence and Patricia Holland (eds) *Family Snaps* (London, Virago, 1991). Reprinted by permission of the author.

Lucy R. Lippard, 'Doubletake: The Diary of a Relationship with an Image' in Steven Yates (ed.) *Poetics of Space: A Critical Photographic Anthology* (Albuquerque, University of New Mexico Press, 1996).

Martin Lister, 'Introduction' to *The Photographic Image in Digital Culture* (London, Routledge, 1995). Reprinted by permission of Taylor & Francis Ltd. http://www.tandf.co.uk

Catherine Lutz and Jane Collins, 'The Photograph as an Intersection of Gazes: The Example of National Geographic' in Lucien Taylor (ed.) *Visualizing Theory: Selected Essays from V.A.R 1990–1994* (New York, Routledge Inc., 1994). Reprinted by permission of Taylor & Francis Inc.

Roberta McGrath, 'Re-reading Edward Weston' in *Ten.8*, No. 27 (1987).

Lev Manovich, 'The Paradoxes of Digital Photography' in V. Amelunxen, Stefan Iglhaut, Florian Rotzer (eds) *Photography After Photography*, (Munich, Verlag der Kunst, 1995). Reprinted by permission of the author.

Rosy Martin and Jo Spence, excerpted from 'Photo Therapy: Psychic Realism as a Healing Art?' in *Ten.8*, No. 30.

Christian Metz, 'Photography and Fetish' in *October* 34, (1985). Cambridge, MIT Press, 1985.

W. J. T. Mitchell, 'Benjamin and the Political Economy of the Photograph' in *Iconology: Image, Text, Ideology* (Chicago, University of Chicago, 1986). Reprinted by permission of the University of Chicago.

László Moholy-Nagy, 'A New Instrument of Vision' extract from 'From Pigment to Light', in *Telebar* Vol. 1/2 (1936).

Wright Morris, 'In Our Image' in *The Massachusetts Review* Vol. XIX, No. 4 (1978) reprinted in Vicki Goldberg (ed.) *Photography in Print* (Albuquerque, University of New Mexico, 1981). Reprinted by permission of the University of New Mexico Press.

Marjorie Perloff, from 'What has occurred only once: Barthes's Winter Garden/ Boltanski's Archives of the Dead' in Jean-Michel Rabaté (ed.) *Writing the Image after Roland Barthes*. Copyright © 1997 University of Pennsylvania Press. Reprinted with permission.

Martha Rosler, 'In, around, and afterthoughts (on documentary photography)' in Richard Bolton (ed.) *The Contest of Meaning* (Cambridge, MIT Press, 1989). Reprinted by permission of the author.

Allan Sekula, 'Reading an Archive: Photography between Labour and Capital' in Patricia Holland, Jo Spence and Simon Watney (eds) *Photography/Politics Two* (London, Comedia, 1986).

Abigail Solomon-Godeau, 'Winning the Game when the Rules have Changed: Art Photography and Postmodernism' in *Screen*, Vol. 25, No. 6 (1984), pp. 88–102. Reprinted by permission of *Screen*.

Susan Sontag, 'Photography within the Humanities' in Eugenia Parry Janis and Wendy MacNeil, *Photography Within the Humanities* (Danbury, 1975).

John Szarkowski, 'Introduction' from *The Photographer's Eye* (New York, MOMA, 1966). Reprinted by permission of the Museum of Modern Art.

John Tagg, 'Evidence, Truth and Order: Photographic Records and the Growth of the State' in *Ten.8*, No. 13 (1984).

Edward Weston, 'Seeing Photographically' from *The Encyclopedia of Photography* Vol. 18 (1964). Text by Edward Weston. © Center for Creative Photography, Arizona Board of Regents.

Peter Wollen, 'Fire and Ice' in John Berger and Olivier Richon, *Other than Itself* (Manchester, Cornerhouse, 1984). Reprinted by permission of the author.

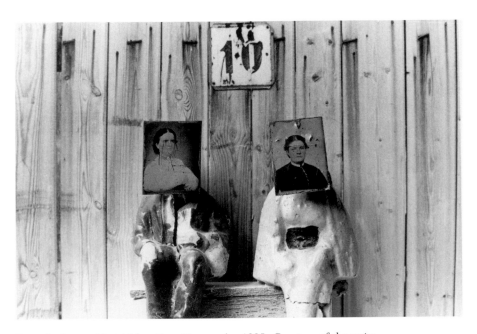

Frontispiece Mari Mahr, *About Photography*, 1985. Courtesy of the artist.

General introduction

The photograph

What is a photograph? Photography and the nature of photographic communication attracted debate throughout the twentieth century. The photograph is a particular sort of image, one which operates through freezing a moment in time, portraying objects, people and places as they appeared within the view of the camera at that moment. Photography has thus contributed to the dislocation of time and space, enlightening and enlivening history and geography. As such, it has attracted scrutiny from philosophers concerned with its semiotic structure and its phenomenological impact.

In an early work (first published in 1940) Jean-Paul Sartre examines the phenomenon of the photograph. Taking the example of a portrait of a friend whom he calls Peter, he comments that:

> The relationship between the image and its object is still very obscure. We said that the image was a consciousness of an object. The object of the image of Peter, we said, is the Peter of flesh and bone, who is actually in Berlin. But, on the other hand, the image I now have of Peter shows him to be at his home, in his room in Paris, seated in a chair well known to me. Consequently the question can be raised whether the object of the image is the Peter who actually lives in Berlin or the Peter who lived last year in Paris. And if we persist in affirming that it is the Peter who lives in Berlin, we must explain the paradox: why and how the imaginative consciousness aims at the Peter of Berlin through the Peter who lived last year in Paris?[1]

Here Sartre muses not on the image itself but on the use of photographs, for instance, as tokens of family or friendship relations.

Discussing the same issue of the character of the photograph and the experience of looking at photographs, John Berger suggests that photography is rather like memory. To be precise, he states this in relation not to the single image but to a whole system of photography. He notes that:

> memory is normally embedded in an ongoing experience of a person who is remembering If the photograph isn't 'tricked' in one way or another, it is authentic like a trace of an event: the problem is that an event, when it is isolated from all the other events that come before it and which go after it, is in another sense not very authentic because it has been seized from that ongoing experience which is the true authenticity. Photographs are both authentic and not authentic; whether the authentic side of photographs can be used authentically or not depends upon how you use them.[2]

Thus Berger's interest in photographs seems based on a notion of the photo as a sort of aide-memoire, but one which falsifies experience.

Both Berger and Sartre are assuming personal familiarity or involvement with the subject of the image. The status and use of a photograph changes according to the viewer's relation with the subject or circumstances. For instance, the same image of 'Peter' might be of interest to social historians, not because of personal familiarity, but as evidence of clothing and furniture from the period and place. Photographs often do not activate individual memory directly, but operate through soliciting identification with needs, desires, and circumstances. Obvious instances of this include advertising, fashion or travel imagery which may mobilise memories – from childhood, of romantic interludes, of family events, or whatever – but the links articulated are more indirect.

Photography encompasses a range of differing types of social and artistic practices engaging various audiences in a wide variety of contexts. As critical photo readers, we need to link considerations about the photograph as a particular sort of artifact with questions of uses of photography and its effects. Through such discussions, we can consider how and in what circumstances, we use photographs. As photographers, curators or critics, we can move from thinking about photography to thinking about the world differently, and, indeed, reconsidering our place and contribution. Not only do we want to ask how photographs operate, we also want to ask how photography can be used to resist dominant structures and practices.

Criticism

Prior to asking what we need to know about photography we might also ask why criticism is of interest to us; how it helps practitioners, curators, historians and

media analysts. Discussing the function of criticism, Terry Eagleton (1984) links criticism with political and social empowerment. He suggests that the European bourgeoisie of the seventeenth and eighteenth centuries began to carve out a public arena wherein debate about literature featured as one element within more general discussions and judgments. Social groups thus emerged, in effect challenging the aristocratic and absolutist state.

> A polite, informed public opinion pits itself against the arbitrary diktats of autocracy; within the translucent space of the public sphere it is supposedly no longer social power, privilege and tradition which confer upon individuals the title to speak and judge, but the degree to which they are constituted as discoursing subjects by sharing in a consensus of universal reason.[3]

Crucial here is the (implicit) link between public debate, education, literacy and empowerment. Of course Eagleton is referencing a relatively privileged group, one which was predominately professional and, although he does not remark this, male. But the key point here is that engagement with criticism, that is analysis and discussion of artifacts, including images, contributes to our sophistication as rational and sentient citizens. Given the inter-relation of theory and practice, critical skills inform and support artistic development as well as contributing to more general involvement with ideas and cultural processes. To lack the analytic skills, knowledge and confidence in judgment involved in critical engagement is, in effect, to be disempowered.

Essentially we are concerned not so much with a history of photography as histories of ideas about photography. The concern is with 'histories', rather than with the singular notion of 'history', which, aside from being inappropriate given postmodern thinking, could never encompass the range of contexts and uses of photography which beg analysis and discussion. Of course histories overlap and inter-sect in curious and interesting ways. Ideas and positions do not supersede one another, or inter-act and synthesise in clear dialectical fashion. Rather we witness an accumulation of models and critical perspectives which sort of fold into one another, re-emerging in shifted formations. For instance the formal and political concerns of the 1920s in Europe involving questions of class and political power were re-articulated in the 1970s, certainly in Britain, but in a new radical context more specifically incorporating issues of representation. Similarly, the debates about identity and multi-culturalism which figured in the 1970s and 1980s, at any rate in Western Europe and in North America, roll over into the issues of self, otherness and digital dialogues which seem central now. The point is that history is culturally formative. Aside from the fascination of history in its own right, study of histories allows us to better understand the references, ideological legacies and sociopolitical inheritances in relation to which we negotiate the contemporary.

Of course history, as a project, is not neutral; ideas about the photograph and about photographic practices are contested. Differing social and political concerns

offer up varying positions from which critical projects are constructed and pursued. The parameters of any project reflect the interests of the historian, both in the priorities and fascinations anchoring any project and in terms of whatever institutional constraints frame it. History may tell us as much about the historian as it does about the place, period, circumstances and activity under scrutiny!

Here, we need to be alert to developments and changes in the focus, purpose and theoretical assumptions central to the work of particular critics. Critics may publish over several decades; not only do their own positions shift, but intellectual fashions also move on as, indeed, do aesthetic, technological and social circumstances. To read one piece of work by a particular writer is not enough if what is sought is understanding of their place within debates. For instance, Roland Barthes was one of the most prominent twentieth-century writers on photography. However, there are at least two and arguably three 'Barthes', spanning a writing period of over twenty years. His first book, *Mythologies* (1957, French; translated 1972) was concerned with semiology (systems of signs) and analysis of visual communications. Later, in his essays 'The Rhetoric of the Image' and 'The Photographic Message', he focused more specifically on the paradoxes of the photograph and its nature, which, at this stage, controversially, he wishes to argue is a medium without a code. His final publication on Photography, *La Chambre claire* (1981; English version, *Camera Lucida*, 1984), is unashamedly personal in its focus on a picture of his mother and, perhaps more importantly, is concerned with the affective impact of the image. His discussion of the subjective response to particular elements in the image (punctum/studium) may be understood as a re-working and broadening of concerns addressed a few years earlier in his discussion of responses to literature, *The Pleasure of the Text* (1973; 1975, in English).

The example of Barthes reminds us that no one book or essay adequately represents the significance of the contribution of a critic of stature to twentieth-century debates; also that critics rarely write only on one subject. Their contribution to the history of debates on a specific medium may be illuminated through reading other discussions in which they have engaged. Indeed, writers such as Walter Benjamin and Susan Sontag, whose essays on photography hold central places in twentieth-century debates, are known for the breadth of their cultural engagement. Furthermore, there are a number of philosophers and cultural critics who never themselves wrote specifically on photography but without whose contribution this field of study would be notably poorer. For instance, Michel Foucault's discussion of systems of surveillance, his insights on the socially specific nature of knowledge, and his linking of knowledge, power and subjectivity have been influential. Likewise, there has been extensive reference to Lacanian psychoanalytic models by those who interpret photographs symptomatically, that is, as indicating something about the photographer or the circumstances of the making of the image as well as in terms of subjective readings and responses to images, for instance, of family or self. Thus, although we are particularly concerned with photography and digital imaging, the pertinent histories of ideas and debates are broader. We need to explore widely, in order to forge links which should, on occasion, be courageous in challenging knowledge parameters and other assumptions.

Contexts

Writings come from somewhere, are motivated, exist in specific historical circum-
stances and contexts. The British cultural critic, Raymond Williams, used the
phrase 'structure of feeling' to refer to 'certain common characteristics in a group
of writers, but also of others, in a particular historical situation'.[4] He draws our
attention to 'tendencies' in formal structure, and content or theme, evident in partic-
ular sets of historical circumstances and social relations, noting the inter-play of
public/political and individual/subjective (un)consciousness. Similarly, the German
revolutionary writer, Bertolt Brecht, argued that as reality changes, the means of
representation also have to change if art is to retain potential for radical impact.
The overall point is that artistic form is not independent of social change. It is
productive to analyse art movements in these terms. For instance, Soviet construc-
tivism and the German Bauhaus were both concerned with the relation between
aesthetic form and sociopolitical function; their critical objectives can best be
understood through taking into account the respective historical circumstances
not as context in the sense of a 'backdrop' for photographic and other practices
but as a productive influence contributing to the shaping of subjectivity and of
artistic sensibilities.

The context in which images are encountered and the organisation of photo-
graphs within particular institutional or everyday settings also beg discussion. As
a number of critics have commented, collections of photographs in public or
private archives are not neutral, but rather reflect the interests and curiosities of
the collector.[5] This is equally applicable to family albums, national collections of
photography as art, posters selected for putting on walls (for instance in student
dormitories) or local history archives. Here, the notion of 'institution' with charac-
teristic ideological positions, pre-occupations, practices and rituals encompasses
not only the institutions of photography – archives, photographers' associations,
photography education, and so on – but also the institutions in relation to which
photography occurs, wherein specific photographic conventions have emerged,
for instance, the family, the advertising agency, the international art market.
Furthermore, the gallery, magazine, hoarding, website or the family album offer
rather different sorts of viewing experiences. When thinking about the meaning
and significance of images we need to take account of the effects of the way they
are organised and the effects of their setting; also of the degree of purposeful-
ness of our engagement. For instance, idly flicking through a magazine with the
telly on, possibly distracted by children and tired at the end of a long day, is very
different to looking at the same photograph, perhaps on a larger scale in better
quality reproduction, in a gallery visited precisely for that purpose.

Contributions to debates

This selection of essays is not all-inclusive for a number of reasons. First, a great
deal has been written about photography and no single volume could do justice

to the number of academically rigorous, playful or provocative pieces of work which both delight and inform. Second, whilst most academics would agree on the centrality of certain contributions and contributors (Benjamin, Barthes, Sontag ...) aside from a handful of essays which regularly appear on university reading lists there is no clear 'canon' of contributions or indeed, writers on the subject. As I remarked in *Photography: A Critical Introduction*[6] this is partly due to the ubiquity of photography and to its diversity of professional and everyday uses and contexts. As Victor Burgin argued some years ago:

> Photography theory has no methodology peculiarly its own. Equally clearly, the wide range of types of photographic practices across a variety of disparate institutions – advertising, amateur art, journalism, etc. – means that photography theory has an object of its own only in the very minimal sense that it is concerned with signifying practices in which still images are used by an instrumentality more automatic than had been previous ways of producing images Photography theory therefore is not, nor is it ever destined to be, an autonomous discipline. It is rather an emphasis within a general history and theory of representations.[7]

And, one might add, an emphasis within communications theory.

Of course, no discipline is autonomous in terms of its concerns and field of knowledge. However, some academic disciplines have established specific histories of debate and methodological conventions. This collection is emphatically not an attempt to establish a similar canon of writings and methods for photography theory. Rather, it demonstrates a diversity of debates and of contexts within which debates have been pursued, as well as varying styles of engagement, from the polemical to the playful, from detailed academic analysis to the more journalistic.

This diversity invites us to consider what methods of analysis help us to understand the operations and affects of photographs. As Dudley Andrew has remarked:

> Technology has flooded us with representations such that we need to develop reflexes of reading in order to cope with a superabundance of signification. Semiotics might be thought of as a critical strategy responding directly to the technology of image production in the modern age. But photographs, because they are in part auto-generated, present enormous problems for those who would control the reading of them. Everything in the photo is potentially significant, even and especially, that which has escaped the control of the photographer pointing the camera. Here the indexical function of the photo comes to the fore, outweighing its iconic function. The photographic plate is etched with experience, like the unconscious; and like the unconscious, it invites a symptomatic reading of the images that escape from it to reach the surface. As was the case with psychoanalysis, the structural

study of latent meaning had eventually to give way to strategies of reading that are stimulated by excessive signification – in other words, poststructural reading strategies.[8]

By extension, it is productive to situate ideas about photography within what has come to be termed visual cultural studies wherein a diversity of methodological issues and critical strategies may be articulated. Here, the emphasis is on bringing a range of questions and methods of analysis to bear upon images and practices in order to accumulate complex understanding of their cultural operations. As Irit Rogoff notes:

> In the arena of visual culture the scrap of an image connects with a sequence of film and with the corner of a billboard or the window display of a shop we have passed by, to produce a new narrative formed out of both our experienced journey and our unconscious. Images do not stay within discrete disciplinary fields such as 'documentary film' or 'Renaissance painting', since neither the eye nor the psyche operates along or recognizes such divisions.[9]

It follows that we may productively draw upon a range of academic arenas including semiotics, psychoanalysis, art history, social history, the history of media technologies, aesthetics, philosophy and the sociology of culture in relation to specific images and photographic practices. Thus, we may want to consider method and methodology in relation to specific fields of practice – documentary, personal photography, art photography, and so on. To do so is productive. This involves taking into account more general questions associated with each particular field. For instance, in examining portraiture of children – whether within the family album or as a more formal public commission – we would want to discuss the concept of childhood relating this to particular historical circumstances and cultural understandings. However, journeys down this path risk distracting us from that which is peculiar to photography as an act and as medium (whether chemical or digital) in terms of contexts of making images and, more particularly, processes of interpretation. We have to balance more general contextual and methodological concerns with more immediate investigation of the photographic.

This book is intended primarily for undergraduate students, although I hope it may prove useful more widely. It brings into focus aspects of twentieth-century debates relating to photography; this includes issues pertaining to aesthetics, theories of knowledge, and the immanent characteristics of the photograph, as well as to uses of photography: images and contexts. This mapping takes place through the reproduction of essays which have made substantial contributions to ideas about photography and to photography criticism.

Criteria for selection of essays in this collection were varied; given the extensive amount that has been written about photography in differing contexts, the final selection was difficult. In some cases I have included essays because of their

extensive influence, for instance, Benjamin's 'artworks' essay. I have also tried to include essays that 'speak' to each other through cross-reference or debate. Sections are organised historically and thematically. Thus the first section is concerned more broadly with reflections on photographs; the following four sections, on photographic seeing, codes and rhetoric, the postmodern and photo-digital, are chronological in terms of ideas and debates; the next sections, on documentary and photojournalism, the gaze, image and identity, and contexts, are thematic, drawing out issues addressed from the late 1970s onwards. Some essays are illustrated. However, due to copyright problems, availability, and, in some instances, space, it has not been possible to include all relevant illustrations. A number of threads run through the book, across and between sections, for instance, questions of gender, or of the power of the photographic gaze, or of affects of photographs. Some decisions were pragmatic: I have taken the opportunity to include a number of essays originally published in *Ten.8* magazine (UK), now defunct and difficult to access outside certain university libraries. By contrast, only one essay from the other key UK magazine of the 1980s, *Camerawork*, has been included, not because its other essays are not equally significant, but because there is an excellent collection of work from the magazine already available.[10] I also wanted to represent as great a range of authors as possible, well-known and less celebrated, and so, with the exception of Roland Barthes, avoided reproducing more than one piece each. This again led to some difficult decisions. In many instances I had to choose between several excellent pieces of writing by the same author; furthermore, as I have already remarked, to select one essay from a body of work inevitably risks misrepresenting the overall position and diversity of explorations of the writer.

The long-list for the book included enough material for at least two volumes. In considering the organisation of material, with regret, I had to eliminate some considerations, for instance, there is little reference to photo-narrative, although there are some interesting debates on the subject, and no direct address to historiography. Aside from the section on documentary – which is also on realism and the significance accorded to images – there is no specific discussion of issues relating to particular fields of practice – fashion photography, medical, architectural, anthropological, and so on. In so far as we can talk about theorising photography, theory needs to take into account specificities of purpose and context but also to transcend this. Most of the essays included, although taking examples from one type of photographic practice – personal, advertising, photojournalism, and so on – have broader implications in terms of theory and methods of analysis. The contributions obviously reflect debates and assumptions of their era. A number of the authors have moved on from the positions, concerns and methods of analysis represented here. Nonetheless, fundamental questions about the nature and status of photographs and the act of photography echoed through much of the twentieth century and remain pertinent now.

Each section also includes a few suggestions for further reading. For a more substantial bibliography of publications on photography students are advised to consult *Photography: A Critical Introduction*, (Wells (ed.) 2000) to which this is something of a companion volume.

This book would not have been possible without the contributions of many people. First of all I should like to thank all the contributors, and their publishers, for allowing their work to be reproduced. Attempts were made to contact each of the contributors to check for any comments or amendments they wished to suggest; particular thanks to those who responded with suggestions. It goes without saying that without the essays this collection could not exist. Second, I must thank Routledge, in particular, Rebecca Barden, for entrusting me with this challenge and responsibility. Also thanks to Christopher Cudmore, Alistair Daniel and Katherine Ahl for their work on the project. Third, acknowledgement to library staff, University of Plymouth at Exeter, for their unfailing help. Draft versions of this introduction were given as papers in research seminars, University of Plymouth at Exeter, at the Society for Photographic Education annual conference, 2001 and at the symposium 'Why Pictures Now?' in Krakow, 2001. My grateful thanks to my colleagues at the university and to conference participants elsewhere, for their many helpful comments and suggestions. Finally, I am grateful for help and support from friends, in particular, David Bate, Martin Lister, and Rosy Martin.

Notes

1 Jean-Paul Sartre (1972) *The Psychology of Imagination*, London: Methuen & Co., p. 16, first published in French in 1940, Eng. trans. 1948, NY: Philosophical Library Inc.
2 Interviewed in 'The Authentic Image', *Screen Education* No. 32/33 Autumn/Winter 1979/80.
3 Eagleton, T. (1984) *The Function of Criticism*, London: Verso, p. 9.
4 Raymond Williams (1980) 'Literature and Sociology' in *Problems in Materialism and Culture*, London: Verso, p. 22.
5 Cf, in particular, Allan Sekula 'Reading an Archive: Photography between Labour and Capital', included in this collection.
6 Liz Wells (ed.) (1997, 2000) *Photography: A Critical Introduction*, London: Routledge. An introduction to key debates in photographic histories and theory. Third edition planned for 2004.
7 Victor Burgin (1984) 'Something about Photography Theory', *Screen* Vol. 25 No. 1 p. 65.
8 Dudley Andrew (1997) *The Image in Dispute*, Austin: University of Texas pp. x/xi.
9 Irit Rogoff (1998) 'Studying Visual Culture' in Nicholas Mirzoeff (1998) *The Visual Culture Reader*, London and NY: Routledge, p. 16.
10 Jessica Evans (ed.) (1997) *The Camerawork Essays*, London: Rivers Oram Press.

Reflections on photography

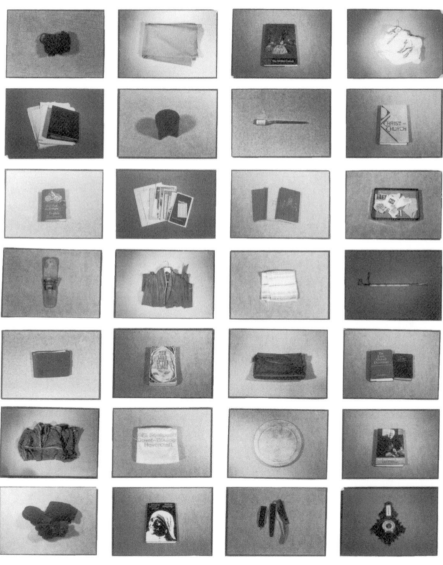

Christian Boltanski, *Inventaire des objets ayant appartenu à un habitant d'Oxford*, 1973. Courtesy of the Marian Goodman Gallery, New York.

Introduction

WHAT DISTINGUISHES PHOTOGRAPHY from other means of visual representation? How do photographs acquire meaning? How do we use them? Such questions have proved perplexing ever since the inception of photography.

In the nineteenth century such debates generally assumed that photography had characteristics which made it a more accurate method of recording and representing than previously existing methods (such as painting or observational drawing). Language reflects attitudes to artifacts and experiences. In French, the camera lens is called the 'objectif', a term which twins defining what we see as the 'object' of vision, and the idea of 'objectivity', in the sense of impartial observation. In Spanish, the camera is called a 'machina', a term which implies the mechanical. As with other machinery, it is possible to use the camera to make images without understanding the technical mechanisms involved. We don't have to analyse and comprehend either the physical 'machinery' or the properties of 'vision' to make an image. Analysis of ideas and experiments in the construction and interpretation of images takes us into the realms of chemistry, optics, physics, as well as those of aesthetics and visual communication (see, for instance, Aumont 1997).

Many historians have noted the coincidence of early photography with realism in painting in the mid-nineteenth century. Realism emphasised painting from observation, as opposed, for instance, to painting narratives from history, or to religious iconography. Realism was thus seated in empirical aesthetics. Photographer and photo-historian, Giselle Freund, suggested that this

> aesthetic equation of visual reality with the reality of nature was also the premise of the photographer, for whom reality in nature was defined only by the optical image of nature Imagination had little role in his work, which consisted only in choosing the subject matter, evaluating the best way to frame it, and selecting the pattern of light and shadow. His work ended there, even before the shutter clicked.
>
> (Freund 1980: 71)

On the other hand, there was emphasis on the expressive properties of the photograph and the creativity of the photographer. This reflected experiments in use of light and chemicals, including contact printing; also, staging of dramatic scenarios (for instance, by Julia Margaret Cameron) or the framing and titling of images to suggest the metaphoric (for instance, H. P. Robinson). Such imagery allowed 'pictorialists', towards the end of the nineteenth century, to claim photography as an art practice. Thus, at the turn of the twentieth century, theoretical investigations and speculations as to the constitution of photographs were influenced by a tension between realist and expressive aesthetics, which to some extent correlated with different intentions and uses of the medium.

By the end of the nineteenth century, photography was being used within a very great range of spheres of activity, from the anthropological and the medical

to the domestic, everyday; from street photography to explicitly poetic imagery. Possibilities for photography burgeoned as firms such as Kodak, Eastman, Lumières Bros set out to invent new, relatively portable and easy-to-use cameras. Indeed, by the end of the 1880s both hand-held cameras and sensitised paper (replacing glass plates) were available. Kodak advertising carried the tag line 'you press the button, we do the rest' (the whole camera was returned for a reel of film to be processed). As manufacturers, their motives were in part profit-driven, but their interest in expanding possibilities made cameras more widely accessible.

For theorists the implications of 'fixing a shadow' remained puzzling. In Latin, 'camera' refers to a vault or arched chamber. The mediaeval camera obscura was thus a darkened, contained space. Susan Sontag's opening essay 'In Plato's Cave' in *On Photography* (Sontag 1979) references this idea of letting light reflect shadows within a dark space. Classical Greek philosopher, Plato, talked of a cave within which light through a hole reflected images from outside of the cave. Sontag's title reminds us that shadow play and the transient effects of the reflection of light have long been a source of fascination. But once the image could be fixed it became an agent of disruption, changing our sense of space and time – of geography and history – as we became able to view images of people and places otherwise unseen.

The debates about the photograph included in this section (and, indeed, in this collection as a whole) focus upon the sociocultural. What impact does photography, which literally means 'writing with light', have on our ways of seeing, experiencing and making sense of experience? How do we use photographs? In what ways might photographs be said to 'frame' vision or preempt interpretation, for instance, when we see photographs of people or places in advance of actually meeting or visiting. What can photographs reveal that would otherwise be imperceptible? Walter Benjamin argues that photography draws attention to the 'optical unconscious':

> Whereas it is a commonplace that, for example, we have some idea what is involved in the act of walking, if only in general terms, we have no idea at all what happens during the fraction of a second when a person *steps out*. Photography, with its devices of slow motion and enlargement, reveals the secret. It is through photography that we first discover the existence of this optical unconscious, just as we discover the instinctual unconscious through psychoanalysis.
>
> (Benjamin 1931: 243)

Photographs, in this respect, can offer explicit evidence of aspects of behaviour (human, animal, plant) that otherwise would not be available for comment or analysis. Through photography, information is brought 'into the picture'.

More recently, philosophers have questioned whether we can distinguish between the world as experienced directly, whether consciously acknowledged or unconsciously taken into account, and the world as represented to us. For instance, semiotician, Umberto Eco, notoriously made a visit to New Orleans (the

city) in order the check whether it lived up to its simulation in Disneyland. Likewise, the postmodern rhetoritician, Jean Baudrillard asserted that *The Gulf War Did Not Take Place*, not because he thought that nothing had actually occurred, but because he wanted to draw attention to the fact that for most people this experience was one of photographic/televisual representation and mediation (Baudrillard 1995). So how can we best understand the inter-relation of image, experience and comprehension? In what ways has photography changed the social world?

Such questions have been central to the concerns of a number of key twentieth-century philosopher-critics whose contemplations on photography have contributed to defining the parameters of theoretical debates. Such contributions have often taken the form of discussion of photography or of photographs within broader phenomenological considerations, as for instance, in Jean-Paul Sartre's musings (see p. 1). Others have written more specifically about photographs and about photography. A number question the relation between the image and the world of objects and appearances which it references. For instance, Max Kosloff in trying to define something of the fascination of photographs suggests that photos 'witness' events, whilst Susan Sontag refers to photographs as 'traces' or 'stencils' imprinted from actuality, whereas John Berger suggests that photographs can best be understood as quotations from actuality (Berger 1982; Kosloff 1979; Sontag 1979). Such terminology is not only indicative of a suggested relation with the world of appearances but also of uses of images; for instance, to conceptualise the photograph as 'witness' is to suggest that photographs offer evidence, that they are testimonials; extending the analogy, Kosloff comments that images can offer false or partial witness. Furthermore, a term such as 'witness' will always imply documentary concerns. By contrast, terms such as 'trace' or 'stencil' or 'quotation' suggest references which become detached from their source, circulating in new contexts but with something of their origins continuing to adhere. Such terminology invites us to consider the slippage between specific histories and experiences and more general historical contexts and circumstances.

Roland Barthes, Susan Sontag and Walter Benjamin are among the preeminent twentieth-century critics who have specifically examined photography. Hence the inclusion of their essays or extracts in this section. In each case, their writing is 'paired' with a response or related piece which in some way engages, places and develops from their contribution.

Camera Lucida was Roland Barthes' final book and therefore, in effect, his last word on the photograph. It is in two parts, composed of forty-eight sections. The first part deals primarily with the nature of the photograph as a phenomenon with a particular sort of relation to history, and echoes some of the concerns engaged a couple of decades earlier by Jean-Paul Sartre (to whom *Camera Lucida* is dedicated), in *L'Imaginaire*. The second part stands as a meditation on photography as a marker of the passage of time. He centrally addresses the image as a courier of emanations from the past, asking what particularly arrests attention. The poignancy of the image is emphasised through his starting point: a photograph of his (deceased) mother. The title of the book, in French *La Chambre claire* sets

up a series of resonances around photography, the empty but illuminated ('clair') chamber, being, like Plato's Cave, a space of inscription.

Barthes' final meditation upon photographs has attracted wide-ranging debate. Here, Marjorie Perloff responds in particular to the second half of the book, Barthes' elegy to his dead mother which centres on the autobiographical. Perloff explores Barthes' contribution through the 'filter' of the work of artist, Christian Boltanski, in particular, his installations based on the Holocaust. Through this comparative analysis, the nature and status of the image and its relation to history, as conceptualised by Barthes, is brought into question. Boltanski's work invites us to think about photographs as markers of absence and to question everyday images, appearances and events. His approach echoes Barthes' own lack of concern with the authoring of the image. Barthes' interest was in everyday imagery, in the photograph as a carrier of meaning, both as a semiotic artifact (the focus of his earlier work) and as a phenomenon with psychological and autobiographical implications (emphasised in his later work).

European photography in the modern era was characterised by a sense of change. It was not alone in this. In particular, after the First World War in Europe and after the Soviet Revolution, there was a sense of a need for reconstruction which linked the artistic, the social and the political. In Germany, the group of philosophers and critics, retrospectively labelled 'Frankfurt School', were concerned, amongst other things, with the relation between public spheres of debate and activity and the private, and also with the social role of art. Within this group, Walter Benjamin paid particular attention to photography, to questions of authorship and to collecting, including the construction of archives. His famous essay on 'The Work of Art in an Age of Mechanical Reproduction' is frequently reproduced and cited in twentieth-century writings on the impact and implications of photography. The essay, first published in 1936, centrally considers two issues: first, the nature of photography as a creative act, one which differs in its immediacy and in its relation to actuality from other forms of activity; second, what he views as the democratising effects of the mass reproducibility of images. Although photography had been widespread since the mid-nineteenth century, it was only at the turn of the twentieth century that developments in lithography allowed for mass reproduction and publication of photo-images. The original German title for the essay literally translates as 'The Work of Art in an Era of Technical *Reproducibility*', emphasising the expanding potential for mass duplication. This essay acquired new life in the 1990s through frequent reference by those concerned to analyse the impact and implications of digital imaging and cyberspace networks.

William J. T. Mitchell's contextualisation of Benjamin's essays on photography helps locate them within Marxist criticism, emphasising the materialist – or economic – foundations of Benjamin's discussion. For Marxism there is a distinction within Capitalism between the cost of production (involving investment in raw materials, machinery and labour) and the exchange value which a product can command in the market place as a socially valued or 'fetishised' commodity. Fetishisation is a consequence of attributes projected onto the commodity – hence Mitchell's reference to the fetishism of aesthetics. The extract is from a much

longer publication in which Mitchell's principal concern is to investigate ideas about imagery.

Issues, ideas and practices age, especially as information, knowledge, understandings and technologies change and develop. Richard Bolton has remarked that:

> The disruptions and challenges posed by modernist invention have been assimilated into the status quo; once-radical methods for producing alternative reality have become apolitical means for reproducing dominant reality. Despite the utopian and anarchic desires that fueled modern art, its lasting impact seems to have been on commodity production, mass media, and other means of social control. Its greatest accomplishment can be found in the public's adjustment to the new productive and reproductive apparatuses of twentieth-century life.
>
> (Bolton 1989: xi)

Likewise, writings reflect contemporary concerns and debates. Philosophical contributions should be considered both in terms of their significance at the time and in terms of their helpfulness in illuminating critical enquiry now.

The third pairing of Susan Sontag and Wright Morris is more indirect, based upon the manner of the critical process rather than upon direct engagement by the one critic with the work of the other. Sontag wrote six essays on photography which were collected as a book in 1973 (and also made into a television discussion under the title *It's Stolen Your Face*, BBC, UK). According to her own account, she wrote the essays in sequence, each pushing her central problematics further. Overall, she questions the moral implications of the making and distribution of photographs. Two years later she was invited to lecture at Jewett Arts Center, Wellesley College, Massachusetts, within a series of ten talks, mostly by photographers, and to contribute to an accompanying exhibition. Her lecture reproduced here, in effect summarises her position on the nature and uses of photography.

Photographs record surface perceptions in a detailed manner which allows that which might be known through the optical unconscious, but not previously articulated, to become explicit. Writing at around the same time as Sontag, Morris is likewise concerned with the implications and effects of the ubiquity and proliferation of photographic images and what he views as the 'rise in status' of the photograph. He distinguishes between the 'image', consequent upon the eye and vision of the photographer as artist; and the 'photograph' which he sees as fixed by the camera. He emphasises the everyday, the pleasure of looking at anonymous, vernacular images, and speculates on the interaction of photographs, history and myth.

Finally, Peter Wollen, in the late 1980s, explores distinctions between the still and the moving image. Through contrasting the time-based nature of film with the 'frozen moment' that is the photograph, Peter Wollen speculates on the defining characteristics of each medium. He suggests that film has an immediacy, a 'here

and nowness', and an ability to carry us along in fascination; this contrasts with the frozen moment, the 'there and thenness', of the photograph. Written originally for a collection focussed on the postmodern and photography, this essay suggests slippages which refuse the possibility of making definitive statements either about distinctions between the time-based and the still or, indeed, about the conceptual nature and affects of photographs.

References and selected further reading

Aumont, J. (1997) *The Image*. London: British Film Institute. First published in French in 1990.

Baudrillard, J. (1995) *The Gulf War Did Not Take Place*. Sydney: Power Publications.

———— (1983) *Simulations*. NY: Semiotext.

Bazin, A. (1967) 'The Ontology of the Photographic Image' in *What is Cinema*? Vol. 1. Berkeley: University of California Press. Original French publication, 1945.

Benjamin, W. (1931) 'A Short History of Photography' included in Benjamin, W. (1979) *One Way Street*. London: New Left Books. Also in Trachtenberg (1980) Classic Essays on Photography: New Haven: Leete's Island Books.

Berger, J. (1980) 'Uses of Photography' in his *About Looking*. London: Writers and Readers.

———— (1982) 'Appearances' in *Another Way of Telling*: London: Writers and Readers.

Bolton, R. (ed.) (1989) *The Contest of Meaning*. Cambridge, Mass: MIT Press. American critical essays reappraising photo-histories.

Buck Morse, S. (1992) 'Aesthetics and Anaesthetics: Walter Benjamin's Artwork Essay Reconsidered' *October* No. 62, Fall, pp. 3–41.

Coleman, A. L. (1979) *Light Readings*. NY: Oxford University Press.

———— (1995) *Critical Focus: Photography in the International Image Community*. Munich: Nazraeli Press. Collections of reviews and essays, mostly written for U.S. magazines and catalogues.

Eco, U. (1990) *Travels in Hyperreality*. San Diego: Harcourt Brace.

Freund, G. (1980) *Photography and Society*. London: Gordon Fraser. Originally published in French, 1974.

Goldberg, V. (ed.) (1981) *Photography in Print: Writings from 1816 to the Present*. Albuquerque: University of New Mexico Press. Organised chronologically in terms of debates and practitioners, the final ten essays dating from the 1970s, indicate something of then contemporary concerns. Aside from one contribution (from Barthes), these particularly reflect American perspectives.

Kosloff, M. (1987) *The Privileged Eye*. Albuquerque: University of New Mexico Press.

———— (1979) *Photography and Fascination*. Danbury, New Hampshire: Addison House. Collections of his essays and reviews published variously in magazines such as *Artforum, Art in America, Village Voice*.

Lomax, Y. (2000) *Writing the Image*. London: I. B. Taurus. Speculation on the nature and uses of photography.

Petruck, P. R. (1979) *The Camera Viewed: writings on twentieth-century photography*. NY: Dutton. Useful collection, including writings by Barthes, Man Ray, Sontag, Duane Michals.

Sartre, J-P. (1948) *The Psychology of the Imagination*. NY: Philosophical Library. First published in French in 1940 as *L'Imaginaire*, Paris: Éditions Gallimard. A broad phenomenological discussion which includes a section on 'The Image Family'.

Sontag, S. (1979) *On Photography*. Harmondsworth: Penguin. First published 1973.

Trachtenberg, A. (ed.) (1980) *Classic Essays on Photography*. New Haven: Leete's Island Books.

A key collection which reflects concerns of the 1970s but includes a number of essays from earlier periods.

Bibliography of essays in Part One

Barthes, R. (1984) *Camera Lucida*. London: Flamingo (Fontana).

Benjamin, W. (1936) 'The Work of Art in an Age of Mechanical Reproduction' in Hannah Arendt (ed.) (1973) *Illuminations*. London: Fontana.

Mitchell, W. J. T. (1986) 'Benjamin and the Political Economy of the Photograph' pp. 178–85 in his *Iconology: Image, Text, Ideology*. Chicago: University of Chicago Press.

Morris, W. (1978) 'In our Image', *The Massachusetts Review* Vol. XIX, No. 4. The Massachusetts Review Inc., pp. 534–45. Reprinted in Vicki Goldberg (1981) *Photography in Print*. Albuquerque: University of New Mexico.

Perloff, M. (1994) 'What has occurred only once: Barthes's Winter Garden/Boltanski's Archives of the Dead' in Jean-Michel Rabate (1997) *Writing the Image After Roland Barthes*. Philadelphia: University of Pennsylvania Press.

Sontag, S. (1976) 'Photography within the Humanities' in Eugenia Parry Janis and Wendy MacNeil, *Photography within the Humanities*. Danbury, New Hampshire: Addison House Publishers.

Wollen, P. (1984) 'Fire and Ice' in John X. Berger and Olivier Richon (1989) *Other than Itself*. Manchester: Cornerhouse.

Roland Barthes

EXTRACTS FROM *CAMERA LUCIDA*

1

ONE DAY, QUITE SOME TIME AGO, I happened on a photograph of Napoleon's youngest brother, Jerome, taken in 1852. And I realized then, with an amazement I have not been able to lessen since: 'I am looking at eyes that looked at the Emperor.' Sometimes I would mention this amazement, but since no one seemed to share it, nor even to understand it (life consists of these little touches of solitude), I forgot about it. My interest in Photography took a more cultural turn. I decided I liked Photography *in opposition* to the Cinema, from which I nonetheless failed to separate it. This question grew insistent. I was overcome by an 'ontological' desire: I wanted to learn at all costs what Photography was 'in itself,' by what essential feature it was to be distinguished from the community of images. Such a desire really meant that beyond the evidence provided by technology and usage, and despite its tremendous contemporary expansion, I wasn't sure that Photography existed, that it had a 'genius' of its own.

2

Who could help me?

From the first step, that of classification (we must surely classify, verify by samples, if we want to constitute a corpus), Photography evades us. The various distributions we impose upon it are in fact either empirical (Professionals / Amateurs), or rhetorical (Landscapes / Objects / Portraits / Nudes), or else aesthetic (Realism / Pictorialism), in any case external to the object, without relation to its essence, which can only be (if it exists at all) the New of which it has been the advent; for these classifications might very well be applied to other, older forms of representation. We might say that Photography is unclassifiable. Then I wondered what the source of this disorder might be.

The first thing I found was this. What the Photograph reproduces to infinity has occurred only once: the Photograph mechanically repeats what could never be repeated existentially. In the Photograph, the event is never transcended for the sake of something else: the Photograph always leads the corpus I need back to the body I see; it is the absolute Particular, the sovereign Contingency, matte and somehow stupid, the *This* (this photograph, and not Photography), in short, what Lacan calls the *Tuché*, the Occasion, the Encounter, the Real, in its indefatigable expression. In order to designate reality, Buddhism says *sunya*, the void; but better still: *tathata*, as Alan Watts has it, the fact of being this, of being thus, of being so; *tat* means *that* in Sanskrit and suggests the gesture of the child pointing his finger at something and saying: *that, there it is, lo!* but says nothing else; a photograph cannot be transformed (spoken) philosophically, it is wholly ballasted by the contingency of which it is the weightless, transparent envelope. Show your photographs to someone – he will immediately show you his: 'Look, this is my brother; this is me as a child,' etc.; the Photograph is never anything but an antiphon of 'Look,' 'See' 'Here it is;' it points a finger at certain *vis-à-vis*, and cannot escape this pure deictic language. This is why, insofar as it is licit to speak of *a* photograph, it seemed to me just as improbable to speak of *the* Photograph.

A specific photograph, in effect, is never distinguished from its referent (from what it represents), or at least it is not *immediately* or *generally* distinguished from its referent (as is the case for every other image, encumbered – from the start, and because of its status – by the way in which the object is simulated): it is not impossible to perceive the photographic signifier (certain professionals do so), but it requires a secondary action of knowledge or of reflection. By nature, the Photograph (for convenience's sake, let us accept this universal, which for the moment refers only to the tireless repetition of contingency) has something tautological about it: a pipe, here, is always and intractably a pipe. It is as if the Photograph always carries its referent with itself, both affected by the same amorous or funereal immobility, at the very heart of the moving world: they are glued together, limb by limb, like the condemned man and the corpse in certain tortures; or even like those pairs of fish (sharks, I think, according to Michelet) which navigate in convoy, as though united by an eternal coitus. The Photograph belongs to that class of laminated objects whose two leaves cannot be separated without destroying them both: the window-pane and the landscape, and why not: Good and Evil, desire and its object: dualities we can conceive but not perceive (I didn't yet know that this stubbornness of the Referent in always being there would produce the essence I was looking for).

This fatality (no photograph without *something* or *someone*) involves Photography in the vast disorder of objects – of all the objects in the world: why choose (why photograph) this object, this moment, rather than some other? Photography is unclassifiable because there is no reason to *mark* this or that of its occurrences; it aspires, perhaps, to become as crude, as certain, as noble as a sign, which would afford it access to the dignity of a language: but for there to be a sign there must be a mark; deprived of a principle of marking, photographs are signs which don't *take*, which *turn*, as milk does. Whatever it grants to vision and whatever its manner, a photograph is always invisible: it is not it that we see.

In short, the referent adheres. And this singular adherence makes it very diffi-cult to focus on Photography. The books which deal with it, much less numerous

moreover than for any other art, are victims of this difficulty. Some are technical; in order to 'see' the photographic signifier, they are obliged to focus at very close range. Others are historical or sociological; in order to observe the total phenomenon of the Photograph, these are obliged to focus at a great distance. I realized with irritation that none discussed precisely the photographs which interest me, which give me pleasure or emotion. What did I care about the rules of composition of the photographic landscape, or, at the other end, about the Photograph as family rite? Each time I would read something about Photography, I would think of some photograph I loved, and this made me furious. Myself, I saw only the referent, the desired object, the beloved body; but an importunate voice (the voice of knowledge, of *scientia*) then adjured me, in a severe tone: 'Get back to Photography. What you are seeing here and what makes you suffer belongs to the category "Amateur Photographs," dealt with by a team of sociologists; nothing but the trace of a social protocol of integration, intended to reassert the Family, etc.' Yet I persisted; another, louder voice urged me to dismiss such sociological commentary; looking at certain photographs, I wanted to be a primitive, without culture. So I went on, not daring to reduce the world's countless photographs, any more than to extend several of mine to Photography: in short, I found myself at an impasse and, so to speak, 'scientifically' alone and disarmed.

[. . .]

4

So I make myself the measure of photographic 'knowledge.' What does my body know of Photography? I observed that a photograph can be the object of three practices (or of three emotions, or of three intentions): to do, to undergo, to look. The *Operator* is the Photographer. The *Spectator* is ourselves, all of us who glance through collections of photographs – in magazines and newspapers, in books, albums, archives . . . And the person or thing photographed is the target, the referent, a kind of little simulacrum, any *eidolon* emitted by the object, which I should like to call the *Spectrum* of the Photograph, because this word retains, through its root, a relation to 'spectacle' and adds to it that rather terrible thing which is there in every photograph: the return of the dead.

One of these practices was barred to me and I was not to investigate it: I am not a photographer, not even an amateur photographer: too impatient for that: I must see right away what I have produced (Polaroid? Fun, but disappointing, except when a great photographer is involved). I might suppose that the *Operator's* emotion (and consequently the essence of Photography-according to-the-Photographer) had some relation to the 'little hole' (*stenope*) through which he looks, limits, frames, and perspectivizes when he wants to 'take' (to surprise). Technically, Photography is at the intersection of two quite distinct procedures; one of a chemical order: the action of light on certain substances; the other of a physical order: the formation of the image through an optical device. It seemed to me that the *Spectator's* Photograph descended essentially, so to speak, from the chemical revelation of the object (from which I receive, by deferred action, the rays), and that the *Operator's* Photograph, on the contrary, was linked to the vision framed by the keyhole of the *camera obscura*.

But of that emotion (or of that essence) I could not speak, never having experienced it; I could not join the troupe of those (the majority) who deal with Photography-according-to-the-Photographer. I possessed only two experiences: that of the observed subject and that of the subject observing . . .

5

It can happen that I am observed without knowing it, and again I cannot speak of this experience, since I have determined to be guided by the consciousness of my feelings. But very often (too often, to my taste) I have been photographed and knew it. Now, once I feel myself observed by the lens, everything changes: I constitute myself in the process of 'posing,' I instantaneously make another body for myself, I transform myself in advance into an image. This transformation is an active one: I feel that the Photograph creates my body or mortifies it, according to its caprice (apology of this mortiferous power: certain Communards paid with their lives for their willingness or even their eagerness to pose on the barricades: defeated, they were recognized by Thiers's police and shot, almost every one).

Posing in front of the lens (I mean: knowing I am posing, even fleetingly), I do not risk so much as that (at least, not for the moment). No doubt it is metaphorically that I derive my existence from the photographer. But though this dependence is an imaginary one (and from the purest image-repertoire), I experience it with the anguish of an uncertain filiation: an image – my image – will be generated: will I be born from an antipathetic individual or from a 'good sort'? If only I could 'come out' on paper as on a classical canvas, endowed with a noble expression – thoughtful, intelligent, etc.! In short, if I could be 'painted' (by Titian) or drawn (by Clouet)! But since what I want to have captured is a delicate moral texture and not a mimicry, and since Photography is anything but subtle except in the hands of the very greatest portraitists, I don't know how to work upon my skin from within. I decide to 'let drift' over my lips and in my eyes a faint smile which I mean to be 'indefinable,' in which I might suggest, along with the qualities of my nature, my amused consciousness of the whole photographic ritual: I lend myself to the social game, I pose, I know I am posing, I want you to know that I am posing, but (to square the circle) this additional message must in no way alter the precious essence of my individuality: what I am, apart from any effigy. What I want, in short, is that my (mobile) image, buffeted among a thousand shifting photographs, altering with situation and age, should always coincide with my (profound) 'self'; but it is the contrary that must be said: 'myself' never coincides with my image; for it is the image which is heavy, motionless, stubborn (which is why society sustains it), and 'myself' which is light, divided, dispersed; like a bottle-imp, 'myself' doesn't hold still, giggling in my jar: if only Photography could give me a neutral, anatomic body, a body which signifies nothing! Alas, I am doomed by (well-meaning) Photography always to have an expression: my body never finds its zero degree, no one can give it to me (perhaps only my mother? For it is not indifference which erases the weight of the image – the Photomat always turns you into a criminal type, wanted by the police – but love, extreme love).

To see oneself (differently from in a mirror): on the scale of History, this action is recent, the painted, drawn, or miniaturized portrait having been, until the spread

of Photography, a limited possession, intended moreover to advertise a social and financial status – and in any case, a painted portrait, however close the resemblance (this is what I am trying to prove) is not a photograph. Odd that no one has thought of the *disturbance* (to civilization) which this new action causes. I want a History of Looking. For the Photograph is the advent of myself as other: a cunning dissociation of consciousness from identity. Even odder: it was *before* Photography that men had the most to say about the vision of the double. Heautoscopy was compared with an hallucinosis; for centuries this was a great mythic theme. But today it is as if we repressed the profound madness of Photography: it reminds us of its mythic heritage only by that faint uneasiness which seizes me when I look at 'myself' on a piece of paper.

This disturbance is ultimately one of ownership. Law has expressed it in its way: to whom does the photograph belong? Is landscape itself only a kind of loan made by the owner of the terrain? Countless cases, apparently, have expressed this uncertainty in a society for which being was based on having. Photography transformed subject into object, and even, one might say, into a museum object: in order to take the first portraits (around 1840) the subject had to assume long poses under a glass roof in bright sunlight; to become an object made one suffer as much as a surgical operation; then a device was invented, a kind of prosthesis invisible to the lens, which supported and maintained the body in its passage to immobility: this headrest was the pedestal of the statue I would become, the corset of my imaginary essence.

The portrait-photograph is a closed field of forces. Four image-repertoires intersect here, oppose and distort each other. In front of the lens, I am at the same time: the one I think I am, the one I want others to think I am, the one the photographer thinks I am, and the one he makes use of to exhibit his art. In other words, a strange action: I do not stop imitating myself, and because of this, each time I am (or let myself be) photographed, I invariably suffer from a sensation of inauthenticity, sometimes of imposture (comparable to certain nightmares). In terms of image-repertoire, the Photograph (the one I *intend*) represents that very subtle moment when, to tell the truth, I am neither subject nor object but a subject who feels he is becoming an object: I then experience a micro-version of death (of parenthesis): I am truly becoming a specter. The Photographer knows this very well, and himself fears (if only for commercial reasons) this death in which his gesture will embalm me. Nothing would be funnier (if one were not its passive victim, its *plastron,* as Sade would say) than the photographers' contortions to produce effects that are 'lifelike': wretched notions: they make me pose in front of my paintbrushes, they take me outdoors (more 'alive' than indoors), put me in front of a staircase because a group of children is playing behind me, they notice a bench and immediately (what a windfall!) make me sit down on it. As if the (terrified) Photographer must exert himself to the utmost to keep the Photograph from becoming Death. But I – already an object, I do not struggle. I foresee that I shall have to wake from this bad dream even more uncomfortably; for what society makes of my photograph, what it reads there, I do not know (in any case, there are so many readings of the same face); but when I discover myself in the product of this operation, what I see is that I have become Total-Image, which is to say, Death in person; others – the Other – do not dispossess me of myself, they turn me, ferociously, into an object, they put me at their mercy, at their disposal, classified in a file, ready for the subtlest deceptions:

one day an excellent photographer took my picture; I believed I could read in his image the distress of a recent bereavement: for once Photography had restored me to myself, but soon afterward I was to find this same photograph on the cover of a pamphlet; by the artifice of printing, I no longer had anything but a horrible disinternalized countenance, as sinister and repellent as the image the authors wanted to give of my language. (The 'private life' is nothing but that zone of space, of time, where I am not an image, an object. It is my *political* right to be a subject which I must protect.)

Ultimately, what I am seeking in the photograph taken of me (the 'intention' according to which I look at it) is Death: Death is the *eidos* of that Photograph. Hence, strangely, the only thing that I tolerate, that I like, that is familiar to me, when I am photographed, is the sound of the camera. For me, the Photographer's organ is not his eye (which terrifies me) but his finger: what is linked to the trigger of the lens, to the metallic shifting of the plates (when the camera still has such things). I love these mechanical sounds in an almost voluptuous way, as if, in the Photograph, they were the very thing – and the only thing – to which my desire clings, their abrupt click breaking through the mortiferous layer of the Pose. For me the noise of Time is not sad: I love bells, clocks, watches – and I recall that at first photographic implements were related to techniques of cabinetmaking and the machinery of precision: cameras, in short, were clocks for seeing, and perhaps in me someone very old still hears in the photographic mechanism the living sound of the wood.

9

I was glancing through an illustrated magazine. A photograph made me pause. Nothing very extraordinary: the (photographic) banality of a rebellion in Nicaragua: a ruined street, two helmeted soldiers on patrol; behind them, two nuns. Did this photograph please me? Interest me? Intrigue me? Not even. Simply, it existed (for me). I understood at once that its existence (its 'adventure') derived from the co-presence of two discontinuous elements, heterogeneous in that they did not belong to the same world (no need to proceed to the point of contrast): the soldiers and the nuns. I foresaw a structural rule (conforming to my own observation), and I immediately tried to verify it by inspecting other photographs by the same reporter (the Dutchman Koen Wessing): many of them attracted me because they included this kind of duality which I had just become aware of. Here a mother and daughter sob over the father's arrest (Baudelaire: 'the emphatic truth of gesture in the great circumstances of life'), and this happens *out in the countryside* (where could they have learned the news? for whom are these gestures?). Here, on a torn-up pavement, a child's corpse under a white sheet; parents and friends stand around it, desolate: a banal enough scene, unfortunately, but I noted certain interferences: the corpse's one bare foot, the sheet carried by the weeping mother (why this sheet?), a woman in the background, probably a friend, holding a handkerchief to her nose. Here again, in a bombed-out apartment, the huge eyes of two little boys, one's shirt raised over his little belly (the excess of those eyes disturb the scene). And here, finally, leaning against the wall of a house, three Sandinists, the lower part of their

faces covered by a rag (stench? secrecy? I have no idea, knowing nothing of the real-
ities of guerrilla warfare); one of them holds a gun that rests on his thigh (I can see
his nails); but his other hand is stretched out, open, as if he were explaining and
demonstrating something. My rule applied all the more closely in that other pictures
from the same reportage were less interesting to me; they were fine shots, they
expressed the dignity and horror of rebellion, but in my eyes they bore no mark
or sign: their homogeneity remained cultural: they were 'scenes,' rather *à la*
Greuze, had it not been for the harshness of the subject.

10

My rule was plausible enough for me to try to name (as I would need to do) these
two elements whose co-presence established, it seemed, the particular interest I
took in these photographs.

The first, obviously, is an extent, it has the extension of a field, which I perceive
quite familiarly as a consequence of my knowledge, my culture; this field can be
more or less stylized, more or less successful, depending on the photographer's skill
or luck, but it always refers to a classical body of information: rebellion, Nicaragua,
and all the signs of both: wretched un-uniformed soldiers, ruined streets, corpses,
grief, the sun, and the heavy-lidded Indian eyes. Thousands of photographs consist
of this field, and in these photographs I can, of course, take a kind of general interest,
one that is even stirred sometimes, but in regard to them my emotion requires the
rational intermediary of an ethical and political culture. What I feel about these
photographs derives from an *average* affect, almost from a certain training. I did not
know a French word which might account for this kind of human interest, but I
believe this word exists in Latin: it is *studium,* which doesn't mean, at least not
immediately, 'study,' but application to a thing, taste for someone, a kind of
general, enthusiastic commitment, of course, but without special acuity. It is by
studium that I am interested in so many photographs, whether I receive them as
political testimony or enjoy them as good historical scenes: for it is culturally (this
connotation is present in *studium)* that I participate in the figures, the faces, the
gestures, the settings, the actions.

The second element will break (or punctuate) the *studium.* This time it is not I
who seek it out (as I invest the field of the *studium* with my sovereign conscious-
ness), it is this element which rises from the scene, shoots out of it like an arrow,
and pierces me. A Latin word exists to designate this wound, this prick, this mark
made by a pointed instrument: the word suits me all the better in that it also refers
to the notion of punctuation, and becaue the photographs I am speaking of are in
effect punctuated, sometimes even speckled with these sensitive points; precisely,
these marks, these wounds are so many *points.* This second element which will
disturb the *studium* I shall therefore call *punctum;* for *punctum* is also: sting, speck,
cut, little hole – and also a cast of the dice. A photograph's *punctum* is that accident
which pricks me (but also bruises me, is poignant to me).

Having thus distinguished two themes in Photography (for in general the photo-
graphs I liked were constructed in the manner of a classical sonata), I could occupy
myself with one after the other.

11

Many photographs are, alas, inert under my gaze. But even among those which have some existence in my eyes, most provoke only a general and, so to speak, *polite* interest: they have no *punctum* in them: they please or displease me without pricking me: they are invested with no more than *studium*. The *studium* is that very wide field of unconcerned desire, of various interest, of inconsequential taste: *I like / I don't like*. The *studium* is of the order of *liking*, not of *loving*; it mobilizes a half desire, a demi-volition; it is the same sort of vague, slippery, irresponsible interest one takes in the people, the entertainments, the books, the clothes one finds 'all right.'

To recognize the *studium* is inevitably to encounter the photographer's intentions, to enter into harmony with them, to approve or disapprove of them, but always to understand them, to argue them within myself, for culture (from which the *studium* derives) is a contract arrived at between creators and consumers. The *studium* is a kind of education (knowledge and civility, 'politeness') which allows me to discover the *Operator*, to experience the intentions which establish and animate his practices, but to experience them 'in reverse,' according to my will as a *Spectator*. It is rather as if I had to read the Photographer's myths in the Photograph, fraternizing with them but not quite believing in them. These myths obviously aim (this is what myth is for) at reconciling the Photograph with society (is this necessary? – Yes, indeed: the Photograph is *dangerous*) by endowing it with *functions*, which are, for the Photographer, so many alibis. These functions are: to inform, to represent, to surprise, to cause to signify, to provoke desire. And I, the *Spectator*, I recognize them with more or less pleasure: I invest them with my *studium* (which is never my delight or my pain).

12

Since the Photograph is pure contingency and can be nothing else (it is always *something* that is represented) – contrary to the text which, by the sudden action of a single word, can shift a sentence from description to reflection – it immediately yields up those 'details' which constitute the very raw material of ethnological knowledge. When William Klein photographs 'Mayday, 1959' in Moscow, he teaches me how Russians dress (which after all I don't know): I note a boy's big cloth cap, another's necktie, an old woman's scarf around her head, a youth's haircut, etc. I can enter still further into such details, observing that many of the men photographed by Nadar have long fingernails: an ethnographical question: how long were nails worn in a certain period? Photography can tell me this much better than painted portraits. It allows me to accede to an infra-knowledge; it supplies me with a collection of partial objects and can flatter a certain fetishism of mine: for this 'me' which likes knowledge, which nourishes a kind of amorous preference for it. In the same way, I like certain biographical features which, in a writer's life, delight me as much as certain photographs; I have called these features 'biographemes'; Photography has the same relation to History that the biographeme has to biography.

[. . .]

25

Now, one November evening shortly after my mother's death, I was going through some photographs. I had no hope of 'finding' her, I expected nothing from these 'photographs of a being before which one recalls less of that being than by merely thinking of him or her' (Proust). I had acknowledged that fatality, one of the most agonizing features of mourning, which decreed that however often I might consult such images, I could never recall her features (summon them up as a totality). No, what I wanted – as Valéry wanted, after his mother's death – was 'to write a little compilation about her, just for myself' (perhaps I shall write it one day, so that, printed, her memory will last at least the time of my own notoriety). Further, I could not even say about these photographs, if we except the one I had already published (which shows my mother as a young woman on a beach of Les Landes, and in which I 'recognized' her gait, her health, her glow – but not her face, which is too far away), I could not even say that I loved them: I was not sitting down to contemplate them, I was not engulfing myself in them. I was sorting them, but none seemed to me really 'right': neither as a photographic performance nor as a living resurrection of the beloved face. If I were ever to show them to friends I could doubt that these photographs would *speak*.

26

With regard to many of these photographs, it was History which separated me from them. Is History not simply that time when we were not born? I could read my nonexistence in the clothes my mother had worn before I can remember her. There is a kind of stupefaction in seeing a familiar being dressed *differently*. Here, around 1913, is my mother dressed up – hat with a feather, gloves, delicate linen at wrists and throat, her 'chic' belied by the sweetness and simplicity of her expression. This is the only time I have seen her like this, caught in a History (of tastes, fashions, fabrics): my attention is distracted from her by accessories which have perished; for clothing is perishable, it makes a second grave for the loved being. In order to 'find' my mother, fugitively alas, and without ever being able to hold on to this resurrection for long, I must, much later, discover in several photographs the objects she kept on her dressing table, an ivory powder box (I loved the sound of its lid), a cut-crystal flagon, or else a low chair, which is now near my own bed, or again, the raffia panels she arranged above the divan, the large bags she loved (whose comfortable shapes belied the bourgeois notion of the 'handbag').

Thus the life of someone whose existence has somewhat preceded our own encloses in its particularity the very tension of History, its division. History is hysterical: it is constituted only if we consider it, only if we look at it – and in order to look at it, we must be excluded from it. As a living soul, I am the very contrary of History, I am what belies it, destroys it for the sake of my own history (impossible for me to believe in 'witnesses'; impossible, at least, to be one; Michelet was able to write virtually nothing about his own time). That is what the time when my mother was alive *before me* is – History (moreover, it is the period which interests me most, historically). No anamnesis could ever make me glimpse this time starting

from myself (this is the definition of anamnesis) — whereas, contemplating a photo-graph in which she is hugging me, a child, against her, I can waken in myself the rumpled softness of her crêpe de Chine and the perfume of her rice powder.

27

And here the essential question first appeared: did I *recognize* her?

According to these photographs, sometimes I recognized a region of her face, a certain relation of nose and forehead, the movement of her arms, her hands. I never recognized her except in fragments, which is to say that I missed her *being*, and that therefore I missed her altogether. It was not she, and yet it was no one else. I would have recognized her among thousands of other women, yet I did not 'find' her. I recognized her differentially, not essentially. Photography thereby compelled me to perform a painful labor; straining toward the essence of her iden-tity, I was struggling among images partially true, and therefore totally false. To say, confronted with a certain photograph, 'That's *almost* the way she was!' was more distressing than to say, confronted with another, 'That's not the way she was at all.' The *almost*: love's dreadful regime, but also the dream's disappointing status — which is why I hate dreams. For I often dream about her (I dream only about her), but it is never quite my mother: sometimes, in the dream, there is something misplaced, something excessive: for example, something playful or casual — which she never was; or again I *know* it is she, but I do not *see* her features (but do we *see*, in dreams, or do we *know*?): I dream about her, I do not dream *her*. And confronted with the photograph, as in the dream, it is the same effort, the same Sisyphean labor: to reascend, straining toward the essence, to climb back down without having seen it, and to begin all over again.

Yet in these photographs of my mother there was always a place set apart, reserved and preserved: the brightness of her eyes. For the moment it was a quite physical luminosity, the photographic trace of a color, the blue-green of her pupils. But this light was already a kind of mediation which led me toward an essential identity, the genius of the beloved face. And then, however imperfect, each of these photographs manifested the very feeling she must have experienced each time she 'let' herself be photographed: my mother 'lent' herself to the photograph, fearing that refusal would turn to 'attitude'; she triumphed over this ordeal of placing herself in front of the lens (an inevitable action) *with discretion* (but without a touch of the tense theatricalism of humility or sulkiness); for she was always able to replace a moral value with a higher one —a civil value. She did not struggle with her image, as I do with mine: she did not *suppose* herself.

28

There I was, alone in the apartment where she had died, looking at these pictures of my mother, one by one, under the lamp, gradually moving back in time with her, looking for the truth of the face I had loved. And I found it.

The photograph was very old. The corners were blunted from having been pasted into an album, the sepia print had faded, and the picture just managed to show two children standing together at the end of a little wooden bridge in a glassed-in conservatory, what was called a Winter Garden in those days. My mother was five at the time (1898), her brother seven. He was leaning against the bridge railing, along which he had extended one arm; she, shorter than he, was standing a little back, facing the camera; you could tell that the photographer had said, 'Step forward a little so we can see you'; she was holding one finger in the other hand, as children often do, in an awkward gesture. The brother and sister, united, as I knew, by the discord of their parents, who were soon to divorce, had posed side by side, alone, under the palms of the Winter Garden (it was the house where my mother was born, in Chennevières-sur-Marne).

I studied the little girl and at last rediscovered my mother. The distinctness of her face, the naïve attitude of her hands, the place she had docilely taken without either showing or hiding herself, and finally her expression, which distinguished her, like Good from Evil, from the hysterical little girl, from the simpering doll who plays at being a grownup – all this constituted the figure of a sovereign *innocence* (if you will take this word according to its etymology, which is: '1 do no harm'), all this had transformed the photographic pose into that untenable paradox which she had nonetheless maintained all her life: the assertion of a gentleness. In this little girl's image I saw the kindness which had formed her being immediately and forever, without her having inherited it from anyone; how could this kindness have proceeded from the imperfect parents who had loved her so badly – in short: from a family? Her kindness was specifically *out-of-play*, it belonged to no system, or at least it was located at the limits of a morality (evangelical, for instance); I could not define it better than by this feature (among others): that during the whole of our life together, she never made a single 'observation.' This extreme and particular circumstance, so abstract in relation to an image, was nonetheless present in the face revealed in the photograph I had just discovered. 'Not a just image, just an image,' Godard says. But my grief wanted a just image, an image which would be both justice and accuracy – *justesse*: just an image, but a just image. Such, for me, was the Winter Garden Photograph.

For once, photography gave me a sentiment as certain as remembrance, just as Proust experienced it one day when, leaning over to take off his boots, there suddenly came to him his grandmother's true face, 'whose living reality I was experiencing for the first time, in an involuntary and complete memory.' The unknown photographer of Chennevières-sur-Marne had been the mediator of a truth, as much as Nadar making of his mother (or of his wife – no one knows for certain) one of the loveliest photographs in the world; he had produced a supererogatory photograph which contained more than what the technical being of photography can reasonably offer. Or again (for I am trying to express this truth) this Winter Garden Photograph was for me like the last music Schumann wrote before collapsing, that first *Gesang des Frühe* which accords with both my mother's being and my grief at her death; I could not express this accord except by an infinite series of adjectives, which I omit, convinced however that this photograph collected all the possible predicates from which my mother's being was constituted and whose suppression

or partial alteration, conversely, had sent me back to these photographs of her which had left me so unsatisfied. These same photographs, which phenomenology would call 'ordinary' objects, were merely analogical, provoking only her identity, not her truth; but the Winter Garden Photograph was indeed essential, it achieved for me, utopically, *the impossible science of the unique being.*

Marjorie Perloff

WHAT HAS OCCURRED ONLY ONCE
Barthes's Winter Garden/Boltanski's archives of the dead

I BEGIN WITH TWO PHOTOGRAPHS, both of them family snapshots of what are evidently a young mother and her little boy in a country setting. Neither is what we would call a 'good' (i.e., well-composed) picture. True, the one is more 'expressive,' the anxious little boy clinging somewhat fearfully to his mother, whereas the impassive woman and child look straight ahead at the camera.

The second pair of photographs are class pictures: The first, an end-of-the-year group photo of a smiling high-school class with their nonsmiling male teacher in the first row, center; the second, a more adult (postgraduate?) class, with their teacher (front row, third from the left) distinguished by his white hair, and smiling ever so slightly in keeping with what is evidently the collegial spirit of the attractive young group.

Both sets may be used to illustrate many of the points Barthes makes about photography in *Camera Lucida*. First, these pictures are entirely ordinary – the sort of photographs we all have in our albums. Their appeal, therefore, can only be to someone personally involved with their subjects, someone for whom they reveal the 'that-has-been' (*ça a été*) that is, for Barthes, the essence or *noème* of photography. 'The photographic referent,' we read in #32, '[is] not the *optionally* real thing to which an image or a sign refers but the *necessarily* real thing which has been placed before the lens, without which there would be no photograph. [. . .] [I]n Photography I can never deny that *the thing has been there*' (*CL*, 76). And again, 'The photograph is literally an emanation of the referent' (*CL*, 80). In this sense, 'every photograph is a certificate of presence' (*CL*, 87).

But 'presence' in this instance, goes hand in hand with death. 'What the Photograph reproduces to infinity has occurred only once: the Photograph mechanically repeats what could never be repeated existentially' (*CL*, 4). As soon as the click of the shutter has taken place, what was photographed no longer exists; subject is transformed into object, 'and even,' Barthes suggests, 'into a museum object'

(*CL*, 13). When we look at a photograph of ourselves or of others, we are really looking at the return of the dead. 'Death is the *eidos* of the Photograph' (*CL*, 15).

Christian Boltanski, whose photographs I have paired with two of the illustrations in *Roland Barthes by Roland Barthes,* shares Barthes's predilection for the ordinary photograph, the photograph of everyday life. Like Barthes, he dislikes 'art photography,' photography that approaches the condition of painting. For him, too, the interesting photograph provides the viewer with testimony that the thing seen *has been,* that *it is thus.* In Barthes's words, 'the Photograph is never anything but an antiphon of "Look," "See," "Here it is"; it points a finger at certain *vis-à-vis,* and cannot escape this pure deictic language' (*CL*, 5). But, in Boltanski's oeuvre, as we shall see, this pure deictic language, this pointing at 'what has occurred only once,' takes on an edge unanticipated in the phenomenology of *Camera Lucida.*

Consider the mother-and-child snapshots above. Both foreground the 'real' referent of the image, the outdoor scene that the camera reproduces. But in what sense are the photographs 'certificates of presence'? [The first] portrays Roland Barthes, age five or six, held by his mother, who stands at some distance from a house (her house?) in a nonspecifiable countryside. The mother's clothes and hairdo place the photograph somewhere in the 1920s; the long-legged boy in kneesocks, shorts, and sweater seems rather big to be held on his mother's arm like a baby. The caption on the facing page accounts for this phenomenon: it reads, 'The demand for love [*la demande d'amour*]' (*RB*, 5).

The second photograph is part of a work (similarly published in the early 1970s) called *Album de photos de la famille D, 1939–64,* which depicts a 'family' (are they a family?) Boltanski did not know. He borrowed several photo albums from his friend Michel Durand-Dessert (hence the *D*), reshot some 150 snapshots from these albums, and tried to establish their chronology as well as the identities of their subjects using what he called an ethnological approach: for example, 'the older man who appeared only at festive occasions must be an uncle who did not live in the vicinity.'[1] But the sequence he constructed turned out to be incorrect: 'I realized,' the artist remarked, 'that these images were only witnesses to a collective ritual. They didn't teach us anything about the Family D. [. . .] but only sent us back to our own past.'[2] And, since the snapshots in the sequence date from the French Occupation and its immediate aftermath, the viewer begins to wonder what this bourgeois provincial family was doing during the war. Were these men on the battlefield? Were they Nazi collaborators or resistance fighters? Did these women have to harbor the enemy? And so on. What, in short, is it that *has been* in the snapshot of the young woman and small boy resting in a shady meadow?

Similar questions are raised by the second Boltanski photograph. Again, the two class pictures make an interesting pair. We have one of the 'S' entries in *Roland Barthes by Roland Barthes*: a photograph of Barthes's seminar, taken sometime in the 1970s. The caption reads: 'The space of the seminar is phalansteric, i.e., in a sense, fictive, novelistic. It is only the space of the circulation of subtle desires, mobile desires; it is, within the artifice of a sociality whose consistency is miraculously extenuated, according to a phrase of Nietzsche's: "the tangle of amorous relations"' (*RB*, 171). The 'real,' 'referential' photograph thus becomes an occasion for pleasurable erotic fantasy.

In contrast, the other class photograph is a picture Boltanski came across by chance. It portrays the 1931 graduating class of the Lycée Chases (Chases Gymnasium), the Jewish high school in Vienna, which was shut down shortly after this end-of-the-year group photograph was taken. If, as Barthes posits, the photograph is coterminal with its referent, here the 'death' of its subjects produced by the camera may well have foreshadowed their real death in the camps. For his 1986 installation *Lycée Chases,* Boltanski rephotographed the individual smiling faces in this 'ordinary' class photograph, enlarging them until they lost any sense of individuality and began to look like skeletal X rays or, better yet, death masks. Yet this version is no more 'real' than the other, since Boltanski never learned what actually happened to the members of the class of 1931. When *Lycée Chases* was shown in New York in 1987, one of the students in the photograph, now in his late sixties, came forward and identified himself to Boltanski. But this Chases graduate, who had emigrated to the United States in the early 1930s, knew nothing of the fate of the other students.[3]

'Every photograph,' says Barthes, 'is somehow co-natural with its referent' (*CL,* 76). But what is the referent of the Chases graduation picture? What 'evidential force' does it possess and for whom? To answer this question, we might begin with Barthes's famed Winter Garden photograph, the photograph whose *punctum* (the prick, sting, or sudden wound that makes a particular photograph epiphanic to a particular viewer) is so powerful, so overwhelming, so implicated in Barthes's anticipation of his own death that he simply cannot reproduce it in *La Chambre clair.*

> I cannot reproduce the Winter Garden Photograph. It exists only for me. For you, it would be nothing but an indifferent picture, one of the thousand manifestations of the 'ordinary'; it cannot in any way constitute the visible object of a science; it cannot establish an objectivity, in the positive sense of the term; at most it would interest your *studium:* period, clothes, photogeny; but in it, for you, no wound.
>
> (*CL,* 73)

The Winter Garden photograph thus becomes the absent (and hence more potent) referent of Barthes's paean to presence, a paean that takes the form of an elegiac *ekphrasis.*

'One November evening, shortly after my mother's death,' Barthes recalls, 'I was going through some photographs. I had no hope of "finding" her. 1 expected nothing from these "photographs of a being before which one recalls less of that being than by merely thinking of him or her"' (*CL,* 63). And Barthes puts in parentheses following the quote the name of the writer who is the tutelary spirit behind his own lyric meditation – Proust. Like the Proust of *Les Intermittences du coeur,* Barthes's narrator has learned, from the repeated disillusionments of life, to expect nothing. The mood is autumnal, sepulchral, and the image of the dead mother cannot be recovered – at least not by the voluntary memory. Different photographs capture different aspects of her person but not the 'truth of the face I had loved': 'I was struggling among images partially true and therefore totally false' (*CL,* 66).

As in Proust, the miraculous privileged moment, the prick of the *punctum,* comes

when least expected. The uniqueness of the Winter Garden photograph – an old, faded, album snapshot with 'blunted' corners – is that it allows Barthes to 'see' his mother, not as he actually saw her in their life together (this would be a mere *studium* on his part), but as the child he had never known in real life, a five-year-old girl standing with her seven-year-old brother 'at the end of a little wooden bridge in a glassed-in conservatory' (*CL*, 67). We learn that brother and sister are united 'by the discord of their parents, who were soon to divorce' (*CL*, 69). But in Barthes's myth, this little girl is somehow self-born. 'In this little girl's image I saw the kindness which had formed her being immediately and forever, without her having inherited it from anyone; how could this kindness have proceeded from the imperfect parents who had loved her so badly – in short, from a family?' (*CL*, 69). In an imaginative reversal, the mother-as-child in the Winter Garden photograph now becomes his child: 'I who had not procreated, I had, in her very illness, engendered my mother' (*CL*, 72). The tomblike glass conservatory thus becomes the site of birth.

'The unknown photographer of Chennevières-sur-Marne,' Barthes remarks, 'had been a mediator of a truth' (*CL*, 70) – indeed, of *the* truth. His inconsequential little snapshot 'achieved for me, utopically, *the impossible science of the unique being*' (*CL*, 71) – impossible because the uniqueness of that being is, after all, only in the eye of the beholder. Like Proust's Marcel, the Barthesian subject must evidently purge himself of the guilt prompted by the unstated conviction that his own 'deviation' (sexual or otherwise) from the bourgeois norms of his childhood world must have caused his mother a great deal of pain. Like Marcel, he therefore invents for himself a perfect mother, her goodness and purity deriving from no one (for family is the enemy in this scheme of things). Gentleness is all: 'during the whole of our life together,' writes Barthes in a Proustian locution, 'she never made a single "observation"' (*CL*, 69). Thus perfected, the mother must of course be dead; the very snapshot that brings her to life testifies to the irreversibility of her death.

Barthes understands only too well that the *punctum* of this photograph is his alone, for no one else would read the snapshot quite as he does. The 'emanation of the referent,' which is for him the essence of the photograph, is thus a wholly personal connection. The intense, violent, momentary pleasure (*jouissance*) that accompanies one's reception of the photograph's 'unique Being' is individual and 'magical,' for unlike all other representations, the photograph is an image without a code (*CL*, 88), the eruption of the Lacanian 'Real' into the signifying chain, a '*satori* in which words fail' (*CL*, 109).

As an elegy for his mother and as a kind of epitaph for himself, *Camera Lucida* is intensely moving. But what about Barthes's insistence on the 'realism' of the photograph, his conviction that it bears witness to what has occurred only once? 'From a phenomenological viewpoint,' says Barthes, 'in the Photograph, the power of authentication exceeds the power of representation' (*CL*, 89). Authentication of what and for whom? Here Boltanski's photographic representations of everyday life raise some hard questions. Indeed, the distance between Barthes's generation and Boltanski's – a distance all the more remarkable in that such central Boltanski photo installations as *La Famille D, Le Club Mickey,* and *Détective* date from the very years when Barthes was composing *Roland Barthes by Roland Barthes, A Lover's Discourse,* and *Camera Lucida* – can be measured by the revisionist treatment Boltanski accords to the phenomenology of authentication practiced by the late Barthes.

Roland Barthes was born in the first year of World War I (26 October 1915); Christian Boltanski, in the last year of World War II, specifically on the day of Paris's liberation (6 September 1944) – hence his middle name, Liberté. Barthes's Catholic father was killed in October 1916 in a naval battle in the North Sea; the fatherless child was brought up in Bayonne by his mother and maternal grandmother in an atmosphere he described as one of genteel poverty and narrow Protestant bourgeois rectitude. Boltanski's father, a prominent doctor, was born a Jew but converted to Catholicism; his mother, a writer, was Catholic, and young Christian was educated by the Jesuits. To avoid deportation in 1940, the Boltanskis faked a divorce and pretended the doctor had fled, abandoning his family, whereas in reality he was hidden in the basement of the family home, in the center of Paris, for the duration of the Occupation. The death of Barthes's father, an event his son under-stood early on as being only too 'real,' may thus be contrasted to the simulated 'death' of Dr. Boltanski at the time of his son's birth. Indeed, this sort of simula-tion, not yet a central issue in World War I when battlelines were drawn on nationalistic rather than ideological grounds, became important in the years of the resistance, when simulation and appropriation became common means of survival. For example, in his fictionalized autobiography *W or the Memory of Childhood*, Georges Perec (a writer Boltanski greatly admires and has cited frequently) recalls that his widowed mother, who was to die at Auschwitz, got him out of Paris and into the Free Zone by putting him on a Red Cross convoy for the wounded en route to Grenoble. 'I was not wounded. But I had to be evacuated. So we had to pretend I was wounded. That was why my arm was in a sling.'[4]

Under such circumstances, *authentication* becomes a contested term. How does one document what has occurred only once when the event itself is perceived to be a simulation? And to what extent has the experience of *studium* versus *punctum* become collective, rather than the fiercely personal experience it was for Barthes? In a 1984 interview held in conjunction with the Boltanski exhibition at the Centre Pompidou in Paris, Delphine Renard asked the artist how and why he had chosen photography as his medium. 'At first,' he replied, 'what especially interested me was the property granted to photography of furnishing the evidence of the real [*la preuve du réel*]: a scene that has been photographed is experienced as being true. [. . .] If someone exhibits the photograph of an old lady and the viewer tells himself, today, she must be dead, he experiences an emotion which is not only of an aesthetic order.'[5]

Here Boltanski seems to accept the Barthesian premise that the 'photographic referent' is 'not the *optionally* real thing to which an image or a sign refers but the *necessarily* real thing which has been placed before the lens, without which there would be no photograph. [. . .] [I]n Photography I can never deny that *the thing has been there*.' But for Boltanski, this 'reasonable' definition is not without its problems:

> In my first little book, *Tout ce qui reste de mon enfance* of 1969, there is a photograph that supplies the apparent proof that I went on vacation to the seashore with my parents, but it is an unidentifiable photograph of a child and a group of adults on the beach. One can also see the photograph of the bed I slept in when I was five years old; naturally, the caption orients the spectator, but the documents are purposely false. [. . .] In most of my photographic pieces, I have utilized this property of the proof

one accords to photography to expose it or to try to show that *photography
lies, that it doesn't speak the truth but rather the cultural code.*

(*BOL*, 75; emphasis added)

Such cultural coding, Boltanski argues, characterizes even the most innocent
snapshot (say, the Winter Garden photograph). The amateur photograph of the late
nineteenth century was based on a preexisting image that was culturally imposed –
an image derived from the painting of the period. Even today the amateur photog-
rapher 'shows nothing but images of happiness, lovely children running around on
green meadows: he reconstitutes an image he already knows' (*BOL*, 76). Tourists
in Venice, for example, who think they are taking 'authentic' photographs of this
or that place, are actually recognizing the 'reality' through the lens of a set of clichés
they have unconsciously absorbed; indeed, they want these pictures to resemble
those they already know. So Boltanski creates an experiment. Together with
Annette Messager he produces a piece called *Le Voyage de noces à Venise* (1975),
composed of photographs taken elsewhere (*BOL*, 76). And in another book, *10
portraits photographiques de Christian Boltanski, 1946–1964* (1972), the temporal frame
(the boy is depicted at different ages) is a pure invention; all the photographs were
actually taken the same day. 'This little book,' says the artist, 'was designed to show
that Christian Boltanski had only a collective reality . . . [that of] a child in a given
society' (*BOL*, 79). In a related book, *Ce dont its se souviennent*, we see what looks
like an updated version of a Proustian scene in which the narrator and Gilberte play
together in the Champs-Elysées; here, ostensibly, are young Christian's friends
playing on the seesaw in the park. This simple little photograph is enormously
tricky. There are actually three seesaws, as evident from the three horizontal
shadows stretching across the ground in the bottom of the frame.[6] The two little
girls next to one another on parallel seesaws on the left look normal enough, but
what is happening at the other end? The slightly crouching boy in the center
(his legs straddling a third seesaw) seems to be staring at what looks like an extra
leg, its knee bent on the board opposite – a leg that suggests a body on the rack
rather than a child at play. The impression is created by the photograph's odd
lighting: the figure on the far right, who is evidently holding down one seesaw in
balance, blocks the second figure (feet dangling) and the head and torso of the third.
Moreover, the ropelike thin line of the third seesaw extends from that bent leg on
the right to the head of the little girl at its opposite pole, creating the illusion that
she is chained to it. Thus the little playground scene takes on an aura of isolation
and imprisonment. Is it winter (the white area could be snow) or a scorchingly
sunny summer? The more one looks at this 'ordinary' photograph (actually,
Boltanski tells us, a found photograph taken from the album of a young woman),
the less clear the 'emanation of the referent' becomes.

But Boltanski's is by no means a simple reversal of the Barthesian *noème*. For
the paradox is that, like Barthes and even more like Perec, he finds nothing as mean-
ingful as the ordinary object, the trivial detail. Photography for him is a form of
ethnography. Boltanski has spoken often of his early fascination with the displays in
the Musée de l'Homme, not so much the displays of large pieces of African sculp-
ture but of everyday objects – Eskimo fishhooks, arrows from the Amazon valley,
and so on:

I saw large metal boxes in which there were little objects, fragile and without signification. In the corner of the case there was often a small faded photograph representing a 'savage' in the middle of handling these little objects. Each case presented a world that has disappeared: the savage of the photograph was no doubt dead, the objects had become useless, and, anyway, no one knew how to use them any more. The Musée de l'Homme appeared to me as a great morgue. Numerous artists have here discovered the human sciences (linguistics, sociology, archeology); here there is still the 'weight of time' which imposes itself on artists . . . Given that we have all shared the same cultural references, I think we will all finish in the same museum.

<div align="right">(BOL, 71)</div>

Does this mean that art discourse can be no more than a cultural index, that the individual artwork is no longer distinguished from its family members? On the contrary. For whereas Barthes posits that what he calls 'the impossible science of the unique being' depends on a given spectator's particular reading of an 'ordinary' photograph, Boltanski enlarges the artist's role: it is the artist who creates those images 'imprecise enough to be as communal as possible' – images each viewer can interpret differently. The same holds true, the artist posits, for captions, the ideal situation being one, for example, in which a picture from an elementary school history book every child has used is reproduced, bearing a caption like 'Ce jour-là, le professeur entra avec le directeur [That day, the teacher entered with the principal]' (BOL, 79).

One of Boltanski's favorite genres is thus the inventory. If many of his albums use 'fake' photos to tell what are supposedly 'true' stories, the Inventaire series work the other way. Consider, for example, the inventaire des objets ayant appartenus à un habitant d'Oxford of 1973 (see section frontispiece to Part I).

Boltanski had read of the untimely death of an Oxford student and wrote to his college asking if his personal effects, 'significant' or otherwise, could be sent to him. Photographed against a neutral background, these objects take on equal value: the pope's photograph, a folded shirt, a suit jacket on a hanger, a set of pamphlets, a toothbrush. The question the inventory poses is whether we can know someone through his or her things. If the clothes make the man, as the adage has it, can we re-create the absent man from these individual items? Or does the subject fragment into a series of metonymic images that might relate to anyone? Is there, in other words, such a thing as identity?

Here again Barthes offers an interesting point de repère. One of the sections in Roland Barthes by Roland Barthes is called 'Un souvenir d'enfance – A Memory of Childhood' and goes like this:

When I was a child, we lived in a neighborhood called Marrac; this neighborhood was full of houses being built, and the children played in the building sites; huge holes had been dug in the loamy soil for the foundations of the houses, and one day when we had been playing in one of these, all the children climbed out except me – I couldn't make it. From the brink up above, they teased me: lost! alone! spied on!

excluded! (to be excluded is not to be outside, it is to be *alone in the hole*, imprisoned under the open sky; *precluded*); then I saw my mother running up; she pulled me out of there and took me far away from the children – against them.

<div align="right">(RB, 121–22)</div>

We could obviously submit this text to a psychosexual reading and discuss its Freudian symbolism. But what interests me here is less the content than Barthes's assumption that the *souvenir d'enfance* has meaning; that memory can invoke the past, revive the fear, panic, and sense of release the boy felt when his mother rescued him. However painful the memory, the little filmic narrative implies, it relates past to present and creates Barthes's sense of identity.

Memory plays no such role in Boltanski's work. 'I have very few memories of childhood,' he tells Delphine Renard, 'and I think I undertook this seeming auto-biography precisely to blot out my memory and to protect myself. I have invented so many false memories, which were collective memories, that my true childhood has disappeared' (*BOL*, 79). Again, Perec's *W or the Memory of Childhood* comes to mind: 'I have no childhood memories. Up to my twelfth year or thereabouts, my story comes to barely a couple of lines'. For writers and artists born in World War II France, and especially for Jewish artists like Perec and Boltanski, the Proustian or Barthesian *souvenir d'enfance* seems to have become a kind of empty signifier, a site for assumed identities and invented sensations.

Take the installation *Détective* (a first version was mounted in 1972, a more extensive one in 1987), which consists of four hundred black-and-white photo-graphs, one hundred ten metal boxes with magazine articles, and twenty-one clamp-on desk lamps. 'These photographs,' we read in the headnote, 'origi-nally appeared in the magazine *Détective*. A weekly specializing in news items, it presents an indiscriminate blend of assassins and victims, the unintentional heroes of forgotten dramas.'[7] The immediate occasion, Boltanski explains, was the 1987 trial in Lyons of the Nazi war criminal Klaus Barbie. 'Barbie has the face of a Nobel Peace Prize Winner,' Boltanski remarked. 'It would be easier if a terrible person had a terrible face' (see *LE*, 81). And in an interview for *Parkett* called 'The White and the Black,' Boltanski explains that his ideas of original sin and grace stem from his Christian upbringing even as his longing for a lost Jerusalem is part of Jewish mythology. 'My work is caught between two cultures as I am.'[8]

The mystery of *Détective* is that one cannot tell the criminals from the victims. Inevitably, when told that this is the case, one tries to rise to the challenge by distin-guishing between the two. The bald man whose head and cheeks have been cropped (top row, third from the left) is surely a killer, isn't he? Or could he be an innocuous person, the local butcher or pharmacist, perhaps, who is one of the murdered? Is he a mental patient? And what about the little boy with blond curls (second row, third from the right); surely he is an innocent victim? Or is it a baby picture of someone who turned out to be an ax murderer? The pictures do not reveal anything. Each and every photograph can be read both ways and there are all sorts of metonymic linkages: compare the woman (if it is a woman) with glasses (bottom row, second from the right) to the man in the top row referred to above. The crop-ping, lighting, and pose are similar. One wears glasses, the other does not. One is

probably female, the other definitely male. Throughout the sequence, each person looks a bit like someone else (e.g., the young girls in bathing suits). Just so, the sequence implies, the middle-class Nazis and Jews of prewar Berlin, for example, were quite indistinguishable.

What sort of evidence, then, does the photograph supply? I have already mentioned the students of *Lycée Chases,* whose faces Boltanski cropped, enlarged, and placed under transparent paper so that they resembled death masks. But the same phenomenon can be found much closer to home: in 1973, in the foyer of a junior high school in Dijon, Boltanski installed the portrait photographs of each of the students attending the school who were then between the ages of ten and thirteen. Thirteen years later he produced an installation using the same photographs, which had been supplied by the children's parents. As Günter Metken explains, '[Boltanski] tightened the format, closing in on the subject, so that the clothing, hairstyle and background disappeared, and only the faces, standardized by their identical presentation remained' (*COL*, 155). In the case of the girl in question, Boltanski

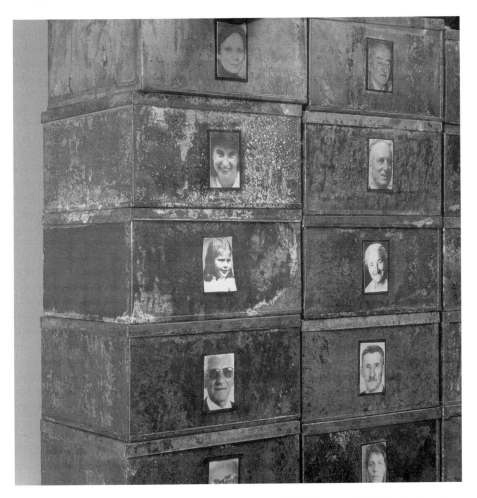

Figure 2.1 Christian Boltanski, from *Les Suisses morts*, 1991. Courtesy of the Marian Goodman Gallery, New York.

enhanced the black-and-white contrast and added glasses — a logical development for a woman now in her mid-twenties. As in the case of *Lycée Chases*, the artist merely brings out what is already there.

The figurative 'death' of the Dijon schoolgirl, reborn a plain woman in glasses, prefigures death itself, which is for Boltanski, as for Barthes, the very essence of photography. In 1991 Boltanski produced a piece called *Les Suisses morts* (see Figure 2.1) that can be read as an interesting public counterpart to Barthes's very private Winter Garden. The 'subjects' are some three thousand dead Swiss citizens as depicted in the-obituary announcements published in the Swiss regional newspaper *Le Nouvelliste du Valais*. Why Swiss? 'Because,' Boltanski explains, 'Switzerland is neutral. There is nothing more neutral than a dead Swiss. Before, I did pieces with dead Jews but "dead" and "Jew" go too well together. It's too obvious. There is nothing more normal than the Swiss. There is no reason for them to die, so they are more terrifying in a way. They are us' (*PAR*, 36). The 'normalcy' of the three thousand Swiss is further heightened by the conventions of the obituary photograph: 'The thing about pictures of dead people is that they are always taken when the subjects are alive, all tanned, muscular, and smiling. The photo replaces the memory. When someone dies, after a while you can't visualize them anymore, you only remember them through their pictures' (*PAR*, 36).

What exactly does one remember? One looks in vain at these obituary photos of men and women, some old, some younger, and even a child or two, for clues about the meaning of their lives. Is theirs a national identity? At moments the viewer persuades herself that these white Aryan Europeans look stolid and bourgeois — the representatives of a country that has never known war, genocide, famine, natural disaster. But what about their private lives? Was the pretty woman in the second row, far left, happily married? Was the man to her right a successful businessman? And what were all these people doing when not smiling at the camera?

'Why,' asks Georgia Marsh in the *Parkett* interview, 'this delectation of the dead?' Boltanski answers:

> I don't really know myself. We are all so complicated and then we die. We are a subject one day, with our vanities, our loves, our worries, and then one day, abruptly, we become nothing but an object, an absolutely disgusting pile of shit. We pass very quickly from one stage to the next, it's very bizarre. It will happen to all of us, and fairly soon too. Suddenly we become an object you can handle like a stone, but a stone that was someone. There is no doubt something sexual about it.
>
> (*PAR*, 36)

This linkage of sexuality and death takes us back to Barthes's elegy for his mother-turned-child in *Camera Lucida* 'What is always fascinating,' says Boltanski, 'is that every being is interchangeable, and at the same time each one has had a very different life with different desires' (*PAR*, 37). For Barthes, still writing as an interpreter in the late modernist tradition, the reception of the photograph is a kind of rescue operation: the *punctum* of the Winter Garden photograph is achieved when its viewer (Barthes) is able to turn the object back into a subject, a sentient and sexual being.

For Boltanski, such individual transcendence is no longer possible. The referent, to paraphrase Barthes, adheres all right, but that referent is *they*, not *she*, and the shock of recognition comes when the viewer recognizes the interchangeability of human beings – an interchangeability paradoxically born out of difference, since each of us has different desires, problems, goals. Personal tragedy – the loss of an adored mother – gives way to a more collective scene of mourning; individuality matters less than positionality (the *à côte de*) in the larger space of inscription. Thus glass, as in glass conservatory (winter garden), gives way to mass, and what has occurred only once may recur again and again. Or it may not have occurred at all.

Notes

1 See Lynn Gumpert, 'The Life and Death of Christian Boltanski,' in *Christian Boltanski: Lessons of Darkness*, ed. L. Gumpert and Mary Jane Jacob (Chicago: Museum of Contemporary Art, 1988), p. 59. This catalog is subsequently cited in the text as *LE*.

2 Christian Boltanski, interview with Suzanne Pagé in *Christian Boltanski – Compositions*, exhibition catalog (Paris: A.R.C./Musée d'art moderne de la Ville de Paris, 1981), p. 7; cited in Lynn Gumpert's translation, in *LE*, p. 59.

3 See *Christian Boltanski: Catalogue, Books, Printed Matter, Ephemera, 1966–91*, ed. Jennifer Flay, with commentaries by Günter Metken (Cologne: Walther König, 1992), p. 155. This catalog is subsequently cited as *COL*.

4 Georges Perec, *W or the Memory of Childhood* [1975], trans. David Bellos (Boston: David Godine, 1988), pp. 54–55. The story about the sling turns out to have been fabricated. In the very next paragraph Perec admits that, according to his aunt, his arm was not in a sling; rather, 'It was as a "son of father deceased", a "war orphan", that I was being evacuated by the Red Cross, entirely within regulations' (55). See also David Bellos, *Georges Perec: A Life in Words* (Boston: David Godine, 1993), pp. 55–59.

5 Delphine Renard, 'Entretien avec Christian Boltanski,' in *Boltanski* (Paris: Centre Georges Pompidou, 1984), p. 75. This catalog is subsequently cited as *BOL*. Translations are my own.

6 In the first version of this essay (*Artes* 2 [1995]: 110–25) I read this photograph as containing two, rather than three, seesaws (see p. 118). The presence of the third (the thin, ropelike one at the furthest distance) was pointed out by Gérard Malanga in a letter to the editor in *Artes* 3 (1996): 146. Malanga discovered (and his interpretation is quite convincing) that the shadows demonstrate the existence of a third seesaw. I am very grateful for his correction, which actually corroborates my reading of the sinister potential of the lighting in this complex image.

7 See *LE*, p. 14. The entire run of photographs is reproduced in this catalog (see pp. 15–48).

8 Georgia Marsh, 'The White and the Black: An Interview with Christian Boltanski,' *Parkett* 22 (1989): 37. This issue of *Parkett* is subsequently cited as *PAR*.

Walter Benjamin

EXTRACTS FROM *THE WORK OF ART IN THE AGE OF MECHANICAL REPRODUCTION*

[. . .]

1

IN PRINCIPLE A WORK OF ART has always been reproducible. Man-made artifacts could always be imitated by men. Replicas were made by pupils in practice of their craft, by masters for diffusing their works, and, finally, by third parties in the pursuit of gain. Mechanical reproduction of a work of art, however, represents something new. Historically, it advanced intermittently and in leaps at long intervals, but with accelerated intensity. The Greeks knew only two procedures of technically reproducing works of art: founding and stamping. Bronzes, terra cottas, and coins were the only art works which they could produce in quantity. All others were unique and could not be mechanically reproduced. With the woodcut graphic art became mechanically reproducible for the first time, long before script became reproducible by print. The enormous changes which printing, the mechanical reproduction of writing, has brought about in literature are a familiar story. However, within the phenomenon which we are here examining from the perspective of world history, print is merely a special, though particularly important, case. During the Middle Ages engraving and etching were added to the woodcut; at the beginning of the nineteenth century lithography made its appearance.

With lithography the technique of reproduction reached an essentially new stage. This much more direct process was distinguished by the tracing of the design on a stone rather than its incision on a block of wood or its etching on a copperplate and permitted graphic art for the first time to put its products on the market, not only in large numbers as hitherto, but also in daily changing forms. Lithography enabled graphic art to illustrate everyday life, and it began to keep pace with

printing. But only a few decades after its invention, lithography was surpassed by photography. For the first time in the process of pictorial reproduction, photography freed the hand of the most important artistic functions which henceforth devolved only upon the eye looking into a lens. Since the eye perceives more swiftly than the hand can draw, the process of pictorial reproduction was accelerated so enormously that it could keep pace with speech. A film operator shooting a scene in the studio captures the images at the speed of an actor's speech. Just as lithography virtually implied the illustrated newspaper so did photography foreshadow the sound film. The technical reproduction of sound tackled at the end of the last century. These convergent endeavours made predictable a situation which Paul Valéry pointed up in this sentence: 'Just as water, gas, and electricity are brought into our houses from far off to satisfy our needs in response to a minimal effort, so we shall be supplied with visual or auditory images, which will appear and disappear at a simple movement of the hand, hardly more than a sign'.[1] Around 1900 technical reproduction had reached a standard that not only permitted it to reproduce all transmitted works of art and thus to cause the most profound change in their impact upon the public; it also had captured a place of its own among the artistic processes. For the study of this standard nothing is more revealing than the nature of the repercussions that these two different manifestations – the reproduction of works of art and the art of the film – have had on art in its traditional form.

2

Even the most perfect reproduction of a work of art is lacking in one element: its presence in time and space, its unique existence at the place where it happens to be. This unique existence of the work of art determined the history to which it was subject throughout the time of its existence. This includes the changes which it may have suffered in physical condition over the years as well as the various changes in its ownership. The traces of the first can be revealed only by chemical or physical analyses which it is impossible to perform on a reproduction; changes of ownership are subject to a tradition which must be traced from the situation of the original.

The presence of the original is the prerequisite to the concept of authenticity. Chemical analyses of the patina of a bronze can help to establish this, as does the proof that a given manuscript of the Middle Ages stems from an archive of the fifteenth century. The whole sphere of authenticity is outside technical – and, of course, not only technical – reproducibility.[2] Confronted with its manual reproduction, which was usually branded as a forgery, the original preserved all its authority; not so *vis à vis* technical reproduction. The reason is twofold. First, process reproduction is more independent of the original than manual reproduction. For example, in photography, process reproduction can bring out those aspects of the original that are unattainable to the naked eye yet accessible to the lens, which is adjustable and chooses its angle at will. And photographic reproduction, with the aid of certain processes, such as enlargement or slow motion, can capture images which escape natural vision. Secondly, technical reproduction can put the copy of the original into situations which would be out of reach for the original itself. Above

all, it enables the original to meet the beholder halfway, be it in the form of a photograph or a phonograph record. The cathedral leaves its locale to be received in the studio of a lover of art; the choral production, performed in an auditorium or in the open air, resounds in the drawing room.

The situations into which the product of mechanical reproduction can be brought may not touch the actual work of art, yet the quality of its presence is always depreciated. This holds not only for the art work but also, for instance, for a landscape which passes in review before the spectator in a movie. In the case of the art object, a most sensitive nucleus – namely, its authenticity – is interfered with whereas no natural object is vulnerable on that score. The authenticity of a thing is the essence of all that is transmissible from its beginning, ranging from its substantive duration to its testimony to the history which it has experienced. Since the historical testimony rests on the authenticity, the former, too, is jeopardized by reproduction when substantive duration ceases to matter. And what is really jeopardized when the historical testimony is affected is the authority of the object.

One might subsume the eliminated element in the term 'aura' and go on to say: that which withers in the age of mechanical reproduction is the aura of the work of art. This is a symptomatic process whose significance points beyond the realm of art. One might generalize by saying: the technique of reproduction detaches the reproduced object from the domain of tradition. By making many reproductions it substitutes a plurality of copies for a unique existence. And in permitting the reproduction to meet the beholder or listener in his own particular situation, it reactivates the object reproduced. These two processes lead to a tremendous shattering of tradition which is the obverse of the contemporary crisis and renewal of mankind. Both processes are intimately connected with the contemporary mass movements. Their most powerful agent is the film. Its social significance, particularly in its most positive form, is inconceivable without its destructive, cathartic aspect, that is, the liquidation of the traditional value of the cultural heritage. This phenomenon is most palpable in the great historical films. It extends to ever new positions. In 1927 Abel Gance exclaimed enthusiastically: 'Shakespeare, Rembrandt, Beethoven will make films . . . all legends, all mythologies and all myths, all founders of religion, and the very religions . . . await their exposed resurrection, and the heroes crowd each other at the gate.'[3] Presumably without intending it, he issued an invitation to a far-reaching liquidation.

3

During long periods of history, the mode of human sense perception changes with humanity's entire mode of existence. The manner which human sense perception is organized, the medium in which it is accomplished, is determined not only by nature but by historical circumstances as well. The fifth century, with its great shifts of population, saw the birth of the late Roman art industry and the Vienna Genesis, and there developed not only an art different from that of antiquity but also a new kind of perception. The scholars of the Viennese school, Riegl and Wickhoff, who resisted the weight of classical tradition under which these later art forms had been buried, were the first to draw conclusions from them concerning the organization

of perception at the time. However far-reaching their insight, these scholars limited themselves to showing the significant, formal hallmark which characterized perception in late Roman times. They did not attempt – and, perhaps, saw no way – to show the social transformations expressed by these changes of perception. The conditions for an analogous insight are more favourable in the present. And if changes in the medium of contemporary perception can be comprehended as decay of the aura, it to show its social causes.

The concept of aura which was proposed above with reference to historical objects may usefully be illustrated with reference to the aura of natural ones. We define the aura of the latter as the unique phenomenon of a distance, however close it may be. If, while resting on a summer afternoon, you follow with your eyes a mountain range on the horizon or a branch which casts its shadow over you, you experience the aura of those mountains, of that branch. This image makes it easy to comprehend the social bases of the contemporary decay of the aura. It rests on two circumstances, both of which are related to the increasing significance of the masses in contemporary life. Namely, the desire of contemporary masses to bring things 'closer' spatially and humanly, which is just as ardent as their bent toward overcoming the uniqueness of every reality by accepting its reproduction.[4] Every day the urge grows stronger to get hold of an object at very close range by way of its likeness, its reproduction. Unmistakably, reproduction as offered by picture magazines and newsreels differs from the image seen by the unarmed eye. Uniqueness and permanence are as closely linked in the latter as are transitoriness and reproducibility in the former. To pry an object from its shell, to destroy its aura, is the mark of a perception whose 'sense of the universal equality of things' has increased to such a degree that it extracts it even from a unique object means of reproduction. Thus is manifested in the field of perception what in the theoretical sphere is noticeable in the increasing importance of statistics. The adjustment of reality to the masses and of the masses to reality is a process of unlimited scope, as much for thinking as for perception.

4

The uniqueness of a work of art is inseparable from its being imbedded in the fabric of tradition. This tradition itself is thoroughly alive and extremely changeable. An ancient statue of Venus, for example, stood in a different traditional context with the Greeks, who made it an object of veneration, than with the clerics of the Middle Ages, who viewed it as an ominous idol. Both of them, however, were equally confronted with its uniqueness, that is, its aura. Originally the contextual integration of art in tradition found its expression in the cult. We know that the earliest art works originated in the service of a ritual – first the magical, then the religious kind. It is significant that the existence of the work of art with reference to its aura is never entirely separated from its ritual function.[5] In other words, the unique value of the 'authentic' work of art has its basis in ritual, the location of its original use value. This ritualistic basis, however remote, is still recognizable as secularized ritual even in the most profane forms of the cult of beauty.[6] The secular cult of beauty, developed during the Renaissance and prevailing for three centuries, clearly showed

that ritualistic basis in its decline and the first deep crisis which befell it. With the advent of the first truly revolutionary means of reproduction, photography, simultaneously with the rise of socialism, art sensed the approaching crisis which has become evident a century later. At the time, art reacted with the doctrine of *l'art pour l'art*, that is, with a theology of art. This gave rise to what might be called a negative theology in the form of the idea of 'pure' art, which not only denied any social function of art but also any categorizing by subject matter. (In poetry, Mallarmé was the first to take this position.)

An analysis of art in the age of mechanical reproduction must do justice to these relationships, for they lead us to an all-important insight: for the first time in world history, mechanical reproduction emancipates the work of art from its parasitical dependence on ritual. To an ever greater degree the work of art reproduced becomes the work of art designed for reproducibility.[7] From a photographic negative, for example, one can make any number of prints; to ask for the 'authentic' print makes no sense. But the instant the criterion of authenticity ceases to be applicable to artistic production, the total function of art is reversed. Instead of being based on ritual, it begins to be based on another practice – politics.

5

Works of art are received and valued on different planes. Two polar types stand out: with one, the accent is on the cult value; with the other, on the exhibition value of the work. Artistic production begins with ceremonial objects destined to serve in a cult. One may assume that what mattered was their existence, not their being on view. The elk portrayed by the man of the Stone Age on the walls of his cave was an instrument of magic. He did expose it to his fellow men, but in the main it was meant for the spirits. Today the cult value would seem to demand that the work of art remain hidden. Certain statues of gods are accessible only to the priest in the cella; certain Madonnas remain covered nearly all year round; certain sculptures on medieval cathedrals are invisible to the spectator on ground level. With the emancipation of the various art practices from ritual go increasing opportunities for the exhibition of their products. It is easier to exhibit a portrait bust that can be sent here and there than to exhibit the statue of a divinity that has its fixed place in the interior of a temple. The same holds for the painting as against the mosaic or fresco that preceded it. And even though the public presentability of a mass originally may have been just as great as that of a symphony, the latter originated at the moment when its public presentability promised to surpass that of the mass.

With the different methods of technical reproduction of a work of art, its fitness for exhibition increased to such an extent that the quantitative shift between its two poles turned into a qualitative transformation of its nature. This is comparable to the situation of the work of art in prehistoric times when, by the absolute emphasis on its cult value, it was, first and foremost, an instrument of magic. Only later did it come to be recognized as a work of art. In the same way today, by the absolute emphasis on its exhibition value the work of art becomes a creation with entirely new functions, among which the one we are conscious of, the artistic function, later

may be recognized as incidental. This much is certain: today photography and the film are the most serviceable exemplifications of this new function.

6

In photography, exhibition value begins to displace cult value all along the line. But cult value does not give way without resistance. It retires into an ultimate retrenchment: the human countenance. It is no accident that the portrait was the focal point of early photography. The cult of remembrance of loved ones, absent or dead, offers a last refuge for the cult value of the picture. For the last time the aura emanates from the early photographs in the fleeting expression of a human face. This is what constitutes their melancholy, incomparable beauty. But as man withdraws from the photographic image, the exhibition value for the first time shows its superiority to the ritual value. To have pinpointed this new stage constitutes the incomparable significance of Atget, who, around 1900, took photographs of deserted Paris streets. It has quite justly been said of him that he photographed them like scenes of crime. The scene of a crime, too, is deserted; it is photographed for the purpose of establishing evidence. With Atget, photographs become standard evidence for historical occurrences, and acquire a hidden political significance. They demand a specific kind of approach; free-floating contemplation is not appropriate to them. They stir the viewer; he feels challenged by them in a new way. At the same time picture magazines begin to put up signposts for him, right ones or wrong ones, no matter. For the first time, captions have become obligatory. And it is clear ,that they have an altogether different character than the tide of a painting. The directives which the captions give to those looking at pictures in illustrated magazines soon become even more explicit and more imperative in the film where the meaning of each single picture appears to be prescribed by the sequence of all preceding ones.

7

The nineteenth-century dispute as to the artistic value of painting versus photography today seems devious and confused. This does not diminish its importance, however; if anything, it underlines it. The dispute was in fact the symptom of a historical transformation the universal impact of which was not realized by either of the rivals. When the age of mechanical reproduction separated art from its basis in cult, the semblance of its autonomy disappeared forever. The resulting change in the function of art transcended the perspective of the century; for a long time it even escaped that of the twentieth century, which experienced the development of the film.

Earlier much futile thought had been devoted to the question of whether photography is an art. The primary question – whether the very invention of photography had not transformed the entire nature of art – was not raised. Soon the film theoreticians asked the same ill-considered question with regard to the film. But the difficulties which photography caused traditional aesthetics were mere child's play as compared to those raised by the film. Whence the insensitive and forced character

of early theories of the film. Abel Gance, for instance, compares the film with hiero-glyphs: 'Here, by a remarkable regression, we have come back to the level of expression of the Egyptians . . . Pictorial language has not yet matured because our eyes have not yet adjusted to it. There is as yet insufficient respect for, insufficient cult of, what it expresses.'[8] Or, in the words of Séverin-Mars: 'What art has been granted a dream more poetical and more real at the same time! Approached in this fashion the film might represent an incomparable means of expression. Only the most high-minded persons, in the most perfect and mysterious moments of their lives, should be allowed to enter its ambience.'[9] Alexandre Arnoux concludes his fantasy about the silent film with the question: 'Do not all the bold descriptions we have given amount to the definition of prayer?[10] It is instructive to note how their desire to class the film among the 'arts' forces these theoreticians to read ritual elements into it – with a striking lack of discretion. Yet when these speculations were published, films like *L'Opinion publique* and *The Gold Rush* had already appeared. This, however, did not keep Abel Gance from adducing hieroglyphs for purposes of comparison, nor Séverin-Mars from speaking of the film as one might speak of paintings by Fra Angelico. Characteristically, even today ultrareactionary authors give the film a similar contextual significance – if not an outright sacred one, then at least a supernatural one. Commenting on Max Reinhardt's film version of *A Midsummer Night's Dream,* Werfel states that undoubtedly it was the sterile copying of the exterior world with its streets, interiors, railroad stations, restaurants, motor-cars, and beaches which until now had obstructed the elevation of the film to the realm of art. 'The film has not yet realized its true meaning, its real possibilities . . . these consist in its unique faculty to express by natural means and with incom-parable persuasiveness all that is fairylike, marvellous, supernatural.'[11]

[. . .]

11

The shooting of a film, especially of a sound film, affords a spectacle unimaginable anywhere at any time before this. It presents a process in which it is impossible to assign to a spectator a viewpoint which would exclude from the actual scene such extraneous accessories as camera equipment, lighting machinery, staff assistants, etc. – unless his eye were on a line parallel with the lens. This circumstance, more than any other, renders superficial and insignificant any possible similarity between a scene in the studio and one on the stage. In the theatre one is well aware of the place from which the play cannot immediately be detected as illusionary. There is no such place for the movie scene that is being shot. Its illusionary nature is that of the second degree, the result of cutting. That is to say, in the studio the mechanical equipment has penetrated so deeply into reality that its pure aspect freed from the foreign sub-stance of equipment is the result of a special procedure, namely, the shooting by the specially adjusted camera and the mounting of the shot together with other similar ones. The equipment-free aspect of reality here has become the height of artifice; the sight of immediate reality has become an orchid in the land of technology.

Even more revealing is the comparison of these circumstances, which differ so much from those of the theatre, with the situation in painting. Here the question

is: How does the cameraman compare with the painter? To answer this we take recourse to an analogy with a surgical operation. The surgeon represents the polar opposite of the magician. The magician heals a sick person by the laying on of hands; the surgeon cuts into the patient's body. The magician maintains the natural distance between the patient and himself; though he reduces it very slightly by the laying on of hands, he greatly increases it by virtue of his authority. The surgeon does exactly the reverse; he greatly diminishes the distance between himself and the patient by penetrating into the patient's body, and increases it but little by the caution with which his hand moves among the organs. In short, in contrast to the magician – who is still hidden in the medical practitioner – the surgeon at the decisive moment abstains from facing the patient man to man; rather, it is through the operation that he penetrates into him.

Magician and surgeon compare to painter and cameraman. The painter maintains in his work a natural distance from reality, the cameraman penetrates deeply into its web. There is a tremendous difference between the pictures they obtain. That of the painter is a total one, that of the cameraman consists of multiple fragments which are assembled under a new law. Thus, for contemporary man the representation of reality by the film is incomparably more significant than that of the painter, since it offers, precisely because of the thoroughgoing permeation of reality with mechanical equipment, an aspect of reality which is free of all equipment. And that is what one is entitled to ask from a work of art.

12

Mechanical reproduction of art changes the reaction of the masses toward art. The reactionary attitude toward a Picasso painting changes into the progressive reaction toward a Chaplin movie. The progressive reaction is characterized by the direct, intimate fusion of visual and emotional enjoyment with the orientation of the expert. Such fusion is of great social significance. The greater the decrease in the social significance of an art form, the sharper the distinction between criticism and enjoyment by the public. The conventional is uncritically enjoyed, and the truly new is criticized with aversion. With regard to the screen, the critical and the receptive attitudes of the public coincide. The decisive reason for this is that individual reactions are predetermined by the mass audience response they are about to produce, and this is nowhere more pronounced than in the film. The moment these responses become manifest they control each other. Again, the comparison with painting is fruitful. A painting has always had an excellent chance to be viewed by one person or by a few. The simultaneous contemplation of paintings by a large public, such as developed in the nineteenth century, is an early symptom of the crisis of painting, a crisis which was by no means occasioned exclusively by photography but rather in a relatively independent manner by the appeal of art works to the masses.

Painting simply is in no position to present an object for simultaneous collective experience, as it was possible for architecture at all times, for the epic poem in the past, and for the movie today. Although this circumstance in itself should not lead one to conclusions about the social role of painting, it does constitute a serious threat as soon as painting, under special conditions and, as it were, against its nature,

is confronted directly by the masses. In the churches and monasteries of the Middle Ages and at the princely courts up to the end of the eighteenth century, a collective reception of paintings did not occur simultaneously, but by graduated and hierarchized mediation. The change that has come about is an expression of the particular conflict in which painting was implicated by the mechanical reproducibility of paintings. Although paintings began to be publicly exhibited in galleries and salons, there was no way for the masses to organize and control themselves in their reception. Thus the same public which responds in a progressive manner toward a grotesque film is bound to respond in a reactionary manner to surrealism.

13

The characteristics of the film lie not only in the manner in which man presents himself to mechanical equipment but also in the manner in which, by means of this apparatus, man can represent his environment. A glance at occupational psychology illustrates the testing capacity of the equipment. Psychoanalysis illustrates it in a different perspective. The film has enriched our field of perception with methods which can be illustrated by those of Freudian theory. Fifty years ago, a slip of the tongue passed more or less unnoticed. Only exceptionally may such a slip have revealed dimensions of depth in a conversation which had seemed to be taking its course on the surface. Since the *Psychopathology of Everyday Life* things have changed. This book isolated and made analyzable things which had heretofore floated along unnoticed in the broad stream of perception. For the entire spectrum of optical, and now also acoustical, perception the film has brought about a similar deepening of apperception. It is only an obverse of this fact that behaviour items shown in a movie can be analyzed much more precisely and from more points of view than those presented on paintings or on the stage. As compared with painting, filmed behaviour lends itself more readily to analysis because of its incomparably more precise statements of the situation. In comparison with the stage scene, the filmed behaviour item lends itself more readily to analysis because it can be isolated more easily. This circumstance derives its chief importance from its tendency to promote the mutual penetration of art and science. Actually, of a screened behaviour item which is neatly brought out in a certain situation, like a muscle of a body, it is difficult to say which is more fascinating, its artistic value or its value for science. To demonstrate the identity of the artistic and scientific uses of photography which heretofore usually were separated will be one of the revolutionary functions of the film.

By close-ups of the things around us, by focusing on hidden details of familiar objects, by exploring commonplace milieus under the ingenious guidance of the camera, the film, on the one hand, extends our comprehension of the necessities which rule our lives; on the other hand, it manages to assure us of an immense and unexpected field of action. Our taverns and our metropolitan streets, our offices and furnished rooms, our railroad stations and our factories appeared to have us locked up hopelessly. Then came the film and burst this prison-world asunder by the dynamite of the tenth of a second, so that now, in the midst of its far-flung ruins and debris, we calmly and adventurously go travelling. With the close-up, space

expands; with slow motion, movement is extended. The enlargement of a snapshot does not simply render more precise what in any case was visible, though unclear: it reveals entirely new structural formations of the subject. So, too, slow motion not only presents familiar qualities of movement but reveals in them entirely unknown ones 'which, far from looking like retarded rapid movements, give the effect of singularly gliding, floating, supernatural motions.'[12] Evidently a different nature opens itself to the camera than opens to the naked eye – if only because an unconsciously penetrated space is substituted for a space consciously explored by man. Even if one has a general knowledge of the way people walk, one knows nothing of a person's posture during the fractional second of a stride. The act of reaching for a lighter or a spoon is familiar routine, yet we hardly know what really goes on between hand and metal, not to mention how this fluctuates with our moods. Here the camera intervenes with the resources of its lowerings and likings, its interruptions and isolations, its extensions and accelerations, its enlargements and reductions. The camera introduces us to unconscious optics as does psycho-analysis to unconscious impulses.

[. . .]

Notes

1 Paul Valéry (1964) *Aesthetics*, trans. Ralph Mannheim NY: Pantheon Books, Bollingen Series originally published as Pièces sur l'Art, Paris, 1934.

2 Precisely because authenticity is not reproducible, the intensive penetration of certain (mechanical) processes of reproduction was instrumental in differentiating and grading authenticity. To develop such differentiations was an important function of the trade in works of art. The invention of the woodcut may be said to have struck at the root of the quality of authenticity even before its late flowering.

3 Abel Gance, 'Le Temps de l'image est venu,' *L'Art cinématographique*, Vol. 2, pp. 94f, Paris, 1927.

4 To satisfy the human interest of the masses may mean to have one's social function removed from the field of vision. Nothing guarantees that a portraitist of today, when painting a famous surgeon at the breakfast table in the midst of his family, depicts his social function more precisely than a painter of the seventeenth century who portrayed his medical doctors as representing this profession, like Rembrandt in his 'Anatomy Lesson.'

5 The definition of the aura as a 'unique phenomenon of a distance however close it may be' represents nothing but the formulation of the cult value of the work of art in categories of space and time perception. Distance is the opposite of closeness. The essentially distant object is the unapproachable one. Unapproachability is indeed a major quality of the cult image. True to its nature, it remains 'distant, however close it may be.' The closeness which one may gain from its subject matter does not impair the distance which it retains in its appearance.

6 To the extent to which the cult value of the painting is secularised the ideas of its fundamental uniqueness lose distinctness. In the imagination of the beholder the uniqueness of the phenomena which hold sway in the cult image is more and more displaced by the empirical uniqueness of the creator or of his creative achievement. To be sure, never completely so; the concept of authenticity always transcends mere genuineness. (This is particularly apparent in the collector who always retains some

traces of the fetishist and who, by owning the work of art, shares in its ritual power.) Nevertheless, the function of the concept of authenticity remains determinate in the evaluation of art; with the secularization of art, authenticity displaces the cult value of the work.

7 In the case of films, mechanical reproduction is not, as with literature and painting, an external condition for mass distribution. Mechanical reproduction is inherent in the very technique of film production. This technique not only permits in the most direct way but virtually causes mass distribution. It enforces distribution because the production of a film is so expensive that an individual who, for instance, might afford to buy a painting no longer can afford to buy a film

8 Abel Gance, *op. cit.*, pp. 100–1.

9 Séverin-Mars, quoted by Abel Gance, *op. cit.*, p. 100.

10 Alexandre Arnoux, *Cinéma pris*, 1929, p. 28.

11 Franz Werfel, 'Ein Sommernachtstraum, Ein Film von Shakespeare und Reinhardt,' *Neues Wiener Journal*, cited in *Lu* 15, November, 1935.

12 Rudolf Arnheim, *Film als Kunst*, Berlin, 1932, p. 138.

W. J. T. Mitchell

BENJAMIN AND THE POLITICAL ECONOMY OF THE PHOTOGRAPH

Each wondrous work of thine excites Surprize;
And, as at Court some fall, when others rise;
So, if thy magick Pow'r thou deign to shew;
The High are humbled, and advanc'd the Low;

[. . .]

Instructive Glass! here human Pride may trace,
Diminish'd Grandeur, and inverted Place.
> Anonymous, *Verses Occasion'd by the
> Sight of a Chamera Obscura* (1747)[1]

I MENTIONED EARLIER A CURIOUS asymmetry in Marxist writing about photography. In spite of the fact that photography was *the* revolutionary medium of the nineteenth century, invented during the years when Marx produced his major writings, he never mentions it except as another kind of 'industry.'[2] It is not hard to see, nevertheless, why photography would take on a special status for later Marxist criticism. The assumption that photography is an inherently realistic medium is very congenial with Marx's own expressed preference for realism in literature and painting. Marx and Engels resisted the notion that literature and art should be merely didactic instruments of socialist propaganda, preferring the realism of a nostalgic royalist like Balzac to the *Tendenzroman*.[3] And in the visual arts, Engels suggested that the leaders of the revolution should not be glorified but should

> be finally depicted in strong Rembrandtian colors, in all their living qualities. Hitherto these people have never been pictured in their real form; they have been presented as official personalities, wearing buskins

and with aureoles around their heads. In these apotheoses of Raphaelite beauty all pictorial truth is lost.[4]

(Marx and Engels 1947: 40)

'Rembrandtian' was, as it happens, one of the terms applied to the daguerreo-type; Samuel Morse called the new images 'Rembrandt perfected' in 1839.[5] The 'realism' celebrated here is not, however, an optical, scientific reconstruction of vision – Vermeer would have been the right analogy for that sort of realism. And it is not 'historical' in the sense of traditional history painting ('apotheoses of Raphaelite beauty'), but an image of *real* history, of flesh-and-blood creatures in their material circumstances. This image replaces the traditional 'aureole' around the figure with a new sort of aura – the 'living qualities' of the subject.

These 'living qualities' are what, notoriously, the camera captures under the right conditions, so that it seems to come equipped with a historical, documentary claim built in to its mechanism: this really happened, and it really looked this way, at this time. This is more than the claim to merely optical fidelity, a correct tran-scription of visual appearances; it is a claim to have captured a piece of the 'historical life-process' as well as the 'physical life-process.' Perhaps we can now see some of the reasons for the Marxist fascination with photography and cinema, and also under-stand its ambivalence. The camera duplicates the ambiguous status of the camera obscura and raises it to a new power, for its images, in their permanence, can become material objects of exchange, and its overcoming of the transience of the 'fairy images' of the camera obscura means that it really can capture the historical process in a way that was only figuratively possible for the camera obscura.

Walter Benjamin's essays on photography provide the most fully developed expression of the Marxist ambivalence about the camera. Benjamin treats the camera as a kind of two-handed engine wielded at the gateway to the revolutionary millen-nium. The camera is, on the one hand, the epitome of the destructive, consumptive political economy of capitalism; it dispels the 'aura' of things by reproducing them in a leveling, automatic, statistically rationalized form: 'that which withers in the age of mechanical reproduction is the aura of the work of art. . . . To pry an object from its shell, to destroy its aura, is the mark of a perception whose "sense of the universal equality of things" has increased to such a degree that it extracts it even from a unique object by means of reproduction.'[6] Benjamin's camera does to the visible world what Marx said (in the *Communist Manifesto*) that capitalism was doing to social life in general: capitalism, like the pitiless eye of the camera, 'strips of its halo every occupation,' and replaces all the traditional forms of life 'veiled by religious and political illusions' with 'naked, shameless, direct, brutal exploitation.'[7] On the other hand, Benjamin also echoes Marx's faith in the dialectical inversion and redemption of these evils by the cunning of historical development: capitalism must run its course, unveil its contradictions, and produce a new class that will be so nakedly dispossessed that a complete social revolution will be inevitable. In a similar fashion, Benjamin hails the invention of photography as 'the first truly revolu-tionary means of production' ('Work of Art,' 224), a medium that was invented 'simultaneously with the rise of socialism' and that is capable of revolutionizing the whole function of art, and of the human senses as well. If Marx thought of ideology as a camera obscura, Benjamin regarded the camera as both the material

incarnation of ideology and as a symbol of the 'historical life-process' that would bring an end to ideology.

Benjamin was not the only one to express ambivalence about the camera, of course. The endless battles over the artistic status of photography and the larger question of whether the photographic image has a special 'ontology' reflect similar contradictory feelings. Is photography a fine art or a mere industry? Is it 'Rembrandt perfected,' as Samuel Morse thought, or a new distraction for the 'idolatrous multitude,' as Baudelaire characterized it? ('An avenging God has heard the prayers of this multitude; Daguerre was his messiah.')[8] Does the camera provide a material incarnation of objective, scientific representation by mechanizing the system of perspective, as Gombrich argues? Or is it an instrument of 'contemplative materialism,' 'a purely ideological apparatus' whose 'monocular' vision ratifies 'the metaphysical centering on the subject' in bourgeois humanism, as Marcel Pleynet contends?[9]

Benjamin finesses all these kinds of disputes by treating them as 'contradictions' in the Marxist-Hegelian sense: they are symptoms of contradictions within capitalism that find their resolution in a historical narrative that foresees a synthesis in the future. Thus, Benjamin can mimic both sides of these debates while criticizing them. He can echo Baudelaire's distaste for the leveling effect of photography as an idol of mass culture, and yet see this leveling as an omen of the classless society. He can absorb the dispute between the 'scientific' and 'ideological' views of the photograph in the same way that Marx absorbed the debate between idealism and empiricism in the metaphor of the camera obscura, by treating them as equally partial, equally deluded options in the dialectic of history. He can rise above the argument over the artistic status of photography by dismissing it as a 'futile' debate that ignores the 'primary question – whether the very invention of photography had not transformed the entire nature of art' ('Work of Art,' 227). The argument that photography is a fine art is denounced as reactionary idolatry:

> Here, with all the weight of its dullness, enters the philistine's concept
> of *art*, to which any technical development is totally foreign, which with
> the provocative challenge of the new technology, feels its own end nearing.
> Nevertheless it was this fetishistic, fundamentally anti-technological
> concept of art with which the theoreticians of photography sought for
> almost a hundred years, naturally without coming to the slightest result.[10]

On the other hand, the dismissal of photography as mere technology is, in Benjamin's view, equally involved in fetishism and idolatry, the sort that tries to exclude the photographic image from the circle of sacred (i.e., artistic) objects. Benjamin quotes the Leipzig *City Advertiser* to illustrate this sort of reaction:

> 'To fix fleeting reflections,' it was written there, 'is not only impossible,
> as has been shown by thoroughgoing German research, but to wish to
> do it is blasphemy. Man is created in the image of God and God's image
> cannot be held fast by a human machine. At the most the pious artist –
> enraptured by heavenly inspiration – may at the higher command of his
> genius dare to reproduce those divine/human features in an instant of
> highest dedication, without mechanical help.'
>
> ('Short History' 1931; 1977: 200)

Photography, for Benjamin, is neither art nor nonart (mere technology): it is a new form of production that transforms the whole nature of art. To hold on to the view of photography as *either* art or as nonart in the traditional sense of the word is to fall into some sort of fetishism, a charge which Benjamin can substantiate simply by quoting the antagonists against one another. One thing Benjamin does not really try to explain, however, is why one version of this fetishism won out. Why did assimilation of the machine-made image into the fine arts by the 'philistine' (recall here that the legendary Philistines were not simply idolaters but also the legendary thieves who stole the Ark of the Covenant from the Israelites; see I Samuel 5:1) overcome the reactionary pieties about man-made images? One answer is that there were certain historical exceptions: early photographs, with their predominance of shadows and oval images have about them the 'aura' or 'halo' that Benjamin sees photography as ultimately destroying ('Short History,' 207). In these early 'pre-industrial' photographs, the 'photographer was on the highest level of his instrument' ('Short History,' 205), and thus occupies, in Benjamin's view, a kind of prophetic or patriarchal status in the history of the medium: 'there seems to have been a sort of Biblical blessing on those first photographers: Nadar, Stelzner, Pierson, Bayard all lived to ninety or a hundred' ('Short History,' 205). Another answer is that there are two ways to dispel the aura around objects in the photographic process: one is the merely technical, vulgar clarity that comes with mass production and improved lighting: 'The conquest of darkness by increased illumination . . . eliminated the aura from the picture as thoroughly as the increasing alienation of the imperialist bourgeoisie had eliminated it from reality' (Short History,' 208). The other is the 'liberation of the object from the aura' that one sees first in Atget, and which prefigures the 'healthy alienation' Benjamin sees in surrealist photography ('Short History,' 208–10).

Neither of these examples, however, really answers the question about the absorption of photography by traditional notions of fine art. When Benjamin praises the production of aura in Nadar, and the destruction of aura in Atget, he is praising them as moments in the formation of a new, revolutionary conception of art that bypasses all the philistine twaddle about creative genius and beauty. And yet it is precisely these traditional notions of aesthetics, with all their attendant claims about craftsmanship, formal subtlety, and semantic complexity, that have sustained the case for the artistic status of photography. Some photographs just happen to be beautiful, by some criterion or other; some have a lot to say, or they present novel, moving, or otherwise interesting subject-matter. If the photograph really has the revolutionary character that Benjamin ascribes to it, one would expect more resistance to its appropriation by traditional aesthetic norms, more inertia in its status as a mere industry, and more unequivocal evidence of its tendency to transform all the other arts – to shift our attention, as it were, from 'photography as a form of art' to 'art as a form of photography' ('Short History,' 211).

The Marxist tradition has an answer to the question of why photography was assimilated to the fine arts, but it does not fit very well with Benjamin's idealization of it as a revolutionary art. Bernard Edelman suggests that the aesthetic idealization of photography is purely an economic and legal matter. The photographer had to gain recognition as a creative artist in order for the law to find grounds for ownership of photographic images. Before the invention of photography, Edelman argues,

the law recognised only 'manual' art – the paintbrush, the chisel – or 'abstract' art – writing. The irruption of modern techniques of the (re)production of the real – photographic apparatuses, cameras – surprises the law in the quietude of its categories. . . . Photographer and film maker must become creators, or the industry will lose the benefit of legal protection.[11]

Edelman suggests, like Benjamin, that the 'pre-industrial' phase of photography is somehow a special moment: 'The photographer of 1860 is the *proletarian of creation*; he and his tool form one body.'[12] But this preindustrial phase is also preaesthetic, and Edelman musters a large number of legal opinions to suggest that the rise of the aesthetic justification – the 'creative subjectivity' of the photographer in particular – is a legal fiction devised to secure property rights.

Edelman is completely silent about Benjamin, an astonishing omission in a Marxist analysis of photography and cinema. But the reason may not be so difficult to see. There is no suggestion in Edelman's account that some photography (except perhaps the earliest) escapes the political economy of capitalism. Edelman presents no sensitive analyses of Agtet or the surrealists, no discoveries of the revolutionary destruction of aura and 'healthy alienation' as Benjamin does: In fact he never discusses a single photograph. He is interested only in photography as a 'legal fiction' and in the photographer as a 'subject in law' under capitalist jurisprudence. In his way, Edelman's version of photography is as idealized as Benjamin's; the difference is that he has some empirical evidence to suggest that his particular idealization (for which he has nothing but contempt) has had the force of law. Benjamin's, we might say, has the force of desire: he wants photography to transform the arts into a revolutionary force; he wants the question of photography as a fine art (or perhaps as just another technique of picture-making) to be bypassed by history. The one place where these two accounts converge is in their agreement that the aestheticizing of photography is a kind of fetishism. For Benjamin, it is the quasi-religious fetishism that tries to reproduce the 'aura' in photography by tricking it up or imitating painterly styles; for Edelman, it is the fetishism of the commodity, the photograph as something that has exchange value. The 'idols of the mind' that Marx saw projected in the camera obscura take their material, incarnate form in the legal and aesthetic status of the photograph as a capitalist fetish. This conclusion fulfills the logic of Marx's thought, but it also produces certain problems for the application of that thought to photography, and to art in general, problems which are centered in the figure of the fetish.

[. . .]

Notes

1 These verses were printed for the noted optician, John Cuff, who probably wrote them. See Heinrich Schwarz, 'An Eighteenth Century English Poem on the Camera Obscura,' in *One Hundred Years of Photographic History: Essays in Honor of Beaumont Newhall*, ed. Van Deren Coke (Albuquerque, University of New Mexico Press, 1975), 128–35. I am grateful to Joel Snyder for leading me to this text.

2 *Capital* (1867), ed. Frederick Engels, trans. from the third German edition (1883) by Samuel Moore and Edward Aveling, 3 vols. (New York: International Publishers, 1967), 1:445. All references to *Capital* will be from this edition, hereafter indicated by C.

3 See Marx and Engels, *Literature and Art* (New York: International Publishers, 1947), 42. A strong argument for placing Marx's aesthetic theory with the Saint-Simonist avant garde is made by Margaret A. Rose in *Marx's Lost Aesthetic* (New York: Cambridge University Press, 1984).

4 *Literature and Art*, 40.

5 *One Hundred Years of Photographic History*, 23.

6 'The Work of Art in the Age of Mechanical Reproduction,' first published in *Zeitschrift für Socialforschung* V, I (1936). Reference here and throughout is to the translation in *Illuminations*, ed. Hannah Arrendt (New York: Shocken, 1969), 221, 223, hereafter cited as 'Work of Art.'

7 See 1:397, for capitalism as a leveler, the 'halo' and 'veil' images occur in *The Communist Manifesto* (1848), ed. Samuel H. Beer (Arlington Heights, Ill.: Harlan Davidson, 1955), 12.

8 Trachtenberg, *Classic Essays on Photography* (New Haven, Connecticut: Leete's Island Books, 1980) 86.

9 See chapter 3 above for a discussion of Gombrich on the scientific status of photography; Pleynet is quoted in Bernard Edelman, *The Ownership of the Image* (London: Routledge & Kegan Paul, 1979), 63–64.

10 Benjamin, 'A Short History of Photography,' originally published in *Literarische Welt* (1931); reprinted from *Artforum* (February, 1977), Phil Patton, trans., in Trachtenberg, 201. Hereafter cited as 'Short History.'

11 *The Ownership of the Image*, 44.

12 Ibid., 45.

Susan Sontag

PHOTOGRAPHY WITHIN THE HUMANITIES*

I AM A WRITER AND A FILMMAKER. I don't consider myself a critic, and I am above all not a critic of photography. But it's from that strictly independent and freelance position that I am saying my say; it's not as a member of the photography establishment or photography anti-establishment, but as an educated outsider.

It has occurred to me, however, that because of my special status in relation to the other people whom you have invited to talk before me that I might be in a better position than some of them to comment on the subject of this series. Obviously, to say 'Photography within the Humanities' is to name two things which raise a whole series of problems. The question is: What is photography? Then there is the other big word with the little ones in between – Humanities, which makes us think of a very particular set of values that refers back to certain cultural and educational ideas, so that Humanities is a term that comes up in, above all, university curricula. But that is a kind of condensation or synthesis or anthology of the most valuable cultural experiences and ideas and works of the imagination or creation within, I say, *a* given culture. But just to catch up with it in its relatively modern form, it does have to do with a notion of curriculum.

Now if anyone would think to suggest as a title for a series of experiences or lectures or discussions, *Photography within the Humanities*, he's probably not mainly thinking of the humanities as being the subject under question but photography, because one of the first things to say about photography is that it is a relatively recent activity. Whether you consider it an art form or not, it is an activity over which people have debated (and) whose status has been under question. A lot of people in the early decades of photography tried to treat it as if it were simply some kind of copying machine, as an aid in reproducing or dispensing a certain kind of visual

* A speech delivered at a Wellesley College photographic symposium on April 21, 1975.

information, but not itself as an independent source of seeing or of material that would fundamentally change our visual sensibility, as, in fact, it has. And the history of taste and argument about photography has roughly consisted, to speak in broad terms, of the continuous upgrading of this activity.

One continues to have a great many debates, needless to say: 'Is photography an art or isn't it?' This very nourishing, if phony, debate has been going on for a century about whether photography is an art or not. I say it's phony not because there are not some real questions, but because I think that the questions – at that level – are oversimplified and fundamentally opaque. But it has been, if it is a form of mystification, an immensely creative mystification. The literature about photography by professional photographers is incredibly defensive. It is both aggressive and defensive, two stances that usually go together. One can sense, under all these exalted claims that are being made for photography, a very interesting and fruitful pressure on the photographer which has been this problematic status of the very activity itself.

By asking about the situation of photography within the humanities, one is covertly raising that old query: Is photography an art? – is it really a serious activity or a serious art; does it really have a proper place in the university curriculum, as a department in museums; is it different from the other art forms? In another sense, it is as I suggested before, a phony debate, because there is no doubt the battle has been won.

The question is rather, if photography is an art and is socially or sociologically accepted, is it an art like any other? It isn't exactly an art, like painting, and perhaps that may explain something about its current influence. In some way I would suggest that photography is not so much an art as a meta-art. It's an art which devours other art. It is a creation, a creation in the form of some certain kind of visual image, but it also cannibalizes and very concretely reproduces other forms of art; there is a creation of images, images which would not exist if we did not have the camera. But there is also a sense in which photography takes the whole world as its subject, cannibalizes all art forms, and converts them into images. And in that sense it seems a peculiarly modern art. It may be the art that is most appropriate to the fundamental terms and concerns of an industrial consumer society. It has the capacity to turn every experience, every event, every reality into a commodity or an object or image. One of the fundamental axes of modern thought is this contrast between image and reality. It doesn't seem wrong to say that our society is rooted or centered in a certain proliferation of images in a way that no other society has been.

To return to the point of departure, if photography has a place within the humanities, it might very well have a kind of central place, because it is not only a form of art under certain restrictions, but it also has a place where all kinds of sociological and moral and historical questions can be raised.

My purpose is not to evaluate the work of particular photographers, but rather to discuss the problems raised by the presence of photography, and these include moral issues as well as aesthetic issues. I think it's a perfectly good idea to study photography. I'm not talking about studying making photographs, but studying looking at them, and learning how to see, because the way in which you learn to see is a general education of sight, and its results can be extended to other ways of seeing. Another point should be made that there is such a thing as photographic

seeing. If you think of people actually going out and looking for photographs as a kind of freelance artistic activity, what people have more and more learned to value is something they get in the camera that they don't get ordinarily, that they can see by means of the camera, and so they are changing their own way of seeing, in the very process of becoming habitual camera users. The world becomes a series of events that you transform into pictures, and those events have reality, so far as you have the pictures of them.

Most people in this society have the idea that to take a picture is to say, among other things: 'this is worth photographing.' And to appraise an event as valuable or interesting or beautiful is to wish to have a photograph of it. It has gotten built into our very way of perceiving things, that we have a fundamentally appropriative relationship to reality. We think that the properly flattering contact with anything is to want to photograph it. And the camera has indeed become part of our sensibility. So when Christopher Isherwood said, 'I am a Camera,' what he really meant was 'I see. I see. I perceive. I am storing this up.'

One of the reasons I don't take pictures is that there are a lot of other people taking them and that's for the moment enough for me; and I feel I already do see photographically. Perhaps I see too much photographically and don't wish to indulge this way of seeing any further. It is a very particular specialization of one's sensibility.

How did you first become involved with photography from the critical point of view?

I've always been a photograph junkie. That is, I've always been very interested in photographs – I cut them out of magazines and collect, not originals, but copies, reproductions of photographs. The only difference is that recently I decided to write about some of the ideas that I've had over the last twenty years. So I embarked on what I thought would be one essay and has turned out to be six. But I'm not, as I told the people who invited me to Wellesley, a photographer; I do not take photographs; I don't like to take photographs; I don't own a camera; and I'm not a photography critic. But my writing about photography represents the expression, and in a certain sense, the liquidation of a very long-term interest. It's precisely because I've been thinking about this for twenty years that I think I can write about it now. Somebody asked me what I thought I was going to do by writing these essays, and I said I'm going to cure myself of my addiction. That hasn't happened, however.

In your opinion, is the normal everyday photographer any more aggressive, cannibalistic toward the world around him or her than a normal, everyday prose writer?

There are an unlimited number of photographs to take, every photographer feels that. There are not an unlimited number of things to write, except in a very cerebral sense, which no writer really feels. Every writer has to reach and is constantly aware of how basically it comes from inside; it all has to be transformed in the

homemade laboratory that you have got in your guts and your brain. Whereas, for the photographer, the world is really there; it is an incredible thing, it is all interesting and in fact, more interesting when seen through the camera than when seen with the naked eye or with real sight. The camera is this thing which can capture the world for you. It is not like a gun; it is not like doing people in, but it is a way of bringing something back. It enables you to transform the world, to miniaturize it. And photographs have a special status for us as icons and as magical objects that other visual images such as paintings and other forms of representational art such as literature do not have. I do not think that any other way of creating image systems has the same kind of obsessional power behind it.

Of course, the word 'cannibalize' is loaded and provocative and is perhaps overly strong, but I do not consider it to be a key part of my argument. My primary point is not to speculate about what picture taking does to people, but to consider the impact of looking at photographs and having this kind of information or experience of the picture. It is the consumption of photographs rather than the taking of them which concerns me and why pictures have become a regular nutriment of our sensibility and a source of information.

I think there are moral issues that are worth talking about, and one shouldn't be afraid of them. I get kind of sad when I realize that what people seem to want is to be told whether photography is okay or not. I mean it's part of the world. Let me give you an example. I'm probably being very indiscreet, but I don't think he would mind – I had a call the other day from Richard Avedon, whom I had gotten to know as a result of these essays for the *New York Review of Books*. In fact, I didn't know him before. I don't think I would have written about photography if I had known any photographers. Anyway, we had become friends and we had a lot of discussion about the ideas of the essays, some of which he agreed with and some of which he didn't. He said, 'I want to know your opinion.' He had spent seven weeks in Saigon in the early seventies and he took a great many photographs of the napalm victims, victims of American bombings of the Vietnamese. He did this on his own, with his own money. He was not sent by anybody. He set up a studio in a hotel in Saigon and among other things he photographed dozens and dozens of people without faces, without hands, bodies covered with scar tissue. He was asked by a major and very commercial magazine a couple of days ago to print these photographs. He's never printed them. He's never published them. He called me up and said, 'What do you think? I don't know what to do. It seems to me a terrible thing to do, and it also seems to me a good thing to do. I mean, I just don't know.' We talked for an hour about it. Was it an exploitation of these people? Are these photographs aesthetic? He had only shown me one, and I haven't seen all of them. He said the photographs were beautiful. In some ways, they're beautiful and in others they are absolutely horrifying. He said, 'I don't know what to do,' and I said, 'I don't know what you should do either; after calling me up to ask my opinion I think I'm just as puzzled as you are. I can think of very good arguments for not doing it, and I can think of very good arguments for doing it.'

This is a tremendous, messy, moral problem. It doesn't start with that phone call either; it starts all the way back when one does it. If you don't publish them, you'll have some regrets; if you do publish them, you'll have some regrets. He agreed. I haven't heard the news, so I do feel a little indiscreet about telling you

the story, but it's not a real secret and you may very well see these photographs in the next few weeks. But the problems are real. The complexity is real. He's very objective about his work, and he's very smart. He said they looked like Avedon pictures, and yet they are of those people. He said he was crying when he took the photographs, and yet they looked like Avedon photographs, very straight-on, white background. He said, now I don't know what to do with them. I wonder if I should have taken them, and yet I know if I had to do it all over again I would still have taken them. It's very interesting; it put his whole activity into question. I do think that people understand this. I don't think I invented these problems, and I think that a lot of photographers are aware of them. These are the real moral and aesthetic questions that are raised by this enterprise.

Do you wish that photography wasn't as ubiquitous as it is? Do you resent that kind of intrusion into your consciousness that you described as happening at age twelve when you first saw photographs of Dachau?[1]

Well, it changed my life. But I don't know that I would say I resent it. A lot of people have seen photographs that have, whether they know it or not, changed their consciousness. It's not a question of my reaction personally; it's a question of naming it – naming this phenomenon which is very formative for us . . . this shock experi- ence It's not that I want to say that you can't be shocked by anything but a photograph, but here is this object, this image, which you can stumble or come upon inadvertently by opening the pages of a magazine. It's not like a painting; you know where the paintings are – they're in museums and galleries and if you want to go that's a special experience; you go to it, so to speak. But photographs come to you because they're all over the place.

Dante vernacular

 The nature of the imagery, in which the imagery is very shocking and painful, is certainly more common now, steadily more common than it was. There was a photograph, you must have seen it, it was on the cover of both *Newsweek* and *Time* magazines a few weeks ago, of a Vietnamese mother holding a child that was wounded probably, or dying, or was already dead in her arms, facing the camera. Now this is a photograph which you would not have seen on the cover of any news magazine several years ago. I am not saying that people were not shocked by the photograph; I am sure some people cancelled their subscriptions to those maga- zines. But that kind of image would not have been acceptable, would have been thought too shocking by the editors of those magazines a few years ago. I think there is a process of becoming inured. I do not know if people become that much more tolerant of the real thing because the imagery becomes that much more accept- able, but inevitably there is a process of dissociation. So that often when people for the first time are confronted in reality with anything like the level of cruelty in the images they have seen, what they think is, 'It's like the photograph' or 'It's like the movie.' They refer back to the images in order to have a direct experience of the reality because they have been prepared, in some very dissociated way, by the images and not by real experience. If you see a lot of images like that, the ante is being raised; the image has to be even more shocking to be really upsetting.

In a way you are not present, you are passive when you look at the photograph. Perhaps that is the disturbing thing. If you are standing watching an operation, next to the operating table, you can change your focus, you can still look different ways, you can change your attention – make the close-ups and the long shots for yourself. There are also the surgeons and the nurses, but you are there. You are not there in a picture, and that is where some of the anxiety comes in; there is nothing you can do when you look at a photograph.

Photographs give us information; it seems that they give us information that is very packaged and they give us the information that we are already prepared to recognize obviously. It's as if the words don't have the weight they should have, so that one of the statements being made by any photograph is: 'This really exists.' The photograph is a kind of job for the imagination to do something that we should have been able to do if we were not so disturbed by so many different kinds of information that are not really absorbed. Photographs have this authority of being testimony, but almost as if you have some direct contact with the thing, or as if the photograph is a piece of the thing; even though it's an image, it really is the thing.

Do you feel that photography has promoted a new kind of seeing?

Oscar Wilde said that the way you see is largely determined by art, in the larger sense. Though people have always seen, now there is a process of framing or selection which is guided by the kinds of things that we see reproduced. Photography is an art form which is basically and fundamentally connected with technology and a technology whose virtues are its simplicity and its rapidity.

Cartier-Bresson has recently said that he wants to stop photographing. He has always painted a little bit, but now he wants to devote himself completely to painting, and the reason he gave is that photography promotes 'fast seeing,' and, having spent a lifetime seeing fast, he now wants to slow down. So he'd rather paint. The existence of the camera does promote habits of seeing which are rapid, and part of their value is how much you can get out of this rapid seeing.

Technologically, the whole history of the development of cameras has been to shorten the exposure time. Beginning a few decades ago, you got virtually instantaneous development. That means there is an increasing enlargement of the scope of the photographic project. Thus, anything can be caught by the camera, and the whole world is material to be photographed. There's no doubt that the reigning taste is for the photograph that makes the thing interesting. It isn't interesting in itself, it's interesting because it's in a photograph. One of the many tendencies is to reduce the subject matter or have a kind of throw-away subject matter in photography. There's nothing that wouldn't make a good picture. I don't think that presumption exists in the history of the other arts or – if it does – it is only recently, and partly because photography has become a model for our consciousness. When you have seen something extraordinary it goes with the telling afterwards that you want to have the photographic record of it; the notion of an event or situation or person being privileged and your taking a camera to record it are intertwined for us.

I was in China a year and a half ago and wherever I went, the Chinese said to me, 'Where is your camera?' I was apparently the first person to ever come to China in the past few years (since foreigners have started going again) who hadn't gone with a camera. They understood, of course, that to get to go to China was a big thing for us foreigners and that what those foreigners did when they came to an event that was particularly interesting was to take a picture of it. I was very interested to see what people do with cameras in China, because it is the one country in the world where there is a conscious effort on the part of the Chinese leadership not to be a consumer society. Wherever I went in China, everybody had photographs of relatives: in wallets, on the glass under desks in offices, on the side of the lathe or the machine in factories. And they'd say, 'That's my aunt so-and-so, or my cousin so-and-so; he lives a thousand miles away, and I haven't seen him in two years; those are my children, those are my parents.' Or you'd see, less often, photographs of famous holy places or important monuments. Those are the only photographs you see. When a foreigner comes to China and takes a picture of an appealing door, the Chinese say, 'What would you want to take a picture of that for?' And the person says, 'Well, it's beautiful.' 'That door is beautiful? It needs a coat of paint.' And you say, 'No, it's beautiful.' The Chinese do not have that idea that objects can disclose some kind of aesthetic value simply when they are reproduced, or that particularly casual, vernacular, off-hand, deteriorated, throw-away objects have a kind of poetry that a camera can reveal.

The point that I make in a number of the essays is that there is a kind of surrealist sensibility in photography which is very important, i.e., the casual ordinary thing is able to reveal its beauties when photographed. There is a whole tradition in photography, and I do not mean necessarily the so-called surrealist photographers, but precisely the people who are doing very straight-on stuff, like Weston photographing toilets and artichokes. One of the great traditions in photography is taking the neglected, homely object, the corner of something, the interesting surface, preferably a bit deteriorated or decayed with some kind of strange pattern on it. That is a way of seeing which is very much promoted by photography and has influenced people's way of seeing – whether they use cameras or not.

Is there a difference in impact between still photographs and film?

The photographs change, depending on the context in which they are seen. One could say there is something exploitative; they become items, visual commodities to be flipped through as you move on to something else. It is perhaps a way of denigrating the subject. For example, I have seen those Minamata photographs, that are downstairs, many times. I have seen them in books and all kinds of magazines, and now I am seeing them in a college art museum; each time they have looked different to me. And they are different. Photographs are these portable objects which are changed by their context. You could say, of course, that that is also true of films. To some extent, under what circumstances you see a film does change it, but the photograph is more changed by its context, especially the still photograph, because it is such a compact and portable object. This is why I tend to favor films over

photographs on this question; the film establishes a proper context for the use of those images, and perhaps still photographs, in fact, are more vulnerable. I certainly think in some way a still image is and always will be more memorable. You can really remember a photograph and you can really describe it, in a way that you cannot describe two or three minutes of film.

What kinds of photographs do you find pleasing or good?

I do not know what it really means to talk about one's favorite or preferred photographs. It is funny, I learned something about my taste this afternoon that I had not seen; the people who organized this set of events asked for us to suggest ten photographs to be put in the exhibit downstairs in the museum. I sent in a list of nine photographs that meant something to me, that I had meditated about. One of the nine pictures could not be obtained, so another photograph by the same photographer was substituted. That photograph stuck out so much for me as not belonging with the others. It seemed quite clear to me that it had a different aesthetic – that anyone who had eyes could have seen that I would not have chosen that photograph, though I could have and did choose the other eight. I chose a very straight, tough, hard edged portrait photograph by Brassaï called 'Rome-Naples Express.' For some reason they could not get it and put this soft-focus, sentimental, touristy Brassaï photograph of a Paris book-stall on the Seine. Seeing the eight I had chosen I realized that they – in contrast with the one I had not – had something in common, even aesthetically. They all had a hard edge quality and a very high definition. All of them are upsetting, for one thing. It is funny since I have never tried to understand what makes me like one photograph over another.

Note

1 Susan Sontag, 'On Photography,' *New York Review of Books*, October 18, 1973.

Wright Morris

IN OUR IMAGE

L ET US IMAGINE A TOURIST FROM ROME, on a conducted tour of the provinces, who takes snapshots of the swarming unruly mob at Golgotha, where two thieves and a rabble rouser are nailed to crosses. The air is choked with dust and the smoke of campfires. Flames glint on the helmets and spears of the soldiers. The effect is dramatic, one, that a photographer would hate to miss. The light is bad, the foreground is blurred, and too much is made of the tilted crosses, but time has been arrested, and an image recorded, that might have diverted the fiction of history. What we all want is a piece of the cross, if there was such a cross. However faded and disfigured, this moment of arrested time authenticates, for us, time's existence. Not the ruin of time, nor the crowded tombs of time, but the eternal present in time's every moment. From this continuous film of time the camera snips the living tissue. So that's how it was. Along with the distortions, the illusions, the lies, a specimen of the truth.

That picture was not taken, nor do we have one of the flood, or the crowded ark, or of Adam and Eve leaving the garden of Eden, or of the Tower of Babel, or the beauty of Helen, or the fall of Troy, or the sacking of Rome, or the landscape strewn with the debris of history — but this loss may not be felt by the modern film buff who might prefer what he sees at the movies. Primates, at the dawn of man, huddle in darkness and terror at the mouth of a cave: robots, dramatizing the future, war in space. We see the surface of Mars, we see the moon, we see planet earth rising on its horizon. Will this image expand the consciousness of man or take its place among the ornaments seen on T-shirts or the luncheon menus collected by tourists? Within the smallest particle of traceable matter there is a space, metaphorically speaking, comparable to the observable universe. Failing to see it, failing to grasp it, do we wait for it to be photographed?

There is a history of darkness in the making of images. At Peche Merle and Altamira, in the recesses of caves, the torchlit chapels of worship and magic, images

of matchless power were painted on the walls and ceilings. These caves were archival museums. Man's faculty for image-making matched his need for images. What had been seen in the open, or from the cave's mouth, was transferred to the interior, the lens in the eye of man capturing this first likeness. The tool-maker, the weapon-maker, the sign-maker, is also an image-maker. In the fullness of time man and images proliferate. Among them there is one God, Jehovah, who looks upon this with apprehension. He states his position plainly.

> Thou shalt not make unto thee any
> graven image, or any likeness of
> any thing that is in heaven above,
> or that is in the earth beneath, or
> that is in the water under the earth:
> . . . for I the Lord thy God am a jealous
> God. . . .

Did Jehovah know something the others didn't, or would rather not know? Did he perceive that images, in their kind and number, would exceed any likeness of anything seen, and in their increasing proliferation displace the thing seen with the image, and that one day, like the Lord himself, we would see the planet earth orbiting in space, an image, like that at Golgotha, that would measurably change the course of history, and the nature of man.

Some twenty years ago, in San Miguel Allende, Mexico, I was standing on a corner of the plaza as a procession entered from a side street. It moved slowly, to the sombre beat of drums. The women in black, their heads bowed, the men in white, hatless, their swarthy peasant faces masks of sorrow. At their head a priest carried the crucified figure of Christ. I was moved, awed, and exhilarated to be there. For this, surely, I had come to Mexico, where the essential rituals of life had their ceremony. This was, of course, not the first procession, but one that continued and sustained the tradition. I stood respectfully silent as it moved around the square, in the direction of the church. Here and there an impoverished Indian, clutching a baby, looked on. The pathetic masquerade of a funeral I had observed in the States passed through my mind. Although a photographer, I took no photographs. At the sombre beat of the drums the procession approached the farther corner, where, in the shadow of a building, a truck had parked, the platform crowded with a film crew and whirring cameras. The director, wearing a beret, shouted at the mourners through a megaphone. This was a funeral, not a fiesta, did they understand? They would now do it over, and show a little feeling. He wrung his hands, he creased his brows. He blew a whistle, and the columns broke up as if unravelled. They were herded back across the square to the street where they had entered. One of the mourners, nursing a child, paused to ask me for a handout. It is her face I see through a blur of confusing emotions. In my role as a gullible tourist, I had been the true witness of a false event, Such circumstances are now commonplace. If I had been standing in another position or had gone off about my business, I might still cherish this impression of man's eternal sorrow. How are we to distinguish between the real and the imitation? Few things observed from one point of view only can be considered *seen*. The multifaceted aspect of reality has been a commonplace since

cubism, but we continue to see what we will, rather than what is there. Image-making is our preference for what we imagine, to what is then to be seen.

With the camera's inception an *imitation of life* never before achieved was possible. More revolutionary than the fact itself, it might be practiced by anybody. Intricately part of the dawning age of technology, the photographic likeness gratified the viewer in a manner that lay too deep for words. Words, indeed, appeared to be superfluous. Man, the image-maker, had contrived a machine for making images. The enthusiasm to take pictures was surpassed by the desire to be taken. These first portraits were daguerreotypes, and the time required to record the impression on a copper plate profoundly enhanced the likeness. Frontally challenged, momentarily 'frozen,' the details rendered with matchless refinement, these sitters speak to us with the power and dignity of icons. The eccentrically personal is suppressed. A minimum of animation, the absence of smiles and expressive glances, enhances the aura of suspended time appropriate to a timeless image. There is no common or trivial portrait in this vast gallery. Nothing known to man spoke so eloquently of the equality of men and women. Nor has anything replaced it. With a strikingly exceptional man the results are awesome, as we see in the portraits of Lincoln: the exceptional, as well as the common, suited the heroic mould of these portraits. Fixed on copper, protected by a sheet of glass, the miraculous daguerreotype was a unique, one-of-a-kind creation. No reproductions or copies were possible. To make a duplicate one had to repeat the sitting.

Although perfect of its kind, and never surpassed in its rendering of detail, once the viewer's infatuation had cooled, the single, unique image aroused his frustration. Uniqueness, in the mid-nineteenth century, was commonplace. The spirit of the age, and Yankee ingenuity, looked forward to inexpensive reproductions. The duplicate had about it the charm we now associate with the original. In the decade the daguerreotype achieved its limited perfection, its uniqueness rendered it obsolete, just as more than a century later this singularity would enhance its value on the market.

After predictable advances in all areas of photographic reproduction, it is possible that daguerreotype uniqueness might return to photographic practice and evaluation. This counter-production esthetic has its rise in the dilemma of over-production. Millions of photographers, their number increasing hourly, take billions of pictures. This fact alone enhances rarity. Is it beyond the realm of speculation that single prints will soon be made from a negative that has been destroyed?

Considering the fervor of our adoption it is puzzling that some ingenious Yankee was not the inventor of the camera. It profoundly gratifies our love for super gadgets, and our instinct for facts. This very American preoccupation had first been articulated by Thoreau:

> If you stand right fronting and face to face to a fact, you will see the sun glimmer on both its surfaces, as if it were a cimiter, and feel its sweet edge dividing you through the heart and marrow, and so you will happily conclude your mortal career. Be it life or death, we crave only reality.

This might serve many photographers as a credo. At the midpoint of the nineteenth century a new world lay open to be seen, inventoried, and documented.

It has the freshness of creation upon it, and a new language to describe it. Whitman has the photographer's eye, but no camera.

> Wild cataract of hair; absurd, bunged-up felt hat, with peaked crown; velvet coat, all friggled over with gimp, but worn; eyes rather staring, look upward. Third rate artist.

Or the commonplace, symbolic object:

> Weapon shapely, naked, wan,
> Head from the mother's bowels drawn

Soon enough the camera will fix this image, but its source is in the eye of the image-maker. Matthew Brady and staff are to photograph the Civil War. In the light of the camera's brief history, does this not seem a bizarre subject? Or did they intuit, on a moment's reflection, that war is the camera's ultimate challenge? These photographers, without precedent or example, turned from the hermetic studio, with its props, to face the facts of war, the sun glimmering on all of its surfaces. Life or death, what they craved was reality.

A few decades later Stephen Crane stands face to face to a war of his imagination.

> He was being looked at by a dead man who was seated with his back against a columnlike tree. The corpse was dressed in a uniform that once had been blue, but was now shaded to a melancholy shade of green. The eyes, staring at the youth, had changed to the dull hue to be seen on the side of a dead fish. The mouth was open. Its red had changed to an appalling yellow. Over the gray skin of the face ran little ants. One was trundling some sort of bundle along the upper lip.

Crane had never seen war, at the time of writing, and relied heavily on the photographs of Brady and Gardner for his impressions. A decade after Crane this taste for what is real will flower in a new generation of writers. The relatively cold war of the depression of the 1930's will arouse the passions of the photographers of the Farm Security Administration, Evans, Lee, Lange, Vachon, Rothstein, Russell, and others. They wanted the facts. Few facts are as photographic as those of blight. A surfeit of such facts predictably restored a taste for the bizarre, the fanciful, the fabled world of fashion, of advertising, of self-expression, and of the photo as an *image*.

Does the word image flatter or diminish the photographs of Brady, Sullivan, Atget, and Evans? Would it please Bresson to know that he had made an 'image' of Spanish children playing in the ruins of war? Or the photographers unknown, numbering in the thousands, whose photographs reveal the ghosts of birds of passage, as well as singular glimpses of lost time captured? Does the word image depreciate or enhance the viewer's involvement with these photographs? In the act of refining, does it also impair? In presuming to be more than what it is, does the photograph risk being less? In the photographer's aspiration to be an 'artist' does he enlarge his own image at the expense of the photograph?

What does it profit the photograph to be accepted as a work of art? Does this dubious elevation in market value enhance or diminish what is intrinsically photographic? There is little that is new in this practice but much that is alien to photography. The photographer, not the photograph, becomes the collectible.

The practice of 'reading' a photograph, rather than merely looking at it, is part of its rise in status. This may have had its origin in the close scrutiny and analysis of aerial photographs during the war, soon followed by those from space. Close readings of this sort result in quantities of disinterested information. The photograph lends itself to this refined 'screening,' and the screening is a form of evaluation. In this wise the 'reading' of a photograph may be the first step in its critical appropriation.

A recent 'reading' of Walker Evans 'attempted to disclose a range of possible and probable meanings.' As these meanings accumulate, verbal images compete with the visual – the photograph itself becomes a point of referral. If not on the page, we have them in mind. 'The Rhetorical Structure of Robert Frank's Iconography' is the title of a recent paper. To students of literature, if not to Robert Frank, this will sound familiar. The ever expanding industry of critical dissertations has already put its interest in literature behind it, and now largely feeds on criticism. Writers and readers of novels find these researches unrewarding. Fifty years ago Laura Riding observed, 'There results what has come to be called Criticism More and more the poet has been made to conform to literature instead of literature to the poet – literature being the name given by criticism to works inspired or obedient to criticism.'

Is this looming in photography's future? Although not deliberate in intent, the apparatus of criticism ends in displacing what it criticizes. The criticism of Pauline Kael appropriates the film to her own impressions. The film exists to generate those impressions. In order to consolidate and inform critical practice, agreement must be reached, among the critics, as to what merits critical study and discussion. These figures will provide the icons for the emerging pantheon of photography. Admirable as this must be for the critic, it imposes a misleading order and coherence on the creative disorder of image-making. Is it merely ironic that the rise of photography to the status of art comes at a time the status of art is in question? Is it too late to ask what photographs have to gain from this distinction? On those occasions they stir and enlarge our emotions, arousing us in a manner that exceeds our grasp, it is as photographs. Do we register a gain, or a loss, when the photographer displaces the photograph, the shock of recognition giving way to the exercise of taste?

In the anonymous photograph, the loss of the photographer often proves to be a gain. We see only the photograph. The existence of the visible world is affirmed, and that affirmation is sufficient. Refinement and emotion may prove to be present, mysteriously enhanced by the photographer's absence. We sense that it lies within the province of photography to make both a personal and an impersonal statement. Atget is impersonal. Bellocq is both personal and impersonal.

In photography we can speak of the anonymous as a genre. It is the camera that takes the picture; the photographer is a collaborator. What we sense to be wondrous, on occasion awesome, as if in the presence of the supernatural, is the impression we have of seeing what we have turned our backs on. As much as we crave the personal, and insist upon it, it is the impersonal that moves us. It is the camera that glimpses

life as the Creator might have seen it. We turn away as we do from life itself to relieve our sense of inadequacy, of impotence. To those images made in our own likeness we turn with relief.

Photographs of time past, of lost time recovered, speak the most poignantly if the photographer is missing. The blurred figures characteristic of long time exposures is appropriate. How better to visualize time in passage? Are these partially visible phantoms about to materialize, or dissolve? They enhance, for us, the transient role of humans among relatively stable objects. The cyclist crossing the square, the woman under the parasol, the pet straining at the leash, are gone to wherever they were off to. On these ghostly shades the photograph confers a brief immortality. On the horse in the snow, his breath smoking, a brief respite from death.

These photographs clarify, beyond argument or apology, what is uniquely and intrinsically photographic. The visible captured. Time arrested. Through a slit in time's veil we see what has vanished. An unearthly, mind-boggling sensation: commonplace yet fabulous. The photograph is paramount. The photographer subordinate.

As a maker of images I am hardly the one to depreciate or reject them, but where distinctions can be made between images and photographs we should make them. Those that combine the impersonality of the camera eye with the invisible presence of the camera holder will mingle the best of irreconcilable elements.

The first photographs were so miraculous no one questioned their specific nature. With an assist from man, Nature created pictures. With the passage of time, however, man predictably intruded on Nature's handiwork. Some saw themselves as artists, others as 'truth seekers.' Others saw the truth not in what they sought, but in what they found. Provoked by what they saw, determined to capture what they had found, numberless photographers followed the frontier westward, or pushed on ahead of it. The promise and blight of the cities, the sea-like sweep and appalling emptiness of the plains, the life and death trips in Wisconsin and elsewhere, cried to be taken, pleaded to be reaffirmed in the teeth of the photographer's disbelief. Only when he saw the image emerge in the darkness would he believe what he had seen. What is there in the flesh, in the palpable fact, in the visibly ineluctable, is more than enough. Of all those who find more than they seek the photographer is preeminent.

In his diaries Weston speaks of wanting 'the greater mystery of things revealed more clearly than the eyes see —' but that is what the observer must do for himself, no matter at what he looks. What is there to be seen will prove to be inexhaustible.

Compare the photographs of Charles van Schaik, in Michael Lesy's *Wisconsin Death Trip*, with the pictures in *Camera Work* taken at the same time. What is intrinsic to the photograph we recognize, on sight, in van Schaik's bountiful archive. What is intrinsic to the artist we recognize in Stieglitz and his followers. In seventy years this gap has not been bridged. At this moment in photography's brief history, the emergence and inflation of the photographer appears to be at the expense of the photograph, of the miraculous.

If there is a common photographic dilemma, it lies in the fact that so much has been seen, so much has been 'taken,' there appears to be less to find. The visible world, vast as it is, through overexposure has been devalued. The planet looks better from space than in a close-up. The photographer feels he must search for, or invent,

what was once obvious. This may take the form of photographs free of all pictorial associations. This neutralizing of the visible has the effect of rendering it invisible. In these examples photographic revelation has come full circle, the photograph exposing a reality we no longer see.

The photographer's vision, John Szarkowski reminds us, is convincing to the degree that the photographer hides his hand. How do we reconcile this insight with the photo-artist who is intent on maximum self-revelation! Stieglitz took many portraits of Georgia O'Keefe, a handsome unadorned fact of nature. In these portraits we see her as a composition, a Stieglitz arrangement. Only the photographer, not the camera, could make something synthetic out of this subject. Another Stieglitz photograph, captioned 'Spiritual America,' shows the rear quarter of a horse, with harness. Is this a photograph of the horse, or of the photographer?

There will be no end of making pictures, some with hands concealed, some with hands revealed, and some without hands, but we should make the distinction, while it is still clear, between photographs that mirror the subject, and images that reveal the photographer. One is intrinsically photographic, the other is not.

Although the photograph inspired the emergence and triumph of the abstraction, freeing the imagination of the artist from the tyranny of appearances, it is now replacing the abstraction as the mirror in which we seek our multiple selves. A surfeit of abstractions, although a tonic and revelation for most of this century, has resulted in a weanness of artifice that the photograph seems designed to remedy. What else so instantly confirms that the world exists? Yet a plethora of such affirmations gives rise to the old dissatisfaction. One face is the world, but a world of faces is a muddle. We are increasingly bombarded by a Babel of conflicting images. How long will it be before the human face recovers the aura, the lustre and the mystery it had before TV commercials – the smiling face a debased counterfeit.

Renewed interest in the snapshot, however nondescript, indicates our awareness that the camera, in itself, is a picture-maker. The numberless snapshots in existence, and the millions still to be taken, will hardly emerge as art objects, but it can be safely predicted that many will prove to be 'collectibles.' Much of what appears absurd in contemporary art reflects this rejection of romantic and esthetic icons. The deployment of rocks, movements of earth, collections of waste, debris and junk, Christo's curtains and earthbound fences, call attention to the spectacle of nature, the existence of the world, more than they do the artist. This is an oversight, needless to say, the dealer and collector are quick to correct. Among the photographs we recognize as masterly many are anonymous. Has this been overlooked because it is so obvious?

If an automatic camera is mounted at a window, or the intersection of streets, idle or busy, or in a garden where plants are growing, or in the open where time passes, shadows shorten and lengthen, weather changes, it will occasionally take exceptional pictures. In these images the photographer is not merely concealed, he is eliminated. Numberless such photos are now commonplace. They are taken of planet earth, from space, of the surface of the moon, and of Mars, of the aisles of stores and supermarkets, and of much we are accustomed to think of as private. The selective process occurs later, when the photographs are sorted for specific uses. The impression recorded by the lens is as random as life. The sensibility traditionally brought to 'pictures,' rooted in various concepts of 'appreciation,' is alien

to the impartial, impersonal photo image. It differs from the crafted art object as a random glance out the window differs from a painted landscape. But certain sensibilities, from the beginning, have appreciated this random glance.

The poet, Rilke, snapped this:

> In the street below there is the following composition: a small wheelbarrow, pushed by a woman; on the front of it, a hand-organ, lengthwise. Behind that, crossways, a baby-basket in which a very small child is standing on firm legs, happy in its bonnet, refusing to be made to sit. From time to time the woman turns the handle of the organ. At that the small child stands up again, stamping in its basket, and a little girl in a green Sunday dress dances and beats a tambourine up toward the windows.

This 'image' is remarkably photogenic. Indeed, it calls to mind one taken by Atget. The poet is at pains to frame and snap the picture, to capture the look of life. His description is something more than a picture, however, since the words reveal the presence of the writer, his 'sensibility.' This very sensitivity might have deterred him from taking the snapshot with a camera. Describe it he could. But he might have been reluctant to take it. In his description he could filter out the details he did not want to expose. From its inception the camera has been destined to eliminate *privacy*, as we are accustomed to conceive it. Today the word describes what is held in readiness for exposure. It is assumed that privacy implies something concealed.

The possibility of filming a life, from cradle to the grave, is now feasible. We already have such records of laboratory animals. If this film were to be run in reverse have we not, in our fashion, triumphed over time? We see the creature at the moment of death, gradually growing younger before our eyes. I am puzzled that some intrepid avant garde film creator has not already treated us to a sampling, say the death to birth of some short-lived creature. We have all shared this illusion in the phenomenon of 'the instant replay.' What had slipped by is retrieved, even in the manner of its slipping. Life lived in reverse. Film has made it possible. The moving picture, we know, is a crick that is played on our limited responses, and the refinement of the apparatus will continue to outdistance our faculties. Perhaps no faculty is more easily duped than that of sight. Seeing is believing. Believing transforms what we see.

If we were to choose a photographer to have been at Golgotha, or walking the streets of Rome during the sacking, who would it be? Numerous photographers have been trained to get the picture, and many leave their mark on the picture they get. For that moment of history, or any other, I would personally prefer that the photograph was stamped *Photographer Unknown*. This would assure me, rightly or wrongly, that I was seeing a fragment of life, a moment of time, as it was. The photographer who has no hand to hide will conceal it with the least difficulty. Rather than admiration, for work well done, I will feel the awe of revelation. The lost found, the irretrievable retrieved.

Or do I sometimes feel that image proliferation has restored the value of the non-image. Perhaps we prefer Golgotha as it is, a construct of numberless fictions,

filtered and assembled to form the uniquely original image that develops in the dark-room of each mind.

Images proliferate. Am I wrong in being reminded of the printing of money in a period of wild inflation? Do we know what we are doing? Are we able to eval-uate what we have done?

Peter Wollen

FIRE AND ICE

THE AESTHETIC DISCUSSION OF PHOTOGRAPHY is dominated by the concept of time. Photographs appear as devices for stopping time and preserving fragments of the past, like flies in amber. Nowhere, of course, is this trend more evident than when still photography is compared with film. The natural, familiar metaphor is that photography is like a point, film like a line. Zeno's paradox: the illusion of movement.

The lover of photography is fascinated both by the instant and by the past. The moment captured in the image is of near-zero duration and located in an ever-receding 'then'. At the same time, the spectator's 'now', the moment of looking at the image, has no fixed duration. It can be extended as long as fascination lasts and endlessly reiterated as long as curiosity returns. This contrasts sharply with film, where the sequence of images is presented to the spectator with a predetermined duration and, in general, is only available at a fixed programme time.

It is this difference in the time-base of the two forms that explains, for example, Roland Barthes' antipathy towards the cinema and absorption in the still photograph. Barthes' aesthetic is governed by a prejudice against linear time and especially against narrative, the privileged form of linear time as he saw it, which he regarded with typically high-modernist scorn and disdain. His major work on literature, S/Z, is a prolonged deceleration and freeze-framing, so to speak, of Balzac's (very) short story, marked throughout by a bias against the hermeneutic and proaeretic codes (the two constituent codes of narrative) which function in 'irreversible time'.

When Barthes wrote about film he wrote about film stills; when he wrote about theatre he preferred the idea of *tableaux vivants* to that of dramatic development. Photography appeared as a spatial rather than temporal art, vertical rather than horizontal (simultaneity of features rather than consecutiveness) and one which allowed the spectator time to veer away on a train of thought, circle back, traverse and criss-cross the image. Time, for Barthes, should be the prerogative of the reader/spectator: a free re-writing time rather than an imposed reading time.

I don't want, here and now, to launch into a defence of narrative; that can keep for another day. But I do want to suggest that the relationship of photography to time is more complex than is usually allowed. Especially, it is impossible to extract our concept of time completely from the grasp of narrative. This is all the more true when we discuss photography as a form of art rather than as a scientific or instructional instrument.

First, I am going to talk about 'aspect' rather than 'tense'. Linguists do not completely agree about the definition of 'aspect'. But we can say that while 'tense' locates an event in time in relation to the present moment of speech, 'aspect' represents its internal temporal structure. Thus, some verbs, like 'know' are 'stative' – they represent 'states', whereas others like 'run' represent dynamic situations that involve change over time – so we can say 'he was running', but not 'he was knowing'. 'Situations' can be subdivided into those that involve single, complete 'events' and those that involve 'processes', with continuous change or a series of changes, and so on. The verbs which represent 'events' and 'processes' will have different relations to 'aspectual' verb forms such as the 'imperfect', the 'perfect' (both past tense), the 'progressive', etc. (Here I must acknowledge my dependence on and debt to Bernard Comrie's book on 'Aspect', the standard work on the subject). Aspect, on one level, is concerned with duration but this, in itself, is inadequate to explain its functioning. We need semantic categories which distinguish different types of situation, in relation to change (or potential for change) and perspective as well as duration. Comrie distinguishes between states, processes and events. Events themselves can be broken down between durative and punctual events. Alongside these categories aspect also involves the concepts of the iterative, the habitual and the characteristic. It is the interlocking of these underlying semantic categories which determines the various aspectual forms taken by verbs in different languages (*grosso modo*).

It is useful to approach photography in the light of these categories. Is the signified of a photographic image to be seen as a state, a process or an event? That is to say, is it stable, unchanging, or, if it is a changing, dynamic situation, is it seen from outside as conceptually complete, or from inside, as ongoing? (In terms of aspect, stative or perfective/imperfective non-stative?) The fact that images may themselves appear as punctual, virtually without duration, does not mean that the situations that they represent lack any quality of duration or other qualities related to time.

Some light is thrown on these questions by the verb-forms used in captions. (A word of warning: English, unlike French, distinguishes between perfective and imperfective forms, progressive and non-progressive, in the present tense as well as the past. The observations which follow are based on English-language captions.) News photographs tend to be captioned with the non-progressive present, in this case, a narrative present, since the reference is to past time. Art photographs are usually captioned with noun-phrases, lacking verb-forms altogether. So also are documentary photographs, though here we do find some use of the progressive present. This imperfective form is used more than usual, for example, in Susan Meiselas' book of photographs, *Nicaragua*. Finally, the imperfective is used throughout in the captions of Muybridge's series photographs, in participle form.

Evidently these choices of verb-form correspond to different intuitions about the subjects or signifieds of the various types of photograph. News photographs are perceived as signifying events. Art photographs and most documentary photographs

signify states. Some documentary photographs and Muybridge's series in particular are seen as signifying processes. From what we know about minimal narratives, we might say that an ideal minimal story-form might consist of a documentary photograph, then a news photograph, then an art photograph (process, event, state).

In fact, the classic early film minimal narrative, Lumière's 'L' Arroseur Arrosé', does follow this pattern: a man is watering the garden (process), a child comes and stamps on the hose (event), the man is soaked and the garden empty (state). What this implies of course is that the semantic structure of still and moving images may be the same or, at least, similar, in which case it would not be movement but sequencing (editing, découpage) which made the main difference by determining duration differently.

Still photographs, then, cannot be seen as narratives in themselves, but as elements of narrative. Different types of still photograph correspond to different types of narrative element. If this conjecture is right, then a documentary photograph would imply the question: 'Is anything going to happen to end or to interrupt this?' A news photograph would imply: 'What was it like just before and what's the result going to be?' An art photograph would imply: 'How did it come to be like this or has it always been the same?' Thus different genres of photography imply different perspectives within durative situations and sequences of situations.

While I was thinking about photography and film, prior to writing, I began playing with the idea that film is like fire, photography is like ice. Film is all light and shadow, incessant motion, transience, flicker, a source of Bachelardian reverie like the flames in the grate. Photography is motionless and frozen, it has the cryogenic power to preserve objects through time without decay. Fire will melt ice, but then the melted ice will put out the fire (like in *Superman III*). Playful, indeed futile, metaphors, yet like all such games anchored in something real.

The time of photographs themselves is one of stasis. They endure. Hence there is a fit between the photographic image which signifies a state and its own signified, whereas we sense something paradoxical about the photograph which signifies an event, like a frozen tongue of fire. In a film, on the contrary, it is the still image (Warhol, Straub-Huillet) which seems paradoxical in the opposite sense: the moving picture of the motionless subject.

Hence the integral relationship between the still photograph and the pose. The subject freezes for the instantaneous exposure to produce a frozen image, state results in state. In *La Chambre claire*, Barthes keeps returning to the mental image of death which shadows the photographs that fascinate him. In fact these particular photographs all show posed subjects. When he treats unposed photographs (Wessing's photograph of Nicaragua, Klein's of May Day in Moscow) Barthes sees not death, even when they show death, but tableaux of history, 'historemes' (to coin a word on the model of his own 'biographemes'). Images, in fact, submitted to the Law.

I can't help wondering whether Barthes ever saw James Van Der Zee's *Harlem Book of the Dead*, with its photographs of the dead posed for the camera in funeral parlours: a triple registration of stasis – body, pose, image. The strange thing about these photographs is that, at first glance, there is an eerie similarity between mourners and corpses, each as formal and immobile as the other. Indeed, the interviewers whose questioning of Van Der Zee makes up the written text of the book,

ask him why the eyes of the bodies aren't opened, since this would make them look more life-like, virtually indistinguishable from the mourners even to the smallest detail.

This view of death, of course, stresses death as a state rather than an event. Yet we know from news photographs that death can be photographed as an event: the Capa photograph of the Spanish Civil War soldier is the *locus classicus*, taken as he is felled. There is a sense, though, in which Barthes was right. This photograph has become a 'historeme', a 'pregnant moment' after Diderot or Greuze, or like the habitual narrative present in Russian, where, according to Comrie, 'a recurrent sequence of events is narrated as if it were a single sequence, i.e. one instance stands for the whole pattern'. In my book of Capa photographs, it is captioned simply 'Spain, 1936'.

The fate of Capa's photograph focusses attention on another important aspect of the way images function in time: their currency, their circulation and re-cycling. From the moment they are published, images are contextualised and, frequently, if they become famous, they go through a whole history of re-publication and re-contextualisation. Far more is involved than the simple doubling of the encounter of photographer with object and spectator with image. There is a very pertinent example of this in the case of Capa's photograph. It is clearly the model for the pivotal image of death in Chris Marker's film photo-roman *La Jetée* – the same toppling body with outstretched arm.

Marker's film is interesting for a lot of reasons. First of all, it is the examplar of a fascinating combination of film and still: the film made entirely of stills. (In just one image there is an eye-movement, the converse of a freeze frame in a moving picture). The effect is to demonstrate that movement is not a necessary feature of film; in fact, the impression of movement can be created by the jump-cutting of still images. Moreover, *La Jetée* shows that still photographs, strung together in a chain, can carry a narrative as efficiently as moving pictures, given a shared dependence on a sound-track.

It is not only a question of narrative, however, but also of fiction. The still photographs carry a fictional diegetic time, set in the future and in the present as past-of-the-future, as well as an inbetween near-future from which vantage-point the story is told. Clearly there is no intrinsic 'tense' of the still image, any 'past' in contrast with a filmic 'present', as has often been averred. Still photography, like film (and like some languages), lacks any structure of tense, though it can order and demarcate time.

Aspect, however, is still with us. In the 'past' of memories to which the hero returns (through an experiment in time-travel) the images are all imperfective, moments within ongoing states or processes seen as they occur. But the object of the time-travel is to recover one fixated memory-image, which, it turns out at the climax of the film, is that of the hero's own death. This image, the one based on Capa's 'Spain, 1936', is perfective; it is seen from the outside as a complete action, delimited in time with a beginning and an end. Although *La Jetée* uses a whole sequence of photographs, the single Capa image in itself carries the condensed implication of a whole action, starting, happening and finishing at one virtual point in time: a 'punctual' situation, in Comrie's terms. And, at this very point, the subject is split into an observer of himself, in accordance with the aspectual change of perspective.

My own fascination with pictorial narrative is not a recalcitrant fascination, like that of Barthes. Unlike him, I am not always longing for a way of bringing the flow to a stop. It is more a fascination with the way in which the spectator is thrown in and out of the narrative, fixed and unfixed. Traditionally, this is explained in terms of identification, distanciation, and other dramatic devices. Perhaps it is also connected with aspect, a dimension of the semantics of time common to both still and moving picture and used in both to place the spectator, within or without a narrative.

Photographic seeing

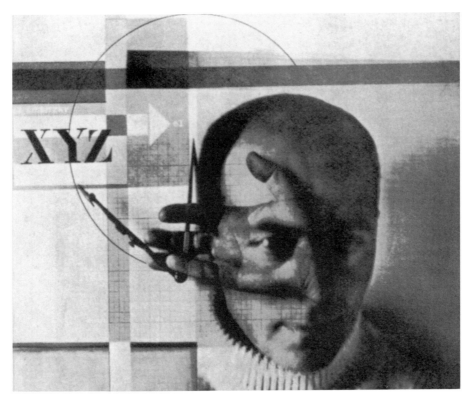

El Lissitzky, *Self-Portrait with Compass*, 1924. Courtesy of the Ubu Gallery.

Introduction

THIS SECTION EXAMINES IDEAS about *photographic* seeing discussed in Europe in the 1920s and 1930s, and in North America slightly later. The writings focus on form and aesthetics, although, as will be seen, the European examples link aesthetic experimentation with social change. Artists, ideas and works of art crossed the Atlantic so debates on the two continents did not develop in isolation. However, the historic circumstances which obtained in Europe through much of the twentieth century (Soviet Revolution; two World Wars; partition between East and West Europe) provoked emphasis on the social role and significance of photography; this is reflected in the writings included here.

In his 'A Short History of Photography', Walter Benjamin suggests that a medium comes of age when it starts to be interrogated, rather than being greeted in terms of the excitement of the new and faith in progress (Benjamin 1931). In terms of aesthetics, towards the end of the nineteenth century 'pictorialist' photographers in Europe and North America had attempted to legitimate photography as fine art, typically taking allegorical themes, using soft focus and deploying light lyrically. In sharp contrast, by the 1920s in Europe such poetics had been superseded by emphasis upon the mechanical and objective characteristics of the 'photo-eye'. As Lucia Moholy-Nagy commented:

> . . . photographers, after having been made over-conscious of tone values and balance, began to be more object-conscious than everbefore. The object in the picture became self-assertive; and so did the details of the object. Nothing was without significance. The minuteness of detail became essential. Impressionist texture of paper surface and technique were rejected. The texture of the object, its own surface, were emphasised. Cuttings and unusual angles were in favour. . . . It was the beginning of modern object photography, sometimes called 'straight' photography.
>
> (Moholy-Nagy 1939: 164)

For artists and designers this 'modern era' was a period of optimism and experiment.

The avant-garde was not unified; rather, explorations ranged from formal experimentation to concern with the social implications of new technologies and new visualities, from subjective existential pre-occupations to, for example, commercial or political photomontage. As Herbert Marcuse later noted:

> Art can be called revolutionary in several senses. In a narrow sense, art may be revolutionary if it represents a radical change in style and technique. Such change may be the achievement of a genuine avantgarde, anticipating or reflecting substantial changes in the society at large. Thus, expressionism and surrealism anticipated the destructiveness of monopoly capitalism and the emergence of new goals of radical

change. But the merely 'technical' definition of revolutionary art says nothing about the quality of the work, nothing about its authenticity and truth.

Beyond this, a work of art can be called revolutionary if, by virtue of the aesthetic transformation, it represents, in the exemplary fate of individuals, the prevailing unfreedom and the rebelling forces, thus breaking through the mystified (and petrified) social reality, and opening the horizon of change (liberation).

(Marcuse 1977: x)

Social and technological change had heralded widespread use of cameras and the mass circulation of imagery. Creative experimentation encouraged new ways of seeing in terms of camera angle, focus, geometry of the image and, by extension, perception and cultural understanding. Furthermore, photography was seen as a part of the new machine age, essentially a modern mode of seeing. Photography, thus, had come to seem socially progressive, not confined by the precepts and preoccupations of more traditional fine arts, especially as aesthetic experimentation interacted with sociopolitical concerns.

Thus, for instance, Ossip Brik, writing in the context of the early years of the Soviet Revolution, discusses how camera technologies might be used to further aesthetic revolution – and, by extension, social change. The essay first appeared in a Moscow magazine, 'Soviet cinema' (*Sovetskoe kino*). Likewise, in Germany, László Moholy-Nagy, who was associated with the Bauhaus movement, argued that photography had the unique potential for drawing attention to social experience in terms of time and space, in effect, extending human perception. In this extract he links analysis of the characteristics of photography with educational possibilities established through emphasis on a new mode of vision.

In North America, with the establishment of a photography section at the Museum of Modern Art, New York, in 1940, the photograph seemed accepted as art. By contrast with Europe, aesthetic experimentation was not immediately connected to social change. As Abigail Solomon-Godeau has noted:

The radical formalism that structured the new Soviet photography had little to do with the Anglo-American variety that propelled the photography of Alfred Stieglitz, Paul Strand, *et al.* toward a fully articulated modernist position, although there were common grounds in the two formalisms – shared convictions, for example, that the nature of the medium must properly determine its aesthetic and that photography must acknowledge its own specific characteristics. Deriving ultimately from Kantian aesthetics, Anglo-American formalism insisted above all on the autonomy, purity and self-reflexivity of the work of art. As such it remained throughout its modernist permutations an essentially idealist stance.

(Solomon-Godeau 1989: 86)

Many of the photographs in the MOMA collection had originally been conceived as social document rather than as images for museums or galleries, so museum acquisition gave status to images originally made for other purposes. Given the dominance of modernist preoccupation with form and materiality within the art establishment of the period, the changing status of the photograph invited analysis of that specific to the medium. For instance, in the piece included at the end of this section, Edward Weston argues for the specificity of photographic seeing, for imagery which transcends painterly conventions. Implicitly distancing himself from documentary photography, he also emphasises pre-conceptualisation of the image and an experimental approach to composition, exposure, developing and printing. For Weston, photography has the potential to reveal and offer emotional insight into the nature of the world.

Although agreeing with Weston that photography needs to find its own partic-ular way of making meaning, John Szarkowski, director of photography at MOMA from 1960–91, emphasised the historical inter-relation of fine art photography and documentary (in his words, 'functional' photography). His approach is analytic. In the essay included here, Szarkowski identified five characteristics of the medium which, he argued, are key to its specificity. As the introduction to the catalogue for the exhibition 'The Photographer's Eye', the essay was intended to support the contention that there exists a shared photographic vocabulary despite diversity of themes, contexts and artistic intentions, that 'the vision (the photographers) share belongs to no school or aesthetic theory, but to photography itself'. (Szarkowski 1966: no page numbers).

The concern to discuss photography in terms of the specificity of the medium is, in itself, characteristic of modernism in art in North America, with its emphasis on personal expressivity and on exploration of the nature of a particular medium. North American modernism's self-reflexivity has been criticised subsequently for the narrowness of its concerns; yet the writings remain pertinent as they invite focus both on photography as a specific means of communication, and, to the extent to which it is valid to seek to comprehend photography in all its diverse forms and contexts, in terms of a defined set of characteristics.

Hence, this section opens with an essay first published in *L'Arc* magazine, Paris, in 1963, at a time when a number of writers, including Sartre, were attempting to comprehend photographs as a particular type of phenomenon. Hubert Damisch draws attention to the fundamental meaning and processes of 'photography', and argues that the camera is neither neutral nor impartial but was constructed to reproduce established image conventions. He also argues that photography creates nothing of 'use' in terms of basic social utility. Rather, he sees the photograph in terms of 'exchange value', the price for which it can be sold or marketed, and implies that the mechanical nature of photography renders image-making essentially industrial and irrefutably seated within the capitalist system. This essay invites us to consider the relation between camera technology, visuality and specific socioeconomic arrangements.

References and selected further reading

Benjamin, W. (1931) 'A Short History of Photography' included in Benjamin, W. (1979) *One Way Street*. London: New Left Books.
> Also in Trachtenberg (1980) *Classic Essays on Photography*. New Haven: Leete's Island Books.
Enzensberger, M. (1974) 'Introduction, Ossip Brik: Selected Writings', *Screen* 15/3.
Goldberg, V. (ed.) (1981) *Photography in Print: Writings from 1816 to the Present*. Albuquerque: University of New Mexico Press.
> Includes a number of writings from or about the modern period.
Harrison, C. and Wood, P. (eds) (1992) *Art in Theory 1900–1990*. Oxford: Blackwell.
> Collection of extracts relating to the idea of a modern world and to modernism in the visual arts; not specifically about photography.
Kracauer, S. (1965) 'Photography', first section in his *Theory of Film*. NY: Oxford University Press.
> On photographic aesthetics and the affinities of photographs.
Marcuse, H. (1979) *The Aesthetic Dimension*. London: Macmillan. Original German publication, 1977.
Moholy-Nagy, L. (1939) *A Hundred Years of Photography*. Harmondsworth: Penguin.
Petruck, P.R. (ed.) (1979) *The Camera Viewed: writings on twentieth-century photography*, Vol. 1. NY: Dutton.
> Volume 1 includes writings from before the Second World War.
Phillips, C. (1989) *Photography in the Modem Era: European Documents and Critical Writings, 1913–1940*. NY: Metropolitan Museum of Art and Aperture.
> Comprehensive collection of documents on photography from France, Germany, Russia and elsewhere which indicates how debates developed through articles and correspondence in journals (as well as retaining, in translation, what now seems a rather ponderous style in which discussions were conducted).
Solomon-Godeau, A. (1989) 'The Armed Vision Disarmed: Radical Formalism from Weapon to Style' in *The Contest of Meaning*. Cambridge, Mass.: MIT Press.
> Originally published in January 1983 in *Afterimage* 11/6.
> Reprinted in Richard Bolton (1989)
Taylor, B. (1991/92) *Art and Literature under the Bolsheviks*, Vols 1 and 2. London: Pluto Press.
> Comprehensive account of events from 1917–32 including discussion of constructivist art, Vol. 1, section 3.
Willett, J. (1978) 'The Camera Eye: new photography, Russian and avant-garde films', Chapter 15 of his *The New Sobriety, Art and Politics in the Weimar Period, 1917–33*. London: Thames and Hudson.
> Progressive uses of photography discussed in the context of critical analysis of the politics of visual arts and design in the inter-war period in Germany and Russia.

Bibliography of essays in Part Two

Brik, O. (1926) 'What the Eye does not See', in Christopher Phillips (1989) *Photography in the Modem Era*. NY: Metropolitan Museum of Art and Aperture.
Damisch, H. (1978) 'Five Notes for a Phenomenology of the Photographic Image' in *October 5, Photography: a Special Issue*, Summer.
> Original French publication, 1963, *L'Arc*, Paris, reprinted in Alan Trachtenberg (ed.) (1980) *Classic Essays on Photography*. New Haven, Connecticut: Leete's Island Books.

Moholy-Nagy, L. (1936) 'A New Instrument of Vision', extract from 'From Pigment to Light', original publication, *Telehor* Vol. 1/2.
 Reprinted in Nathan Lyons (ed.) (1966) *Photographers on Photography*. NJ: Prentice Hall.
Szarkowski, J. (1966) 'Introduction' to *The Photographer's Eye*. NY: MOMA.
 Reprinted (1980) London: Secker & Warburg.
Weston, E. 'Seeing Photographically' from Willard D. Morgan (ed.) (1964) *The Encyclopedia of Photography*, Vol. 18. NY: Greystone Press.
 Reprinted in Trachtenberg *Classic Essays, op. cit.*

Hubert Damisch

FIVE NOTES FOR A PHENOMENOLOGY OF THE PHOTOGRAPHIC IMAGE

1

THEORETICALLY SPEAKING, PHOTOGRAPHY is nothing other than a process of recording, a technique of *inscribing*, in an emulsion of silver salts, a stable image generated by a ray of light. This definition, we note, neither assumes the use of a camera, nor does it imply that the image obtained is that of an object or scene from the external world. We know of prints obtained from film directly exposed to a light source. The prime value of this type of endeavor is to induce a reflection on the nature and function of the photographic image. And insofar as it successfully eliminates one of the basic elements of the very idea of 'photography' (the camera obscura, the camera), it produced an experimental equivalent of a phenomenological analysis which purports to grasp the essence of the phenomenon under consideration by submitting that phenomenon to a series of imaginary variations.

2

The reluctance one feels, however, in describing such images as photographs is a revealing indication of the difficulty of reflecting phenomenologically – in the strict sense of an eidetic experience, a reading of essences – on a *cultural* object, on an essence that is historically constituted. Moreover, the full purview of a photographic document clearly involves a certain number of 'theses' which, though not of a transcendental order, appear nevertheless as the conditions for apprehending the photographic image as such. To consider a document of this sort like any other image is to claim a bracketing of all knowledge – and even, as we shall see, of all prejudice – as to its genesis and empirical functions. It therefore follows that the photographic situation cannot be defined a priori, the division of its fundamental components from its merely contingent aspects cannot be undertaken in the absolute.

The photographic image does not belong to the natural world. It is a product of human labor, a cultural object whose being – in the phenomenological sense of the term – cannot be dissociated precisely from its historical meaning and from the necessarily datable project in which it originates. Now, this image is characterized by the way in which it presents itself as the result of an objective process. Imprinted by rays of light on a plate or sensitive film, these figures (or better perhaps, these signs?) must appear as the very *trace* of an object or a scene from the real world, the image of which inscribes itself, without direct human intervention, in the gelatinous substance covering the support. Here is the source of the supposition of 'reality,' which defines the photographic situation. A photograph is this paradoxical image, without thickness or substance (and, in a way, entirely unreal), that we read without disclaiming the notion that it retains something of the reality from which it was somehow released through its physiochemical make-up. This is the constitutive deception of the photographic image (it being understood that every image, as Sartre has shown, is in essence a deceit). In the case of photography, however, this ontological deception carries with it a *historical* deceit, far more subtle and insidious. And here we return to that object which we got rid of a little too quickly: the black box, the photographic camera.

3

Niepce, the successive adepts of the Daguerreotype, and those innumerable inventors who made photography what it is today, were not actually concerned to create a new type of image or to determine novel modes of representation; they wanted, rather, to fix the images which 'spontaneously' formed on the ground of the camera obscura. The adventure of photography begins with man's first attempts to retain that image he had long known how to make. (Beginning in the eleventh century, Arab astronomers probably used the camera obscura to observe solar eclipses.) This long familiarity with an image so produced, and the completely objective, that is to say automatic or in any case strictly mechanical, appearance of the recording process, explains how the photographic representation generally appeared as *a matter of course*, and why one ignores its highly elaborated, arbitrary character. In discussions of the invention of film, the history of photography is most frequently presented as that of a *discovery*. One forgets, in the process, that the image the first photographers were hoping to seize, and the very *latent image* which they were able to reveal and develop, were in no sense naturally given; the principles of construction of the photographic camera – and of the camera obscura before it – were tied to a conventional notion of space and of objectivity whose development preceded the invention of photography, and to which the great majority of photographers only conformed. The lens itself, which had been carefully corrected for 'distortions' and adjusted for 'errors,' is scarcely as objective[1] as it seems. In its structure and in the ordered image of the world it achieves, it complies with an especially familiar though very old and delapidated system of spatial construction, to which photography belatedly brought an unexpected revival of current interest.

(Would the art, or rather the craft, of photography not consist partly in allowing us to forget that the black box is not 'neutral' and that its structure is not impartial?)

4

The retention of the image, its development and multiplication, form an ordered succession of steps which composed the photographic act, taken as a whole. History determined, however, that this act would find its goal in reproduction, much the way the point of film as spectacle was established from the start. (We know that the first inventors worked to fix images and simultaneously to develop techniques for their mass distribution, which is why the process perfected by Daguerre was doomed from the very outset, since it could provide nothing but a *unique* image). So that photography's contribution, to use the terms of classical economy, is less on the level of *production*, properly speaking, than on that of *consumption*. Photography creates nothing of 'use' (aside from its marginal and primarily scientific applications); it rather lays down the premises of an unbridled destruction of utility. Photographic activity, even though it generally takes the form of craft, is nonetheless, in principle, industrial; and this implies that of all images the photographic one – leaving aside its documentary character – wears out the most quickly. But it is important to note that even when it gives us, through the channels of publishing, advertising, and the press, only those images which are already half consumed, or so to speak, 'predigested,' this industry fulfills the initial photographic project: the capturing and restoration of an image already worn beyond repair, but still, through its physical nature, unsuited to mass consumption.

5

Photography aspires to art each time, in practice, it calls into question its essence and its historical roles, each time it uncovers the contingent character of these things, soliciting in us the producer rather than the consumer of images. (It is no accident that the most *beautiful* photograph so far achieved is possibly the first image Nicéphore Niepce fixed in 1822, on the glass of the camera obscura – a fragile, threatened image, so close in its organization, its granular texture, and its emergent aspect, to certain Seurats – an incomparable image which makes one dream of a photographic *substance* distinct from subject matter, and of an art in which light creates its own metaphor.)

Note

1 The play here is on the French word for lens: *objectif*.

Ossip Brik

WHAT THE EYE DOES NOT SEE

VERTOV IS RIGHT. The task of the cinema and of the camera is not to imitate the human eye, but to see and record what the human eye normally does not see.

The cinema and the photo-eye can show us things from unexpected viewpoints and in unusual configurations, and we should exploit this possibility.

There was a time when we thought it was enough just to photograph objects at eye level, standing with both feet firmly on the ground. But then we began to move around, to climb mountains, to travel on trains, steamships, and automobiles, to soar in airplanes and drop to the bottom of the sea. And we took our camera with us everywhere, recording whatever we saw.

So we began to shoot from more complex angles which became increasingly diverse, even though the link with the human eye and its usual optical radius remained unbroken.

However, that link is not really needed. Beyond that, it actually limits and impoverishes the possibilities of the camera. The camera can function independently, can see in ways that man is not accustomed to – can suggest new points of view and demonstrate how to look at things differently.

This is the kind of experiment that Comrade Rodchenko undertook when he photographed a Moscow house from an unusual viewpoint.

The results proved extremely interesting: that familiar object (the house) suddenly turned into a never-before-seen structure, a fire escape became a monstrous object, balconies were transformed into a tower of exotic architecture.

When you look at these photos it is easy to imagine how a cinematic sequence could be developed here, what great visual potential it could have – much more effective than the usual shots on location.

The monotony of form in the cinematic landscape has inspired some people to seek an answer in movie decorations, props, and displacements, or to prevail upon

the artist to 'invent an interesting slice of life,' to build 'fantasy houses' and construct a 'nonexistent nature.'

A hopeless task. The camera does not tolerate props, and mercilessly exposes any cardboard theatricality offered instead of the real thing.

That's not the answer, and there's only one way out of the dilemma: we must break out beyond the customary radius of the normal human eye, we must learn to photograph objects with the camera outside the bounds of that radius, in order to obtain a result other than the usual monotony. Then we will see our concrete reality rather than some kind of theater prop, and we will see it as it has never been seen before.

The cinema and the photo-eye must create their own point of view, and use it. They must expand – not imitate – the ordinary optical radius of the human eye.

Translated by John E. Bowlt

László Moholy-Nagy

A NEW INSTRUMENT OF VISION

I N PHOTOGRAPHY WE POSSESS AN extraordinary instrument for repro-
duction. But photography is much more than that. Today it is in a fair way to
bringing (optically) something entirely new into the world. The specific elements
of photography can be isolated from their attendant complications, not only theo-
retically, but tangibly, and in their manifest reality.

The unique quality of photography

The photogram, or camera-less record of forms produced by light, which embodies
the unique nature of the photographic process, is the real key to photography. It
allows us to capture the patterned interplay of light on a sheet of sensitized
paper without recourse to any apparatus. The photogram opens up perspectives of
a hitherto wholly unknown morphosis governed by optical laws peculiar to itself.
It is the most completely dematerialized medium which the new vision commands.

What is optical quality?

Through the development of black-and-white photography, light and shadow were
for the first time fully revealed; and thanks to it, too, they first began to be employed
with something more than a purely theoretical knowledge. (Impressionism in
painting may be regarded as a parallel achievement). Through the development of
reliable artificial illumination (more particularly electricity), and the power of regu-
lating it, an increasing adoption of flowing light and richly gradated shadows ensued;
and through these, again a greater animation of surfaces, and a more delicate optical
intensification. This manifolding of gradations is one of the fundamental 'materials'
of optical formalism: a fact which holds equally well if we pass beyond the im-

mediate sphere of black-white-grey values and learn to think and work in terms of colored ones.

When pure color is placed against pure color, tone against tone, a hard, poster-like decorative effect generally results. On the other hand the same colors used in conjunction with their intermediate tones will dispel this poster-like effect, and create a more delicate and melting impression. Through its black-white-grey reproductions of all colored appearances photography has enabled us to recognize the most subtle differentiations of values in both the grey and chromatic scales: differentiations that represent a new and (judged by previous standards) hitherto unattainable quality in optical expression. This is, of course, only one point among many. But it is the point where we have to begin to master photography's inward properties, and that at which we have to deal more with the artistic function of expression than with the reproductive function of portrayal.

Sublimated technique

In reproduction – considered as the objective fixation of the semblance of an object – we find just as radical advances and transmogrifications, compared with prevailing optical representation, as in direct records of forms produced by light (photograms). These particular developments are well known: bird's-eye views, simultaneous interceptions, reflections, elliptical penetrations, etc. Their systematic co-ordination opens up a new field of visual presentation in which still further progress becomes possible. It is, for instance, an immense extension of the optical possibilities of reproduction that we are able to register precise fixations of objects, even in the most difficult circumstances, in a hundredth or thousandth of a second. Indeed, this advance in technique almost amounts to a psychological transformation of our eyesight[1], since the sharpness of the lens and the unerring accuracy of its delineation have now trained our powers of observation up to a standard of visual perception which embraces ultra-rapid snapshots and the millionfold magnification of dimensions employed in microscopic photography.

Improved performance

Photography, then, imparts a heightened, or (in so far as our eyes are concerned) increased, power of sight in terms of time and space. A plain, matter-of-fact enumeration of the specific photographic elements – purely technical, not artistic, elements – will be enough to enable us to divine the power latent in them, and prognosticate to what they lead.

The eight varieties of photographic vision

1. Abstract seeing by means of direct records of forms produced by light: the photogram which captures the most delicate gradations of light values, both chiaroscuro and colored.

2. Exact seeing by means of the normal fixation of the appearance of things: reportage.
3. Rapid seeing by means of the fixation of movements in the shortest possible time: snapshots.
4. Slow seeing by means of the fixation of movements spread over a period of time: e.g., the luminous tracks made by the headlights of motor cars passing along a road at night: prolonged time exposures.
5. Intensified seeing by means of:
 a) micro-photography;
 b) filter-photography, which, by variation of the chemical composition of the sensitized surface, permits photographic potentialities to be augmented in various ways – ranging from the revelation of far-distant landscapes veiled in haze or fog to exposures in complete darkness: infra-red photography.
6. Penetrative seeing by means of X-rays: radiography.
7. Simultaneous seeing by means of transparent superimposition: the future process of automatic photomontage.
8. Distorted seeing: optical jokes that can be automatically produced by:
 a) exposure through a lens fitted with prisms, and the device of reflecting mirrors; or
 b) mechanical and chemical manipulation of the negative after exposure.

What is the purpose of the enumeration?

What is to be gleaned from this list? That the most astonishing possibilities remain to be discovered in the raw material of photography, since a detailed analysis of each of these aspects furnishes us with a number of valuable indications in regard to their application, adjustment, etc. Our investigations will lead us in another direction, however. We want to discover what is the essence and significance of photography.

The new vision

All interpretations of photography have hitherto been influenced by the aesthetic-philosophic concepts that circumscribed painting. These were for long held to be equally applicable to photographic practice. Up to now, photography has remained in rather rigid dependence on the traditional forms of painting; and like painting it has passed through the successive stages of all the various art 'isms'; though in no sense to its advantage. Fundamentally new discoveries cannot for long be confined to the mentality and practice of bygone periods with impunity. When that happens all productive activity is arrested. This was plainly evinced in photography, which has yielded no results of any value except in those fields where, as in scientific work, it has been employed without artistic ambitions. Here alone did it prove the pioneer of an original development, or of one peculiar to itself.

 In this connection it cannot be too plainly stated that it is quite unimportant whether photography produces 'art' or not. Its own basic laws, not the opinions of

art critics, will provide the only valid measure of its future worth. It is sufficiently unprecedented that such a 'mechanical' thing as photography, and one regarded so contemptuously in an artistic and creative sense, should have acquired the power it has, and become one of the primary objective visual forms, in barely a century of evolution. Formerly the painter impressed his own perspective outlook on his age. We have only to recall the manner in which we used to look at landscapes, and compare it with the way we perceive them now! Think, too, of the incisive sharpness of those camera portraits of our contemporaries, pitted with pores and furrowed by lines. Or an air-view of a ship at sea moving through waves that seem frozen in light. Or the enlargement of a woven tissue, or the chiselled delicacy of an ordinary sawn block of wood. Or, in fact, any of the whole gamut of splendid details of structure, texture and 'factor' of whatever objects we care to choose.

The new experience of space

Through photography, too, we can participate in new experiences of space, and in even greater measure through the film. With their help, and that of the new school of architects, we have attained an enlargement and sublimation of our appreciation of space, the comprehension of a new spatial culture. Thanks to the photographer, humanity has acquired the power of perceiving its surroundings, and its very existence, with new eyes.

The height of attainment

But all these are isolated characteristics, separate achievements, not altogether dissimilar to those of painting. In photography we must learn to seek, not the 'picture,' not the aesthetic of tradition, but the ideal instrument of expression, the self-sufficient vehicle for education.

Series (photographic image sequences of the same object)

There is no more surprising, yet, in its naturalness and organic sequence, simpler form than the photographic series. This is the logical culmination of photography. The series is no longer a 'picture,' and none of the canons of pictorial aesthetics can be applied to it. Here the separate picture loses its identity as such and becomes a detail of assembly, an essential structural element of the whole which is the thing itself. In this concatenation of its separate but inseparable parts a photographic series inspired by a definite purpose can become at once the most potent weapon and the tenderest lyric. The true significance of the film will only appear in a much later, less confused and groping age than ours. The prerequisite for this revelation is, of course, the realization that a knowledge of photography is just as important as that of the alphabet. The illiterate of the future will be ignorant of the use of camera and pen alike.

Note

1 Helmholtz used to tell his pupils that if an optician were to succeed in making a human
 eye, and brought it to him for his approval, he would be bound to say: 'this is a
 clumsy job of work.'

John Szarkowski

INTRODUCTION TO *THE PHOTOGRAPHER'S EYE*

T HE INVENTION OF PHOTOGRAPHY provided a radically new picture-making process – a process based not on synthesis but on selection. The difference was a basic one. Paintings were *made* – constructed from a storehouse of traditional schemes and skills and attitudes – but photographs, as the man on the street put it, were *taken*.

The difference raised a creative issue of a new order: how could this mechanical and mindless process be made to produce pictures meaningful in human terms – pictures with clarity and coherence and a point of view? It was soon demonstrated that an answer would not be found by those who loved too much the old forms, for in large part the photographer was bereft of the old artistic traditions. Speaking of photography Baudelaire said: 'This industry, by invading the territories of art, has become art's most mortal enemy.'[1] And in his own terms of reference Baudelaire was half right; certainly the new medium could not satisfy old standards. The photographer must find new ways to make his meaning clear.

These new ways might be found by men who could abandon their allegiance to traditional pictorial standards – or by the artistically ignorant, who had no old allegiances to break. There have been many of the latter sort. Since its earliest days, photography has been practiced by thousands who shared no common tradition or training, who were disciplined and united by no academy or guild, who considered their medium variously as a science, an art, a trade, or an entertainment, and who were often unaware of each other's work. Those who invented photography were scientists and painters, but its professional practitioners were a very different lot. Hawthorne's daguerreotypist hero Holgrave in *The House of the Seven Gables* was perhaps not far from typical:

'Though now but twenty-two years old, he had already been a country schoolmaster; salesman in a country store; and the political editor of a country newspaper. He had subsequently travelled as a peddler of cologne water and other essences. He had studied and practiced dentistry. Still more recently he had been a public lecturer

on mesmerism, for which science he had very remarkable endowments. His present phase as a daguerreotypist was of no more importance in his own view, nor likely to be more permanent, than any of the preceding ones.'[2]

The enormous popularity of the new medium produced professionals by the thousands – converted silversmiths, tinkers, druggists, blacksmiths and printers. If photography was a new artistic problem, such men had the advantage of having nothing to unlearn. Among them they produced a flood of images. In 1853 the *New-York Daily Tribune* estimated that three million daguerreotypes were being produced that year.[3] Some of these pictures were the product of knowledge and skill and sensibility and invention; many were the product of accident, improvisation, misunderstanding, and empirical experiment. But whether produced by art or by luck, each picture was part of a massive assault on our traditional habits of seeing.

By the latter decades of the nineteenth-century the professionals and the serious amateurs were joined by an even larger host of casual snapshooters. By the early eighties the dry plate, which could be purchased ready-to-use, had replaced the refractory and messy wet plate process, which demanded that the plate be prepared just before exposure and processed before its emulsion had dried. The dry plate spawned the hand camera and the snapshot. Photography had become easy. In 1893 an English writer complained that the new situation had 'created an army of photographers who run rampant over the globe, photographing objects of all sorts, sizes and shapes, under almost every condition, without ever pausing to ask themselves, is this or that artistic? . . . They spy a view, it seems to please, the camera is focused, the shot taken! There is no pause, why should there be? For art may err but nature cannot miss, says the poet, and they listen to the dictum. To them, composition, light, shade, form and texture are so many catch phrases. . . .'[4]

These pictures, taken by the thousands by journeyman worker and Sunday hobbyist, were unlike any pictures before them. The variety of their imagery was prodigious. Each subtle variation in viewpoint or light, each passing moment, each change in the tonality of the print, created a new picture. The trained artist could draw a head or a hand from a dozen perspectives. The photographer discovered that the gestures of a hand were infinitely various, and that the wall of a building in the sun was never twice the same.

Most of this deluge of pictures seemed formless and accidental, but some achieved coherence, even in their strangeness. Some of the new images were memorable, and seemed significant beyond their limited intention. These remembered pictures enlarged one's sense of possibilities as he looked again at the real world. While they were remembered they survived, like organisms, to reproduce and evolve.

But it was not only the way that photography described things that was new; it was also the things it chose to describe. Photographers shot '. . . objects of all sorts, sizes and shapes . . . without ever pausing to ask themselves, is this or that artistic?' Painting was difficult, expensive, and precious, and it recorded what was known to be important. Photography was easy, cheap and ubiquitous, and it recorded anything: shop windows and sod houses and family pets and steam engines and unimportant people. And once made objective and permanent, immortalized in a picture, these trivial things took on importance. By the end of the century, for the first time in history, even the poor man knew what his ancestors had looked like.

The photographer learned in two ways: first, from a worker's intimate under-standing of his tools and materials (if his plate would not record the clouds, he could point his camera down and eliminate the sky); and second he learned from other photographs, which presented themselves in an unending stream. Whether his concern was commercial or artistic, his tradition was formed by all the photographs that had impressed themselves upon his consciousness. . . .

It should be possible to consider the history of the medium in terms of photog-raphers' progressive awareness of characteristics and problems that have seemed inherent in the medium. Five such issues are considered below. These issues *do not* define discrete categories of work; on the contrary they should be regarded as inter-dependent aspects of a single problem – as section views through the body of photographic tradition. As such, it is hoped that they may contribute to the formu-lation of a vocabulary and a critical perspective more fully responsive to the unique phenomena of photography.

The thing itself

The first thing that the photographer learned was that photography dealt with the actual; he had not only to accept this fact, but to treasure it; unless he did, photog-raphy would defeat him. He learned that the world itself is an artist of incomparable inventiveness, and that to recognize its best works and moments, to anticipate them, to clarify them and make them permanent, requires intelligence both acute and supple.

But he learned also that the factuality of his pictures, no matter how convincing and unarguable, was a different thing than the reality itself. Much of the reality was filtered out in the static little black and white image, and some of it was exhibited with an unnatural clarity, an exaggerated importance. The subject and the picture were not the same thing, although they would afterwards seem so. It was the photographer's problem to see not simply the reality before him but the still invis-ible picture, and to make his choices in terms of the latter.

This was an artistic problem, not a scientific one, but the public believed that the photograph could not lie, and it was easier for the photographer if he believed it too, or pretended to. Thus he was likely to claim that what our eyes saw was an illusion, and what the camera saw was the truth. Hawthorne's Holgrave, speaking of a difficult portrait subject said: 'We give [heaven's broad and simple sunshine] credit only for depicting the merest surface, but it actually brings out the secret character with a truth that no painter would ever venture upon, even could he detect it. . . . the remarkable point is that the original wears, to the world's eye . . . an exceedingly pleasant countenance, indicative of benevolence, openness of heart, sunny good humor, and other praiseworthy qualities of that cast. The sun, as you see, tells quite another story, and will not be coaxed out of it, after half a dozen patient attempts on my part. Here we have a man, sly, subtle, hard, imperious, and withal, cold as ice.'[5]

In a sense Holgrave was right in giving more credence to the camera image than to his own eyes, for the image would survive the subject, and become the remem-bered reality. William M. Ivins, Jr. said 'at any given moment the accepted report

of an event is of greater importance than the event, for what we think about and act upon is the symbolic report and not the concrete event itself.'[6] He also said: 'The nineteenth century began by believing that what was reasonable was true and it would end up by believing that what it saw a photograph of was true.'[7]

The detail

The photographer was tied to the facts of things, and it was his problem to force the facts to tell the truth. He could not, outside the studio, pose the truth; he could only record it as he found it, and it was found in nature in a fragmented and unexplained form – not as a story, but as scattered and suggestive clues. The photographer could not assemble these clues into a coherent narrative, he could only isolate the fragment, document it, and by so doing claim for it some special significance, a meaning which went beyond simple description. The compelling clarity with which a photograph recorded the trivial suggested that the subject had never before been properly seen, that it was in fact perhaps *not* trivial, but filled with undiscovered meaning. If photographs could not be read as stories, they could be read as symbols.

The decline of narrative painting in the past century has been ascribed in large part to the rise of photography, which 'relieved' the painter of the necessity of story telling. This is curious, since photography has never been successful at narrative. It has in fact seldom attempted it. The elaborate nineteenth-century montages of Robinson and Rejlander, laboriously pieced together from several posed negatives, attempted to tell stories, but these works were recognized in their own time as pretentious failures. In the early days of the picture magazines the attempt was made to achieve narrative through photographic sequences, but the superficial coherence of these stories was generally achieved at the expense of photographic discovery. The heroic documentation of the American Civil War by the Brady group, and the incomparably larger photographic record of the Second World War, have this in common: neither explained, without extensive captioning, what was happening. The function of these pictures was not to make the story clear, it was to make it *real*. The great war photographer her Robert Capa expressed both the narrative property and the symbolic power of photography when he said, 'If your pictures aren't good, you're not close enough.'

The frame

Since the photographer's picture was not conceived but selected, his subject was never truly discrete, never wholly self-contained. The edges of his film demarcated what he thought most important, but the subject he had shot was something else; it had extended in four directions. If the photographer's frame surrounded two figures, isolating them from the crowd in which they stood, it created a relationship between those two figures that had not existed before.

The central act of photography, the act of choosing and eliminating, forces a concentration on the picture edge – the line that separates in from out – and on the shapes that are created by it.

During the first half-century of photography's lifetime, photographs were printed the same size as the exposed plate. Since enlarging was generally impractical, the photographer could not change his mind in the darkroom, and decide to use only a fragment of his picture, without reducing its size accordingly. If he had purchased an eight by ten inch plate (or worse, prepared it), had carried it as part of his back-bending load, and had processed it, he was not likely to settle for a picture half that size. A sense of simple economy was enough to make the photographer try to fill the picture to its edges.

The edges of the picture were seldom neat. Parts of figures or buildings or features of landscape were truncated, leaving a shape belonging not to the subject, but (if the picture was a good one) to the balance, the propriety, of the image. The photographer looked at the world as though it was a scroll painting, unrolled from hand to hand, exhibiting an infinite number of croppings – of compositions – as the frame moved onwards.

The sense of the picture's edge as a cropping device is one of the qualities of form that most interested the inventive painters of the latter nineteenth century. To what degree this awareness came from photography, and to what degree from oriental art, is still open to study. However, it is possible that the prevalence of the photographic image helped prepare the ground for an appreciation of the Japanese print, and also that the compositional attitudes of these prints owed much to habits of seeing which stemmed from the scroll tradition.

Time

There is in fact no such thing as an instantaneous photograph. All photographs are time exposures, of shorter or longer duration, and each describes a discrete parcel of time. This time is always the present. Uniquely in the history of pictures, a photograph describes only that period of time in which it was made. Photography alludes to the past and the future only in so far as they exist in the present, the past through its surviving relics, the future through prophecy visible in the present.

In the days of slow films and slow lenses, photographs described a time segment of several seconds or more. If the subject moved, images resulted that had never been seen before: dogs with two heads and a sheaf of tails, faces without features, transparent men, spreading their diluted substance half across the plate. The fact that these pictures were considered (at best) as partial failures is less interesting than the fact that they were produced in quantity; they were familiar to all photographers, and to all customers who had posed with squirming babies for family portraits.

It is surprising that the prevalence of these radical images has not been of interest to art historians. The time-lapse painting of Duchamp and Balla, done before the First World War, has been compared to work done by photographers such as Edgerton and Mili, who worked consciously with similar ideas a quarter-century later, but the accidental time-lapse photographs of the nineteenth century have been ignored – presumably *because* they were accidental.

As photographic materials were made more sensitive, and lenses and shutters faster, photography turned to the exploration of rapidly moving subjects. Just as the eye is incapable of registering the single frames of a motion picture projected

on the screen at the rate of twenty-four per second, so is it incapable of following the positions of a rapidly moving subject in life. The galloping horse is the classic example. As lovingly drawn countless thousands of times by Greeks and Egyptians and Persians and Chinese, and down through all the battle scenes and sporting prints of Christendom, the horse ran with four feet extended, like a fugitive from a carousel. Not till Muybridge successfully photographed a galloping horse in 1878 was the convention broken. It was this way also with the flight of birds, the play of muscles on an athlete's back, the drape of a pedestrian's clothing, and the fugitive expressions of a human face.

Immobilizing these thin slices of time has been a source of continuing fascination for the photographer. And while pursuing this experiment he discovered something else: he discovered that there was a pleasure and a beauty in this fragmenting of time that had little to do with what was happening. It had to do rather with seeing the momentary patterning of lines and shapes that had been previously concealed within the flux of movement. Cartier-Bresson defined his commitment to this new beauty with the phrase *The decisive moment*, but the phrase has been misunderstood; the thing that happens at the decisive moment is not a dramatic climax but a visual one. The result is not a story but a picture.

Vantage point

Much has been said about the clarity of photography, but little has been said about its obscurity. And yet it is photography that has taught us to see from the unexpected vantage point, and has shown us pictures that give the sense of the scene, while withholding its narrative meaning. Photographers from necessity choose from the options available to them, and often this means pictures from the other side of the proscenium, showing the actors' backs, pictures from the bird's view, or the worm's, or pictures in which the subject is distorted by extreme foreshortening, or by none, or by an unfamiliar pattern of light, or by a seeming ambiguity of action or gesture.

Ivins wrote with rare perception of the effect that such pictures had on nineteenth-century eyes: 'At first the public had talked a great deal about what it called photographic distortion. . . . [But] it was not long before men began to think photographically, and thus to see for themselves things that it had previously taken the photograph to reveal to their astonished and protesting eyes. Just as nature had once imitated art, so now it began to imitate the picture made by the camera.'[8]

After a century and a quarter, photography's ability to challenge and reject our schematized notions of reality is still fresh. In his monograph on Francis Bacon, Lawrence Alloway speaks of the effect of photography on that painter: 'The evasive nature of his imagery, which is shocking but obscure, like accident or atrocity photographs, is arrived at by using photography's huge repertory of visual images. . . . Uncaptioned news photographs, for instance, often appear as momentous and extraordinary. . . . Bacon used this property of photography to subvert the clarity of pose of figures in traditional painting.'[9]

The influence of photography on modern painters (and on modern writers) has been great and inestimable. It is, strangely, easier to forget that photography

has also influenced photographers. Not only great pictures by great photographers, but *photography* – the great undifferentiated, homogeneous whole of it – has been teacher, library, and laboratory for those who have consciously used the camera as artists. An artist is a man who seeks new structures in which to order and simplify his sense of the reality of life. For the artist photographer, much of his sense of reality (where his picture starts) and much of his sense of craft or structure (where his picture is completed) are anonymous and untraceable gifts from photography itself.

The history of photography has been less a journey than a growth. Its movement has not been linear and consecutive, but centrifugal. Photography, and our understanding of it, has spread from a center; it has, by infusion, penetrated our consciousness. Like an organism, photography was born whole. It is in our progressive discovery of it that its history lies.

Notes

1 Charles Baudelaire, 'Salon de 1859,' translated by Jonathan Mayne for *The Mirror of Art, Critical Studies by Charles Baudelaire*. London: Phaidon Press, 1955. (Quoted from *On Photography, A Source Book of Photo History in Facsimile*, edited by Beaumont Newhall. Watkins Glen, N.Y.: Century House, 1956, p. 106.)

2 Nathaniel Hawthorne, *The House of the Seven Gables*. New York: Signet Classics edition, 1961, pp. 156–7.

3 A. C. Willers, 'Poet and Photography,' in *Picturescope*, Vol. XI, No. 4. New York: Picture Division, Special Libraries Association, 1963, p. 46.

4 E. E. Cohen, 'Bad Form in Photography,' in *The International Annual of Anthony's Photographic Bulletin*. New York and London: E. and H. T. Anthony, 1893, p. 18.

5 Hawthorne, op. cit., p. 85.

6 William M. Ivins, Jr., *Prints and Visual Communication*. Cambridge, Mass.: Harvard University Press, 1953, p. 180.

7 Ibid., p. 94.

8 Ibid., p. 138.

9 Lawrence Alloway, *Francis Bacon*. New York: Solomon II. Guggenheim Foundation, 1963, p. 22.

Edward Weston

SEEING PHOTOGRAPHICALLY

EACH MEDIUM OF EXPRESSION IMPOSES its own limitations on the artist – limitations inherent in the tools, materials, or processes he employs. In the older art forms these natural confines are so well established they are taken for granted. We select music or dancing, sculpture or writing because we feel that within the *frame* of that particular medium we can best express whatever it is we have to say.

The photo-painting standard

Photography, although it has passed its hundredth birthday, has yet to attain such familiarization. In order to understand why this is so, we must examine briefly the historical background of this youngest of the graphic arts. Because the early photographers who sought to produce creative work had no tradition to guide them, they soon began to borrow a ready-made one from the painters. The conviction grew that photography was just a new kind of painting, and its exponents attempted by every means possible to make the camera produce painter-like results. This misconception was responsible for a great many horrors perpetrated in the name of art, from allegorical costume pieces to dizzying out-of-focus blurs.

But these alone would not have sufficed to set back the photographic clock. The real harm lay in the fact that the false standard became firmly established, so that the goal of artistic endeavor became photo-painting rather than photography. The approach adopted was so at variance with the real nature of the medium employed that each basic improvement in the process became just one more obstacle for the photo-painters to overcome. Thus the influence of the painters' tradition delayed recognition of the real creative field photography had provided. Those who should have been most concerned with discovering and exploiting the new

pictorial resources were ignoring them entirely and, in their preoccupation with producing pseudopaintings, departing more and more radically from all photographic values.

As a consequence, when we attempt to assemble the best work of the past, we most often choose examples from the work of those who were not primarily concerned with esthetics. It is in commercial portraits from the daguerreotype era, records of the Civil War, documents of the American frontier, the work of amateurs and professionals who practiced photography for its own sake without troubling over whether or not it was art, that we find photographs that will still stand with the best of contemporary work.

But in spite of such evidence that can now be appraised with a calm, historical eye, the approach to creative work in photography today is frequently just as muddled as it was eighty years ago, and the painters' tradition still persists, as witness the use of texture screens, handwork on negatives, and ready-made rules of composition. People who wouldn't think of taking a sieve to the well to draw water fail to see the folly in taking a camera to make a painting.

Behind the photo-painter's approach lay the fixed idea that a straight photograph was purely the product of a machine and therefore not art. He developed special technics to combat the mechanical nature of his process. In this system the negative was taken as a point of departure – a first rough impression to be 'improved' by hand until the last traces of its unartistic origin had disappeared.

Perhaps if singers banded together in sufficient numbers, they could convince musicians that the sounds they produced through *their machines* could not be art because of the essentially mechanical nature of their instruments. Then the musician, profiting by the example of the photo-painter, would have his playing recorded on special discs so that he could unscramble and rescramble the sounds until he had transformed the product of a good musical instrument into a poor imitation of the human voice!

To understand why such an approach is incompatible with the logic of the medium, we must recognize the two basic factors in the photographic process that set it apart from the other graphic arts: the nature of the recording process and the nature of the image.

Nature of the recording process

Among all the arts photography is unique by reason of its instantaneous recording process. The sculptor, the architect, the composer all have the possibility of making changes in, or additions to, their original plans while their work is in the process of execution. A composer may build up a symphony over a long period of time; a painter may spend a lifetime working on one picture and still not consider it finished. But the photographer's recording process cannot be drawn out. Within its brief duration, no stopping or changing or reconsidering is possible. When he uncovers his lens every detail within its field of vision is registered in far less time than it takes for his own eyes to transmit a similar copy of the scene to his brain.

Nature of the image

The image that is thus swiftly recorded possesses certain qualities that at once distinguish it as photographic. First there is the amazing precision of definition, especially in the recording of fine detail; and second, there is the unbroken sequence of infinitely subtle gradations from black to white. These two characteristics constitute the trademark of the photograph; they pertain to the mechanics of the process and cannot be duplicated by any work of the human hand.

The photographic image partakes more of the nature of a mosaic than of a drawing or painting. It contains no *lines* in the painter's sense, but is entirely made up of tiny particles. The extreme fineness of these particles gives a special tension to the image, and when that tension is destroyed – by the intrusion of handwork, by too great enlargement, by printing on a rough surface, etc. – the integrity of the photograph is destroyed.

Finally, the image is characterized by lucidity and brilliance of tone, qualities which cannot be retained if prints are made on dull-surface papers. Only a smooth, light-giving surface can re-produce satisfactorily the brilliant clarity of the photographic image.

Recording the image

It is these two properties that determine the basic procedure in the photographer's approach. Since the recording process is instantaneous, and the nature of the image such that it cannot survive corrective handwork, it is obvious that the *finished print must be created in full before the film is exposed.* Until the photographer has learned to visualize his final result in advance, and to predetermine the procedures necessary to carry out that visualization, his finished work (if it be photography at all) will present a series of lucky – or unlucky – mechanical accidents.

Hence the photographer's most important and likewise most difficult task is not learning to manage his camera, or to develop, or to print. It is learning to *see photographically* – that is, learning to see his subject matter in terms of the capacities of his tools and processes, so that he can instantaneously translate the elements and values in a scene before him into the photograph he wants to make. The photo-painters used to contend that photography could never be an art because there was in the process no means for controlling the result. Actually, the problem of learning to see photographically would be simplified if there were fewer means of control than there are.

By varying the position of his camera, his camera angle, or the focal length of his lens, the photographer can achieve an infinite number of varied compositions with a single, stationary subject. By changing the light on the subject, or by using a color filter, any or all of the values in the subject can be altered. By varying the length of exposure, the kind of emulsion, the method of developing, the photographer can vary the registering of relative values in the negative. And the relative values as registered in the negative can be further modified by allowing more or less light to affect certain parts of the image in printing. Thus, within the limits of his medium, without resorting to any method of control that is not photographic

(i.e., of an optical or chemical nature), the photographer can depart from literal recording to whatever extent he chooses.

This very richness of control facilities often acts as a barrier to creative work. The fact is that relatively few photographers ever master their medium. Instead they allow the medium to master them and go on an endless squirrel cage chase from new lens to new paper to new developer to new gadget, never staying with one piece of equipment long enough to learn its full capacities, becoming lost in a maze of technical information that is of little or no use since they don't know what to do with it.

Only long experience will enable the photographer to subordinate technical considerations to pictorial aims, but the task can be made immeasurably easier by selecting the simplest possible equipment and procedures and staying with them. Learning to see in terms of the field of one lens, the scale of one film and one paper, will accomplish a good deal more than gathering a smattering of knowledge about several different sets of tools.

The photographer must learn from the outset to regard his process as a whole. He should not be concerned with the 'right exposure,' the 'perfect negative,' etc., such notions are mere products of advertising mythology. Rather he must learn the kind of negative necessary to produce a given kind of print, and then the kind of exposure and development necessary to produce that negative. When he knows how these needs are fulfilled for one kind of print, he must learn how to vary the process to produce other kinds of prints. Further he must learn to translate colors into their monochrome values, and learn to judge the strength and quality of light. With practice this kind of knowledge becomes intuitive; the photographer learns to see a scene or object in terms of his finished print without having to give conscious thought to the steps that will be necessary to carry it out.

Subject matter and composition

So far we have been considering the mechanics of photographic seeing. Now let us see how this camera-vision applies to the fields of subject matter and composition. No sharp line can be drawn between the subject matter appropriate to photography and that more suitable to the other graphic arts. However, it is possible, on the basis of an examination of past work and our knowledge of the special properties of the medium, to suggest certain fields of endeavor that will most reward the photographer, and to indicate others that he will do well to avoid.

Even if produced with the finest photographic technic, the work of the photo-painters referred to could not have been successful. Photography is basically too honest a medium for recording superficial aspects of a subject. It searches out the actor behind the make-up and exposes the contrived, the trivial, the artificial, for what they really are. But the camera's innate honesty can hardly be considered a limitation of the medium, since it bars only that kind of subject matter that properly belongs to the painter. On the other hand it provides the photographer with a means of looking deeply into the nature of things, and presenting his subjects in terms of their basic reality. It enables him to reveal the essence of what lies before his lens with such clear insight that the beholder may find the recreated image more real and comprehensible than the actual object.

It is unfortunate, to say the least, that the tremendous capacity photography has for revealing new things in new ways should be overlooked or ignored by the majority of its exponents – but such is the case. Today the waning influence of the painter's tradition, has been replaced by what we may call *Salon Psychology*, a force that is exercising the same restraint over photographic progress by establishing false standards and discouraging any symptoms of original creative vision.

Today's photographer need not necessarily make his picture resemble a wash drawing in order to have it admitted as art, but he must abide by 'the rules of composition.' That is the contemporary nostrum. Now to consult rules of composition before making a picture is a little like consulting the law of gravitation before going for a walk. Such rules and laws are deduced from the accomplished fact; they are the products of reflection and after-examination, and are in no way a part of the creative impetus. When subject matter is forced to fit into preconceived patterns, there can be no freshness of vision. Following rules of composition can only lead to a tedious repetition of pictorial clichés.

Good composition is only the strongest way of seeing the subject. It cannot be taught because, like all creative effort, it is a matter of personal growth. In common with other artists the photographer wants his finished print to convey to others his own response to his subject. In the fulfillment of this aim, his greatest asset is the directness of the process he employs. But this advantage can only be retained if he simplifies his equipment and technic to the minimum necessary, and keeps his approach free from all formula, art-dogma, rules, and taboos. Only then can he be free to put his photographic sight to use in discovering and revealing the nature of the world he lives in.

PART THREE

Codes and rhetoric

Dormeuil Advertisement. *Cloth for Men*

Introduction

THE IDEA OF SEMIOTICS, the science of signs, was proposed in 1916 by
Ferdinand de Saussure, but it was only in the 1950s and 1960s that theo-
rists, including Roland Barthes (France) and C. S. Pierce (USA), set about
examining the structure of non-verbal systems of communication. The aim was to
comprehend how meaning is produced. In linguistics there is a distinction between
grammar, the rules or system of any particular language, and words, specific units
of expression. The relation between words and the objects or events to which
they refer is generally arbitrary, resulting from convention (even when onomato-
poeic). Meaning emerges from the inter-relation of words and their organisation
into phrases, sentences and paragraphs in accordance with particular rules. Thus,
language is a coded system (like morse code) within which comprehension relies
upon the familiarity of the reader with the codes and conventions in play, on the
ability to 'decode'.

In photography, the question of codification has seemed complex, principally
because of direct resemblance between the image and the object of the photo-
graph. Roland Barthes argued that the photographic image in itself is not coded,
in effect, photos are 'transparent' renderings of that which they record. Film
critic, André Bazin argued that the photographic was at its most authentic when
intervention on the part of the film-maker (or photographer) was minimised.
Such positions support the proposition that there is a natural and direct relation
between the photograph and the person, place or occurrence recorded (the pro-
photographic event).

Others have characterised the photograph in terms of imprint, or trace, or
physical correspondence, but draw attention to what Umberto Eco defines as
'codes of transmission' (associated with technical processes) and to photographic
codes (use of light, focus, and so on). Such codes are conventional in that they
are contrived; but they tend to operate unnoticed, having become taken-for-
granted constituents of the 'good' photograph. This model accepts that something
of the object, person or place adheres to the image, and that this trace is moti-
vated (a direct effect of the pro-photographic) rather than arbitrary. However, it
proposes that the operations of particular coded systems immanently influence
interpretation. Various code systems are inter-layered within the image so that we
simultaneously see, for instance, clusters of silver on paper (the technical) consti-
tuting tonal contrast, which contributes to precision and clarity organised through
depth of field (photographic coding), and the formal organisation of the image in
terms of aesthetic conventions (art historical).

Semioticians initially proposed that the reader was 'positioned' by the image
in ways which constructed specific interpretation. Emphasis was laid upon the
power of the image as a text, rather than upon processes of interpretation, although
the influence of particular cultural knowledge on 'reading' was acknowledged.
Later, attention was paid to effects of differences between social groups and indi-
viduals on meaning and interpretation. In early writings on the semiotics of the
image, the photographer as producer of meaning was also sidelined as Barthes,

and others, proposed (rhetorically) 'the death of the author' arguing that meaning emerged through symbolic convention and, by extension, that the image-maker was merely an agent for the recirculation of conventional imagery. This appears borne out in everyday circulation of imagery wherein, repeatedly, we seem to see the same sorts of news picture, advertisement or domestic photograph. (For example, German artist, Joachim Schmid, advertised for people to send in their family photographs, which he used to demonstrate that we all make similar images (Schmid, 1993).) However, relegation of authorship means not taking into account effects of individual style, subject-matter and commitment of particular image-makers, historically and now, working within various contexts including the gallery and social documentary.

Here, the rhetorical may be paramount; the image may seem to provide evidence or support a particular point of view. As Susan Sontag has remarked 'A photograph passes for incontrovertible proof that a given thing happened. The picture may distort; but there is always a presumption that something exists, or did exist, which is like what's in the picture' (Sontag, 1979: 5). The image in itself tells us little about the specific sociohistorical context of its making. Captions are commonly used for further information, and, as is evident in Barthes' essay on 'Rhetoric of the Image' one of the concerns of semiotics has been to investigate the relation between the image and the written text. This essay was originally published in French in 1964 in *Communications* to accompany – and, in effect, as a case study for – his 'Elements of Semiology'. It extended and consolidated some of the methodological techniques first proposed in *Mythologies* (1957), in which he commented on a range of everyday cultural phenomena in order to analyse the workings of language (the text of a message) and myth (ideas and references invoked). Subsequently, in 'The Photographic Message' (1961), he problematised the photographic, defining the photograph as an analogue of reality and, thus, as a 'message without a code'. There he noted a distinction between the activities of semiotics and questions to do with the making and with the reception of the message, which he viewed as properly belonging to sociology. He proceeded to focus on ways in which elements within the image, such as pose, or photogenic effects, may provoke connotative responses. Here, he invites us to analyse images in terms of the complex layering of signification.

By contrast, Umberto Eco suggests that the rhetorical function of the image emerges principally from iconographic emphasis. Analysing the operations of film, Eco has argued that a combination of codes are complexly articulated in the photographic. As already indicated, these include technical codes associated with optics and perception or seated in the mode of transmission (for instance, the dots that form newsprint or, now, the digital) along with broader cultural codes of recognition, representation and iconography; aesthetics; stylistic and rhetorical conventions. Here, Eco explores the symbolic power of the (photo journalistic) image. Its inclusion both remarks the force of photojournalism and acknowledges the status of Eco as, alongside Barthes, a key figure in visual semiotic analysis.

Semiotics was part of a broader concern to analyse and comprehend cultures in terms of integral structures of meaning; this was developed in particular within

anthropology, by Claude Lévi-Strauss. Early semiotics was criticised for formalism, in particular for failure to take into account audience reception and interpretation. In consequence psychoanalysis was increasingly drawn upon in conjunction with semiotics in order to analyse photographic effects in relation to ideological operations. Victor Burgin's contribution, written when he was teaching photography students at the Polytechnic of Central London (now University of Westminster), employs semiotic and psychoanalytic models in order to investigate the structure of representation of the image and the position offered to the viewer in terms of ideology and subjectivity. It is one of three essays by him included in his edited collection, *Thinking Photography*, which was one of the key contributions of its era towards a materialist analysis of photography. (His introduction to the collection remains worth noting for its succinct definitional discussion of the Marxist debates about ideology and culture which influenced academic enquiry in Britain at the time.)

More recent emphasis on *social* semiotics combines textual analysis with attempts to take into account particular biographical and cultural experience in order to more precisely analyse processes whereby meaning is negotiated. As with each of the essays in this section, the final essay, by Christian Metz, is concerned with photography in the everyday context which he explores through contrasting film and photography (including reference to Peter Wollen's musings on the subject. See Part 1, pp. 76–80). Drawing upon Freud, Metz considers the photograph as a 'fetish' in the twin sense that it stands-in for and thereby comes to symbolise that to which it refers and it also, in psychoanalytic terms, displaces difficulties associated with the referent. His final point qualifying psychoanalytic theory as influential *through suggestion* remains pertinent when considering theoretical models and methods in visual studies.

Semiotics now tends to be used in conjunction with other disciplines within visual cultural studies. As such, what might otherwise have been dismissed as an over-rigid structuralist discipline has had lasting academic influence.

References and selected further reading

Bignell, J. (1997) *Media Semiotics, an introduction*. Manchester: Manchester University Press.
 Includes discussion of the work of Roland Barthes and sections analysing words and images in advertising, newspapers, and women's magazines.
Freud, S. (1927) [1977] 'Fetishism' in *On Sexuality*, Vol. 7, *The Pelican Freud Library*. Harmondsworth: Penguin.
Hawkes, T. (1991) *Structuralism and Semiotics*. London: Methuen; revised edition.
 Introduction to models and debates.
Lister, M. and Wells, L. (2000) 'Seeing Beyond Belief: cultural studies as an approach to analysing the visual' in Carey Jewitt and Theo van Leeuwen *Handbook of Visual Analysis*. London: Sage.
 Semiotics deployed as one of a range of approaches to visual analysis.

Bibliography of essays in Part Three

Barthes, R. (1977) 'Rhetoric of the Image' in Stephen Heath (trans. and ed.) *Image-Music-Text*. London: Fontana.

Burgin, V. (1982) 'Looking at Photographs' in Burgin (ed.) *Thinking Photography*. London: Macmillan

Eco, U. (1986) 'A Photograph' in *Faith in Fakes*. London: Secker & Warburg.

Metz, C. (1985) 'Photography and Fetish' in *October 34*. Cambridge: MIT Press. Reprinted in Carol Squires (ed.) (1990) *The Critical Image* Seattle: Bay Press/ London: Lawrence and Wishart.

Roland Barthes

RHETORIC OF THE IMAGE

ACCORDING TO AN ANCIENT ETYMOLOGY, the word *image* should be linked to the root *imitari*. Thus we find ourselves immediately at the heart of the most important problem facing the semiology of images: can analogical representation (the 'copy') produce true systems of signs and not merely simple agglutinations of symbols? Is it possible to conceive of an analogical 'code' (as opposed to a digital one)? We know that linguists refuse the status of language to all communication by analogy – from the 'language' of bees to the 'language' of gesture – the moment such communications are not doubly articulated, are not founded on a combinatory system of digital units as phonemes are. Nor are linguists the only ones to be suspicious as to the linguistic nature of the image; general opinion too has a vague conception of the image as an area of resistance to meaning – this in the name of a certain mythical idea of Life: the image is re-presentation, which is to say ultimately resurrection, and, as we know, the intelligible is reputed antipathetic to lived experience. Thus from both sides the image is felt to be weak in respect of meaning: there are those who think that the image is an extremely rudimentary system in comparison with language and those who think that signification cannot exhaust the image's ineffable richness. Now even – and above all if – the image is in a certain manner the *limit* of meaning, it permits the consideration of a veritable ontology of the process of signification. How does meaning get into the image? Where does it end? And if it ends, what is there *beyond*? Such are the questions that I wish to raise by submitting the image to a spectral analysis of the messages it may contain. We will start by making it considerably easier for ourselves: we will only study the advertising image. Why? Because in advertising the signification of the image is undoubtedly intentional; the signifieds of the advertising message are formed *a priori* by certain attributes of the product and these signifieds have to be transmitted as clearly as possible. If the image contains signs, we can be sure that in advertising these signs are full, formed with a view to the optimum reading: the advertising image is *frank*, or at least emphatic.

The three messages

Here we have a Panzani advertisement: some packets of pasta, a tin, a sachet, some tomatoes, onions, peppers, a mushroom, all emerging from a half-open string bag, in yellows and greens on a red background.[1] Let us try to 'skim off' the different messages it contains.

The image immediately yields a first message whose substance is linguistic; its supports are the caption, which is marginal, and the labels, these being inserted into the natural disposition of the scene, '*en abyme*'. The code from which this message has been taken is none other than that of the French language; the only knowledge required to decipher it is a knowledge of writing and French. In fact, this message can itself be further broken down, for the sign *Panzani* gives not simply the name of the firm but also, by its assonance, an additional signified, that of 'Italianicity'. The linguistic message is thus twofold (at least in this particular image): denotational and connotational. Since, however, we have here only a single typical sign,[2] namely that of articulated (written) language, it will be counted as one message.

Putting aside the linguistic message, we are left with the pure image (even if the labels are part of it, anecdotally). This image straightaway provides a series of discontinuous signs. First (the order is unimportant as these signs are not linear), the idea that what we have in the scene represented is a return from the market. A signified which itself implies two euphoric values: that of the freshness of the products and that of the essentially domestic preparation for which they are destined. Its signifier is the half-open bag which lets the provisions spill out over the table, 'unpacked'. To read this first sign requires only a knowledge which is in some sort implanted as part of the habits of a very widespread culture where 'shopping around for oneself' is opposed to the hasty stocking up (preserves, refrigerators) of a more 'mechanical' civilization. A second sign is more or less equally evident; its signifier is the bringing together of the tomato, the pepper and the tricoloured hues (yellow, green, red) of the poster; its signified is Italy or rather *Italianicity*. This sign stands in a relation of redundancy with the connoted sign of the linguistic message (the Italian assonance of the name *Panzani*) and the knowledge it draws upon is already more particular; it is a specifically 'French' knowledge (an Italian would barely perceive the connotation of the name, no more probably than he would the Italicity of tomato and pepper), based on a familiarity with certain tourist stereotypes. Continuing to explore the image (which is not to say that it is not entirely clear at the first glance), there is no difficulty in discovering at least two other signs: in the first, the serried collection of different objects transmits the idea of a total culinary service, on the one hand as though Panzani furnished everything necessary for a carefully balanced dish and on the other as though the concentrate in the tin were equivalent to the natural produce surrounding it; in the other sign, the composition of the image, evoking the memory of innumerable alimentary paintings, sends us to an aesthetic signified: the '*nature morte*' or, as it is better expressed in other languages, the 'still life';[3] the knowledge on which this sign depends is heavily cultural. It might be suggested that, in addition to these four signs, there is a further information pointer, that which tells us that this is an advertisement and which arises both from the place of the image in the magazine and from the emphasis of the labels (not to mention the caption). This last information,

however, is co-extensive with the scene; it eludes signification insofar as the adver-
tising nature of the image is essentially functional; to utter something is not
necessarily to declare *I am speaking*, except in a deliberately reflexive system such
as literature.

Thus there are four signs for this image and we will assume that they form a
coherent whole (for they are all discontinuous), require a generally cultural knowl-
edge, and refer back to signifieds each of which is global (for example, *Italianicity*),
imbued with euphoric values. After the linguistic message, then, we can see a
second, iconic message. Is that the end? If all these signs are removed from the
image, we are still left with a certain informational matter; deprived of all knowl-
edge, I continue to 'read' the image, to 'understand' that it assembles in a common
space a number of identifiable (nameable) objects, not merely shapes and colours.
The signifieds of this third message are constituted by the real objects in the scene,
the signifiers by these same objects photographed, for, given that the relation
between thing signified and image signifying in analogical representation is not 'arbi-
trary' (as it is in language), it is no longer necessary to dose the relay with a third
term in the guise of the psychic image of the object. What defines the third message
is precisely that the relation between signified and signifier is quasi-tautological; no
doubt the photograph involves a certain arrangement of the scene (framing, reduc-
tion, flattening) but this transition is not a *transformation* (in the way a coding can
be); we have here a loss of the equivalence characteristic of true sign systems and
a statement of quasi-identity. In other words, the sign of this message is not drawn
from an institutional stock, is not coded, and we are brought up against the paradox
(to which we will return) of a *message without a code*.[4] This peculiarity can be seen
again at the level of the knowledge invested in the reading of the message; in order
to 'read' this last (or first) level of the image, all that is needed is the knowledge
bound up with our perception. That knowledge is not nil, for we need to know
what an image is (children only learn this at about the age of four) and what a
tomato, a string-bag, a packet of pasta are, but it is a matter of an almost anthro-
pological knowledge. This message corresponds, as it were, to the letter of the
image and we can agree to call it the literal message, as opposed to the previous
symbolic message.

If our reading is satisfactory, the photograph analysed offers us three messages:
a linguistic message, a coded iconic message, and a non-coded iconic message. The
linguistic message can be readily separated from the other two, but since the latter
share the same (iconic) substance, to what extent have we the right to separate
them? It is certain that the distinction between the two iconic messages is not made
spontaneously in ordinary reading: the viewer of the image receives *at one and the
same time* the perceptual message and the cultural message, and it will be seen later
that this confusion in reading corresponds to the function of the mass image (our
concern here). The distinction, however, has an operational validity, analogous to
that which allows the distinction in the linguistic sign of a signifier and a signified
(even though in reality no one is able to separate the 'word' from its meaning except
by recourse to the metalanguage of a definition). If the distinction permits us to
describe the structure of the image in a simple and coherent fashion and if this
description paves the way for an explanation of the role of the image in society, we
will take it to be justified. The task now is thus to reconsider each type of message

so as to explore it in its generality, without losing sight of our aim of understanding the overall structure of the image, the final inter-relationship of the three messages. Given that what is in question is not a 'naive' analysis but a structural description[5] the order of the messages will be modified a little by the inversion of the cultural message and the literal message; of the two iconic messages, the first is in some sort imprinted on the second: the literal message appears as the *support* of the 'symbolic' message. Hence, knowing that a system which takes over the signs of another system in order to make them its signifiers is a system of connotation,[6] we may say immediately that the literal image is *denoted* and the symbolic image *connoted*. Successively, then, we shall look at the linguistic message, the denoted image, and the connoted image.

The linguistic message

Is the linguistic message constant? Is there always textual matter in, under, or around the image? In order to find images given without words, it is doubtless necessary to go back to partially illiterate societies, to a sort of pictographic state of the image. From the moment of the appearance of the book, the linking of text and image is frequent, though it seems to have been little studied from a structural point of view. What is the signifying structure of 'illustration'? Does the image duplicate certain of the informations given in the text by a phenomenon of redundancy or does the text add a fresh information to the image? The problem could be posed historically as regards the classical period with its passion for books with pictures (it was inconceivable in the eighteenth century that editions of La Fontaine's *Fables* should not be illustrated) and its authors such as Menestrier who concerned themselves with the relations between figure and discourse.[7] Today, at the level of mass communications, it appears that the linguistic message is indeed present in every image: as title, caption, accompanying press article, film dialogue, comic strip balloon. Which shows that it is not very accurate to talk of a civilization of the image – we are still, and more than ever, a civilization of writing,[8] writing and speech continuing to be the full terms of the informational structure. In fact, it is simply the presence of the linguistic message that counts, for neither its position nor its length seem to be pertinent (a long text may only comprise a single global signified, thanks to connotation, and it is this signified which is put in relation with the image). What are the functions of the linguistic message with regard to the (twofold) iconic message? There appear to be two: *anchorage and relay*.

As will be seen more clearly in a moment, all images are polysemous; they imply, underlying their signifiers, a 'floating chain' of signifieds, the reader able to choose some and ignore others. Polysemy poses a question of meaning and this question always comes through as a dysfunction, even if this dysfunction is recuperated by society as a tragic (silent, God provides no possibility of choosing between signs) or a poetic (the panic 'shudder of meaning' of the Ancient Greeks) game; in the cinema itself, traumatic images are bound up with an uncertainty (an anxiety) concerning the meaning of objects or attitudes. Hence in every society various techniques are developed intended to fix the floating chain of signifieds in such a way as to counter the terror of uncertain signs; the linguistic message is one of these

techniques. At the level of the literal message, the text replies – in a more or less direct, more or less partial manner – to the question: *what is it?* The text helps to identify purely and simply the elements of the scene and the scene itself; it is a matter of a denoted description of the image (a description which is often incomplete) or, in Hjelmslev's terminology, of an *operation* (as opposed to connotation).[9] The denominative function corresponds exactly to an *anchorage* of all the possible (denoted) meanings of the object by recourse to a nomenclature. Shown a plateful of something (in an *Amieux* advertisement), I may hesitate in identifying the forms and masses; the caption ('*rice and tuna fish with mushrooms*') helps me to choose *the correct level of perception*, permits me to focus not simply my gaze but also my understanding. When it comes to the 'symbolic message', the linguistic message no longer guides identification but interpretation, constituting a kind of vice which holds the connoted meanings from proliferating, whether towards excessively individual regions (it limits, that is to say, the projective power of the image) or towards dysphoric values. An advertisement (for *d'Arcy* preserves) shows a few fruits scattered around a ladder; the caption ('*as if from your own garden*') banishes one possible signified (parsimony, the paucity of the harvest) because of its unpleasantness and orientates the reading towards a more flattering signified (the natural and personal character of fruit from a private garden); it acts here as a counter-taboo, combatting the disagreeable myth of the artificial usually associated with preserves. Of course, elsewhere than in advertising, the anchorage may be ideological and indeed this is its principal function; the text *directs* the reader through the signifieds of the image, causing him to avoid some and receive others; by means of an often subtle *dispatching*, it remote-controls him towards a meaning chosen in advance. In all these cases of anchorage, language clearly has a function of elucidation, but this elucidation is selective, a metalanguage applied not to the totality of the iconic message but only to certain of its signs. The text is indeed the creator's (and hence society's) right of inspection over the image; anchorage is a control, bearing a responsibility – in the face of the projective power of pictures – for the use of the message. With respect to the liberty of the signifieds of the image, the text has thus a *repressive* value[10] and we can see that it is at this level that the morality and ideology of a society are above all invested.

Anchorage is the most frequent function of the linguistic message and is commonly found in press photographs and advertisements. The function of relay is less common (at least as far as the fixed image is concerned); it can be seen particularly in cartoons and comic strips. Here text (most often a snatch of dialogue) and image stand in a complementary relationship; the words, in the same way as the images, are fragments of a more general syntagm and the unity of the message is realized at a higher level, that of the story, the anecdote, the diegesis (which is ample confirmation that the diegesis must be treated as an autonomous system).[11] While rare in the fixed image, this relay-text becomes very important in film, where dialogue functions not simply as elucidation but really does advance the action by setting out, in the sequence of messages, meanings that are not to be found in the image itself. Obviously, the two functions of the linguistic message can co-exist in the one iconic whole, but the dominance of the one or the other is of consequence for the general economy of a work. When the text has the diegetic value of relay, the information is more costly, requiring as it does the learning of a digital code

(the system of language); when it has a substitute value (anchorage, control), it is the image which detains the informational charge and, the image being analogical, the information is then 'lazier': in certain comic strips intended for 'quick' reading the diegesis is confided above all to the text, the image gathering the attributive informations of a paradigmatic order (the stereotyped status of the characters); the costly message and the discursive message are made to coincide so that the hurried reader may be spared the boredom of verbal 'descriptions', which are entrusted to the image, that is to say to a less 'laborious' system.

The denoted image

We have seen that in the image properly speaking, the distinction between the literal message and the symbolic message is operational; we never encounter (at least in advertising) a literal image in a pure state. Even if a totally 'naive' image were to be achieved, it would immediately join the sign of naivety and be completed by a third – symbolic – message. Thus the characteristics of the literal message cannot be substantial but only relational. It is first of all, so to speak, a message by eviction, constituted by what is left in the image when the signs of connotation are mentally deleted (it would not be possible actually to remove them for they can impregnate the whole of the image, as in the case of the 'still life composition'). This evictive state naturally corresponds to a plenitude of virtualities: it is an absence of meaning full of all the meanings. Then again (and there is no contradiction with what has just been said), it is a sufficient message, since it has at least one meaning at the level of the identification of the scene represented; the letter of the image corresponds in short to the first degree of intelligibility (below which the reader would perceive only lines, forms, and colours), but this intelligibility remains virtual by reason of its very poverty, for everyone from a real society always disposes of a knowledge superior to the merely anthropological and perceives more than just the letter. Since it is both evictive and sufficient, it will be understood that from an aesthetic point of view the denoted image can appear as a kind of Edenic state of the image; cleared utopianically. of its connotations, the image would become radically objective, or, in the last analysis, innocent.

This utopian character of denotation is considerably reinforced by the paradox already mentioned, that the photograph (in its literal state), by virtue of its absolutely analogical nature, seems to constitute a message without a code. Here, however, structural analysis must differentiate, for of all the kinds of image only the photograph is able to transmit the (literal) information without forming it by means of discontinuous signs and rules of transformation. The photograph, message without a code, must thus be opposed to the thawing which, even when denoted, is a coded message. The coded nature of the drawing can be seen at three levels. Firstly, to reproduce an object or a scene in a drawing requires a set of *rule-governed* transpositions; there is no essential nature of the pictorial copy and the codes of transposition are historical (notably those concerning perspective). Secondly, the operation of the drawing (the coding) immediately necessitates a certain division between the significant and the insignificant: the drawing does not reproduce *every-thing* (often it reproduces very little), without its ceasing, however, to be a strong

message; whereas the photograph, although it can choose its subject, its point of view and its angle, cannot intervene *within* the object (except by trick effects). In other words, the denotation of the drawing is less pure than that of the photograph, for there is no drawing without style. Finally, like all codes, the drawing demands an apprenticeship (Saussure attributed a great importance to this semiological fact). Does the coding of the denoted message have consequences for the connoted message? It is certain that the coding of the literal prepares and facilitates connotation since it at once establishes a certain discontinuity in the image: the 'execution' of a drawing itself constitutes a connotation. But at the same time, insofar as the drawing displays its coding, the relationship between the two messages is profoundly modified: it is no longer the relationship between a nature and a culture (as with the photograph) but that between two cultures; the 'ethic' of the drawing is not the same as that of the photograph.

In the photograph – at least at the level of the literal message – the relationship of signifieds to signifiers is not one of 'transformation' but of 'recording', and the absence of a code clearly reinforces the myth of photographic 'naturalness': the scene *is there*, captured mechanically, not humanly (the mechanical is here a guarantee of objectivity). Man's interventions in the photograph (framing, distance, lighting, focus, speed) all effectively belong to the plane of connotation; it is as though in the beginning (even if utopian) there were a brute photograph (frontal and clear) on which man would then lay out, with the aid of various techniques, the signs drawn from a cultural code. Only the opposition of the cultural code and the natural non-code can, it seems, account for the specific character of the photograph and allow the assessment of the anthropological revolution it represents in man's history. The type of consciousness the photograph involves is indeed truly unprecedented, since it establishes not a consciousness of the *being-there* of the thing (which any copy could provoke) but an awareness of its *having-been-there*. What we have is a new space-time category: spatial immediacy and temporal anteriority, the photograph being an illogical conjunction between the *here-now* and the *there-then*. It is thus at the level of this denoted message or message without code that the *real unreality* of the photograph can be fully understood: its unreality is that of the *here-now*, for the photograph is never experienced as illusion, is in no way a *presence* (claims as to the magical character of the photographic image must be deflated); its reality that of the *having-been-there*, for in every photograph there is the always stupefying evidence of *this is how it was*, giving us, by a precious miracle, a reality from which we are sheltered. This kind of temporal equilibrium (*having-been-there*) probably diminishes the projective power of the image (very few psychological tests resort to photographs while many use drawings): the *this was so* easily defeats the *it's me*. If these remarks are at all correct, the photograph must be related to a pure spectatorial consciousness and not to the more projective, more 'magical' fictional consciousness on which film by and large depends. This would lend authority to the view that the distinction between film and photograph is not a simple difference of degree but a radical opposition. Film can no longer be seen as animated photographs: the *having-been-there* gives way before a *being-there* of the thing; which omission would explain how there can be a history of the cinema, without any real break with the previous arts of fiction, whereas the photograph can in some sense elude history (despite the evolution of the techniques and ambitions of the photo-

graphic art) and represent a 'flat' anthropological fact, at once absolutely new and definitively unsurpassable, humanity encountering for the first time in its history *messages without a code*. Hence the photograph is not the last (improved) term of the great family of images; it corresponds to a decisive mutation of informational economies.

At all events, the denoted image, to the extent to which it does not imply any code (the case with the advertising photograph), plays a special role in the general structure of the iconic message which we can begin to define (returning to this question after discussion of the third message): the denoted image naturalizes the symbolic message, it innocents the semantic artifice of connotation, which is extremely dense, especially in advertising. Although the *Panzani* poster is full of 'symbols', there nonetheless remains in the photograph, insofar as the literal message is sufficient, a kind of natural *being-there* of objects: nature seems spontaneously to produce the scene represented. A pseudo-truth is surreptitiously substituted for the simple validity of openly semantic systems; the absence of code disintellectualizes the message because it seems to found in nature the signs of culture. This is without doubt an important historical paradox: the more technology develops the diffusion of information (and notably of images), the more it provides the means of masking the constructed meaning under the appearance of the given meaning.

Rhetoric of the image

It was seen that the signs of the third message (the 'symbolic' message, cultural or connoted) were discontinuous. Even when the signifier seems to extend over the whole image, it is nonetheless a sign separated from the others: the 'composition' carries an aesthetic signified, in much the same way as intonation although suprasegmental is a separate signifier in language. Thus we are here dealing with a normal system whose signs are drawn from a cultural code (even if the linking together of the elements of the sign appears more or less analogical). What gives this system its originality is that the number of readings of the same lexical unit or *lexia* (of the same image) varies according to individuals. In the *Panzani* advertisement analysed, four connotative signs have been identified; probably there are others (the net bag, for example, can signify the miraculous draught of fishes, plenty, etc.). The variation in readings is not, however, anarchic; it depends on the different kinds of knowledge – practical, national, cultural, aesthetic – invested in the image and these can be classified, brought into a typology. It is as though the image presented itself to the reading of several different people who can perfectly well co-exist in a single individual: *the one lexia mobilizes different lexicons*. What is a lexicon? A portion of the symbolic plane (of language) which corresponds to a body of practices and techniques.[12] This is the case for the different readings of the image: each sign corresponds to a body of 'attitudes' – tourism, housekeeping, knowledge of art – certain of which may obviously be lacking in this or that individual. There is a plurality and a co-existence of lexicons in one and the same person, the number and identity of these lexicons forming in some sort a person's *idiolect*.[13] The image, in its connotation, is thus constituted by an architecture of signs drawn from a variable depth of lexicons (of idiolects); each lexicon, no matter how 'deep', still being coded, if,

as is thought today, the *psyche* itself is articulated like a language; indeed, the further one 'descends' into the psychic depths of an individual, the more rarified and the more classifiable the signs become – what could be more systematic than the readings of Rorschach tests? The variability of readings, therefore, is no threat to the 'language' of the image if it be admitted that that language is composed of idiolects, lexicons and sub-codes. The image is penetrated through and through by the system of meaning, in exactly the same way as man is articulated to the very depths of his being in distinct languages. The language of the image is not merely the totality of utterances emitted (for example at the level of the combiner of the signs or creator of the message), it is also the totality of utterances received:[14] the language must include the 'surprises' of meaning.

Another difficulty in analysing connotation is that there is no particular analytical language corresponding to the particularity of its signifieds – how are the signifieds of connotation to be named? For one of them we ventured the term *Italianicity*, but the others can only be designated by words from ordinary language (*culinary preparation, still life, plenty*); the metalanguage which has to take charge of them at the moment of the analysis is not specialized. This is a difficulty, for these signifieds have a particular semantic nature; as a seme of connotation, 'plenty' does not exactly cover 'plenty' in the denoted sense; the signifier of connotation (here the profusion and the condensation of the produce) is like the essential cipher of all possible plenties, of the purest idea of plenty. The denoted word never refers to an essence for it is always caught up in a contingent utterance, a continuous syntagm (that of verbal discourse), oriented towards a certain practical transitivity of language; the seme 'plenty', on the contrary, is a concept in a pure state, cut off from any syntagm, deprived of any context and corresponding to a sort of theatrical state of meaning, or, better (since it is a question of a sign without a syntagm), to an *exposed* meaning. To express these semes of connotation would therefore require a special metalanguage and we are left with barbarisms of the *Italianicity* kind as best being able to account for the signifieds of connotation, the suffix *-icity* deriving an abstract noun from the adjective: *Italianicity* is not Italy, it is the condensed essence of everything that could be Italian, from spaghetti to painting. By accepting to regulate artificially – and if needs be barbarously – the naming of the semes of connotation, the analysis of their form will be rendered easier.[15] These semes are organized in associative fields, in paradigmatic articulations, even perhaps in oppositions, according to certain defined paths or, as A. J. Greimas puts it, according to certain semic axes:[16] *Italianicity* belongs to a certain axis of nationalities, alongside Frenchicity, Germanicity or Spanishicity. The reconstitution of such axes – which may eventually be in opposition to one another – will clearly only be possible once a massive inventory of the systems of connotation has been carried out, an inventory not merely of the connotative system of the image but also of those of other substances, for if connotation has typical signifiers dependent on the different substances utilized (image, language, objects, modes of behaviour) it holds all its signifieds in common: the same signifieds are to be found in the written press, the image or the actor's gestures (which is why semiology can only be conceived in a so to speak total framework). This common domain of the signifieds of connotation is that of *ideology*, which cannot but be single for a given society and history, no matter what signifiers of connotation it may use.

To the general ideology, that is, correspond signifiers of connotation which are specified according to the chosen substance. These signifiers will be called *connotators* and the set of connotators a *rhetoric*, rhetoric thus appearing as the signifying aspect of ideology. Rhetorics inevitably vary by their substance (here articulated sound, there image, gesture or whatever) but not necessarily by their form; it is even probable that there exists a single rhetorical *form*, common for instance to dream, literature and image.[17] Thus the rhetoric of the image (that is to say, the classification of its connotators) is specific to the extent that it is subject to the physical constraints of vision (different, for example, from phonatory constraints) but general to the extent that the 'figures' are never more than formal relations of elements. This rhetoric could only be established on the basis of a quite considerable inventory, but it is possible now to foresee that one will find in it some of the figures formerly identified by the Ancients and the Classics,[18] the tomato, for example, signifies *Italianicity* by metonymy and in another advertisement the sequence of three scenes (coffee in beans, coffee in powder, coffee sipped in the cup) releases a certain logical relationship in the same way as an asyndeton. It is probable indeed that among the metabolas (or figures of the substitution of one signifier for another),[19] it is metonymy which furnishes the image with the greatest number of its connotators, and that among the parataxes (or syntagmatic figures), it is asyndeton which predominates.

The most important thing, however, at least for the moment, is not to inventorize the connotators but to understand that in the total image they constitute *discontinuous* or better still *scattered traits*. The connotatators do not fill the whole of the lexia, reading them does not exhaust it. In other words (and this would be a valid proposition for semiology in general), not all the elements of the lexia can be transformed into connotators; there always remaining in the discourse a certain denotation without which, precisely, the discourse would not be possible. Which brings us back to the second message or denoted image. In the *Panzani* advertisement, the Mediterranean vegetables, the colour, the composition, the very profusion rise up as so many scattered blocks, at once isolated and mounted in a general scene which has its own space and, as was seen, its 'meaning': they are 'set' in a syntagm *which is not theirs and which is that of the denotation*. This last proposition is important for it permits us to found (retro-actively) the structural distinction between the second or literal message and the third or symbolic message and to give a more exact description of the naturalizing function of the denotation with respect to the connotation. We can now understand that *it is precisely the syntagm of the denoted message which 'naturalizes' the system of the connoted message*. Or again: connotation is only system, can only be defined in paradigmatic terms; iconic denotation is only syntagm, associates elements without any system: the discontinuous connotators are connected, actualized, 'spoken' through the syntagm of the denotation, the discontinuous world of symbols plunges into the story of the denoted scene as though into a lustral bath of innocence.

It can thus be seen that in the total system of the image the structural functions are polarized: on the one hand there is a sort of paradigmatic condensation at the level of the connotators (that is, broadly speaking, of the symbols), which are strong signs, scattered, 'reified'; on the other a syntagmatic 'flow' at the level of the denotation – it will not be forgotten that the syntagm is always very close to speech,

and it is indeed the iconic 'discourse' which naturalizes its symbols. Without wishing to infer too quickly from the image to semiology in general, one can nevertheless venture that the world of total meaning is torn internally (structurally) between the system as culture and the syntagm as nature: the works of mass communications all combine, through diverse and diversely successful dialectics, the fascination of a nature, that of story, diegesis, syntagm, and the intelligibility of a culture, withdrawn into a few discontinuous symbols which men 'decline' in the shelter of living speech.

Notes

1 The *description* of the photograph is given here with prudence, for it already constitutes a metalanguage.

2 By *typical sign* is meant the sign of a system insofar as it is adequately defined by its substance: the verbal sign, the iconic sign, the gestural sign are so many typical signs.

3 In French, the expression *nature morte* refers to the original presence of funereal objects, such as a skull, in certain pictures.

4 Cf. 'The photographic message', in *Image-Music-Text* ed. Stephen Heath (1977) pp. 15–31.

5 'Naive' analysis is an enumeration of elements, structural description aims to grasp the relation of these elements by virtue of the principle of the solidarity holding between the terms of a structure: if one term changes, so also do the others.

6 Cf. R. Barthes, *Eléments de sémiologie, Communications* 4, 1964, p. 130 [trans. *Elements of Semiology*, London 1967 and New York 1968, pp. 89–92].

7 Menestrier, *L'Art des emblèmes*, 1684.

8 Images without words can certainly be found in certain cartoons, but by way of a paradox; the absence of words always covers an enigmatic intention.

9 *Eléments de sémiologie*, pp. 131–2 [trans. pp. 90–4].

10 This can be seen clearly in the paradoxical case where the image is constructed according to the text and where, consequently, the control would seem to be needless. An advertisement which wants to communicate that in such and such a coffee the aroma is 'locked in' the product in powder form and that it will thus be wholly there when the coffee is used depicts, above this proposition, a tin of coffee with a chain and padlock round it. Here, the linguistic metaphor ('locked in') is taken literally (a well-known poetic device); in fact, however, it is the image which is read first and the text from which the image is constructed becomes in the end the simple choice of one signified among others. The repression is present again in the circular movement as a banalization of the message.

11 Cf. Claude Bremond, 'Le message narratif', *Communications* 4, 1964.

12 Cf. A. J. Greimas, 'Les problèmes de la description mécanographique', *Cahiers de Lexicologie*, 1, 1959, p. 63.

13 Cf. *Eléments de sémiologie*, p. 96 [trans. pp. 21–2].

14 In the Saussurian perspective, speech (utterances) is above all that which is emitted, drawn from the language-system (and constituting it in return). It is necessary today to enlarge the notion of language [*langue*], especially from the semantic point of view: language is the 'totalizing abstraction' of the messages emitted *and received*.

15 *Form* in the precise sense given it by Hjelmslev (cf. *Eléments de sémiologie*, p. 105 [trans. pp. 39–41]), as the functional organization of the signifieds among themselves.

16 A. J. Greimas, *Cours de Sémantique*, 1964 (notes roneotyped by the Ecole Normale Supérieure de Saint-Cloud).

17 Cf. Emile Benveniste, 'Remarques sur la fonction du langage dans la découverte freudienne', *La Psychanalyse* 1, 1956, pp. 3–16 [reprinted in E. Benveniste, *Problèmes de linguistique généale*, Paris 1966, Chapter 7; translated as *Problems of General Linguistics*, Coral Gables, Florida 1971].

18 Classical rhetoric needs to be rethought in structural terms (this is the object of a work in progress); it will then perhaps be possible to establish a general rhetoric or linguistics of the signifiers of connotation, valid for articulated sound, image, gesture, etc. See 'L'ancienne Rhétorique (Aide-mémoire)', *Communications* 16, 1970.

19 We prefer here to evade Jakobson's opposition between metaphor and metonymy for if metonymy by its origin is a figure of contiguity, it nevertheless functions finally as a substitute of the signifier, that is as a metaphor.

Umberto Eco

A PHOTOGRAPH

T HE READERS OF *L'ESPRESSO* will recall the tape of the last minutes of Radio Alice,[1] recorded as the police were hammering at the door. One thing that impressed many people was how the announcer, as he reported in a tense voice what was happening, tried to convey the situation by referring to a scene in a movie. There was undoubtedly something singular about an individual going through a fairly traumatic experience as if he were in a film.

There can be only two interpretations. One is the traditional: life is lived as a work of art. The other obliges us to reflect a bit further: it is the visual work (cinema, videotape, mural, comic strip, photograph) that is now a part of our memory. Which is quite different, and seems to confirm a hypothesis already ventured, namely that the younger generations have absorbed as elements of their behavior a series of elements filtered through the mass media (and coming, in some cases, from the most impenetrable areas of our century's artistic experimentation). To tell the truth, it isn't even necessary to talk about new generations: If you are barely middle-aged, you will have learned personally the extent to which experience (love, fear, or hope) is filtered through 'already seen' images. I leave it to moralists to deplore this way of living by intermediate communication. We must only bear in mind that mankind has never done anything else, and before Nadar and the Lumières, it used other images, drawn from pagan carvings or the illuminated manuscripts of the Apocalypse.

We can foresee another objection, this time not from cherishers of the tradition: Isn't it perhaps an unpleasant example of the ideology of scientific neutrality, the way, when we are faced by active behavior and searing, dramatic events, we always try again and again to analyze them, define them, interpret them, dissect them? Can we define that which by definition eludes all defining? Well, we must have the courage to assert once more what we believe in: Today more than ever political news itself is marked, motivated, abundantly nourished by the symbolic.

Understanding the mechanisms of the symbolic in which we move means being political. Not understanding them leads to mistaken politics. Of course, it is also a mistake to reduce political and economic events to mere symbolic mechanisms; but it is equally wrong to ignore this dimension.

There are unquestionably many reasons, and serious ones, for the outcome of Luciano Lama's intervention[2] at the University of Rome, but one particular reason must not be overlooked: the opposition between two theatrical or spatial structures. Lama presented himself on a podium (however makeshift), thus obeying the rules of a frontal communication characteristic of trade-union, working-class spatiality, facing a crowd of students who have, however, developed other ways of aggregation and interaction, decentralized, mobile, apparently disorganized. Theirs is a different way of organizing space and so that day at the University there was the clash also between two concepts of perspective, the one we might call Brunelleschian and the other cubist. True, anyone reducing the whole story to these factors would be mistaken, but anyone trying to dismiss this interpretation as an intellectual game would be mistaken, too. The Catholic Church, the French Revolution, Nazism, the Soviet Union, and the People's Republic of China, not to mention the Rolling Stones and soccer clubs, have always known very well that the deployment of space is religion, politics, ideology. So let's give back to the spatial and the visual the place they deserve in the history of political and social relations.

And now to another event. These past months, within that variegated and shifting experience that is called 'the movement,' the men carrying .38's have emerged. From various quarters the movement has been asked to denounce them as an alien body; and there were forces exerting pressure both from outside and from within. Apparently this demand for rejection encountered difficulties, and various elements came into play. Synthetically, we can say that many belonging to the movement didn't feel like labeling as outsiders forces that, even if they revealed themselves in unacceptable and tragically suicidal ways, seemed to express a reality of social protest that couldn't be denied. I am repeating discussions that all of us have heard. Basically what was said was this. They are wrong, but they are part of a mass movement. And the debate was harsh, painful.

Now, last week, there occurred a kind of precipitation of all the elements of the debate previously suspended in uncertainty. Suddenly, and I say suddenly because decisive statements were issued in the space of a day, the gunmen were cut off. Why at that moment? Why not before? It's not enough to say that recent events in Milan[3] made a deep impression on many people, because similar events in Rome had also had a profound effect. 'What happened that was new and different? We may venture a hypothesis, once again recalling that an explanation never explains everything, but becomes part of a landscape of explanations in reciprocal relationship. A photograph appeared.

Many photographs have appeared, but this one made the rounds of all the papers after being published in the *Corriere d'Informazione*. As everyone will recall, it was the photograph of a young man wearing a knitted ski-mask, standing alone, in profile, in the middle of a street, legs apart, arms outstretched horizontally, with both hands grasping a pistol. Other forms can be seen in the background, but the photograph's structure is classical in its simplicity: the central figure, isolated, dominates it.

If it is licit (and it is necessary) to make aesthetic observations in such cases, this is one of those photographs that will go down in history and will appear in a thousand books. The vicissitudes of our century have been summed up in a few exemplary photographs that have proved epoch-making: the unruly crowd pouring into the square during the 'ten days that shook the world'; Robert Capa's dying *miliciano*; the marines planting the flag on Iwo Jima; the Vietnamese prisoner being executed with a shot in the temple; Che Guevara's tortured body on a plank in a barracks. Each of these images has become a myth and has condensed numerous speeches. It has surpassed the individual circumstance that produced it; it no longer speaks of that single character or of those characters, but expresses concepts. It is unique, but at the same time it refers to other images that preceded it or that, in imitation, have followed it. Each of these photographs seems a film we have seen and refers to other films that had seen it. Sometimes it isn't a photograph but a painting, or a poster.

What did the photograph of the Milanese gunman 'say'? I believe it abruptly revealed, without the need for a lot of digressive speeches, something that has been circulating in a lot of talk, but that words alone could not make people accept. That photograph didn't resemble any of the images which, for at least four generations, had been emblems of the idea of revolution. The collective element was missing; in a traumatic way the figure of the lone hero returned here. And this lone hero was not the one familiar in revolutionary iconography, which when it portrayed a man alone always saw him as victim, sacrificial lamb: the dying *miliciano* or the slain Che, in fact. This individual hero, on the contrary, had the pose, the terrifying isolation of the tough guy of gangster movies or the solitary gunman of the West – no longer dear to a generation who consider themselves metropolitan Indians.

This image suggested other worlds, other figurative, narrative traditions that had nothing to do with the proletarian tradition, with the idea of popular revolt, of mass struggle. Suddenly it inspired a syndrome of rejection. It came to express the following concept: Revolution is elsewhere and, even if it is possible, it doesn't proceed via this 'individual' act.

The photograph, for a civilization now accustomed to thinking in images, was not the description of a single event (and, in fact, it makes no difference who the man was, nor does the photograph help in identifying him): it was an argument. And it worked.

It is of no interest to know if it was posed (and therefore faked), whether it was the testimony of an act of conscious bravado, if it was the work of a professional photographer who gauged the moment, the light, the frame, or whether it virtually took itself, was snapped accidentally by unskilled and lucky hands. At the moment it appeared, its communicative career began: once again the political and the private have been marked by the plots of the symbolic, which, as always happens, has proved producer of reality.

Notes

1 An independent radical radio station closed down by the police after the Bologna student riots of 1977, on the grounds that the station had incited the rioters and given them information about police movements.

2 Luciano Lama, leader of the Communist-oriented General Confederation of Labor, was violently rejected when he tried to speak to students occupying the University of Rome. The incident confirmed the rupture between the Communist Party and the student movement of 1977.

3 During a confrontation between rioters and police, a policeman was shot.

Victor Burgin

LOOKING AT PHOTOGRAPHS

IT IS ALMOST AS UNUSUAL to pass a day without seeing a photograph as it is to miss seeing writing. In one institutional context or another – the press, family snapshots, billboards, etc. – photographs permeate the environment, facilitating the formation/reflection/inflection of what we 'take for granted'. The daily instrumentality of photography is clear enough, to sell, inform, record, delight. Clear, but only to the point at which photographic representations lose themselves in the ordinary world they help to construct. Recent theory follows photography beyond where it has effaced its operations in the 'nothing-to-explain'.

It has previously been most usual (we may blame the inertia of our educational institutions for this) to view photography in the light of 'art' – a source of illumination which consigns to shadow the greater part of our day-to-day experience of photographs. What has been most often described is a particular nuancing of 'art history' brought about by the invention of the camera, a story cast within the familiar confines of a succession of 'masters', 'masterworks' and 'movements' – a *partial* account which leaves the social fact of photography largely untouched.

Photography, sharing the static image with *painting*, the camera with *film*, tends to be placed 'between' these two mediums, but it is encountered in a fundamentally different way from either of them. For the majority, paintings and films are only seen as the result of a voluntary act which quite clearly entails an expenditure of time and/or money. Although photographs may be shown in art galleries and sold in book form, most photographs are not seen by deliberate choice, they have no special space or time allotted to them, they are *apparently* (an important qualification) provided free of charge – photographs offer themselves *gratuitously*; whereas paintings and films readily present themselves to critical attention as objects, photographs are received rather as an environment. As a free and familiar coinage of meaning, largely unremarked and untheorised by those amongst whom it circulates, photography shares an attribute of language. However, although it has long been common to speak, loosely, of the 'language of photography', it was not

until the 1960s that any systematic investigation of forms of communication outside of natural language was conducted from the standpoint of linguistic science; such early 'semiotic' studies, and their aftermath, have radically reorientated the theory of photography.

Semiotics, or semiology, is the study of signs, with the object of identifying the systematic regularities from which meanings are construed. In the early phase of 'structuralist' semiology (Roland Barthes's *Elements of Semiology* first appeared in France in 1964)[1] close attention was paid to the analogy between 'natural' language (the phenomenon of speech and writing) and visual 'languages'. In this period, work dealt with the codes of analogy by which photographs denote objects in the world, the codes of connotation through which denotation serves a secondary system of meanings, and the 'rhetorical' codes of juxtaposition of elements within a photograph and between different but adjacent photographs.[2] Work in semiotics showed that there is no 'language' of photography, no single signifying system (as opposed to technical apparatus) upon which all photographs depend (in the sense in which all texts in English ultimately depend upon the English language); there is, rather, a heterogeneous complex of codes upon which photography may draw. Each photograph signifies on the basis of a plurality of these codes, the number and type of which varies from one image to another. Some of these are (at least to first analysis) peculiar to photography (e.g. the various codes built around 'focus' and 'blur'), others are clearly not (e.g. the 'kinesic' codes of bodily gesture). Further, importantly, it was shown that the putatively autonomous 'language of photography' is never free from the determinations of language itself. We rarely see a photograph *in use* which does not have a caption or a title, it is more usual to encounter photographs attached to long texts, or with copy superimposed over them. Even a photograph which has no actual writing on or around it is traversed by language when it is 'read' by a viewer (for example, an image which is predominantly dark in tone carries all the weight of signification that darkness has been given in social use; many of its interpretants will therefore be linguistic, as when we speak metaphorically of an unhappy person being 'gloomy').

The intelligibility of the photograph is no simple thing; photographs are *texts* inscribed in terms of what we may call 'photographic discourse', but this discourse, like any other, engages discourses beyond itself, the 'photographic text', like any other, is the site of a complex 'intertextuality', an overlapping series of previous texts 'taken for granted' at a particular cultural and historical conjuncture. These prior texts, those *presupposed* by the photograph, are autonomous; they serve a role in the actual text but do not appear in it, they are latent to the manifest text and may only be read across it 'symptomatically' (in effect, like the dream in Freud's description, photographic imagery is typically *laconic* – an effect refined and exploited in advertising). Treating the photograph as an object-text, 'classic' semiotics showed that the notion of the 'purely visual' *image* is nothing but an Edenic fiction. Further to this, however, whatever specificity might be attributed to photography at the level of the 'image' is inextricably caught up within the specificity of the social acts which intend that image and its meanings: news-photographs help transform the raw continuum of historical flux into the product 'news', domestic snapshots characteristically serve to legitimate the institution of the family, and so on. For any photographic practice, given materials (historical flux,

existential experience of family life, etc.) are transformed into an identifiable type of product by men and women using a particular technical method and working within particular social institutions. The significant 'structures' which early semiotics found in photography are not spontaneously self-generated, they originate in determinate modes of human organisation. The question of meaning therefore is constantly to be referred to the social and psychic formations of the author/reader, formations existentially simultaneous and coextensive but theorised in separate discourses; of these, Marxism and psychoanalysis have most informed semiotics in its moves to grasp the determinations of history and the subject in the production of meaning.

In its structuralist phase, semiotics viewed the text as the objective site of more or less determinate meanings produced on the basis of what significant systems were empirically identifiable as operative 'within' the text. Very crudely characterised, it assumed a coded message and authors/readers who knew how to encode and decode such messages while remaining, so to speak, 'outside' the codes – using them, or not, much as they might pick up and put down a convenient tool. This account was seen to fall seriously short in respect of this fact: as much as we speak language, so language 'speaks' us. All meaning, across all social institutions – legal systems, morality, art, religion, the family, etc. – is articulated within a network of *differences*, the play of presence and absence of conventional significant features which linguistics has demonstrated to be a founding attribute of language. Social practices are structured *like* a language, from infancy, 'growing up' is a growing *into* a complex of significant social practices including, and founded upon, language itself. This general symbolic order is the site of the determinations through which the tiny human animal becomes a social human being, a 'self' positioned in a network of relations to 'others'. The structure of the symbolic order channels and moulds the social and psychic formation of the individual subject, and it is in this sense that we may say that language, in the broad sense of symbolic order, speaks us. The subject inscribed in the symbolic order is the product of a channelling of predominantly sexual basic drives within a shifting complex of heterogeneous cultural systems (work, the family, etc.): that is to say, a complex interaction of a *plurality* of subjectivities presupposed by each of these systems. This subject, therefore, is not the fixed, innate, entity assumed in classic semiotics but is itself a function of textual operations, an unending process of *becoming* – such a version of the subject, in the same movement in which it rejects any absolute discontinuity between speaker and codes, also evicts the familiar figure of the *artist* as autonomous *ego*, transcending his or her own history and unconscious.

However, to reject the 'transcendental' subject is not to suggest that either the subject or the institutions within which it is formed are caught in a simple mechanistic determinism; the institution of photography, while a product of the symbolic order, also *contributes* to this order. Some earlier writings in semiology, particularly those of Barthes, set out to uncover the language-like organisation of the dominant myths which command the meanings of photographed appearances in our society. More recently, theory has moved to consider not only the structure of appropriation to ideology of that which is 'uttered' in photographs but also to examine the ideological implications inscribed within the *performance* of the utterance. This enquiry directs attention to the object/subject constructed within the technical

apparatus itself.[3] The signifying system of photography, like that of classical painting, at once depicts a scene *and the gaze of the spectator*, an object *and* a viewing subject. The two-dimensional analogical signs of photography are formed within an apparatus which is essentially that of the *camera obscura* of the Renaissance. (The *camera obscura* with which Niépce made the first photograph in 1826 directed the image formed by the lens via a mirror on to a ground-glass screen – precisely in the manner of the modern single-lens reflex camera.) Whatever the object depicted, the manner of its depiction accords with laws of geometric projection which imply a unique 'point-of-view'. It is the position of point-of-view, occupied in fact by the camera, which is bestowed upon the spectator. To the point-of-view, the system of representation adds the *frame* (an inheritance which may be traced through easel painting, via mural painting, to its origin in the convention of post and lintel architectural construction); through the agency of the frame the world is organised into a coherence which it actually lacks, into a parade of tableaux, a succession of 'decisive moments'.

The structure of representation – point-of-view and frame – is intimately implicated in the reproduction of ideology (the 'frame of mind' of our 'points-of-view'). More than any other textual system the photograph presents itself as 'an offer you can't refuse'. The characteristics of the photographic apparatus position the subject in such a way that the object photographed serves to conceal the textuality of the photograph itself – substituting passive receptivity for active (critical) *reading*. When confronted with puzzle photographs of the 'What is it?' variety (usually, familiar objects shot from unfamiliar angles) we are made aware of having to select from sets of possible alternatives, of having to supply information the image itself does not contain. Once we have discovered what the depicted object *is*, however, the photograph is instantly transformed for us – no longer a confusing conglomerate of light and dark tones, of uncertain edges and ambivalent volumes, it now shows a 'thing' which we invest with a full identity, a *being*. With most photographs we see, this decoding and *investiture* takes place instantaneously, unselfconsciously, 'naturally'; but it does take place – the wholeness, coherence, identity, which we attribute to the depicted scene is a projection, a refusal of an impoverished reality in favour of an imaginary plenitude. The imaginary object here, however, is not 'imaginary' in the usual sense of the word, it is *seen*, it has projected an image. An analogous imaginary investiture of the real constitutes an early and important moment in the construction of the self, that of the 'mirror stage' in the formation of the human being, described by Jaques Lacan:[4] between its sixth and eighteenth month, the infant, which experiences its body as fragmented, uncentred, projects its potential unity, in the form of an ideal self, upon other bodies and upon its own reflection in a mirror; at this stage the child does not distinguish between itself and others, it *is* the other (separation will come later through the knowledge of sexual *difference*, opening up the world of language, the symbolic order); the idea of a unified body necessary to the concept of self-identity has been formed, but only through a rejection of reality (rejection of incoherence, of separation).

Two points in respect of the mirror-stage of child development have been of particular interest to recent semiotic theory: first, the observed correlation between the formation of identity and the formation of *images* (at this age the infant's powers of vision outstrip its capacity for physical co-ordination), which led Lacan to speak

of the 'imaginary' function in the construction of subjectivity; second, the fact that the child's recognition of itself in the 'imaginary order', in terms of a reassuring coherence, is a *misrecognition* (what the eye can see for its-*self* here is precisely that which is not the case). Within the context of such considerations the 'look' itself has recently become an object of theoretical attention. To take an example – *General Wavell watches his gardener at work*, made by James Jarché in 1941[5]; it is easy enough today to read the immediate connotations of paternalistic imperialism inscribed in this 35-year-old picture and anchored by the caption (the general watches *his* gardener). A first analysis of the object-text would unpack the connotational oppositions constructing the ideological message. For example, primarily and obviously, *Western/Eastern*, the latter term of this opposition englobing the marks of a radical 'otherness'; or again, the placing of the two men within the implied opposition *capital/labour*. Nevertheless, even in the presence of such obviousness another obviousness asserts itself – the very 'natural' casualness of the scene presented to us disarms such analysis, which it characterises as an *excessive* response. But excess production is generally on the side of ideology, and it is precisely in its apparent ingenuousness that the ideological power of photography is rooted – our conviction that we are free to choose what we make of a photograph hides the complicity to which we are recruited in the very act of *looking*. Following recent work in film theory,[6] and adopting its terminology, we may identify four basic types of look in the photograph: the look of the camera as it photographs the 'pro-photographic' event; the look of the viewer as he or she looks at the photograph; the 'intra-diegetic' looks exchanged between people (actors) depicted in the photograph (and/or looks from actors towards objects); and the look the actor may direct to the camera.

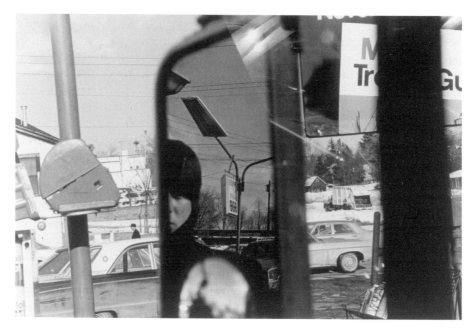

Figure 15.1 *Hillcrest, NY*, Lee Friedlander, 1970. © Lee Friedlander. Courtesy of the artist and the Fraenkel Gallery, San Francisco.

In the reading implied by the title to Jarché's photograph, the general looks at the gardener, who receives this look with his own gaze cast submissively to the ground. In an additional reading, the general's look may be interpreted as directed at the camera, that is to say, to the viewing subject (representation identifies the camera's look with that of the subject's point-of-view). This full frontal gaze, a posture almost invariably adopted before the camera by those who are not professional models, is a gaze commonly received when we look at ourselves in a mirror, we are invited to return it in a gaze invested with narcissistic identification (the dominant alternative to such identification *vis-à-vis* photographic imagery is voyeurism). The general's look returns our own in direct line, the look of the gardener intersects this line. Face hidden in shadow (labour here is literally featureless) the gardener *cuts off* the general (our own power and authority in imaginary identification) from the viewing subject; the sense of this movement is amplified via the image of the mower – instrument of amputation – which condenses references to scythe and, through its position (still photographs are texts built upon *coincidences*), penis (the correlates: white fear of black sexuality/fear of castration). Even as we turn back (as we invariably must) from such an excess of reading to the literal 'content' of this picture we encounter the same figure: the worker 'comes between' the general and the peace of his garden, the black man literally *disturbs*. Such overlaying determinations, which can be only sketchily indicated here, act in concert with the empirically identifiable connotators of the object-text to show the gardener as out-of-place, a threat, an intruder in what presumably is his own land – material considerations thus go beyond the empirical in the overdetermination of ideology.

The effect of representation (the recruitment of the subject in the production of ideological meaning) requires that the stage of the represented (that of the photograph as object-text) meet the stage of the representing (that of the viewing subject) in a 'seamless join'. Such an integration is achieved within the system of Jarché's picture where the inscribed ideology is read from a subject position of founding centrality; in the photograph *Hillcrest, New York*, by Lee Friedlander (1970) (see Figure 15.1) this position itself is under threat. The attack comes from two main sources: first, the vanishing-point perspective system which recruits the subject in order to complete itself has here been partially subverted through ambiguous figure/ground relationships – it is only with some conscious effort that what is seen in this photograph may be organised in terms of a coherent and singular site/(sight); second, the device of the minor central to the picture here generates a fundamental ambivalence. A bisected head and shoulders rises from bottom-centre frame; the system of representation has accustomed us to identifying our own point-of-view with the look of the camera, and therefore a full-frontal mirror reflection with the self; here, however, there is no evidence (such as the reflection of the camera) to confirm whether we are looking at the reflection of the photographer or at that of some other person – the quartered figure has unresolved '(imaginary) self'/'other' status. In Friedlander's picture, the conjunction of technical photographic apparatus and raw phenomenological flux has almost failed to guarantee the subjective *effect* of the camera – a coherence founded in the unifying gaze of a unified, punctual, subject. Almost, but not quite – the picture (and therefore the subject) remains 'well composed' (in common with Jarché's picture, albeit differently from it). We know very well what 'good' composition is – art schools know how to teach it –

but not *why* it is; 'scientific' accounts of pictorial composition tend merely to reiterate *what* it is under a variety of differing descriptions (e.g., those of Gestalt psychology). Consideration of our *looking* at photographs may help illuminate this question, and return us to the topic of our characteristic use of photographs, with which we began.

To look at a photograph beyond a certain period of time is to court a frustration; the image which on first looking gave pleasure has by degrees become a veil behind which we now desire to see. It is not an arbitrary fact that photographs are deployed so that we do not look at them for long; we use them in such a manner that we may play with the coming and going of our *command* of the scene/(seen) (an official of a national art museum who followed visitors with a stop-watch found that an average of ten seconds was devoted by an individual to any single painting – about the average shot-length in classic Hollywood cinema). To remain long with a single image is to risk the loss of our imaginary command of the look, to relinquish it to that absent other to whom it belongs by right – the camera. The image then no longer receives *our* look, reassuring us of our founding centrality, it rather, as it were, avoids our gaze, confirming its allegiance to the other. As alienation intrudes into our captivation by the image we can, by averting our gaze or turning a page, reinvest our looking with authority. (The 'drive to master' is a component of scopophiia, sexually based pleasure in looking.)

The awkwardness which accompanies the over-long contemplation of a photograph arises from a consciousness of the monocular perspective system of representation as a systematic deception. The lens arranges all information according to laws of projection which place the subject as geometric point of origin of the scene in an imaginary relationship with real space, but facts intrude to deconstruct the initial response: the eye/(I) cannot move within the depicted space (which offers itself precisely to such movement), it can only move *across* it to the points where it encounters the frame. The subject's inevitable recognition of the *rule* of the frame may, however, be postponed by a variety of strategies which include 'compositional' devices for moving the eye from the framing edge. 'Good composition' may therefore be no more or less than a set of devices for prolonging our imaginary command of the point-of-view, our *self*-assertion, a device for retarding recognition of the autonomy of the frame, and the authority of the *other* it signifies. 'Composition' (and indeed the interminable discourse *about* composition – formalist criticism) is therefore a means of prolonging the imaginary force, the real power to please, of the photograph, and it may be in this that it has survived so long, within a variety of rationalisations, as a criterion of value in visual art generally. Some recent theory[7] has privileged film as the *culmination* of work on a 'wish-fulfilling machine', a project for which photography, in this view, constitutes only a historical moment; the darkness of the cinema has been evinced as a condition for an artificial 'regression' of the spectator; film has been compared with hypnosis. It is likely, however, that the apparatus which desire has constructed for itself incorporates *all* those aspects of contemporary Western society for which the Situationists chose the name *spectacle* : aspects forming an integrated specular regime, engaged in a mutual exchange of energies, not strung out in mutual isolation along some historicist progress; desire needs no material darkness in which to stage its imaginary satisfactions; day-dreams, too, can have the potency of hypnotic suggestion.

Precisely because of its real role in constructing the imaginary, the misrecognitions necessary to ideology, it is most important that photography be recovered from its own appropriation to this order. Counter to the nineteenth-century aesthetics which still dominate most teaching of photography, and most writings on photography, work in semiotics has shown that a photograph is not to be reduced to 'pure form', nor 'window on the world', nor is it a gangway to the presence of an author. A fact of primary social importance is that the photograph is a *place of work*, a structured and structuring space within which the reader deploys, and is deployed by, what codes he or she is familiar with in order to *make sense*. Photography is one signifying system among others in society which produces the ideological subject in the same movement in which they 'communicate' their ostensible 'contents'. It is therefore important that photography theory take account of the production of this subject as the complex totality of its determinations are nuanced and constrained in their passage through and across photographs.

Notes

1 Published in English by Jonathan Cape, 1967.
2 For an overview of this work, in its application to photography, see Victor Burgin, 'Photographic Practice and Art Theory', *Studio International*, July–August 1975.
3 See Jean-Louis Baudry, 'Ideological Effects of the Basic Cinematographic Apparatus'. *Film Quarterly*, Winter 1974–5.
4 Published in English as 'The Mirror-phase as Formative of the Function of the I', *New Left Review*, September–October 1968.
5 Unfortunately it has not been possible to obtain this photograph for reproduction here. See Burgin, *Thinking Photography* (1982) for the illustration. (Ed.)
6 Anyone familiar with recent film theory will recognise the extent to which my remarks here are indebted to it. The English language locus of this work is *Screen* magazine (see particularly Laura Mulvey, 'Visual Pleasure and Narrative Cinema', *Screen*, vol. 16, no. 3, Autumn 1975).
7 See particularly Jean-Louis Baudry, 'The Apparatus', *Camera Obscura*, Autumn 1976.

Christian Metz

PHOTOGRAPHY AND FETISH*

To BEGIN I WILL BRIEFLY RECALL some of the basic differences between film and photography. Although these differences may be well known, they must be, as far as possible, precisely defined, since they have a determinant influence on the respective status of both forms of expression in relation to the fetish and fetishism.

First difference: the spatio-temporal size of the *lexis*, according to that term's definition as proposed by the Danish semiotician Louis Hjelmslev. The lexis is the socialized unit of reading, of reception: in sculpture, the statue; in music, the 'piece.' Obviously the photographic lexis, a silent rectangle of paper, is much smaller than the cinematic lexis. Even when the film is only two minutes long, these two minutes are *enlarged*, so to speak, by sounds, movements, and so forth, to say nothing of the average surface of the screen and of the very fact of projection. In addition, the photographic lexis has no fixed duration (= temporal size): it depends, rather, on the spectator, who is the master of the look, whereas the timing of the cinematic lexis is determined in advance by the filmmaker. Thus on the one side, 'a free rewriting time'; on the other, 'an imposed reading time,' as Peter Wollen has pointed out.[1] Thanks to these two features (smallness, possibility of a lingering look), photography is better fit, or more likely, to work as a fetish.

Another important difference pertains to the social use, or more exactly (as film and photography both have many uses) to their principal legitimated use. Film is considered as collective entertainment or as art, according to the work and to the social group. This is probably due to the fact that its production is less accessible to 'ordinary' people than that of photography. Equally, it is in most cases fictional, and our culture still has a strong tendency to confound art with fiction.

* A version of this essay was delivered at a conference on the theory of film and photography at the University of California, Santa Barbara, in May 1984.

Photography enjoys a high degree of social recognition in another domain: that of the presumed real, of life, mostly private and family life, birthplace of the Freudian fetish. This recognition is ambiguous. Up to a point, it does correspond to a real distribution of social practices: people do take photographs of their children, and when they want their feature film, they do go to the movies or watch TV. But on the other side, it happens that photographs are considered by society as works of art, presented in exhibitions or in albums accompanied by learned commentary. And the family is frequently celebrated, or self-celebrated, in private, with super-8 films or other nonprofessional productions, which *are* still cinema. Nevertheless, the kinship between film and collectivity, photography and privacy, remains alive and strong as a social myth, half true like all myths; it influences each of us, and most of all the stamp, the look of photography and cinema themselves. It is easy to observe – and the researches of the sociologist Pierre Bordieu,[2] among others, confirm it – that photography very often primarily means souvenir, keepsake. It has replaced the portrait, thanks to the historical transition from the period when long exposure times were needed for true portraits. While the social reception of film is mainly oriented towards a show-business-like or imaginary referent, the real referent is felt to be dominant in photography.

There is something strange in this discrepancy, as both modes of expression are fundamentally *indexical*, in Charles Sanders Pierce's terms. (A recent, remarkable book on photography by Philippe Dubois is devoted to the elaboration of this idea and its implications.)[3] Pierce called indexical the process of signification (*semiosis*) in which the signifier is bound to the referent not by a social convention (= 'symbol'), not necessarily by some similarity (= 'icon'), but by an actual contiguity or connection in the world: the lightning is the index of the storm. In this sense, film and photography are close to each other, both are *prints* of real objects, prints left on a special surface by a combination of light and chemical action. This index-icality, of course, leaves room for iconic aspects, as the chemical image often looks like the object (Pierce considered photography as an index *and* an icon). It leaves much room for symbolic aspects as well, such as the more or less codified patterns of treatment of the image (framing, lighting, and so forth) and of choice or orga-nization of its contents. What is indexical is the mode of production itself, the principle of the *taking*. And at this point, after all, a film is only a series of photo-graphs. But it is more precisely a series with supplementary components as well, so that the unfolding as such tends to become more important than the link of each image with its referent. This property is very often exploited by the narrative, the initially indexical power of the cinema turning frequently into a realist guarantee for the unreal. Photography, on the other hand, remains closer to the pure index, stubbornly pointing to the print of what *was*, but no longer *is*.

A third kind of difference concerns the physical nature of the respective signi-fiers. Lacan used to say that the only materialism he knew was the materialism of the signifier. Whether the only one or not, in all signifying practices the material definition is essential to their social and psychoanalytic inscription. In this respect – speaking in terms of set theory – film 'includes' photography: cinema results from an addition of perceptive features to those of photography. In the visual sphere, the important addition is, of course, movement and the plurality of images, of shots. The latter is distinct from the former: even if each image is still, switching from

one to the next creates a *second movement*, an ideal one, made out of successive and different immobilities. Movement and plurality both imply *time*, as opposed to the timelessness of photography which is comparable to the timelessness of the unconscious and of memory. In the auditory sphere – totally absent in photography – cinema adds phonic sound (spoken words), nonphonic sound (sound effects, noises, and so forth), and musical sound. One of the properties of sounds is their expansion, their development in time (in space they only irradiate), whereas images construct themselves in space. Thus film disposes of five more orders of perception (two visual and three auditory) than does photography, all of the five challenging the powers of silence and immobility which belong to and define all photography, immersing film in a stream of temporality where nothing can be *kept*, nothing stopped. The emergence of a fetish is thus made more difficult.

Cinema is the product of two distinct technological inventions: photography, and the mastering of stroboscopy, of the ϕ-effect. Each of these can be exploited separately: photography makes no use of stroboscopy, and animated cartoons are based on stroboscopy without photography.

The importance of immobility and silence to photographic *authority*, the nonfilmic nature of this authority, leads me to some remarks on the relationship of photography with death. Immobility and silence are not only two objective aspects of death, they are also its main symbols, they *figure* it. Photography's deeply rooted kinship with death has been noted by many different authors, including Dubois, who speaks of photography as a 'thanatography,' and, of course, Roland Barthes, whose *Camera Lucida*[4] bears witness to this relationship most poignantly. It is not only the book itself but also its position of enunciation which illustrates this kinship, since the work was written just after (and because of) the death of the mother, and just before the death of the writer.

Photography is linked with death in many *different* ways. The most immediate and explicit is the social practice of keeping photographs in memory of loved beings who are no longer alive. But there is another real death which each of us undergoes every day, as each day we draw nearer to our own death. Even when the person photographed is still living, that moment when she or he *was* has forever vanished. Strictly speaking, the person who *has been photographed* – not the total person, who is an effect of time – is dead: 'dead for having been seen,' as Dubois says in another context.[5] Photography is the mirror, more faithful than any actual mirror, in which we witness at every age, our own aging. The actual mirror accompanies us through time, thoughtfully and treacherously; it changes with us, so that we appear not to change.

Photography has a third character in common with death: the snapshot, like death, is an instantaneous abduction of the object out of the world into another world, into another kind of time – unlike cinema which replaces the object, after the act of appropriation, in an unfolding time similar to that of life. The photographic *take* is immediate and definitive, like death and like the constitution of the fetish in the unconscious, fixed by a glance in childhood, unchanged and always active later. Photography is a cut inside the referent, it cuts off a piece of it, a fragment, a pan object, for a long immobile travel of no return. Dubois remarks that with each photograph, a tiny piece of time brutally and forever escapes its ordinary fate, and thus is protected against its own loss. I will add that in life, and to some

extent in film, one piece of time is indefinitely pushed backwards by the next: this is what we call 'forgetting.' The fetish, too, means both loss (symbolic castration) and protection against loss. Peter Wollen states this in an apt simile: photography preserves fragments of the past 'like flies in amber.'[6] Not by chance, the photographic act (or acting, who knows?) has been frequently compared with shooting, and the camera with a gun.

Against what I am saying, it could of course be objected that film as well is able to perpetuate the memory of dead persons, or of dead moments of their lives. Socially, the family film, the super-8, and so forth, to which I previously alluded, are often used for such a purpose. But this pseudosimilarity between film and photography leads me back, in a paradoxical way, to the selective kinship of photography (not film) with death, and to a fourth aspect of this link. The two modes of perpetuation are very different in their effects, and nearly opposed. Film gives back to the dead a semblance of life, a fragile semblance but one immediately strengthened by the wishful thinking of the viewer. Photography, on the contrary, by virtue of the objective suggestions of its signifier (stillness, again) maintains the memory of the dead *as being dead*.

Tenderness toward loved beings who have left us forever is a deeply ambiguous, split feeling, which Freud has remarkably analyzed in his famous study on *Mourning and Melancholia*,[7] The work of mourning is at the same time an attempt (not successful in all cases: see the suicides, the breakdowns) to survive. The object-libido, attached to the loved person, wishes to accompany her or him in death, and sometimes does. Yet the narcissistic, conservation instinct (ego-libido) claims the right to live. The compromise which normally concludes this inner struggle consists in transforming the very nature of the feeling for the object, in learning progressively to love this object *as dead*, instead of continuing to desire a living presence and ignoring the verdict of reality, hence prolonging the intensity of suffering.

Sociologists and anthropologists arrive by other means at similar conceptions. The funeral rites which exist in all societies have a double, dialectically articulated signification: a remembering of the dead, but a remembering as well *that they are dead*, and that life continues for others. Photography, much better than film, fits into this complex psycho-social operation, since it suppresses from its own appearance the primary marks of 'livingness,' and nevertheless conserves the convincing print of the object: a past presence.

All this does not concern only the photographs of loved ones. There are obviously many other kinds of photographs: landscapes, artistic compositions, and so forth. But the kind on which I have insisted seems to me to be exemplary of the whole domain. In all photographs, we have this same act of cutting off a piece of space and time, of keeping it unchanged while the world around continues to change, of making a compromise between conservation and death. The frequent use of photography for private commemorations thus results in part (there are economic and social factors, too) from the intrinsic characteristics of photography itself. In contrast, film is less a succession of photographs than, to a large extent, a destruction of the photograph, or more exactly of the photograph's power and action.

At this point, the problem of the space off-frame in film and in photography has to be raised. The fetish is related to death through the terms of castration and

fear, to the off-frame in terms of the look, glance, or gaze. In his well-known article on fetishism,[8] Freud considers that the child, when discovering for the first time the mother's body, is terrified by the very possibility that human beings can be 'deprived' of the penis, a possibility which implies (imaginarily) a permanent danger of castration. The child tries to maintain its prior conviction that all human beings have the penis, but in opposition to this, what has been seen continues to work strongly and to generate anxiety. The compromise, more or less spectacular according to the person, consists in making the seen retrospectively unseen by a disavowal of the perception, and in *stopping the look*, once and for all, on an object, the fetish – generally a piece of clothing or under-clothing – which was, with respect to the moment of the primal glance, near, just prior to, the place of the terrifying absence. From our perspective, what does this mean, if not that this place is positioned off-frame, that the look is framed close by the absence? Furthermore, we can state that the fetish is taken up in two chains of meaning: metonymically, it alludes to the contiguous place of the lack, as I have just stated; and metaphorically, according to Freud's conception, it is an equivalent of the penis, as the primordial displacement of the look aimed at replacing an absence by a presence – an object, a small object, a part object. It is remarkable that the fetish – even in the common meaning of the word, the fetish in everyday life, a re-displaced derivative of the fetish proper, the object which brings luck, the mascot, the amulet, a fountain pen, cigarette, lipstick, a teddybear, or pet – it is remarkable that the fetish always combines a double and contradictory function: on the side of metaphor, an inciting and encouraging one (it is a pocket phallus); and, on the side of metonymy, an apotropaic one, that is, the averting of danger (thus involuntarily attesting a belief in it), the warding off of bad luck or the ordinary, permanent anxiety which sleeps (or suddenly wakes up) inside each of us. In the clinical, nosographic, 'abnormal' forms of fetishism – or in the social institution of the striptease, which pertains to a collective nosography and which is, at the same time, a progressive process of framing/deframing – pieces of clothing or various other objects are absolutely necessary for the restoration of sexual power. Without them nothing can happen.

Let us return to the problem of off-frame space. The difference which separates film and photography in this respect has been partially but acutely analyzed by Pascal Bonitzer.[9] The filmic off-frame space is *étoffé*, let us say 'substantial,' whereas the photographic off-frame space is 'subtle.' In film there is a plurality of successive frames, of camera movements, and character movements, so that a person or an object which is off-frame in a given moment may appear inside the frame the moment after, then disappear again, and so on, according to the principle (I purposely exaggerate) of the *turnstile*. The off-frame is taken into the evolutions and scansions of the temporal flow: it is off-frame, but not off-film. Furthermore, the very existence of a sound track allows a character who has deserted the visual scene to continue to mark her or his presence in the auditory scene (if I can risk this quasi-oxymoron: 'auditory' and 'scene'). If the filmic off-frame is substantial, it is because we generally know, or are able to guess more or less precisely, what is going on in it. The character who is off-frame in a photograph, however, will never come into the frame, will never be heard – again a death, another form of

death. The spectator has no empirical knowledge of the contents of the off-frame, but at the same time cannot help imagining some off-frame, hallucinating it, dreaming the shape of this emptiness. It is a projective off-frame (that of the cinema is more introjective), an immaterial, 'subtle' one, with no remaining print. 'Excluded,' to use Dubois's term, excluded once and for all. Yet nevertheless present, striking, properly fascinating (or hypnotic) – insisting on its status *as excluded* by the force of its absence *inside* the rectangle of paper, which reminds us of the feeling of lack in the Freudian theory of the fetish. For Barthes, the only part of a photograph which entails the feeling of an off-frame space is what he calls the *punctum*, the point of sudden and strong emotion, of small trauma; it can be a tiny detail. This *punctum* depends more on the reader than on the photograph itself, and the corresponding off-frame it calls up is also generally subjective; it is the 'metonymic expansion of the *punctum*.'[10]

Using these strikingly convergent analyses which I have freely summed up, I would say that the off-frame effect in photography results from a singular and definitive cutting off which figures castration and is figured by the 'click' of the shutter. It marks the place of an irreversible absence, a place from which the look has been averted forever. The photograph itself, the 'in-frame,' the abducted part-space, the place of presence and fullness – although undermined and haunted by the feeling of its exterior, of its borderlines, which are the past, the left, the lost: the far away even if very close by, as in Walter Benjamin's conception of the 'aura'[11] – the photograph, inexhaustible reserve of strength and anxiety, shares, as we see, many properties of the fetish (as object), if not directly of fetishism (as activity). The familiar photographs that many people carry with them always obviously belong to the order of fetishes in the ordinary sense of the word.

Film is much more difficult to characterize as a fetish. It is too big, it lasts too long, and it addresses too many sensorial channels at the same time to offer a credible unconscious equivalent of a lacking part-object. It does *contain* many potential part-objects (the different shots, the sounds, and so forth), but each of them disappears quickly after a moment of presence, whereas a fetish has to be kept, mastered, held, like the photograph in the pocket. Film is, however, an extraordinary activator of fetishism. It endlessly mimes the primal displacement of the look between the seen absence and the presence nearby. Thanks to the principle of a *moving cutting off*, thanks to the changes of framing between shots (or within a shot: tracking, panning, characters moving into or out of the frame, and so forth), cinema literally *plays* with the terror and the pleasure of fetishism, with its combination of desire and fear. This combination is particularly visible, for instance, in the horror film, which is built upon progressive re-framings that lead us through desire and fear, nearer and nearer the terrifying place. More generally, the play of framings and the play with framings, in all sorts of films, work like a striptease of the space itself (and a striptease proper in erotic sequences, when they are constructed with some subtlety). The moving camera caresses the space, and the whole of cinematic fetishism consists in the constant and teasing displacement of the cutting line which separates the seen from the unseen. But this game has no end. Things are too unstable and there are too many of them on the screen. It is not simple – although still possible, of course, depending on the character of each spectator – to stop and

isolate one of these objects, to make it able to work as a fetish. Most of all, a film cannot be *touched*, cannot be carried and handled: although the actual reels can, the projected film cannot.

I will deal more briefly with the last difference – and the problem of belief–disbelief – since I have already spoken of it. As pointed out by Octave Mannoni,[12] Freud considered fetishism the prototype of the cleavage of belief: 'I know very well, *but*' In this sense, film and photography are basically similar. The spectator does not confound the signifier with the referent, she or he knows what a *representation* is, but nevertheless has a strange feeling of reality (a denial of the signifier). This is a classical theme of film theory.

But the very nature of *what* we believe in is not the same in film and photography. If I consider the two extreme points of the scale – there are, of course, intermediate cases: still shots in films, large and filmlike photographs, for example – I would say that film is able to call up our belief for long and complex dispositions of actions and characters (in narrative cinema) or of images and sounds (in experimental cinema), to disseminate belief; whereas photography is able to fix it, to concentrate it, to spend it all at the same time on a single object. Its poverty constitutes its force – I speak of a poverty of means, not of significance. The photographic effect is not produced from diversity, from itinerancy or inner migrations, from multiple juxtapositions or arrangements. It is the effect, rather, of a laser or lightning, a sudden and violent illumination on a limited and petrified surface: again the fetish and death. Where film lets us believe in more things, photography lets us believe more in one thing.

In conclusion, I should like to add some remarks on the use of psychoanalysis in the study of film, photography, theater, literature, and so on. First, there are presentations, like this one, which are less 'psychoanalytic' than it might seem. The notion of 'fetish,' and the word, were not invented by Freud; he took them from language, life, the history of cultures, anthropology. He proposed an *interpretation* of fetishism. This interpretation, in my opinion, is not fully satisfactory. It is obvious that it applies primarily to the early evolution of the young *boy*. (Incidentally, psychoanalysts often state that the recorded clinical cases of fetishism are for the most part male.) The fear of castration and its further consequence, its 'fate,' are necessarily different, at least partially, in children whose body is similar to the mother's. The Lacanian notion of the *phallus*, a symbolic organ distinct from the penis, the real organ, represents a step forward in theory; yet it is still the case that within the description of the human subject that psychoanalysis gives us, the male features are often dominant, mixed with (and as) general features. But apart from such distortions or silences, which are linked to a general history, other aspects of Freud's thinking, and various easily accessible observations which confirm it, remain fully valid. These include: the analysis of the fetishistic nature of male desire; in both sexes the 'willing suspension of disbelief' (to use the well-known Anglo-Saxon notion), a suspension which is determinant in all representative arts, in everyday life (mostly in order to solve problems by half-solutions), and in the handling of ordinary fetishes; the fetishistic pleasure of framing-deframing.

It is impossible to *use* a theory, to 'apply' it. That which is so called involves, in fact, two aspects more distinct than one might at first believe: the intrinsic degree of perfection of the theory itself, and its power of suggestion, of activation, of enlightenment *in another field* studied by other researchers. I feel that psychoanalysis has this power in the fields of the humanities and social sciences because it is an acute and profound discovery. It has helped *me* – the personal coefficient of each researcher always enters into the account, despite the ritual declarations of the impersonality of science – to explore one of the many possible paths through the complex problem of the relationship between cinema and photography. I have, in other words, used the theory of fetishism as a fetish.

Psychoanalysis, as Raymond Bellour has often underscored, is contemporary in our Western history with the technological arts (such as cinema) and with the reign of the patriarchal, nuclear, bourgeois family. Our period has invented neurosis (at least in its current form), *and* the remedy for it (it has often been so for all kinds of diseases). It is possible to consider psychoanalysis as the founding myth of our emotional modernity. In his famous study of the Oedipus myth, Lévi-Strauss has suggested that the Freudian interpretation of this myth (the central one in psycho-analysis, as everybody knows) could be nothing but the last variant of the myth itself.[13] This was not an attempt to blame: myths are always true, even if indirectly and by hidden ways, for the good reason that they are invented by the natives them-selves, searching for a parable of their own fate.

After this long digression, I turn back to my topic and purpose, only to state that they could be summed up in one sentence: film is more capable of playing on fetishism, photography more capable of itself becoming a fetish.

Notes

1 Peter Wollen, 'Fire and Ice,' *Photographies*, 4 (1984), cf. Ch. 7 in this volume, pp. 76–80 [Ed.].

2 Pierre Bordieu *et al.*, *Un art moyen. Essai sur les usages sociaux de la photographie*. Paris, Editions de Minuit, 1965.

3 Philippe Dubois, *L'acte photographique*, Paris and Brussels, Nathan and Labor, 1983.

4 Roland Barthes, *Camera Lucida*, New York, Hill and Wang, 1981.

5 Dubois, p. 89.

6 Wollen, Ibid.

7 Sigmund Freud, 'Mourning and Melancholia,' *The Standard Edition of the Complete Psychological Works of Sigmund Freud*, trans. James Strachey, London, The Hogarth Press and the Institute of Psycho-Analysis, 1953–1974, vol. 14.

8 Freud, 'Fetishism,' *S.E.*, vol. 21.

9 Pascal Bonitzer, 'Le hors-champ subtil,' *Cahiers du cinéma*, no. 311 (May 1980).

10 Barthes, p. 45.

11 Walter Benjamin, 'A Short History of Photography,' trans. Phil Patton, *Classic Essays on Photography*, ed. Alan Trachtenberg, New Haven, Conn., Leete's Island Books, 1980.

12 Octave Mannoni, 'Je sais bien mais quand même . . .,' *Clefs pour l'imaginaire; ou, L'autre scène*, Paris, Seuil, 1969.

13 Claude Lévi-Strauss, *Anthropologie structurale*, Chapter 11, 'La structure des mythes,' Paris, Plon, 1958; translated as *Structural Anthropology*, New York, Basic Books, 1963.

PART FOUR

Photography and the postmodern

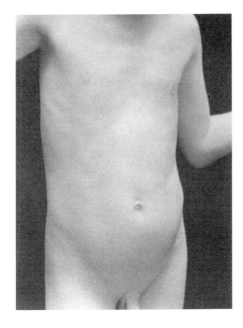

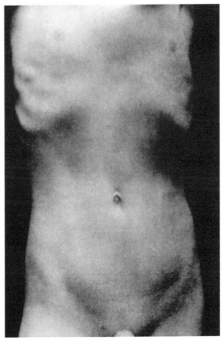

Edward Weston, *Torso of Neil*, 1925. Courtesy of the Centre for Creative Photography.

Sherrie Levine, *Portrait of Neil, after Edward Weston*, 3, 1980. Courtesy of the artist.

Introduction

POSTMODERNISM REFERS TO A SET of developments in philosophy, architecture and the arts towards the end of the twentieth century, propelled primarily by new currencies in French thought. If we take the modern to date from the eighteenth century 'age of enlightenment' with its emphasis upon rationality, technological progress, and the explanatory power of empirical sciences, then the postmodern (literally 'after the modern') challenged modern concepts and concerns.

The postmodern was characterised by a mixture of, on the one hand, political and cultural malaise and, on the other hand, an apparently knowing playfulness in the arts from fine art to the commercial. In the humanities, postmodernism intersected with the poststructuralist critique of structuralism in linguistics and communications and, perhaps more loosely, with the postcolonial challenges to the hegemony of Western culture and philosophy. Thus, the postmodern was associated with, first, new semiotic models, as Madan Sarup noted:

> While structuralism sees truth as being 'behind' or 'within' a text, post-structuralism stresses the interaction of reader and text as a productivity. In other words, reading has lost its status as a passive consumption of a product to become performance. Post-structuralism is highly critical of the unity of the stable sign (the Saussurian view). The new movement implies a shift from the signified to the signifier: and so there is a perpetual detour on the way to a truth that has lost any status or finality. . . . Post-structuralism, in short, involves a critique of metaphysics, of the concepts of causality, of identity, of the subject, and of truth.
>
> (Sarup 1993: 3)

Questions of language were centrally addressed, with emphasis upon the play of references and of systems of difference within which meaning is endlessly deferred or flexible. For French linguistic philosopher, Jacques Derrida, the deconstruction of language systems involved investigating ways in which words, as units referencing particular concepts, carry, by implication, the erasure of alternative referential possibilities, and operate within a chain of signification whereby each ensuing word contributes to orienting the developing line of interpretation. Here, emphasis is upon the play of meaning, its lack of fixity. Transferred to the visual, it would be argued that the picture, say, of a traditional rural landscape, derives its force not only from that which is represented but also from that to which it might be opposed, for instance, the industrial or the urban, or, indeed, a mountainous wilderness. Furthermore, aesthetic and technological codes operating across the picture plain would be seen as contributing within the fluidity of signification. Meaning here is seen more as a product of play within and between possibilities, than of formal, relatively rigid (visual) language structures.

Second, by extension, and following the writings of another key French philosopher, Jean Baudrillard, the postmodern dislocated any direct relation

between the signifier and the real. Images were seen as central to consumer culture, but involved reference and discursive relations, rather than representation; focus was upon surface style, rather than form and function, opening space for parody, pastiche and irony which draw eclectically upon previous movements in art and popular culture. In effect, this challenged the notions of originality and genius previously associated with the arts and literature. It emphasised the 'emptiness' of the signifier, that is the photograph in itself as a communicative artifact.

Third, postmodern philosophy challenged the legitimising myths and narratives of the modern era, including faith in technological progress, and proposed pluralistic models in place of what became seen as a monocular (Western-centric) world view. This induced historical and cultural investigations exemplified in particular in the critical writings of Michel Foucault in France and of Fredric Jameson in the USA. In relation to the arts, Foucault's excavation of circumstances, specific contexts and power relations in which knowledges are asserted or assumed, offers a model for analysing cultural histories and institutions. Likewise, Jameson, in considering the postmodern not as a decisive rupture with the modern, but rather as a logical consequence of the relation between industry and consumerism, contributes contemporary insights grounded in Marxist analysis.

To an extent, the postmodern seemed reactive, rather than proactive, in that, whilst critiquing previous artistic modes and cultural tenets, no new manifesto or set of principles was supported. Here, there is some resonance between feminist theory and the postmodern. Feminism, in the 1970s, challenged patriarchal values within liberalism and within Marxism, thereby clearly contributing to critique of totalising theory. However, as has been pointed out most assertively by French feminists including Julia Kristeva and Luce Irigaray, debates within postmodernism continued to be largely dominated by masculine voices and perspectives.

In photography, the central impact of the postmodern was to destabilise links between representation and reality. Thus, in genres such as photojournalism, documentary and, indeed, family photography, images were no longer to be taken at face value. Also, the unitary constitution of the viewer as subject was challenged in terms which started to take into account more fluid notions of identity and the influence of representation (see Part 8, p. 375 ff.) Philosophic interrogations were particularly marked in European debates; theoretical and critical studies, including critique of aesthetic traditions, became common within the university and art college curriculum. As such, postmodernism was experienced primarily in terms of critical positions. Notwithstanding the contribution of a number of academics (for instance, in journals such as *October*), in North America 'postmodernism appeared more as an aesthetic movement through which formalist art practices and the set-up of the art institution was challenged. Thus, paradoxically, just as photography had become accepted as a modern art practice – within which emphasis was upon aesthetics and the fine print – so postmodern artists started to appropriate or pastiche the photographic or use photography to refer to popular culture, in order to question the themes of the art gallery and the status accorded to art objects. Hence, in the essay included here, Abigail Solomon-Godeau invites art photographers to reflect upon and reconsider the tenets of their practice.

Briefly noting different manifestations of postmodern styles in architecture, dance and painting as a prelude to a more detailed discussion of photography, Grundberg, like Solomon-Godeau, emphasises strategic uses of the photographic within contemporary art. But, in direct contrast to Solomon-Godeau's concluding critique of art photography, Grundberg suggests re-reading earlier twentieth-century imagery, noting, for instance, humour, irony and a sense of the apocalyptic as tactical effects predating the postmodern. Although some such activity took place beyond the established gallery circuit – on billboards, or installation in public spaces – paradoxically much of the questioning of elitism, taste, and so on, continued to use the art gallery as a site, attract agents, and, as cynics have remarked, operate profitably within the international art market – as can be seen in the contemporary collections held by institutions such as MOMA, New York and the Tate Modern, London.

The final essay included here focusses on the everyday and argues against the notion of the postmodern as a critical category. Through wide-ranging critique of then contemporary theory, and taking examples from the high street store, Steve Edwards questions globalism, reminds us of the political purposefulness of the critical photographers of the 1920s, and remarks ways in which political priorities are reflected in consumer imagery. Published in the British radical photography magazine, *Ten.8*, ten years into Margaret Thatcher's rule as British Prime Minister, this (slightly amended) essay took the *Next catalogue* – then new to the high street chain of the same name – as an example of emphasis on 'dressing for success'. 1980s debates thus challenged dominant modes of thought, and also brought new subject-matter into focus within photography criticism, in particular, media and consumer culture.

References and selected further reading

Bolton, R. (ed.) (1990) *The Contest of Meaning*. MIT Press.
 A collection of essays on photography published in the 1980s in USA journals.
Foster, H. (1996) *The Return of the Real*. Cambridge, Massachusetts: MIT Press.
 On critical theory and avant-garde art at the end of the twentieth century.
Jameson, F. (1992) *Signatures of the Visible*. London and NY: Routledge.
 Essays on theory and contemporary visual culture (argued through particular reference to cinema).
Sarup, M. (1993) (2nd ed.) *Post-Structuralism and Postmodernism*. Hertfordshire: Harvester Wheatsheaf.
 Critical introductory discussion including chapters on Lacan, Derrida, Foucault, Lyotard and Baudrillard (not about photography).

Bibliography of essays in Part Four

Edwards, S. (1989) 'Snapshooters of History: passages on the postmodern argument', *Ten.8* No. 32.

Grundberg, A. (1990) 'The Crisis of the Real: Photography and Postmodernism' in his book of same title. NY: Aperture.
 Reprinted in Daniel P. Younger, (ed.) (1991) *Multiple Views*. Albuquerque: University of New Mexico Press; collection of essays courtesy the Logan Grants support for new writing on photography.
Solomon-Godeau, A. (1984) 'Winning the game when the rules have been changed: art photography and postmodernism', *Screen* Vol. 25/6, Nov/Dec.

Abigail Solomon-Godeau

WINNING THE GAME WHEN THE RULES HAVE BEEN CHANGED
Art photography and postmodernism

I WOULD LIKE TO BEGIN THIS DISCUSSION with a brief considera-
tion of two images: one, a canonical photograph of high modernist art photog-
raphy made in 1926; the other, a work made in 1979 by a postmodernist artist
with no allegiance – either pedagogical, formal, or professional – to art photog-
raphy *per se*. The first is Edward Weston's study – one of a series – of his son Neil;
the second is a rephotograph of the Edward Weston photograph by Sherrie Levine,
an artist whose practice for the past six years or so has been to rephotograph photo-
graphs or, more recently, paintings and drawings by German Expressionist artists,
and to present them as her own (see Frontispiece to Part 4, p. 147).

We may begin by legitimately asking what is the difference between the two
works. In the context of their reproduction in these pages, there very obviously is
no difference whatsoever. Were we, however, to put the actual vintage print of
Weston's *Neil* next to Levine's rephotographed print and examine them side by
side, a certain amount of difference would be apparent. Variations in tonality of the
prints, amount of detail, sharpness and delicacy of the forms and shadows, etc.,
could then be easily distinguished. But inasmuch as most people who can immedi-
ately recognise Weston's study of Neil are most likely to know it from reproductions
in books and magazines, we might also say that the difference between the photo-
graph by Weston and the photograph by Levine does not in any way represent a
fundamental or essential one.

What then *is* the difference between these two images? We might begin by
stating that while Weston is the *author* of the portrait of Neil, Levine is the thief,
or, put somewhat less baldly, the confiscator, the plagiarist, the appropriator, the
pasticheur. But to have said that is really to have said very little, because the theft

This article originally appeared in *New Mexico Studies in the Fine Arts*, Volume 7, 1983. It is based on
a public lecture given at the Rhode Island School of Design, April 26, 1983.

of this particular image is in every sense both obvious and transparent. Even with Sherrie Levine's name typed neatly below the image when it is exhibited, who after all would mistake Levine's purloined *Neil* for the real thing?

But what do we mean when we talk about the *real thing?* Were we referring to Manet's *Olympia* or to Vermeer's *View of Delft* there would be little ambiguity. The real *Olympia* is installed in the Jeu de Paume, in Paris; the *View of Delft* in the Mauritshuis in The Hague. Both are singular, unique. The real thing in reference to *Olympia* would never be taken to refer to the actual model – Victorine Meurand – any more than it would be confused with Manet's conception of a Second Empire courtesan. Still less would the real thing be conflated with the reproduction of it in Janson's *History of Art*. Similarly, although Vermeer's *View of Delft* is a minutely detailed view of the city, we know the real thing is not the city, but Vermeer's rendering of it. Are these notions of authenticity and singularity the same when we speak of Weston's study of Neil as the real thing?

To answer this query we must begin by acknowledging that although there is but one negative of this individual study of Neil, there are any number of prints made from the negative by Weston himself. Additionally, there exist prints made by Cole Weston bearing the imprimatur of the estate, and presumably printed with the privileged knowledge and insight regarding Weston's formal intentions that such an enterprise would imply. There is also a limited edition of prints made by George Tice some years ago, commissioned (I believe) by Lee Witkin and the Weston estate, of an extreme exquisiteness that would have made Weston *père* quite happy. Finally, there are the scores of reproductions of Weston's *Neil* gracing everything from the cover of *The Male Nude* to the various monographs and exhibition catalogues on Edward Weston or the F/64 group, or the art and history of photography itself. Where then are we to locate the real thing in relation to this particular image?

Carrying the inquiry a bit further, we might here examine the nature and quality of Weston's photograph, which may be justly described as a virtual icon of photographic modernism, an exemplar of Weston's mature style, and a monument to the rigorous and controlled perfection of so-called straight art photography. Certainly the authority and classical beauty of this photograph derives in part from our knowledgeable recognition of precisely that source of beauty Weston drew upon, viewed, framed, and represented in the person of his son Neil. It is, of course, the stylised perfection of Praxiteles' or Phidias' marble nudes that we see in Neil's living torso: the flesh made art as much as the three dimensions of the body have been transformed into two. Headless, armless, legless, even genital-less, this fragment of Neil speaks primarily of pure form. Its eroticism, while present, is tamed – subordinated to the aesthetic which, in any case, constitutes the historic ground rules for the presentation of the nude. But must we not, in the final analysis, consider the real thing to be, at least in part, the living Neil in the year 1926? And does not this final acknowledgment that this originary point must be – as it is for all photography – the living world which has been imprinted on paper further problematise the search for the real thing? Sherrie Levine in fact remarked that when she showed her photographs to a friend he said that they only made him want to see the originals. 'Of course,' she replied, 'and the originals make you want to see that little boy, but when you see the boy, the art is gone.' And elaborating on this comment, Douglas Crimp has commented:

> For the desire that is initiated by that representation does not come to
> closure around that little boy, is not at all satisfied by him. The desire
> of representation exists only insofar that it never be fulfilled, insofar as
> the original always be deferred. It is only in the absence of the original
> that representation may take place. And representation takes place
> because it is already there in the world as representation. It was of
> course, Weston himself who said that 'the photograph must be visual-
> ized in full before the exposure is made.' Levine has taken the master
> at his word and in so doing has shown him what he really meant. The
> *a priori* Weston had in mind was not really in his mind at all; it was in
> the world and Weston only copied it.[1]

But Sherrie Levine is concerned with more than making a point about the condi-
tions of representation, more too than underscoring the rather murky notion of
what constitutes an 'original' within a technology of mechanical reproduction. Like
Melville's Bartleby the Scrivener, Levine's critical stance is manifested as an act of
refusal: refusal of authorship, uncompromising rejection of all notions of self-expres-
sion, originality, or subjectivity. Levine, as has been pointed out often enough, does
not make photographs; she takes photographs, and this act of confiscation, as much
as the *kinds* of images she takes, generates a complex analysis and critique of the
forms, meanings and conventions of photographic imagery (particularly that which
has become canonised as art) at the same time that it comments obliquely on the
implications of photography as a museum art.

In earlier work dealing with photography, Levine made copy photographs of
reproductions of photographs printed in books or posters, as in the case of the
Weston studies of Neil. Alternatively – for example, in her rephotographs of Walker
Evans' FSA photographs – she made copy prints of copy prints. Thus, while concep-
tually creating a photographic hall of mirrors effect, Levine cogently demonstrated
the contradictions implicit in the assimilation of photography into traditional art
discourse. Inasmuch as appropriation functions by putting visual quotation marks
around the stolen image, its critical application lies in its ability to compel the viewer
to see dialectically. In Levine's rephotographs of Eliot Porter's trees, the mere act
of their confiscation, displacement, and re-presentation, enables the viewer to grasp
immediately the wholly conventional (and, as Roland Barthes would have said,
entirely mythological) scheme in which 'Nature' is made to be seen as 'Beautiful'.
Unlike the international typologies of industrial structures made by Hilla and Bernd
Becher, the Porter photographs are revealed as unintentional typologies; artifacts
of culture no less than the Bechers' steel mills and water towers. Similarly, the
rephotographed Walker Evans photographs, whose graininess and obvious screen
clearly attest to their already-reproduced status, underline the cultural and repre-
sentational codes that structure our reading of (respectively) the Great Depression,
the rural poor, female social victims, and the *style* of Walker Evans.

Levine's refusal of traditional notions of authorship has social and political impli-
cations as well. The word 'author' is etymologically linked to that of 'authority'
just as it is to 'authorise'. Historically, the concept of the author is linked to that
of property in that the production of the author comes, within the framework of
capitalist development, to be understood as property. Copyright legislation protects

that property, and in fact Levine's Weston and Porter rephotographs are quite literally illegal works of art. Too, the notion of the author is integrally linked with that of patriarchy; to contest the dominance of the one, is implicitly to contest the power of the other. Enacted against the larger art world context characterised by the cynical (and as has been often noted, predominantly male) effusions of neo-expressionist macho pastiche, Levine's acerbic and deadpan confiscations serve efficiently to expose the hollowness as well as the specious atavism of such work. To refuse authorship itself functions to puncture the ideology of the artist as the bearer of a privileged subjectivity. Levine is thus a kind of guerrilla feminist within the precincts of the art world – a position shared by a number of other artists using photography within the postmodernist camp.

I chose to begin this essay with a discussion of Sherrie Levine's work because it illustrates in a rather forceful and dramatic way that the methods and assumptions of traditional art photography and those of various artists employing photography outside the conventional framework of art photography have come to occupy antipodes within photographic discourse and practice. Levine's work often provokes outrage, nowhere more evident than among the ranks of art photographers. If after a hundred and fifty years of upwardly mobile striving, art photography has been definitively validated as a 'creative' fine art, what does it mean that artists such as Levine should so energetically jettison those very values which elevated photography to parity with the other arts? Levine, now in her mid-thirties, has emerged from the art world, as have a considerable number of other artists using photography such as Vikky Alexander, James Casebere, Sarah Charlesworth, Silvia Kolbowski, Barbara Kruger, Richard Prince, Laurie Simmons, Cindy Sherman and Jim Welling. They are themselves linked to an older generation of artists such as John Baldessari or, for that matter, Andy Warhol. The list could easily be extended to include a wide range of artists using photography since the mid-sixties that would encompass artists as disparate as the Bechers, Victor Burgin, Jan Dibbets, Gilbert & George, Dan Graham, Joseph Kosuth, Ed Ruscha, Jeff Wall and William Wegman. As photography galleries have crumpled left and right (in New York in 1983, the casualty lists included Light Gallery, Photograph Gallery, Robert Samuels Gallery, and the Photographic Division of Leo Castelli) Cindy Sherman's star, for example, has risen meteorically. As the Photography Department of the Museum of Modern Art drifts into blue chip senility with no less than four Atget exhibitions or feeble resuscitations of formalist schema ('Big Pictures'), artists employing photography are in increasing numbers being absorbed into the mainstream art gallery nexus.

These two simultaneous developments – the ghettoisation and marginality of art photography at precisely the moment when the use of photography by artists has become a relative commonplace – deserves some scrutiny. In order to understand the conceptual cul-de-sac that contemporary art photography represents, it is important to trace the assumptions and claims that paralleled (and fueled) its trajectory and then to examine the merit and usefulness of these notions as they exist in the present.

It has long been an uncontested claim in standard photographic history that the work of Paul Strand done in the late teens – and more particularly, its championship by Alfred Stieglitz in the last two issues of *Camera Work* – signalled the coming

of age of art photography as an authentically modernist, and hence, fully self-conscious art form. For while Stieglitz himself had for most of his career made unmanipulated 'straight' prints, it was Strand's uncompromising formulation of the aesthetics of straight photography, his insistence that photographic excellence lay in the celebration of those very qualities intrinsic to the medium itself, that has traditionally been viewed as the moment of reorientation and renewal of American art photography.

Stieglitz's epiphanous designation of Strand as the aesthetic heir apparent would seem a reasonable point of demarcation in the art history of American photography. For although the insistence that the camera possesses its own unique aesthetic has been asserted in various ways since the 1850s, the pictorialist phenomenon supplanted earlier concepts of photographic integrity or purity[2] and instead established a quite different aesthetic agenda. This agenda, however, had a pedigree fully as vulnerable as that of the proto-formalist one: specifically, the presumption that photography, like all the traditional visual arts, could lay claim to the province of the imaginary, the subjective, the inventive – in short, all that might be inscribed within the idea of the *creative*.

The specific strategies adapted by pictorialist photographers – be they the retrieval of artisanal printing processes, the appropriation of high art subject matter (F Holland Day crucified on the Cross, Gertrude Kasebier's Holy Families, etc.), or the use of gum bichromate and other substances, with extensive working of the negative or print and the concommitant stress on fine photography as the work of hand as well as eye – are now generally supposed to constitute an historical example of the misplaced, but ultimately important energies of art photography at an earlier stage of evolution. Misplaced, because current 'markers' and print manipulators notwithstanding, contemporary photographic taste is predominantly formalist; important, because the activities and production of the Photo-Secession were a significant and effective lobby for the legitimation of photography as art. Thus, if on the one hand, Edward Steichen's 1901 self-portrait, in which the photographer is represented as a painter and the pigment print itself disguised as a work of graphic art, is now reckoned to be distinctly un-modernist in its conception, on the other hand, the impulses that determined its making can be retrospectively recuperated for the progressive camp. Viewed from this position, photography's aspiration to the condition of painting by emulating either the subject or the look of painting was considered by the 1920s and the accompanying emergence of the post-Pictorialist generation – Sheeler, Strand, Weston and the others – to have been an error of means, if not ends.

What I here wish to argue is that the *ends* of mainstream art photography, what we might consider as its methods or ideology, have remained substantially unchanged throughout all its various permutations – stylistic, technological, and cultural – that it has undergone during its hundred and forty year history. Of far greater importance than the particular manifestations and productions of art photography is the examination of the conditions that define and determine them. What needs to be stressed is that an almost exclusive concentration on the stylistic developments in art photography, no less than the accompanying preoccupation with its exemplary practitioners, tends to obscure the structural continuities between the 'retrograde' pictorialism of the earlier part of the century and the triumphant

modernism of its successors. Steichen's tenebrous platinum and gum print nude of 1904 entitled 'In Memoriam' might well seem on the stylistic evidence light years away from the almost hallucinatory clarity of Weston's work of the 1930s, but Steichen's 'it is the artist that creates a work of art, not the medium' and Weston's 'man is the actual medium of expression – not the tool he elects to use as a means' are for all intents and purposes virtually identical formulations. The shared conviction that the art photograph is the expression of the photographer's interior, rather than or in addition to the world's exterior, is, of course, *the* doxa of art photography and has been a staple of photographic criticism almost from the medium's inception. Implicit in the notion of the photographer's expressive mediation of the world through the use of his or her instrument is a related constellation of assumptions: originality, authorship, authenticity, the primacy of subjectivity, assumptions immediately recognisable as those belonging to what Walter Benjamin termed the theology of art. It is the hegemony of these assumptions that integrates within a unified field the photography of Clarence White and Tod Papageorge, the criticism of Sadakichi Hartmann and John Szarkowski. Such is the continuing value and prestige of these notions in photographic criticism and history that they tend to be promiscuously imposed on just about any photographic oeuvre which presents itself as an appropriate subject for contemporary connoisseurship. Thomson and Riis, Atget and Weegee, Salzmann and Russell, Missions Héliographiques or 49th Parallel Survey: all tend finally to be grist for the aesthetic mill, irrespective of intention, purpose, application or context.

Insofar as such concepts as originality, self expression and subjectivity have functioned, at least since romanticism, as the very warranty of art, the claims of art photography were *a priori* ordained to be couched in precisely such terms. 'Nature viewed through a temperament' could be grafted onto the photographic enterprise as easily as to painting or literature and could, moreover, encompass both maker and machine. Thus was met the first necessary condition of the *genus* art photography: that it be considered, at very least by its partisans, as an expressive as well as transcriptive medium.

Why then the need for a pictorialist style at all? And to the extent that exponents of art photography since the 1850s had established a substantial body of argument bolstering the claims to photographic subjectivity, interpretive ability and expressive potential, why nearly half a century later was the battle refought specifically on painting's terms?

Certainly one contributing factor, a factor somewhat elided in the art history of photography, was the second wave of technological innovation that occurred in the 1880s. The fortunes of art photography, no less than those of scientific, documentary, or entrepreneural photography, have always been materially determined by developments in its technologies and most specifically by its progressive industrialisation.[3] The decade of the eighties witnessed not only the perfection of photogravure and other forms of photomechanical reproduction (making possible the photographically illustrated newspaper and magazine), but the introduction and widespread dissemination of the gelatino-bromide dry plates, perfected enlargers, hand cameras, rapid printing papers, orthochromatic film and plates, and last but not least, the Kodak push button camera. The resulting quantum leap in the sheer ubiquity of photography, its vastly increased accessibility (even to children, as was

now advertised) and the accompanying diminution in the amount of expertise and know-how required to both take and process photographs, compelled the art photographer to separate in every way possible his or her work from that of the common run of commercial portraitist, Sunday amateur, or family chronicler. In this context, too, it should be pointed out that pictorialism was an international style: in France its most illustrious practitioners were Robert Demachy and Camille Puyo; in Germany Heinrich Kuhn, Frank Eugene, Hugo Henneberg and others were working along the same lines, and in the States, Stieglitz and the other members of the Secession effectively promoted pictorialism as the official style of art photography. And while influences ranging from symbolism, the arts and crafts movement, *l'art pour l'art*, and Jugendstil variously informed the practice of art photography in all these countries, the primary fact to be reckoned with is that art photography has always defined itself – indeed, was compelled to define itself – in opposition to the normative uses and boundless ubiquity of all other photography.

It is suggestive, too, that the pictorialist and Photo-Secession period involved the first comprehensive look at early photography. Calotypes by David Octavious Hill and Robert Adamson and albumen prints by Julia Margaret Cameron were reproduced in *Camera Work*, Alvin Langdon Coburn printed positives from negatives by Hill and Adamson, Thomas Keith and Lewis Carroll, and exhibitions of nineteenth-century photography were mounted in France, Germany and Great Britain. These activities were to peak in 1939,[4] the centenary of the public announcement of the daguerreotype, and were to be matched (in fact, exceeded substantially) only in the decades following 1960.

One need not belabour the point to see certain correspondences between the art photography scene of the period of the Photo-Secession and that of the past fifteen years. If gum and oil prints are perhaps not in evidence, contemporary photography galleries and exhibitions are nonetheless replete with the products of 8 × 10 view cameras, palladium prints, platinum prints, dye transfer prints, etc. Such strategies are as much mandated by a thoroughly aestheticised notion of photography as they are by the demands of the art photography market. To those who would counter such a categorisation with remonstrations as to the increasing shoddiness of commercially manufactured materials and the need for archival permanence, I would simply reassert that the art photographer's aspirations to formal invention, individual expression and signatural style are perpetually circumscribed, if not determined, by manufacturing and production decisions. Indeed, the very size and shape of the photographic image are the result of industrial decisions; the requirements of artists were only taken into account in camera design for a brief historical moment well before the industrialisation of photography.

When the legacy of art photography passed from pictorialism to what Stieglitz described as the 'brutally direct' photographic production of Strand and his great contemporaries, a crucial and necessary displacement of the art in art photography was required. No longer located in particular kinds of subject matter, in the blurred and gauzy effects of soft focus or manipulations of negative or print, in allegorical or symbolic meanings, the locus of art was now squarely placed within the sensibility – be it eye or mind – of the photographers themselves. Thus from Heinrich Kuhn's 'the photographic instrument, the lifeless machine, is compelled by the superior will of the personality to play the role of the subordinate' through Paul Strand's

formulation of photography as instrumental 'to an even fuller and more intense self-realisation' to Walker Evans' litany of art photography's 'immaterial qualities, from the realms of the subjective' among which he included 'perception and penetration: authority and its cousin, assurance, originality of vision, or image innovation; exploration; invention' to, finally, Tod Papageorge's 'as I have gotten older, however, and have continued to work, I have become more concerned with expressing who I am and what I understand' there exists a continuous strand that has remained unbroken from *Camera Work* to *Camera Arts*.

But if the strand has remained continuous, the quality of the art photography produced has not. Few observers of the contemporary art photography scene would dispute, I think, the assertion that the work produced in the past fifteen years has neither the quality nor the authority of that of photographic modernism's heroic period, a period whose simultaneous apogee and rupture might be located in the work of Robert Frank. Too, it seems clear that the obsequies for the so-called photography boom may have something to do with the general state of exhaustion, academicism and repetition evident in so much art photography as much as with the collapse of an over-extended market.[5]

The oracular pronouncements of Evans, Stieglitz, Strand, or Weston often have a portentous or even pompous ring, but the conviction that underlay them was validated by the vitality and authority of the modernism they espoused. To the extent that a modernist aesthetic retained legitimacy, credibility, and most importantly, function as the vessel and agent of advanced art, it permitted for the production of a corpus of great, now canonical, photography. The eclipse – or collapse, as the case may be – of modernism is coincident with art photography's final and triumphant vindication, its wholesale and unqualified acceptance into all the institutional precincts of fine art: museum, gallery, university, and art history.[6] The conditions surrounding and determining art photography production were now, of course, substantially altered. No longer in an adversarial position, but in a state of parity with the traditional fine arts, two significant tendencies emerged by the early 1960s. One was the appearance of photography – typically appropriated from the mass media – in the work of artists such as Robert Rauschenberg and Andy Warhol as well as its increased deployment by a group of conceptual artists such as John Baldessari. The second tendency was a pronounced academicisation of art photography both in a literal sense (photographers trained in art school and universities, the conferring of graduate degrees in photography) and in a stylistic sense: that is to say, the retrieval and/or reworking of photographic strategies now both fully conventionalised and formulaic, derived from the image bank of modernist photography, or even from modernist painting, and producing a kind of neo-pictorialist hybrid.

What was – and is – important about the two types of photographic practice was the distinct and explicit opposition built into these different uses. For the art photographer, the issues and intentions remained those traditionally associated with the aestheticising use and forms of the medium: the primacy of formal organisation and values, the autonomy of the photographic image, the subjectivisation of vision, the fetishising of print quality, and the unquestioned assumption of photographic authorship. In direct contrast, the artists who began to employ photography did so in the service of vastly different ends. More often than not, photography figured in

their works in its most ubiquitous and normative incarnations. Thus, it was conscripted as a readymade image from either advertising or the mass media in its various and sundry manifestations in the quotidian visual environment, or alternatively, employed in its purely transcriptive and documentary capacities. In this latter usage, it did service to record site specific works, objects or events that had been orchestrated, constructed or arranged to be constituted anew, preserved, and represented in the camera image.

It is from this wellspring that the most interesting and provocative new work in photography has tended to come. Although this relatively recent outpouring of art production utilising photography covers a broad spectrum of concerns, intentions, and widely differing formal strategies, the common denominator is its collective resistance to any type of formal analysis, psychological interpretation, or aesthetic reading. Consistent with the general tenor of postmodern practice, such work takes as its point of departure not the hermetic enclave of aesthetic self-referencing (art about art, photography about photography), but rather, the social and cultural world of which it is a part. Thus, if one of the major claims of modernist art theory was the insistence on the autonomy and purity of the work of art, postmodern practice hinges on the assertion of contingency and the primacy of cultural codes. It follows that a significant proportion of postmodern art based on photographic usages is animated by a critical, or, if one prefers, deconstructive impulse. The intention of such work is less about provoking feeling, than provoking thought.

In addition to the work of Sherrie Levine with which this paper opened, I would like briefly to consider here the work of four other artists who may be seen as having a shared agenda, albeit with different inflections and emphases. Appropriators all, their work nonetheless ranges from entirely unmediated confiscation, as in the case of Levine, to the recropped, repositioned assemblages of Vikky Alexander and Silvia Kolbowski, to the composed texts superimposed over Barbara Kruger's purloined images, to the heroicised fragments of glossy advertisements that Richard Prince isolates and reshoots.

What gives their work its integrity, its cutting edge, is the common enterprise of 'making the invisible visible' — a goal whose strategies are now determined by a new arena: the world of mass produced images themselves. In contrast with many of the art movements of the earlier part of the century which promised liberation, the unshackling of vision and perception, these artists are clearly more modest in their goals, more pessimistic in what they conceive of as possible in what Guy Debord termed 'The Society of the Spectacle'. Nonetheless, in compelling a conscious reading of the ideology inscribed in various photographic uses, and in investing strategies that unravel their connotational structures, these artists may be seen as continuing that tradition of art making which views as its mission the unmasking of appearance by revealing its codes.

In the case of Richard Prince the dialectical, and hence, deconstructive readings effected by Levine's tactics, are arrived at by somewhat different means. Taking as his object of inquiry the highly mediated and technologically sophisticated advertising image, Prince has progressively sought to counter the manipulated and often synthetically composed advertising image with a comparable degree of simulation in his own appropriations. In this sense, Kate Linker has proposed[7] that the theoretical model for Prince's practice be located in Jean Baudrillard's concept of the

simulacrum, which surpasses representation and reproduction, and instead produces a synthetic 'hyperreality', a 'real without origin or reality'. Much of the power of Prince's work derives from his ability to make the concept of the commodity fetish at once concrete and visible. The hyped-up, almost hallucinatory quality of his details of cigarette ads, expensive watches, shimmering whiskey logos, *et al.*, are made to reveal their own strategies of overdetermination. There is an obsessional quality about Prince's work which has little to do with irony (and its attendant aspect of distancing) that informs much appropriative practice. The element of nightmare that subtly attaches itself to the erotic glitter and voluptuousness of the commodity (or the ambiance of the commodity) is similar in idea to the traditional Christian emblem of Luxuria – the head of a beautiful woman merging into the body of a serpent. Prince's rejection of traditional notions of authorship, while less programmatic than Levine's, have nonetheless originated in a comparable under-standing of the conditions of spectacular society. Prince has quite precisely described his relation to authorship (as well as his own working method) in the following text:

> His way to make it new was to make it again . . . and making it again
> was enough for him and certainly, personally speaking, 'almost him'.[8]

The notion of identity as 'almost him' functions as an analogue to a fully conven-tionalised reality composed of images or simulacra; reality can no more be located in the world than 'authenticity' in the author.

For Silvia Kolbowski and Vikky Alexander the nature of their appropriations, and the operations they make upon them, mark their concerns as more centrally located within feminist discourse. Informed by aspects of psychoanalytic, linguistic, and feminist theory, Kolbowski's *Model Pleasure*, composed of seven discrete but integrally related images, brackets cropped close-ups of five veiled models, with a woman 'veiled' behind venetian blinds, and a single shot of a man looking at a woman 'veiled' by dark glasses. Through appropriations, cropping, positioning and serial organisation, Kolbowski contrives a critical reading of the fashion image calculated to rupture the fictions of such representation. Voyeurism depicted within the series is counterpointed with the spectator's, a strategy that illumines the larger ideologi-cal system in which the construction of the female (as different, as Other) inevitably relegates her to the object of the gaze (which is always male) rather than permitting her to be the origin of it. When the image of the woman is presented for woman (as is generally the case with fashion photography) the female viewer must inescapably project her own sexual identity within this narcissistic cul-de-sac of being-looked-at, and hence existing by and for the eyes of men. Similarly, the constellation of sexual mythologies – women as enigma, as mystery – that are integrally bound with objec-tification and oppression are literally demonstrated in Kolbowski's orchestration of images. The final image – a woman's veiled and smiling mouth, brushed by a male hand – is placed upside down, in order, as Kolbowski explains, 'to make an analogy between the feminine gaze and the woman spoken'. For central to feminist theory is the recognition that woman does not speak herself; rather, she is spoken for and all that that implies: looked at, imaged, mystified and objectified.

Like Kolbowski's, Vikky Alexander's work of the past few years is grounded in a feminist critique of fashion imagery, the ideological terrain in which women

are presented not only as ritual objects, but as commodities. Alexander has set herself the conceptual problem of rhetorically re-presenting the given image in such a way that its hidden codes are made legible. Through relatively subtle interventions in the original image (cropping in such a way that the ritualised aspects of pose or 'look' are thereby accentuated), by repetition and/or format (diptych, triptych, etc.), Alexander compels awareness of not only the codes themselves, but the way they function.

In *Ecstasy*, three identical fashion photographs of a female model alone are alternated with two identical ones depicting a male and female model together. Part of the wit of the piece resides in its play with the notion of quotation itself – as it functions in language as well as tactically – as an artmaking strategy. For in the very act of describing such imagery in language, we must have recourse to the use of quotes in order to indicate its various levels of simulation. Accordingly, we would begin by noting that all the female models display an 'ecstatic' expression. Certainly not the expression of Bernini's St Teresa, or Titian's Mary Magdalene, but a more up-to-date version: the conventionalised ecstasy which has emerged recently in fashion photography; closed, shiny eyelids, wet, slightly opened mouth. We would then go on to note that the couple are 'making love'. The quotational act by which the work has been constructed is thereby made to illustrate and expose the highly mediated simulation of the images' content. The inclusion of the single model – equally 'ecstatic' – insures our understanding that the depicted ecstasy, no less than the depiction of the women themselves, is a spectacle. Further, the spectacle of the ecstatic woman is intimately bound with representational structures of voyeurism, narcissism and power. By de-naturing such images, Alexander unmasks them.

Barbara Kruger's work – aggressive, graphic and occasionally almost brutal – appropriates not only the images themselves, but the 'look', address, and discursive mode of certain types of mass media institutions (the tabloid press, the billboard, the poster). Kruger's *modus operandi* consists of canny table-turning, whereby all the communicative tools in the arsenal of power are deployed against themselves. Appropriating the disembodied voice of patriarchal authority (expressed in bold face type), Kruger then makes superimpositions against found images (usually crude, rather anonymous looking ones) that are made to double back against themselves. Very rarely, this is effected by having the image in some sense contradict the text. For example, a narrowly cropped image of a man kissing the hand of an (unseen) woman is emblazoned with the text 'You reenact the dance of insertion and wounding' with 'dance of' and 'wounding' in larger, differentiated typeface. More typically, however, the juxtaposition of Kruger's composed texts and found images creates new and subversive meanings for both. Thus, utilising a thoroughly stereotypical image conventionally signifying mother love – the tiny baby hand clutching the mother's finger – Kruger distills a far more trenchant observation; 'Your every wish (in small type face over the two hands) is our command.' Roland Barthes' concept of caption and text functioning as anchorage and relay is nowhere more eloquently demonstrated than in Kruger's iconic/lexographic sleight-of-hands. Much of her work is extremely witty (a group of formally dressed men laughingly giving one of their number a 'going over' is captioned, 'You construct intricate rituals which allow you to touch the skin of other men'), a strategy as capable of critical analysis as any other.

Differences in emphasis, tactics and degree of appropriation notwithstanding, Alexander, Kolbowski, Kruger, Levine and Prince are artists whose concerns are grounded in the cultural, the political, the sexual. Viewed individually, collectively, or as sample representatives of postmodernist art practice, their work contrasts vividly with the parochialism, insularity, and conservatism of much art photography.

The title of this paper – winning the game when the rules have been changed – relates to precisely this phenomenon. Having achieved institutional legitimation as a fine art among the others, art photography remains rooted in a conceptual impasse of its own making. Most art photographers, particularly those established within the past fifteen years or so, and now ensconced within the photography departments across the land, give little thought to the general collapse of the modernism which provided the ballast for the triumphant rise of art photography. The teaching of photography tends to be cordoned off from what goes on in the rest of the art department. So while young painters are reading art magazines and often as not following to some degree developments in film, performance or video, photography students are reading photography magazines, disputing the merits of documentary mode over self expression, or resurrecting onto the fourth generation an exhausted formalism that can no longer generate either heat or light.

Often the reaction of art photographers to postmodernist photographic work is bafflement, if not a sense of affront. The irony is that photography, a medium which by its very nature is so utterly bound to the world and its objects, should have had, in a variety of ways, to divorce itself from this primary relationship in order to claim for itself a photographic aesthetics.

Notes

1 Douglas Crimp, 'The Photographic Activity of Postmodernism', *October 15*, Winter, 1980, pp. 91–100. An indispensable essay on the subject, to which my own is much indebted. Crimp discusses at some length Levine's position within postmodernist theory and practice. See also Rosalind Krauss. 'The Originality of the Avant-Garde: A Postmodernist Reception', *October 18*, Fall, 1981, pp. 46–66.

2 The Société Française de Photographie, for example, from its inception in 1851 forbade any retouching on the photographic submissions to its regular exhibitions.

3 See in this light, Bernard Edelman, *Ownership of the Image: Elements for a Marxist Theory of Law*, London, Routledge and Kegan Paul, 1979.

4 In 1937 the important exhibition on the history of photography was mounted at the Museum of Modern Art which resulted in Beaumont Newhall's now standard text *History of Photography*. For a discussion of the significance of this exhibition, see Christopher Phillips, 'The Judgment Seat of Photography', *October 22*, Fall, 1982, pp. 27–63.

5 See Carol Squiers' discussion, 'Photography: Tradition and Decline', *Aperture 91*, Summer 1983, pp. 72–76.

6 An examination of these two related phenomena may be found in Douglas Crimp's 'The Museum's Old, The Library's New Subject', *Parachute 22*, Spring, 1981, pp. 32–7.

7 Kate Linker, 'On Richard Prince's Photographs', *Art Magazine*, November 1982, pp. 121–23.

8 Richard Prince, *Why I Go to the Movies Alone*, NY: Tantum Press, 1983.

Andy Grundberg

THE CRISIS OF THE REAL
Photography and postmodernism

Disneyland is presented as imaginary in order to make us believe that the rest is real, when in fact all of Los Angeles and the America surrounding it are no longer real, but of the order of the hyperreal and of simulation. It is no longer a question of a false representation of reality (ideology), but of concealing the fact that the real is no longer real. . . .

Jean Baudrillard[1]

TODAY WE FACE A CONDITION in the arts that for many is both confusing and irritating – a condition that goes by the name of postmodernism. But what do we mean when we call a work of art postmodernist? And what does postmodernism mean for photography? How does it relate to, and challenge, the tradition of photographic practice as Beaumont Newhall has so conscientiously described it?[2] Why are the ideas and practices of postmodernist art so unsettling to our traditional ways of thinking? These are questions that need to be examined if we are to understand the nature of today's photography, and its relation to the larger art world.

What *is* postmodernism? Is it a method, like the practice of using images that already exist? Is it an attitude, like irony? Is it an ideology, like Marxism? Or is it a plot hatched by a cabal of New York artists, dealers, and critics, designed to overturn the art-world establishment and to shower money and fame on those involved? These are all definitions that have been proposed, and, like the blind men's descriptions of the elephant, they all may contain a small share of truth. But as I hope to make clear, postmodernist art did not arise in a vacuum, and it is more than merely a demonstration of certain theoretical concerns dear to twentieth-century

This essay is the title piece of the author's anthology, *Crisis of the Real* (New York: Aperture, 1990). It also appears in a substantially revised version in *Photography and Art: Interactions Since 1946* (New York: Abbeville Press, 1987).

intellectuals. I would argue, in short, that postmodernism, in its art and its theory, is a reflection of the conditions of our time.

One complication in arriving at any neat definition of postmodernism is that it means different things in different artistic media. The term first gained wide currency in the field of architecture,[3] as a way of describing a turn away from the hermetically sealed glass boxes and walled concrete bunkers of modern architecture. In coming up with the term postmodern, architects had a very specific and clearly defined target in mind: the 'less is more' reductivism of Mies van der Rohe and his disciples. At first, postmodernism in architecture meant eclecticism: the use of stylistic flourishes and decorative ornament with a kind of carefree, slapdash, and ultimately value-free abandon.

Postmodernist architecture, however, combines old and new styles with an almost hedonistic intensity. Freed of the rigors of Miesian design, architects felt at liberty to reintroduce precisely those elements of architectural syntax that Mies had purged from the vocabulary: historical allusion, metaphor, jokey illusionism, spatial ambiguity. What the English architectural critic Charles Jencks says of Michael Graves's Portland building is true of postmodern architecture as a whole:

> It is evidently an architecture of inclusion which takes the multiplicity of differing demands seriously: ornament, colour, representational sculpture, urban morphology – and more purely architectural demands such as structure, space and light.[4]

If architecture's postmodernism is involved with redecorating the stripped-down elements of architectural modernism, thereby restoring some of the emotional complexity and spiritual capacity that the best buildings seem to have, the postmodernism of dance is something else. Modern dance as we have come to know it consists of a tradition extending from Loie Fuller, in Paris in the 1890s, through Martha Graham, in New York in the 1930s. As anyone who has seen Graham's dances can attest, emotional, subjective expressionism is a hallmark of modern dance, albeit within a technically polished framework. Postmodernist dance, which dates from the experimental work performed at the Judson Church in New York City in the early 1960s, was and is an attempt to throw off the heroism and expressionism of modernist dance by making dance more vernacular.[5] Inspired by the pioneering accomplishments of Merce Cunningham, the dancers of the Judson Dance Theater – who included Trisha Brown, Lucinda Childs, Steve Paxton, and Yvonne Rainer – based their movements on everyday gestures such as walking and turning, and often enlisted the audience or used untrained walk-ons as dancers. Postmodern dance eliminated narrative, reduced decoration, and purged allusion – in other words, it was, and is, not far removed from what we call modern in architecture.

More recently this esthetic of postmodernist dance has been replaced in vanguard circles in New York by an as-yet-unnamed style that seeks to reinject elements of biography, narrative, and political issues into the structure of the dance, using allusion and decoration and difficult dance steps in the process. It is, in its own way, exactly what postmodern architecture is, inasmuch as it attempts to revitalize the art form through inclusion rather than exclusion. Clearly, then, the term postmodernism is used to mean something very different in dance than it does in

architecture. The same condition exists in music, and in literature – each defines its postmodernism in relation to its own peculiar modernism.

To edge closer to the situation in photography, consider postmodernism as it is constituted in today's art world – which is to say, within the tradition and practice of painting and sculpture. For a while, in the 1970s, it was possible to think of postmodernism as equivalent to pluralism, a catchword that was the art-world equivalent of Tom Wolfe's phrase 'The Me Decade.' According to the pluralists, the tradition of modernism, from Paul Cézanne to Kenneth Noland, had plumb tuckered out – had, through its own assumptions, run itself into the ground. Painting was finished, and all that was left to do was either minimalism (which no one much liked to look at) or conceptualism (which no one could look at, its goal being to avoid producing still more art 'objects'). Decoration and representation were out, eye appeal was suspect, emotional appeal thought sloppy if not gauche.

Facing this exhaustion, the artists of the 1970s went off in a hundred directions at once, at least according to the pluralist model. Some started making frankly decorative pattern paintings. Some made sculpture from the earth, or from abandoned buildings. Some started using photography and video, mixing media and adding to the pluralist stew. One consequence of the opening of the modernist gates was that photography, that seemingly perennial second-class citizen, became a naturalized member of the gallery and museum circuit. But the main thrust was that modernism's reductivism – or, to be fair about it, *what was seen as modernism's reductivism* – was countered with a flood of new practices, some of them clearly antithetical to modernism.

But was this pluralism, which is no longer much in evidence, truly an attack on the underlying assumptions of modernism, as modernism was perceived in the mid to late 1970s? Or was it, as the critic Douglas Crimp has written, one of the 'morbid symptoms of modernism's demise'?[6] According to those of Mr. Crimp's critical persuasion (which is to say, of the persuasion of *October* magazine), postmodernism in the art world means something more than simply what comes after modernism. It means, for them, an attack on modernism, an undercutting of its basic assumptions about the role of art in the culture and about the role of the artist in relation to his or her art. This undercutting function has come to be known as 'deconstruction,' a term for which the French philosopher Jacques Derrida is responsible.[7] Behind it lies a theory about the way we perceive the world that is both rooted in, and a reaction to, structuralism.

Structuralism is a theory of language and knowledge, and it is largely based on the Swiss linguist Ferdinand de Saussure's *Course in General Linguistics* (1916). It is allied with, if not inseparable from, the theory of semiotics, or signs, pioneered by the American philosopher Charles S. Pierce about the same time. What structuralist linguistic theory and semiotic sign theory have in common is the belief that things in the world – literary texts, images, what have you – do not wear their meanings on their sleeves. They must be deciphered, or decoded, in order to be understood. In other words, things have a 'deeper structure' than common sense permits us to comprehend, and structuralism purports to provide a method that allows us to penetrate that deeper structure.

Basically, its method is to divide everything in two. It takes the sign – a word, say, in language, or an image, or even a pair of women's shoes – and separates it

into the 'signifier' and the 'signified.' The signifier is like a pointer, and the signified is what gets pointed to. (In Morse code, the dots and dashes are the signifiers, and the letters of the alphabet the signifieds.) Now this seems pretty reasonable, if not exactly simple. But structuralism also holds that the signifier is wholly arbitrary, a convention of social practice rather than a universal law. Therefore structuralism in practice ignores the 'meaning,' or the signified part of the sign, and concentrates on the relations of the signifiers within any given work. In a sense, it holds that the obvious meaning is irrelevant; instead, it finds its territory within the structure of things – hence the name structuralism.

Some of the consequences of this approach are detailed in Terry Eagleton's book *Literary Theory: An Introduction*:

> First, it does not matter to structuralism that [a] story is hardly an example of great literature. The method is quite indifferent to the cultural value of its object. . . . Second, structuralism is a calculated affront to common sense. . . . It does not take the text at face value, but 'displaces' it into a quite different kind of object. Third, if the particular contents of the text are replaceable, there is a sense in which one can say that the 'content' of the narrative is its structure.[8]

We might think about structuralism in the same way that we think about a sociology, in the sense that they are pseudo-sciences. Both attempt to find a rationalist, scientific basis for understanding human activities – social behavior in sociology's case, writing and speech in structuralism's. They are symptoms of a certain historical desire to make the realm of human activity a bit more neat, a bit more calculable.

Structuralism fits into another historical process as well, which is the gradual replacement of our faith in the obvious with an equally compelling faith in what is not obvious – in what can be uncovered or discovered through analysis. We might date this shift to Copernicus, who had the audacity to claim that the earth revolves around the sun even though it is obvious to all of us that the sun revolves around the earth, and does so once a day. To quote Eagleton:

> Copernicus was followed by Marx, who claimed that the true significance of social processes went on 'behind the backs' of individual agents, and after Marx Freud argued that the real meanings of our words and actions were quite imperceptible to the conscious mind. Structuralism is the modern inheritor of this belief that reality, and our experience of it, are discontinuous with each other.[9]

Poststructuralism, with Derrida, goes a step further. According to the poststructuralists, our perceptions only tell us about what our perceptions are, not about the true conditions of the world. Authors and other sign makers do not control their meanings through their intentions; instead, their meanings are undercut, or 'deconstructed,' by the texts themselves. Nor is there any way to arrive at the 'ultimate' meaning of anything. Meaning is always withheld, and to believe the opposite is tantamount to mythology. As Eagleton says, summarizing Derrida:

> Nothing is ever fully present in signs: it is an illusion for me to believe
> that I can ever be fully present to you in what I say or write, because
> to use signs at all entails that my meaning is always somehow dispersed,
> divided and never quite at one with itself. Not only my meaning, indeed,
> but *me*: since language is something I am made out of, rather than merely
> a convenient tool I use, the whole idea that I am a stable unified entity
> must also be a fiction. . . . It is not that I can have a pure, unblemished
> meaning, intention or experience which then gets distorted and refracted
> by the flawed medium of language: because language is the very air I
> breathe, I can never have a pure, unblemished meaning or experience
> at all.[10]

This inability to have 'a pure, unblemished meaning or experience at all,' is, I
would submit, exactly the premise of the art we call postmodernist. And, I would
add, it is the theme which characterizes most contemporary photography, explicitly
or implicitly. Calling it a 'theme' is perhaps too bland: it is the crisis which photog-
raphy and all other forms of art face in the late twentieth century.

But once we know postmodernism's theoretical underpinnings, how are we to
recognize it in art? Under what guise does it appear in pictures? If we return to
how postmodernism was first conceived in the art world of the 1970s – namely,
under the banner of pluralism – we can say quite blithely that postmodernist art is
art that looks like anything *except* modernist art. In fact, we could even concede that
postmodernist art could incorporate the modernist 'look' as part of its diversity.
But this pinpoints exactly why no one was ever satisfied with pluralism as a concept:
it may well describe the absence of a single prevailing style, but it does not describe
the *presence* of anything. A critical concept that embraces everything imaginable is
not of much use.

The critical theory descended from structuralism has a much better chance of
defining what postmodernist visual art should look like, but even with that there is
some latitude. Most postmodernist critics of this ideological bent insist that post-
modernist art be oppositional. This opposition can be conceived in two ways: as
counter to the modernist tradition, and/or as counter to the ruling 'mythologies'
of Western culture, which, the theory goes, led to the creation of the modernist
tradition in the first place. These same critics believe that postmodernist art there-
fore must debunk or 'deconstruct' the 'myths' of the autonomous individual
('the myth of the author') and of the individual subject ('the myth of originality').
But when we get to the level of *how* these aims are best accomplished – that is,
what style of art might achieve these ends – we encounter critical disagreement and
ambiguity.

One concept of postmodernist style is that it should consist of a mixture of
media, thereby dispelling modernism's fetishistic concentration on the medium as
message – painting about painting, photography about photography, and so on. For
example, one could make theatrical paintings, or filmic photographs, or combine
pictures with the written word. A corollary to this suggests that the use of so-called
alternative media – anything other than painting on canvas and sculpture in metal –
is a hallmark of the postmodern. This is a view that actually lifts photography up from
its traditional second-class status, and privileges it as the medium of the moment.

And there is yet another view that holds that the medium doesn't matter at all, that what matters is the way in which art operates within and against the culture. As Rosalind Krauss has written, 'Within the situation of postmodernism, practice is not defined in relation to a given medium – [e.g.,] sculpture – but rather in relation to the logical operations on a set of cultural terms, for which any medium – photography, books, lines on walls, mirrors, or sculpture itself – might be used.'[11] Still, there is no denying that, beginning in the 1970s, photography came to assume a position of importance within the realm of postmodernist art, as Krauss herself observed.[12]

Stylistically, if we might entertain the notion of style of postmodernist art, certain practices have been advanced as essentially postmodernist. Foremost among these is the concept of pastiche, of assembling one's art from a variety of sources. This is not done in the spirit of honoring one's artistic heritage, but neither is it done as parody. As Fredric Jameson explains in an essay called 'Postmodernism and Consumer Society':

> Pastiche is, like parody, the imitation of a peculiar or unique style, the wearing of a stylistic mask, speech in a dead language; but it is a neutral practice of such mimicry, without parody's ulterior motive, without the satirical motive, without laughter, without that still latent feeling that there exists something *normal* compared to which what is being imitated is rather comic. Pastiche is blank parody, parody that has lost its sense of humor. . . .[13]

Pastiche can take many forms; it doesn't necessarily mean, for example, that one must collage one's sources together, although Robert Rauschenberg has been cited as a kind of Ur-postmodernist for his combine paintings of the 1950s and photocollages of the early 1960s.[14] Pastiche can also be understood as a peculiar form of mimicry in which a simultaneous process of masking and unmasking occurs.

We can see this process at work in any number of artworks of the 1980s. One example is a 1982 painting by Walter Robinson titled *Revenge*. The first thing to be said about *Revenge* is that it looks like something out of a romance magazine, not something in the tradition of Picasso or Rothko. It takes as its subject a rather debased, stereotypical view of the negligee-clad *femme fatale*, and paints her in a rather debased, illustrative manner. We might say that it adopts the tawdry, male-dominated discourse of female sexuality as found at the lower depths of the mass media. It wears that discourse as a mask, but it wears this mask not to poke fun at it, nor to flatter it by imitation, nor to point us in the direction of something more genuine that lies behind it. It wears this mask in order to unmask it, to point to its internal inconsistencies, its inadequacies, its failures, its stereotypical unreality.

Other examples can be found in the paintings of Thomas Lawson, such as his 1981 canvas *Battered to Death*. Now nothing in this work – which depicts a blandly quizzical child's face in almost photo-realist style – prepares us in the least for the title *Battered to Death*. Which is very much to the point: the artist has used as his source for the portrait a newspaper photograph, which bore the unhappy headline that is the painting's title. The painting wears the mask of banality, but that mask is broken by the title, shifted onto a whole other level of meaning, just as it was

when it appeared in the newspaper. So this painting perhaps tells us something about the ways in which newspapers alter or manipulate 'objectivity,' but it also speaks to the separation between style and meaning, image and text, object and intention in today's visual universe. In the act of donning a mask it unmasks – or, in Derrida's terminology, it deconstructs.

There is, it goes without saying, a certain self-consciousness in paintings like these, but it is not a self-consciousness that promotes an identification with the artist in any traditional sense, as in Velasquez's *Las Meninas*. Rather, as Mark Tansey's painting *Homage to Susan Sontag* (1982) makes explicit, it is a self-consciousness that promotes an awareness of photographic representation, of the camera's role in creating and disseminating the 'commodities' of visual culture.

This self-conscious awareness of being in a camera-based and camera-bound culture is an essential feature of the contemporary photography that has come to be called postmodernist. In Cindy Sherman's well-known series *Untitled Film Stills*, for example, the 8-by-10-inch glossy is used as the model from which the artist manufactures a series of masks for herself. In the process, Sherman unmasks the conventions not only of *film noir* but also of woman-as-depicted-object. The stilted submissiveness of her subject refers to stereotypes in the depiction of women and, in a larger way, questions the whole idea of personal identity, male or female. Since she uses herself as her subject in all her, photographs, we might want to call these self-portraits, but in essence they deny the self.

A number of observers have pointed out that Sherman's imagery borrows heavily from the almost subliminal image universe of film, television, fashion photography, and advertising. One can see, for instance, certain correspondences between her photographs and actual film publicity stills of the 1950s. But her pictures are not so much specific borrowings from the past as they are distillations of cultural types. The masks Sherman creates are neither mere parodies of cultural roles nor are they layers like the skins of an onion, which, peeled back, might reveal some inner essence. Hers are perfectly poststructuralist portraits, for they admit to the ultimate unknowable-ness of the 'I.' They challenge the essential assumption of a discrete, identifiable, recognizable author.

Another kind of masking goes on in Eileen Cowin's tableaux images taken since 1980, which she once called *Family Docudramas*. Modeled loosely on soap-opera vignettes, film stills, or the sort of scenes one finds in a European *photo-roman*, these rather elegant color photographs depict arranged family situations in which a sense of discord and anxiety prevails. Like Sherman, Cowin uses herself as the foil of the piece, and she goes further, including her own family and, at times, her identical twin sister. In the pictures that show us both twins at once, we read the two women as one: as participant and as observer, as reality and fantasy, as anxious ego and critical superego. Cowin's work unmasks many of the conventions of familial self-depiction, but even more important, they unmask conventional notions of interpersonal behavior, opening onto a chilling awareness of the disparity between how we think we behave and how we are seen by others to behave.

Laurie Simmons's photographs are as carefully staged – as fabricated, as directorial – as those of Cindy Sherman and Eileen Cowin, but she usually makes use of miniaturized representations of human beings in equally miniaturized environments. In her early doll-house images, female figures grapple somewhat uncertainly with

the accoutrements of everyday middle-class life – cleaning bathrooms, confronting dirty kitchen tables, bending over large lipstick containers. Simmons clearly uses the doll figures as stand-ins – for her parents, for herself, for cultural models as she remembers them from the sixties, when she was a child growing up in the suburbs. She is simultaneously interested in examining the conventions of behavior she acquired in her childhood and in exposing the conventions of representations that were the means by which these behavior patterns were transmitted. As is true also of the work of Ellen Brooks, the doll house functions as a reminder of lost innocence.

The works of Sherman, Cowin, and Simmons create surrogates, emphasizing the masked or masking quality of postmodernist photographic practice. Other photographers, however, make work that concentrates our attention on the process of unmasking. One of these is Richard Prince, the leading practitioner of the art of 'rephotography.' Prince photographs pictures that he finds in magazines, cropping them as he sees fit, with the aim of unmasking the syntax of the advertising photography language. His art also implies the exhaustion of the image universe: it suggests that a photographer can find more than enough images already existing in the world without the bother of making new ones. Pressed on this point, Prince will admit that he has no desire to create images from the raw material of the physical world; he is perfectly content – happy, actually – to glean his material from photographic reproductions.

Prince is also a writer of considerable talent. In his book, *Why I Go to the Movies Alone*, we learn something of his attitudes toward the world – attitudes that are shared by many artists of the postmodernist persuasion. The characters he creates are called 'he' or 'they,' but we might just as well see them as stand-ins for the artist, as his own verbal masks:

> Magazines, movies, TV, and records. It wasn't everybody's condition but to him it sometimes seemed like it was, and if it really wasn't, that was alright, but it was going to be hard for him to connect with someone who passed themselves off as an example or a version of a life put together from reasonable matter. . . . His own desires had very little to do with what came from himself because what he put out (at least in part) had already been out. His way to make it new was *make it again*, and making it again was enough for him and certainly, personally speaking, *almost* him.

And a second passage:

> They were always impressed by the photographs of Jackson Pollock, but didn't particularly think much about his paintings, since painting was something they associated with a way to put things together that seemed to them pretty much taken care of.
>
> They hung the photographs of Pollock right next to these new 'personality' posters they just bought. These posters had just come out. They were black and white blow-ups . . . at least thirty by forty inches. And picking one out felt like doing something any new artist should do.

The photographs of Pollock were what they thought Pollock was about. And this kind of take wasn't as much a position as an attitude, a feeling that an abstract expressionist, a TV star, a Hollywood celebrity, a president of a country, a baseball great, could easily mix and associated together . . . and what measurements or speculations that used to separate their value could now be done away with. . . .

I mean it seemed to them that Pollock's photographs looked pretty good next to Steve McQueen's, next to JFK's, next to Vince Edwards', next to Jimmy Piersal's and so on. . . .[15]

Prince's activity is one version of a postmodernist practice that has come to be called appropriation. In intelligent hands like those of Prince, appropriation is certainly postmodernist, but is not the *sine qua non* of post-modernism. In certain quarters appropriation has gained considerable notoriety, thanks largely to works like Sherrie Levine's 1979 *Untitled (After Edward Weston)*, for which the artist simply made a copy print from a reproduction of a famous 1926 Edward Weston image (*Torso of Neil*) and claimed it as her own. It seems important to stress that appropriation as a tactic is not designed *per se* to tweek the noses of the Weston heirs, to *épater la bourgeoisie*, or to test the limits of the First Amendment. It is, rather, a direct, if somewhat crude, assertion of the finiteness of the visual universe. And it should be said that Levine's *tabula rasa* appropriations frequently depend on (one) their captions, and (two) a theoretical explanation that one must find elsewhere.

Those artists using others' images believe, like Prince, that it is dishonest to pretend that untapped visual resources are still out there in the woods, waiting to be found by artists who can then claim to be original. For them, imagery is now overdetermined – that is, the world already has been glutted with pictures taken in the woods. Even if this weren't the case, however, no one ever comes upon the woods culture free. In fact, these artists believe, we enter the woods as prisoners of our preconceived image of the woods, and what we bring back on film merely confirms our preconceptions.

Another artist to emphasize the unmasking aspects of postmodernist practice is Louise Lawler. While perhaps less well-known and publicized than Sherrie Levine, Lawler examines with great resourcefulness the structures and contexts in which images are seen. In Lawler's work, unlike Levine's, it is possible to read at least some of its message from the medium itself. Her art-making activities fall into several groups: photographs of arrangements of pictures made by others, photographs of arrangements of pictures arranged by the artist herself, and installations of arrangements of pictures.

Why the emphasis on arrangement? Because for Lawler – and for all post-modernist artists, for that matter – the meaning of images is always a matter of their context, especially their relations with other images. In looking at her work one often gets the feeling of trying to decode a rebus: the choice, sequence, and position of the pictures she shows us imply a rudimentary grammar or syntax. Using pictures by others – Jenny Holzer, Peter Nadin, Sherrie Levine's notorious torso of Neil – she urges us to consider the reverberations between them.

In James Welling's pictures yet another strategy is at work, a strategy that might be called appropriation by inference. Instead of representing someone else's image

they present the archetype of a certain kind of image. Unlike Prince and Lawler, he molds raw material to create his pictures, but the raw material he uses is likely to be as mundane as crumpled aluminum foil, Jelo, or flakes of dough spilled on a velvet drape. These pictures look like pictures we have seen – abstractionist photographs from the Equivalent school of modernism, for instance, with their aspirations to embody some essence of human emotion. In Welling's work, however, the promise of emotional expressionism is always unfulfilled.

Welling's pictures present a state of contradiction. In expressive terms they seem to be 'about' something specific, yet they are 'about' everything and nothing. In the artist's eyes they embody tensions between seeing and blindness; they offer the viewer the promise of insight but at the same time reveal nothing except the inconsequence of the materials with which they were made. They are in one sense landscapes, in another abstractions; in still another sense, they are dramatizations of the postmodern condition of representation.

The kind of postmodernist art I have been discussing is on the whole not responsive to the canon of art photography. It takes up photography because photography is an explicitly reproducible medium, because it is the common coin of cultural image interchange, and because it avoids the aura of authorship that poststructuralist thought calls into question – or at least avoids that aura to a greater extent than do painting and sculpture. Photography is, for these artists, the medium of choice; it is not necessarily their aim to be photographers, or, for most of them, to be allied with the traditions of art photography. Indeed, some of them remain quite happily ignorant of the photographic tradition. They come, by and large, from another tradition, one rooted theoretically in American art criticism since World War II and one rooted practically in conceptual art, which influenced many of them when they were in art school. But at least as large an influence on these artists is the experience of present-day life itself, as perceived through popular culture – TV, films, advertising, corporate logoism, PR, *People* magazine – in short, the entire industry of mass-media image making.

I hope I have made clear so far that postmodernism means something different to architects and dancers and painters, and that it also has different meanings and applications depending on which architect or dancer or painter one is listening to. And I hope that I have explained some of the critical issues of postmodernism as they have made themselves manifest in the art world, and shown how these issues are embodied in photographs that are called postmodernist. But there remains, for photographers, still another question: 'What about Heinecken?' That is to say, didn't photography long ago become involved with pastiche, appropriation, questions of mass-media representation, and so on? Wasn't Robert Heinecken rephotographing magazine imagery, in works like *Are You Rea?* (Fig. 18.1), as early as 1966, when Richard Prince was still in knickers?

To clarify the relationship between today's art world-derived postmodernist photography and what some feel are its undersung photographic antecedents, we need to consider what I would call photography's inherent strain of postmodernism. To do this we have to define photography's modernism.

Modernism in photography is a twentieth-century esthetic which subscribes to the concept of the 'photographic' and bases its critical judgments about what constitutes a good photograph accordingly. Under modernism, as it developed over the

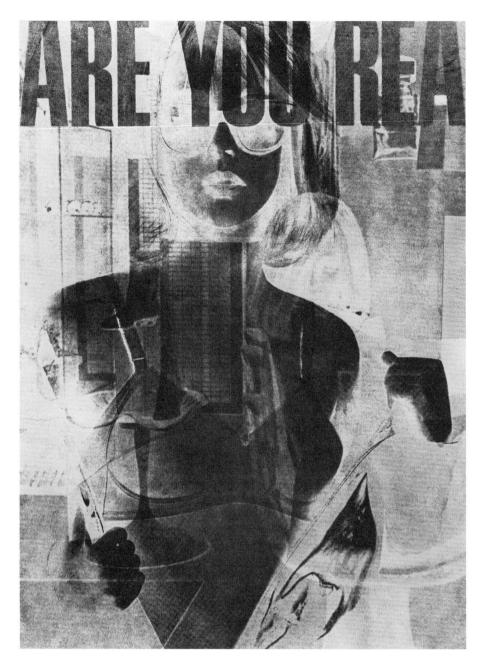

Figure 18.1 Robert Heinecken, *Are You Rea #1*. © 1966, Robert Heinecken. Courtesy Pace/MacGill Gallery, New York.

course of this century, photography was held to be unique, with capabilities of description and a capacity for verisimilitude beyond those of painting, sculpture, printmaking, or any other medium. Modernism in the visual arts valued (I use the past tense here partly as a matter of convenience, to separate modernism from post-modernism, and partly to suggest modernism's current vestigial status) the notion that painting should be about painting, sculpture about sculpture, photography about photography. If photography were merely a description of what the pyramids along the Nile looked like, or of the dissipated visage of Charles Baudelaire, then it could hardly be said to be a form of art. Modernism required that photography cultivate the photographic – indeed, that it invent the photographic – so that its legitimacy would not be questioned.

In a nutshell, two strands – Alfred Stieglitz's American Purism and László Moholy-Nagy's European experimental formalism – conspired to cultivate the photographic, and together they wove the shape of modernism in American photography. Moholy, it should be remembered, practically invented photographic education in America, having founded the Institute of Design in Chicago in the 1930s. As the heritage of Stieglitzian Purism and Moholy's revolutionary formalism developed and coalesced over the course of this century, it came to represent photography's claim to be a modern art. Ironically, however, just at the moment when this claim was coming to be more fully recognized by the art world – and I refer to the building of a photographic marketplace in the 1970s – the ground shifted underneath the medium's feet.

Suddenly, it seemed, artists without any allegiance to this tradition were using photographs and, even worse, gaining a great deal more attention than traditional photographers. People who hardly seemed to be serious about photography as a medium – Rauschenberg, Ed Ruscha, Lucas Samaras, William Wegman, David Haxton, Robert Cumming, Bernd and Hilla Becher, David Hockney, etc., etc. – were incorporating it into their work or using it plain. 'Photographic-ness' was no longer an issue, once formalism's domain in the art world collapsed. The stage was set for what would come next; what came next we now call postmodernism.[16] Yet one can see the seeds of a postmodernist attitude within what we think of as American modernist photography, beginning, I would argue, with Walker Evans. However much we admire Evans as a documentarian, as the photographer of *Let Us Now Praise Famous Men*, as a 'straight' photographer of considerable formal intelligence and resourcefulness, one cannot help but notice in studying his work of the 1930s how frequently billboards, posters, road signs, and even other photographs are found in his pictures.

It is possible to believe, as some have contended, that these images within Evans's images are merely self-referential – that they are there to double us back and bring us into awareness of the act of photographing and the two-dimensional, cropped-from-a-larger-context condition of the photograph as a picture. But they are also there as signs. They are, of course, signs in the literal sense, but they are also signs of the growing dominion of acculturated imagery. In other words, Evans shows us that even in the dirt-poor South, images of Hollywood glamour and consumer pleasures – images designed to create desire – were omnipresent. The Nehi sign Evans pictured was, in its time, as much a universal sign as the Golden Arches of hamburgerland are today.

Evans's attention to signs, and to photography as a sign-making or semiotic medium, goes beyond the literal. As we can see in the images he included in *American Photographs*, and in their sequencing, Evans was attempting to create a *text* with his photographs. He in fact created an evocative nexus of signs, a symbology of things American. Read the way one reads a novel, with each page building on those that came before, this symbology describes American experience as no other photographs had done before. And the experience Evans's opus describes is one in which imagery plays a role that can only be described as political. The America of *American Photographs* is governed by the dominion of signs.

A similar attempt to create a symbolic statement of American life can be seen in Robert Frank's book *The Americans*. Frank used the automobile and the road as metonymic metaphors of the American cultural condition, which he envisioned every bit as pessimistically as today's postmodernists. While not quite as obsessive about commonplace or popular-culture images as Evans, he did conceive of imagery as a text – as a sign system capable of signification. In a sense, he gave Evans's take on life in these United States a critical mass of pessimism and persuasiveness.

The inheritors of Frank's and Evans's legacy adopted both their faith in the photograph as a social sign and what has been interpreted to be their skeptical view of American culture. Lee Friedlander's work, for example, despite having earned a reputation as formalist in some quarters, largely consists of a critique of our conditioned ways of seeing. In his picture *Mount Rushmore, South Dakota*, we find an amazingly compact commentary on the role of images in the late twentieth century (Fig. 18.2). Natural site has become acculturated sight. Man has carved the mountain in his own image. The tourists look at it through the intervention of lenses, like the photographer himself. The scene appears only as a reflection, mirroring or doubling the condition of photographic appearances, and it is framed, cropped by the windows, just like a photograph.

Although Friedlander took this picture in 1969, well before anyone thought to connect photography and postmodernism, it is more than a modernist explication of photographic self-referentiality: I believe it also functions critically in a postmodernist sense. It could almost be used as an illustration for Jean Baudrillard's apocalyptic statement, 'For the heavenly fire no longer strikes depraved cities, it is rather the lens which cuts through ordinary reality like a laser, putting it to death.'[17] The photograph suggests that our image of reality is made up of images. It makes explicit the dominion of mediation.

We might also look again at the work of younger photographers we are accustomed to thinking of as strictly modernist. Consider John Pfahl's 1977 image *Moonrise over Pie Pan*, from the series *Altered Landscapes*. Pfahl uses his irrepressible humor to mask a more serious intention, which is to call attention to our absence of innocence with regard to the landscape. By intervening in the land with his partly conceptual, partly madcap bag of tricks, and by referencing us not to the scene itself but to another photograph, Ansel Adams's *Moonrise over Hernandez*, Pfahl supplies evidence of the postmodern condition. It seems impossible to claim in this day and age that one can have a direct, unmediated experience of the world. All we see is seen through the kaleiodoscope of all that we have seen before.

So, in response to the Heinecken question, there is abundant evidence that the photographic tradition incorporates the sensibility of postmodernism within its late

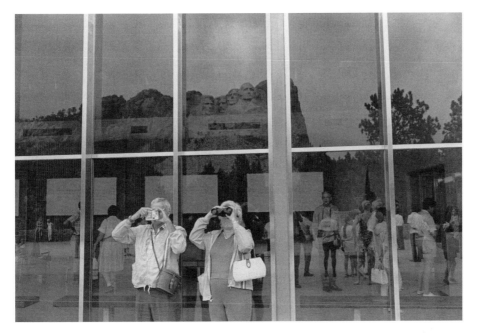

Figure 18.2 Lee Friedlander, *Mount Rushmore, South Dakota*, 1969. Courtesy of the artist and the Fraenkel Gallery, San Francisco.

or high modernist practice. This overlap seem to appear not only in photography but in the painting and sculpture tradition as well, where, for example, one can see Rauschenberg's work of the 1950s and 1960s as proto-postmodern, or even aspects of Pop Art, such as Andy Warhol's silkscreen paintings based on photographs.[18] Not only did Rauschenberg, Johns, Warhol, Lichtenstein, and others break with Abstract Expressionism, they also brought into play the photographic image as raw material, and the idea of pastiche as artistic practice.

It seems unreasonable to claim, then, that postmodernism in the visual arts necessarily represents a clean break with modernism – that, as Douglas Crimp has written, 'Post-Modernism can only be understood as a specific breach with Modernism, with those institutions which are the preconditions for and which shape the discourse of Modernism.'[19] Indeed, there is even an argument that postmodernism is inextricably linked with modernism – an argument advanced most radically by the French philosopher Jean François Lyotard in the book *The Postmodern Condition: A Report on Knowledge*:

> What, then, is the Postmodern? . . . It is undoubtedly a part of the modern. All that has been received, if only yesterday . . . must be suspected. What space does Cézanne challenge? The Impressionists. What object do Picasso and Braque attack? Cézanne's. What presupposition does Duchamp break with in 1912? That which says one must make a painting. . . . *A work can become modern only if it is first postmodern.* Postmodernism thus understood is not modernism at its end but in the nascent state, and this state is constant.[20]

It is clear, in short, that postmodernism as I have explained it — not the post-modernism of pluralism, but the postmodernism that seeks to problematize the relations of art and culture — is itself problematic. It swims in the same seas as the art marketplace, yet claims to have an oppositional stance toward that marketplace. It attempts to critique our culture from inside that culture, believing that no 'outside' position is possible. It rejects the notion of the avant garde as one of the myths of modernism, yet in practice it functions as an avant garde. And its linkage to linguistic and literary theory means that its critical rationale tends to value intellect more than visual analysis. But for all that, it has captured the imagination of a young generation of artists. And the intensity of the reactions to postmodernist art suggests that it is more than simply the latest fashion in this year's art world.

Many people, photographers among them, view postmodernism with some hostility, tinged in most cases with considerable defensiveness. I suspect that the problem for most of us with the idea of postmodernism is the premise that it represents a rupture with the past, with the traditions of art that most of us grew up with and love. But it is only through considerable intellectual contortions that one can postulate so clean a break. One has to fence in modernism so tightly, be so restrictive about its practice, that the effort hardly seems worthwhile. So perhaps, *contra* Crimp, we can find a way to conceive of postmodernism in a way that acknowledges its evolution from modernism but retains its criticality.

One of the ways we might do this is by shifting the ground on which we define postmodernism from questions of style and intention to the question of how one conceives the world. Postmodernist art accepts the world as an endless hall of mirrors, as a place where all we *are* is images, as in Cindy Sherman's world, and where all we *know* are images, as in Richard Prince's universe. There is no place in the postmodern world for a belief in the authenticity of experience, in the sanctity of the individual artist's vision, in genius or originality. What postmodernist art finally tells us is that things have been used up, that we are at the end of the line, that we are all prisoners of what we see. Clearly these are disconcerting and radical ideas, and it takes no great imagination to see that photography, as a nearly indiscriminate producer of images, is in large part responsible for them.

Notes

1 Jean Baudrillard, *Simulations*, trans. Paul Foss, Paul Patton, and Philip Beitchman (New York: Foreign Agents Series/Semiotext(e), 1983), 25.

2 In his classic text, *The History of Photography from 1839 to the Present*, Newhall uses the technological development of the medium as a model for describing its esthetic tradition. In other words, by his account the artistic practice of photography progresses in an ascending curve from its primitive beginnings to an apotheosis in the High Modernism of the 1930s. As a result, in his 1983 revision of the history (Museum of Modern Art, New York) Newhall is unable to account coherently for photography's path since. Anything after Weston and Cartier-Bresson is, in his eyes, *prima facie* 'post.'

3 I have been unable to ascertain a 'first use' of the term *Post modern*, which is also encountered as *Postmodern* or *Post-modern*, but it almost certainly dates from the late 1960s. In architecture, it is most often associated with Robert Venturi, the advocate

of vernacular forms. In 'On the Museum's Ruins' (*October* 13), Douglas Crimp cites the usage of 'postmodernism' by the art critic Leo Steinberg in 1968, in Steinberg's analysis of the paintings of Robert Rauschenberg. But the term's popularity in the art world came much later; as late as 1982 John Russell of *The New York Times* could call postmodernism 'the big new flower on diction's dungheap' (August 22, 1982, Section 2, p. 1).

4 Charles Jencks, *The Language of Post-Modern Architecture* (New York: Rizzoli International Publishers, 1981), 5.

5 See Sally Banes, *Terpsichore in Sneakers: Post-Modern Dance* (New York: Houghton-Mifflin, 1980), 1–19.

6 Douglas Crimp, 'The Museum's Old, the Library's New Subject,' *Parachute* 22 (Spring 1981): 37.

7 See Derrida's seminal work, *Writing and Difference* (Chicago: University of Chicago Press, 1978), a collection of eleven essays written between 1959 and 1966.

8 Terry Eagleton, *Literary Theory: An Introduction* (Minneapolis: University of Minnesota Press, 1983), 96.

9 Ibid., 108.

10 Ibid., 129–30.

11 Rosalind Krauss, 'Sculpture in the Expanded Field,' *October* 8 (Spring 1979): 42.

12 'If we are to ask what the art of the '70s has to do with all of this, we could summarize it very briefly by pointing to the pervasiveness of the photograph as a means of representation. It is not only there in the obvious case of photo-realism, but in all those forms which depend on documentation – earth-works . . ., body art, story art – and of course in video. But it is not just the heightened presence of the photography itself that is significant. Rather it is the photograph combined with the explicit terms of the index.' Rosalind Krauss, 'Notes on the Index: Part 1,' *October* 3 (Spring 1977): 78.

13 Fredric Jameson, 'Postmodernism and Consumer Society,' in *The Anti-Aesthetic: Essays on Postmodern Culture*, ed. Hal Foster (Port Townsend, Wash.: Bay Press, 1983), 114.

14 See, for example, Douglas Crimp's essay 'Appropriating Appropriation,' in the catalogue *Image Scavengers* (Philadelphia: Institute of Contemporary Art, 1982), 33.

15 Richard Prince, *Why I Go to the Movies Alone* (New York: Tantam Press, 1983), 63 and 69–70.

16 A more elaborated and political view of art photography's waning dominion can be found in Abigail Solomon-Godeau's 'Winning the Game When the Rules Have Been Changed: Art Photography and Postmodernism,' *New Mexico Studies in the Fine Arts*, reprinted in *Exposure* 23:1 (Spring 1985): 5–15, cf. Ch. 17 in this volume, pp. 152–163. [Ed.].

17 Baudrillard, *Simulations*, 51.

18 For further evidence of photographic imagery's impact on Pop and concurrent movements see the catalogue to the show 'Blam,' organized by the Whitney Museum, which surveyed the art of the sixties.

19 Douglas Crimp, 'The Photographic Activity of Postmodernism,' *October* 15 (Winter 1980): 91.

20 Jean François Lyotard, *The Postmodern Condition: A Report on Knowledge*, trans. Geoff Bennington and Brian Massumi (Minneapolis: University of Minnesota Press, 1984), 79. The emphasis is mine.

Steve Edwards

SNAPSHOOTERS OF HISTORY
Passages on the postmodern argument

The postmodern world from within

IN THE SHOP BELOW MY FLAT stand two medium sized trees. Between them is a sign which reads:

'We are approved stockists & installation specialists for the Rain Forest range of artificial foliage. The lifelike appearance of this range includes the natural stem trees together with sophisticated photographic techniques for printing the image of the original leaf on fabric. Overcome the problems of maintenance, changing, temperatures & lighting which are experienced with live plants.'

Nature is photographically transformed into its opposite. This artificial rain foliage is part of the dense and nihilistic forest of signs that make up the postmodern condition. For in our age the mass media saturates all experience. We live in, and through, this network of signs. Information swirls around us in a vast process of exchange, no longer coming to rest on an object. This media(ted) exchange creates the objects of our knowledges, calls up our desires and frees us from our illusions of coherence. It is clear, according to Lyotard and others, that information is the principle force of production. They claim our world is that of the simulacrum – the exact copy of that which has never existed.

The postmodern media form a huge sphere. or perhaps a double helix: for if our knowledges are produced by this circulation of mass media signs (and from where else could they originate?) then it is clear that the knowledge generating machine is itself always already media(ted). We live not in some world prior to representation that is then expressed, reflected or articulated at some other level. There is nothing any more but surface. Representation is all there is and can ever be. There, simply, can be no outside to this endless round of meaningless meaning. What we experience as reality is, in reality, the reality effect. The age of a life beyond the image has gone forever. Now, all we can know are media projections; the beams of flickering images, and the whirr of tape heads. As Lyotard has argued,

'Data banks are the Encyclopedia of tomorrow. They are "nature" for postmodern man.'[1] Abandoning our nostalgia for the fixed and the stable we should grasp the possibilities offered by the fluid subject and cast off the barriers to our desires. Following Baudrillard[2], television can be seen as the direct prefiguration of what this subject might be, creating and recreating itself in the flow of signs like flicking stations. But while T.V. with its multiple channels may provide a useful model for thinking through this transformation, photography waits in the wings.

If we take, for instance, that manual of the postmodern – *The Next Directory* – we can see how photography constructs for us, in full simulated colour, worlds without origin or end. Here the popular apes high culture, draped in quality, authenticity and class. As we flip the pages multiple identities whizz past our eves. Distance and depth collapse into the intricate and exquisite surface of the image. What is there now to prevent us switching back and forth between these marvellous identities. She: now sipping tea on the lawn of the country seat, bathed in golden light, 'well-dressed, well-bred,' in that 'endless summer.' Now the belle of the southern states, young and raw, perhaps with an illicit negro love. Now the cultured woman, on her travels through Europe in search of adventure. He: from big city gentleman, to rugged biker, to the fictions of Havana. These are the worlds that the photograph has to offer. Back and forth, one on one day, another the next. Extending in all directions, like the great nineteenth-century department stores, growing section by section, and producing ordering knowledges in the process. We dwell inside the directory, within a set of photographs whose boundaries frame us. Our only choice is between its choices, we have no choice but to consume . . . or so the argument goes.

Snaps for the album

It's impossible to enter the field of cultural debate in the 1980s without encountering the 'Postmodern': however, this does not grant the argument immunity from criticism.[3] The all-encompassing world of the *Directory*, for example, is in some difficulty, with Next's profits down by £12 million, its standing on the stock market at a low and its founder and guru removed from the Board of Directors. Postmodernism needs to be scrutinised rather than assumed precisely because in practice and theory its positions are produced, distributed and consumed on industrial proportions. So that by the time this essay appears another half dozen important works will already be on the shelves. This is to say that the themes of postmodernism have attained the status of 'radical' common sense. While some of this work has been productive, particularly in relation to gender and race, exposing many reactionary assumptions as cultural productions, increasingly it has come to silence other arguments. Or, in the parlance of the moment, it attributes to them the prefix *post*. Postmodernism's radical credentials go unquestioned. But as Dews has argued: 'while there has often been *a de facto* alliance between the intellectual left and recent French theory, with post-structuralism providing tools of analysis which have been widely applied, there has sometimes been little attempt to think through the ultimate compatability of progressive political commitments with the dissolution of the subject, or a totalising suspicion of the concept of truth.'[4]

We need, then, to attempt to freeze this flow in order to examine, frame by frame, the assumptions of postmodernism. To ask why modernism has been abandoned with such undignified haste.

Photographs without objects

In an often cited text, 'The originality of the Avant-Garde: A Postmodern Repetition',[5] Rosalind Krauss argues that to perceive a landscape as picturesque is (obviously) to see it as a picture. As such the picturesque is always prefigured, always already, an image. But this notion of the copy, she believes, is a home truth rigorously repressed by modernism which always seeks to construe itself as a practice which grasps the original moment. The truly radical question would be what constitutes a discourse of reproduction without an original? Answer – Sherrie Levine.

For if Levine re-presents facsimiles of Eliot Porter's landscapes, are we not then in the presence of images of images of images . . . Levine's public exhibition of her copies of other photographers' work, for the theorists of postmodernism, is a move which opens up to question the sanctity of the author as origin. For who is the author of Levine's work?

Levine and her compatriots – Vikky Alexander, Sylvia Kolbowski, Barbara Kruger, Richard Prince, Cindy Sherman and one could add, the Burgin school in Britain – are seen to question the assumed idea that photographs depict some pro-filmic event. Their's is a practice which is fundamentally cynical to the claims that there is a world prior to the shutter, or a meaning authorised by the artistic subject. This group of artist-photographers concentrate on media images, working on their categories, tropes, epistemes. According to the postmodern argument the mass media produce our knowledges and desires. Any political project which would wish to re-route those definitions must, then, compete on this terrain.

Of this group Sherman's work is probably the best known in Britain. In a range of 'Film Stills' she has anatomised the media ideologies of 'feminity'. She pictures herself in the roles presented for woman; as virgin/whore, starlet/housewife, and so on. Each of these pictures is staged with great detail and attention to the codes, so that taken together they display a set of ideological spaces and invite us to ask, 'Which is the real Cindy Sherman?'

In the recent exhibition of portraits by Mapplethorpe at the National Portrait Gallery, a soft and diffuse picture of Sherman operated as a kind of banana skin under the institution's master-plan to cast Mapplethorpe as Cecil Beaton for the 1980s. For given Sherman's own practice, why should we be prepared to accept this image of her (and by extension any of the other pictures) as either privileged or loaded with authorial integrity.

We needn't disagree with the postmodernist description of Sherman. Her attention to the sense of ambiguity between the identity of woman and the signs which locate her is undoubtedly productive: it depicts just how limited and limiting these possibilities are. We encounter a difficulty when a critic like Douglas Crimp wishes to claim that Sherman isn't acting a role but is. in fact, a role or a series of roles.[6] And this reveals the fiction of all selves. But if all subjects are fictions then by definition there can be nothing special about Sherman's work. At best it is just less

deluded. The real problem, however, arises when the particulars of Sherman's prac-
tice are extended to form a generalised model of culture (while simultaneously, the
cultural form of the age always boils down to three or four photographers).
Ultimately it's their own method which produces this closure. Because, for the
shock troops of the postmodern transformation, there is no outside to representa-
tion. If our ideas and knowledges are products of texts then everything is framed
by representation, and there is no limit to this framing. Any attempt to find some
prior space of meaning can only be a naive illusion. All is just an image. A discourse
of representations without origins: or rather, representations that are now theo-
rised as origins. For we are within the realm of the reality effect. The photographer
doesn't capture an image of the world on celluloid, only an image of that which is
already an image. Yve Lomax suggests:

> If the photograph ceases to refer to the real world; if the photograph no
> longer points to that which we assumed is beyond the frame which
> photography snaps; if the outside of the frame ceases to be the photo-
> graph's reference point, in what terms can we constitute to speak of
> representation?[7]

Saussure's shock troops

The category postmodernism should not simply be assumed to be a descriptive
label, but needs to be perceived as the product of a certain theory of representa-
tion. In the tradition of Saussurian linguistics meaning can only be produced internal
to the formal system (or, in post-structuralism, in its breakdown). The Swiss linguist
Ferdinand De Saussure argued that traditional theories of language assumed some
necessary connection between a word and object; in this sense they were adamic,
with god assigning names. What Saussure did was to point out that language is arbi-
trary, having no necessary connection to that which it is assumed to refer. This gives
rise to a problem: if words (or more specifically signs) are products of convention,
then how can language be understood? Saussure's solution was to argue that language
is a formal, self-regulating, system in which difference constitutes sense. We under-
stand the word *cat* because it's not *bat* or *can*. This formal and autonomous system
necessitated, at the level of abstraction at least, the privileging of *langue* (system)
over *parole* (actual language use).

Saussure continued to believe that the sign was linked to the signified (the
intended meaning) like two sides of a sheet of paper. Built into this theory, however,
is an inherent instability. For if meaning is produced by the movement from sign
to sign (difference) rather than from sign to object (reference), then there is no way
to prevent some smart theorist (enter Jacques Derrida) from severing the link
between signifier and signified and asserting pure difference. Language, or any other
system of signs, then becomes not only arbitrary but autonomous.

Representation. in this argument, then ceases to refer to anything but itself. As
Terry Eagleton has argued the Saussurian sign is best understood on the models of
the commodity which represses the marks of its production in order to present itself
as pure and unmediated exchange.[8]

Once this model has been set up representation can be perceived as an infinitely flexible, infinitely unstable system in which meanings slip and slide. With no external world to anchor meaning signification can never be exhausted; there are always more possible readings and none of these can be privileged over others. Any attempt to introduce a prior reality to stabilise this flow of signification is not only vain but a terroristic attempt to smuggle in a 'transcendental signified'. [. . .] Don Slater writes in this vein: 'Behind the photograph there is no real object, only another image (even if this "image" happens to be in the form of a commodity, or art unemployment figure, or a Falklands war). We consume photographs of photographs of photographs . . .'[9]

We need grasp, however, that this is a particular theory of language, not a self-evidently correct argument. Nor is it even necessarily the best theory, but simply one which, for a number of historical reasons, has come to be seen as the model. The commitment to repressing the referential dimensions of representation could only result in severing the links between language and the world to the extent that a 'megalomania of the signifier' develops. All other social activities become explained by reference to this linguistic model.[10] Thus, post-Saussurian linguistics which weaken any notion of cause condemn us to dwell in a world of eternal now. This conventionalism can be seen as the fundamental reason why postmodernist critique has been confined to the ideological. Any attempt at a systematic critique of postmodernism requires the elaboration of a different theory of representation. I do not intend, in this short piece, to deal with that key question beyond indicating that a sophisticated theory of this kind already exists in the work of the Bakhtin School.[11] This group of Soviet semioticians working in the 1920s treated representation not as a fixed and immutable practice but, by refusing to elevate *langue* over *parole*, insisted that meaning was bound to definite historical contexts. In this theory language works, not as some kind of indeterminate play, but as a dynamic set of social representations. Meaning in Bakhtin's argument cannot be infinite because it is bound to historical blocks and conflictual social forces; it cannot spiral or plummet beyond their protocols. For Bakhtin representation may be problematic (it's certainly never self-evident) but the problematic is not the same as chaos.

A flat world rediscovered

According to Baudrillard and other doyens of postmodernism, representation doesn't distort or reflect, re-present or articulate some prior reality: it's all there is. This move signals a fundamental transformation in the way society is thought about. While we have traditionally considered representations in relation to some other prior realm which could be seen to hold the key to their secrets, postmodernism operates with a flat earth theory: a conception which Fredric Jameson has called 'the disappearance of the depth model'.[12] Within theories based upon deep structure, discourses have been explained by reference to some other theory which is perceived not as a discourse but as truth itself. In this way discourses could be looked through, as if they were transparent: documentary photography stands as the obvious example. But it is precisely these meta-narratives, the theories which claim universal validity and hence the ability to render the truth of representation,

which for postmodernists have to be abandoned. Now we are told there is only surface. The meta-narrative has become the very paradigm of metaphysics which attempts to deny the problematic status of representation by smuggling in some prior unmediated instance (the transcendental signifier).

Thus the depth-model has come to be seen as a kind of terrorism that seeks to halt the inevitable play of difference by claiming some fictitious universal knowledge. Lyotard argues. 'I will use the term *modern* to designate any science that legitimates itself with reference to a metadiscourse of this kind, making an explicit appeal to grand narrative: such as the dialectics of Spirit, the hermeneutics of meaning, the emancipation of the rational or the working subject, or the creation of wealth.[13]

For the postmodernist the key theorisations of the modern world are either no longer valid, or else were always fictions (according to whom you read). For example, Lyotard argues that it is impossible for any one person to now master the proliferation of machine languages; therefore humanist or speculative knowledge is forced to abandon its legitimation duties.[14] Any claim to be able to interpret representations by reference to some deeper level of meaning is seen as an illusion. While Marxism and psychoanalysis are the obvious targets of this polemic, photography also stands accused. If the surface is all there is, if what you see is what you get, then any claim of a photographic dialogue with the world is an illusion. If meaning is constructed within the frame, photography turns out to be far more deluded than art. Philosophy is dethroned by the young pretender literature. It might be noted, however, that whilst this kind of post-structuralist/postmodernist argument presents itself as the latest or even the last word in philosophical chic, these debates are little more than a re-run of phenomenological or analytic language philosophy, where they were presented with a greater sense of modesty.

The postmodern assault on the idea of the meta-narrative includes an attack on totality – the idea that all can be grasped through some great single theory of society. Postmodernists argue that the notion of this totalising discourse represses social differences: it produces a terrible homogeneity, a singularity in whose name dissent and difference are persecuted. We are told that the radical way out of this problem is to embrace pluralism and respect difference. This is a cultural politics that would have its audience identify with the oppressed and the 'marginalised'. It invites us to join them in a manner which solicits liberal guilt. Part of the postmodern argument, then, cancels Brecht's theory of alienation (or disidentification) which sought to provide a critical distance between audience and narrative. With the collapse of that distance, the notion of a totalising theory which might critically reposition those forms of oppression and marginality is itself rendered as a form of totalitarian power. As Lyotard wrote in 1979, 'In any case, there is no question here of proposing a "pure" alternative to the system: we all know, as the 1970s come to a close, that an attempt at an alternative of that kind would end up resembling the system it was meant to replace.'[15] This is another sign of the swing to the right by the Parisian intelligentsia.

All we have left is a pragmatics of representation, a kind of listing of differences to be imaged. This one is Tagg's: '. . . men and women, black and white, working class and middle class, manual and mental workers, able bodied and disabled, young and old, and so on . . .'[16]

It is important to stress just how productive this conception of difference has been. As a theoretical category, difference has enabled us to blast apart so many received, homogenous notions, and to call into question the idea of a singular audience or unified work. It has allowed us to operate with a set of social registers too often ignored by a conception of class as a necessary unity. But ultimately, it must be said, difference remains a theoretical term embedded in liberalism. The politics it produces are the politics of pluralism.

The central tenet of this flat field is that none of these differences is any more fundamental than any other. Each is equally productive of meaning, while any attempt to elevate some over others is repressive. While on the one hand, it's apparent that these differences can occur in limitless combinations, recreating the individual subject, the real difficulty with the argument lies in the opposite direction – in the abandonment of agency. If the subject is simply a product of discourse, then conscious action disappears into the discursive. The crisis of certain theories of the subject is seen as the death of the subject. Instead we concentrate on unpacking representation in an (idealist) belief that the subject can thus be reformed.

Without depth the play of representation can be endless. The need for tactical thinking disappears into the freeplay of difference. Unity is perceived as homogeneity, internationalism as universalism. Postmodernism rubs shoulders with a rediscovered notion of the market. While Baudrillard announces the end of the social, Margaret Thatcher pronounces there is no society. This abandonment of social transformation has inclined postmodernists to search for dissipation and difference, for ways of surviving under capitalism. They have developed a politics which has annexed the ideas of feminism and at the same time abandoned the concept of liberation: this seems to me one of the most dangerous effects of the postmodern rhetoric. To disagree that the world isn't flat has come to be seen by many cultural workers as a sign of masculine terrorism. Nothing could be more terroristic.

A commitment to social transformation, however, necessitates tactical thinking, and this means we have to locate some agency capable of carrying through this project. Whilst the kinds of difference of which postmodernists speak might be a fine democratic ideal, the problem remains how to face a highly organized, disciplined and motivated state with a hippy notion of spontaneous difference. Marxists, on the other hand, have traditionally argued that the working class, because of its potential cohesion and possible structural power, constitutes the indispensable agency of socialism. Postmodernism seems incapable of grasping how this class can be simultaneously fractured and yet totalised by its conditions of existence. How to think this problem through remains the base-line for any left photographic practice.

While philosophical ideas cannot be proved, they can be tried out in practice. But this necessitates long durations if research programmes are not to be abandoned at the first hurdle. As such, we need to consider theories in relation to various possible contingencies. This might be stated as a theory of plausibility. Postmodernism can grip the intelligentsia in periods of Thatcherite offensive, for instance, but can't think the conditions under which it would be implausible. The return of a counter-offensive remains, forever, its structured absence. In this sense postmodernists are 'blind' to the historical determinants of their own discourse. The outcome of this failure to historicise their own practice means, of necessity, they misrecognise their dilemmas, their *imaginaire* as the (post) modern condition.

They misread their inability to produce a discourse which fastens onto the real as the impossibility of realism. They misconstrue their inability to hold onto history as society's loss of history. By a peculiar route we come back to the traditional intellectuals' universalisation of their crisis as the crisis of all knowledge.[17]

The Baudrillard effect

Probably nothing stands in the postmodernist phantasmagoria quite like the Centre Georges Pompidou (Beaubourg). Important to this mytheme is Baudrillard's essay 'The Beaubourg Effect.'[18] For Baudrillard, the Beaubourg Centre is a condensation of key postmodern themes: a monumental cultural and social implosion which causes a vacuum of meaning. It is a kind of mediated black hole which draws in society, only to turn it inside out, creating an arch simulacrum: a copy of meanings and experiences that have no originals. He describes it thus: 'A monument to mass simulation effects, the Centre functions like an incinerator, absorbing and devouring all cultural energy, rather like the black monolith of 2001 – a mad convection current for the materialisation, absorption, and destruction of all the contents within it.'[19]

This vacuum-making machine functions like a nuclear power centre, where the real threat is not from pollution or explosion but from 'the maximum security system that radiates from it.'

The Centre, operating as a kind of cultural fission, draws in resistance only to crush it under the weight of its overbearing and repressive structures. In this way, it becomes the very model of political deterrence. It is a machine of power or total mechanism of control to which there can be no outside, no alternative space from which to read, no other uses. And yet, in Mike Baldwin's television broadcast for the Open University[20] which is closely based on this analysis, as he describes this strategic response to the radical movements of 1968, this monument to discussion, there ascending the escalator is the socialist historian of photography André Rouillé.[21]

Thus we have one of the key contradictions of postmodernist theory and practice. For if a Baudrillard here, or a Foucault there, tells us that power is total and always present, if the subject is constituted by the relations of power, and the wish for a pure space on its outside is a dream, then from what space do they write? How does Baudrillard get outside to look in? This a real problem of knowledge that has bedeviled the cultural left at least since Althusser. Unless a theoretical system has built contradiction into it as the possible site of resistance, the author's own space of opposition becomes a mystery.

The solution to this dilemma, as far as postmodernism is concerned, is through a slip of the word-processor. It always turns out that there is some contradiction in the apparatus of power which causes it to implode. In this case:

> Happily, this whole simulacrum of cultural values is undermined from the very outset by the architectural shell . . . This thing openly declares [that] our only culture is basically that of hydrocarbons – that of refining molecules, and of their recombination into synthetic products. This Beaubourg-Museum wants to hide, but Beaubourg-Carcass proclaims it.

And here, truly, is the source of the shell's beauty and the disaster of the interior spaces. The very ideology of "cultural production" is, in any case, antithetical to culture, just as visibility and multi-purpose spaces are: for culture is a precinct of secrecy, seduction, initiation, and symbolic exchange, highly ritualised and restrained. It can't be helped. Too bad for populism. Tough on Beaubourg.[22]

This is the postmodern theorists' small print. This is the point at which their research programme comes into contradiction with the way people live social relations. Rather than abandon the method as untenable, they fudge, and introduce an *ad hoc* escape clause to exempt themselves from the 'logic' of their own constructs. Having totalised power so that it constitutes the objects of knowledge, not only within discourse but as real objects, postmodernism has become unable to explain resistance. How well Marx's notion of contradictory material interests fares in the face of this anarcho-Nietzchean 'will-to-power,' that at present characterises postmodernist politics.

Modernism's other, enlightenment's opposite

To speak of postmodernism means that we have some idea of that which has been superseded – modernism. However, the problem is that there have been a multiplicity of modernisms. Which one is selected depends on medium and a set of ideological resonances: Joyce or Kafka, Schoenberg or Stravinsky, Moholy-Nagy or Rodchenko, Modetti or Weston. . . .

The track that postmodernists usually take through the minefield of visual modernism is heavily indebted to the art critic Clement Greenberg. Greenberg's particular research programme gained a pre-eminence in the post-war art schools. Stressing that which separated painting from the other arts he came increasingly to emphasize the medium's formal characteristics, primarily its flatness. His was also a historicist method in which end is already inscribed in origin. Whilst the narrative may begin with Manet it is always destined to come to rest in the studio of Jackson Pollock. Like all forms of historicism, Greenberg's reading of art history is incredibly selective; it is instructive as much for what it excludes as includes. In fact Greenberg's story of art depends on the particular axis Paris/New York.

If we take an alternative pathway through the culture of modernism then a very different picture emerges. The pathway I nave in mind is Berlin/Prague/St Petersburg/Moscow. We see a dialectic of surface and representation, in which a complex process of fracturing broke with an art of resemblance in order to depict those experiences and contradictions which could not be pictured as homogenous surface. This was an art of juxtaposition which sought to make passive consumption difficult. For instance, Heartfield's montages of confrontation and opposition, which sought to get below the surface of Nazi representation, always insisted they were arguments put up for discussion rather than smuggled in under the guise of empirical truth. Or Rodchenko's attempt to construct a 'visual' practice which problematized the idea of value-free imaging in line with the transformation of the USSR. This is not to valorise the work of the pioneers of left modernism but to

point out that their project entailed a sophisticated attempt to scrutinise representation while at the same time trying to grip the real.

Postmodern theorists have, essentially, accepted Greenberg's account of modernism (and in photography its close relative promulgated by Szarkowsky from MOMA in New York). This cardboard modernism then becomes an easy target. It is a relatively simple matter to dispatch its ideology of the subjective genius as no more than a bourgeois illusion; its theory of expression as a fiction of mastery over language, which actually resists and masters its user: its overt masculinism and Eurocentrism. Having vanquished an illusory foe, the credentials of postmodern can be established. The difficulty comes, however, when we shift axis and ask if Heartfield. Rodchenko, Hoch, or Modetti ignore race and gender? Or if the authors of some of the fiercest anti-author polemics ever to have been written (Heartfield and Grosz) held a naive belief in the mastery of the subject?

It ought to be clear by now that the postmodernist assault on modernism is part of a much wider assault on the theories of modernity. There is more at stake here than art. As Jürgen Habermas has written, 'The idea of modernity is intimately tied to the development of European art, but what I call "the project of modernity" comes only into focus when we dispense with the usual concentration on art.'[23]

This project was formulated in the eighteenth century by the philosophers of the Enlightenment as a narrative of the rational growth of the human subject. It contained as its central kernel the belief in Human emancipation. In the first instance this meant liberation from superstition (religion) and ignorance through the application of science and a rationalist ethics. These philosophers believed that higher levels of truth could be attained by working through the inner logics of the various rational disciplines. These knowledges could then be deployed to order the world. It is, or ought to be, clear that this heritage is not unproblematic. The narrative of continual growth of knowledge and wealth clearly does not stand up well in the face of twentieth-century history; the particular conception of rationality is instrumental, oppressive and has definite gender implications. The overall cast of this thought is historicist, with all the closures and absences that this entails. But it is also clear that an attempt to abandon the Enlightenment is immensely problematic. As Terry Eagleton has argued, 'Those who now fight for justice and emancipation in their pluralistic, post-Enlightenment ways forget too quickly that it was the Enlightenment which bred and nurtured those very values for our time: that what they do is, ineluctably, at once enabled and impeded by it.'[24]

The modern critics of the Enlightenment often seem to believe that to recite the tragedies of the twentieth-century is enough to be rid of it. What the Trotskyist writer Victor Serge called the midnight of the century, that conjuncture that gave us Nazism and Stalinism, Auschwitz, the labour camps and Hiroshima, is seen to prove decisively that human liberation is a naive dream. And worse, a dream with a dark side, in which the very belief in social change contains a will to power that has as its necessary corollary repression. But this a fatalism/determinism of a staggeringly banal kind. Lyotard in *The Postmodern Condition* assumes as a first category that Hitler and Stalin were inevitable, nothing could be done to prevent their narratives of mastery and power. Yet even a cursory knowledge of the history of the period would indicate its numerous 'might have beens'. The important question

remains whether the Enlightenment project is over, or if its present problems stem from its necessary incompleteness.

As an alternative to this meta-narrative of emancipation postmodernism postulates a kind of dropping out and doing your own thing. Transformation now impossible, any alternative just more of the same, postmodernism advocates a culture of hippy resistance: working on ideologies and representations, exposing their rhetorics, demonstrating that all knowledge is representation and all representation contains its own will to power. Instead of an attempt to go beyond capitalism we should work for a pluralism that accepts our differences . . .

While these strategies of endless resistance might from time to time produce the odd rupture. discontinuity or instability, at bottom this is simply a good pragmatics to replace a bad one. Having long ago abandoned the possibility of human liberation as metaphysics, having collapsed socialism into Stalinism, the theorists of postmodernism now see anti-capitalist struggle as part of the regulation of the system. But as Eagleton argues, if socialism has been defeated by capitalism, it shouldn't have much trouble with the odd unorthodox experiment, scientific, literary or whatever.[25] If power is endless and always already present then resistance is at best a thankless task. One might as well stay at home.

This does not bode well for photography. If the postmodern excision of Enlightenment/modernism is accepted, then photography, which is linked to the instrumental practices of optics and chemistry, and which is implicated in vision as a founding moment of the unified subject, would have nothing to do but deconstruct its own impulses. This is a para-photography so thoroughgoing in its idealism that it forgets just how industrial the photographic field is. From its very beginnings photography has been circled by the debates of an industrial society, while its matrix of meanings have been produced in and through the multiple registers of an industrial mode of production. Severed from these founding conditions, photography implodes. To activate the differences for the photographic is, then, as problematic as it is social democratic.

Benjamin's spector exorcised

The implications of postmodernism for photography are immense, most obviously if, *pace* Saussure, meaning is constructed internal to the frame: then photography becomes exactly like any other form of art. Having excised reference the photograph is reduced to a painting with light. Photogenic Drawing makes a spectacular comeback. So that any dialogue with the pro-filmic event is characterised as an ideological fiction.

Armed with this critique whole sectors of the cultural left have turned to a practice as problematic as documentary but smug in its knowingness and content in its self-assured anti-illusionism. Increasingly, we have come to identify a certain kind of studio work with left photography itself. A radical orthodoxy which, for a theoretical position which worships at the altar of openness and indeterminacy, has everything worked out in advance, a series of rigorous formulas to be replicated. This practice reaches its high point with the Burgin school which works through a set of conventions, a hierarchy of subjects, established procedures, codified

knowledges, institutional sites, and canonical texts. For an approach which makes so much of difference it produces a sameness, a practical homogeneity unrivalled by anything but the nineteenth century academy. It has created a house style of enigmatic, tangential text combined with studio images typically modelled on, or incorporating, the painted image of a woman. Are we seriously to believe that the female subject is produced by magazine advertisements? Or consider Burgin's own anti-photographic photography. A practice in which ever more sophisticated readings of feminist readings of Lacan's reading of Freud produce a work dazzled by its own (thoroughly hermetic) brilliance. A project which set out to challenge the art school idea of 'private language' comes about as close to that philosophical absurdity as anyone is likely to get. The difficulty of producing a representational practice which can deal with the density of history is reduced to a fetishistic picturing of its surface images. These are endlessly and parasitically recycled, so that history figures as a mere repository of advertisements, magazine photographs and general media ideologies.

For Benjamin and the productionist aesthetic more generally, photography had a key role to play in breaking down the metaphysical ideologies of art. In closing the distance between the privileged object and its audience through mass circulation, they believed, art's bogus religiosity could be blown apart. Their's was a materialist practice based upon active intervention through the accessible technologies of image and publication.[26] Many of these ideas, and the attendant practice of Heartfield, Rodchenko, or Arbeiter Fotographen have become inscribed in the cultural consciousness. It is, as such, interesting to note that while Burgin *et al.* pay at least a formal homage to Benjamin they simultaneously reinstate the art object into the privileged space of eternity. As Eagleton notes, postmodern parody isn't simply neutral but a sick joke on the revolutionary avant-garde whose major impulse was to dismantle art and its institutional base.[27] Postmodernist anti-avant-gardism can very easily he seen as a manoeuvre to construct for itself the space of the avant-garde. In this form at least, with modernism inverted, postmodernism reverts to pre-modernism and reinstates the aura. Henry Peach Robinson's 'Little Red Riding Hood' turns out to be the epitome of revolutionary good sense.

Into the depths

There was the Englishman who worked in the London office of a multi-national corporation based in the United States. He drove home one evening in his Japanese car. His wife, who worked for a firm which imported German kitchen equipment was already at home. Her small Italian car was often quicker through the traffic. After a meal which included New Zealand lamb. Californian carrots, Mexican honey, French cheese and Spanish wine, they settled down to watch a programme on their television set which had been made in Finland. The programme was a retrospective celebration of the war to recapture the Falkland Islands. As they watched they felt warmly patriotic, and very proud to be British.[28]

In a recent essay in the magazine *Flash Art*, Deitch and Guttman argue that the recent stockmarket crash constitutes a perfect example of 'economic post-modernism.'[29] The securities market, they insist, once had a direct relationship to the general economy, but this relationship has now broken down, reacting more to its own internal process than to any demand from the manufacturing sector. This is an occurrence entrenched by the postmodern instantaneous international communications network. The stockmarket functions as spectacle: incapable of representation it draws attention to itself.

A straw target perhaps: art critics who might be expected to know no better. But the example serves, at least, as a useful textual trope. For one of the key problems of postmodernism is, given its separation of society into discreet and autonomous units, the rejection of deep-structure. This move has the effect of rendering postmodern arguments untestable. Contradictions between different practices cannot be assessed. John Tagg has recently stated this clearly, arguing that it is not possible to combine a Marxist theory of levels with a conception of language as arbitrary and differential.[30] This is indeed the case. If representation is the only reality and its criteria of assessment are internal coherence and effectivity then any attempt to reference the social relations of production is already 'offside'. Postmodernism produces for itself an hermetic space. Sealed off from these social relations often labelled (ignorantly) as the economic, it can continue to replicate its untroubled culturalism. In this manoeuvre history is in effect randomised, reduced to a kind of junk store that can be picked through for whatever knick-knacks might interest the cultural producer. Locking together incompatible styles or contradictory arguments, the past is plundered. In the 'anything goes' world of the postmodern the one thing that does go is the coherence of arguments. The road from Sir Karl Popper's cold war text *The Poverty of Historicism* to the postmodern ideology is a fairly straight one. While Popper's targets were the work of Hegel and Marx, postmodernism claims to reject all totalising theories (despite this claim being one itself), so that history is randomised. Deprived of some general theory, the historical process can only appear as the chance combination of accidents and/or discourse, and is thus placed beyond the control of human agents. A micro-politics of despair is the outcome.

If, however, we suspend our contemporary knowingness regarding the necessary autonomy of culture, then a very different picture emerges. Whilst postmodernism is structurally linked to the various kinds of post-industrial society theories which, in the last 20 years, have come to posit knowledge, information, science and so on as the principle forces of production, industrial capitalism spreads across the globe undaunted.

The economist Nigel Harris has in two recent books[31] tracked this growth, arguing that the fundamental contradictions of the capitalist mode of production now encompass the entire planet. So that the process of capital accumulation and its attendant contradictions now invade all lands. There is no longer any hiding place from the ravenous appetite of the accumulators. Harris argues that this process of world economic integration, the formation of one market in which sectors of capital compete, whether they are private corporations or state capitals, is leading to the end of the Third World. He means by this not the disappearance of countries, or their poor, but of an ideology: an ideology of subordination which came to posit

nation rather than class as the key category of struggle. This era, Harris insists, is drawing to a close as capitalist production spreads way beyond its heartlands of western Europe and North America.

These books need to be read to sample their extraordinary erudition and no attempt will be made here to examine the dense statistical information that litter the texts. It is enough to note the emergence of The Newly Industrialized Countries onto the world market: the four Pacific Tigers – South Korea, Taiwan, Singapore and Hong Kong; the three Latin American Giants – Brazil, Mexico and Argentina: and in addition India, South Africa, Iran, Poland and Japan. These countries have decisively broken the grip of the older capitalist nations. It is predicted that Europe and the US will generate less than half the world's manufacturing output by 1990.[32]

This is the terrain of post-industrialism and postmodernism: a Eurocentric reflex. This is the farewell to the working class and to modernism. It's broadening out across the globe so that the conditions of modern life are now experienced from Korea to Brazil, while the contradictions of capitalism reverberate from the Phillipines to Burma, to South Africa. The theorists of the postmodern are, I would argue, unconscious of the way their own discourse is produced as part of this trans-formation. For there is clearly no reason (other than that old metropolitan response) why the important articulations of our world should not emanate from Taiwan rather than from New York or Paris. The ground of the postmodern debate is this spread of commodity culture out of its heartlands, and with it the transformation of life, cultural, social and economic in the new and old centres of capital accumulation.

It must be noted that in this process the structural power of the working class is not necessarily weakened in the old heartlands. In fact, it can be argued that whilst fewer industrial workers have power concentrated in their hands, ever larger layers of white-collar workers find themselves proletarianised. Reduced production and reduced producers are not the same thing.

While the new technologies are once again hailed as the end of the capitalist world, similar arguments echo in the cultural sphere where the new information and entertainment technologies are represented as the end of civilisation as we know it. This is little more than a fanciful and despairing technological determinism; it is put into perspective if we consider the analogous outcry over the end of art and the industrialisation of social life produced by photography in the 1840s. This crude determinism brings with it the notion that people are unable to resist the values purveyed by the media. This is a very real arrogance, for it rules out the possibility of those millions who have no access to media production ever being able to deter-mine their own lives. And by return of post, medianics are set up as the social vanguard.

Having abolished historical time, it's probably no wonder that this programme is so short term. It may well be that people for much of the time live through ideas, images, spectacles drawn from media (though even this weak formulation under-values popular knowledges). But what is missing from this argument is any sense of counter-veiling tendencies, contradictory interests which pull in other directions, and which at moments of crisis can blast apart these spectacles. This is what mater-ialism means – a dynamic or set of contradictions which carry on often unseen and unheard; which operate independently of commodified consciousness, but which

nevertheless, sooner or later, emerge into visibility. Intersecting with material interests they wrench consciousness in a different direction. At such moments oppositional politics and representations come into their own. Struggling over the signs of our times, pulling them this way and that in a fierce dialogue between conflictual social forces. Photography contributes to this process of meaning formation, focussing images and desires. But it must be understood that there are definite limits to this dialogue, and those limits are the material interest which contest our world. Deep-structure continues to be the sense of our time. Picturing it remains our problem.

Notes

1 J.F. Lyotard, *The Postmodern Condition: A Report on Knowledge*, 1979. (trans G. Bennington and B. Massumi) Manchester University Press 1986 p. 51.

2 J. Baudrillard, *The Ecstasy of Communication, Postmodern Culture*, Edited by Hal Foster, Pluto 1985, p. 128.

3 It must be noted that there is an ambiguity throughout this text that could have been rendered (tediously) by enclosing the term postmodernism in inverted commas. While it is clear that postmodernism exists as a discourse within the intelligentsia and this gives it a certain status as a set of objects in the world, I remain fundamentally sceptical about its claims to constitute an ontology – a theory of being in the world. To collapse these two categories can only lead to more confusion, and it's possible that in places I have been guilty of just that. This only serves to indicate that we need to approach the postmodern debate with a good deal more acuity than has often been the case. Further, I have assumed some identity between postmodernism and post-structuralist theory.

4 P. Dews, *Logics of Disintegration, Post-Structuralist Thought and the Claims of Critical Theory*, Verso 1987, p. xv.

5 R. Krauss, 'The Originality of the Avant-Garde: A Postmodern Repetition', *October 18*, Fall 1981.

6 D. Crimp, 'The Photographic Activity of Postmodernism', *October 15*, Winter 1980.

7 Y. Lomax, 'When Roses are no Longer Given Meaning in Terms of Human Future'. *Camerawork* No. 26. 1983, p. 10.

8 T. Eagleton, 'Wittgenstein's Friends' in *Against the Grain, Selected Essays*, Verso 1986, p. 119.

9 D. Slater, 'The Object of Photography', *Camerawork*, No. 26. 1983. p. 4.

10 See P. Anderson, *In The Tracks of Historical Materialism*, Verso 1983, p. 41–44. It is worth noting that Levi-Strauss's two principle extensions of structural linguistics to explain 'the exchange of women' as the basis of kinship structure and the exchange of goods in the economy were the two moves specifically ruled out by Saussure.

11 The key works of this group include, V.N. Volosinov. *Marxism and the Philosophy of Language and Freudianism, a Marxist Critique*: P.M. Medvedev, *The Formal Method in Literary Scholarship*, M.M. Bakhtin. *Rabelais and His World, Problems in Dostoevsky's Poetics* and *The Dialogic Imagination*.

12 F. Jameson, 'Postmodernism, or the Cultural Logic of Late Capitalism. *New Left Review*, No. 146, July–August 1984. This influential essay contains many subtle readings of individual works and conjunctures. Whether this commits us to an ontology of postmodernism is, however, another question.

13 Lyotard, op. cit., introduction p. xiiii.

14 Ibid. p. 41.

15 Ibid. p. 66.

16 J. Tagg, 'Practicing Theories, an interview with John Tagg', *Afterimage* January 1988, p. 6.

17 For an elaboration of this argument see P. Anderson, op. cit: A. Callinicos. *Is There a Future for Marxism?* Macmillan 1982, Chapter 1: 'Postmodernism, Post-Structuralism, Post-Marxism?' in *Theory, Culture & Society*, Vol. 2 No. 3 1985: and A. Rifkin, 'Humming and Hegemony', Block Winter 1986/87.

18 J. Baudrillard, *The Bealbourg Effect: Implosion and Deterrence* (trans. R. Krauss and Michelson) October 20 Spring 82.

19 Ibid. p. 3.

20 Mike Baldwin, 'Beaubourg', Open University, A315. *Modern Art and Modernism*, BBC TV31.

21 André Rouillé is editor of the journal *La Recherche Photographique*, and amongst other works is the author of *L'Empire de la Photographie*, 1839–1870, Editions Le Sycamore, Paris 1982; *Le Corps et Son Image, Photographies Du Dix-Neuvieme Siecle*, Contrejour 1986: and, with Jean-Claude Lemagny, co-editor of *A History of Photography*, translated by Janet Lloyd, Cambridge University Press, 1987.

22 Baudrillard, 'The Beaubourg Effect . . .'. op. cit., p. 5.

23 J. Habermas, 'Modernity – An Incomplete Project', in Foster op. cit., p. 5.

24 T. Eagleton, 'The Politics of Subjectivity', *Identity*, ICA Documents 6, p. 47.

25 T. Eagleton, 'Capitalism, Modernism and Postmodernism', *Against the Grain . . .* op. cit., p. 134–135.

26 See W. Benjamin, 'The Work of Art in the Age of Mechanical Reproduction,' *Illuminations*, Fontana 1970.

27 T. Eagleton, 'Capitalism, Modernism and Postmodernism' op. cit., p. 131.

28 R. Williams, *Towards 2000*, Penguin 1985, p. 177.

29 J. Deitch and M. Guttman, 'Art and Corporations', *Flash Art* No. 139, March–April 1988.

30 J. Tagg, *The Burden of Representation, Essays on Photographies and Histories*, Macmillan 1988, p. 23.

31 N. Harris, *Of Bread and Guns, The World Economy in Crisis*, Penguin 1983; *The End of the Third World, Newly Industrializing Countries and the End of an Ideology*, Penguin 1986, as well as numerous essays in the journal *International Socialism*.

32 N. Harris, *The End of the Third World*, ibid. p. 102.

PART FIVE

Photo-digital

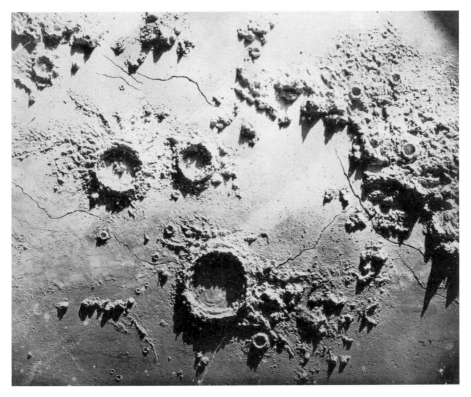

James Nasmyth, *Lunar Crater*, 1845–1860. One of 15 assorted photographs of the moon taken by James Nasmyth (1808–1890) a wealthy engineer who is best known for his invention of the steam hammer. He retired to pursue his interests in astronomy and in particular to study the sun and the moon. Courtesy of the Science Museum/Science and Society picture library, London.

Introduction

FOR SOME CRITICS, DEVELOPMENTS in digital imaging in the 1980s and 1990s heralded the 'death' of photography and new modes of vision. It was suggested that digital imaging would replace previous image-making forms, primarily through rupturing any necessary link between image and reality. As William J. Mitchell argued:

> Photographs appeared to be reliably manufactured commodities, readily distinguishable from other types of images. They were comfortably regarded as causally generated truthful reports about things in the real world The visual discourses of recorded fact and imaginative construction were conveniently segregated. But the emergence of digital imaging has irrevocably subverted these certainties, forcing us to adopt a far more wary and more vigilant interpretive stance. . . . An interlude of false innocence has passed. Today, as we enter the post-photographic era, we must face once again the ineradicable fragility of our ontological distinctions between the imaginary and the real, and the tragic elusiveness of the Cartesian dream. We have indeed learnt to fix shadows, but not to secure their meanings or to stabilize their truth values; they still flicker on the walls of Plato's cave.
>
> (Mitchell 1992: 225)

A number of theorists have argued that this approach either rests upon a false assumption about the nature of chemical photography and its essential relation to reality, or overstates the significance of this technological shift. Debates have been pursued variously, including: reference to the contribution of semiotics in demonstrating the coded nature of the image; and emphasis upon continuities of aesthetic traditions despite changing means of creating images. Also, dominant histories of photography have been challenged through drawing attention to the long history of alternative practices (for instance, cameraless artisanal modes of image-making such as cyanotypes and rayograms). Others have stressed the importance of usages of photographs, of social investments and expectations, and of the representational power of the image, rather than the manner of its generation. For instance, taking the infamous 1982 example of the narrowing of space between the pyramids in order that an image might fit the cover of *National Geographic*, Martha Rosler has asked 'if we move (the pyramids) photographically, are we betraying history? Are we asserting the easy domination of our civilization over all times and all places, as *signs* that we casually absorb in the form of loot?' (Rosler 1991: 55).

What, then, is at stake in thinking photo-digital? Here, the ontological status of the image comes up for discussion in two key respects. First, the loss of a sense of originality. There is no longer a precise creative moment when the image is photo-graphed, literally 'written with light'. This not only affects the value of the fine print as an art market commodity, but also has legal ramifications in terms of

authorship, ownership and copyright. Second, the loss of the real. There is no longer a necessary link between the people, places and events pictured and the image, which may be digitally constructed or manipulated. If a photograph is to be taken as some form of witness or testament then emphasis is thrown onto the circumstances of its making, the intentions of the photographer and the context of publication. But, it has long been noted that, as documents of personal or social history, photographs offer selective testament, tending to record highlights of personal and public events, births, weddings, carnival, school or student graduation, and so on, rather than the everyday banal. Also, that selection, framing, editing, cropping are integral to picture-making. What is of interest here is not so much the manner of the making of the image as the continuing desire to claim photographic accuracy. Discussions in the mid-1990s as to whether photojournalistic images should carry some sort of certificate of authenticity strangely echoed nineteenth-century claims for veracity whereby illustrations were published with a caption asserting that they were based on actual photographs. With digital imaging, it is not the method of the making so much as the authority of the message which is primarily in question. To reflect upon the loss of the 'shadow' or 'trace' immanent to lens-based, chemical photographs is to ignore the relative insignificance of this element within the image economy.

As Martin Lister has commented, debates about the impact of the digital have been conducted at two very different levels: on the one hand, as noted above, there has been concern about impact on the practical and embodied procedures of photography, one in which the photographer traditionally acted as observer. On the other hand, the digital has been greeted as heralding an epochal shift in our relation to and understanding of the world as a social and economic space. In this respect, much reference has been made to Benjamin's 'Artworks' essay and its engagement with what may be seen as an earlier but equally significant paradigmatic shift in the circulation of cultural artifacts. (Lister 1995: 3–4) At both levels, rather than somehow simply superseding previous modes of production and practices, technological developments engage dialectically with previous forms, and do so within multifarious historical and cultural contexts. Ways of seeing articulate complexities of physiological responses, cultural associations and conventions, memories and desires. New visualities may articulate discourses differently; in dialectical terms this represents an engagement with that which obtained previously, one which does not necessarily imply wholesale displacement or erasure.

The first two essays included here directly engage philosophical issues relating to the impact of the photo-digital. Addressing the loss of the real, Kember critiques positivism and scientific rationality as key theoretical positions underpinning emphasis on the photograph as 'truth', and asks what is at stake in investment in photographic realism. This essay was first published in the mid-1990s when debates about the nature of the digital and its impact upon photographic practices were central. At around the same time, Lister argued that the newness of the digital had been over-emphasised through setting up a false opposition with lens-based media and proposed a dialectical approach to analysing the impact of

the digital within which historical and cultural continuities, along with the contexts within which images operate, are kept in focus. This extract is from the introduction to one of the first British collections of essays on photo-digital.

Historically, photography has incorporated various innovations – and obsolescences. The second two essays particularly explore this, the first more in relation to gallery practices and the second through reference to graphic communications. Batchen is best known for his archaeology of photography wherein he questions singular, progressive accounts of the history of photography and also the idea of an 'original' (authorial) print (Batchen 1997). In this essay, he suggests conceptual similarities between the digital and older photographic processes, arguing that the electronic image, derived through code, can be compared with the work of the early Victorian photographer, Anna Atkins, who made systematic use of the photogram. Likewise, criticising William J. Mitchell's heralding of the 'post-photographic', Manovich argues that such assertions are based upon partial and selective histories of photographic practices, especially stress on the relation of photographs to actuality. This is illustrated through noting aesthetic continuities in everyday visual communication, for instance, the hyper-realism common within computer graphics. Overall, each essay makes the fundamental point that the economy of the photographic is not determined by the technological. Rather, it encompasses a multiplicity of concepts and variously articulates images and concerns associated with time and space, with nature and culture, with subject–object relations, with aesthetics, with representation, memory and identity.

References and selected further reading

Batchen, G. (1997) *Burning with Desire, the conception of photography*. Cambridge, Mass: MIT Press.

Cameron, A. (ed.) (1991) 'Digital Dialogues: an introduction', *Ten.8* Vol. 2/2, Autumn. Special issue of the British-based journal; essays by various authors.

Coleman, A.D. (1998) *The Digital Evolution*. Munich: Nazraeli Press. Reviews, talks, and interviews, 1967–1998.

Cubitt, S. (1998) *Digital Aesthetics*. London: Sage.

Druckery, T. (ed.) (1996) *Electronic Culture*. NY: Aperture. See especially Section Two, on 'Representation: Photography and After'.

Mitchell, W.J.T. (1992) The Reconfigured Eye: Visual Truth in the Post-photographic Era. Cambridge, Massachusetts: MIT Press. Emphasises rupture between the photographic and the digital.

Rosler, M. (1991) 'Image simulations, computer manipulations: some considerations' in Cameron (1991), see above.

Wombell, P. (ed.) (1991) *Photovideo: Photography in the Age of the Computer*. London: Rivers Oram Press. Catalogue for exhibition of same title, Photographer's Gallery, London.

Bibliography of essays in Part Five

Batchen, G. (1998) 'Photogenics' in *History of Photography* Vol. 22/No. 1, Spring. London: Taylor & Francis.

Kember, S. (1996) 'The shadow of the object': photography and realism' *Textual Practice* 10/1, London: Routledge.

Reprinted as Chapter 1 of her book, *Virtual Anxiety, Photography, New Technologies and Subjectivity*. Manchester University Press, 1998.

Lister, M. (1995) 'Introductory essay' in Lister (ed.) *The Photographic Image in Digital Culture*. London: Routledge.

Manovich, L. (1995) 'The Paradoxes of Digital Photography' in Hubertus v. Amelunxen *et al.* (eds) (1996) *Photography After Photography*, G + B Arts or at: http://jupiter.ucsd.edu/%7Emanovich/essays.html, 25 June 2000.

Sarah Kember

'THE SHADOW OF THE OBJECT'[1]
Photography and realism

> The question at hand is the danger posed to *truth* by computer-manipulated photographic imagery. How do we approach this question in a period in which the veracity of even the *straight*, unmanipulated photograph has been under attack for a couple of decades?
>
> (Rosler 1991: 52)

M ARTHA ROSLER EXPOSES THE PARADOX which is at the heart of debates about the current status of photographic realism. Computer manipulated and simulated imagery appears to threaten the truth status of photography even though that has already been undermined by decades of semiotic analysis. How can this be? How can we panic about the loss of the real when we know (tacitly or otherwise) that the real is always already lost in the act of representation? Any representation, even a photographic one only constructs an image-idea of the real; it does not capture it, even though it might seem to do so. A photograph of the pyramids is an image-idea of the pyramids, it is not *the* pyramids. Semiotics is at large outside of the academy. It informs a variety of cultural practices including advertising and photography itself, and it may well have slipped along a chain of signifiers from Marlboro to Mazda into a collective cultural awareness. But it is not necessary to be a semiotician in order to know that photographs, much as we might choose to believe in them, are not 'true'.

This is a particularly thorny issue for photojournalists who have an ethical and professional stake in the truth status of the photograph and resort in some cases to semantic and logical gymnastics in order to defend it. Before the threat posed by new imaging technologies to photographic realism had become apparent, Harold Evans stated that: 'The camera cannot lie; but it can be an accessory to untruth' (Evans 1978, Introduction). In his more recent book addressing 'the coming revolution in photography', Fred Ritchin argues that photography is indeed an 'interpretation' of Nature, but one which remains 'relatively unmediating' and therefore 'trustworthy'

(Ritchin 1990: 2). Ritchin disavows his knowledge of photography as a language, a form of representation, in order to assert that computer imaging practices pose a fundamental threat to the truth of the image and indeed that they signal 'the end of photography as we have known it' (Ritchin 1991).

Following on from these issues, this essay sets out to do two things: first, to explore the paradox of photography's apparently fading but always mythical realism, and to suggest that the panic over the loss of the real is actually a displacement or projection of a panic over the potential loss of our dominant and as yet unsuccessfully challenged *investments* in the photographic real. These investments are social and psychological. They exist in the terms of power and knowledge and in the terms of desire and subjectivity. What I will argue is that the current panic over the status of the image, or object of photography, is technologically deterministic and masks a more fundamental fear about the status of the self or the subject of photography, and about the way in which the subject uses photography to understand the world and intervene in it.

The second aim of the essay is to examine the subject's social and psychological investment in photography in some detail and to suggest ways in which the reappraisal of photography brought about by technological change has made possible a different investment in the medium and a transformation in the terms of knowledge, power and subjectivity.

Digital iconoclasm – the pyramids, the Queen and Tom Cruise

Icons are doubly valued: for their realism, and for their reverence toward a sacred object. Traditionally, they are representations of Christ, angels and saints. Contemporary secular icons may include members of the Royal Family, politicians and film stars and more often than not they are photographic. Photographic icons appear to be representationally faithful to the object, and photography is a cheap and efficient means of promoting secular-sacred objects for mass consumption.

Digital images would seem to be inherently iconoclastic – unrealistic and irreverent. Three instances of digital iconoclasm which I want to look at include: *National Geographic*'s manipulation of the pyramids at Giza, Benetton's blackening of the Queen's face and *Newsweek*'s unconventional portrait of Tom Cruise and Dustin Hoffman.

The Italian clothes company Benetton blackened the Queen as part of an advertising campaign which addressed issues of race. Prior to the publication of the image *The Guardian* reported that 'Her Majesty's nose and lips have been broadened in the computer-aided photograph, which will appear with the words "What if?"'. The newspaper also mentions the other photos due to appear in the Benetton catalogue *Colours*: 'the Pope as Chinese, Arnold Schwarzenegger as black and Michael Jackson and Spike Lee as white' (Saturday, 27 March 1993). The lack of amusement reported from Buckingham Palace was not overtly about the image itself, but about its use to promote products (presumably other than the usual Royal Family paraphernalia).

Ritchin discusses the issue of *Newsweek* which ran a feature on the film *Rain Man* and included an image of Dustin Hoffman and Tom Cruise apparently shoulder to

shoulder in their camaraderie over their joint box-office success. Only their story and sentiment seems fake when it emerges that the image was composited from two separate photographs:

> The actors were not together when the image was made (one turned out to have been in Hawaii and the other in New York). The caption, which simply read 'Happy ending. The two "main men" of "Rain Man" beam with pardonable pride', does not explain that this image was not the photograph it seemed to be.
>
> (Ritchin 1990: 9)

The actor's complicity in this fake, but not unusual, sort of image renders it icon-oclastic for Ritchin, who also finds his belief in the facticity of the photograph and the immutability of the observable world 'extraordinarily shaken':

> Certainly subjects have been told to smile, photographs have been staged, and other such manipulations have occurred, but now the viewer must question the photograph at the basic physical level of fact. In this instance, I felt not only misled but extraordinarily shaken, as if while intently observing the world it had somehow still managed to signifi-cantly change without my noticing.
>
> (Ritchin 1990: 9)

The case of the moving pyramids is already well documented.[2] In February 1982 *National Geographic* published a 'photograph' of two of the pyramids at Giza on its front cover. The image had been digitally altered in order to obtain the required vertical format from the original horizontal format photograph. The alteration involved moving the two pyramids closer together. As Fred Ritchin points out, this move 'has been talked about a great deal in photojournalistic circles' (1990: 14) and the editor's reference to it as 'merely the establishment of a new point of view by the retroactive repositioning of the photographer a few feet to the side' (1990: 17), though totally credible, did nothing to lessen the talk. Despite the time-honoured and generally acknowledged tradition of manipulating or staging press and documentary photographs, this act of digital manipulation appears to have over-stepped the ethical mark. Ritchin doesn't exactly specify why, but goes on to discuss the fate of the photographer's valued ability to capture the 'decisive moment' of a scene or event:

> The 'decisive moment', the popular Henri Cartier-Bresson approach to photography in which a scene is stopped and depicted at a certain point of high visual drama, is now possible to achieve at any time. One's photographs, years later, may be retroactively 'rephotographed' by repositioning the photographer or the subject of the photograph, or by adding elements that were never there before but now are made to exist concurrently in a newly elastic sense of space and time.
>
> (1990: 17)

Along with the decisive moment then, there seems to be a threat to the integrity of the original photograph, to the subject and object of the photograph, and to time and space itself. For Martha Rosler 'the pyramids are the very image of immutability – the immutability of objects' (1991: 52). She is referring to natural objects, the object of Nature, and she goes on to ask what moving the pyramids 'as a whim, casually' (p. 53) tells us about ourselves:

> are we betraying history? Are we asserting the easy dominion of our civilization over all times and all places, as *signs* that we casually absorb as a form of loot?
>
> (1991: 55)

If this is the case, then the looting of time and space, of places and objects, is what has become more apparent with the advent of new imaging technologies, and some photojournalists at least, don't like it. They want their external world to stay where they imagined it was, to be there for them (to represent). However, photography was considered to be the means of representing this reassuring world in which everything appeared to stay in its time, space and place.

The technical procedure for digitally manipulating photographs is also well documented[3] and is not of primary concern here, except in as far as a brief sketch serves to reinforce the sense of an object world made newly mutable. The process of manipulation then, involves scanning a photograph, translating it into digital information (or number codes) and feeding into a computer. On the computer screen the photograph is broken down into pixels, or picture elements – very small squares that can be changed individually or collectively. Colour and brightness can be changed instantly, and areas of the photograph can be either deleted or cloned. The borders of the image can be either cropped or extended and other images or text can be seamlessly incorporated. Whereas retouching a photograph by conventional means is time-consuming and detectable, these changes are immediate and effectively undetectable.

Techniques of scanning, sampling and 'electrobricollage' (Mitchell 1992: 7) differ fundamentally from the techniques of traditional realist photography where the impact of light onto film at one specific moment in time and space 'faithfully' records a scene or event for posterity. For Andy Cameron the new techniques and technologies of image-making transform photography from a modernist to a post-modernist practice (1991: 6). Mitchell also locates this transformation in the development of technology itself:

> The tools of traditional photography were well suited to Strand's and Weston's high-modernist intentions – their quest for a kind of objective truth assured by a quasi-scientific procedure and closed, finished perfection.
>
> (Mitchell 1992: 8)

But the most striking facility of new imaging technologies is their ability to generate a realistic image out of nothing – to simulate it from scratch using only numerical codes as the object or referent. Tim Druckrey gives the example of a press

'photograph' of a fighter plane crashing in Finland. Although there was a plane and it did crash, there was never a photograph as such. The image was simulated, assembled by a computer on the basis of eyewitness descriptions (Druckrey 1991: 17). The techniques which enable 'photographs' to be simulated also form the basis of other modes of image simulation including virtual reality. Here, the object world is not regarded as being simply mutable but totally malleable. It no longer exists as something exterior, but marks the realization of the subject's desire and imagination.

From a technologically deterministic viewpoint this malleability signals a revolution in image-making and the final demise of photography. If a completely simulated computer image, or even a digitally manipulated photograph can masquerade effectively as a straight photograph, then surely the authority and integrity of photography are always going to be in question? This is certainly so if you accept the prior existence of straight photography and an unmediated real, and if you only consider change wrought by technology itself. But photography is clearly much more than a particular technology of image-making. It is also a social and cultural practice embedded in history and human agency. Like any other form of technology it has neither determined nor been wholly determined by wider cultural forces, but it has had its part to play in the history of how societies and individuals represent and understand themselves and others. I agree with Kevin Robins that 'the question of technology . . . is not at all a technological question', and that new imaging technologies are informed by the values of western culture and 'by a logic of rationality and control'. This wider framework undermines technologically deterministic and apocalyptic claims and presents us with 'the continuities and transformations of particular dynamics in western culture' (Robins 1991: 55). Also, as Robins further points out, underneath the logic of rationality and control that informs the development of technology there are 'powerful expressions of fantasy and desire' which reveal the presence of the subject behind the rhetoric of objectivity (p. 57).

According to Mitchell, the alarm occasioned by digital imaging is the result of a breakdown of the boundaries between objectivity and subjectivity, causality and intentionality:

> the smug apartheid that we have maintained between the objective, scientific discourses of photography and the subjective, artistic discourses of the synthesized image seemed in danger of breaking down.
> (Mitchell 1992: 16)

He states that 'the distinction between the causal process of the camera and the intentional process of the artist can no longer be drawn so confidently and categorically' (p. 30). What the loss of such a distinction signifies is not only an instability in the terms of photographic representation, but an instability in the epistemological foundations of photography – its structures of knowledge and thought. What is more, epistemological uncertainty undermines the stability of the subject.

I can't think therefore I don't know who I am

> We have faith in the photograph not only because it works on a physically descriptive level, but in a broader sense because it confirms our sense of omnipresence as well as the validity of the material world.
>
> (Ritchin 1990: 132)

Realist photography is traditionally informed by a scientific system of thought fashioned in Enlightenment philosophy and by Cartesian dualism and perspectivalism. Cartesian thought splits and privileges the mind over the body, the rational over the irrational, culture over nature, the subject over the object and so on along an infinite chain which continues to structure western epistemology. Feminist work on philosophy, epistemology and the history of science has established that these dualisms are value-laden and specifically gendered.[4] The female body of nature emerges as a symbolic construct in Bacon's writings[5] and serves as the object of scientific inquiry (and of the rational, masculine scientific mind). Nature, in Bacon's account, is at times quite an elusive object, and he employs a rhetoric of domination and control in order to demonstrate the process by which scientific knowledge is to be obtained. Nature must if necessary be 'forced to reveal her secrets' – and even 'raped'.[6] Bacon's use of language exposes the fault lines of power and desire which underlie and ultimately threaten his apparently value-free, neutral method of scientific inquiry.

Inductivism is a means of acquiring knowledge through detailed observation and experimentation in the natural world. It is opposed to deductivism – a method of trying out preconceived ideas, of testing a hypothesis, of imposing a theory rather than exposing a fact. Inductivism was Francis Bacon's preferred method because it was a supposedly truer method of gaining knowledge about the natural or object world. But it is clearly not commensurate with the use of force. Inductivism is premised on a passive, willing, submissive sort of Nature, but it is clear that Bacon's concept of it was fundamentally split. The presence of such a split in his theory is perhaps not surprising since Nature, for Bacon, had symbolically acquired a female body, and the female body in Christian discourse was either pure or impure.

Ludmilla Jordanova has identified the eroticism of images and metaphors of unveiling in early modern science and particularly medicine (1989: 89). Nature, personified in the body of a woman, is figuratively unveiled or undressed before science (p. 87). Female corpses are stripped of their skin in anatomical drawings and paintings (p. 104). Dead or inert Nature is unveiled. Wild or untamed Nature is subjected to a greater force of power and desire because it takes more effort to master and threatens to deny mastery altogether. Nature, for science, was always an unstable object, encompassing elements of elusiveness and availability which somehow could not be held together in one image, but became split off in an attempt to divide and rule.

Bacon's inductivism was one of a number of seventeenth-century scientific developments which marked a major epistemological shift away from the holistic world view of the Middle Ages. Elsewhere, I have referred to this as a shift from an analogical to an anatomical world view, and one which encompasses the 'discoveries' of Copernicus and Vesalius.[7] What these explorers in outer and inner space discovered is that the geometry of what Burgin calls 'classical space' (Burgin 1990)

could not be upheld. Microcosm and macrocosm do not accurately map each other or the universe, and as Leonardo da Vinci found out 'the veins of the centenarian were in fact not a bit like the rivers of Tuscanny' (Kember 1991: 58). The geometry of classical space is the geometry of concentric spheres where earth and man are the stable focus point of a closed and complementary system. The geometry of classical space is displaced by that of modern space, and this takes the form not of concentric spheres but of the 'cone of vision' (Burgin). Imagine a circle within a circle, then imagine occupying the inner circle and looking outwards. The cone of vision represents the way you see when you take up your previously figurative position at the centre of the universe. You see space extend infinitely from the fixed point of your eye. For Burgin, the Euclidean geometry of the cone of vision maps out 'the space of the humanist subject in its mercantile entrepreneurial incarnation' (Burgin 1990: 108). This space is not infinite however – it only appears to be. Modern space reaches an end point; it implodes and is reformed in postmodern space 'traversed by electronics' (ibid.).

The authority of photographic realism is founded on the principle of Euclidean geometry (the cone of vision) and on the application of scientific methods to forms of social life. When light is refracted through the lens of a camera the cone of vision is inverted – just as it is through the lens of the human eye. This is how we obtain focused images.

Victor Burgin points to the connection between Euclidean geometry and the concept of perspective in the history of art (Burgin 1990: 106) and in an article on the politics of focus, Lindsay Smith states that 'in histories of documentary photography, "focus" has been instrumental in confirming a belief in the sovereignty of geometrical perspective' (Smith 1992: 238). The focused image is geometrically and therefore optically 'true'. It is an 'authoritative mapping of the visual' (ibid.). Smith points out how 'a deconstruction of the "truth" of documentary . . . has grown out of a recognition of the historical, material, ideological and psychic complexities implicit in Barthes' now familiar coinage, "the evidential force of the photograph"' (ibid.). But she remains critical of recent photography theories which fail to recognize the instability in the optical truth status of photography since its inception in the nineteenth century. She is also critical of how these theories remain unaware of the gender politics of focus in early photographic practice. They seem to her to tacitly accept that in the nineteenth century the ungendered, universal humanist subject was unproblematically centred in the field of photographic vision. She is referring in part to the work of Allan Sekula and John Tagg who have used Foucault's concepts of surveillance and control to problematize and politicise the scientific status of nineteenth-century medical and legal photographs, and social documentary photographs of the 1930s.

It seems to me that the crucial term which displaces and then effectively replaces the authority of geometrical perspective in Foucauldian accounts of nineteenth-century photography is not as much panopticism as positivism. The panopticon is an architectural model which comes to structure and universalize the operations of the camera. But positivism is the philosophy behind panopticism, and one which structures and universalises the operations of the human eye and the human subject in its quest for knowledge. Positivism (after Comte) holds that the (inductivist) methods of the natural sciences may be transferable to the social or human sciences.

Like the sciences it derives from, positivism assumes the unproblematic existence of an observable external reality and a neutral, detached and unified observing subject. The sovereignty of this universal humanist subject is centred and affirmed in positivism through the retention of Cartesian hierarchical dualism.

Positivism is regarded as photography's originary and formative way of thinking. It appears to transcend historical and disciplinary boundaries and constitute the stable foundation of realist and documentary practices. I have suggested that the gendered and unconscious relation between the photographer and photographed can be seen to destabilize both epistemology and subjectivity, not least through the constitution of the photographed object as a fetish (Kember 1995). Similarly, Lindsay Smith outlines the existence of 'difference in vision' in the nineteenth century and demonstrates how a gendered politics of focus and a variation in practice enacts 'a critique of the ahistorical, "disembodied" subject perpetuated by "Cartesian Perspectivalism"' (1992: 244). She compares the work of Julia Margaret Cameron with that of Lewis Carroll and finds that whereas Cameron contests the authority of focus and 'the ideology of perceptual mastery' (p. 248), Carroll retains the authority of focus and thereby 'mobilises processes of fetishism' (p. 256) as a defence against the object which threatens him with the loss of his own power and authority (a loss symbolized by the threat of castration).

Smith is careful to acknowledge that Foucauldian debates on nineteenth-century photography apply only to specific institutional practices such as medicine and law, but is right to insist that they are nevertheless woefully ungendered and fail to give an account of contesting practices or dynamics. (Sekula does problematize the authority of optical realism however.) This, I would add, is largely a facet of the uncomplicated importation of Foucault's early monolithic and also ungendered account of power and the docile body.[8] What this use of Foucault fails to do for photography theory is to give an adequate picture of the instability in the terms of photographic realism and its positivist and humanist base that was always already there.

Foucault exposes the ideology of positivism and humanism and provides an invaluable critique of the Enlightenment with his formulation of knowledge as power. But this formulation is frequently represented in photography theory as an almost unshakable formula of perceptual mastery and control. However, the gendered and unconscious relation between observer and observed, knower and known constitutes an inherent weakness in the formula, a weakness manifested through sexual difference and through fear and desire.

Psychoanalysis provides a means of inquiring into the unconscious aspects of subjectivity and for Adam Phillips, a psychoanalytic theory 'is a story about where the wild things are' (1993: 18). It is undoubtedly problematic as 'a fiction which functions in truth' (Walkerdine 1990) and as one wrought with the hierarchical binaries and gender discriminations. But I would maintain that it is nevertheless the most illuminating story about the wild things like fear and desire which by comparison are inadequately accounted for elsewhere. And I support the call of Haraway and others not only to persist in our consideration of psychoanalysis as a story, but to dare to imagine new and better ones.[9]

Fetishism is a resonant concept within psychoanalysis and one which originates in Freud's story of castration and the Oedipal complex. Fetishism is a scopic

mechanism of defence based on the male child's identification of the mother's body as castrated. He defends himself against the threat of castration by creating a fetish object. The fetish object serves as an unstable defence – as both a compensation for and a reminder of the terrifying space of absence. Fetishism may be tied to the Oedipal and to the concept of the female body as lack but it can be reconceptualized through alternative psychoanalytic stories and it is useful as a means of discussing other objects, cultural objects, which are used as a way of defending the subject against a perceived threat, or of compensating the subject for a felt or imagined loss.

A photograph can be, and has been regarded as one such object.[10] Photography, as Susan Sontag now famously stated 'is mainly a social rite, a defense against anxiety, and a tool of power' (1979: 8). Family photographs 'restate symbolically, the imperilled continuity and vanishing extendedness of family life' and tourist photographs 'help people to take possession of space in which they are insecure' (p. 9). They are not only forms of power-knowledge but also reactions to fear (Phillips 1993: 18). They supply the 'token presence' (Sontag 1979: 9) of that which is lost or absent, and 'give people an imaginary possession of a past that is unreal' (ibid.). They are able to do this by means of their status as small, tangible, collectable objects.

Yet photographs are fragile not only as material objects 'easily torn or mislaid' (Sontag 1979: 4), but as compensatory or fetish objects:

> Photographs are a way of imprisoning reality, understood as recalcitrant, inaccessible; of making it stand still. . . . But. . . . To possess the world in the form of images is, precisely, to reexperience the unreality and remoteness of the real.
>
> (1979: 164)

So the photograph as an object which contains the subject's conscious and unconscious investments in the external world both embodies and shatters the realist enterprise and its positivst and humanist baggage. At its most grandiose, says Sontag, the photographic enterprise gives us 'the sense that we can hold the whole world in our heads' (p. 3), but this same enterprise generates objects that remind us that the whole world only ever exists in our heads.

What happens in the transition from analogue to digital photography is that this reminder is underlined, the constructedness of the real becomes far more visible. One response to this increased awareness is a re-fetishization of the photographic image-object as evidence.

In this context, it is clear that despite his acknowledgement that 'photography's relationship with reality is as tenuous as that of any other medium' (Ritchin 1990: 1), Ritchin finds it fundamentally reassuring in its facility of 'confirming human perception in the quasi-language of sight' (p. 2). He also makes it very clear that once this apparent confirmation is removed, the subject can be left with a considerable amount of anxiety. While travelling on the New York City subway, Ritchin imagines that the advertising photographs inside the train are 'unreal' and that 'everything depicted in them had never been'. The result is quite striking:

> As I stared more, at images of people in business suits, on picnics, in a taxi, I became frightened. I looked at the people sitting across from me

in the subway car underneath the advertisements for reassurance, but they too began to seem unreal. . . . I became very anxious, nervous, not wanting to depend upon my sight, questioning it. It was as if I were in a waking dream with no escape, feeling dislocated, unable to turn elsewhere, even to close my eyes, because I knew when I opened them there would be nowhere to look and be reassured.

(Ritchin 1990: 3)

Ritchin finds that he is trapped in his own head, unable to rely on what he sees to confirm his or another's existence in the external world. His anxiety about what is real is experienced as a feeling of 'dislocation', and it is experienced psychologically and emotionally.

It is then apparent to him that an image which depicts something that has never been (that has no connection with the external world) is a projection, a facet of desire and of the subject's interior world rather than of the exterior world of objects. And what is worse: 'the viewer cannot tell what is being depicted and what projected' (1990: 5). Ritchin encounters both fear and desire in the experience of new imaging technologies, and in the perceived loss of photography's epistemological and psychological certainties.

In response to his experience, he seems to go in two different directions. On the one hand he is willing to accept the projective status of the image in general, and to envision a reappraisal of the photograph as an image-statement which the photographer is made newly responsible for. On the other, he seeks to reinstate the photograph as depiction. As a photojournalist he is concerned to maintain the integrity of photographic practice, and such a concern tends to lead to a re-fetishization of the photograph as evidence. But there is also a concern in Ritchin's work – one which is related but somehow separate – to maintain the integrity of a certain experience which is unique or essential to photography. This can be described as 'a sense of being there' (Ritchin 1990: 116) – or as affectivity.

The aesthetic moment – photography as a transformational object

Ritchin is not alone in his presentation of Vietnam war photography as having a special status in the history of photojournalism. Photographs of Vietnam were images 'that contradicted official thinking and challenged the legitimacy of the American-sponsored war'. They preceded a time when 'greater corporate control was exerted on publications' (Ritchin: 42). He is referring to a set of images which are still widely known and reproduced:

a little girl running from nepalm, a Buddhist monk self-immolating, a member of the Viet Cong being summarily executed, a grieving widow crying over an anonymous body bag.

(p. 42)

Susan Sontag compares this impact of photographic images of the war with television coverage and suggests that photographs are more memorable than moving

images 'because they are a neat slice of time, not a flow' (Sontag 1979: 17) and can be kept and pondered over. She says that photographs like that of the South Vietnamese girl sprayed by nepalm 'running down a highway toward the camera, her arms open, screaming with pain – probably did more to increase public revulsion against the war than a hundred hours of televised barbarities' (p. 18).

Photography's status as a portable object is a means to both avowal and disavowal, memory and forgetfulness. According to Sontag, what sticks in the memory does not filter into sustained political and ethical consciousness because photographs offer only uncontextualized, fragmented bits of information:

> The camera makes reality atomic, manageable, and opaque. It is a view of the world which denies interconnectedness, continuity, but which confers on each moment the character of a mystery. Any photograph has multiple meanings; indeed, to see something in the form of a photograph is to encounter a potential object of fascination.
>
> (Sontag 1979: 23)

These war photographs then, deliver a short, sharp but undirected shock. They resonate in the subject's memory but perhaps more at an unconscious than at a conscious level. What they capture becomes mysterious and they become objects of fascination. It may be said that the photographic image is not merely memorable but that it mimics memory:

> It is easier for us, most of the time, to recall an event or a person by summoning up a single image, in our mind's eye we can concentrate on a single image more easily than a sequence of images. And the single image can be rich in meaning because it is a trigger image of all the emotions aroused by the subject.
>
> (Evans 1978: 5)

This affective capacity of the photograph may be accidental or sought after. In *Camera Lucida* Barthes describes his own exploration and experience of what he calls the power of 'affect' (p. 21) which functions as the essence or 'aesthetic moment' (Bollas 1994) of photography. In order to arrive at this essence or to experience the aesthetic moment Barthes finds that he must reject all means of classifying the image (for example aesthetically as 'Realism/Pictorialism' (Barthes 1980: 4)) and all theoretical disciplines, including semiology which he was so central in establishing. Barthes declares his 'ultimate dissatisfaction' with critical language (p. 8) and so resolves to 'make myself the measure of photographic "knowledge"' (p. 9). 'What', he asks, 'does my body know of Photography?' (ibid.).

Barthes experiences the power of affect in his being – more in his body than his mind, and more in emotion than in thought. The affect is ultimately non-verbal: 'what I can name cannot really prick me' (p. 51). The power of affect in photography seems to derive – perversely – from the 'Real' that critical languages can reason away but cannot finally expunge from the subject's experience of photography. That is, we can *know* the impossibility of the real in representation (as Barthes clearly does) but we can nevertheless *feel* its presence. And here I agree with one of Ritchin's final points that:

> The photograph, held up as the more efficient inheritor of the replicating
> function, has survived the advent of Freud and semiology; its reputation
> for fidelity remains largely intact in the popular imagination.
>
> (Ritchin 1990: 143)

But perhaps it is intact at a level other than that of knowledge and understanding.
The action of knowledge is, for Barthes, a secondary action but a photograph 'in
effect, is never distinguished from its referent (from what it represents), or at least
it is not *immediately* or *generally* distinguished from its referent' (Barthes 1980: 5).
Barthes chooses the term 'punctum' to describe the immediacy of a photograph's
affect on him. The punctum is that element of the photograph that does not belong
to language or culture, and it is more accidental than sought after: 'it is this element
which rises from the scene, shoots out of it like an arrow, and pierces me' (p. 26).
As the punctum can be a detail or 'partial object' it shares some qualities of the
fetish, but it becomes apparent in the context of the affect Barthes seeks from a
photograph of his mother, that he is seeking something more like avowal than
disavowal, more like memory than forgetting. In this case, the photograph is func-
tioning as something other than a fetish object for Barthes.

Barthes wrote *Camera Lucida* shortly after his mother's death, and shortly before
his own. Ostensibly, he seeks a photograph of his mother which will enable him to
disavow her death, and in a sense, bring her back for a moment:

> There I was, alone in the apartment where she had died, looking at these
> pictures of my mother, one by one, under the lamp, gradually moving
> back in time with her, looking for the truth of the face I had loved. And
> I found it.
>
> (p. 67)

What he found was a photograph of his mother aged five, taken in 1898. She was
standing in a conservatory or 'Winter Garden' with her brother and 'holding one
finger in the other hand, as children often do, in an awkward gesture' (p. 69). Here
Barthes 'at last rediscovered my mother' (ibid.) in one true or 'just image' (p. 70).

Even if this photograph does function in some way as a fetish object, it also
functions more profoundly as what Christopher Bollas terms a 'transformational
object'. A transformational object is one through which the adult subject remem-
bers 'not cognitively but existentially' an early object experience (Bollas 1994: 17).
The object here is the infant's primary love object – the mother. What stimulates
this memory is an 'intense affective experience' or an 'aesthetic moment', and what
is being remembered is 'a relationship which was identified with cumulative trans-
formational experiences of the self' (ibid.).

So the mother is the original transformational object, and it is the infant's trans-
formational experience of her that is sought through the adult's search for
subsequent objects which may, according to Bollas, take the form of the analyst or
of the aesthetic experience of 'a painting, a poem, an aria or symphony, or a natural
landscape' (p. 16) – or presumably a photograph.

The concepts of the transformational object and of the aesthetic moment shed
a new light (not an Enlightenment light) on our not altogether rational insistence

on the separateness and integrity of an object world. Not only do 'our individual and collective sanities' depend on it, as Bollas suggests, but there are occasions when we actively seek the moment when we feel with 'absolute certainty' that we have been 'cradled by, and dwelled with, the spirit of the object' (Bollas 1994: 30). Such moments are 'fundamentally wordless' and they are 'notable for the density of the subject's feeling and the fundamentally non-representational knowledge of being embraced by the aesthetic object' (p. 31). Despite Barthes' attempts to put his experience of the Winter Garden Photograph into words, as it were retrospectively, the experience itself is wordless and so unique to him that he sees no point in reproducing the photograph in his book.

Because aesthetic moments are non-verbal, or rather pre-verbal, they constitute part of what Bollas terms 'the unthought known'. That is, they are part of the essential or 'true self' which is known but has not yet been thought – brought into consciousness and into representation. The transformation which the subject seeks through a transformational object or an aesthetic moment, is of the unthought known into thought. And this transformation occurs when the shadow of the object falls on the subject, or when the mother's presence is felt.

For Barthes the maternal replaces (is exchangeable with) the real, or the referent. Nature, the object and the female body are (still) aligned, but the relation he seeks with them is originary and undifferentiated. It is not caught up in the dualistic terms of knowledge and representation. It is symbiotic, not split and hierarchical – an encounter with origin that facilitates a certain evolution, a transformation of the self and of the unthought known into thought.

Barthes' search for the place where he has been is related to his concern with 'that-has-been' – a quality which he considers to be essential to photography. He reproduces a photograph of an old house in Grenada where he would like to live (pp. 38, 39). He describes this 'longing to inhabit' as 'fantasmatic, deriving from a kind of second sight which seems to bear me forward to a utopian time, or to carry me back to somewhere in myself' (p. 40). Landscapes like this give him a certain sense 'of having been there or of going there' which he relates to Freud's 'heimlich' (ibid.) and the uncanny.

The Winter Garden Photograph presents him with the mother-as-child, and it is the experience of his dying mother as being like a child which seems to transform and bring into thought Barthes' sense of his own death. Shortly before he found the Winter Garden Photograph, Barthes nursed his weak and dying mother. He tells how 'she had become my little girl, uniting for me with that essential child she was in her first photograph' (p. 72). This experience of her as his 'feminine child' provided him with a 'way of resolving Death' (ibid.). Childless himself, he had engendered his mother, and 'once she was dead I no longer had any reason to attune myself to the progress of the superior Life Force (the race, the species) From now on I could do no more than await my total, undialectical death'. This, he says, 'is what I read in the Winter Garden Photograph' (p. 72).

I am suggesting then, that for Barthes (in *Camera Lucida*) the photograph has a dual function. It is (at once) a fetish object and a transformational object (the two may be closer together than they appear in Oedipal terms). The photograph is also the means by which the shadow of the object understood as the real (and/as the mother) falls on the subject. The moment in which the shadow of the object

falls on the subject may be understood as the aesthetic moment of photography, and the affect of this moment is of a transformation of the unthought known into thought.

It may be said that this transformative experience of the self based on an uncanny encounter with the real has been at the heart of our persistent (but irrational) faith in photography. It is a faith which precisely cuts across our more rational investments in, and our knowledge about, the truth status of photography – because it is placed in a real located ultimately in our own interior worlds rather than in an exterior one.

I have argued that digital images pose a threat to our investments in photographic realism. These investments are in a sense of mastery and control over the object world which is secured (unsafely) by positivism, and conversely in a transformative experience of the self which occurs in a non-hierarchical relationship to the object world. Because positivism obscures the presence of the subject in photography, its guarantees and reassurances are ultimately illusory and were always already lost. Positivism is, it would seem, a faulty way of thinking which maintains that the real is representable rather than experiential – located in the exterior world rather than the interior world of the subject. Our investment in photography as a transformational object is an investment in our experience of the real, and it implies a different, non-positivist, way of thinking. This other way of thinking which is latent in our experience of photography as a transformational object is, of necessity, coming nearer to being thought through our experience of digital images, and our awareness of their constructedness.

Digital images may be regarded as partial rather than universal forms of knowledge, and as image statements rather than truths. Ritchin recognized that they may become newly authored and situated in language and culture (Ritchin 1990: 88, 99) and that they 'represent both openings to new knowledge and an invitation to its constriction' (p. 144). In her reappraisal of the epistemological foundations of science and technology, Donna Haraway argues that only partial knowledge guarantees objectivity (Haraway 1991: 192). Similarly, when he acknowledges the possibility of a radical reappraisal of image-making, Ritchin maintains that images should be a means for 'exploring territories that exist independently of us' (1990: 146) and wonders whether we will 'use photography to respect and value the complexity of the other, whether another person, place, people, idea, or the other that exists in ourselves?' (ibid.).

An epistemological shift in the terms of image-making involves a transformation in the relationship between the subject and object of the image, or between the self and other. The object is no longer understood as being wholly separate from the subject, but retains an equivalent status and integrity. This subject-object relation is inherent in our experience of photography as a transformational object and it may be continuous, I would argue, with a reappraisal of photography in the light of digital imaging.

Notes

1 C. Bollas, *The Shadow of the Object. Psychoanalysis of the Unthought Known* (London: Free Association Books, 1994).

2 See, for example, F. Ritchin, *In Our Own Image. The Coming Revolution in Photography* (New York: Aperture, 1990) and M. Rosler, 'Image simulations, computer manipulations, some considerations', *Ten. 8 Digital Dialogues. Photography in the age of Cyberspace*, vol. 2, no. 2, 1991.

3 See W. J. Mitchell, *The Reconfigured Eye. Visual Truth in the Post-photographic Era* (Cambridge Mass.: MIT Press, 1992).

4 See particularly S. Harding, *The Science Question in Feminism* (Ithaca: Cornell University Press, 1986), and D. Haraway, *Simians, Cyborgs and Women* (London: Free Association Books, 1991).

5 See M. Jacobus, E. Fox Keller and S. Shuttleworth (eds) *Body/Politics. Women and the Discourses of Science* (London: Routledge, 1990).

6 See C. Merchant, *The Death of Nature* (New York: Harper & Row, 1990).

7 S. Kember, 'Medical diagnostic imaging: the geometry of chaos', *New Formations*, no. 15, 1991.

8 M. Foucault, *Discipline and Punish* (London: Allen Lane, 1977).

9 See D. Haraway interview in C. Penley and A. Ross (eds), *Technoculture* (Minneapolis: University of Minnesota Press, 1991), p. 9, and A. Braidotti, *Nomadic Subjects. Embodiment and Sexual Difference in Contemporary Feminist Theory* (New York: Columbia University Press, 1994).

10 C. Metz, 'Photography and fetish', *October*, 34, cf. Ch. 16 in this volume, pp. 138–45 [Ed.].

Bibliography

Barthes, R. (1980) *Camera Lucida*, Flamingo, London.

Bollas, C. (1994) *The Shadow of the Object. Psychoanalysis of the Unthought Known*, Free Association Books, London.

Burgin, V. (1990) 'Geometry and abjection', J. Fletcher, A. Benjamin (eds), *Abjection, Melancholia and Love. The Work of Julia Kristeva*, Routledge, London.

Cameron, A. (1991) 'Digital dialogues: an introduction', *Ten.8 Digital Dialogues. Photography in the Age of Cyberspace*, vol. 2, no. 2.

Chaudhary, V. (1993) 'Benetton "Black Queen" Raises Palace Hackles', *Guardian*, Saturday, 27 March.

Druckrey, T. (1991) 'Deadly representations', *Ten. 8 Digital Dialogues*.

Evans, H. (1978) *Pictures on a Page. Photojournalism, Graphics and Picture Editing*, Heinemann, London.

Haraway, D. (1991) *Simians, Cyborgs and Women*, Free Association Books, London.

Jordanova, L. (1989) *Sexual Visions. Images of Gender in Science and Medicine between the Eighteenth and Twentieth Centuries*, Harvester Wheatsheaf, Brighton.

Kember, S. (1991) 'Medical diagnostic imaging: the geometry of chaos', *New Formations*, no. 15.

Kember, S. (1995) 'Medicine's new vision?', M. Lister (ed.), *The Photographic Image in Digital Culture*, Routledge, London.

Mitchell, W. J. (1992) *The Reconfigured Eye. Visual Truth in the Post-Photographic Era*, M.I.T., Massachussets.

Phillips, A. (1993) *On Kissing, Tickling and Being Bored. Psychoanalytic Essays on the Unexamined Life*, Faber & Faber, London.

Ritchin, F. (1990) *In Our Own Image. The Coming Revolution in Photography*, Aperture, New York.

Ritchin, F. (1991) 'The end of photography as we have known it', P. Wombell (ed), *Photo Video. Photography in the Age of the Computer*, Rivers Oram Press, London.

Robins, K. (1991) 'Into the image: visual technologies and vision cultures', P. Wombell (ed.) *PhotoVideo. Photography in the Age of the Computer*, Paul & Co., NY.

Rosler, M. (1991) 'Image simulations, computer manipulations, some considerations', *Ten. 8 Digital Dialogues*.

Smith, L. (1992) 'The politics of focus: feminism and photography theory', I. Armstrong (ed.) *New Feminist Discourses*, Routledge, London.

Sontag, S. (1979) *On Photography*, Penguin.

Walkerdine, V. (1990) *Schoolgirl Fictions*, Verso, London.

Martin Lister

EXTRACTS FROM *INTRODUCTION TO THE PHOTOGRAPHIC IMAGE IN DIGITAL CULTURE*

[. . .]

IN QUITE UNTENABLE WAYS, the rhetoric surrounding new image technologies has constructed an idea of their 'newness' by setting up some false dichotomies and oppositions with lens based media. Almost overnight, it seemed, the photographic image and other analogue visual media (film, television and video) became realist images viewed by passive dupes. Simple mirrors held up to mundane realities at which we passively gaze. 'Media which we are familiar with as passive will become active' claims the video artist Simon Biggs, writing about the future of video. He dismisses virtual reality hardware as defunct before it has hardly left the laboratory. He leaps over research aimed at scanning information on the retina (there is no mention of whose retina or why!), and speaks of 'more advanced research' which is aimed at 'the direct stimulation of the optic nerve as a means of dispensing with inflexible and difficult to use hardware' (Biggs 1991: 71). In three sentences we lurch from the familiar video camera to a Gibsonian world of post-biological surgery and neural prostheses.

Kevin Robins has characterised what he has called the 'techno-fetishistic' approach to new image technologies (Robins 1995). This is an approach toward technology which he characterises as euphoric, exultant and full of a 'sense of omnipotence' at the opening up of 'unbounded possibilities'. He quotes, elsewhere, from an article titled 'From Today Photography is Dead':

> Photographers will be freed from our perpetual constraint, that of having, by definition, to record the reality of things, that which is really occurring Freed at last from being mere recorders of reality, our creativity will be given free rein.
>
> (Robins 1991: 56)

As Robins argues, claims for 'What is "superior" about the post-photographic future becomes clear, then through contrast with what is seen as an inferior, obsolete, photographic past'. What digital technologies are being claimed to offer is at least partly achieved by a highly selective attention to the history of the photographic image.

Photographic realism (resurrected)

This casting of photographic images (not always negatively as in the current cases) as slavish imprints of physical reality, as mirrors held up to the world, or as open windows through which it can be directly seen, are as old as photography itself (Snyder and Allen 1975, Snyder 1980). In the current tendency to oppose photography to digital imagery we are actually witnessing a continuation of an old debate about photography. This is the debate between those who have stressed the photographic image's privileged status as a trustworthy mechanical analogue of reality and those who have stressed its constructed, artifactual, and ideological character. The former position stresses the automatic means by which a photograph is produced, the latter the myriad decisions, conventions, codes, operations and contexts which are in play both when the photograph is made and when it is made sense of by a viewer (Barthes 1977b).

This vexed and often tedious argument about something called the *photographic medium* is now being cast as a debate *between* photography and the digital image. In this new opposition, what were formerly two broad and often contradictory ways of understanding photographs themselves have been parted. One view, the realist, stays attached (in a less subtle but newly zealous form) to photography; the other, what could be called the constructivist position, has been transferred to the digital. The same debate continues but from different sites. And it looks as if the realist position has a new, if rather crude, currency. In its earliest forms it was often used to distinguish photography (again negatively) from a romantic view of painting as the expressed subjectivity of a gifted individual or from a waning classicism in which worthwhile images were refined by the artist's intellect. In its early twentieth-century forms it was used to claim something essential and unique about photography as it claimed its own place within high modernist culture. Now it is being used to distinguish a suddenly sad and earthbound photography from the creative realms of the new digital technologies.

Realist theories give priority to the mechanical origins of the photographic image. They argue that the mechanical arrangement of the photographic camera means that 'physical objects themselves print their image by means of the optical and chemical action of light' (Arnheim 1974). Photographs are spoken of as '"cosubstantial with the objects they represent", "perfect analogons", "stencils off the real", "traces", or as "records" of objects or of images of objects' (Snyder and Allen 1975). Hence, what is stressed is a guaranteed causal link with the physical world; photographic images are automatically produced and are passive in the face of reality. It is this quality of the photographic image that Barthes (op. cit.) calls its 'being thereness'. It is argued by realists that this is the source of the photographic image's special force as evidence. In his application of semiotic theory to the photograph, Barthes built upon this concept of 'indexicality' for different reasons; to show how

it lends enormous power to the photograph's symbolic and mythological proper-
ties by masking them as natural or real and not historical and cultural. But in many
versions of realist theory, the photographic image is seen as more or less short-
circuiting the filter of ideas, cultural codings, and intentions which the producer is
conventionally thought to bring to other kinds of representations. In this way it is
claimed that, due to the kind of technology which produces a photographic image,
it is distinctly and absolutely different from all other kinds of representation. Such
theories appeal deeply to common sense. They resonate strongly with positivistic
beliefs about the facts of a situation being transparently clear to us when open to
inspection by vision.

However, such accounts have their source in a restricted view of how photo-
graphic images come to have meaning. Such realist theories are fixated with the
historical difference between the technological means employed in photography and
all other kinds of autographic and manual means of image making and reproduc-
tion. This technological difference has been abstracted – isolated and generalised –
as a principle which can be used to explain the special significance of the photo-
graphic image.

One important outcome of this insistence on defining 'the photographic' in
technological terms has been a related preoccupation with trying to read beneath
all of its varied and contradictory social uses (the different practices of fashion and
surveillance photography for instance, or between a surrealist's and a documen-
tarist's use of the technology). This was in order to find its essential and unifying
characteristics as a 'medium'. As John Tagg (1988: 14–15) has pointed out, it is
more helpful to think of 'photographies' which have different 'histories' than it is
to think of a singular medium with a singular, grand and sweeping history. The
conventional history of photography has been written like The History of Literature
or Art. It would be better understood as like a history of writing. By which Tagg
means that it is better understood as a technique which is employed in many different
kinds of work. Writing for instance is a technique employed in the different tasks
of making shopping lists, surveyors' reports, advertising copy, poems, etc. These
cannot be usefully understood as if they all belonged to one grand, selective and
linear enterprise held together by a unifying idea and a defining set of canonical
works. Neither can photography.

Yet, recently, in the face of the biggest radical shift in the technology of images
since the emergence of photography itself, the polarised terms of the old debate
seem to have returned in a particularly crude way. The monolithic view of photog-
raphy is being resurrected. Its technological basis again becomes its defining feature.
And this is contrasted with a digital technology which itself is rapidly gaining the
status of a new essentialised 'medium'. But this time, not one which guarantees
access to reality but one which celebrates that impossibility and offers to construct
virtual ones instead.

Photographic meanings

The question of how our belief in the special veracity and evidential force of the
photographic image gets attached to the material image itself can be approached by

considering the photographic image in more historical and sociological ways (Tagg 1988: 3–5) This can also lead us to question the view that there is a fundamental cultural break between the photographic and the digital. Instead of focusing attention upon the photograph as the product of a specific mechanical and chemical technology, we need to consider its technological, semiotic, and social hybridness; the way in which its meanings and power are the result of a mixture and compound of forces and not a singular, essential and inherent quality.

Over a period of 150 years photographic images have contributed to how we see and think about the world, ourselves and others. But they have not achieved this historical shaping of perception in isolation or through technological means alone. First, the still photographic image has circulated, eventually on a global scale, via other graphic and technical processes and predominantly alongside the meanings of the printed word. As John Tagg puts it:

> With the introduction of the half-tone plate in the 1880's, the entire economy of image production was recast . . . half tone plates at last enabled the economical and limitless reproduction of photographs in books, magazines and advertisements, and especially newspapers. The problem of printing images immediately alongside words and in response to daily changing events was solved The era of throwaway images had begun.
>
> (Tagg 1988: 56)

From this time on the discrete chemical photographic print is, relatively, a rarity. Yet, the chemical process itself came to stand at the centre and as the originating point of the modern world's web of reprographic processes and print media. The path from chemical photograph to its social availability and circulation in the magazine, newspaper, book, etc., is complex and mediated. For the modern saturation of experience by images to have occurred, the photo-mechanical process was a necessary but by no means a sufficient cause. This depended upon a convergence of photography with print, graphic, electronic and telegraphic technologies. With the emergence of digital technology this convergence is exponentially increasing. It can be seen, at least in part, as an acceleration of historical processes already surrounding the photographic image. In the cycle of cultural production and reception, which passes through many technical, social and political stages, the meanings of a photographic image or a text can be fixed or changed at a number of points. In this respect the opposition between an isolated photo-chemical technology (seen as having automatic, guaranteed and fixed meanings) and hybrid 'new media' (as having more open and layered meanings) depends, to a considerable extent, upon collapsing the cultural form of the photographic image into the technological form of the chemical photograph. Once we reflect upon the technological and social complexity of how we meet the photographic images which circulate in everyday life, this particular opposition is greatly diminished.

Second, at the point of reception or consumption, photographic images are seldom, if ever, met in isolation. They are embedded and contexted in other sign systems. Primarily, these are those of the written word, graphic design and institutional connotations. As Barthes (1977b: 15) puts it, the photograph is at the centre

of 'a complex of concurrent messages'; in a newspaper these are the text, the title, the caption, the layout, and even the title of the newspaper or publication itself: a photograph can change its meaning as it passes from the page of the conservative to the radical press.

Apart from this close relationship with the written word, photographic images become meaningful by the context of the spoken word and casual, oral culture. For still images, this is particularly the case in the domestic world where snapshots are virtually an occasion for talk, reminiscence and commentary. This is also the case with the educational uses of photographs, in the classroom, lecture theatre or public event. While having an obvious relationship to text, the meanings of photographic images in newspapers and magazines may also be inflected as they are spoken about or argued over. If we extend the definition to the images of cinema, television and video then their crucial relationship to sound and speech is obvious, although more complex than we ordinarily imagine (Ellis 1991: 127–44, Altman 1980). But for current purposes it is the very fact of the connection itself which is important; between the technological forms of sound and visual reproduction. Writing about photography and film in 1936, Walter Benjamin pointed out that the photographic image actually called forth a new relationship between the visual image, the human voice and speech.

> Just as lithography virtually implied the illustrated newspaper, so did photography foreshadow the sound film, [because,] Since the eye perceives more swiftly than the hand can draw, the process of pictorial reproduction was accelerated so enormously that it could keep pace with speech.
>
> (Benjamin 1973: 221)

The sheer pervasiveness of photographic images, in all major areas of social and cultural life, is also the grounds for their intertextuality. The meanings of any particular photographic image are not freestanding and autonomous, as if fenced off from all others. Each one or each cultural form in which they circulate, is a small element in a history of image production and a contemporary 'image world'. Photographic images belong to a kind of 'second nature'; a dense historical environment of mass-produced images, symbolic objects, spectacles and signs (Buck-Morss 1991). Within this environment, the photographic image gains its meaning by a continual borrowing and cross-referencing of meanings between images. The still photograph quotes a movie, the cinematographer adopts the style of an advertising photographer, the music video mimics an early silent movie, etc.

If what a photograph refers to is at least partly the way the world is represented in other images, then another kind of distinction between the photographic and the digital becomes less sharp. The frequently made observation that digital images are reworkings of received images, are built from the fragments and layers of other images, is better understood as a meta-form of processes long involving the photographic image; not a radical difference but an acceleration of a shared quality.

Each of these relationships between the photographic image and other technologies of representation and communication takes place within social institutions and forms of organisation: media organisations, entertainment industries, bureaucracies, families, educational establishments, workplaces, cities. It is mainly in the

way that photographic technology was understood, and used, within institutions in the nineteenth and early twentieth centuries, that photographs came to have their distinctive significance(s). John Tagg (1988) and others (Sekula 1983, McGrath 1994, Green 1984) have carefully researched the manner in which still photographs have gained their various statuses as art, evidence or document – the meanings that we now take for granted and see as actual properties of the 'chemically discoloured' pieces of paper themselves (Tagg 1988: 4).

In *The Burden of Representation,* John Tagg researched early uses of photographs as evidence in courts and public enquiries, as medical and police records, and as saleable commodities which photographers wanted to own and copyright. He traces the way in which all these uses had to be fought for, or 'produced' as he puts it. It was not, to start with, self evident that a photographic image was more truthful than any other kind of image. Neither was it evident that an image produced by a machine could be owned by an individual; that it could have an author. It was by appealing to other sources of power and authority, and connecting the photographic image to them, that these values were established. Principally, these sources of authority were the new social sciences, civic authorities, courts of law, the premises of capitalist economics, and traditional ideas about artistic creation where the artist is thought to have 'given' something of 'themselves' to their work.

The significance of photographic images can not then be fully grasped without looking to the systems of ideas, and the ways of ordering knowledge and experience, in which they became implicated from the middle of the nineteenth century. And then, having been produced and made meaningful in these ways, they come to be understood within yet other sets of ideas and beliefs. The theories of the 'realists' for example, whose thinking separated the photograph from its social embeddedness and sought its significance in its technological means of production.

That I take a photograph to give me 'the facts' of a situation is 'guaranteed' by the extent to which I consciously or unconsciously accept the principles of empirical scientific method. That I read a photograph as the 'subjective expression' of an artist's idiosyncratic way of seeing the world depends upon my having the idea that this is what art and artists do (and that it is appropriate to see a photograph in this way). When a photograph is a poignant token of my past life, it is so because of a powerful compound of my belief in its scientific basis and my desire for what I have lost.

We need, then, to think about photography as a set of practices with different purposes. Whilst they share a technological basis we do not get very far thinking about these different practices in technological terms alone. We now also need to recognise that digital technology has more than one relationship to this range of photographic practice. Even in these early years, digital image technology is being used in more than one way and these ways inevitably owe much to the established forms, discourses and institutions of photographic production.

Digitisation

Beneath the technological surface of digital image production, important cultural continuities are at work. In a fuller account than it is possible to give here, we

would need to think separately about the digital coding of the analogue chemical photograph, and the *simulation* of 'chemical' photographs by digital means; the production of 'photographic' images which have no specific or causal referent in the world of objects and events. Third, it would probably be useful to distinguish the latter from the scenarios of virtual reality. As these ultimately centre upon an aspiration to dissolve material images altogether; the removal of any material interface between vision and image.

The first two uses of digital technology: the recoding and the simulation of photographs, bear very directly upon what can be done with the photographic image. The third, while being quite remote from the practical production of photographic images, is frequently seen as part of a teleology of the cinema – a progressive technological fulfilment of the cinema's illusionistic power. It is important to stress that beyond research laboratories and 'shoot-em-up' arcades 'virtual realities' are not socially available in any meaningful way. The apparatus is presently more of a 'discursive' than a material object. That is, it is something that is reported rather than seen, something that is talked and speculated about, and represented in other media: cinema, TV, novels, comics, rather than used (Hayward 1993). However, while not at the centre of this essay's concerns, 'VR' has much to do with the notion of a 'digital culture' and the ideological context into which photographic images are now entering. It is, surely, the imagined and desired object into which the 'hard copy' and screen based image manifestations of digitisation are frequently and confusingly collapsed. Not only by techno-theorists but also by manufacturers of popular computer software.

However, closer to the present in which images have their meaning, the digitisation of chemical photographs and video stills was immediately seen to have implications for the continuing (and already problematic) status of photo-reportage, journalism and documentary practice. At the same time, the use and recontexting of digitally scanned and digitally *simulated* photographs, has been primarily applied to entertainment, corporate training and education, in the form of interactive multimedia. It may be useful to see these two developments as pulling in two directions. Broadly, the use of digital technology within documentary and reportage traditions is leading to a defensive preoccupation with issues of authorship and integrity. While within multimedia practice there is, at least at an ideological level (copyright issues are still fiercely pursued, if confused, at the level of material production and product control), a celebration of 'interactivity', of openness, and the dissolution of concepts of original, singular, authorship. (See Barthes 1977a: 142–8, Foucault 1979: 108–19, Lury 1992: 380–5, on concepts of authorship.) This has been a longstanding tension within photographic culture which may now be stretched to breaking point.

The historical use of photographs as 'evidence' and reliable documentation has long been in continual contradiction with other uses of photographs, particularly as art, and in advertising and corporate publicity. As Sekula has put it:

> the hidden imperatives of photographic culture drag us in two contradictory directions: toward 'science' and a myth of 'objective truth' on the one hand, and toward 'art' and a cult of 'subjective experience' on

the other. This dualism haunts photography, lending a certain goofy inconsistency to most commonplace assertions about the medium.

(Sekula 1986: 160)

Sekula points to the way that photographic images are seen, now as the product of an autonomous technological force, now as a matter of aesthetics, pleasure, expression and subjective interiority. This problematic position of photography as it has been caught up in philosophical and institutional divisions of science and art, has always troubled its theorists. Yet it is unlikely that it has troubled its practitioners and institutions to the same extent, on one side of the line or the other. At present, it seems that the advent of digital 'post photography', despite its capacity to confound realist/constructivist categories, is still being thought about with the 'goofy inconsistency' that Sekula points to. Practitioners and institutions with an investment in 'myths of objective truth' are attempting to shore up these ideological partitions (Ritchin 1990b: 36, Mitchell 1992: 8). On the other hand, in both popular and more formal, academic ways, the technology is being seized upon as confirming the dissolution of the science/art, objective/subjective, divide and, in particular, the image's status as any kind of reliable index of a prior reality.

In a short section of his book *The Reconfigured Eye,* entitled 'Digital Images and the Postmodern Era' (Mitchell 1992), William Mitchell proposes that the emergence of digital imaging can be seen as a means to

> expose the aporias in photography's construction of the visual world, to deconstruct the very ideas of photographic objectivity and closure, and to resist what has become an increasingly sclerotic tradition.
>
> (Mitchell 1992: 8)

At one level, Mitchell could well be pointing to the way in which a software programme such as Adobe Photoshop can operate rather like a practical demonstration of photographic semiotics. Within a couple of hours' use, such a programme opens up, in principle at least, the post-production manipulations of photographic representation: manipulations which previously would have been the outcome of several months' apprenticeship in the chemical darkroom. Digital software becomes a heuristic tool for *understanding* photographic representation.

Mitchell goes beyond this. By means of what can only be described as a homology — a sense of a 'fit' or resonance — he suggests that a (digital) medium which 'privileges fragmentation, indeterminacy, and heterogeneity and that emphasises process or performance' is the technological counterpart to some propositions of cultural and linguistic theory. He sees 'post-photographic' practice as analogous to 'poststructuralist' theory, both embraced within a world characterised as 'postmodern'. Where the search of the high modernist heroes of photography, such as Paul Strand and Edward Weston, for a kind of 'objective truth assured by a quasi-scientific procedure and closed, finished perfection', is anachronistic and no longer supportable.

He points to the open-endedness of the digitised image and the manner in which image manipulation software is designed to facilitate change, alteration and recombination of elements. He sees this as being in contrast to the 'one to one' relationship

which the photographic image conventionally has to the scene or object which it represents. He then draws an analogy with poststructuralist theories of language and meaning. The emphasis in such theories is upon the polysemic nature of signs, their capacity to mean more than one fixed thing. It is also upon their 'indeterminacy', the way that language and sign-systems are always in process as they are used. They never reach a final destination of fixed, settled meaning; that is any kind of 'closure'. It is in the emergent form of interactive multimedia that such ideas might be thought to find their analogy in the production of digital image 'texts'.

Multimedia, whether encoded on CD Rom or in its promised 'on-line' forms, raises many questions and issues. With the multimedia 'text' the consumer or user is seen to be empowered by being able to navigate through a potentially immense range of knowledge and information. In making their own connections, choosing their own pathways, by being active in making their own sense of the material, they are thought to be newly included in the construction of meaning. By looking at what is involved in this emergent cultural form, we can take up again the discussion of cultural continuities between the photographic and the digital image. For it looks as if the dispersed social and technological complexity of photographic meaning, which was discussed earlier, has found a kind of concentrated technological form in multimedia production.

[. . .]

Multimedia texts are designed frameworks and structures, holding selective contents, in which a necessarily constrained interactive function is offered to the user/consumer. It is also the case that the signifying powers of the photographic images carried on digital media, the ideological frameworks in which multimedia texts are built, and the conventions which are established to make them meaningful, have to come from somewhere. This 'somewhere' is, in the first instance, the skills, practices and conventions which have been historically developed around the still and moving photographic image. And like the photographic image itself, the range of other signifying and discursive systems which contribute to its meaning. New kinds of production conventions, forms of exhibition, institutions, and new audience or consumer practices are likely to develop for multimedia. They do not, however, exist as pure forms waiting to be divined. They are being built in negotiation with the forms of a photographic culture.

References

Altman, R. (1980) 'Moving Lips: Cinema as Ventriloquism', *Yale French Studies*: 60.

Arnheim, R. (1974) 'On the Nature of Photography', *Critical Enquiry*, 1, September; 155.

Barthes, R. (1977a) 'The Death of the Author', in Barthes, *Image Music Text*, London: Fontana.

—— (1977b) 'The Photographic Message', in Barthes, *Image Music Text*, London: Fontana.

Benjamin, W. (1973) 'The Work of Art in the Age of Mechanical Reproduction', in H. Arendt (ed.), *Illuminations*, Glasgow: Fontana/Collins.

Biggs, S. (1991) 'Media Art and Its Virtual Future', *LVA Catalogue*: 69–72.

Buck-Morss, S. (1991) *The Dialectics of Seeing: Walter Benjamin and the Arcades Project*, Cambridge, Mass.: MIT Press.

Ellis, J. (1991) *Visible Fictions: Cinema: Television: Video*, London and New York: Routledge.

Foucault, M. (1979) 'What is an Author?', in J. V. Harari (ed.), *Textual Strategies: Perspectives in Post-Structuralist Criticism*, Ithaca, NY: Cornell University Press, 108–19.

Green, D. (1984) 'Classified Subjects', *Ten.8*, 14: 30–7.

Hayward, P. (1993) 'Situating Cyberspace; The Popularisation of Virtual Reality', in P. Hayward and T. Wollen (eds), *Future Visions: New Technologies of the Screen*, London: BFI Publishing.

Lury, C. (1992) 'Popular Culture and the Mass Media', in R. Bocock and K. Thompson (eds), *Social and Cultural Forms of Modernity*, Cambridge: Polity Press.

Mitchell, W. J. (1992) *The Reconfigured Eye: Visual Truth in the Post-Photographic Era*, Cambridge, Mass.: MIT Press.

Ritchin, F. (1990b) 'Photojournalism in the Age of Computers', in C. Squiers (ed.), *The Critical Image*, Seattle: Bay Press, 28–37.

Robins, K. (1991) 'Into the Image: Visual Technologies and Vision Cultures', in P. Wombell (ed.), *Photo Video*, London: Rivers Oram Press.

Sekula, A. (1983) 'Photography between Labour and Capital', in B. H. D. Buchloh and R. Wilkie (eds), *Mining Photographs and Other Pictures: A Selection from the Negative Archives of Sheddon Studio, Glace Bay, Cope Breton, 1948–1968*, Nova Scotia: The Press of Nova Scotia College of Art and Design/University College of Cape Breton Press.

—— (1986) 'Reading An Archive: Photography between Labour and Capital', in P. Holland, J. Spence and S. Watney (eds), *Photography/Politics: Two*. London: Comedia.

Snyder, J. (1980) 'Picturing Vision', *Critical Enquiry*, 6, Spring: 499–526.

Snyder, J. and Allen, N. W. (1975) 'Photography, Vision, and Representation', *Critical Enquiry*, 2, Autumn: 143–69.

Tagg, J. (1988) *The Burden of Representation*, London: Macmillan.

Chapter 22

Geoffrey Batchen

PHOTOGENICS

THIS ESSAY WAS PROMPTED BY an exhibition of the past decade's photography acquisitions at the Art Museum of the University of New Mexico in Albuquerque.[1] Not that the work in the exhibition was particularly exceptional. As one might expect in a museum already well known for its photography holdings, it featured a broad range of different photographic approaches, functions and techniques (from an anonymous 1865 portrait of an amputated leg made for an Army Medical Corps to an illustrated fan by contemporary Japanese photo-artist Yasumasa Morimura), and exemplary prints by some *well-known* names (Watkins, Seeley, Salomon, Lange, Friedlander). An impressive collection, especially for a university museum. But what caught the attention was not the work itself but the way in which it was presented. Hung on the usual tastefully coloured walls, the display was organized in a roughly chronological fashion; that is, as a kind of history, a history of photography. Nothing exceptional here either, except for the way the exhibition chose to begin and end its chronology. For the exhibition's curators began their historical exposition with one of photography's earliest products, an 1850 cyanotype contact print by Anna Atkins, and ended with another much larger cyanotype work made in 1977 by American artist Barbara Kasten. The exhibition thereby seemed to be presenting photography's history, as one of the wall texts explicitly told us, as a 'full circle'.

To repeat, this otherwise unassuming exhibition chose to represent photography's history as a movement that is now turning back on itself, almost consuming itself, repeating certain motifs and self-understandings in a kind of cannibalistic homage to itself. It is as if the exhibition wanted to tell us that photography's history has reached a point not of no return but of nothing but returns. This sense of photographic history as a narrative constituted by 'forward motion through endless return' was made all the more poignant by a recent phenomenon that the exhibition excluded from its story; specifically, the displacement of traditional photographs by computer-generated digital images.[2] Continuing in the spirit of the UNM Art

Museum curators, my essay therefore seeks to place the digital phenomenon back into this exhibition's intriguing historical circuitry.

On 2 April 1996, Corbis Corporation, owned by American billionaire Bill Gates, announced that it had signed a long-term agreement with the Ansel Adams Publishing Rights Trust for the exclusive electronic rights to works by Adams. This followed an earlier announcement from Corbis regarding its acquisition of the Bettmann Archive, one of the world's largest image libraries.[3] In this one purchase Gates gained reproduction rights to over 16 million photographic images. But this is only the beginning. Thousands of new images are being added to the Corbis Collection every week, drawn from a multitude of individual commercial photographers as well as institutions such as NASA, the National Institutes of Health, the Library of Congress, the National Gallery of Art in London, the Seattle Art Museum, the Philadelphia Museum of Art and the Hermitage in St Petersburg.[4] Selected images are scanned into the Corbis computer banks, promoted via Web Site, CD-ROMs and catalogues, and then leased, in the form of digital files; to those who are willing to pay for specified electronic 'use-rights'. According to its 1996 catalogue, Corbis is now able to offer its customers over 700,000 of these digital images to choose from.[5]

Even the *New York Times* felt the need to refer to Marxist critic Walter Benjamin when trying to describe the potential consequences of this new industry (for Corbis is but one company in a rapidly expanding trade in electronic images).[6] Benjamin's 1936 essay on the effects of mechanical reproduction tells a rather complicated tale of sacrifice and resurrection.[7] According to this tale, authentic social relations are depleted by their technically induced commodification, in the process creating the conditions for the phoenix-like return of these relations in a post-capitalist economy. His central point was that the shift from production to reproduction, one of the 'basic conditions' of capitalism, would also be the source of this system's downfall. Technological manifestations of this shift, such as photography, therefore embodied the potential for both oppression and liberation. This explains Benjamin's strange ambivalence about technical reproducibility. Interestingly, it is an ambivalence that has been repeated in many of the commentaries on its electronic version. These commentaries often combine Utopian predictions of unfettered, democratized access to the world's visual archives with a fear of the potential trivialization or meaning and history produced by this same access.

There is also a certain nervousness about the prospect of one man, none other than the world's wealthiest capitalist, gaining so much power over the very process, reproduction, that Benjamin saw as crucial to capitalism's demise. This nervousness is understandable when one puts Gates's sudden interest in images into a bigger picture. The Internet is on the verge of becoming an essential part of daily life, providing a vast, competitive electronic market-place in which virtually anything can be bought and sold. Microsoft, another Gates company, is currently struggling with smaller corporate entities such as Netscape to achieve dominance over the means of access to this market. For example, Microsoft is spending millions to develop search and navigation software that will make it possible for any interested subscriber, from schoolchild to industry executive, to locate, download and automatically pay for the images owned by Corbis. The consequence of all this is that Gates may soon control not only the vehicle but also a major portion of the visual

content being conveyed over the information superhighway. To really cash in, all he needs to devise now is the right sort of electronic toll-gate. Here we have the ultimate goal of this whole exercise, and Gates obviously plans to make considerable profits on his investments. But will this new enterprise also accelerate the alienation of his subscribers from their own culture, thereby hastening what Benjamin saw as that culture's inevitable implosion and transformation? Only time will tell.

While we wait, there are a number of more immediate concerns to ponder. One of these is censorship. In November 1995, America Online declared that 'breast' was an indecent word and cut off access to any users' groups who identified themselves with it. The decision was later reversed in the face of complaints from enraged subscribers interested in information on breast cancer. In December 1995, Compuserve temporarily denied four million users of the Internet access to more than 200 discussion groups and picture databases after a federal prosecutor in Munich said the material contained in them violated German pornography laws. On 8 February 1996, American legislators, keen to capture the moral high ground in the lead-up to an election, introduced laws designed to outlaw electronic traffic considered 'indecent'.[8] The Microsoft Network, like the other companies currently offering access to the Internet, already warns its subscribers against exchanging what it deems 'offensive' speech.

It remains to be seen whether Corbis chooses to exercise a similar level of control over its ever-expanding image empire. At this stage the company claims to have no formal policy on the matter, using the undefined criterion of what a spokesman called 'good taste' as a way of assessing images offered to them (resulting, for example, in their rejection of an offer of images of 'babes'). Presumably the company will eventually have to monitor the range of pictures made available to its school-age market. But to what degree will this censorship be extended to its adult customers? As I say, no policy has yet been announced. However, on one level, a selection process of some kind or other is already taking place – only about 5 per cent of the company's holdings have been converted to digital form. Perhaps certain pictures will simply never see the (electronic) light of day.

By dominating the market in electronic reproductions, Gates has also acquired a measure of control over what many might have naively thought to be a public resource – history. Remember that image of Truman holding up the premature issue of the *Chicago Daily Tribune* declaring his defeat by Dewey? It is in the Corbis catalogue. Remember Malcolm X pointing out over his crowd of listeners, the airship *Hindenberg* exploding in the New Jersey sky, that naked Vietnamese child running towards us after being burned by napalm, Churchill flashing his V-for-victory sign, Dorothea Lange's *Migrant Mother*, Patty Hearst posing with her gun in front of the Symbionese Liberation Army banner, LBJ being sworn into office aboard Air Force One beside a blood-spattered Jacky? Corbis offers to lease us electronic versions of them all; it offers to sell us, in other words, the ability to reproduce our memories of our own culture, and therefore of ourselves.

The company's objective, according to its chief executive officer, is to 'capture the entire human experience throughout history'.[9] Notice that experience and image are assumed to be one and the same thing, as are image and reproduction. The 1996 Corbis Catalogue reiterates its CEO's ideal by dividing the company's offerings into

an exhibition of digestable themes: Historical Views, World Art, Entertainment, Contemporary Life, Science and Industry, Animals, Nature, Travel and Culture. In the world according to Corbis, human experience is defined by the needs and demands of commercial publishing. More than anything else, the Corbis Catalogue is full of generic images of the kind desired by busy picture editors: human faces from across the globe, plants and animals of every stripe, cityscapes from Agra to New York, human activity in all its varieties. Want an image of a bi-racial couple? Want a shot of rosary beads and a bible? Want the view from across the handle-bars of a speeding mountain bike? Want to see a welder working on a high-rise building? Corbis can supply any of these and many more like it, all in a glossy, saturated colour, perfect for magazine reproduction and company brochures. Human experience comes suspended in the sickly-sweet amniotic fluid of commer-cial photography. And a world normally animated by abrasive differences is blithely reduced to a single, homogeneous *National Geographic* way of seeing.

All this talk of capturing things brings us to another question – what exactly is Corbis buying and selling? What *is* a digital image? It is notable that in the case of the work of Ansel Adams, they have not bothered to acquire any actual prints (although Gates could obviously afford them). They do not even own the copyright to any of the photographs by Adams (this has been retained by the Adams Publishing Trust). All that Corbis owns are the electronic reproduction rights to certain of Adams's images. The assumption is that, in the near future, *electronic* reproduction is the only kind that is going to matter. The other assumption in play here is that *reproduction* is already the only aspect of an image worth owning. The world's richest man has declared in no uncertain terms that the original print, always a contradic-tion in terms for photography in any case, is of absolutely no interest. He does not want to accumulate photographs; he just wants to be able to sell endless repro-ductions of them. He seeks to control not photography but the total flow of photo-data.

And that is just what he's going to do. *Moonrise, Hernandez, New Mexico*, a photo-graph taken by Adams in November 1941, has been transformed through the wizardry of the computer into a series of digits that take up somewhere between 20 and 50 megabytes of an optical disk (depending on the quality of the reproduc-tion you want).[10] After you pay the required fee, Corbis removes its electronic watermark and gives you the temporary use of a certain system of coded numbers. These numbers, when transposed through a computer program and printer, will reproduce an image that resembles the photograph taken by Adams. If we go back to Benjamin's commentary for a moment, we might conclude that capital has here finally reached the limits of its own logic. It has erased the aura of authenticity from its system of values, and replaced it once and for all with the glitter of repro-ducibility.

In effect, what a customer is leasing from Corbis is the performance rights to a digitized Adams score.[11] But this otherwise useful musical analogy is also a little misleading. For what Corbis actually seems to want to bring to photography is the logic of a certain kind of science. After all, the Corbis Catalogue is insistent that, 'we bring you all the beauty of the original work in a convenient digital format'. In positing a faithful one-to-one correspondence between original and copy, code and image, Corbis claims to go beyond mere performance, inviting us instead to

associate digitization with the precise replication practices of something like genetic engineering.

What are the consequences of such an association? For a start, Corbis's photogenics runs against the grain of photography as understood and practised by Adams. When one orders, for example, *Moonrise, Hernandez, New Mexico* from Corbis one gets a quite particular reproduction. No matter how many times a customer might order this title from Corbis, one is guaranteed exactly the same image, an image precisely cloned from the genetic code that is the new identity of this picture. However, I myself have seen several versions by Adams based on the negative.[12] Indeed, Mary Street Alinder's 1996 biography of Adams details the complex history of this picture, which she suggests is 'for many . . . the greatest photograph ever made'.[13] Alinder suggests that *Moonrise* is an early product of his Zone System of photography, a differentiation of visible light devised by Adams to allow the practitioner to previsualise the entire gamut of values that will appear in the final print. Thus the image comes before the photograph (which is merely its reproduction) and the film is already inscribed with a picture before it is ever exposed to light. This particular exposure was taken by Adams under difficult circumstances on the side of a road in failing light; a recalcitrant negative was the result. Adams made his first print from it in late November 1941, now in the collection of the Museum of Modern Art. In 1948 he attempted to intensify the foreground of the negative, and made further prints in December of that year. By 1980, when he stopped printing from it, Adams had made at least 1300 original prints from that negative, dodging and burning selected areas of the print in an evolving interpretation of its tonal possibilities.

The complication of photography's physical identity (and we are not talking here about the added complexities of contextual or historical determinations of a photograph's meaning) has always been that there is no fixed point of origin; neither the negative nor any one print can be said to represent in its entirety the entity that is called *Moonrise, Hernandez, New Mexico*. And if there is no 'original work', then there can be no 'faithful copy' either. To borrow a phrase from Ferdinand de Saussure's description of language, in photography there are 'only differences *without positive terms*'.[14] As a consequence, photography is produced within and as an economy that Jacques Derrida calls *différance*; any particular photographic image is 'never present in and of itself' but 'is inscribed in a chain or in a system within which it refers to the other, to other [images], by means of the systematic play of differences'.[15] The irony haunting Corbis's electronic reproduction business is that cloning obeys this same [il]logic. In biology, a clone is a copy of another organism produced by implanting an unfertilized egg with a 'differentiated' sample of that organism's DNA.[16] The clone is genetically identical to its donor (its DNA code is a replication of the donor's) and yet the clone is not the same being – it is younger (a lamb is produced from the mammary cell of an adult sheep) – even while, at the same time, its genetic material carries the history of that donor alongside and within its own. *Moonrise* has an equally complicated identity, produced by differentiation and further dividing itself from itself in each and every one of its clones (which are always the same but different, even if this difference is not immediately discernible to the eye).

Bill Gates does not see this proliferation of reproductions as a problem. In his book *The Road Ahead*, he argues that 'exposure to the reproductions is likely to

increase rather than diminish reverence for the real art and encourage more people to get out to museums and galleries'.[17] This is the hope of museums and historians alike, many of whom now offer Web sites as an enticement to potential visitors or as an archival resource for scholars. But what is interesting about the new archiving is that everyone who has access to the data can curate their own museum or devise their own history. Gates, for example, has commissioned a series of large electronic screens to be installed in his new thirty-million dollar house in Seattle and these will be linked to the Corbis database. 'If you're a guest, you'll be able to call up on screens throughout the house almost any image you like – presidential portraits, reproductions of High Renaissance paintings, pictures of sunsets, airplanes, skiers in the Andes, a rare French stamp, the Beatles in 1965'.[18] The eclecticism of his proposed choices – choices so kitsch they're sublime – suggests a further element of digital imaging.[19] Classification, once the closely policed art form of the librarian, is now as potentially idiosyncratic as the famous entry from 'a certain Chinese ency-clopedia' that so amused both Borges and Foucault.[20] Participants who follow the Gates lead can surf an image archive as arbitrarily as people already surf art museums, happily jumping from Rembrandt to ancient Egyptian sculpture to Japanese armour, or from sunsets to stamps to Nobel Prize winners, as the whim takes them.[21] With electronic reproduction, no one has to care about history as a linear sequence any more. History instead becomes a matter of individual inven-tion, a conjuring of talismans of the not-now as a way of confirming our own fragile presence in time and space. History, in other words, takes on something of the poignantly personal character of the photographic (at least as this is described by Roland Barthes in *Camera Lucida*).[22]

Imagine this future. You will venture, electronically of course, into the global supermarket and find offered for sale, side by side on your screen, digital files for an Adams photograph, an improved heart valve and a disease-resistant zucchini. Impossible? Actually, that future is already here. In 1994 Calgene, a California-based biotechnology company, put a tasty genetically engineered tomato on the market, a programmed vegetable that *Newsweek* magazine playfully called 'DNA on a plate'. The human body is already on that same plate. The Human Genome project, for example, presumes that *homo sapiens* too is no more than so much manifest data. At least four firms are currently racing to produce a genetically modified pig whose DNA, having been rendered identical to that of humans, will allow rejection-free organ transplants to take place. In 1995 the US Department of Health and Human Services received a patent (No. 5 397 696) for a virus-resistant cell line found in the blood of Hagahai tribespeople in New Guinea.[23] The list could go on. The point is that Corbis and other companies like it are intent on taking photography into a well-established economy, an economy all about the distillation and exchange of the world's most valuable commodity – data. And within the logic of that (electronic) economy, the identity of an image is no longer distinguishable from that of any other piece of data, be it animal, vegetable or 'experiential' in origin. Indeed, given the rhizomatic structure of the electronic universe, the point of origin is no longer of consequence. All that matters (in every sense of this word) is the possibility of data's instant dissemination and exact reproduction.

Here we have one of the major consequences of advent of the age of electronic reproduction. The old familiar distinctions between reality and its representation,

original and reproduction, nature and culture – we are talking about the very infra-structure of our modern world-view – seem to have collapsed in on each other. More specifically, the substance of an image, the matter of its identity, is no longer to do with paper or particles of silver or pictorial appearance or place of origin; it instead comprises a pliable sequence of digital codes and electrical impulses. It is their configuration that will decide an image's look and significance, even the possi-bility of its continued existence. It is their reproduction and consumption, flow and exchange, maintenance and disruption, that already constitute our culture (that now constitute even our own flesh and blood).

This meditation on the current state of photography's identity brings me back to my essay's beginning, just as the UNM Art Museum's exhibition layout had suggested it would. For it might well be argued that much of what I have just iden-tified with the digital phenomenon can already be found in the work of the medium's earliest practitioners. In the work of Anna Atkins (1799–1871), for example. The cyanotype that opened UNM's exhibition, *Hymenophyllum Wilsoni*, comes from a systematic series of 389 such images that Atkins produced between October 1843, when she issued the first part of her pioneering photographically illustrated book (titled *Photographs of British Algae: Cyanotype Impressions*), and 1853, when it was completed. Thus the inspiration for this image was the science of botany, a disci-pline in which Atkins's father was an established expert, and to whom her book is dedicated. [. . .]

The visual design of Atkins's book followed the lead of an established botanical genre in which actual specimens of seaweed were mounted in bulky, annotated albums or botanical specimens were transformed into engravings, silhouettes or 'cut flower mosaics'.[24] Using William Harvey's unillustrated *Manual of British Algae* of 1841 as her guide, Atkins tells us in her introduction to Part 1 of *British Algae* that she was attempting a 'systematic arrangement', trying to photographically repre-sent 'the Tribes and Species in their proper order'. In Atkins's own schema then, the photogram titled *Hymenophyllum Wilsoni* is but one typical example of a genus; it was made to be representative of a group of images thought to have common structural properties. It should be remembered that each image was printed about 15 times for the different editions of the book, usually re-using the same botanical specimen for each print. So each page always contains the same basic information but also always with slight variations in the arrangement of that information between each edition, as befits a hand-made contact print. In short, like Gates, Atkins presents her images as data, as precisely repeated, invariably differentiated infor-mation derived from a common master code and disseminated in image form. Accordingly, to refer to the original print of *Hymenophyllum Wilsoni* would be a nonsense; for Atkins, photography is a processing of data that produces nothing but reproductions.

There is some confusion as to how this reproduction was actually achieved. In *Sun Gardens*, Larry Schaaf suggests that 'the evidence is that she printed most of her specimens "nude", not mounted on any surface. This can be detected from the fact that identical specimens were sometimes printed in different positions, including as a perfect mirror image'.[25] A little later in a caption for one of these mirrored pairs, he claims that their existence 'prove[s] that Atkins printed many of the plates by placing the unmounted dried-algae original directly on the cyanotype paper'.[26] But

if the two images are mirror-versions of each other, surely this verifies that she cannot have simply placed them directly on the prepared paper? To get an exact mirror copy, surely she must have sandwiched them between two sheets of glass or mica, as Schaaf elsewhere suggests, and then flipped the sheets over as she went from one print to the next?[27] The existence of a mirror version of certain images implies a desire for an exact, even if reversed, copy of a particular specimen. But it also suggests a fledgling effort towards a system of mass production, a gesture towards the possibility of that endless reproduction of images now being engineered by Corbis. [. . .]

The particular example in the UNM exhibition repeats the major visual attributes of all the others Atkins made (a repetition that itself works to give the project some 'scientific' credence). She has carefully centred the image on her page, leaving the plant form to float in an appropriately blue sea of cyan. This symmetry gives the image both a pleasing aesthetic order but also the reasoned geometry of a scientific illustration. A desirably scientific character is further enhanced by the addition of an appropriate Latin name in a photographic facsimile of Atkins's own handwriting, along the lower edge of each print.

What more could be said about these images? What further possible relation could they be said to have to the logic of electronic reproduction? Atkins herself described these images as 'impressions of the plants themselves'. She thus conjures up that direct indexical relationship between an object and its representation which is presumed to be photography's special privilege. As Allan Sekula puts it, photographs are 'physical traces of their objects'.[28] This raises the whole question of the relationship between photograph and object, and necessitates some investigation of 'tracing' in general. Talbot tells us in 1839 about how he showed a contact print of a piece of lace to some friends and asked them whether it was a good representation. The friends replied, he tells us with some pride, 'that they were not to be so easily deceived, for that it was evidently no picture, but the piece of lace itself'.[29] The philosophical dimensions of the blurring of this distinction must surely have occurred to Atkins as she or her servants laboriously made each of her own botanical contact prints.

To make a contact print or photogram, objects such as specimens of seaweed are placed directly on a material made sensitive to the difference between the presence and absence of light. Here object and image, reality and representation, come face to face, literally touching each other. Indeed the production of a photogram requires real and representation to begin as a single merged entity, as inseparable as a mirror and its image, as one and its other. These objects have to be removed before their photographic trace (the articulation of a differential exposure to light) can be seen. By this means, photography allows botanical specimens to be present as image even when they are absent as objects. This continuous play between presence and absence provides, as Talbot put it, 'evidence of a novel kind'.[30] For the photogram's persuasive power depends on precisely a lingering spectre of the total entity, a continual re-presentation of this coming together of image and object on the photographic paper. This is the prior moment, that something other than itself, to which the photogram must always defer in order to be itself.

The photogram (which Rosalind Krauss has argued 'only forces, or makes explicit, what is the case of *all* photography') therefore could be said to mark what

is set aside from itself.[31] It is a marker of the space between the object and its image, but also the temporal movement (the *spacing*) of this object's placement and setting aside – the very condition of the image's production. So we are actually talking about a surprisingly complicated manoeuvre here, a manoeuvre that simultaneously circumscribes and divides the identity summoned by the photogram. Sekula is obviously right to describe the essence of photography as 'trace', for the word itself simultaneously designates both a mark and the act of marking, both a path and its traversal, both the original inscription and its copy, both that which is and that which is left behind, both a plan and its decipherment. To call photography a form of trace is therefore to recognize activity that, as Derrida puts it, 'produces what it forbids, making possible the very thing that it makes impossible'.[32]

To reiterate, the photogram could be said to incorporate a kind of spacing that Derrida has described as 'the impossibility for an identity to be closed in on itself, on the inside of its proper interiority, or on its coincidence with itself'.[33] The contact print, then, like the digital image, represents a visible convolution of the binary relationship of absence/presence, nature/culture, real/representation, inside/outside, time/space, that seemingly constitutes the very possibility of photographing of any kind. So with Atkins's prints we witness not just the beginnings of photography, but also that same collapse of oppositional terms (original/reproduction) that I have already identified with electronic reproduction. Moreover, this investigation of the photogram once again reveals not a simple correspondence of object and photograph, code and image, but what Derrida calls 'an infinite chain, ineluctably multiplying the supplementary mediations that produce the sense of the very thing they defer: the image of the thing itself, of immediate presence, of originary perception'.[34]

I have tried to show that the model adopted by UNM's exhibition, its presentation of photographic history as a 'full circle' comprising a paradoxical play of continuities and differences, absences and presences, differences and deferrals, is repeated wherever one looks – in the work of Anna Atkins and in the logic of electronic reproduction, at the beginnings of photography and at its ends. In that context, I hope I have also been able to present a way of thinking photography that persuasively accords with the medium's own undeniable conceptual and historical complexity.

Notes

1 The exhibition, curated by Kathleen Howe with the assistance of Floramae Cates and Carol McCusker, was titled '*With the Help of Our Friends: Photography Acquisitions, 1985–1995*' (28 August 1996 to 8 December 1996). This paper is an expanded version of a talk I gave in conjunction with the exhibition on 8 October 1996, under the title 'Photography as Trace'. It also incorporates aspects of a talk, 'The Matter of Photography', I gave at the College Art Association Annual Conference in New York on 13 February 1997, and elements of two earlier publications 'Manifest data: the image in the age of electronic reproduction', *Afterimage*, 24:3 (November/December 1996), 5–6, and 'Evidence of a novel kind: photography as trace', *San Francisco Camerawork*, 23:1 (Spring/Summer 1996), 4–7. Thanks to Carla Yanni, Thomas Barrow, Larry Schaaf, Sheldon Brown, and Vicky Kirby for their editional suggestions.

2 See the bibliography in this issue of *History of Photography*, and my 'Ectoplasm: The photograph in the age of electronic reproduction', in Carol Squiers, ed., *The Critical Image: Essays on Contemporary Photography* (Seattle: Bay Press, second edn 1997).

3 Steve Lohr, 'Huge photo archive bought by software billionaire Gates', *New York Times* (11 October 1995), C1, C5.

4 For example, Corbis announced on 4 December 1996 that it had expanded its New York stock agency business with the purchase of the LGI Photo Agency. LGI specializes in images for the entertainment business and editorial market-place. It should be noted that, for most of the institutions mentioned, Corbis has actually negotiated non-exclusive rights, with each institution continuing to have some say over where and how their pictures are reproduced.

5 Corbis, *Corbis Catalogue: Selections from the Corbis Digital Archive, Volume One*, Seattle: Corbis Corporation 1996.

6 See Edward Rothstein, 'How Bill Gates is imitating art', *New York Times* (15 October 1995), E3. For more on Corbis and its operations, see Corey S. Powell, 'The Museum of Modern Art', *World Art*, 1:2 (1994), 10–13; Richard Rapaport. 'In his image', *Wired*, 4:11 (November 1996), 172–75, 276–83; Warren St John, 'Bill Gates just points and clicks, zapping New York's photo libraries', *New York Observer*, 10:48 (16 December 1996), 1, 19; and my 'Manifest data: The image in the age of electronic reproduction', *Afterimage*, 24:3 November/December 1996), 5–6.

7 See Walter Benjamin, 'The work of art in the age of mechanical production' (1936), in *Illuminations*, London: Fontana/Collins 1970, 219–53.

8 On 27 June 1997, the US Supreme Court declared unconstitutional a Federal law that had made it a crime to send 'indecent' material over the Internet. This ruling associated the Internet with books and newspapers in terms of its entitlement to freedom of speech (rather than with the more limited rights accorded broadcast and cable television). For general discussions of this decision and other legal debates about indecency on the Internet see, Linda Greenhouse, 'Statute on Internet indecency draws High Court's review', *New York Times* (7 December 1996), A1, A8; Linda Greenhouse, 'What level of protection for Internet speech?', *New York Times* (24 March 1997), C5; and Linda Greenhouse, 'Decency act fails: effort to shield minors is said to infringe the First Amendment', *New York Times* (27 June 1997), A1, A16.

9 This aspiration was voiced by Corbis's CEO Doug Rowen, in Kate Hafner, 'Picture this', *Newsweek* (24 June 1996), 88–90.

10 In 1991 an amateur astronomer, Dennis di Cicco, calculated the exact time and date when this photograph was taken: 4:49:20 p.m. Mountain Standard Time on 1 November 1941. Interestingly, this calculation was achieved by first transforming the photograph into astronomical data (derived from the pictured moon's altitude and angle from true north). See Mike Haederle, '"Moonrise" Mystery', *Los Angeles Times* (31 October 1991), E1, E4, Thanks to Tom Barrow for this reference.

11 For an introduction to the complexities of American copyright law, see Robert A. Gorman, *Copyright Law*, Washington: Federal Judicial Center, 1991. As Gorman points out, 'Copyright is a form of "intangible" property. The subject of copyright – the words of a poem or the notes of a song – can exist in the mind of the poet or composer, or can be conveyed orally, without being embodied in any tangible medium. Even when thus embodied, it is possible for persons to recite a poem, sing a song, perform a play, or view a painting without having physical possession of the original physical embodiment of the creative work' (p. 6). For this reason a computer program is covered by copyright law as a form of 'literary work'.

12 The Christie's auction catalogue of 17 April 1997, for example, reproduces two visibly different versions of this image, one printed between 1958 and 1961 and one printed in 1978 (Lots 278 and 282).

13 Mary Street Alinder, *Ansel Adams: A Biography*, New York: Henry Holt 1996, 185.

14 Ferdinand de Saussure, *Course in General Linguistics*, trans. Wade Baskin, New York: McGraw-Hill 1966, 120.

15 Jacques Derrida, 'Différance' (1968), in *Margins of Philosophy*, trans. Alan Bass, Chicago: University of Chicago Press 1982, 63.

16 Scottish scientist Ian Wilmut announced that he had cloned the first mammal from a single adult cell on 22 February 1997. For commentaries on this event, see Gina Kolota, 'With cloning of a sheep, the ethical ground shifts', *New York Times* (24 February 1997), A1, C17; Lawrence M. Fisher, 'Cloned animals offer companies a faster path to new drugs', *New York Times* (24 February 1997), C17; Michael Specter, with Gina Kolata, 'After decades and many missteps, cloning success', *New York Times* (3 March 1997), A1, A8–A10; J. Madeleine Nash, 'The age of cloning', *Time* (10 March 1997), 62–5: Sharon Begley, 'Little lamb, who made thee?', *Newsweek* (10 March 1997), 52–9.

17 Bill Gates, *The Road Ahead* London: Penguin 1996, 258.

18 Ibid, 257.

19 Lyotard claims that 'modern aesthetics is an aesthetic of the sublime, though a nostalgic one'. See Jean-François Lyotard, 'Answering the question: what is postmodernism?' (1982), in *The Postmodern Condition: A Report on Knowledge*. Minneapolis: University of Minnesota Press, 1984, 71–82, and 'Presenting the unrepresentable: the sublime'. *Artforum* (April 1982), 64–9. Commenting on these articles. Sydney-based critics Rex Butler and David Messer have offered the following speculation: 'I wonder if a "true" Sublime art – if it existed – could seem anything other than kitsch to us, because it must always attempt to "present the unrepresentable", that which cannot be represented, and fail. Whether, in fact, the *art itself* would not always be this fallen Sublime, or kitsch? That there could be a Sublime but never a sublime art, except *in the very form of kitsch?*' See Rex Butler and David Messer, 'Notes towards a supreme fiction: an interview with Meaghan Morris', *Frogger* 15 (May 1985), 11.

20 Foucault opens his Preface to *The Order of Things* by recalling his encounter with a passage written by the novelist Borges. The passage quotes from a 'certain Chinese encyclopedia' in which it is written that 'animals are divided into: (a) belonging to the Emperor, (b) embalmed, (c) tame, (d) sucking pigs, (e) sirens, (f) fabulous, (g) stray dogs, (h) included in the present classification, (i) frenzied, (j) innumerable, (k) drawn with a very fine camelhair brush, (l) *etcetera*, (m) having just broken the water pitcher, (n) that from a long way off look like flies'. Foucault speaks of the 'wonderment of this taxonomy', taking it to demonstrate 'the exotic charm of another system of thought'. But it also makes him think more keenly about the presumed logic of his own. See Michel Foucault, *The Order of Things: An Archaeology of the Human Sciences*, New York: Vintage Books 1973, xv–xx.

21 As Gates has suggested, 'We make it so easy to call up images, whether art or people or beaches or sunsets or Nobel Prize winners'. See Trip Gabriel, 'Filling in the potholes in the "Road Ahead"', *New York Times* (28 November 1996), B6.

22 See Roland Barthes, *Camera Lucida: Reflections on Photography*, trans. Richard Howard, New York: Hill & Wang 1981. Barthes describes his relationship to photography in terms of an intensely personal experience he calls *punctum*; 'it is what I add to the photograph and *what is nonetheless already there*' (p. 55),

23 See Laura Shapiro, 'A tomato with a body that just won't quit', *Newsweek* (6 June 1994), 80–2; Lawrence M. Fisher, 'Down on the farm, a donor: genetically altered pigs bred for organ transplants', *New York Times* (5 January 1996), C1, C6; Teresa Riordan, 'A recent patent on a Papua New Guinea tribe's cell line prompts outrage and charges of "biopiracy"', *New York Times* (27 November 1995), C2. The genetically

engineered foods that are now, or soon will be, available to consumers include abalone, apples, asparagus, carrots, catfish, chestnuts, corn, grapes, lettuce, potatoes, prawns, rice, salmon, walnuts and wheat. As the *New York Times* reports, 'for now the only way Americans can avoid genetically engineered food is to choose certified organic food'. See Marian Burros, 'Trying to get labels on genetically altered food', *New York Times* (21 May 1997), B8.

24 In 1823 Atkins had herself produced 256 drawings of shells which were then transformed into engravings to illustrate her father's translation of Lamarck's *Genera of Shells*. The 'cut flower mosaic' technique of illustration was invented by a Mrs Delany in the eighteenth century. See plate 50 in Mrs Neville Jackson, *Silhouette: Notes and Dictionary*, New York: Charles Scribner's Sons 1938.

25 Larry Schaaf, *Sun Gardens: Victorian Photograms by Anna Atkins*, New York: Aperture 1985, 31.

26 Ibid, 33. The reference is to Figure 13A–C, showing the same specimen of *Dictyota dichotoma* in three different arrangements.

27 In email correspondence with the author, exchanged in October 1996, Schaaf made the following comment on this possibility: 'Mica was available in larger sheets than we are used to now but it was still scarce and relatively expensive. She might have used waxed paper (as in the labels) but I have no direct evidence of this. But the number of specimens that are arranged in subtly different ways – i.e. rotated slightly, would indicate that they were printed nude. If one was working with even a very large sheet of mica, one would be likely to orient it more consistently'.

28 Allan Sekula, 'Photography between labour and capital', in Benjamin H. D. Buchloh and Robert Wilkie, eds, *Mining Photographs and Other Pictures 1948–1968: A Selection from the Negative Archives of Shedden Studio, Glace Bay, Cape Breton*, Halifax: Press of the Nova Scotia College of Art and Design and The University College of Cape Breton Press, 1983, 218.

29 William Henry Fox Talbot, 'Some account of the art of photogenic drawing' (1839) in Beaumont Newhall, ed., *Photography: Essays an Images*, New York: Museum of Modem Art 1980, 24,

30 William Henry Fox Talbot, *The Pencil of Nature*, 1844–46; facsimile edition, New York: Da Capo 1968, plate 3.

31 Rosalind Krauss, 'Notes on the Index: Part I' (1977), in *The Originality of the Avant-Garde and Other Modernist Myths*, Cambridge, MA; MIT Press 1985, 203.

32 Jacques Derrida, *Of Grammatology*, trans. Gayatri Spivak, Baltimore: Johns Hopkins University Press 1976, 143.

33 Jacques Derrida, *Positions*, trans. Alan Bass, Chicago: University Chicago Press 1991, 94.

34 Derrida, *Of Grammatology*, 157.

Lev Manovich

THE PARADOXES OF DIGITAL PHOTOGRAPHY

Digital revolution?

COMPUTERIZED DESIGN SYSTEMS that flawlessly combine real photographed objects and objects synthesized by the computer. Satellites that can photograph the license plate of your car and read the time on your watch. 'Smart' weapons that recognize and follow their targets in effortless pursuit – the kind of new, post-modern, post-industrial dance to which we were all exposed during the televised Gulf war. New medical imaging technologies that map every organ and function of the body. On-line electronic libraries that enable any designer to acquire not only millions of photographs digitally stored but also dozens of styles which can be automatically applied by a computer to any image.

All of these and many other recently emerged technologies of image-making, image manipulation, and vision depend on digital computers. All of them, as a whole, allow photographs to perform new, unprecedented, and still poorly understood functions. All of them radically change what a photograph is.

Indeed, digital photographs function in an entirely different way from traditional – lens and film based – photographs. For instance, images are obtained and displayed by sequential scanning; they exist as mathematical data which can be displayed in a variety of modes – sacrificing color, spatial or temporal resolution. Image processing techniques make us realize that any photograph contains more information than can be seen with the human eye. Techniques of 3-D computer graphics make possible the synthesis of photo realistic images – yet, this realism is always partial, since these techniques do not permit the synthesis of any arbitrary scene.[1]

Digital photographs function in an entirely different way from traditional photographs. Or do they? Shall we accept that digital imaging represents a radical rupture with photography? Is an image, mediated by computer and electronic technology, radically different from an image obtained through a photographic lens and

embodied in film? If we describe film-based images using such categories as depth of field, zoom, a shot or montage, what categories should be used to describe digital images? Shall the phenomenon of digital imaging force us to rethink such fundamental concepts as realism or representation?

In this essay I will refrain from taking an extreme position of either fully accepting or fully denying the idea of a digital imaging revolution. Rather, I will present the logic of the digital image as paradoxical; radically breaking with older modes of visual representation while at the same time reinforcing these modes. I will demonstrate this paradoxical logic by examining two questions: alleged physical differences between digital and film-based representation of photographs and the notion of realism in computer generated synthetic photography.

The logic of the digital photograph is one of historical continuity and discontinuity. The digital image tears apart the net of semiotic codes, modes of display, and patterns of spectatorship in modern visual culture – and, at the same time, weaves this net even stronger. The digital image annihilates photography while solidifying, glorifying and immortalizing the photographic. In short, this logic is that of photography after photography.

Digital photography does not exist

It is easiest to see how digital (r)evolution solidifies (rather than destroys) certain aspects of modern visual culture – the culture synonymous with the photographic image – by considering not photography itself but a related film-based medium – cinema. New digital technologies promise to radically reconfigure the basic material components (lens, camera, lighting, film) and the basic techniques (the separation of production and post-production, special effects, the use of human actors and non-human props) of the cinematic apparatus as it has existed for decades. The film camera is increasingly supplemented by the virtual camera of computer graphics which is used to simulate sets and even actors (as in *Terminator 2* and *Jurassic Park*). Traditional film editing and optical printing are being replaced by digital editing and image processing which blur the lines between production and post-production, between shooting and editing.

At the same time, while the basic technology of film-making is about to disappear, being replaced by new digital technologies, cinematic codes find new roles in the digital visual culture. New forms of entertainment based on digital media and even the basic interface between a human and a computer are being increasingly modeled on the metaphors of movie making and movie viewing. With Quicktime technology, built into every Macintosh sold today, the user makes and edits digital 'movies' using software packages whose very names (such as Director and Premiere) make a direct reference to cinema. Computer games are also increasingly constructed on the metaphor of a movie, featuring realistic sets and characters, complex camera angles, dissolves, and other codes of traditional filmmaking. Many new CD-ROM games go even further, incorporating actual movie-like scenes with live actors directed by well known Hollywood directors. Finally, SIGGRAPH, the largest international conference on computer graphics technology, offers a course entitled 'Film Craft in User Interface Design' based on the premise that 'The rich

store of knowledge created in 90 years of filmmaking and animation can contribute to the design of user interfaces of multimedia, graphics applications, and even character displays.'[2]

Thus, film may soon disappear – but not cinema. On the contrary, with the disappearance of film due to digital technology, cinema acquires a truly fetishistic status. Classical cinema has turned into the priceless data bank, the stock which is guaranteed never to lose its value as classic films become the content of each new round of electronic and digital distribution media – first video cassette, then laser disk, and, now, CD-ROM (major movie companies are planning to release dozens of classic Hollywood films on CD-ROM by the end of 1994). Even more fetishized is 'film look' itself – the soft, grainy, and somewhat blurry appearance of a photographic image which is so different from the harsh and flat image of a video camera or the too clean, too perfect image of computer graphics. The traditional photographic image once represented the inhuman, devilish objectivity of technological vision. Today, however, it looks so human, so familiar, so domesticated – in contrast to the alienating, still unfamiliar appearance of a computer display with its 1,280 by 1,024 resolution, 32 bits per pixel, 16 million colors, and so on. Regardless of what it signifies, any photographic image also connotes memory and nostalgia, nostalgia for modernity and the twentieth century, the era of the pre-digital, pre-post-modern. Regardless of what it represents, any photographic image today first of all represents photography.

So while digital imaging promises to completely replace the techniques of filmmaking, it at the same time finds new roles and brings new value to the cinematic apparatus, the classic films, and the photographic look. This is the first paradox of digital imaging.

But surely, what digital imaging preserves and propagates are only the cultural codes of film or photography. Underneath, isn't there a fundamental physical difference between film-based image and a digitally encoded image?

The most systematic answer to this question can be found in William Mitchell's recent book *The Reconfigured Eye: Visual Truth in the Post-Photographic Era*.[3] Mitchell's entire analysis of the digital imaging revolution revolves around his claim that the difference between a digital image and a photograph 'is grounded in fundamental physical characteristics that have logical and cultural consequences.'[4] In other words, the physical difference between photographic and digital technology leads to the difference in the logical status of film-based and digital images and also to the difference in their cultural perception.

How fundamental is this difference? If we limit ourselves by focusing solely, as Mitchell does, on the abstract principles of digital imaging, then the difference between a digital and a photographic image appears enormous. But if we consider concrete digital technologies and their uses, the difference disappears. Digital photography simply does not exist.

The first alleged difference concerns the relationship between the original and the copy in analog and in digital cultures. Mitchell writes: 'The continuous spatial and tonal variation of analog pictures is not exactly replicable, so such images cannot be transmitted or copied without degradation . . . But discrete states can be replicated precisely, so a digital image that is a thousand generations away from the original is indistinguishable in quality from any one of its progenitors.'[5] Therefore,

in digital visual culture, 'an image file can be copied endlessly, and the copy is distinguishable from the original by its date since there is no loss of quality.'[6] This is all true – in principle. However, in reality, there is actually much more degradation and loss of information between copies of digital images than between copies of traditional photographs. A single digital image consists of millions of pixels. All of this data requires considerable storage space in a computer; it also takes a long time (in contrast to a text file) to transmit over a network. Because of this, the current software and hardware used to acquire, store, manipulate, and transmit digital images uniformly rely on lossy compression – the technique of making image files smaller by deleting some information.[7] The technique involves a compromise between image quality and file size – the smaller the size of a compressed file, the more visible are the visual artifacts introduced in deleting information. Depending on the level of compression, these artifacts range from barely noticeable to quite pronounced. At any rate, each time a compressed file is saved, more information is lost, leading to more degradation.

One may argue that this situation is temporary and once cheaper computer storage and faster networks become commonplace, lossy compression will disappear. However, at the moment, the trend is quite the reverse with lossy compression becoming more and more the norm for representing visual information. If a single digital image already contains a lot of data, then this amount increases dramatically if we want to produce and distribute moving images in a digital form (one second of video, for instance, consists of 30 still images). Digital television with its hundreds of channels and video on-demand services, the distribution of full-length films on CD-ROM or over Internet, fully digital post-production of feature films – all of these developments will be made possible by newer compression techniques.[8] So rather than being an aberration, a flaw in the otherwise pure and perfect world of the digital, where even a single bit of information is never lost, lossy compression is increasingly becoming the very foundation of digital visual culture. This is another paradox of digital imaging – while in theory digital technology entails the flawless replication of data, its actual use in contemporary society is characterized by the loss of data, degradation, and noise; the noise which is even stronger than that of traditional photography.

The second commonly cited difference between traditional and digital photography concerns the amount of information contained in an image. Mitchell sums it up as follows: 'There is an indefinite amount of information in a continuous-tone photograph, so enlargement usually reveals more detail but yields a fuzzier and grainier picture . . . A digital image, on the other hand, has precisely limited spatial and tonal resolution and contains a fixed amount of information.'[9] Here again Mitchell is right in principle: a digital image consists of a finite number of pixels, each having a distinct color or a tonal value, and this number determines the amount of detail an image can represent. Yet in reality this difference does not matter any more. Current scanners, even consumer brands, can scan an image or an object with very high resolution: 1,200 or 2,400 pixels per inch is standard today. True, a digital image is still comprised of a finite number of pixels, but at such resolution it can record much finer detail than was ever possible with traditional photography. This nullifies the whole distinction between an 'indefinite amount of information in a continuous-tone photograph' and a fixed amount of detail in a digital image.

The more relevant question is how much information in an image can be useful to the viewer. Current technology has already reached the point where a digital image can easily contain much more information than anybody would ever want. This is yet another paradox of digital imaging.

But even the pixel-based representation, which appears to be the very essence of digital imaging, can no longer be taken for granted. Recent computer graphics software have bypassed the limitations of the traditional pixel grid which limits the amount of information in an image because it has a fixed resolution. Live Picture, an image editing program for the Macintosh, converts a pixel-based image into a set of equations. This allows the user to work with an image of virtually unlimited size. Another paint program Matador makes possible painting on a tiny image which may consist of just a few pixels as though it were a high-resolution image (it achieves this by breaking each pixel into a number of smaller sub-pixels). In both programs, the pixel is no longer a 'final frontier'; as far as the user is concerned, it simply does not exist.

Mitchell's third distinction concerns the inherent mutability of a digital image. While he admits that there has always been a tradition of impure, re-worked photography (he refers to 'Henry Peach Robinson's and Oscar G. Reijlander's nineteenth-century "combination prints," John Heartfield's photomontages'[10] as well as numerous political photo fakes of the twentieth century) Mitchell identifies straight, unmanipulated photography as the essential, 'normal' photographic practice: 'There is no doubt that extensive reworking of photographic images to produce seamless transformations and combinations is technically difficult, time-consuming, and outside the mainstream of photographic practice. When we look at photographs we presume, unless we have some clear indications to the contrary, that they have not been reworked.'[11] This equation of 'normal' photography with straight photography allows Mitchell to claim that a digital image is radically different because it is inherently mutable: 'the essential characteristic of digital information is that it can be manipulated easily and very rapidly by computer. It is simply a matter of substituting new digits for old . . . Computational tools for transforming, combining, altering, and analyzing images are as essential to the digital artist as brushes and pigments to a painter.'[12]

From this allegedly purely technological difference between a photograph and a digital image, Mitchell deduces differences in how the two are culturally perceived. Because of the difficulty involved in manipulating them, photographs 'were comfortably regarded as causally generated truthful reports about things in the real world.'[13] Digital images, being inherently (and so easily) mutable, call into question 'our ontological distinctions between the imaginary and the real'[14] or between photographs and drawings. Furthermore, in a digital image, the essential relationship between signifier and signified is one of uncertainty.[15]

Does this hold? While Mitchell aims to deduce culture from technology, it appears that he is actually doing the reverse. In fact, he simply identifies the pictorial tradition of realism with the essence of photographic technology and the tradition of montage and collage with the essence of digital imaging. Thus, the photographic work of Robert Weston and Ansel Adams, nineteenth- and twentieth-century realist painting, and the painting of the Italian Renaissance become the essence of

photography; while Robinson's and Reijlander's photo composites, constructivist montage, contemporary advertising imagery (based on constructivist design), and Dutch seventeenth-century painting (with its montage-like emphasis on details over the coherent whole) become the essence of digital imaging. In other words, what Mitchell takes to be the essence of photographic and digital imaging technology are two traditions of visual culture. Both existed before photography, and both span different visual technologies and mediums. Just as its counterpart, the realistic tradition extends beyond photography *per se* and at the same time accounts for just one of many photographic practices.

If this is so, Mitchell's notion of 'normal' unmanipulated photography is problematic. Indeed, unmanipulated 'straight' photography can hardly be claimed to dominate the modern uses of photography. Consider, for instance, the following photographic practices. One is Soviet photography of the Stalinist era. All published photographs were not only staged but also retouched so heavily that they can hardly be called photographs at all. These images were not montages, as they maintained the unity of space and time, and yet, having lost any trace of photographic grain due to retouching, they existed somewhere between photography and painting. More precisely, we can say that Stalinist visual culture eliminated the very difference between a photograph and a painting by producing photographs which looked like paintings and paintings (I refer to Socialist Realism) which looked like photographs. If this example can be written off as an aberration of totalitarianism, consider another photographic practice closer to home: the use of photographic images in twentieth century advertising and publicity design. This practice does not make any attempt to claim that a photographic image is a witness testifying about the unique event which took place in a distinct moment of time (which is how, according to Mitchell, we normally read photography). Instead, a photograph becomes just one graphic element among many: few photographs coexist on a single page; photographs are mixed with type; photographs are separated from each by white space, backgrounds are erased leaving only the figures, and so on. The end result being that here, as well, the difference between a painting and a photograph does not hold. A photograph as used in advertising design does not point to a concrete event or a particular object. It does not say, for example, 'this hat was in this room on May 12.' Rather, it simply presents 'a hat' or 'a beach' or 'a television set' without any reference to time and location.

Such examples question Mitchell's idea that digital imaging destroys the innocence of straight photography by making all photographs inherently mutable. Straight photography has always represented just one tradition of photography; it always coexisted with equally popular traditions where a photographic image was openly manipulated and was read as such. Equally, there never existed a single dominant way of reading photography; depending on the context the viewer could (and continue to) read photographs as representations of concrete events, or as illustrations which do not claim to correspond to events which have occurred. Digital technology does not subvert 'normal' photography because 'normal' photography never existed.

Real, all too real: socialist realism of *Jurassic Park*

I have considered some of the alleged physical differences between traditional and digital photography. But what is a digital photograph? My discussion has focused on the distinction between a film-based representation of an image versus its representation in a computer as a grid of pixels having a fixed resolution and taking up a certain amount of computer storage space. In short, I highlighted the issue of analog versus digital representation of an image while disregarding the procedure through which this image is produced in the first place. However, if this procedure is considered, another meaning of digital photography emerges. Rather than using the lens to focus the image of actual reality on film and then digitizing the film image (or directly using an array of electronic sensors) we can try to construct three-dimensional reality inside a computer and then take a picture of this reality using a virtual camera also inside a computer. In other words, 3-D computer graphics can also be thought off as digital – or synthetic – photography.

I will conclude by considering the current state of the art of 3-D computer graphics. Here we will encounter the final paradox of digital photography. Common opinion holds that synthetic photographs generated by computer graphics are not yet (or perhaps will never be) as precise in rendering visual reality as images obtained through a photographic lens. However, I will suggest that such synthetic photographs are already more realistic than traditional photographs. In fact, they are too real.

The achievement of realism is the main goal of research in the 3-D computer graphics field. The field defines realism as the ability to simulate any object in such a way that its computer image is indistinguishable from its photograph. It is this ability to simulate photographic images of real or imagined objects which makes possible the use of 3-D computer graphics in military and medical simulators, in television commercials, in computer games, and, of course, in such movies as *Terminator 2* or *Jurassic Park*.

These last two movies, which contain the most spectacular 3-D computer graphics scenes to date, dramatically demonstrate that total synthetic realism seems to be in sight. Yet, they also exemplify the triviality of what at first may appear to be an outstanding technical achievement – the ability to fake visual reality. For what is faked is, of course, not reality but photographic reality, reality as seen by the camera lens. In other words, what computer graphics has (almost) achieved is not realism, but only photorealism – the ability to fake not our perceptual and bodily experience of reality but only its photographic image.[16] This image exists outside of our consciousness, on a screen – a window of limited size which presents a still imprint of a small part of outer reality, filtered through the lens with its limited depth of field, filtered through film's grain and its limited tonal range. It is only this film-based image which computer graphics technology has learned to simulate. And the reason we think that computer graphics has succeeded in faking reality is that we, over the course of the last hundred and fifty years, have come to accept the image of photography and film as reality.

What is faked is only a film-based image. Once we came to accept the photographic image as reality, the way to its future simulation was open. What remained were small details: the development of digital computers (1940s) followed by a

perspective-generating algorithm (early 1960s), and then working out how to make a simulated object solid with shadow, reflection and texture (1970s), and finally simulating the artifacts of the lens such as motion blur and depth of field (1980s). So, while the distance from the first computer graphics images circa 1960 to the synthetic dinosaurs of *Jurassic Park* in the 1990s is tremendous, we should not be too impressed. For, conceptually, photorealistic computer graphics had already appeared with Félix Nadar's photographs in the 1840s and certainly with the first films of the Lumières in the 1890s. It is they who invented 3-D computer graphics.

So the goal of computer graphics is not realism but only photorealism. Has this photorealism been achieved? At the time of this writing (May 1994) dinosaurs of *Jurassic Park* represent the ultimate triumph of computer simulation, yet this triumph took more than two years of work by dozens of designers, animators, and programmers of Industrial Light and Magic (ILM), probably the premier company specializing in the production of computer animation for feature films in the world today. Because a few seconds of computer animation often requires months and months of work, only the huge budget of a Hollywood blockbuster could pay for such extensive and highly detailed computer generated scenes as seen in *Jurassic Park*. Most of the 3-D computer animation produced today has a much lower degree of photorealism and this photorealism is uneven, higher for some kinds of objects and lower for others.[17] And even for ILM photorealistic simulation of human beings, the ultimate goal of computer animation, still remains impossible.

Typical images produced with 3-D computer graphics still appear unnaturally clean, sharp, and geometric looking. Their limitations especially stand out when juxtaposed with a normal photograph. Thus one of the landmark achievements of *Jurassic Park* was the seamless integration of film footage of real scenes with computer simulated objects. To achieve this integration, computer-generated images had to be degraded; their perfection had to be diluted to match the imperfection of film's graininess.

First, the animators needed to figure out the resolution at which to render computer graphics elements. If the resolution were too high, the computer image would have more detail than the film image and its artificiality would become apparent. Just as Medieval masters guarded their painting secrets now leading computer graphics companies carefully guard the resolution of images they simulate.

Once computer-generated images are combined with film images additional tricks are used to diminish their perfection. With the help of special algorithms, the straight edges of computer-generated objects are softened. Barely visible noise is added to the overall image to blend computer and film elements. Sometimes, as in the final battle between the two protagonists in *Terminator 2*, the scene is staged in a particular location (a smoky factory in this example) which justifies addition of smoke or fog to further blend the film and synthetic elements together.

So, while we normally think that synthetic photographs produced through computer graphics are inferior in comparison to real photographs, in fact, they are too perfect. But beyond that we can also say that paradoxically they are also too real.

The synthetic image is free of the limitations of both human and camera vision. It can have unlimited resolution and an unlimited level of detail. It is free of the depth-of-field effect, this inevitable consequence of the lens, so everything is in

focus. It is also free of grain – the layer of noise created by film stock and by human perception. Its colors are more saturated and its sharp lines follow the economy of geometry. From the point of view of human vision it is hyperreal. And yet, it is completely realistic. It is simply a result of a different, more perfect than human, vision.

Whose vision is it? It is the vision of a cyborg or a computer; a vision of Robocop and of an automatic missile. It is a realistic representation of human vision in the future when it will be augmented by computer graphics and cleansed from noise. It is the vision of a digital grid. Synthetic computer-generated image is not an inferior representation of our reality, but a realistic representation of a different reality.

By the same logic, we should not consider clean, skinless, too flexible, and in the same time too jerky, human figures in 3-D computer animation as unrealistic, as imperfect approximation to the real thing – our bodies. They are a perfectly realistic representation of a cyborg body yet to come, of a world reduced to geometry, where efficient representation via a geometric model becomes the basis of reality. The synthetic image simply represents the future. In other words, if a traditional photograph always points to the past event, a synthetic photograph points to the future event.

We are now in a position to characterize the aesthetics of *Jurassic Park*. This aesthetic is one of Soviet Socialist Realism. Socialist Realism wanted to show the future in the present by projecting the perfect world of future socialist society on a visual reality familiar to the viewer – streets, faces, and cities of the 1930s. In other words, it had to retain enough of the then everyday reality while showing how that reality would look in the future when everyone's body will be healthy and muscular, every street modern, every face transformed by the spirituality of communist ideology.

Exactly the same happens in *Jurassic Park*. It tries to show the future of sight itself – the perfect cyborg vision free of noise and capable of grasping infinite details – vision exemplified by the original computer graphics images before they were blended with film images. But just as Socialist Realist paintings blended the perfect future with the imperfect reality of the 1930s and never depicted this future directly (there is not a single Socialist Realist work of art set in the future), *Jurassic Park* blends the future super-vision of computer graphics with the familiar vision of film image. In *Jurassic Park*, the computer image bends down before the film image, its perfection is undermined by every possible means and is also masked by the film's content.

This is then, the final paradox of digital photography. Its images are not inferior to the visual realism of traditional photography. They are perfectly real – all too real.

Notes

1 Lev Manovich, 'Assembling Reality: Myths of Computer Graphics,' *Afterimage* 20/2 (September 1992), pp. 12–14.
2 SIGGRAPH 93. ADVANCE PROGRAM (ACM: New York, 1993), 28.
3 William Mitchell, The Reconfigured Eye: Visual Truth in the Post-Photographic Era (Cambridge, Mass.: MIT Press, 1992).

4 Ibid., 4.

5 Ibid., 6.

6 Ibid., 49.

7 Currently the most widespread technique for compressing digital photographs is JPEG. For instance, every Macintosh comes with JPEG compression software.

8 For almost a century, our standard of visual fidelity was determined by the film image. A video or television image was always viewed as an imperfect, low quality substitute for the 'real thing' – a film-based image. Today, however, a new even lower quality image is becoming increasingly popular – an image of computer multi-media. Its quality is exemplified by a typical, as of this writing, Quicktime movie: 320 by 240 pixels, 10–15 frames a second. Is the 35 mm film image going to remain the unchallenged standard with computer technology eventually duplicating its quality? Or will a low quality computer image be gradually accepted by the public as the new standard of visual truth?

9 Mitchell, The Reconfigured Eye, p. 6.

10 Ibid., 7.

11 Ibid.

12 Ibid.

13 Ibid., 225.

14 Ibid.

15 Ibid., 17.

16 The research in virtual reality aims to go beyond the screen image in order to simulate both the perceptual and bodily experience of reality.

17 See Manovich, 'Assembling Reality.'

PART SIX

Documentary and photojournalism

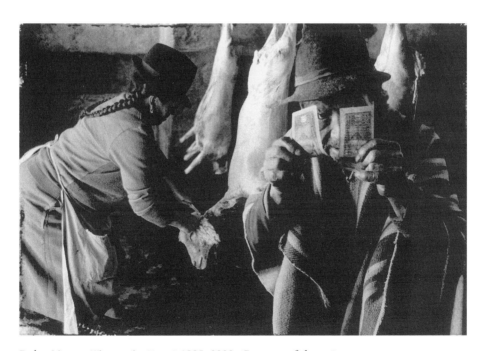

Pedro Meyer, *Where is the Money?* 1985–2000. Courtesy of the artist.

Introduction

PEDRO MEYER'S IMAGE, 'Where is the Money?' (frontispiece to this Part) is a digital composite of two photographs, both taken at the same time and place in Ecuador. The background image of the woman with the dead sheep was turned round in order to synthesise the direction of light within the picture and make space for the man with the money (Meyer 2000). So is this a documentary image? Meyer argues that it is, in that it draws information together to make a point, just as journalists draw upon notes and interviews in order to weave a story, and documentary film-makers utilise narrative conventions and editing processes. Debates about documentary and photojournalism regularly return to questions of authenticity. Yet arguably the fundamental issues are ethical, relating primarily not to questions of naturalistic accuracy, but to seriousness of purpose, detail and depth of research, and to integrity of story-telling.

The term 'documentary' was coined by Scottish film-maker, John Grierson, in 1926, to designate work based upon the 'creative interpretation of reality'. However, documentary-style street photography dates from the mid-1860s (for instance, Thomas Annan in Glasgow, John Thomson in London, Jacob Riis in New York). Experiments in half-tone printing of photographs, thereby allowing their mass circulation in 'illustrated' magazines, also date from the late nineteenth century. Sylvia Harvey suggests that, historically, documentary – as opposed to news – was not popular in Britain. Generally, it was photographers from the middle and upper classes who sought images of the poor for purposes which included curiosity, philanthropy and sociology, but also policing and social control (Harvey 1986: 28). Likewise John Tagg has argued:

> Though an honorific culture continued, in which it was a privilege to be looked at and pictured, its representations were institutionally and economically separated from instrumental archives in which the production of normative typologies was joined to the tasks of surveil-lance, record, and control. To be pictured here was not an honor, but a mark of subjugation: the stigma of an other place; the burden of a class of fetishized Others; scrutinized, pathologized, and trained, forced to show but not to speak, cut off from the powers and pleasures of producing and possessing meaning, fashioned and consumed in . . . a cycle of derision and desire.
>
> (Tagg 1988: 11–12)

Arguably, the documentary movements of the 1930s in Britain and USA (e.g. Humphrey Spender, Mass Observation and Walker Evans, Dorothea Lange of the Farm Security Administration (FSA) were characterised by paternalism which, despite the veneer of liberalism, is equally stigmatic. Yet the 1930s also witnessed radical film and photography workshops (fostered by the communist parties in Britain and North America) which portrayed events and social circumstances from

a working class position. In other words, in assessing particular projects we need to take into account underlying purposes and attitudes.

It is difficult now to imagine a world without images of different, often distant, places. But, as Giselle Freund has remarked:

> Before the first press pictures, the ordinary man [sic] could visualize only those events that took place near him, on his street, or in his village The faces of public personalities became familiar and things that happened all over the globe were his to share. As the reader's outlook expanded, the world began to shrink.
>
> (Freund 1980: 103)

As Susan Sontag has commented, photographs give us an *unearned* sense of familiarity with and knowledge about the world (Sontag 1979). Photographs reflect particular points of view and sets of attitudes. In photojournalism, subject-matter and photographic coding intersect with broader sets of codes and conventions associated with news publications (see Hall 1973). They are subject to the social and political practices of news production and circulation.

The idea of documentary attracted much debate in the 1970s and 1980s. This stemmed in part from concern with the politics of representation, and in part from more abstract philosophical debates through which the Cartesian distinction between subject and object, viewer and viewed, was challenged (see Kember, Part 5, p. 202 ff.). These strands of debate came together to undermine the twin bases of documentary, namely, the idea of documentary 'truth' and the notion of the neutrality of the observer. The photographer as observer had been seen as the framer and taker of the image, with creativity in photography reliant on recognising 'telling' moments. French photographer, Cartier-Bresson famously emphasised the 'decisive moment' when aesthetic composition and subject matter come together. But, Bill Jay has remarked on the willingness of photographers to abandon 'good behavior' for the sake of a picture remarking that 'this image of the photographer/aggressor is inescapable in the fictional characters of photographers in short stories and novels . . .'. (Jay 1984: 8). Indeed, as Susan Sontag observed, the terminology of photography is analogous to that of the military: 'load', 'aim', 'shoot' (Sontag 1979: 14). In the 1970s, images were interrogated in terms of the context of making, the intentions and power of the photographer, and how meaning shifts as photographs become variously recontextualised. Questions were raised as to who got to photograph whom, in what circumstances, in what ways, why and for what purposes?

One consequence of such concerns was a burgeoning number of books and exhibitions exploring the lives of the working people in order to expose and question taken-for-granted social histories. Such projects inter-linked with work by feminists and radical labour historians and, slightly later, those involved in post-colonial studies. Here, archive photographs, including family albums, were seen as sources of information or taken as evidence of ways of life; as well as becoming

interrogated as particular types of documents whose origins lay in specific class relations. Photography projects were set up to encourage people to explore their own locality and social relations; such projects often inter-connected with local oral history projects. In this context, photography workshops were intended not only to assert alternative stories/histories (in terms of class, locality, gender, ethnicity) but also to empower people as makers of images.

The first two essays included here interrogate ways in which photographs are used as evidence, and question documentary attitudes and practices. John Tagg draws attention to uses of images as documents within government disciplinary systems. In the 1980s increasing attention was paid to Michel Foucault's research on ways in which the organisation of ideas or systems or things (for instance, buildings, such as prisons; the writing of history; knowledge hierarchies) reflects authority and power relations. Archives of photographs thus can be seen as systems begging analysis. Tagg's essay argues that photography as such has no identity but is formed through the play of various discourses. It was first published in the British journal, *Ten.8* in 1984, then an emerging focus for critical discussions of photography and of the 'politics of representation'.

Likewise, in an essay first published in 1981, Martha Rosler discusses the power relations which characterise documentary, arguing that photographs of the poor and the dispossessed are framed by a liberal rhetoric and morality which stands in place of political activism; furthermore, that photos – aestheticised and marketable – have become a part of the genre of documentary, rather than a part of a politics. Political concerns about America's role in Vietnam, along with the civil rights movement and the women's movement, had contributed a radical edge to debates about representation and participation in decision-making processes; this in turn influenced critical debates about the photograph and the attitudes, role and responsibilities of the photographer. The third essay directly addresses questions of accountability. Lisa Henderson's study was conceived in the tradition of the 'anthropology of visual communication': the situation and responsibilities of the photographer were analysed in terms of social interaction, and of attitudes expressed by photographers (interviewed during her research when she was an MA student). It is suggested that the exploitative relation between subject and photographer is consequent not only on class relations but also on the structures and contexts of image publishing.

The remaining three essays are concerned with photojournalism, commodification and representation. Given extensive debate in the 1970s about the status and impact of photographs as evidence of events, there was concern that 'image fatigue', the idea that the public becomes inured to images of distress (war, famine . . .), was leading to increasingly explicit pictures as, for a photograph to arrest attention, it needed to stand out from the general flow of visual information. John Berger argues that violent imagery, abstracted from particular contexts, universalises the idea of suffering rather than inviting analysis of specific events, and provokes a sense of moral inadequacy on the part of the reader as opposed to provoking political proactivity. Karin E. Becker offers a brief historical outline of uses of photography in magazines and newspapers, as a prelude for critical

discussion of photojournalism and the tabloid press. Her fundamental concern is with contexts and uses of images, including those by picture editors and art directors. It is argued that photography in the tabloid press both illustrates and serves to deconstruct news. Finally, Edmundo Desnoes considers images of Central America. The essay was first published in a collection concerned with meaning, semiotic systems and the materiality of signs. In that context it stood as an example of the value of semiotics in decoding the photographic image, taking into account first world presumptions and third world perspectives. In this context, it is included to indicate ways in which photographs reinforce currencies of ideas, regularly repeated, albeit articulated slightly differently in various spheres of practice from travel photography to art practices, from advertising and fashion to photojournalism and documentary.

References and selected further reading

Freund, G. (1980) *Photography and Society*. London: Gordon Fraser.
 Originally published in French, 1974. Part 2 includes a critical history of press photography.
Gidal, T. (1973) *Modern Photojournalism: Origin and Evolution, 1910–1933*. NY: Collier Books.
 On the origins of photojournalism in Germany between the wars.
Hall, S. (1973) 'The determinations of news photographs' in Stanley Cohen and Jock Young (eds) *The Manufacture of News*. London: Constable.
 Detailed discussion of decoding, meaning and contexts.
Harvey, S. (1986) 'Who wants to know what and why? – some problems for documentary in the 80s'. *Ten.8* No. 23, pp. 26–31.
Jay, B. (1984) 'The Photographer as Aggressor' in David Featherstone (ed.) *Observations*. Carmel, CA: Friends of Photography.
Mayer, P. (2000) 'Redefining Documentary Practice' in *Zonezero*. www.zonezero.com/editorial, 4 February 2001.
Roberts, J. (1998) *The Art of Interruption*. Manchester: Manchester University Press.
 On twentieth-century theory, photography, art, realism and the everyday within which the realist dimension of the photograph is reclaimed despite the recent critique of positivism.
Sekula, A. (1984) *Photography Against the Grain*. Halifax, Nova Scotia: The Press of Nova Scotia College of Art and Design.
 Collection of his essays variously discussing realism, photography, the collection and the circulation of images.
Sontag, S. (1979) *On Photography*. Harmondsworth: Penguin.
Tagg, J. (1988) 'The Proof of the Picture', *Afterimage* 15:6, pp. 11–13.

Bibliography of essays in Part Six

Becker, K. E. (1992) 'Photojournalism and the Tabloid Press' in Peter Dahlgren and Colin Sparks (eds) *Journalism and Popular Culture*. London: Sage.
Berger, J. (1980) 'Photographs of Agony' in *About Looking*. London: Writers and Readers.
Desnoes, E. (1995) 'Cuba Made Me So' in Marshall Blonsky (ed.) *On Signs*. Oxford: Basil Blackwell.

Henderson, L. (1988) 'Access and Consent in Public Photography' in Larry Gross, John Stuart Katz and Jay Ruby (eds) *Image Ethics*. NY and Oxford: OUP.

Rosler, M. (1989) 'In, around, and afterthoughts (on documentary photography) in Richard Bolton (ed.) *The Contest of Meaning*. Cambridge: MIT Press.
First published, 1981, in Martha Rosler, *3 works*. Halifax: The Press of the Nova Scotia College of Art and Design.

Tagg, J. (1988) 'Evidence, Truth and Order: Photographic Records and the Growth of the State', Chapter 2 of his *The Burden of Representation*. London: Macmillan.
First published, 1984, as 'The Burden of Representation: Photography and the Growth of the State,' *Ten:8*.

John Tagg

EVIDENCE, TRUTH AND ORDER
Photographic records and the growth of the state

I N THE LAST QUARTER OF THE NINETEENTH CENTURY, the photographic industries of France, Britain and America, in common with other sectors of the capitalist economy, underwent a second technical revolution which laid the basis for a major transition towards a structure dominated by large-scale corporate monopolies. The development of faster dry plates and flexible film and the mass production of simple and convenient photographic equipment opened up new consumer markets and accelerated the growth of an advanced industrial organisation. At the same time, the invention of means of cheap and unlimited photomechanical reproduction transformed the status and economy of image-making methods as dramatically as had the invention of the paper negative by Fox Talbot half a century earlier. In the context of generally changing patterns of production and consumption, photography was poised for a new phase of expansion into advertising, journalism, and the domestic market. It was also open to a whole range of scientific and technical applications and supplied a ready instrumentation to a number of reformed or emerging medical, legal and municipal apparatuses in which photographs functioned as a means of record and a source of evidence. Understanding the role of photography in the documentary practices of these institutions means retracing the history of a far from self-evident set of beliefs and assertions about the nature and status of the photograph, and of signification generally, which were articulated into a wider range of techniques and procedures for extracting and evaluating 'truth' in discourse. Such techniques were themselves evolved and embodied in institutional practices central to the governmental strategy of capitalist states whose consolidation demanded the establishment of a new 'regime of truth' and a new 'regime of sense'. What gave photography its power to evoke a truth was not only the privilege attached to mechanical means in industrial societies, but also its mobilisation within the emerging apparatuses of a new and more penetrating form of the state.

At the very time of photography's technical development, the functions of the state were expanding and diversifying in forms that were both more visible and more rigorous. The historical roots of this process, however, go back fifty years across a period which coincides exactly with the development and dispersal of photographic technology, especially in Britain and France. Here, the reconstruction of social order in the period following the economic crises and revolutionary upheavals of the late 1840s depended, in different ways, on a bolstering of state power which in turn rested on a condensation of social forces. At the expense of an exclusive political rule which they could not sustain, the economically dominant industrial and financial middle classes of both countries entered into a system of political alliances with older, contending class fractions which stabilised the social conflicts that had threatened to destroy the conditions in which capitalist production could expand and diversify. These increasingly integrated, though continually modified, governing blocs dominated national political life and thus the expanding machinery of the centralised state. This great bureaucratic and military machine may have appeared to stand to one side, but it secured capitalism's conditions of existence, not only by intervention but precisely by displacing the antagonisms of contending class fractions and appearing to float above sectional concerns and represent the general or national interest.

At the local level, however, and especially within the expanding industrialised urban areas, the dominance of industrial capital and its allied mercantile and intellectual strata was more explicit and less subject to compromise. Here, too, an increasingly secure middle-class cultural domination was cashed at the level of more diffuse practices and institutions which were nonetheless crucial to the reproduction and reconstruction of social relations. This more general hegemony was, by stages, secured and made effective through a constellation of regulatory and disciplinary apparatuses, staffed by newly professionalised functionaries, and subjected to a centralised municipal control. The pressing problem, locally and generally, was how to train and mobilise a diversified workforce while instilling docility and practices of social obedience within the dangerously large urban concentrations which advanced industrialisation necessitated. The problem was solved by more and more extensive interventions in the daily life of the working class within and without the workplace, through a growing complex of medical, educational, sanitary, and engineering departments which subsumed older institutions and began to take over the work of private and philanthropic agencies. Force was not, of course, absent. Local police forces and the administrative arms of the Poor Law were of central importance to the emerging local state, but even these could not operate by coercion alone. They depended on a more general organisation of consent, on disciplinary techniques and a moral supervision which, at a highly localised and domestic level, secured the complex social relations of domination and subordination on which the reproduction of capital depended. In a tightening knot, the local state pulled together the instrumentalities of repression and surveillance, the scientific claims of social engineering, and the humanistic rhetoric of social reform.

By the closing decades of the century, bourgeois hegemony in the economic, political and cultural spheres seemed beyond all challenge. In the midst of economic depression, the break up of liberalism, and the revival of independent working-class movements, the apparatuses of the extended state provided the means of containing

and negotiating change within the limits of democratic constitutionalism, even while the state itself took on an increasingly monolithic and intrusive form, liable to panic and periodic relapse into directly repressive measures. But such relapses cannot belie the important fact that a crucial shift had taken place. In the course of a profound economic and social transformation, the exercise of power in advanced capitalist societies had been radically restructured. The explicit, dramatic and total power of the absolute monarch had given place to what Michel Foucault has called a diffuse and pervasive 'microphysics of power', operating unremarked in the smallest duties and gestures of everyday life. The seat of this capillary power was a new 'technology': that constellation of institutions – including the hospital, the asylum, the school, the prison, the police force – whose disciplinary methods and techniques of regulated examination produced, trained and positioned a hierarchy of docile social subjects in the form required by the capitalist division of labour for the orderly conduct of social and economic life. At the same time, the power transmitted in the unremitting surveillance of these new, disciplinary institutions generated a new kind of knowledge of the very subjects they produced; a knowledge which, in turn, engendered new effects of power and which was preserved in a proliferating system of documentation – of which photographic records were only a part.

The conditions were in play for a striking *rendezvous* – the consequences of which we are still living – between a novel form of the state and a new and developing technology of knowledge. A key to this technology from the 1870s on was photography, and it is into the workings of the expanded state complex that we must pursue it, if we are to understand the power that began to accrue to photography in the last quarter of the nineteenth century. It is in the emergence, too, of new institutions of knowledge that we must seek the mechanism which could enable photography to function, in certain contexts, as a kind of proof, even while an ideological contradiction was negotiated so that a burgeoning photographic industry could be divided between the domain of artistic property, whose privilege, resting on copyright protection, was a function of its lack of power, and the scientifico-technical domain, whose power was a function of its renunciation of privilege. What we begin to see is the emergence of a modern photographic economy in which the so-called medium of photography has no meaning outside its historical specifications. What alone unites the diversity of sites in which photography operates is the social formation itself: the specific historical spaces for representation and practice which it constitutes. Photography as such has no identity. Its status as a technology varies with the power relations which invest it. Its nature as a practice depends on the institutions and agents which define it and set it to work. Its function as a mode of cultural production is tied to definite conditions of existence, and its products are meaningful and legible only within the particular currencies they have. Its history has no unity. It is a flickering across a field of institutional spaces. It is this field we must study, not photography as such.

Like the state, the camera is never neutral. The representations it produces are highly coded, and the power it wields is never its own. As a means of record, it arrives on the scene vested with a particular authority to arrest, picture and transform daily life; a power to see and record; a power of surveillance that effects a complete reversal of the political axis of representation which has confused so many labourist historians. This is not the power of the camera but the power of the

apparatuses of the local state which deploy it and guarantee the authority of the images it constructs to stand as evidence or register a truth. If, in the last decades of the nineteenth century, the squalid slum displaces the country seat and the 'abnormal' physiognomies of patient and prisoner displace the pedigreed features of the aristocracy, then their presence in representation is no longer a mark of celebration but a burden of subjection. A vast and repetitive archive of images is accumulated in which the smallest deviations may be noted, classified and filed. The format varies hardly at all. There are bodies and spaces. The bodies – workers, vagrants, criminals, patients, the insane, the poor, the colonised races – are taken one by one: isolated in a shallow, contained space; turned full face and subjected to an unreturnable gaze; illuminated, focused, measured, numbered and named; forced to yield to the minutest scrutiny of gestures and features. Each device is the trace of a wordless power, replicated in countless images, whenever the photographer prepares an exposure, in police cell, prison, mission house, hospital, asylum, or school. The spaces, too – uncharted territories, frontier lands, urban ghettos, working-class slums, scenes of crime – are confronted with the same frontality and measured against an ideal space: a clear space, a healthy space, a space of unobstructed lines of sight, open to vision and supervision; a desirable space in which bodies will be changed into disease-free, orderly, docile and disciplined subjects; a space, in Foucault's sense, of a new strategy of power-knowledge. For this is what is at stake in missionary explorations, in urban clearance, sanitary reform and health supervision, in constant regularised policing – and in the photography which furnished them from the start with so central a technique.

These are the strands of a ravelled history tying photography to the state. They have to do not with the 'externals' of photography, as modernists would have us believe, but with the very conditions which furnish the materials, codes and strategies of photographic images, the terms of their legibility, and the range and limits of their effectiveness. Histories are not backdrops to set off the performance of images. They are scored into the paltry paper signs, in what they do and do not do, in what they encompass and exclude, in the ways they open on to or resist a repertoire of uses in which they can be meaningful and productive. Photographs are never 'evidence' of history; they are themselves the historical. [. . .]

Martha Rosler

IN, AROUND, AND AFTERTHOUGHTS (ON DOCUMENTARY PHOTOGRAPHY)

1

THE BOWERY, IN NEW YORK, is an archetypal skid row. It has been much photographed, in works veering between outraged moral sensitivity and sheer slumming spectacle. Why is the Bowery so magnetic to documentarians? It is no longer possible to evoke the camouflaging impulses to 'help' drunks and down-and-outers or 'expose' their dangerous existence.

How can we deal with documentary photography itself as a photographic practice? What remains of it? We must begin with it as a historical phenomenon, a practice with a past. Documentary photography[1] has come to represent the social conscience of liberal sensibility presented in visual imagery (though its roots are somewhat more diverse and include the 'artless' control motives of police record keeping and surveillance). Photo documentary as a public genre had its moment in the ideological climate of developing state liberalism and the attendant reform movements of the early-twentieth-century Progressive Era in the United States and withered along with the New Deal consensus some time after the Second World War. Documentary, with its original muckraking associations, preceded the myth of journalistic objectivity and was partly strangled by it. We can reconstruct a past for documentary within which photographs of the Bowery might have been part of the aggressive insistence on the tangible reality of generalized poverty and despair – of enforced social marginality and finally outright social uselessness. An insistence, further, that the ordered world of business-as-usual take account of that reality behind those images newly seen, a reality newly elevated into consideration simply by being photographed and thus exemplified and made concrete.

In *The Making of an American*, Jacob Riis wrote:

> We used to go in the small hours of the morning to the worst tene-
> ments . . . and the sights I saw there gripped my heart until I felt that

Dante kept a record of his experience

> I must tell of them, or burst, or turn anarchist, or something. . . . I
> wrote, but it seemed to make no impression. One morning, scanning
> my newspaper at the breakfast table, I put it down with an outcry that
> startled my wife, sitting opposite. There it was, the thing I had been
> looking for all those years. A four-line dispatch from somewhere in
> Germany, if I remember right, had it all. A way had been discovered,
> it ran, to take pictures by flashlight. The darkest corner might be
> photographed that way.[2]

In contrast to the pure sensationalism of much of the journalistic attention to
working class, immigrant, and slum life, the meliorism of Riis, Lewis Hine, and
others involved in social-work propagandizing argued, through the presentation
of images combined with other forms of discourse, for the rectification of wrongs.
It did not perceive those wrongs as fundamental to the social system that tolerated
them – the assumption that they were tolerated rather than bred marks a basic
fallacy of social work. Reformers like Riis and Margaret Sanger[3] strongly appealed
to the worry that the ravages of poverty – crime, immorality, prostitution, disease,
radicalism – would threaten the health and security of polite society as well as by
sympathy for the poor, and their appeals were often meant to awaken the self-
interest of the privileged. The notion of charity fiercely argued for far outweighs
any call for self-help. Charity is an argument for the preservation of wealth, and
reformist documentary (like the appeal for free and compulsory education) repre-
sented an argument within a class about the need to give a little in order to mollify
the dangerous classes below, an argument embedded in a matrix of Christian ethics.

Documentary photography has been much more comfortable in the company
of moralism than wedded to a rhetoric or program of revolutionary politics. Even
the bulk of work of the U.S. version of the (Workers') Film and Photo League[4] of
the Depression era shared in the muted rhetoric of the popular front. Yet the force
of documentary surely derives in part from the fact that the images might be more
decisively unsettling than the arguments enveloping them. Arguments for reform –
threatening to the social order as they might seem to the unconvinced – must have
come as a relief from the potential arguments embedded in the images. With the
manifold possibilities for radical demands that photos of poverty and degradation
suggest, any coherent argument for reform is ultimately both polite and negotiable.
Odious, perhaps, but manageable; it is, after all, social discourse. As such, these
arguments were surrounded and institutionalized into the very structures of govern-
ment; the newly created institutions, however, began to prove their inadequacy –
even to their own limited purpose – almost as soon as they were erected.

2

Let us consider the Bowery again, the site of victim photography in which the
victims, insofar as they are now victims of the camera – that is, of the photographer
– are often docile, whether through mental confusion or because they are just lying
there, immortality unconscious. (But if you should show up before they are suffi-
ciently distracted by drink, you are likely to be met with hostility, for the men on

the Bowery are not particularly interested in immortality and stardom, and they've had plenty of experience with the Nikon set.) Especially now, the meaning of all such work, past and present, has changed: the liberal New Deal state has been dismantled piece by piece. The War on Poverty has been called off. Utopia has been abandoned, and liberalism itself has been deserted. Its vision of moral idealism spurring general social concern has been replaced with a mean-minded Spencerian sociobiology that suggests, among other things, that the poor may be poor through lack of merit (read Harvard's Richard Herrnstein as well as, of course, between Milton Friedman's lines[5]). There is as yet no organized national Left, only a Right. There is not even drunkenness, only 'substance abuse' – a problem of bureaucratic management. The exposé, the compassion and outrage, of documentary fueled by the dedication to reform has shaded over into combinations of exoticism, tourism, voyeurism, psychologism and metaphysics, trophy hunting – and careerism.

Yet documentary still exists, still functions socially in one way or another. Liberalism may have been routed, but its cultural expressions still survive. This mainstream documentary has achieved legitimacy and has a decidedly ritualistic character. It begins in glossy magazines and books, occasionally in newspapers, and becomes more expensive as it moves into art galleries and museums. The liberal documentary assuages any stirrings of conscience in its viewers the way scratching relieves an itch and simultaneously reassures them about their relative wealth and social position; especially the latter, now that even the veneer of social concern has dropped away from the upwardly mobile and comfortable social sectors. Yet this reminder carries the germ of an inescapable anxiety about the future. It is both flattery and warning (as it always has been). Documentary is a little like horror movies, putting a face on fear and transforming threat into fantasy, into imagery. One can handle imagery by leaving it behind. (*It is them, not us.*) One may even, as a private person, support causes.

Documentary, as we know it, carries (old) information about a group of powerless people to another group addressed as socially powerful. In the set piece of liberal television documentary, Edward R. Murrow's *Harvest of Shame*, broadcast the day after Thanksgiving in 1960, Murrow closes with an appeal to the viewers (then a more restricted part of the population than at present) to write their congressmen to help the migrant farm workers, whose pathetic, helpless, dispirited victimhood had been amply demonstrated for an hour – not least by the documentary's aggressively probing style of interview, its 'higher purpose' notwithstanding – because these people can do nothing for themselves. But which political battles have been fought and won by someone for someone else? Luckily, César Chàvez was not watching television but rather, throughout that era, was patiently organizing farm workers to fight for themselves. This difference is reflected in the documentaries made by and for the Farm Workers' Organizing Committee (later the United Farm Workers of America, AFL-CIO), such works as *Sí Se Puede* (Yes, We Can) and *Decision at Delano*; not radical works, perhaps, but militant works.

In the liberal documentary, poverty and oppression are almost invariably equated with misfortunes caused by natural disasters: causality is vague, blame is not assigned, fate cannot be overcome. Liberal documentary blames neither the victims nor their willful oppressors – unless they happen to be under the influence of our own global enemy, World Communism. Like photos of children in pleas for

donations to international charity organizations, liberal documentary implores us to look in the face of deprivation and to weep (and maybe to send money, if it is to some faraway place where the innocence of childhood poverty does not set off in us the train of thought that begins with denial and ends with 'welfare cheat.')

Even in the fading of liberal sentiments one recognizes that it is impolite or dangerous to stare in person, as Diane Arbus knew when she arranged her satisfy-ingly immobilized imagery as a surrogate for the real thing, the real freak show. With the appropriate object to view, one no longer feels obligated to suffer empathy. As sixties' radical chic has given way to eighties' pugnacious self-interest, one displays one's toughness in enduring a visual assault without a flinch, in jeering, or in cheering. Beyond the spectacle of families in poverty (where starveling infants and despairing adults give the lie to any imagined hint of freedom and become merely the currently tedious poor), the way seems open for a subtle imputation of pathetic-heroic choice to victims-turned-freaks, of the seizing of fate in straitened circumstances. The boringly sociological becomes the excitingly mythological/psychological. On this territory a more or less overt sexualization of the photo-graphic image is accomplished, pointing, perhaps, to the wellspring of identification that may be the source of this particular fascination.[6]

3

It is easy to understand why what has ceased to be news becomes testimonial to the bearer of the news. Documentary testifies, finally, to the bravery or (dare we name it?) the manipulativeness and savvy of the photographer, who entered a situation of physical danger, social restrictedness, human decay, or combinations of these and saved us the trouble. Or who, like the astronauts, entertained us by showing us the places we never hope to go. War photography, slum photography, 'subculture' or cult photography, photography of the foreign poor, photography of 'deviance,' photography from the past – W. Eugene Smith, David Douglas Duncan, Larry Burrows, Diane Arbus, Larry Clark, Danny Lyon, Bruce Davidson, Dorothea Lange, Russell Lee, Walker Evans, Robert Capa, Don McCullin, Susan Meiselas . . . these are merely the most currently luminous of documentarian stars.

W. Eugene Smith and his wife Aileen Mioko Smith spent the early 1970s on a photo-and-text exposé of the human devastation in Minamata, a small Japanese fishing and farming town, caused by the heedless prosperity of the Chisso chemical firm, which dumped its mercury-laden effluent into their waters. They included an account of the ultimately successful but violence-ridden attempt of victims to gain redress. When the major court fight was won, the Smiths published a text and many photos in the American magazine *Camera 35*.[7] Smith had sent in a cover photo with a carefully done layout. The editor, Jim Hughes, knowing what sells and what doesn't, ran a picture of Smith on the cover and named him 'Our Man of the Year' ('*Camera 35*'s first and probably only' one). Inside, Hughes wrote: 'The nice thing about Gene Smith is that you know he will keep chasing the truth and trying to nail it down for us in words and pictures; and you know that even if the truth doesn't get better, Gene will. Imagine it!'[8] The Smiths' unequivocal text argues for strong-minded activism. The magazine's framing articles handle that directness; they

convert *the Smiths* into *Smith*; and they congratulate him warmly, smothering his message with appreciation.

Help preserve the 'cultural heritage' of the mudmen in New Guinea, urges the travel editor of the Vancouver Province. Why should you care?, he asks; and he answers, to safeguard the value received for your tourist dollar (Canadians also love Disneyland and Disney World). He is asking for donations to a cultural center. The 'mudmen' formerly made large, grimacing pull-on masks to frighten their opponents in war and now wear them in adventure ads for Canadian Club ('We thought we were in a peaceful village until . . .'). The mudmen also appear in the 'small room' of Irving Penn's *Worlds in a Small Room*,[9] an effete mimicry of anthropological documentary, not to mention in photos with the Queen. Edward S. Curtis was also interested in preserving someone's cultural heritage and, like other itinerant photographers operating among native North American peoples, he carried a stock of more or less authentic, more or less appropriate (often less, on both counts) clothing and accoutrements with which to deck out his sitters.[10] Here, as with Robert Flaherty a bit later,[11] the heritage was considered sufficiently preserved when captured within the edges of the photographic record and in the ethnographic costume shops being established in museums of 'natural' history. In Curtis's case, the photographic record was often retouched, gold-toned, and bound in gold-decorated volumes selling for astonishing sums and financed by J. P. Morgan. We needn't quibble over the status of such historical romances, for the degree of truth in them may (again) be more or less equivalent to that in any well-made ethnographic or travel photo or film. An early – 1940s, perhaps – Kodak movie book[12] tells North American travelers, such as the Rodman C. Pells of San Francisco, pictured in the act of photographing a Tahitian, how to film natives so that they seem unconscious of the camera. Making such photos heightened patriotic sentiments in the States but precluded any understanding of contemporary native peoples as experiencing subjects in impoverished or at least modern circumstances; it even assisted the collective projection of Caucasian guilt and its rationalizations onto the 'Indians' for having sunk so and having betrayed their own heritage. To be fair, some respect was surely also gained for these people who had formerly been allowed few images other than those of abject defeat; no imagination, no transcendence, no history, no morals, no social institutions, only vice. Yet, on balance, the sentimental pictorialism of Curtis seems repulsively contorted, like the cariogenic creations of Julia Margaret Cameron or the saccharine poems of Longfellow. Personally, I prefer the cooler, more 'anthropological' work of Adam Clark Vroman.[13] We can, nevertheless, freely exempt all the photographers, all the filmmakers, as well as all the ethnographers, ancillas to imperialism, from charges of willful complicity with the dispossession of the American native peoples. We can even thank them, as many of the present-day descendants of the photographed people do, for considering their ancestors worthy of photographic attention and thus creating a historical record (the only visual one). We can thank them further for not picturing the destitution of the native peoples, for it is difficult to imagine what good it would have done. If this reminds you of Riis and Hine, who first pictured the North American immigrant and native-born poor, the connection is appropriate as far as it goes but diverges just where it is revealed that the romanticism of Curtis furthered the required sentimental mythification of the Indian peoples, by then physically absent from most of

the towns and cities of white America. Tradition (traditional racism), which decreed that the Indian was the genius of the continent, had nothing of the kind to say about the immigrant poor, who were fodder for the Industrial Moloch and a hotbed of infection and corruption.

Or consider a photo book on the teeming masses of India – how different is looking through it from going to an Indian restaurant or wearing an Indian shift or sari? We consume the world through images, through shopping, through eating. . . .

> Your world is waiting and Visa is there.
>> 120 countries
>> 2.6 million shops, hotels, restaurants and airlines
>> 70,000 banking offices
>> For traveling, shopping and cash advances . . .
>> Visa is the most widely recognized name in the world.
>> We're keeping up with you.

This current ad campaign includes photographs taken here and there in the world, some 'authentic,' some staged. One photo shows a man and a boy in dark berets on a bicycle on a tree-lined road, with long baguettes of bread tied across the rear of the bike: rural France. But wait – I've seen this photo before, years ago. It turns out that it was done by Elliott Erwitt for the Doyle Dane Bernbach ad agency on a job for the French office of tourism in the fifties. Erwitt received fifteen hundred dollars for the photo, which he staged using his driver and the man's nephew: 'The man pedaled back and forth nearly thirty times till Erwitt achieved the ideal composition. . . . Even in such a carefully produced image, Erwitt's gift for documentary photography is evident,' startlingly avers Erla Zwingle[14] in the column 'Inside Advertising' in the December 1979 issue of *American Photographer* – which also has articles, among others, on Bill Owens's at best ambivalent photos of mid-American suburbs, leisure activities, and work ('sympathetic and honest, revealing the contentment of the American middle class,' according to Amy M. Schiffman), on a show of the Magnum news-photo agency photos in a Tokyo department store ('soon after the opening [Magnum president Burk] Uzzle flew off to hunt down refugees in Thailand while Glinn remained in Japan, garnering much yen from assignments for the likes of IBM, Seagram, and Goldman Sachs,' says E.F.), on Geoff Winningham's photos of Texas high-school football ('Inevitably one can compare him with the legendary Robert Frank, but the difference . . . is that . . . Winningham clearly loves the craziness [more on craziness below] he dwells upon,' writes Schiffman), on Larry Clark's photos of Tulsa speed freaks ('A beautiful, secret world, much of it sordid' and 'although there is plenty of sex, death, violence, anxiety, boredom . . . there is no polemic apparent . . . so it doesn't really matter whether or not we can trust these photos as documents; to see them as photographs, no more and no less, is enough,' remarks Owen Edwards). There is a Washington column by James Cassell complaining that 'the administration frowns upon inspired photojournalism' and a page on Gamma photographer David Burnett, who arrived in Santiago de Chile a few days after the brutal putsch in 1973. On a government tour of the infamous stadium where people were detained and shot, he and other photographers 'noticed a fresh batch of prisoners.' Burnett says, 'The Chileans had heard many stories about people being

shot or disappearing . . . and they were terribly frightened. The haunting gaze of one man in particular, whose figure was framed by two armed soldiers . . . caught my eye. The picture has always stayed with me.' We see a contact sheet and that image enlarged. The article, by Yvette E. Benedek, continues: 'Like most agency photographers, Burnett must shoot both color and black and white to satisfy many publications in different countries, so he often works with three Nikons and a Leica. His coverage of the coup . . . won the Overseas Press Club's Robert Capa Award . . . "for exceptional courage and enterprise:"'

What happened to the man (actually men) in the photo? The question is inappropriate when the subject is photographs. And photographers. The subject of the article is the photographer. The name of the magazine is *American Photographer*. In 1978 there was a small news story on a historical curiosity: the real-live person who was photographed by Dorothea Lange in 1936 in what became the world's most reproduced photograph. Florence Thompson, seventy-five in 1978, a Cherokee living in a trailer in Modesto, California, was quoted by the Associated Press as saying, 'That's my picture hanging all over the world, and I can't get a penny out of it.' She said that she is proud to be its subject but asked, 'What good's it doing me?' She has tried unsuccessfully to get the photo suppressed. About it, Roy Stryker, genius of the photo section of the Farm Society Administration, for which Lange was working, said in 1972: 'When Dorothea took that picture, that was the ultimate. She never surpassed it. To me, it was the picture of Farm Security. . . . So many times I've asked myself what is the thinking? She has all of the suffering of mankind in her but all of the perseverance too. . . . You can see anything you want to in her. She is immortal.'[15] In 1979, a United Press International story about Mrs. Thompson said she gets $331.60 a month from Social Security and $44.40 for medical expenses. She is of interest solely because she is an incongruity, a photograph that has aged; of interest solely because she is a postscript to an acknowledged work of art. Mr. Burnett's Chilean photograph will probably not reach such prominence (I've never seen it before, myself), and we probably will not discover what happened to the people in it, not even forty-two years later.

A good, principled photographer I know, who works for an occupational-health-and-safety group and cares about how his images are understood, was annoyed by the articles about Florence Thompson. He thought they were cheap, that the photo *Migrant Mother*, with its obvious symbolic dimension, stands over and apart from her, is not-her, has an independent life history. (Are photographic images, then, like civilization, made on the backs of the exploited?) I mentioned to him that in the book *In This Proud Land*,[16] Lange's field notes are quoted as saying, 'She thought that my pictures might help her, and so she helped me.' My friend the labor photographer responded that the photo's publication caused local officials to fix up the migrant camp, so that although Mrs. Thompson didn't benefit directly, others like her did. I think she had a different idea of their bargain.

I think I recognize in his response the well-entrenched paradigm in which a documentary image has two moments: (1) the 'immediate,' instrumental one, in which an image is caught or created out of the stream of the present and held up as testimony, as evidence in the most legalistic of senses, arguing for or against a social practice and its ideological-theoretical supports, and (2) the conventional 'aesthetic-historical' moment, less definable in its boundaries, in which the viewer's

argumentativeness cedes to the organismic pleasure afforded by the aesthetic 'right-ness' or well-formedness (not necessarily formal) of the image. The second moment is ahistorical in its refusal of specific historical meaning yet 'history minded' in its very awareness of the pastness of the time in which the image was made. This covert appreciation of images is dangerous insofar as it accepts not a dialectical relation between political and formal meaning, not their interpenetration, but a hazier, more reified relation, one in which topicality drops away as epochs fade, and the aesthetic aspect is, if anything, enhanced by the loss of specific reference (although there remains, perhaps, a cushioning backdrop of vague social sentiments limiting the 'mysteriousness' of the image). I would argue against the possibility of a nonideo-logical aesthetic; any response to an image is inevitably rooted in social knowledge – specifically, in social understanding of cultural products. (And from her published remarks one must suppose that when Lange took her pictures she was after just such an understanding of them, although by now the cultural appropriation of the work has long since removed it from this perspective.)

A problem with trying to make such a notion workable within actual photo-graphic practice is that it seems to ignore the mutability of ideas of aesthetic rightness. That is, it seems to ignore the fact that historical interests, not transcen-dental verities, govern whether any particular form is seen as adequately revealing its meaning – and that you cannot second-guess history. This mutability accounts for the incorporation into legitimate photo history of the work of Jacob Riis along-side that of the incomparably more classical Lewis Hine, of Weegee (Arthur Fellig) alongside Danny Lyon. It seems clear that those who, like Lange and the labor photographer, identify a powerfully conveyed meaning with a primary sensuousness are pushing against the gigantic ideological weight of classical beauty, which presses on us the understanding that in the search for transcendental form, the world is merely the stepping-off point into aesthetic eternality.

The present cultural reflex of wrenching all art works out of their contexts makes it difficult to come to terms with this issue, especially without seeming to devalue such people as Lange and the labor photographer, and their work. I think I understand, from the inside, photographers' involvement with the work itself, with its supposed autonomy, which really signifies its belongingness to their own body of work and to the world of photographs.[17] But I also become impatient with this perhaps-enforced protectiveness, which draws even the best intentioned of us nearer and nearer to exploitiveness.

The Sunday *New York Times Magazine*, bellwether of fashionable ideological conceits, in 1980 excoriated the American documentary milestone *Let Us Now Praise Famous Men* (written by James Agee and photographed by Walker Evans in July and August of 1936, in Hale County, Alabama, on assignment from *Fortune* magazine, but not published until 1941).[18] The critique[19] is the same as that suggested in germ by the Florence Thompson news item. We should savor the irony of arguing before the ascendant class fractions represented by the readership of the Sunday *New York Times* for the protection of the sensibilities of those marginalized sharecroppers and children of sharecroppers of forty years ago. The irony is greatly heightened by the fact that (as with the Thompson story) the 'protection' takes the form of a new documentary, a 'rephotographic project,' a reconsignment of the marginal and pathetic to marginality and pathos, accompanied by a stripping away of the false

names given them by Agee and Evans – Gudger, Woods, Ricketts – to reveal their real names and 'life stories.' This new work manages to institute a new genre of victimhood – the victimization by someone else's camera of helpless persons, who then hold still long enough for the indignation of the new writer to capture them, in words and images both, in their current state of decrepitude. The new photos appear alongside the old, which provide a historical dimension, representing the moment in past time in which these people were first dragged into history. As readers of the *Sunday Times*, what do we discover? That the poor are ashamed of having been exposed as poor, that the photos have been the source of festering shame. That the poor remain poorer than we are, for although they see their own rise in fortunes, their escape from desperate poverty, we *Times* readers understand that our relative distance has not been abridged; we are still doing much better than they. Is it then difficult to imagine these vicarious protectors of the privacy of the 'Gudgers' and 'Ricketts' and 'Woods' turning comfortably to the photographic work of Diane Arbus?

The credibility of the image as the explicit trace of the comprehensible in the living world has been whittled away for both 'Left' and 'Right' reasons. An analysis which reveals social institutions as serving one class by legitimating and enforcing its domination while hiding behind the false mantle of even-handed universality necessitates an attack on the monolithic cultural myth of objectivity (transparency, unmediatedness), which implicates not only photography but all journalistic and reportorial objectivity used by mainstream media to claim ownership of all truth. But the Right, in contradistinction, has found the attack on credibility or 'truth value' useful to its own ends. Seeing people as fundamentally unequal and regarding elites as natural occurrences, composed of those best fitted to understand truth and to experience pleasure and beauty in 'elevated' rather than 'debased' objects (and regarding it as social suicide to monkey with this natural order), the Right wishes to seize a segment of photographic practice, securing the primacy of authorship, and isolate it within the gallery-museum-art-market nexus, effectively differentiating elite understanding and its objects from common understanding. The result (which stands on the bedrock of financial gain) has been a general movement of legitimated photography discourse to the right – a trajectory that involves the aestheticization (consequently, formalization) of meaning and the denial of content, the denial of the existence of the political dimension. Thus, instead of the dialectical understanding of the relation between images and the living world that I referred to earlier – in particular, of the relation between images and ideology – the relation has simply been severed in thought.

The line that documentary has taken under the tutelage of John Szarkowski at New York's Museum of Modern Art – a powerful man in a powerful position – is exemplified by the career of Garry Winogrand, who aggressively rejects any responsibility for his images and denies any relation between them and shared or public human meaning. Just as Walker Evans is the appropriate person within the history of street photography to compare with Lee Friedlander, the appropriate comparison for Winogrand is Robert Frank (who is compared with almost everyone), whose purloined images of American life in the 1950s suggest, however, all the passionate judgments that Winogrand disclaims.[20] Images can yield any narrative, Winogrand says, and all meaning in photography applies only to what resides within

the 'four walls' of the framing edges. What can, in Frank's work, be identified as a personally mediated presentation has become, in Szarkowski's three 'new documentarians,' Winogrand, Arbus, and Friedlander, a privatized will o' the wisp:

> Most of those who were called documentary photographers a generation ago . . . made their pictures in the service of a social cause to show what was wrong with the world, and to persuade their fellows to take action and make it right. . . . A new generation of photographers has directed the documentary approach toward more personal ends. Their aim has not been to reform life, but to know it. Their work betrays a sympathy – almost an affection – for the imperfections and frailties of society. They like the real world, in spite of its terrors, as the source of all wonder and fascination and value – no less precious for being irrational. . . . What they hold in common is the belief that the commonplace is really worth looking at, and the courage to look at it with a minimum of theorizing.[21]

Szarkowski wrote that introduction to the 'New Documents' show in 1967, in an America already several years into the 'terrors' and disruptions of the Vietnam War. He makes a poor argument for the value of disengagement from a 'social cause' and in favor of a connoisseurship of the tawdry. How, for example, do we define the boundaries and extent of 'the world' from looking at these photographer's images, and how can we be said to 'know it'? The global claim he makes for their work serves to point out the limits of its actual scope. At what elevated vantage point must we stand to regard society as having 'frailties' and 'imperfections'? High enough to see it as a circus before our eyes, a commodity to be 'experienced' the way a recent vodka ad entices us to 'experience the nineteenth century' by having a drink. In comparison with nightmarish photos from Vietnam and the United States' Dominican adventure, the work of Friedlander, Winogrand, and Arbus might be taken as evidencing a 'sympathy' for the 'real world.' Arbus had not yet killed herself, though even that act proved to be recuperable by Szarkowki's ideological position. In fact, the forebears of Szarkowski are not those 'who made their pictures in the service of a social cause' but bohemian photographers like Brassaï and the early Kertész and Cartier-Bresson. But rather than the sympathy and almost-affection that Szarkowski claimed to find in the work, I see impotent rage masquerading as varyingly invested snoop sociology – fascination and affection are far from identical. A dozen years later, aloofness has given way to a more generalized nihilism.

In the San Francisco Sunday paper for November 11, 1979, one finds Jerry Nachman, news director of the local headline-and-ad station, saying:

> In the Sixties and Seventies all-news radio had its place in people's lives: What was happening in Vietnam? Did the world blow up last night? Who's demonstrating where? . . . Now we're on the cusp of the Eighties and things are different. To meet these changes KCBS must deliver what's critical in life in a way that's packaged even perversely. . . . There's a certain craziness that goes on in the world and we want people to understand that we can chronicle it for them.

Nachman also remarks, 'Our broadcasters tell people what they saw out there in the wilderness today.' The wilderness is the world, and it inspires in us, according to this view, both anxiety and perverse fascination, two varieties of response to a spectacle.

[. . .]

6

Sure, images that are meant to make an argument about social relations can 'work.' But the documentary that has so far been granted cultural legitimacy has no such argument to make. Its arguments have been twisted into generalizations about the condition of 'man,' which is by definition not susceptible to change through struggle. And the higher the price that photography can command as a commodity in dealerships, the higher the status accorded to it in museums and galleries, the greater will be the gap between that kind of documentary and another kind, a documentary incorporated into an explicit analysis of society and at least the beginning of a program for changing it. The liberal documentary, in which members of the ascendant classes are implored to have pity on and to rescue members of the oppressed, now belongs to the past. The documentary of the present, a shiver-provoking appreciation of alien vitality or a fragmented vision of psychological alienation in city and town, coexists with the germ of another documentary – a financially unloved but growing body of documentary works committed to the exposure of specific abuses caused by people's jobs, by the financier's growing hegemony over the cities, by racism, sexism and class oppression, works about militancy, about self-organization, or works meant to support them. Perhaps a radical documentary can be brought into existence. But the common acceptance of the idea that documentary precedes, supplants, transcends, or cures full, substantive social activism is an indicator that we do not yet have a real documentary.

Notes

1 In England, where documentary practice (in both film and photography) has had a strong public presence (and where documentary was named, by John Grierson), with well-articulated theoretical ties to social-democratic politics, it is customary to distinguish social documentary from documentary per se (photos of ballerinas, an English student said contemptuously). The more general term denotes photographic practice having a variety of aesthetic claims but without involvement in exposé. (What is covered over by this blanket definition, such as the inherently racial type of travelogue, with its essentialist rather than materialist theories of cultural development, will have to remain under wraps for now). [. . .] If this were a historical essay, I would have to begin with ideas of truth and their relation to the developments of photography, would have to spell out the origins of photographic instrumentalism, would have to tease apart the strands of 'naturalistic,' muckraking, news, socialist, communist, and 'objective' photographic practice, would have to distinguish social documentary from less defined ideas of documentary unqualified. [. . .]

2 Jacob A. Riis, *The Making of an American* (1901; reprint ed., New York: Harper Torchbooks, 1966), p. 267.

3 In quoting Jacob Riis, I am not intending to elevate him above other documentarians (particularly not above Lewis Hine, whose straightforward involvement with the struggles for decent working hours, pay, and protections, as well as for decent housing, schooling, and social dignity, for the people whom he photographed and the social service agencies intending to represent them, and whose dedication to photography as the medium with which he could best serve those interests, was incomparably greater than Riis's, to whom photography was at best an adjunct to a journalistic career.

Margaret Sanger, a nurse in turn-of-the-century New York, became a crusader for women's control over reproduction. She founded the American Birth Control League in the 1920s (and much later became the first president of the International Planned Parenthood Federation) and similar leagues in China and Japan. Like many women reformers, she was arrested and prosecuted for her efforts, which ranged from disseminating birth-control literature to maintaining a clinic. [. . .]

4 The buried tradition of 'socialist photography,' a defined – though no doubt restricted – practice in some parts of Europe and North America in the late nineteenth and early twentieth centuries, is being excavated by Terry Dennett (of Photography Workshop) in England. His research suggests that the showing of lantern slides depicting living and working conditions and militant actions were a regular part of the working-class political organizing, and references to 'socialist photography' or photographers appeared in the leftist press in that period. Furthermore, the world's first news-photo agency, World's Graphic Press, seems to have had a leftish orientation. In the collection *Photography/Politics: One* (London: Photography Workshop, 1979), a start was made toward a worldwide history of the photo leagues. In relation to Left photography, one must mention the illustrated magazines, the most popular of which was the German *Arbeiter-Illustrierte Zeitung*, or *AIZ* ('Worker-Illustrated Newspaper,' 1924–1938).

5 For a discussion of the work of Richard Herrnstein, chairman of the psychology department at Harvard University, see articles by Karl W. Deutsch and Thomas B. Edsall, 'The Meritocracy Scare,' *Society* (Sept./Oct., 1972) and Richard Herrnstein, Karl W. Deutsch, and Thomas B. Colsall, 'I.Q.: Measurement of Race and Class?' (May/June 1973); both are reprinted in Bertram Silverman and Murray Yanowitz, eds., *The Worker in 'Post-Industrial' Capitalism: Liberal and Radical Responses* (New York: Free Press, 1974). See also Richard Herrnstein's original article, 'I.Q.,' in *Atlantic Monthly* (September 1971): 43–64, and Arthur Jensen, 'How Much Can We Boost IQ and Scholastic Achievement?,' *Harvard Educational Review*, reprint series no. 2 (1969): 126–34. See, e.g., Samuel Bowles and Herbert Gintis, 'IQ in the U.S. Class Structure,' *Social Policy* (Nov./Dec. 1972 and Jan./Feb. 1973), also reprinted in Silverman and Yanowitz, *The Worker*, for a critique of the theorizing behind intelligence testing. There have been many critiques of I.Q. (a very readable one is Jeffrey Blum's *Pseudoscience and Mental Ability* (New York: Monthly Review Press, 1977) – and of sociobiology, exposing their ideological foundations and poor scientific grounding – critiques that haven't inhibited either enterprise.

Milton Friedman, best known of the extremely conservative 'Chicago school' (University of Chicago) anti-Keynesian, 'monetarist' economists, has strongly influenced the policies of the Conservative Thatcher government in England [. . .]. Implicit in the pivotal conception of economic 'freedom' (competition) is that the best will surely rise and the worst will sink to their proper level. [. . .]

6 A remarkable instance of one form that such fascination may take, in this case one that presented itself as militantly chaste, is provided by the lifelong obsession of an English Victorian barrister, Arthur J. Munby, which was the observation of women

manual laborers and servants. (The souvenir *cartes de visite* of young women mine workers, at the pit head and in studio poses, suggest that some version of Munby's interest was widely shared by members of his class.) [. . .]

The huge Munby collection at Cambridge, consisting of six hundred surviving photos as well as his sketches and private papers running to millions of words, provided the material for Derek Hudson's *A. J. Munby, Man of Two Worlds: The Life and Diaries of Arthur J. Munby, 1828–1910* (London: J. Murray, 1972), and Michael Hiley's lavishly illustrated *Victorian Working Women: Portraits from Life* (London: Gordon Fraser, 1979).

7 April 1974. The Smiths subsequently published a book whose title page reads *Minamata, Words and Photographs* by Eugene Smith and Aileen M. Smith (New York: Holt, Rinehart and Winston, 1975). The Smiths' work at Minamata evidently was important in rallying support for the struggle throughout Japan.

8 *Camera 35* (April 1974): 3.

9 Irving Penn, *Worlds in a Small Room, by Irving Penn as an Ambulant Studio Photographer* (New York: Grossman, 1974).

10 The work of Edward S. Curtis, incorporating photographs from his monumental work *The North American Indian*, is now widely available [. . .] One can speculate that it was the interest of the 'counterculture' in tribalism in the late 1960s and early 1970s coupled with Native American militancy of the same period that ultimately called forth the new edition.

Curtis, who lived in Seattle, photographed Native Americans for several years before J. Pierpont Morgan – to whom Curtis was sent by Teddy Roosevelt – agreed to back his enterprise. (Curtis's 'first contact with men of letters and millionaires,' in his phrase, had come accidentally: on a mountaineering expedition Curtis aided a stranded party of rich and important men, including the chiefs of the U. S. Biological Survey and the Forestry Department and the editor of *Forest and Stream* magazine, and the encounter led to a series of involvements in governmental and private projects of exploration and the shaping of attitudes about the West.) According to Curtis, over half the cost of a million and a half dollars was borne by Morgan and his estate.

Curtis dedicated himself completely to his task, and in addition to his photography and notes (and the writing of popular books, two of which became best sellers), he recorded thousands of songs on wax rolls, many of which, along with oral histories, were transcribed and published in his magnum opus. Curtis's fictionalized film about the Kwakiutl of Vancouver Island, British Columbia, was originally titled *In the Land of the Head Hunters* (1914) but has recently been released under the title *In the Land of the War Canoes*.

On the subject of costuming, see, for example, Joanna Cohan Scherer, 'You Can't Believe Your Eyes: Inaccuracies in Photographs of North American Indians,' *Studies in the Anthropology of Visual Communication* 2:2 (Fall 1975), reprinted in *Exposure* (Journal of the Society for Photographic Education) 16:4 (Winter 1978). [. . .]

11 Robert Flaherty is well known for his fictionalized ethnographic films, especially the first, *Nanook of the North* (made in 1919–20, released in 1922). A catalogue of his photographs of the Inuit, with several essays and many reproductions, has been published by the Vancouver Art Gallery: *Robert Flaherty, Photographer-Filmmaker. The Inuit 1910–1922,* edited by Joanne Birnie Danzker (Vancouver: The Vancouver Art Gallery, 1980).

12 Eastman Kodak Company, *How to Make Good Movies* (Rochester, N.Y.: Kodak, n.d.).

13 Cameron's work can be found in *Victorian Album: Julia Margaret Cameron and Her Circle*, edited by Graham Ovenden (New York: Da Capo Press, 1975), and elsewhere. For Vroman's work, see *Photographer of the Southwest: Adam Clark Vroman, 1856–1916*, edited by Ruth Mahood (Los Angeles: Ward Ritchie Press, 1961; reprinted, Sparks,

Nev. [?]: Bonanza Books, n.d.), or *Dwellers at the Source, Southwestern Indian Photographs of Adam Clark Vroman, 1895–1904*, edited by William Webb and Robert A. Weinstein (New York: Grossman, n.d.).

14 Zwingle's story seems to derive almost verbatim from the book *Private Experience, Elliott Erwitt: Personal Insights of a Professional Photographer*, with text by Sean Callahan and the editors of Alskog, Inc. (Los Angeles: Alskog/Petersen, 1974). [. . .] The question of documentary in the wholly fabricated universe of advertising is a question that can have no answer.

15 Roy Emerson Stryker and Nancy Wood, *In This Proud Land: America, 1935–1943, as Seen in the FSA Photographs* (Greenwich, Conn.: New York Graphic Society, 1973; New York: Galahad Books, 1973), p. 19.

16 Ibid.

17 I am not speculating about the 'meaning' of photography to Lange but rather speaking quite generally here.

18 Agee and Evans went to Hale County to do an article or a series on a white share-cropper family for Henry Luce's *Fortune* magazine; because Evans was employed by the Historical Section of the Farm Security Administration, it was agreed that his negatives would belong to it. When Agee and Evans completed their work (dealing with three families), *Fortune* declined to publish it; it finally achieved publication in book form in 1941. Its many editions have included, with the text, anywhere from sixteen to sixty-two of the many photographs that Evans made. A new, larger, and more expensive paperback edition has recently been published; during Agee's life-time the book sold about 600 copies.

19 Howell Raines, 'Let Us Now Praise Famous Folk,' *New York Times Magazine*, May 25, 1980, pp. 31–46. The article seems to take for granted the uselessness of Agee's and Evans's efforts and in effect convicts them of the ultimately tactless sin of prying.

20 Frank's 1950s photo book *The Americans* seems to imply that one might travel through America and simply see its social-psychological meaning, which is apparent every-where to those alive to looking; Winogrand's work suggests only the apparent inaccessibility of meaning, for the viewer cannot help seeing himself, point-of-view shifts from person to person within and outside the image, and even the thought of social understanding, as opposed to the leering face of the spectacle, is dissipated.

21 John Szarkowski, introduction (wall text) to the 'New Documents' exhibition, February 28–May 7, 1967.

Lisa Henderson

ACCESS AND CONSENT IN PUBLIC PHOTOGRAPHY

FRAMED AS AN ASPECT of photographic practice, the issue of consent in public photography occurs at the juncture of at least two sets of contingencies; the first includes features of social interaction between photographers and their subjects, and the second, organizational constraints on doing photographic work – for example, those imposed by the division of labor in newspaper production. In the discussion of consent that follows I concentrate on the first, social interaction in photographic encounters, drawing from research on the strategies both amateur and professional photographers use to take pictures of people unknown to them in public places.[1]

The study was based on a conception of photographing as patterned social interaction among photographers, subjects and off-camera participants in particular settings, and of photographs as products of this interaction whose meaning depends in part on its assessment. Moreover, while all photographic behavior is conventional to some degree, in public encounters between photographers and subjects unknown to each other, picture-taking is adapted to the broader setting, in contrast to situations or events organized around photographic imperatives, among them studio portrait sessions and press conferences. This adaptive perspective implies the need to contextualize a description of photographic strategies in public places; such a description must account for those contextual features that constrain photographers' choices among possible strategic alternatives.

By 'strategy' I mean the behavioral move or set of moves a photographer makes in order to get the picture he or she wants. 'Strategy' needn't imply premeditation or even consciousness of these analytically distinct moves at the moment they and the picture are made, though some photographers' descriptions of their activities do suggest degrees of premeditation, particularly where they or their pictures are threatened. Suffice to say that premeditation is a frequent though not required criterion of 'strategy' as I use the term here.

As well, 'context' is not defined by the setting alone but refers to a more general set of constraints upon what photographers do, including features of the subject and of the shifting relations between photographer, subject and setting. Context also embraces a photographers' notions of both the nature of photography and of his or her professional or avocational role, to the extent these notions may foster, inhibit, or justify particular interactional approaches. Finally, it includes formal and informal conceptions of privacy photographers hold.

Consent

In photographic interactions, what do subjects consent to? To have their pictures taken or to have them used in some way? While photographic encounters imply both issues, consent strategies are framed in terms of what photographers do to sustain access (and in some cases co-operation) long enough to get the pictures they want, in other words, consent to take. In this attempt, some explanation of how the image will be used is occasionally though not necessarily offered as part of a photographer's strategic repertoire. While photographers recognize that a subject's uncertainty about the use of a picture is often the source of interactional tension, they are for the most part sufficiently confident about the harmlessness of their photographing (to subjects) or its importance (to themselves, or to 'public infor-mation') and sufficiently interested in carrying on doing it that consent is not so much to be reckoned with among subjects as dispensed with. The rule of thumb is to offer up only as detailed an explanation of one's conduct as might be required to sustain access, in some cases for moments, in others for months. There is an effective distinction between consent to take and consent to use, and the second issue, consent to use, is typically not part of the strategy during the encounter.

If consent to take pictures is therefore a matter of access, how do photogra-phers get access and how do they keep it? At the most general level, they do so by maintaining what Erving Goffman has called 'normal appearances.'

In *Relations in Public* (1971), Goffman outlines eight 'territories of the self' to which we stake claims in our social lives. These territories include: personal space; stalls, fixed and portable, such as theatre seats and beach mats; use space, respected because of apparent instrumental need; turns, that is, the order in which goods of some kind are received; sheath of skin and clothing; possessional territory ('personal effects'); information preserve, 'that set of facts about himself to which an indi-vidual expects to control access while in the presence of others'; and conversation preserve, controlling when and by whom the individual can be summoned into talk.[2] Here I am concerned with a subset of 'information preserve,' in particular those facts about an individual that can be directly perceived, his body sheath and his current behavior. As Goffman points out, the cultural issue is the individual's right not to be stared at or examined, and between strangers in public places, a glance, a look, or a penetration of the eyes may constitute a violation of this territory, or, in more familiar terms, an invasion of privacy.

As practitioners (and sometimes perpetrators) of a technical form of looking, photographers are aware of the threats to privacy they sometimes pose when they

work in public places. In some cases, a camera may reduce the threat of the stare by identifying its proprietor as a photographer, with a mission to look and a right to be there in the first place – for example, as a tourist or a representative of the media.[3] In others, enough people may be photographing to render the act unremarkable. In still other cases, the camera is the very source of suspicion. In any event, and in the interests of a particular type of photograph, photographers attempt to maintain 'normal appearances.'

In Goffman's terms, 'normal appearances mean that it is safe and sound to continue with the activity at hand with only peripheral attention given to checking up on the stability of the environment'.[4] Importantly, such appearances may be real or contrived, reflecting either a stable situation or a predator's successful attempt to conceal from his prey his threatening intentions. Only rarely, however, does such an extreme model represent the circumstance between photographers and their subjects. Typically, the photographer is aware of the minor threat he may pose or the curiosity he may arouse, and will address himself in advance to the task of learning what is unexceptional for the setting, then engage in photography in whatever form or with whatever approach will fit. Maintaining normal appearances is a behavioral fact attended to by people in their everyday lives quite apart from activities as specific as photographing; to varying degrees we monitor ourselves and others all the time with or without a camera present. But where the ante is raised by photography is in the camera's capacity not to only observe but record a person's behavior (to whatever manipulated degree, be it slight or extreme, intended or naive). Recording devices effectively undermine the everyday assumption that 'there is only a hearsay link between what happens inside the frame and allegations made about this outside the frame'[5]

The maintenance of normal appearances needn't imply the photographer's concealment of himself or his camera, though in some cases this is an option and a preference. Rather, it means he will be present but of no concern. Thus a photographer's verbal or non-verbal declaration of his presence and his intention to photograph also fit within the normal appearances rubric to the extent that he is recognized as doing what is conventional for photographers to do. We therefore have a stylistic continuum in the maintenance of normal appearances that extends between concealment and declaration, with a popular midpoint of non-concealment, where photographers neither hide nor deliberately inform potential subjects of ther imminent subjectivity; they are simply there.

Access and practice in public places: settings, subjects, and strategies

The utility of the concept of normal appearances lies in its descriptive breadth and its sensitivity to context. 'Normal appearances' does not denote a specific set of moves or behaviors, but a quality of the environment sustained by a variety of behaviors depending on the type of setting and the type of interaction. What follows then is a description of those features of settings and subjects that make a difference to how photographers take pictures in public places.

Settings

Setting features relevant to photographic strategies include (1) familiarity; (2) whether the setting constitutes the 'front' or 'back' region of a larger area or establishment; (3) the frequency of photographic activity within the setting; and (4) the general spirit or purpose of the primary events taking place.

By 'familiarity' is meant the photographer's familiarity with a specific setting, a setting category, or both (e.g. Washington Square Park in particular or parks in general). The greater a photographer's familiarity the easier it is to maintain normal appearances. He or she is better acquainted with what subjects consider ordinary and thus better able to adjust his or her conduct. However, familiarity also goes beyond the specific instance and the category to include sub-cultural knowledge about the setting and its participants that can't be known from the setting alone. Thus some photographers work amid groups in which they are or used to be members, tailoring their interactive style in light of what they know to be threatening or appealing to current participants.

The distinction between 'front' and 'back' regions derives from a theatrical metaphor Goffman uses to assign role, function, and stage places to social actors in day-to-day life. 'Performers appear in the front regions and back regions; the audience appears only in the front region, and the outsiders are excluded from both regions.'[6]

For photographic strategies, the front/back distinction implies the variety of access routes photographers take into settings which, while public to a degree, demand special status from their members. Some examples are film production units on location in public and semi-public places and repair sites in subway tunnels. Both locales are back regions in settings made up of front and back, where photographers have attempted short-term status changes from audience to performer. Again, the goal is to maintain normal appearances, and in back regions this is managed in part by acquiring or pretending to appropriate status or by affiliation with a legitimate performer. For example, a photojournalist working on a feature story about the Philadelphia subway system was accompanied by a police officer, allowing her protection and entree to areas usually reserved for technicians and other officials. In another instance, a photographer's equipment choice reflects his interest in being identified as a denizen of the back stage:

> [On the sets] I used a 35mm, because it was one that I'd always used and I felt the most comfortable with it. It also was the one that the still photographer who was hired as part of the production crew used, so I seemed to be just part of the production crew in a way, or at least I felt more comfortable.

In front regions, special status is not required for access once admission to the 'audience' is secure, though special claims for the photographer's role are sometimes made to mediate between other features of the situation and picture-taking.

Photographers describe an ease in photographing among other photographers whose cameras are aimed at the same principal subjects. The group's activity absorbs or neutralizes the behavior of any one member; observation and photography are

expected components of the situation. Settings that include a number of photographers can therefore be thought of on a continuum of access between those in which photographing is clearly an invasion requiring maximum negotiation and those designed and conducted to accommodate photographers – for example, press conferences. However, such a neutralizing effect varies depending on the nature and function of the setting or event, be it festive or serious. In either case, the meaning of the camera in the setting changes, and with it the role identification of the photographer to other participants. At a festive event the photographer may be a reporter or specially equipped and appreciative spectator. In many instances she is an otherwise undifferentiated member of the crowd, depending on her participation in a variety of activities within the setting. At a political demonstration on the other hand, a new role for photographers is introduced, that of surveillance agent. For example:

> . . . photographing at the cruise-missile conversion project, people always ask me what I'm doing . . . One time at a demonstration there was a man who was convinced without having spoken to me that I was a detective, and that I was doing some sort of surveillance or something. He was very snarky. He said something like 'did you get that one? did you get the shot that time? Do they pay you by the shot or by the hour? Who pays for your film?' and those kinds of questions . . . he was convinced that I was working for some group that was trying to infiltrate or survey that group, and I just didn't say anything.

This sense of surveillance persists where photography poses the threat of personal identification or where people are generally concerned about security if not their personal identity. Conduct ordinarily considered unremarkable is contextually redefined. Threats to security are thus among the features that define a setting for a photographer. Where the possibility of posing such a threat is known, a photographer with normal appearances at heart can try to balance the situation through a variety of verbal or non-verbal means, generally declaring her intentions and not making any moves she feels would substantiate her subject's fear. In situations where the threat can't be anticipated, where she fails to anticipate it, or where it's ignored, a photographer may discover herself embroiled in that rare instance of non-compliance and be forced to restore the equilibrium or leave. If the picture is worth it, she may persist, depending on her sense of the likely consequences. A scolding is tolerable, being shot at isn't, though the forms of non-compliance are routinely more subtle than such consequences suggest.

Subjects

No group of people is categorically off-limits or of no interest to photographers. Still, a shifting set of characteristics among subjects invite photographers to take pictures in some instances, intimidate them in others, and modify their practice in most. The most salient among these characteristics are age, race, sex, apparent social class, situational mobility, engagement in instrumental activities, solitude or group

membership, and role relation to the setting (e.g. as visitor, employee, passerby, performer, or victim).

A frequently photographed subject group (especially for amateurs) is made up of front-stage participants in a variety of formal and informal outdoor performances. Street musicians, parade marchers, craftspeople demonstrating their work, dancers, acrobats, and drill team members are familiar examples. Taking pictures of performers, photographers are usually among other spectators, making their presence and attention unexceptional and in many cases a welcome and flattering sign of appreciation. But even without a stationary audience – for example, in the case of the street musician who plays for money from passers-by – a person's engagement in focused activity often relieves a photographer of special negotiation. Characterized both by display and engagement, such performances occupy the high end of an access continuum which diminishes as a subject's activity becomes less focused or more personal. This isn't to say that people who fall at the other end aren't photographed, but rather that different consequences are anticipated or different strategies employed, for example, using a telephoto lens. However, such an approach also depends on whether the subject is alone or with a group.

The photographers I interviewed describe photographing people in public places as a form of 'singling out' that sometimes requires an explanation or justification, especially when it is clear to an individual that he or she is being isolated by the lens and where it's not apparent that he or she has special status in the setting (for example, as performer). But this too varies depending on the nature of the location. At well-populated festivities, few restrictions are felt to exist even when singling out individuals. If the territory is uncrowded and the activity more private, care is required to avoid alarming subjects.

The situation is tempered further if the person is mobile, either walking, running, or riding a bicycle. Under these circumstances photographers anticipate that people are less likely to notice them, less likely to be sure they were the ones being photographed, and less likely to interrupt their course in any event.

Demographically, normal appearances (and thus access) are sustained most smoothly when photographers work among people whose status or characteristics they share, particularly in settings that are racially, economically, or generationally segregated. (Photographing children is an exception. Children are thought to be less self-conscious about their appearance and less likely to anticipate the 'possible horrors' of photographs as they might appear in publication.) Though occupants of segregated areas can move amongst each other in integrated locations, a strong sense of tolerance or intolerance upon entry into segregated territory is apparent to the newcomer whose race or economic status is different from the established community's. This is particularly true when he or she arrives as a mechanically equipped observer, prepared to leave with recorded images that probably don't reflect the community's sense of itself and which, most likely, its members will never see. Moreover, such features of a setting not only modify how photographers approach its residents, they often prevent photographers (particularly amateurs) from even considering that setting in the first place, depending on what and how much they know or believe about the place through experience or hearsay.

Strategies

The emphasis given to long-term projects by the photographers I interviewed sets up an initial point of access I call the entry point. Where entry to a setting is controlled (for example, by invitation, membership, or price of admission), a photographer has to get in before access to individuals becomes an issue.

In some cases entry is made through a sympathetic contact who provides a photographer with both passage and a personal introduction to individual subgroups. Entry is also made through official permission from an organizer or organizing body, allowing a photographer initial access and legitimate status thereafter. Finally, a photographer may be recruited to photograph particular aspects of an event and then extend his activity beyond his assignment.

Getting in is often a matter of fitting in where access to a setting is not restricted but where the population is well-defined. Appearing to belong, in terms of such immediately visible characteristics as age, sex, and dress can be enough to enter.

In situations that require entry moves, making them relieves photographers of a lot of subsequent negotiation. Once a photographer's position is established, individuals assume he's entitled to be there and he probably won't have to explain himself from subject to subject. This is not to say that having gained entry, photographers disregard the type and form of activity among their subjects – they don't, and here we shift from getting access to keeping it.

Fitting in is used to stay in a situation as well as to enter it, requiring a photographer's attention to how she looks and how she acts. This is particularly true among groups marked by conformity in appearance and conduct, be they businessmen at lunch meetings or teenagers at parties.

Particularly in small spaces a photographer's work is almost never concealed, but rather moves between non-concealment and declaration while remaining unobtrusive. His presence is known and acknowledged, though he rarely asks subjects to do anything for the camera. If and how people pose reflects their own preference, though is usually a conventional response to a photographer's declared intention to photograph (e.g. grouping for portraits or smiling).

Some photographers act like regular participants, working their way into subgroups within the setting as they might without a camera, treating it merely as an accessory. The following comment comes from an art photographer working on a project about upper-class teenagers in bars.

> I bought a Leica winder for my camera which advances the film, but it doesn't have the attachment for a flash bracket to fit onto the bottom, so if you use a flash, you have to hold it in your left hand, and hold the camera with the winder attachment in your right hand. I immediately realized the futility of a system like that for what I'm doing, because I want to be able to photograph with one hand, since I socialize with them all the time, my way of getting closer. So 1 have to hold a beer. Or a cigarette. My way to get close to them is I go up and say hey, can I have a cigarette? Okay. I smoke the cigarette and take their picture.

In still other instances, photographers render their activity as un-alarming as possible by remaining within a conventional role, in turn exploiting the authority that role is typically accorded. Several non-photojournalists, professionals and amateurs among them, describe a photojournalist's deliberateness as a good way to appear to belong when you don't engage as a regular participant in the ongoing activity. Journalists are said to look almost blasé about their work. They photograph constantly, then break, never appearing undecided about what their next picture will be. When they're not working, they put their camera bags down and relax rather than glancing furtively from one person to the next. When something interesting occurs, they recognize it and take the picture, lending a purposive air to their activity rather than wandering aimlessly. To dramatize work or the idea of 'serious business' by taking on a journalistic style is useful only where a journalist's presence is unremarkable in the first place. Still, photographers cultivate those features of a journalistic approach that work in their favor without necessarily hoping to be identified as photojournalists.

Finally, photographers who wish to return to a setting over a period of time are careful to stop photographing from visit to visit when it becomes apparent they are no longer welcome. They notice individuals breaking away from small groups as they approach, or waning enthusiasm among people once eager to have their picture taken. To continue despite these signs can cost photographers co-operation or even admission next time around, therefore they rarely persist.

In open settings, where no specific entry move is in order and where access need be sustained momentarily, a different set of strategies comes into play. Here photographers stress the need to be fast and ready to shoot. This means either knowing your equipment well enough to reflexively control focus and exposure, or using a preset camera. It also means swift framing, sometimes at the expense of preferred composition, and agile though not necessarily speedy movement among people. The goal is to attract as little notice as possible, and fast maneuvering through a slow-moving crowd can provoke unwanted attention. Where the stakes are high and the risks great, photographers keep moving, exposing just a frame or two in any one spot. In this way they're able to minimize the duration of each encounter and thus the duration of their focused attention on potentially hostile subjects. However, most photographers also want to avoid appearing sneaky or suspicious. They carry cameras where they can be seen or use wide lenses that often require them to be close to their subjects. They effectively engage in what Goffman has called the 'overdetermination of normalcy'[7], declaring their intentions to a degree that won't be interpreted as covert or suspect.

In open situations, photographers rarely offer subjects prior explanation of their activity unless they want them to adjust what they're doing in some way, unless they anticipate difficulty, or unless they need information, such as the subject's name for a newspaper caption. In these cases, photographers simply ask people if they mind having their picture taken, or they offer a brief explanation of why someone was selected in the first place. But even here, guided by the premises of photographic naturalism, photographers usually wait until after they've exposed the negative to explain themselves or ask permission, not necessarily telling their subjects that pictures have already been taken. The technique is to 'get in a few

frames' before disturbing the event by asking questions. However, if things are happening quickly or an emergency is under way, photographers shoot first and ask questions later. Appearances are already not normal and expectations rearranged about what is ordinary conduct. The event is news and doesn't require delicate negotiation.

In the absence of constraints such as newspaper identification, photographers explain their activity only when subjects ask, though they may seek consent informally, in some cases a swift 'take your picture?' followed by an equally swift positioning of the camera and release of the shutter. More often, photographers let subjects see the camera at some point then wait for a sign of their approval. This may be a nod or smile; or it is simply inferred from the absence of overt disapproval.

Finally, those photographers who conceal their activity are usually after a particular kind of picture though are sometimes concerned for their safety. Only in extreme circumstances do they try to hide their activity altogether, using very small cameras or very long lenses, or shooting from the hip. Rather, they simply avoid making it clear who is being photographed. Those members of a group who care to notice may realize an active photographer is present, without knowing that they are his subjects at any given moment. A common approach here is to point the lens away from the subject, pretending to photograph something or someone else until people no longer attend to the camera directed toward them. At the moment, the photographer can shift aim and expose.

Resistance

When photographers encounter resistance (any move on the subject's part that makes a photographer think she has to do more than just take the picture) they consider whether the photograph is worth it before persevering with unwilling or threatening subjects. If it is, they can take it and leave or stay and face the consequences. On the other hand, they may attempt to neutralize resistance so that no consequences remain to be faced. In the latter two circumstances photographers undertake 'remedial work'[8] in order to allay any fear, anger, or annoyance their subjects might experience. Simple requests for permission to photograph (tacit and explicit, verbal and non-verbal) are the common form of remedial work, and with the exception of the news photographer who shoots first and asks later, are usually made before the picture is taken. However, more labor-intensive forms are sometimes necessary. Again, the issue is access; photographers must judge whether co-operation is required and, if it is, what kind of account is needed to continue.

The most efficient communicative mode for remedial work is talk and the kinds of remedial talk photographers engage in include explanation, elaboration, justification, flattery, and trivialization, each or all brought to bear depending on the photographer's sense of why the subject resisted in the first place. If a subject seems wary, the photographer may trivialize his activity, claiming, for example, to be taking pictures 'only' for himself, not for the newspaper or vice squad. If the subject

seems to be shy, the photographer can try flattery. Indeed, many photographers report the tiresome frequency with which subjects respond to their declared intentions or to their requests by saying, 'Nah, it'll break your lens.' This is clearly a conventional response that may refer to a variety of types of self-consciousness quite apart from whether a subject thinks himself attractive. It is also a polite way of evading the picture, that is, without having to refuse the photographer directly. In either case, it requires the persistent assurance by the photographer that in fact the subject looks terrific and should consent to the exposure.

The flattery in this example may also constitute an elaborating move where it follows a permission request and thus becomes the second in a series of two or more remedial tasks, or an element in the process of remedial exchange. What is elaborated is the photographer's appeal for access, and in this sense every such move a photographer makes elaborates those made earlier. However, more specific elaborative talk extends on initial explanation by offering further detail concerning the photographer's motivation and purpose. For example, a newspaper photographer I interviewed approached riders on the Philadelphia subway by introducing herself as a *Daily Planet* staffer working on a subway story and explaining what it was about the subject that had caught her eye. At that point, she followed any resistance with an embellished description of the attractive feature, be it how the children's red plastic trains looked great against their navy coats, or how the gentleman holding his baby looked pleasantly calm amid the chaos of rush-hour. In turn, she followed these elaborations with another permission request and the photograph was rarely denied.

What is being elaborated upon in these examples is the initial explanation. Photographers explain themselves in order to assure subjects that their motives are honest, benign, or exciting (witness the prospect of having one's picture published in a high-circulation daily). In the subway examples, the elaborated explanations serve in part to tone down the minor threat of singling out. They account for why a subject was chosen in the first place and help him overcome any mild suspicion he might experience about his selection. This can also be accomplished by describing the subject as a member of a class of subjects ('I'm photographing shoppers') or by displacing accountability for the choice ('My boss told me to,' 'It's a school project'). Such institutional affiliations (work, school) are also called upon to justify a photographer's actions under scrutiny.

An important issue relevant to all types of remedial talk is the potential for photographers to fabricate their explanations. Some photographers make up stories as a way of getting around lengthy truths they feel would be meaningless to subjects, in exchange for terse and effective deceptions. They believe that as long as no harm will come to their subjects as a result of the photograph, it's okay to tell them whatever they seem to want to hear based on who they appear to be and how their apprehensions are expressed. From these photographers I got the sense that *they* considered their work and their photographs to be innocent and their subjects' suspicions unreasonable. Again the emphasis is on getting the picture. However, even the most concerted efforts at remedial work are sometimes unsuccessful, and here photographers usually don't persist. Though photographers on the run often shoot despite a mild frown or left-to-right nod of the head, those who fail to get permission after an elaborated attempt rarely take the picture.

Conclusion: photography and privacy

What emerges from an account of photographic practice in public places is a contradiction between taking pictures and 'informed consent,' if by this phrase we mean consent without coercion given the consequences of taking and publishing a picture to the extent these consequences can be anticipated. In other words, there emerges a contradiction between consent to take and consent to use. In maintaining normal appearances, photographers downplay the intrusion or threat a camera represents, a practice clearly at odds with the discussion that would ensue were any subset of the potential outcomes of publication to be understood by photographer and subject. While photographers recognize this incompatibility, their practice is guided by the notion that 'you can decide not to publish, but you can never publish what you didn't take.' The practical emphasis is on getting the picture, and the ethical emphasis, where there is one, is on whether or not to publish it.

Not one of the photographers I interviewed, amateur or professional, reported ever using model releases for public photography. As a legal issue, the invasion for privacy by photographic means is based on the non-consensual publication of a photograph for purposes of advertising or trade.[9] Generally, in the U.S. news photography and artistic exhibition are protected by the First Amendment. Among amateur public photographers, the legal right to privacy isn't an issue because their photographs aren't sold. Among professionals, it is rarely an issue because their photographs are used for technically 'editorial' purposes (in the case of news, documentary, and artistic publication).[10] Moreover, those photographers who have thought about consent consider model releases strictly in terms of their own protection and vulnerability to legal action. They are a way of 'covering yourself,' not a means of ensuring that the rights and concerns of subjects are respected.

Cast as a more broadly defined social issue, however, personal privacy is of concern to photographers, related to a subject's activity and his capacity to resist being photographed if he so chooses, or in other words, to his power. These two dimensions intersect whenever someone's activity renders him powerless to resist – for example, the victim laying prone at the scene of a car accident. For subjects in intimate, embarrassing, or grievous circumstances, some photographers consider it improper or cruel to intrude upon the situation at the moment or to create a record of private behaviour that subjects would probably find undesirable or that might violate cultural norms. Even if there is nothing apparently grievous or embarrassing about the situation, it may deny participants the chance to present themselves to the camera in their 'best light,' according to prevailing standards of representation.

However, it is part of a professional photographer's socialization to overcome a reluctance to photograph in the face of grief or threat (conditions routinely encountered by photojournalists). Among fellow professionals, it is a sign of competence and reliability to be able to get pictures regardless of the circumstances, an ability seasoned photographers are assumed to possess and novices are rewarded for acquiring.

What the practical contingencies of public photography therefore suggest is the essentially exploitative relationship that prevails between photographers and subjects. Moreover, as long as professional photography continues as it is currently

organized in the news, documentary, and artistic mainstreams, the likelihood of changing that relationship is small.[11] This is not to say that photographers are an unusually predatory group, for anyone whose work requires the participation of others who stand to gain little or nothing in exchange are similarly implicated, be they photographers, film-makers, or social-science fieldworkers. Despite some recent challenges (see note 10), existing privacy law is not designed to protect the public except against invasive abuses as they are commercially defined. Importantly, however, it is not only the 'abusive' photographers, the *paparazzi*, who exploit their subjects. It is instead a quality of the relationship that persists as long as photographers and their employers, not subjects, control the production of photographs. Some people, with more money and more power, are better able to intervene in this relationship, better able to inhibit access, maintain privacy, and take to task those photographers and publishers whom, for whatever reasons, they feel have trespassed. But this doesn't help the less-monied, less powerful person whose objections to being photographed are dismissed by the photographer working on assignment, or the person who might not object until some unanticipated consequence occurs after the picture is published.

Notes

1 This exploratory research combined field observation and in-depth, semi-structured interviews with fifteen photographers, representing the traditions of photojournalism and art photography. Henderson, Lisa. 1983. 'Photographing in Public Places: Photography as Social Interaction.' Unpublished Master's Thesis, Annenberg School of Communications, University of Pennsylvania.

2 Goffman, Erving. 1971. *Relations in Public*. New York: Harper Colophon, pp. 40–1.

3 Becker, Howard. 1974. 'Photography and Sociology,' *Studies in the Anthropology of Visual Communication* 1(1), 3–26.

4 Goffman, 1971, op. cit., p. 239.

5 Goffman, 1971, op. cit., p. 286.

6 Goffman, Erving. 1959. *The Presentation of Self in Everyday Life*. New York: Anchor Doubleday, p. 145.

7 Goffman, 1971, op. cit., p. 256.

8 Goffman, 1971, op. cit., p. 108–9.

9 *Galella vs. Onassis* is an important exception, where a photographer was held liable not for publication but for his aggressive conduct while photographing. For a good discussion of *paparazzi* photography in general and Galella in particular, see Sekula, Allan. 1984. 'Paparazzo Notes,' in *Photography Against the Grain: Essays and Photo Works 1973–1983*. Halifax: The Press of the Nova Scotia College of Art and Design.

10 However, in 1982 news photography was threatened by the New York State Court of Appeals ruling in partial favor of the plaintiff in *Arrington vs. New York Times Company et al*. Three years earlier, Clarence Arrington, a financial analyst in New York City, has sued the New York Times, Contact Press Images photo agency, CPI director Robert Pledge, and CPI freelancer Gianfranco Gorgoni for the non-consensual publication of a photograph of him in the *New York Times Magazine*. Unbeknownst to Arrington before hearing from a friend one Sunday morning, he'd been photographed by Gorgoni for the over illustration of an article 'Making It in the Black Middle Class,' an article he felt offensively misrepresented the attitudes of many middle-class blacks. Arrington's suit was dismissed in the State Supreme Court, though his complaint

against CPI and its employees and directors was upheld on appeal. According to the appeals court ruling, the *New York Times* involvement with the photograph was for purposes of news and therefore not actionable, while the agency's involvement was for purposes of trade and therefore liable under state privacy law. Though the suit was finally settled out of court some two years later, the interim threat to freelance agencies and their photographers was widely felt. Either photographers would have to get signed model releases from all identifiable individuals in any photograph that would eventually be sold, or indemnify clients against claims of privacy invasion, both measures that would have radically altered, or destroyed, the freelance industry and publications dependent upon it.

11 Some photographers, notably members of oppositional groups, have tried to find ways of doing things more collaboratively. See, for example, JEB (Joan E. Biren), 1983. 'Lesbian Photography – Seeing Through Our Own Eyes,' *Studies in Visual Communication* 9(2), Spring, 81–96.

John Berger

PHOTOGRAPHS OF AGONY

T HE NEWS FROM VIETNAM did not make big headlines in the papers this morning. It was simply reported that the American air force is systematically pursuing its policy of bombing the north. Yesterday there were 270 raids.

Behind this report there is an accumulation of other information. The day before yesterday the American air force launched the heaviest raids of this month. So far more bombs have been dropped this month than during any other comparable period. Among the bombs being dropped are the seven-ton superbombs, each of which flattens an area of approximately 8,000 square metres. Along with the large bombs, various kinds of small antipersonnel bombs are being dropped. One kind is full of plastic barbs which, having ripped through the flesh and embedded themselves in the body, cannot be located by x-ray. Another is called the Spider: a small bomb like a grenade with almost invisible 30-centimetre-long antennae, which, if touched, act as detonators. These bombs, distributed over the ground where larger explosions have taken place, are designed to blow up survivors who run to put out the fires already burning, or go to help those already wounded.

There are no pictures from Vietnam in the papers today. But there is a photograph taken by Donald McCullin in Hue in 1968 which could have been printed with the reports this morning. (See *The Destruction Business* by Donald McCullin, London, 1972.) It shows an old man squatting with a child in his arms, both of them are bleeding profusely with the black blood of black-and-white photographs.

In the last year or so, it has become normal for certain mass circulation newspapers to publish war photographs which earlier would have been suppressed as being too shocking. One might explain this development by arguing that these newspapers have come to realise that a large section of their readers are now aware of the horrors of war and want to be shown the truth. Alternatively, one might argue that these newspapers believe that their readers have become inured to violent images and so now compete in terms of ever more violent sensationalism.

The first argument is too idealistic and the second too transparently cynical. Newspapers now carry violent war photographs because their effect, except in rare cases, is not what it was once presumed to be. A paper like the *Sunday Times* continues to publish shocking photographs about Vietnam or about Northern Ireland whilst politically supporting the policies responsible for the violence. This is why we have to ask: What effect do such photographs have?

Many people would argue that such photographs remind us shockingly of the reality, the lived reality, behind the abstractions of political theory, casualty statistics or news bulletins. Such photographs, they might go on to say, are printed on the black curtain which is drawn across what we choose to forget or refuse to know. According to them, McCullin serves as an eye we cannot shut. Yet what is it that they make us see?

They bring us up short. The most literal adjective that could be applied to them is *arresting*. We are seized by them. (I am aware that there are people who pass them over, but about them there is nothing to say.) As we look at them, the moment of the other's suffering engulfs us. We are filled with either despair or indignation. Despair takes on some of the other's suffering to no purpose. Indignation demands action. We try to emerge from the moment of the photograph back into our lives. As we do so, the contrast is such that the resumption of our lives appears to be a hopelessly inadequate response to what we have just seen.

McCullin's most typical photographs record sudden moments of agony – a terror, a wounding, a death, a cry of grief. These moments are in reality utterly discontinuous with normal time. It is the knowledge that such moments are probable and the anticipation of them that makes 'time' in the front line unlike all other experiences of time. The camera which isolates a moment of agony isolates no more violently than the experience of that moment isolates itself. The word *trigger*, applied to rifle and camera, reflects a correspondence which does not stop at the purely mechanical. The image seized by the camera is doubly violent and both violences reinforce the same contrast: the contrast between the photographed moment and all others.

As we emerge from the photographed moment back into our lives, we do not realise this; we assume that the discontinuity is our responsibility. The truth is that any response to that photographed moment is bound to be felt as inadequate. Those who are there in the situation being photographed, those who hold the hand of the dying or staunch a wound, are not seeing the moment as we have and their responses are of an altogether different order. It is not possible for anyone to look pensively at such a moment and to emerge stronger. McCullin, whose 'contemplation' is both dangerous and active, writes bitterly underneath a photograph: 'I only use the camera like I use a toothbrush. It does the job.'

The possible contradictions of the war photograph now become apparent. It is generally assumed that its purpose is to awaken concern. The most extreme examples – as in most of McCullin's work – show moments of agony in order to extort the maximum concern. Such moments, whether photographed or not, are discontinuous with all other moments. They exist by themselves. But the reader who has been arrested by the photograph may tend to feel this discontinuity as his own personal moral inadequacy. *And as soon as this happens even his sense of shock is dispersed:*

his own moral inadequacy may now shock him as much as the crimes being committed in the war. Either he shrugs off this sense of inadequacy as being only too familiar, or else he thinks of performing a kind of penance – of which the purest example would be to make a contribution to OXFAM or to UNICEF.

In both cases, the issue of the war which has caused that moment is effectively depoliticised. The picture becomes evidence of the general human condition. It accuses nobody and everybody.

Confrontation with a photographed moment of agony can mask a far more extensive and urgent confrontation. Usually the wars which we are shown are being fought directly or indirectly in 'our' name. What we are shown horrifies us. The next step should be for us to confront our own lack of political freedom. In the political systems as they exist, we have no legal opportunity of effectively influencing the conduct of wars waged in our name. To realise this and to act accordingly is the only effective way of responding to what the photograph shows. Yet the double violence of the photographed moment actually works against this realisation. That is why they can be published with impunity.

Chapter 28

Karin E. Becker

PHOTOJOURNALISM AND
THE TABLOID PRESS[1]

PHOTOGRAPHY HAS A LONG AND UNCOMFORTABLE history
within western journalism. Despite its very visible presence in the daily and
weekly press of the past century, photography is rarely admitted to settings in which
journalism is discussed, investigated, and taught. Whenever the distinction is drawn
between information and entertainment, or the serious substance of a journalism
appealing to an intellectual reading public is defended against the light, trivial appeal
of the popular, photography falls within the popular, excluded from the realm of
the serious press. Nowhere are the consequences of this position more evident than
in the pages and discussion of the tabloid press. There the display and presumed
appeal of the photographs are used as criteria for evaluating, and ultimately
dismissing, tabloid newspapers as 'merely' popular.

The history of this link between photography and the tabloid press can be traced
to photography's successive adoption by three distinct types of publications: first in
the elite periodical press with its established tradition of illustration; then in the
tabloid press with a more popular appeal; and almost simultaneously, in weekly
supplements to the respected organs of the daily press. Examining this history
reveals the development of discourses about photojournalism, including beliefs
about the nature of the medium, that continue to inform photography's positions
in the contemporary press.

Beliefs that photographs supply unmediated pictures of actual events could have
been the foundation for treating photographs as news by institutions whose credi-
bility rests on the facticity and accuracy of their reports about the world. Yet there
is a contradiction, because photography, when constructed as a purely visual
medium, is also thought to bypass those intellectual processes that journalism will
specifically address and cultivate. Photography's more immediate, direct appeal is
seen as a threat to reason, and to the journalistic institution's Enlightenment
heritage. The tension inherent in these reconstructions of photography and jour-
nalism permeates the discourse in which these practices coexist. Tracing the history

of this discourse, and particularly journalism's ambivalance toward photography's popular appeal, one finds patterns of use and journalistic structures that refer to photography and exploit its popularity, while simultaneously insulating the elite segments of the daily press in exclusively verbal forms of journalistic practice.

Analysing the role of photography in the press can thus help illuminate the simultaneous problems of the 'political' and the 'aesthetic' in contemporary communication studies, and offers insights into the relationships among representation, historical knowledge, and value at the heart of the postmodern debate. This chapter engages these issues first, by examining the historical development of the use of photographs in the western press, and secondly, by analysing the tabloid press as the contemporary context in which photography continues to be a primary means of representing the news.

The early picture press

In the early 1840s illustrated magazines were launched almost simultaneously in several European countries. The *Illustrated London News*, founded in 1842, was a well-written weekly magazine which hired illustrators to portray important current events (Hassner 1977; Taft 1938). Its success[2] was echoed by *L'Illustration* in France and *Illustrierte Zeitung* in Germany (both founded in 1843) and which were soon followed by others. *Frank Leslie's Illustrated Newspaper* (1855) and *Harper's Weekly – Journal of Civilization* (1857) were the first such publications to appear in North America.

These magazines were all using wood engravings to illustrate the news. Well-known artists were hired to 'cover' events, and competed to be the first with their reports. *Leslie's*, for example, sent an illustrator to the hanging of the anti-slavery movement leader John Brown in 1859, with instructions to take the first train back to New York where sixteen engravers worked through the night to meet the press deadline. The text published with the engraving stated that it was 'from a sketch by our own artist taken on the spot', invoking the authority of the eye-witness (Hassner 1977: 170).

At that time the publication of actual photographs was technically impossible, but wood engravings were preferred for other reasons. The camera's 'likeness' apparently was considered stiff and too dependent on the luck of the machine, in contrast with the hand-drawn image that reflected the artist's perspective and the engraver's craft. When a photograph was used (often quite loosely) as a referent for the engraver, a statement like 'from a photograph' frequently accompanied it, lending the machine's authority to the artist's work. By the 1860s, the engraving was considered 'a meticulously faithful reproduction of reality' within a 'sphere of objectivity around the medium itself' (Johannesson 1982).

Thus, the periodical press had established patterns of visual reporting several decades before the half-tone process was developed to facilitate printing photographs and text side by side. The topics that were covered, the ideals of immediacy and accuracy and the competition valorizing both the journalistic process and its product (both the hunt and its trophy), were well established on publications that carried an aura of quality and distinction. The 1890s saw these conventions of illustration gradually being adapted to photography.

Histories of photojournalism trace a heritage to a limited number of prestige periodicals, locating a tradition of photographic reportage in the work of a few editors and photographers (Hassner 1977; Edom 1976; Kobre 1980). *Collier's Weekly*, a 'cultural magazine emphasizing literary material', is often named as one of the first to shift from illustration to photo-reportage. Photographer James Hare, *Collier's*' primary correspondent throughout the Spanish–American War, is seen as the chief reason for the magazine's success.[4] Hare's assignment to investigate the sinking of the battleship *Maine* is among the earliest examples used to present the photojournalist as hero:

> He snapped the wreck of the *Maine* from every point of the compass. He caught divers still busy at the somber task of bringing up the drowned. . . . With the aid of an interpreter, Jimmy prowled through reconcentrado camps. He photographed swollen bodies with bones breaking through the skin; he took pictures of the emaciated living, and of babies ravaged by disease. Every ship that passed Morrow Castle enroute to New York carried a packet of snapshots. Their influence upon public opinion can hardly be overestimated
> (Carnes 1940: 15; Edom 1976: 38).

The rapid expansion of weekly magazines in the United States was due in part to the overheated atmosphere and competitive coverage of the war with Spain. Technical innovations and new legal privileges were also encouraging growth, and most important, with industrialization and the shift to a market economy, advertising began to provide significant support for the weekly press. As many magazines cut their purchase prices in half, a potentially nation-wide market suddenly opened up and the so-called 'general interest mass circulation magazine' arose. Advertising volume grew from 360 million to 542 million dollars between 1890 and 1900 (Kahan 1968; Hassner 1977: 216–17). The availability of large advertising revenues and the assumption of a mass appeal would become foundations of the picture magazines in the 1930s.

At the turn of the century, however, there are few indications that photography actually increased magazine sales (Kahan 1968: 194; Hassner 1977: 218). Nevertheless, 'the weekly photo-news magazine concept' had been established, and the heroic construction of its news photographer had begun.

The tabloid = sensationalism = photography

Daily newspapers did not have an established tradition of illustration predating photography, which helps to explain the slow introduction of half-tone reproduction in the daily press. Daily deadline requirements also meant that the early half-tone process was too cumbersome for newspaper production routines. By the late 1890s, more than a decade after the process was invented, many papers only occasionally published photographs. The exception was the United States' 'yellow press', and particularly the fierce competition between two New York papers, Joseph Pulitzer's *World* and William Randolph Hearst's *Journal*, where pictures were seen as a key to

successful and sensational coverage. The *World*, for example, carried what is claimed were 'the first actual photographs of the wreck' of the *Maine* in 1898, and which were in fact drawn simulations of photographs (Time-Life 1983: 16).

It was in the tabloid press of the 1920s that large sensational photographs first appeared, with violence, sex, accidents and society scandals as the major themes. United States press historians point to this as a low point for the press, an expression of what they consider the loose morals and loss of ethical standards that threatened public and private life. It was a time 'made to order for the extreme sensationalism of the tabloid and for a spreading of its degrading journalistic features to the rest of the press' (Emery 1962: 624). The *New York Daily News* was a primary culprit, and by 1924 had the largest circulation of any US newspaper. Its main competitors were the *Daily Mirror* and the *Daily Graphic*. England's *Daily Mirror* (founded 1904) had established 'a genre making public the grief of private individuals', and in the 1920s was, together with the *Daily Express*, among the newspapers influenced by the US tabloids' use of photographs (Baynes 1971: 46, 51).

'Sensational' journalism breaks the press, ascribed guidelines of ethical practice with the intention of attracting attention in order to sell more papers. In this process, journalism's audience – its 'public' – is reconstructed as a mass, undifferentiated and irrational. The 'sensational' occurs within journalistic discourses that are also bounded by cultural, historical and political practices that in turn position the ethical guidelines around different types of content, an important point to remember when examining the tabloid press of different countries.[5] Yet, a component common to the various constructions of the sensational is that attracting attention takes precedence over other journalistic values, including accuracy, credibility and political or social significance. In the US, the sensationalism of the tabloid press was intensified by 'photographs of events and personalities reproduced which are trite, trivial, superficial, tawdry, salacious, morbid, or silly' (Taft 1938: 448). It was not the subject matter, in other words, but the ways the photographs reproduced it which appealed to the emotions and thereby created the sensation.

Herein lies the rationale for prohibiting the photographing of news-worthy events that take place where reason and order are seen as crucial, that is, within most judicial and legislative bodies. Newspaper violations of these prohibitions have been held up as examples confirming the need for exclusion (Dyer and Hauserman 1987) or, conversely, within photojournalistic discourse to point to the need for self-regulation (Cookman 1985). One frequently cited case was a New York divorce trial in which the husband, a wealthy white manufacturer, wanted to annul his marriage on the grounds that his wife had concealed from him that she was part African-American, which she in turn claimed was obvious to him at the time of their marriage. At one point in the trial, when she was required to strip to the waist, the courtroom was cleared and no photographs were permitted. The *Evening Graphic* constructed what it proudly called a 'composograph' by recreating the scene using actors, then pasting in photographs of the faces of actual trial participants (Hassner 1977: 282; Kobre 1980: 17). No discussion of this obvious montage as a dismantling of photographic truth is offered in today's texts, nor is the outcome of the trial itself. They do note, however, that such practices led to the *Graphic*'s nickname, 'the *Porno-graphic*' (see Time-Life 1983: 17).

The *Daily News* is seen as the leader of that 'daily erotica for the masses' (Kobre 1980: 17), particularly for heating up competition, and thus increasing the excesses of sensationalism among the tabloids. The execution of Ruth Snyder, found guilty of murdering her husband after a much publicized 'love triangle' trial in 1928, is often given as an example. Although reporters were allowed to witness the electrocution, photographers were excluded (Time-Life 1983: 17). The day before, the *Graphic* had promised its readers 'a woman's final thoughts just before she is clutched in the deadly snare that sears and burns and FRIES AND KILLS! Her very last words, exclusively in tomorrow's *Graphic*' (cited in Emery 1962: 629).

The *Daily News*, however, had a Chicago press photographer, unknown to New York prison authorities and press, in the execution chamber with a camera taped to his ankle. At the key moment he lifted his trouser leg and made an exposure using a cable release in his pocket. 'DEAD!' was the simple heading over the photograph in the *Daily News'* extra edition. The caption gave it scientific legitimation as 'the most remarkable exclusive picture in the history of criminology', and described details ('her helmeted head is stiffened in death') difficult to distinguish in the heavily retouched photograph. The edition sold a million copies, easily beating the *Graphic*'s non-visual account of the event (Emery 1962: 629).

Within this journalistic discourse, the photograph itself had come to mean sensational journalism. In his history of photography in America in 1938, William Taft claimed:

> Such prodigious and free use of photographs in picture newspapers and magazines has in a measure defeated their own object, presumably that of disseminating news. Such journals are carelessly thumbed through, the reader glances hastily at one picture – looks but does not see or think – and passes on to the next in the same manner and then throws the periodical aside – a picture album with little purpose or reason.
>
> These criticisms and abuses the pictorial press must meet and correct if it is to command the respect of intelligent people.
>
> (Taft 1938: 448–9)

Here we see, if not the origins, then a full-blown expression of the historical antagonism between the liberal and the popular press, and photography's exclusive identification with the inferior, the popular, side of that antagonism.

The daily press 'supplements' the news

With the exception of the tabloid press, photographs rarely appeared in the daily newspapers of Europe and North America until 1920. Technical and time constraints offer a partial explanation for this delay. However, by the time daily photojournalism became practical, conventions of press photography had already been established. On the one hand, the abundant illustration in the magazines of the late nineteenth century had a broader content than 'the political, legal and economic matters [that] constituted the primary news in the traditional newspaper' (Hård af Segerstad 1974: 143). On the other hand, the leading role photography was playing

in the tabloids' abuses of press credibility made it increasingly difficult to see the photograph as a medium for serious news.

Photographic realism as an ideal had entered the *verbal* codes of the daily press shortly after photography's invention. Metaphors of the American newspaper as 'a faithful daguerreotype of the progress of mankind' were common from the 1850s, with the reporter employed as a 'mere machine to repeat' each event as a seamless whole, 'like a picture'. According to Dan Schiller (1977: 93) photography 'was becoming the guiding beacon of reportorial practice'. Although the conception of photographic realism had become intertwined with the roots of objectivity in the occupational ideology of American journalism, press photography itself had been enclosed in a different and conflicting discursive field.

Daily newspapers instead had begun to print weekly supplements on the new gravure presses. The first of these appeared in New York and Chicago in the 1890s and were illustrated predominantly with photographs. Many, such as the *New York Times Midweek Pictorial*, provided substantive complements to the newspaper's daily coverage of World War I. By 1920, New York's five major newspapers had rotogravure supplements to their Sunday editions (Schuneman 1966, cited in Hassner 1977: 279). Established during the period when half-tone reproduction became feasible, these magazines were a response to the popularity of photography. Material was gathered and packaged with a weekly deadline in a magazine format on smooth paper that raised the quality of reproduction. Within this format newspapers had succeeded in developing a way to use photography that complemented the structure and appearance of the daily news, while insulating and protecting the newspaper's primary product from being downgraded by the photograph. Contemporary examples of this phenomenon persist,[6] offering a showcase for 'good' photojournalism, pursued separately from the daily news product.

Photography had followed three distinct routes in its entry into the western press, establishing separate and overlapping discourses of photojournalism which, by the 1920s, were serving as three models. One may argue that this construction is based on secondary sources, the received histories of journalism and its photography, without looking at the primary material, that is, the press itself. Yet received histories undeniably serve as models for practice, indeed that is their power. It is the memory of how things were done in the past as reconstructed in contemporary discourse – not the day-to-day production process from any specific or actual period of time – which informs today's practice.

The picture magazines' legacy

Before turning to the specific case of the contemporary tabloid press, it is important to mention briefly the mass-circulation picture magazines. Although they have had little direct influence on tabloid photojournalism, their histories and the trajectories they established continue to inform photojournalistic discourse, including standards of practice and aesthetic value (Becker 1985).

Mass circulation picture magazines emerged between the wars, first in Germany, soon thereafter in other European countries, and by the late 1930s were established in England and the United States (Gidal 1973; Hall 1972; Hassner 1977;

Eskildsen 1978; Ohrn and Hardt 1981). Not only did these magazines establish new genres of photoreportage – notably the photo essay and the practice of documenting both the famous and the ordinary citizen in the same light. More important, they emerged during a period when, in various ways in each of their respective countries, what Victor Burgin has described as 'a dismantling of the differentiation between high and low culture was taking place' (Burgin 1986: 5). The notion of 'mass' art – referring to both the production and consumption of the work – had emerged to challenge the notion of 'high' culture as the sole repository of aesthetic value. Photography, in particular documentary photography, became accepted as popular art, and made its first major entry into the museum world.[7]

Walter Benjamin's predictions (1936) that the mass production of photographic images would bring about a defetishization of the art object had very nearly been reversed by the post-war years. Instead, we find an 'aura' reconstructed to privilege particular spheres of mass production and popular culture, including in this case, photojournalism. Within the magazines, photography was bearing the fruits of becoming a mass medium in a form that was popular and respected. Supported by consistently rising circulations and mass-market national advertising, and operating in a cultural climate which could accept the products of mass production as popular art, the status of photojournalism and of the men and women who produced it reached unprecedented heights. Several specific elements of this photojournalism continue to be seen as meriting the institutionalized culture's stamp of value: the formal structural properties of the ideal photo essay; the determination of the single photograph as an idealized moment – fetishized as 'the decisive moment' either alone or at the centre of the essay; and the reconstruction of the photojournalist as artist.[8]

The elevation of photography's status continued to exclude the tabloid press. The ideology of cultural value which had shifted to admit photojournalistic documents into museum collections, gallery exhibitions and finely produced books has persisted in treating tabloid press photography as 'low' culture. This meant, with few exceptions, not considering it at all.[9] The vacuum which has persisted around the tabloid press would be reason enough to examine its photojournalism. This is, after all, the daily press where photography continues to play a major role.

The contemporary domain of the tabloid

Many very different kinds of newspapers are published in a tabloid format. The present investigation, based on examples from the United States, England, Australia, Austria, Norway, Sweden and Denmark,[10] found wide variation in the degree to which the different papers overlapped with news agendas of the elite press and, in the cases of overlap, distinctly different ways of angling the news.[11] The few characteristics these papers have in common include an almost exclusive reliance on news-stand sales, a front page that seems to work like a poster in this context – dominated by a photograph and headlines referring to a single story – and photographs occupying a much larger proportion of the editorial content than one finds in other segments of the daily press.

The particular 'look' often associated with the photography of the tabloid press

– where action and expression are awkwardly and garishly caught in the flat, raw light of bare bulb flash – is relatively uncommon. Far more frequently, one encounters photographs of people posed in conventional ways, looking directly into the camera. Celebrities, including entertainers and sports figures, in addition to the pose, are often portrayed performing. Occasionally famous people are also 'revealed' by the camera, drawing on a set of stylistic features that have long been thought to typify tabloid photojournalism. Coverage of political events, that category of coverage which overlaps most with news in the elite press, is constructed using photographs following each of these forms. But this is also where one is more likely to see photographs that exhibit the traditional look of the tabloid press.

These three broad and occasionally overlapping categories of coverage – of private or previously non-famous persons in circumstances that make them newsworthy, of celebrities, and of events that correspond to conventional constructions of news – provide a framework for analysing this photography in terms of its style, communicative value and its political implications.

Plain pictures of ordinary people

Most photographs in the tabloid press are in fact very plain. They present people who appear quite ordinary, usually in their everyday surroundings: a family sitting around a kitchen table or on their living room sofa, couples and friends embracing, children with their pets. Sometimes the people in the photographs are holding objects that appear slightly out of place, so that we see the objects as 'evidence': a woman hugging a child's toy, or presenting a photograph to the camera, for example. Sometimes the setting itself is the evidence behind the formal pose: a woman standing next to a grave, or a man sitting in the driver's seat of a taxi. Their faces often express strong emotion, easy to read as joy or sorrow. These are not people whom readers recognize as famous. One would not be likely to pay much attention to them in another context.

From the words we learn what has happened to them, why they are in the newspaper. 'Pals for years', the two happily embracing women never dreamed that they were sisters who had been separated at birth. The family sitting in their kitchen has just had their children's stomachs pumped for narcotics, amphetamine capsules the pre-schoolers had found on the playground. The woman with the child's toy continues to hope her kidnapped son will be returned safely. The little girl hugging her chimpanzee has donated one of her kidneys to save the pet's life. The middle-aged woman lounging on her sofa in a tight-fitting outfit is upset after losing a job-discrimination suit; despite her sex-change operation, employers have refused to accept that she is a woman.

Sometimes they are people whose lives have been directly affected by major national or international events. Rising interest rates are forcing the family to sell their 'dream house'. A man holds the framed photograph of his daughter and grandchildren who have been held hostage in Iraq for two months.

If one can temporarily disregard the impact of the text on the meanings we construct for these pictures (the impossibility of doing so in practice will be returned to at a later point), they almost resemble ordinary family photographs. Many of the

settings and postures are recognizable from that familiar genre. The photographs are also characterized by their frontality, a tendency toward bi-lateral symmetry, and the fact that people are looking directly into the camera. The pictures do not mimic precisely the forms found in family photograph collections: the attention to and control over light and framing give them a more professional look, while the private or informal settings distinguish them from formal portraits with their typical blank backgrounds.

Yet the particular ways that these press photographs resonate with other forms of photography that are private and familiar, make the people in them accessible to viewers. The straightforward frontality of the photographs and, in particular, the level eye-contact between the person pictured and the person looking at the picture establishes them as equals, or at least as comprehensible to each other. The people photographed do not appear to have been manipulated into those postures and settings. Instead the form suggests that the act of making the photograph was cooperative. They seem aware of the way they are being presented, even to have chosen it themselves. It is their story that is being told. And they are not so different from us.

There are two other patterns for presenting photographs of non-famous people in the tabloids, which although less common, are significant. The first is the use of the official identification, or 'i.d.' portrait. Although this is also a frontal photograph with the subject frequently in eye-contact with the camera, it carries none of the connotations of the family photograph. Instead, the tight facial framing and the institutional uses of this form immediately link it to a tragic and usually criminal act.

The second exception appears spontaneous, often candid, and usually portrays action, an event that is underway. Such photographs are part of the tabloids' coverage of news events and usually include ordinary people who have become actors in those events. They are, therefore, considered in the analysis of the tabloids' photographic treatment of conventional news later in this chapter.

Celebrities

Of the several ways that famous people appear in the tabloid press, the plain photograph of the person posing at home is probably the most common. Sports figures, entertainers and, occasionally, politicians are photographed 'behind the scenes' of their public lives, together with family and loved ones. These pictures, arranged in the same manner that characterizes the pictures of non-famous people, lack only the emotional extremes to be read from the celebrities' faces; these people all appear relaxed and happy. The obviously domestic environments naturalize the stars. The photographs suggest we are seeing them as they 'really' are. At the same time, through angle and eye-contact with the camera, they are brought down to the viewer's level. The photographic construction which presents the private person as someone 'just like us' accomplishes the same task when framing the public figure.

The difference between how these two kinds of domestic pictures work assumes that the viewer can recognize this person as famous. It is not necessary for the viewer to be able to identify the person, only that this recognition takes place. Once it has, however, the home photograph does more than present the person as the viewer's equal, someone 'just like us'. In addition, it has become *revealing*. Recognizing the

person's celebrity status establishes the photograph as a privileged look behind the façade of public life.

Performance photographs are also quite common, often published next to the behind-the-scenes photograph of the celebrity at home. The picture of the singer or rock star performing is often a file photograph, and the particular performance is rarely identified. The sports figure's performance, on the other hand, is presented in a recent action photograph usually from the game or competition which provides the reason for coverage.[12] These photographs present the recognizable and familiar public face of the celebrity.

File photographs of celebrities' performances occasionally accompany stories about scandals surrounding them. When a star is arrested on gambling charges or is reportedly undergoing treatment for a drug problem, for example, the performance photograph introduces a discontinuity. The photograph contrasts the controlled public view the star has previously presented with the revelations of the present scandal.

Candid photographs which penetrate the celebrity's public façade form a distinct genre of the tabloid press. However, like the posed photograph at home, many photographs that *appear* candid must be seen as extensions of the institutional edifice constructed around the star.[23] The apparently spontaneous flash photograph of the rock musician leaving a 'gala' event with a new lover at his side, for example, may be a scoop for the photographer or a revelation for fans, but it cannot be read as a penetration of the star's public façade. He has agreed (and probably hoped) to be photographed in this public setting and, as with the photograph at home, we assume he has done all he can to control the picture that is the outcome.

Candid photographs of celebrities' unguarded moments, on the other hand, do appear in the tabloids, although with far less frequency than one is led to expect by the reputation of these newspapers. The *paparazzi*, the name Fellini gave to the celebrity-chasing photographers in his film *La Dolce Vita*, find a larger market for their work in the weekly popular press than in the daily tabloids (Freund 1980: 181). However, the death of a major film star brings *paparazzi* work into the tabloid press. And the film star whose son is on trial for murder or the sports star who was withdrawn from public life following a drug scandal are examples of celebrities the tabloids pursue for photographs.

The look of these photographs is awkward, overturning the classical rules of good composition. Objects intrude into the foreground or background, light is uneven and often garish, and even focus may be displaced or imprecise. The photographs freeze movement, thus creating strange physical and facial contortions. They appear to be the result of simply pointing the camera in the direction that might 'make a picture'.[14] This style of 'candid' photography is grounded, as Sekula (1984) argues, in 'the theory of the higher truth of the stolen image'. The moment when the celebrity's guard is penetrated 'is thought to manifest more of the "inner being" of the subject than is the calculated gestalt of immobilized gesture, expression, and stance' (Sekula 1984: 29). The higher truth revealed in the candid moment is a notion that is repeated and expanded in the tabloids' photographic coverage of news events.

The news event

'News' is defined and constructed in many different ways within tabloid newspapers, yet there is a core of nationally and internationally significant events that receive coverage across the spectrum of the tabloid daily press. In addition to the posed photographs of people whose lives have been touched by news events (discussed above), photographs are sometimes published from the time the event was taking place. These are usually action photographs and appear candid, in the sense that people are acting as if unaware of the photographer's presence. It is incorrect to think of the events themselves as unplanned, for many are scheduled and the press has mapped out strategies for covering them. These strategies include obtaining spontaneous photographs of people at the moment they are experiencing events that are seen as momentous, even historic (Becker 1984).

Many of the photographs bear a strong similarity to the candid pictures of celebrities. Like those images, these undermine the institutionally accepted precepts of 'good' photography in their awkward composition, harsh contrasts and uncertain focus. Another similarity is that candid news photographs are structured to reveal how people react when the comfortable façade of daily life is torn away. Facing experiences of great joy or tragic loss, people expose themselves, and photographs of such moments are thought to reveal truths of human nature. Examples include photographs taken at the airport as freed political hostages are reunited with their families, or those of policemen weeping at a co-worker's funeral.

These candid photographs are typically treated as belonging to a higher order of truth than the arranged pose. Yet to rank them along some absolute hierarchy of documentary truth ignores the cultural practices we use to distinguish between nature and artifice. Examples of these practices within photojournalism include specific technical effects (artifice) that are integrated into the tabloids' construction of realism (or nature).

Extreme conditions, including darkness or bad weather, can reduce the technical quality of news photographs. So can surveillance-like techniques, such as using a powerful telephoto lens to photograph from a distance, or using a still picture from a security video camera to portray a bank robbery. Technical 'flaws' like extreme graininess and underexposure have actually become conventions of the tabloids' style, visually stating the technical compromises the newspaper will accept in its commitment to presenting the 'real' story. The techniques work to enhance the appearance of candour, lending additional support to the construction of these photographs as authentic.

Many of the tabloids have a legacy of active crime reporting, and this style suggests a continuation of that tradition.[15] In contemporary tabloids, however, suspected and convicted criminals are not as common as are the faces and testimony of ordinary people caught in traumatic circumstances not of their own making. Photographs of political leaders are likely to be small portraits and file photographs, while the common people acting in the event receive the more prominent visual coverage. This is particularly marked when a photographer has been sent to cover foreign news.

Political turmoil and natural disasters are reasons for sending photographer-reporter teams on foreign assignments. Earthquakes and famine, elections threatened by violence, the redrawing of national and international borders, popular

resistance movements and their repression attract major coverage. The coverage may include photographs of local officials, but the emphasis is on ordinary people, particularly children, who are affected by the events. The photographs establish their perspective, portraying their actions and reactions in the candid style typical of tabloid news photography. Yet the words often transform the style of the coverage into a first-person account, relocating the photographer as the subject of the story. Here again, we encounter the impossibility of seeing the photographs independently from the ways they are framed by the text.

Reframing the picture in words and layout

Photographs attain meaning only in relation to the settings in which they are encountered. These settings include, as this investigation hopefully has demonstrated, the historically constructed discourses in which specific topics and styles of photography are linked to particular tasks or patterns of practice (Sekula 1984: 3–5). The photograph's setting also includes the concrete, specific place it appears in and how it is presented. In the newspaper, photographs have no meaning independent of their relationship to the words, graphic elements and other factors in the display which surround and penetrate them. It is these elements which are, to borrow Stuart Hall's phrase, 'crucial in "closing" the ideological theme and message' of the photograph (Hall 1973: 185).

In general, the text which frames photographs in the tabloid press is far more dramatic than the photographs alone. Even a cursory analysis indicates that it is the words, in particular the headlines, which carry the tone of 'sensationalism'. 'Thirteen-year-old chopped up watchman' is the headline over a photograph of the victim's widow, posing with his photograph. 'Devil's body guard' are the words next to a photograph of two masked men standing beside a coffin draped with the IRA flag. Over a dark colour photograph of an oil platform, we read 'Capsized – 49 jumped into the sea last night'. The text is large in relation to the page size, generally in unadorned typefaces. Punctuation consists of exclamation points and quotation marks, enhancing both the drama and the authenticity of the words: '"It feels like I'm dying little by little"' is inserted into one of the last pictures of the aged film star [Greta Garbo]. Often headlines are short, as for example, the single word 'Convicted!' over the police photograph of the man found guilty of murdering the prime minister.

The relationship between text and the official i.d. photograph is relatively simple to unwind. The explicit purpose of this tightly framed, frontal portrait with its frozen expression is to identify its subject in the most neutral way possible. Through its instrumental service to institutional needs, it has acquired a primary association with law enforcement and police investigations. Any time a photograph in this form is linked with news, it now connotes criminal activity, tragedy and death. The words published with the photograph serve to strengthen those connotations by repeating the associations awakened by the photograph alone and adding details that anchor the photograph's meaning in a specific event.

The relationship between text and the photographs most prevalent in the tabloids – of ordinary people posed in domestic settings – is more complex.

Typically the text contradicts the 'ordinary' appearance of these subjects; they are not what they seem. The words tell us that their lives have been struck by tragedy, confusion, some unexpected joy, or else that they are deviant, carrying some secret which is not evident on the surface. The disjunction between photograph and text is greatest for photographs that present no 'evidence' that something is out of place, and instead mimic the private family portrait without interrupting its connotations of familiar security.

In these cases the text seems to carry the greater authority; it tells us what we are 'really' seeing in the photographs. The text here *illustrates* the image, instead of vice versa, as Barthes has pointed out, by 'burdening it with a culture, a moral, an imagination'. Whereas in the case of the i.d. photograph the text was 'simply amplifying a set of connotations already given in the photograph', here the text *inverts* the connotations, by retroactively projecting its meanings into the photograph (Barthes 1977: 26–7). The result is a new denotation; we actually locate evidence in the photograph of what lies behind the formal pose. From the photograph and the apparently contradictory text together, we have constructed a deeper 'truth'.

Candid photographs, whether of celebrities or of events conventionally defined as news, offer a third case, for their look of candour depends on visual conventions that connote unreconstructed reality. Their subjects and the messages of the accompanying texts are too varied to reveal one specific pattern capable of explaining how they work together in the construction of meaning. In general, the stylistic features of the candid photograph appear to confer the text with greater authority.

When portions of the text are marked as direct quotations, a technique often used in the tabloids, additional nuances of meaning are constructed. If the quoted text is offered as the words of the person in the photograph, it becomes a testimony of that individual's experience. The quotation bonds with the subject's 'inner being' that we see revealed in the candid photograph, enhancing the connotations of closeness and depth being produced individually within the photograph and text.

Occasionally the text also specifically constructs the tabloid's photographer. Accounts include how a certain subject was photographed, emphasizing the persistence and devotion the work required. The 45-year-old *paparrazo* who took the last photographs of Great Garbo, 'for ten years lived only for taking pictures of "the Goddess", and now plans to leave New York and find something else to do; 'My assignment is finished', he said.

The photographer becomes a major figure, the public's eye-witness, when the words establish the photographs as first-hand exclusive reports of major news events. The two journalists sent by their newspaper to Beijing in June 1989 found themselves 'in the middle of the blood bath' that took place in 'Death Square'. The tabloid's coverage included portraits of the reporter and photographer, first-person headlines often in the present tense, heightening the immediacy, and enclosed in quotation marks ('"He dies as I take the picture"'), several articles written in the first person and many candid photographs, taken at night, showing the violence and its young victims.

This style of coverage, while it underscores many of the news values of conventional journalism, at the same time contradicts the ideal role of the journalist as one standing apart from the events being reported. Here the photographer is constructed as a subject, an actor in the events. The valorization of the

photographer, a common theme in the wider discourse of photojournalism, enters a specific news story. This further heightens the authority of the coverage as an unmediated account: we are seeing events as they happened in front of the subject's eyes, as if we were present.

These specific techniques, the first-person text together with the harsh, high contrast candid photographs, further work to establish this as a sensational story. The events were so unusual that the journalists' conventional rules of news coverage proved inadequate. Their professional role stripped from them by what they were seeing, they were forced to respond directly and immediately, as subjects. The coverage is constructed to bring us closer, through the journalists' subjective response, to the extraordinary nature of these events.

Again, one must remember that what we see in the tabloid is not the work of photographers. Despite the presence of bylines, the photographs bear little resemblance to the photographers' frames. Extreme sizes, both large and small, and shapes that deviate sharply from the originals' rectangular proportions are routine. Photographs are combined in many different ways, creating contrasts and sequences. Graphic elements are imposed over the photographs, including text, directional arrows and circles, or black bands over subjects' eyes. Montages and obvious retouching of photographs are not unusual.

Many of these techniques contradict the conventions for presenting photographs as representations of fact. According to the rules applied in other areas of photojournalism and documentary photography, the integrity of the rectangular frame is not to be violated.[16] With few exceptions (which are often discussed heatedly by photographers and editors), the frame is treated as a window looking out on an actual world. Changes in perspective should be limited to moving the borders in or out: any penetration of the frame is disallowed as a change in the way the frame 'naturally' presents reality.[17]

The tabloid press' consistent violation of these conventions confronts the persistent construction of the photograph as unmediated. Here we see the 'original' image repeatedly manipulated and altered with irreverent disregard for the standards that guide the elite press. At the same time that the text and photographs combine to support the revelation of deeper truths in the tabloid's coverage, the journalistic 'package' continually overturns the guidelines established to protect the notion of photographic truth.

Conclusions

Contemporary photojournalism has attained the status of popular art, outside the margins of the daily press. Yet those characteristics which have been used to increase photojournalism's cultural capital in other spheres we see confronted and even inverted in tabloid newspapers. Instead of cleanly edited photo essays, the tabloids are more likely to present heavily worked layouts of overlapping headlines, photographs and text. In place of the idealized grace of the 'decisive moment', the individual photograph is generally either a compositionally flat and ordinary pose or a haphazardly awkward candid shot. And instead of the photojournalist as respected artist successfully interweaving realism and self-expression, the photographers who

occasionally emerge from the muddled pages of the tabloid are impulsive individuals, consumed by the events they were sent to photograph.

The dichotomies that are usually drawn to distinguish between the tabloid and elite segments of the press cannot accommodate this photography. In the tabloid press, photographs appear to both support and contradict the institutional standards of journalistic practice. The practices used to present major news events are at the same time serious and emotional. Topics that lie well outside the news agendas of the elite press are covered using strategies that conform to standard news routines. Tabloid photojournalism is framed in texts that work to establish the photograph as credible and authentic and simultaneously prevent it from being seen as a window on reality. Such apparent inconsistencies are contained within a journalistic discourse that is irreverent, antagonistic and specifically anti-elitist.

Sekula reminds us that 'the making of a human likeness on film is a political act' (Sekula 1984: 31), and publishing that likeness in a newspaper compounds the political implications. Within the journalistic discourse of the tabloid press, photography appears anti-authoritarian and populist. There are many ways in which its specific techniques construct photographers, the people in the photographs and the people who look at them all as subjects. These subjects are accessible and generally are presented as social equals. But it is difficult to locate a systemic critique in this work.

The critique that emerges from the tabloid press, and particularly its photography, is directed instead against the institutionalized standards and practices of elite journalism. In the pages of this press, we witness the deconstruction of both the seamless and transparent character of news and the ideal of an unbiased and uniform professionalism. The photographs within the discourse of tabloid journalism work simultaneously as vehicles for news and the means of its deconstruction.

Notes

1 This essay is a revised version of the paper, 'The simultaneous rise and fall of photojournalism, a case study of popular culture and the western press', presented at the seminar 'Journalism and Popular Culture', Dubrovnik, Yugoslavia, 7–11 May 1990.

2 *Illustrated London News* circulation rose from 60,000 the first year to 200,000 in 1855, the year the tax on printed matter was repealed (Hassner 1977: 157).

3 Johannesson has also identified competing syntaxes that apparently rendered reality somewhat differently. Whereas in the United States engravings began imitating the syntax of the photograph, in Europe the engraving followed the other visual arts (Johannesson 1982).

4 *Collier's* circulation doubled during 1898, the first year of Hare's employment, and by 1912 had reached one million (Hassner 1977: 224).

5 For several examples from the present investigation see note 11, below.

6 The *New York Times Sunday Magazine* is an outstanding example, frequently commissioning well-known photojournalists to cover specific topics.

7 Maren Stange offers a convincing analysis of the political and aesthetic adjustment that occurred within the Museum of Modern Art in New York as Edward Steichen launched the first major exhibitions in the documentary style, culminating in 1955 with the spectacular popularity of 'Family of Man' and its 'universalizing apolitical

themes'. This major cultural institution, she argues, had 'installed documentary photography yet more firmly in the realm of popular entertainment and mass culture' (Stange 1989: 136).

8 The reader is referred to Becker (1990) for a full development of this point. For a discussion of the left-humanist art theory which provides the basis for the recon- struction of the photojournalist as artist, see Burgin (1986: 157).

9 Exceptions include the re-interpretation of a particular style of photojournalism – in which elements are 'caught' in the frame in strange relationships to each other, usually with the added effect of bare-bulb flash – as surrealist art. Photographer Arthur ('Weegee') Fellig's work is the best-known example of art institutional redefinition of this style (Sekula 1984: 30).

The Museum of Modern Art exhibition 'From the Picture Press' is another example of this tendency to 'surrealize' photojournalism. The exhibit consisted primarily of *New York Daily News* photographs selected with the help of photographer Diane Arbus (Szarkowski 1973). Henri Cartier-Bresson has long preferred to call his work 'surrealism' instead of 'photojournalism'.

10 I am grateful to Mattias Bergman and Joachim Boes, Peter Bruck, John Fiske, Jostein Gripsrud, John Langer, David Rowe, Herdis Skov and Colin Sparks for providing copies of many of the tabloids on which this analysis is based.

11 Some contrasts may be explained by national differences in newspaper consumption patterns: in England, tabloid press readership increased during the period when people began to confine their reading to one newspaper, whereas in Sweden the after- noon tabloids continue to be used as a complement to the morning broadsheet papers.

Differences in content also suggest cultural variation in the construction of the sensational. A striking ease is the conditions under which sex becomes an explicit topic, ranging from near-nude pin-ups as a regular feature in British and Danish papers, to unusual cases of sexual preference treated as news, to the virtual absence of sex in the most serious Australian tabloids. Another contrast is the extensive coverage the British and Australian papers devote to the 'private' lives of their royalty, whereas the Scandinavian papers only cover their royal families when one member is seriously ill, is presiding over some official occasion, or has become involved in a political debate. Explaining such differences, significant though they may be, remains beyond the scope of this chapter.

12 The sports action photograph in the tabloid press appears to correspond precisely to the same genre in the sports sections of elite newspapers. If true, this raises inter- esting issues about why sports photography in particular is found without modification in both classes of newspapers.

13 Here I have drawn on Alan Sekula's discussion of *paparazzi* photography, although my analysis and conclusions are somewhat different (Sekula, 1984).

14 Weegee, one who is credited with creating the style, said of his photograph from an opening night at New York's Metropolitan Opera, that it was too dark to see, but 'I could *smell* the smugness so I aimed the camera and made the shot' (Time-Life 1983: 54).

15 The style was associated with a particular way of working by photographers who chased down tips from their police radios into places that were dark, crowded, confusing and where they were not wanted. Although the style is now considered outmoded, a guarded admiration survives for the photographers who still follow this work routine. I wish to thank Roland Gustafsson, who has conducted interviews among the staff of Stockholm's *Expressen*, for drawing this point to my attention.

16 This convention also constructs the photographer as the authority, the intermediary through which this view of reality is refracted.

17 See, for example, the textbook guidelines for creating a 'clean' picture layout in the
 style of the classic photo essays (Hurley and McDougall 1971; Edey 1978; Kobre
 1980: 271–81).

References

Barthes, Roland (1977) 'The photographic message', in Stephen Heath (ed. and trans.)
 Image, Music, Text. New York: Farrar, Straus and Giroux. pp. 15–31.

Baynes, Kenneth (ed.) (1971) *Scoop Scandal and Strife: a Study of Photography in Newspapers*.
 London: Lund Humphries.

Becker, Karin E. (1984) 'Getting the moment: newspaper photographers at work', paper
 presented at the American Folklore Society Annual Meeting, San Diego.

Becker, Karin E. (1985) 'Forming a profession: ethical implications of photojournalistic
 practice on German picture magazines, 1926–1933', *Studies in Visual Communication*
 11 (2):44–60.

Becker, Karin E. (1990) 'The simultaneous rise and fall of photojournalism. A case study
 of popular culture and the western press', paper presented at the seminar 'Journalism
 and Popular Culture', Dubrovnik.

Benjamin, Walter (1936) 'The work of art in the age of mechanical reproduction' in Hannah
 Arendt (ed.), *Illuminations*. New York: Schocken, 1969. pp. 217–52.

Burgin, Victor (1986) *The End of Art Theory. Criticism and Postmodernity*. London: Macmillan.

Carnes, Cecil (1940) *Jimmy Hare, News Photographer*. New York: Macmillan.

Cookman, Claude (1985) *A Voice is Born*. Durham, NC: National Press Photographers
 Association.

Dyer, Carolyn Stewart and Hauserman, Nancy (1987) 'Electronic coverage of the courts:
 exceptions to exposure', *The Georgetown Law Journal* 75(5): 1634–700.

Edey, Maitland (1978) *Great Photographic Essays from Life*. New York: Little, Brown.

Edom, Clifton C. (1976) *Photojournalism. Principles and Practices*. Dubuque, IA: Wm. C.
 Brown.

Emery, Edwin (1962) *The Press and America. An Interpretive History of Journalism*, 2nd edn.
 Englewood Cliffs, NJ: Prentice-Hall.

Eskildsen, Ute (1978) 'Photography and the Neue Sachlichkeit movement', in David Mellor
 (ed.), *Germany. The New Photography, 1927–33*. London: Arts Council of Great Britain.
 pp. 101–12.

Freund, Gisèle (1980) *Photography and Society*. London: Gordon Fraser.

Gidal, Tim (1973) *Modern Photojournalism: Origin and Evolution, 1910–1933*. New York:
 Collier Books.

Hall, Stuart (1972) 'The social eye of the *Picture Post*', in *Working Papers in Cultural Studies
 2*. Birmingham: CCCS.

Hall, Stuart (1973) 'The determinations of news photographs', in Stanley Cohen and Jock
 Young (eds), *The Manufacture of News*. London: Constable. pp. 176–90.

Hassner, Rune (1977) *Bilder för miljoner* (Pictures for the millions). Stockholm: Rabén &
 Sjögren.

Hurley, Gerald D. and McDougall, Angus (1971) *Visual Impact in Print*. Chicago, IL: Visual
 Impact.

Hård af Segerstad, Thomas (1974) 'Dagspressens bildbruk. En funktionsanalys av bildut-
 budet i svenska dagstidningar 1900–1970'. (Photography in the daily press), Doctoral
 dissertation, Uppsala University.

Johannesson, Lena (1982) *Xylografi och pressbild* (Wood-engraving and newspaper illustra-
 tion). Stockholm: Nordiska museets Handlingar, 97.

Kahan, Robert Sidney (1968) 'The antecedents of American photojournalism', PhD dissertation, University of Wisconsin.

Kobre, Kenneth (1980) *Photojournalism. The Professionals' Approach*. Somerville, MA: Curtin & London.

Ohrn, Karin B. and Hardt, Hanno (1981) 'Camera reporters at work: the rise of the photo essay in Weimar Germany and the United States', paper presented at the Convention of the American Studies Association, Memphis, TN.

Schiller, Dan (1977) 'Realism, photography, and journalistic objectivity in 19th century America', *Studies in the Anthropology of Visual Communication* 4(2): 86–98.

Schuneman, R. Smith (1966) 'The photograph in print: an examination of New York daily newspapers. 1890–1937', PhD dissertation, University of Minnesota.

Sekula, Allan (1984) *Photography Against the Grain*. Halifax: The Press of the Nova Scotia College of Art and Design.

Stange, Maren (1989) *Symbols of Ideal Life. Social Documentary Photography in America 1890–1950*. Cambridge: Cambridge University Press.

Szarkowski, John (ed.) (1973) *From the Picture Press*. New York: Museum of Modern Art.

Taft, Robert (1938) *Photography and the American Scene. A Social History*, 1839–1889. New York: Dover.

Time-Life (1983) *Photojournalism*, rev. edn. Alexandria, VA: Time-Life Books.

Edmundo Desnoes

CUBA MADE ME SO

1

A LMOST TWENTY YEARS AGO, I was rash enough to write something on how they see us in the North and how we see ourselves in the South. This dialogue came out with a descriptive, if clumsily worded, title: 'The Photographic Image of Underdevelopment.' I have just reread it, and it creaks with the sound and fury of the sixties. How much of it has survived and how much is dead?

Photography is no longer the Cinderella of the fairy-tale of criticism. Within the visual arts, it now has its body of ideas, its beauty parlour, and even an incipient grammar. A respectable discourse that allows it to look and be looked at in galleries and museums.

Excuse the irony. It is the irritating question of where and how one breathes the atmosphere of culture. We Latin Americans complain when doors are closed to us and nobody wants to listen to us, and if some doors are then opened and we are observed attentively, we suspect that we are being manipulated and turned into court buffoons. The world is impure – and we should be glad not to be angels – but if life is being used, knowing *how* to use is creation. Photography is in fashion – and we are glad.

'Photography,' I wrote then, 'has fooled the world. There's no more convincing fraud. Its images are nothing but the expression of the invisible man working behind the camera. They are not reality, they form part of the language of culture.'

Today it would be going too far to insist that 'reality and photography *are not* the same thing.' Roland Barthes and Susan Sontag have done for photography what those of us on the outskirts of Western culture could only have dreamed of offering you: they have defined and minutely examined its cultural operations and ambiguous spiritual impact.

Photography is not reality, but it does have a special relationship with reality. It is another of art's plausible lies, as Picasso thought. But it would not be a bad idea to give this lie a special place.

I am interested in the space (a word I would not have used ten or fifteen years ago) of photography and the way it functions. If in those days a sad ignorance prevailed, today too much critical competence can succeed by its subtleties in breaking down the obvious image and causing it to evaporate. Physical reality is the specific raw material of photography. The environment, the people, the objects are physically present – found, surprised, placed or arranged – they are outside, before the camera, not in memory.

Let us take a look.

'As she stared she found herself wondering why it was that a diseased face, which basically means nothing, should be so much more horrible to look at than a face whose tissues are healthy but whose expression reveals an interior corruption. Port would say that in a non-materialistic age, it would not be thus. And probably he would be right.' The heroine of Paul Bowles' novel *The Sheltering Sky* is contemplating the face of a North African beggar.

That diseased face, or that face of healthy tissues, is photography's point of departure.

The novelist could have recorded or invented the scene, but the photographer could only have been there, stolen the reality, and snatched a face from the beggar.

The existence of the photographic camera allows man's intervention to be reduced to a minimum, but at the same time it forces him to impose his presence at the moment of creation, to establish a living relationship with the subject, and to initiate a hand-to-hand struggle. He disappears behind the keyhole but he cannot separate himself from the door. His absence is his presence.

The inexhaustible material world and the camera – the black artefact of the profession – create a new space for photography, a space of its own, a breach that henceforth will always belong to the photographer.

There is no more down-to-earth art than photography – beside it, the cinema is dreamland, a composite of time and space, a daydream in the darkness. Next to this red fringe come dance, theatre, painting, literature, and music. Photography is always the same temperature as the planet.

And everything comes out in the interpreter of photographs: in the reaction of the spectators of photographic violence; in the perceptual penetration of the image and its effect in the field of consciousness. Let us go back to our specific theme and continue with what I wrote in 1966:

> Photography is just as closely tied to economic and political interests as to dreams and art. The photographic image of underdevelopment, for example, impinges constantly on our experience and is a decisive ingredient in our vision of the Third World. We live in that world and we are not sure to what extent we are conditioned by the gaze of the other one. Our thoughts are often based on press, propaganda, fashion, and art photographs that claim to express our surroundings. Photography is a much more influential and penetrating cultural ingredient than the great majority of people are capable of realizing. The visual code – and

here one can only agree with Barthes — depends on language. And language in its turn on social action, without separating us from certain fundamental Marxist formulations.

(Desnoes 1966)

Photography is an index of values. Both in production and consumption. Photographs are matter in cultural movement. In order to live, they include their time and space. The analysis or contemplation of photographs as objects in themselves, independent of their context, outside the system of social circulation, is an illusion, a methodological trap. There is no great difference, and we should not, or rather we cannot, separate looking from seeing, perception from the perceived. What our eyes propose and what we see. Photographs are detonators. They explode in us. We are the gaze as well as the gazed-at. The observer and the observed.

2

What we observe today in the Third World has changed little since the middle of the sixties — that is, if we go by the tourist business. Travel folders still insist on a photographic utopia of endless, deserted, unpolluted beaches. We may travel accompanied by our partner, or meet her/him at the hotel — the photograph is not clear on this point — but the sea, rippled by the breeze, and the soft white sand are both obvious and real, as is the protective shade of the palm trees that have sprung up at the proper distance so that we can stretch our hammock and relax. It remains only to buy the airline ticket and make our hotel reservations. Hardly any changes are to be seen in these photographs over the last ten years. They form part of a conservative and effective advertising method. Our Caribbean goes on being a tropical paradise.

If some inhabitant of paradise appears, he/she is being photographed to show that the natives are obliging and of an innocent and exotic beauty. If we are unable to travel, a photograph then helps us to travel as consumers. The products of our world are pure, free of chemical contamination; sweaty black hands separate the two halves of a wholesome green coconut and from its heart emerges the white bottle of CocoRibe liqueur. Naturally, the sharp machete cannot fail to be seen in the foreground.

In recent years, alongside the well-behaved savage and the traditional planter, alongside the profitable local product, a worldly native middle class has emerged. The last advertising campaign for Puerto Rican rums offers us a gallery of elegant professionals from the national bourgeoisie, with drinks in their hands and on the table, made with island rum. Architects or horse trainers. This new and accordingly young bourgeoisie is the one appointed to know and relish the major products of its native land. It is a campaign that also indicates the growing importance and strength of the national white elite of dark-skinned America.

Certain advertising appeals have disappeared. The sixties were marked by radical political tremors and wars of national liberation in Asia, Africa and Latin America. Advertising then helped to neutralize political anxiety. At first it made use of the social prestige, the impact of revolutionary ideas; the revolution was a fabric, and

men wore Tergal shirts and pants, with Mexican hats and decorative guns; only the most resistant gear survived lawful violence; the women's revolution was Popoff, the underwear that set off the sensual lines of the body. Photographs demonstrate the commercial effectiveness of advertising pseudo-reality.

'Advertising based on situations of political confrontation', Umberto Eco pointed out as early as 1971, 'is declining. A recent statistic shows a shrinking of the political theme, an obvious sign that the public at large is entering a phase of proletarian tranquillity and middle-of-the-road indifference.' The observation can be extended to the whole capitalist world; by the mid-seventies it develops into a sharp turn to the right. However much it uses its voice, advertising is still an echo – and there is every reason to suspect that since 1968, fear has elicited pacifying advertising campaigns.

For the moment, it is preferable to bathe with Vita-bath of the forest, amid delicate ferns and beneath refreshing waterfalls as seen in an Italian advertisement: to return to the condition of the noble savage, guided by the nostalgic text rein-forced by the photograph, in order for men to 'feel like Tarzan' and women to come back into their own.

The social revolution might have gone on being a necessity, but it was no longer in fashion; fear clothed itself with loathing. In the twilight of the seventies, fashion was playing with Arab oil. The West was contemplating the world of the petrodollar with fear and fascination. Models posed like odalisques on soft cushions, and even a towel could be converted, at least in the pages of *Vogue*, into a chaste and perilous veil. And from there to the social tranquillity, preserver of poverty, of India and its worn-out mystery. They went back to posing in front of an elephant (though Richard Avedon had already placed Dovima between two elephants in 1955) or a camel for variation.

Today, revolution in the United States is no longer related to sex, as during the sixties, but to food. Food is the sex obsession of the eighties. *New York* maga-zine, in its 1 August 1983 cover, refers to the new conservative orgasm: food – 'You've had sushi, falafel, dim sum, bacon cheeseburgers and tandoori chicken. Now it's time for the Mexican Revolution.' At the table, eating next to the gringo, sits a taciturn survivor of the troops of Pancho Villa. The food is as hot as the revo-lution: and as they eat under the burning title, the revolution in Central America is just a distant echo, one of the possible connotations of the image. Taming the barbarian, the heathen, has been a lucrative game. Some southern countries will be swallowed up by the attractive skin of the consumer society; others will find their own way. But the most deplorable, perhaps inevitable, aspect is the interiorization in underdeveloped countries of the metropolitan vision, and the squandering of photographic opportunities to affirm our identity and create or reflect adequate values. Creating values, and disputing them if they are empty – these are the two sides of cultural activity.

Fashion photographs are an even more critical field, since clothes do indeed make the man. Our manner of dressing – the fashion photographs in our publica-tions – indeed transmit popular values and cultural identity. On our continent, the photographs of clothed (and even unclothed) models imitate like parrots when they exaggerate colours, or like monkeys when they copy the styles of Paris or the dynamic capitalism of New York. Latin American magazines, from the Rio Grande

to Patagonia, operating in the fertile soil of a middle-class subservience to the industrial centres of capitalism, are a warning to the countries of Africa and Asia that are still capable of learning from the mistakes of others. These two continents still have a strong identity in their wearing apparel, adapted to the cultural and climatic realities of each region.

Photography, by its special relation to reality, plays a decisive role in this implacable dream. A dream fabricated and conditioned by base interests, but with a credible face thanks to this blessed or cursed photography. The advertising world, fashion as we know it today, would collapse without it. Painting and the written word lack the realistic charms of a photograph.

As a young man in Cuba I saw the world, history, in photographic imagery. History took place where photographs were taken, shot. I remember how stupidly thrilled I was, at the age of twenty-four, when I saw the island in *Harper's Bazaar*. 'Flying Down to Cuba;' who is up and who is down in a round earth? I felt the pulpless fashion model was validating the island by coming down to sight-see and be seen in a magazine that infused meaning into every sight she appeared before.

Even the discourse of travel was convincing, sequential: the Angel announced our existence as she landed at the Havana airport; the proof was there: the airstrip, the fuselage of the plane, her expensive suitcase. A 'Cadillac from Havana's Amber Motors' arrived to pick her up. The Hotel Nacional, the Plaza de la Catedral, the sugarcane fields, the cock fights. It was true, because I recognized the background; she was beautiful because she was powerful (her name never appeared in the captions, only the price of the garments). I was being culturally colonized by the Annunciation.

If the image had the strength of physical existence – regardless of how impossible the model was as a prop for the camera statement – the text of the photograph essay reveals the weaving of arbitrary relations. The Cuban background for the fashions is justified because, for example, they are 'in colours that happen to be native to the Cuban scene.' 'Daiquirí white fleece. The whipped, golden white that foams on the rim of your Bacardí daiquirí', and 'under it, rich pungent brown – Tobacco brown.' Words reveal the gimmickry of a meaning the photographs hide in their contrived physicality.

'Native to the scene,' a double-spread tryptich of photographs, enhances the packaged model as she deigns to chat with smiling, ragged toothless campesinos. The model, like the ladies of the Spanish court, uses wasted creatures to heighten her beauty.

The model wears white gloves to avoid the dangerous parasites that lodge under your fingernails in the tropics as she talks to a child, as she looks down to a child while a creased old man admires her androgynous presence. Or she stands before an ox-cart as she shows off her calm, cool clothes and blesses poverty; she spreads her arms, palms out, as a saint or a magician.

Cuba – then an economic colony of the United States – made me see the ideal, the rag flower doll; Cuba – as a country involved in building a socialist society – made me appreciate the fruit, the wound hidden behind the froth of a daiquirí. I decode within a cultural context. I can't help it, Cuba made me so.

3

Only a few attempt, in press photographs and reports, to reveal the true face of the world, the scar hidden under the froth. Various traps are customarily laid.

The true scar of Africa, one of the deepest wounds of the world, is the work of white men in the name of European civilization; there is nevertheless an insistence on black barbarism, on the dark-skinned savage as an irresponsible murderer. The skill displayed in the photographs of the innocent whites of Kolwezi, that froth of the world, those inert, blond, white-skinned bodies rotting amid the demolished equipment of the mining camp, is proof of the effectiveness of the press, of its power of empathy, in the insolent capitalist world. Next to the full-colour photograph of the livid corpses, there had to be, of course, a black-and-white reproduction of the true wounded of the continent, forced to prostrate themselves on the ground before soldiers of the French Inquisition. These two pages of *Newsweek*, published on 5 June 1978, are an admirable treatise on the photographic wisdom of the historical murderers.

And to make you shriek with laughter there is the grotesque coronation of Bokassa, in full imperial colour, with his uniform, arrogantly bracing himself on his Napoleonic throne. The naïve savage repeats history as a farce. The reporting takes advantage of the context to reinforce prejudices and profound myths of Western Culture.

In October 1978, *Life* came out with an article on the Shah of Iran and his royal family. On the last page, a general, having just arrived from Teheran, receives instructions from the monarch. Everything is in order, to the point of reverence. Then an explosion: but the American press reports that the armed forces are keeping the situation, a popular uprising, under control. The army always manages to disperse the demonstrators. Baktiar stands fast, and lets himself be photographed next to a picture of Mossadegh. The carrot and the stick. Tanks patrol the calm streets. The Ayatollah Khomeini is neither seen nor spoken of. He does not exist.

This is the way they write history. Readers are always informed by what the press wants to see and to say with photographs. And even as it misinforms, it does not lose credibility. Yesterday's news stories and photographs are forgotten. It is an absence. It is the final trap. The lies of yesterday are always the truth of today.

Faced with photographic pseudo-reality, one can only rely on one's memory and an inconsolable intelligence.

Rebellion in the Third World has passed to urban centres without abandoning the rural areas; from Beirut and Teheran to Soweto and San Salvador the masses are taking to the streets, burning the symbols of consumerist colonization, and defying the military repression. It is a new revolutionary reality, a new photographic countenance.

Nicaragua, because of the feudal cruelty of Somoza, counted for a moment on the sympathy of the world. The pictures of the young people of Masaya, León, Jinotega and Matagalpa filled us with astonishment. The bandit's kerchief has become the uniform of urban revolution in Central America. The pistol is added to the rifle, and carnival masks protect the identity of the new urban guerrilla. Susan Meiselas' photographs, taken inside the liberated towns and not from behind or in the footsteps of the National Guard, seize us with their sensual texture and pierce

us by their political sympathy. The tension is overwhelming. The position of the photographer and the angle of press photographs are what is most difficult to neutralize: though not impossible.

These photographs followed two paths: they fell on the cushion of established publications, and they circulated in a series of projections designed to collect funds to continue the struggle against Somoza. A lone photographer, no matter what his or her photographs may say, is powerless unless he functions within a definite context, unless the pressure of other bodies exists behind his images. If five years ago the photographs of revolution in Nicaragua were used to support the Sandinistas, today the photographs of revolution in El Salvador are used against the rebels. Yet it is the same Central American revolution.

The least deceitful publications acknowledge a political party, a stated bias; they can be mistaken and often are, but we know beforehand what their viewpoint is.

When we read the newspaper *Granma*, we hold in our hands the official organ of the Cuban Communist Party; we understand why a picture of a brigade of sugar-cane cutters that have downed a million juicy stalks takes up more space than one of Carter, Giscard, Callaghan and Schmidt holding a summit meeting on the island of Guadalupe in 1979. It is a value judgement, and these everyday images corre-spond to a well-defined, consciously motivated social plan.

The decade of the seventies opened with an irreproachable figure in the Moneda Palace. Salvador Allende holds the office of President of Chile under all the provi-sions of the law. His noble portrait appears repeatedly on the pages of the world press, while the millions of faces and bodies that make up Chile leap in the streets, without weapons, to show that they are not starving. The tragedy is summed up in two indelible moments: the burning of the Moneda Palace and the dignified President in his white helmet, gripping a rifle given to him by Fidel, and with this image he defends his words: 'I am not made of the stuff of martyrs, I am a simple social fighter, but I want it clearly understood that I am fulfilling the mandate of the people, and to get me out of the Moneda Palace they'll have to take me out dead.'

So much for press photographs.

4

There is a kind of photography that has a refined presence in the history of images stolen from reality. It is the art photograph as a lie. It transcends fluid reality and creates a closed unity. When it achieves an aesthetic synthesis, it immediately attains static unity. Cartier-Bresson's photographs taken in Indonesia, for example, have this paralysing effect. One is compelled to believe in the perfection of the original reality; the image is a harmonious entity in itself. 'Do not change a single thing!', one feels inclined to exclaim, like a stupid tourist in any 'exotic and primitive' country. The closed architecture of the image is beauty that tends, as the Greeks thought, to be its own justification. Art frequently creates a comfortable world that detaches itself and becomes independent from action. The photographs of Edward Weston, for example, are closer to the world of painting than to the active realism that characterizes impure photography. Weston's sensual texture or Cartier-Bresson's implacable composition are apt to close over themselves, attaining the

perfection of a certain sensual and harmonious bliss. We see textures, volumes, equilibrium – and reality, open and ragged, is lost and transcended. Images as self-sufficient, perceptually and culturally, as Velásquez's *Las Meninas*, irreproachable in their own space.

There is another manner of escaping: the effects obtained through excessive interference when the photograph is taken and especially when it is processed in the darkroom. Effects that break the obvious, recognized connection with physical reality.

On emerging from the embrace of reality, photographs do not remain floating in a no-man's land: they cross the frontier and surrender to the world of painting. They are perceived and analysed within a sensibility refined by painting: texture, composition, equilibrium and spatial tension, eternal harmony. If painting is already this archetypal world of absolute and eternal truth, photography governs the field of the contingent, the temporal, the broken, and the scattered, the interrupted.

This, roughly speaking, is the way to read the kind of photography that has matured in our time. An unsettled composition, an uprooted space, an intercepted light. The other way of producing images, of seeking closed and organized images, belongs to painting. From a Weston nude to a crumbling wall by Enrique Bostelmann. It is photography but we read it as painting.

This is not an absurd excommunication, it is a distinction. Let us for the moment assign to the established canons of painting the photograph that longs for fluid reality. A photographic genre in no way to be despised, it would merit a separate analysis of its own – both for the pleasure and the astonishment it sometimes affords us. Modern man's avidity is constant because it is insatiable: no one, especially today, voluntarily resigns himself to limiting his intake. Not to speak of the Latin American, who, with his broad context and cultural pressures, has a universal curiosity well expressed by Pablo Neruda: 'I am omnivorous of feelings, beings, books, events, and battles. I would eat the whole earth. I would drink the whole sea.'

This vast and recognizable link with reality has special importance for the critical photography of the emerging South. Our America (Latin, not Anglo-America), particularly now that its economic, political and cultural development allows it to speak out vigorously on an equal footing, requires the weight of the planet. Now that we can travel all over the world like exotic Indians and obliging blacks, we must develop photography as a critical attitude revealing and directing a world that can offer a possible alternative, another reality, to the Euro- and USA-centric vision and cultural conceptions. Not only do we live other economic and social problems, but we live them differently.

We are recognized for artistic imagination, elemental strength and creative exuberance. I have given a certain weight to theoretical and ideological discourse in this essay because it is less important to affirm our presence than to define our outlook. Our criticism and thought have consumed our creative energies from Simón Bolívar to Fidel Castro, in the struggle for political independence. 'There is no literature that expresses anything' – I extend José Martí's words to culture as a whole – 'so long as there is no essence in it to be expressed. There will be no Hispanic American literature so long as there is no Hispanic America.'

If we judge the photography of our continent – the most advanced and aware

in the southern world – by some of its more striking recent examples, we can recognize that, on the one hand, it largely satisfies the requirements of a critical and orienting vision and, on the other, gives evidence of a sensibility open to all currents.

These photographs have freed themselves from certain deep and recurrent myths that have been imposed on us and which we sometimes internalize: archetypes that have accompanied us since the Conquest. In press and advertising photographs, for example, the view of the noble savage or the atrocious cannibal is obvious. Either we are innocent and docile, living in surprising harmony with our surroundings, or this natural beauty turns into the ferocious grimace of the irrational savage, who manifests his discontent by overturning cars and setting fire to shops and proconsular offices, incapable of understanding the civilizing influence of Europe and the United States. Either we are noble examples of utopia, or we are soulless inferior beings, incapable of joining the modern world: docile parrots or dangerous jaguars.

Three friendly female natives offer themselves smiling to the colonizer in a girlie magazine, *Hustler*. The metaphor could not be more eloquent. The women open themselves, surrender willingly to the new God. A double oppression, as natives and as women. Could this posed photograph fail to explain why many women's organizations in the United States support revolution in Latin America?

In the field of artistic photography, the myths live on by the eternal return: the immensity of nature, the vastness of rivers, plains and mountains; the delicate beauty of the hummingbird or the endless voracity of the boa constrictor; the utopian beauty of civilizations destroyed by the Conquest; ruins with ruined people, who are nevertheless deserving in their beautiful handmade rags.

When some of these subjects appear, their idealist and exotic burden may be neutralized by their position in a specific historical and social context. Or they may be converted into symbols, like the photograph of the destroyed, roofless colonial church by the Mexican Renato von Hanffstengel; the typical hut is also destroyed by fire in the pathetic desolation of the touristic development of Brazil, depicted by Adriana de Queirós.

The urbanized Indian affirms his stubbornness before a wall that shrieks Coca-Cola; as a mother with her baby on her back, sitting on the sidewalk with her miserable subsistence merchandise, this Indian suffers under the circumspect and classical gaze of the white stone sculpture adorning so many parks and residences of the New World; and he even appears with class-conscious satisfaction when he sits in the colonizer's chair in front of the photographer Pedro Meyer. Blacks and mestizos are men and women in the photographs of the Panamanian Sandra Eleta; to be men and women is not an easy thing for the Latin Americans who sustain the continent. Photographing men and women, as men and women, is here a positive and vital feat.

It is not an easy vision. It involves a knowledge that is erotic and at the same time rational. The eros of knowledge must join with the logos of our America. Without knowledge, intuitive or conscious, of the structure of the world around us, we are lost.

Alejo Carpentier, in touching on the present problems of Latin American fiction, opened his eyes to the continent:

Someone has written a novel about the jungle after peering at it for a couple of days. As for myself, I believe that certain American realities, for not having been exploited in literature, not having been named, require a prolonged, vast, patient process of observation. And that perhaps our cities, for not having yet entered into literature, are more difficult to handle than the jungles or mountains.

Carpentier is speaking of the novel, but he conjures up our photography as well. Naming things can be confusing and tiring for the reader of novels. Photography, with its immense visual ambiguity, its ability to cover so much in the little time it takes to absorb it, is different.

Our cities *have no style*. And yet we are now beginning to discover that they have what we might call a *third style*: the style of things that have no style . . . What happens is that the *third style*, just as it defies every-thing that was hitherto been taken for *good style* and *bad style* – synonyms for *good taste* and *bad taste* – is usually ignored by those who contem-plate it every day, until a clever writer or photographer proceeds to reveal it. . . . It is difficult to *reveal* something that offers no preliminary information in books, an archive of emotions, contacts, epistolary excla-mations, personal images and approaches; it is difficult to see, define, weigh something like what Havana was, scorned for centuries by its own inhabitants, the object of allegations expressing tedium, the wish to escape, the inability to understand.

This necessity, although it can manifest itself as pure scenography, answers to a real need to name our things and situate them in a real context.

The coexistence of people of the same nationality belonging to different races, Indians, blacks, and whites, of different cultural levels, often living simultaneously in *different periods*, if you consider their degree of cultural development. . . . The political and military context of Latin America has inexhaustible implications. Though it should be taken into account, one must be careful not to fall into a facile and declamatory literature of *denunciation*. . . . Valid connections should be established between the man of America and chthonic contexts, without resorting to the exploitation – in any case, discredited – of the bright colors of the shawl, the charm of the sarape, the embroidered blouse, or the flower worn over the ear. *Distance* is another important context, as is the *scale of proportions*. The dimensions of what surrounds the American man. . . . The disproportion is cruel insofar as it conflicts with the module, Pythagorean eurhythmy, the beauty of number, the golden section.

All this has to do with photography.
The Latin American photographer has the possibility, and the means, for naming the things of our world, for demonstrating that there is another kind of beauty, that faces of the First World are not the only ones. These Indian, black, plundered white

and mestizo faces are the first element defining the demographic content of our photography. Cultural, economic and social conflicts are also obvious in many photographs. An eagerness to name our reality is present in the dark splendour of most of these images, as well as the need to reject the exploitation of exotic colours so as not to fall into a facile and declamatory photography of denunciation.

The military and religious contexts also appear in our photography, without resorting to the visual pamphlet. As heirs of Spanish colonization, we are still countries of soldiers and priests. But although the priests are privileged, many Latin Americans are genuine believers, poor devotees of syncretisms of Afro-Spanish origin. 'Religious suffering is, on the one hand, the expression of real suffering, and on the other a protest against it': Marx's acute observation now applies more to us than to the North. The two faces of religion, oppression and escape, are nevertheless, a powerful refuge in this uncertain and fluid decade.

The same cannot be said when we find the military in certain photographs: it is always the naked form of power, deciding national destinies and repressing genuine aspirations, those aspirations that have continued to propel us since the emancipation struggles of the last century. This active, revolutionary face seldom appears. The rebellion of the continent appears in a photograph of Allende in the hands of the Chilean people and in the frustrated scrawl of the word 'revolution' on a rough wall.

The revolution in power is the presence of Cuba. Yet historic images appear in many Cuban photographs: militiamen of Playa Girón, armed peasants, popular demonstrations, grimy machete wielders more staunch than smiling. Cuban photographs have the force of nostalgia, they are historical pictures, imbued with the spirit of the sixties. The image of the sixties is the most powerful and recognized one of Cuba. It is a real vision, but already stereotyped. The decade of the seventies is visually almost unknown. Enough of scratching the surface, naming the absent appearances: the jeans of the high-school student in the Campo, the white helmets of the members of the micro-brigades, the epaulettes and uniform caps of the military. Adventure has given way to order. Images have to be analysed for a programmed response. Critical photography of everyday life is inseparable from cultural dialogue.

The style of Cuban photographs can be recognized by a certain frontal candour. The photographer seems to be arrested frontally before a powerful reality where the struggle is as obvious as an open smile, where social homogeneity produces a photography of pure denotation, with no remote connotations. These are testimonies that open like fruits in the smile of Nicolás Guillén or the worker with the machete standing with his trophies in his hands on a vast field of cut sugarcane. Mayito and Marucha artfully transcend this ingenuous frontality.

I would say it is no accident that the least regional photographs, those most obviously related to international photography – both in theme and in the way of treating the theme – are made in Mexico and Brazil, the countries with the highest level of economic development, and where modern neocapitalist society is already the lifestyle of a substantial minority. They are authentic photographs of a real colonization.

Theft, as Picasso used to say, is only justified when it is followed by a murder. In many photographs we easily discover the chicken thief. Chickens from another

roost: desolate urban landscapes, ostracized transvestites, fragments of figures, surrealistic montages, hygienic textures, and so on.

Perhaps the only excusable case might be that of Francisco X. Camplis, with his photograph of a Chicano nude. Faced with the erotic buffetings of Anglo-American beauties, he gives us the female beauty of his own race. It is an ambiguous photograph, as ambiguous as the difficult position of the Chicano artist in the United States. The photographer himself acknowledges it:

> I am keenly aware of the influence, subliminally or otherwise, upon my work by the plethora of American designed imagery. . . . We continue to hold a fascination for things European, for *gente güera*, for *la gabacha* or *gringa* and so forth. In effect, we help to perpetuate the myth that beauty solely resides in creatures blonde and blue-eyed.

Latin American photographers in the United States suffer – with greater violence – the same contradictions when they speak or look at themselves in the mirror. The face and features are Chicano, but the whole body responds to the aesthetic standards of the North. Their graphic style could have been used to specify another physical type: strong face, short legs, broad hips. The photograph is a sweet trap. On a macho continent, marked by rigid and watertight sexual definitions.

Centred around the positive social pole are the photographs of Paolo Gasparini, a critical artist committed to one of the most difficult tasks of Latin American photography: to clean away the golden, filthy cobwebs that hinder moral clarity. His work has dwelt for the past twenty years on the revealing contexts of our southern world: the vast American geography marked by the exploitation of its natural resources and by immense garbage dumps of consumerism. The geography that Gasparini has shown us includes not only the tenacity of its men but also its cemeteries of crosses and oil rigs. The money that reposes on the neoclassical columns of the banks and the garbage that the many mestizos of the continent transport in order to live.

His pictures today preach about diamonds and children. One series is devoted to the exploitation of diamonds in Venezuela. They are images of the hellish circle of plunder. Earth and men plundered by livid, invisible hands that create a vicious circle, which in San Salvador de Paúl wastes away 'a small mirror in which the history of lost humankind is concentrated.' These are his own words:

> Children looking without much astonishment at wealth consuming itself, wealth that generates poverty right there in the very place where the offense, the crime against nature, was committed. The diamond becomes poverty despite the mirth of the prostitute, in the greed and futility of the middleman.

Children, for Gasparini, have taken on the role of witnesses; Latin American children, who will inherit what we, the adults, are already revealing and imprinting on their minds.

When he gets to this point, Gasparini breaks out in curses. His voice is the most despairing of all. 'Each image can be read in many ways,' he remarks in connection with his Venezuelan diamonds.

In a Finnish museum, these photographs might simulate exotic appetites, in a European or American magazine they would form part of one more "coverage," in socialist Cuba they might illustrate an article in *Prensa Latina* on the inconsistencies of democracy, in the house of a friend they would appear as "the body of Maria Luisa inviting you to go to bed," to the squinting eyes of some museum curator the out-of-focus hand of the same Maria Luisa would be disturbing, and for me it will go on being a vivid experience, an apprenticeship in memory that draws me back to the garden of childhood.

Gasparini's perplexity emerges from the monstrous distance between creation and distribution: between creation and the form of consumption. This distance, which erodes or destroys the work and the original intention, is more pronounced and exaggerated with photography.

Its images are scattered, they do not have the inner cohesion of the cinema film nor the precise location of a projection room. The ambiguity of the image, including the documentary reportage, requires definition, demands a context. Inexorably we fall into the trap: be it the magazine with its columns of print or the museum wall with its antiseptic time and space. In a magazine, the photograph usually argues as it informs, and in the museum it casts off its historical and social moorings.

Museums and galleries are a new element; they increase the distance but satisfy a repressed vanity of the creator of photographs: to be recognized as wholly an artist in society. Yet photography triumphs when 'the press photograph merges with world news, the family portrait with everyday life, and the photo in a magazine or book with countless cups of coffee.' This is the greatest and most ambiguous triumph of photography.

But the photographer who has very precise intentions feels himself at a loss. 'Is photography capable of giving a good version of reality? At least an adequate version of our intentions? I don't think so, nor am I even sure of what photographs really say,' the despairing Gasparini concludes.

5

There throbs in all of us a certain overevaluation of photography, art and the mass media. Despair, the need to entrust everything to the effectiveness of creative beauty, the hope of concentrating everything in the content of a message, is an illness, a form of alienation. It is not art, photography included, that will liberate us but a revolution in our way of working and living. Photographs and art are indexes of value. They are elements for cultural dialogue. They refer to our existence but they are not our existence.

Let us not reject the aesthetic, humanizing function. The young Marx based his work on the prospect of placing man in the centre of his world: 'The eye has been transformed into a human eye, just as man has become a social, human aim, an aim flowing from man for man.'

It is not, however, an isolated element.

The richness of our contemporary visual world must be seen as a danger. It is

an overwhelming and oppressive world. A world that manifests itself fundamentally through the image is only a few steps from totalitarian manipulation. Images, the visual power of present-day capitalism, like the ritual constructions of ancient Egypt, are refined ways of inhibiting and crushing man. I have lived more than twenty years with these anxieties. I am convinced of the effectiveness of shared, collective work, and of the decisive importance of dialogue among people. I have learned much more by conversing, in animated exchanges and collective discussions, than in eyeing and reading the barrage of information that imposes on us a docile passivity. That is the lure of pseudo-reality.

The photographs in magazines and books, or blown-up on posters and billboards, have the limited power of a watchword, of visual phraseology. We do not commit ourselves by giving our word, we do not assume a real and considered position within the group. The image only incites us, it does not commit us. It customarily manipulates us. For better or for worse. The visual image has a limited value within a social and cultural system.

The Greek habit of dialogue continues to be a liberating principle; and when this dialogue becomes universal among men and bases itself on work, on coherent action – only then will the image be able to play a humanizing role.

The prestige of the visual image is out of all proportion. Photographs are ideas, memories, feelings, thought – and thought devotes itself only to death, to what is mechanical in life, to regularities or distortions. Life is first action, then words, and a photograph in death. It is an instantaneous truth that has already ceased to exist.

Photography has taught us not to twist ourselves around a discourse that should always be an open dialogue. It is what we have been, and not necessarily what we will be. We are ignorant of the future.

There are one, two, three paths . . .

PART SEVEN

The photographic gaze

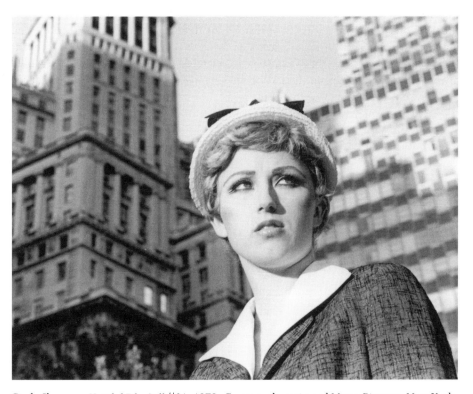

Cindy Sherman, *Untitled Film Still* #21, 1978. Courtesy the artist and Metro Pictures, New York.

Introduction

> Men look at women. Women watch themselves being looked at. This
> determines not only most relations between men and women but also
> the relation of women to themselves.'
>
> (Berger 1972: 47)

DEBATES ABOUT 'THE GAZE' in photography date emerged from general
feminist theoretical perceptions and debates of the 1970s/1980s. Discussing
classic Hollywood narrative cinema Laura Mulvey drew upon psychoanalysis to
argue that images of women on screen are constructed for the gratification of the
male spectator. Freud's discussion of voyeurism is premised on his proposition
that scopophilia, that is, the desire to look, is a primary human instinct. In patriar-
chal cultures the male I/eye is central within discourse and woman is 'other'; in
psychoanalytic terms she is complexly construed as simultaneously the object of
desire and a source of fears and insecurities. Mulvey noted that this objectifica-
tion of women is reinforced cinematically both through the use of the camera to
frame her image, and through the audience being drawn into identification with
the point of view or 'look' of male characters within the fictional narrative (Mulvey
1975). It is this formulation that Victor Burgin acknowledges and draws upon in
his discussion of 'the look' in photography (see Part 3, p. 130 ff.); he later suggests
that the effect of the 'still' of the photograph, the permission for the eye to roam
within the frame, and the apparent artlessness or naturalism of the image – by
contrast with, for instance, an oil painting – also need taking into account (Burgin
1990). Thus, in considering what is sometimes termed 'the phallic gaze of the
camera' in relation to the still image, we need to consider both specific charac-
teristics of photographs and broader cultural attitudes.

Debates not only raised questions of gender. Discourses inter-sect. For
instance, articulated with gendered relations of looking are discourses of age and
ethnicity whereby the idealised female image is, almost without exception, young,
slim, light-skinned. In photography, discussion focused on female representation,
in particular, feminist critics argued that 'the nude' is a masquerade, a genre in
art which essentially acts as an excuse for contemplating nakedness, however
abstractly or pleasingly pictured. The female nude was thus reconceptualised as
a patriarchal fetish, whilst the homo-eroticism of male nudity in European classical
art was also acknowledged. In the first essay here, Roberta McGrath analyses the
work of Edward Weston, drawing upon his own daybooks, as well as upon femi-
nist interrogations of the ambiguity of woman as sign within patriarchal discourses.

Since the initial discussions of relations of power and powerlessness of the
surveyor and the surveyed in terms of gender there has been concern to develop
debates more complexly. As Anne Williams commented:

> Relations of looking, whether socially or in visual representations, are
> governed by convention which unsurprisingly are structured according
> to the norms of masculinity and femininity – man the active subject of

the look, the looker, woman its passive object. A number of questions occur. How does the woman look? Is she forced to share the way of seeing of the man, or might there be a specifically female gaze? Can the man too be the object of the gaze? Can such a clear distinction be made between male and female, masculine and feminine?

(Williams 1987: 6)

Such debates have been extensively explored, including, for example, interrogating the male nude in photography (Cooper 1990; Pultz 1995); lively discussion of the work of Robert Mapplethorpe; lesbian looking and the performative (Boffin/Fraser 1991; Bright 1999). Debates were also explored through practice, for instance, in Cindy Sherman's work, which has been discussed as postmodern art and in terms of image and identity. In the essay reproduced here, Avgikos argues that Sherman's practice is also founded in feminist perceptions. Both Weston and Sherman are generally encountered in the context of the art gallery or art publications. The critical discussions have broader implications as questions of patriarchy, desire and voyeurism are equally relevant to analysis of commercial imagery including advertising, fashion, erotica and the pornographic.

Extending from debates about the gaze in terms of gender and sexuality, representation and desire have been interrogations of ways in which, historically and now the 'colonial gaze' implicates and reinforces privilege. Critiques of colonial attitudes not only brought into question the positivist pretensions of traditional anthropology, but also articulated issues of exoticism and otherness (Green 1984; Graham-Brown 1988). Post-colonial theory also encompasses critical practices in which ethnic, regional and cultural difference were differently pictured, re-positioning otherness. Here interrogations take into account subjective positions and perspectives on the part of the photographer or critic as well as questioning issues of representation. For instance, in the third essay included here, taking a single photograph of a family group of Native Americans in Canada as a starting point, Lippard dissects layers of past and present relations and assumptions, always noting her own reactions as viewer of the image.

Indeed, photographs can be conceptualised and productively examined as points of inter-section of multiplicities of gazes. Such an approach relates textual decodings to broader historical and cultural questions. In the final essay in this section, Lutz and Collins analyse examples from *National Geographic*, taking into account a regime of visibility whereby definitions of otherness mirror and contribute, often problematically, to conceptions of self (both in terms of individual subjectivity and in terms of nationhood).

References and selected further reading

Berger, J. (1972) *Ways of Seeing*. Harmondsworth: Penguin.
Bhabha, H. (1983) 'The Other Question: Homi K. Bhabha Reconsiders the Stereotype and Colonial discourse', *Screen* 24/6, pp. 18–36.

Boffin, T. and Fraser, J. (1991) *Stolen Glances: Lesbians Take Photographs*. London: Pandora Press.

Bright, D. (1998) *The Passionate Camera*. London: Routledge.

Burgin, V. (1990) 'Perverse Space' in (1996) *In/Different Spaces*. Berkeley and LA: University of California Press.
> On 'the look' and theorising the photograph as a semiotic space.

Chalfen, R. (1980) 'Tourist Photography', *Afterimage* 8, Summer, pp. 26–9.

Cooper, E. (1990) *Fully Exposed: the Male Nude in Photography*. London: Routledge.

Graham-Brown, S. (1988) *Images of Women: the Portrayal of Women in Photography of the Middle East 1860–1950*. London: Quartet Books.

Green, D. (1984) 'Classified Subjects', *Ten.8* No.14, pp. 30–7.
> On anthropology and the ethnic other.

Hall, S. (1997) 'The Spectacle of the "Other"' in S. Hall (ed.) *Representation: Cultural Representations and Signifying Practices*. London: Sage and The Open University. On ethnic and sexual difference as represented in popular visual culture; includes examples from a range of historical archives.

Mercer, K. (1994) 'Reading Racial Fetishism: The Photographs of Robert Mapplethorpe' in *Welcome to the Jungle*. London: Routledge.

Mulvey, L. (1975) 'Visual Pleasure and Narrative Cinema' , *Screen* 16/3 Autumn.
> Widely reprinted including in her (1989) *Visual and Other Pleasures*, London: Macmillan.

Pultz, J. (1995) *Photography and the Body*. London: George Weidenfeld and Nicolson.

Urry, J. (1990) *The Tourist Gaze: Leisure and Travel in Contemporary Societies*. London: Sage.
> Includes a definitional discussion of the term, 'colonial gaze', in relation to imperial histories and ethnic otherness.

Williams, A. (1987) 'Re-viewing the Look: Photography and the Female Gaze', *Ten.8* No. 25, pp. 4–11.

Bibliography of essays in Part Seven

Avgikos, J. (1983) 'Cindy Sherman: Burning Down the House', *Artforum*, Jan. 1993.
> Reprinted in Liz Heron and Val Williams (eds) *Illuminations*. London: I. B. Tauris.

Lippard, L. R. (1992) 'Doubletake: The Diary of a Relationship with an Image' in Lippard (ed.) *Partial Recall: Photographs of Native North Americans*. NY: New Press.
> Reprinted in Steven Yates (ed.) (1995) *Poetics of Space: A Critical Photographic Anthology*. Albuquerque: University of New Mexico Press.

Lutz, C. and Collins, J. (1991) 'The Photograph as an Intersection of Gazes: The Example of *National Geographic*' in Lucien Taylor (ed.) (1994) *Visualizing Theory: Selected Essays from V.A.R 1990–1994*. London and NY: Routledge.

McGrath, R. (1987) 'Re-reading Edward Weston' in *Ten.8*, No. 27.

Roberta McGrath

RE-READING EDWARD WESTON
Feminism, photography and psychoanalysis

EDWARD WESTON IS, PERHAPS, UNUSUAL in that unlike many other photographers his work has been dominated by his own writing. In his diaries (published as *The Day Books* in 1961 and 1966[1]) he records his life through his photography, his sons, his appetite for women and health foods, and his dreams.

Despite this body of knowledge, his photographic work is most commonly accounted for in terms borrowed from modernist art criticism. Emphasis is placed firmly on formal qualities; a purifying of the visual vocabulary; and truth to the (photographic) medium. From such received and well-worn criticism we learn how Weston emerges from the murky depths of nineteenth-century pictorialism into the blinding light of twentieth-century modernism. The trajectory traced is that of a star. To quote Buckland and Beaton, Weston was 'a man ahead of his time',[2] who then arose from obscurity to fame via New York.

As the dominant ideological ruse of twentieth-century art criticism, modernism has functioned not only to suppress any concern for the wider social matrix of which all cultural production is part, but has also hidden issues of class and race and – crucially – those of gender.

For beneath all the fancy talk of the universal genderlessness of art, as women we know that such truths are meant for *men only*. Such knowledge is kept suppressed. How else could the illusion be preserved that the real meanings of art are universal, beyond the interests of any one class or sex?[3]

It is clear that a feminist art criticism cannot afford to have any truck with modernist discourse. Lucy Lippard has described the feminist contribution to modernism as precisely a *lack* of contribution.

It is therefore not accidental that in the title of this essay I place feminism before photography and psychoanalysis. The task which faces feminist practice is double-edged. On the one hand we must work to de-construct male paradigms, and on the other to construct female perspectives. Both are necessary if we are to change those traditions which have silenced and marginalised us.

To this end feminist scholarship has turned attention to a vast array of discursive practices as a means of understanding not just women's economic oppression but also our oppression within patriachal culture. Much of this work has come about as a result of the women's movement in the late 1960s and early 1970s. and owes a debt not only to Marxism, but also to psychoanalysis and linguistics.

While Marxist analyses of culture have contributed greatly to an understanding of representations it must be recognised that as a body of theory it cannot answer all the questions. For feminists, of course, the problem is that Marxism takes no account of the sexual division of labour. The Marxist subject is a genderless and universal one. For psychoanalysis the problem is that the Marxist subject is alienated only in a capitalist society which supposedly prevents us from becoming 'whole' beings.

If Marxism proposes that struggle exists between classes (class division of labour) then feminism proposes that struggle exists between sexes (sexual division of labour); and psychoanalysis proposes that struggle exists within ourselves The unconscious provides evidence of this. The psychoanalytic subject is one which instead of being coherent, whole, complete is always already alienated, split fragmentary. Entry into the world is at a price. The human subject is one which is always lacking and hence always desiring to fill a gap which is, by very definition, unable to be filled.

Psychoanalysis has also been important for feminism in providing evidence that subjects are formed through sexuality. Sexual difference, masculinity and femininity, is not biologically determined but socially, psychologically and culturally constructed. For Simone de Beauvoir, 'one is not born a woman. But rather one becomes a woman'.[4] The question is 'not what woman is, but how she comes into being.'[5] Such ideas may seem to be a far cry from the work of Edward Weston. But as we shall see, within his work we can read the traces of such debates: we can read attitudes to Marxism and psychoanalysis as well as to women.

Having said that, there is no doubt that such theoretical accounts would have sat very uneasily with Weston himself. In his Day Books he records attending a John Reid Club meeting in the 1930s and the call to 'realise dialectical materialism'. This had little appeal for Weston who believed passionately that 'the individual adds more or combines more than the mass does. He stands out more clearly, a prophet with a background, a future and strength'. Weston was, of course, writing himself into art history, carving out the mould which others would diligently fill in. As such Weston becomes an artist, a genius – perhaps even a saint within orthodox photographic theology.[6]

But of all approaches to photography, the psychoanalytic was the most vehemently rejected – not just by Weston, but by the women who surrounded and defended him. For example, Nancy Newhall regarded his promiscuity as signal evidence that there were no sexual connotations in his work. 'His plethora of love shows that he had no need to seek erotic forms in his work.'[7]

And Weston's second wife and model Charis Wilson insisted that the inclusion of models' faces in the photographs of nudes would have reduced what she, and he, perceived to be a universal theme to a portrait of a particular individual: 'If the face appears, the picture is inevitably a portrait and the expression of the face will dictate the viewer's response to the body.'[8] This would interrupt what she and Weston believed to be the aesthetic appreciation of naked beauty. The *body* of the woman

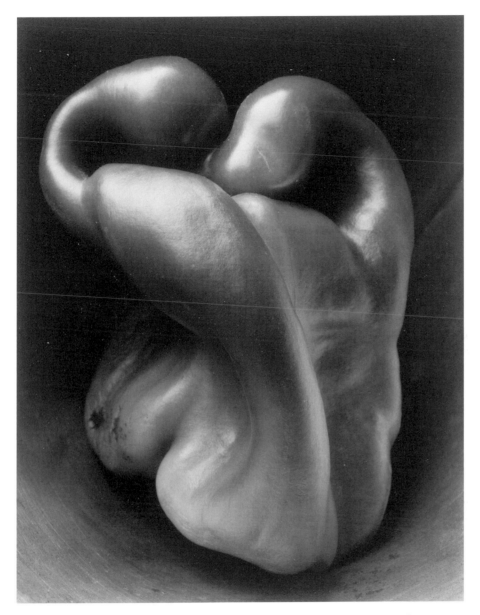

Figure 30.1 Edward Weston, *Pepper no. 30*, 1930. Courtesy of the Centre for Creative Photography. 'Weston is compelled to sexualise, even genitalise everything . . .'

was, for them both, one of only three perfect shapes in the world. (The other two were the hull of a boat and a violin . . .) The compulsion to choose such forms as perfect was understood within the formalist aesthetics of modernism: We must never speak of *content*.

But the denial of the role of the unconscious and the psychological drives can in no way eradicate them. They are there to be seen, not so much in the pictures, but in the encounter, in the relationship, in the gap between artist and object,

a gap which neither an art history nor a technological history can bridge. This is the place of production: both material work carried out in the darkroom and work carried out in that other dark space, the unconscious.

Precisely because psychoanalysis occupies a unique space between nature/culture, between the biological/the social, it can provide a way out of this stagnant binary logic of dominant photographic history, criticism and practice into an area which is less mapped out, After all, as Rosalind Coward says, 'The invisible is not simply anything at all outside the relationship between objects posited and a discourse. It is within the discourse, it is what the light of the discourse scans without picking up its reflection. In the fullness of the (photographic) text there are oversights. lacunae. . . .'[9]

Because photography is a medium which seems to be purged of all traces of its production and because it offers us so much to see, most writing on photography concentrates on this world as seen through photographs as if it were a transparent medium, rather than concentrating on *how* those images are *produced*. But what interests me here is precisely those gaps, those oversights. If we borrow a term from psychoanalysis (dream-work: condensation and displacement which underlies the dream) we could say that what is missing, what is rendered obsolete in photo-criticism is the *photo-work*. Of course, photographs are not dreams. They have an advantage in that they can satisfy the unconscious desires of many people. What I am suggesting is that psychoanalysis may provide a route out of this double-bind. I say *might* because it can only do so on one condition: namely, that it provides a materialist psychoanalytic understanding of the apparatus of photography. It is perfectly possible to produce idealist psychoanalytic interpretations. The revelation of latent content or the psycho-biography can be accommodated in art appreciation. Those are not my concerns here. It is not my intention to prove that Weston is in some way a 'perverse' rather than 'straight' photographer. Far more is at stake.

I now, therefore, want to turn to this photographic work and to the language of photography itself.

Close encounters

'Taking' a photograph is a way of making sense of the world. It imposes an order, a unity upon the world which is lacking. To take a photograph is to exercise an illusory control, a mastery which is characteristic of voyeurism. But the sexual connotations of the verb are also obvious: the slang for carnal knowledge. It implies a physical penetration of the other while the photograph is a penetration of the space of the other. For Weston this taking, whether photographic or sexual, was closely linked and well-documented.

In his Day Books he records how photographic sessions were frequently interrupted. The eye was replaced by the penis, making a photograph by making love. It is here that we begin to see an oscillation between photography/sex, (between the print/the real). But we need to pause over this because the penis and the eye are not interchangeable. The satisfaction of one must mean the denial of the other. However, for the male the eye is often a substitute for the penis since its satisfaction is intimately linked to the possibility of an erection.

Photography has an obvious role in this web of pleasures The voyeur and the photographer must at all costs maintain a distance from the object and the photograph ensures this distance par excellence. To move too close, to touch would put an end to scopic mastery and lead to the exercise of the other drives, the senses of touch and hence to orgasm.[10] Thus, the photograph acts not so much like a window on the world as a one-way mirror where the tantalizing object of desire remains just out of reach so close, and yet. . . . (We should also note Weston's fascination with Atget's photographs of windows). Moreover, the photograph allows the voyeur to look without fear of retribution. Unlike the woman herself the photograph is portable, can be referred to at will, and is always a compliant source of pleasure. Without this scenario the camera is another device of denial and retention (which is always fully a part of pleasure). But there is a complication. The camera itself, 'the body', 'the lens' (eye), 'equipment' can become an object of love, a *fetish*, a re-assuring object that affords pleasure and that the photographer may know more intimately and with less danger than the woman who is likely, one way or another, to put an end to his erection. Weston often refers to his camera as his 'love', reminiscent of the traditional ascription of femininity to photography, as female as a 'hand-maiden', a box with an aperture that passively receives the imprint of an image – but only in negative.

In his diary Weston makes the following slip: 'I made a negative – I started to say nude. . . .' This analogy of negative to nude is significant since the implication for both is a certain lack: the minus sign, the horizontal, the hyphen or gap. It also suggests woman as less than, more incomplete; possessing, perhaps, only a negative capacity.

This lack is one which can be made good by photography. Weston describes photography as 'seeing plus'. Is it through the print, ('which will remain *faithful* to the negative') that he can compensate the woman/the world for their lack? Is this the vertical crossing through of the horizontal, the turning of this minus sign into the plus?

But in speaking of voyeurism and fetishism, I am getting ahead of my argument. And to understand them we need to introduce a third and even more unpleasant term: castration.

In 1938 Stieglitz wrote to Weston: 'For the first time in 55 years I am without a camera'. Weston replied, 'to be without one (to be what one might call cameraless) must be like losing a leg or *better* an eye.[11] Not worse, *better*. Castration – and by analogy – death, are clearly in the air. It indicates Weston's desire (attested to elsewhere in the notebooks) to usurp Stieglitz the Father of Modern Photography. Weston visited Stieglitz in 1922 and it is well known that he never received the recognition from Stieglitz which he so desperately desired.

It also attests to Weston's own fears of castration: the loss of a leg or an eye (perhaps the third leg in Charis's description of Weston's Graflex camera as 'a giant eye on three legs'[12]). This is a reference to the myth of Oedipus in which blindness is symbolic of castration. Within this scenario the mother is photography and Stieglitz and Weston are the rivals for her attention. This makes sense of the closing lines of the same letter in which Stieglitz wrote to Weston of his cameralessness. He continued: Waldo Frank said some years ago. 'Stieglitz, when you're dead, I'll write your biography'. I wondered how much he knew about me and why wait till

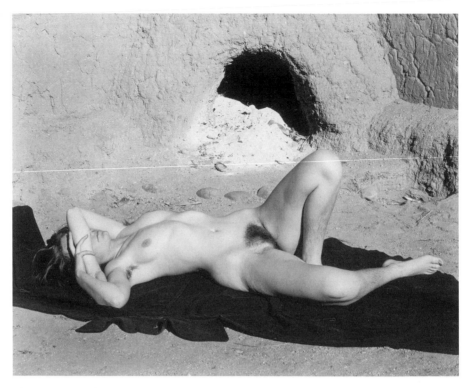

Figure 30.2 Edward Weston, *Nude, New Mexico* 1937. Courtesy of the Centre for Creative Photography. 'She does not look, pretends she is not being looked at, and yet in the same moment we know very well that she knows . . .'

I'm dead? But all I said was: Frank my biography will be a simple affair. *If you can imagine photography in the guise of a woman and you'd ask her what she thought of Stieglitz, she'd say: He always treated me like a gentleman.* So you see that is why I am jealous of photography.'[13]

Photography comes in the guise of a woman; and for woman the ultimate accolade is to treated as an honorary man.

Castration, simply put, is a fear of damage being done to a part of the body (primarily the male body) which is considered to be a source of pleasure. In Freudian psychoanalysis the fear supposedly arises from seeing the mother's genitals and the realisation that some people do not have the penis. To the small boy who knows nothing about anatomy this provides evidence that castration is possible (he believes that his mother has had the penis and through some misdemeanour has lost it). This leads to the phantasy of the all-powerful mother (who does not lack) and to women as symbols of castration. This threat posed by women can be dealt with in two ways. through voyeurism (subjecting women to a controlling and unreturned gaze) *and* through fetishism (the displacement or substitution of the anxiety onto a re-assuring object which comes to stand in for the missing penis). The fetish, of course, has no value in itself. The reverence which the male feels for it is for the erection which it maintains. For Weston, photography in the form of the camera, was 'that

pleasurable extension to the eye': both it and the faithful photographic print become fetishes; necessary props.

Voyeurism and fetishism are both inscribed on the photographic arrangement. Photographs themselves are curiously like fetishes requiring a disavowal of knowledge. We know that they are only flimsy scraps of paper but we over-invest them with meanings. Moreover, photographs come to stand in for the missing object. The condition for the photograph is precisely the absence of the real object.

The major benefit of interposing the camera between his eye and the nude was to gain a more fundamental knowledge of reality. According to Weston: 'The discriminating photographer can direct its (the camera's) penetrating vision so as to present his subject in terms of its basic reality. He can reveal the essence of what lies before his lens with such insight that the beholder will find the re-created image more real and comprehensive than the actual object'. This is the search for the elusive and impossible real. In photography the infinite number of photographs, the quest for the 'one' attests to the drive to collapse signifier into signified, the photograph into reality: to make a photograph which has no other, a phantasy moment of suppression of separateness, which closes the gap – and the compulsion to close this gap becomes paramount. The pleasure and indeed the problem for the voyeur is one of how to maximise the pleasure of looking. This aesthetic requirement can partly be found by technical expertise. I mentioned earlier that 'taking' the photograph involved the penetration of the space of the other. The pleasure/problem is one of how to deepen this penetration; how to make the piece of paper more three dimensional and consequently real.

f/64

Weston belonged to a group of West Coast photographers who adopted the name f/64. This referred to a technical device – the aperture which achieves maximum depth of field with sharpest possible focus. It combines microscopic detail with telescopic depth. We could also describe it as a heightening of visual qualities which excite and invoke (without allowing) the sense of touch. Retention, we remember, is fully a part of pleasure.

This deeper penetration of the real could be further enhanced in the process of 'printing up'. By 1927 Weston was citing the advantages of using high gloss paper. It would 'retain most of the original negative quality'. Moreover, he went on, 'I can print much deeper without fear of losing the shadows.' He saw this as a logical step in his 'desire for photographic beauty'. Beauty frequently has its roots in sexual stimulus. The gloss of the paper mimicked the glassy quality of the plate negative, but shine also connotes a moistness which is associated with sex, and similarly, glossy paper seemed to adhere, bind with the image. It fused with the image in an imaginary moment of pleasure. This is what Weston means when he says, 'paper seems to compete with the image instead of becoming part of it.' Signalled here is the desire for a mythic fusion (as in sex) between photography and the real, the desire to suppress the gap between the subject and the object of desire, between the negative and the print, between the subject's own body and the other's body, ultimately the phantasy moment of orgasm. (The latest book on Weston is entitled *Supreme Instant*).

Perhaps we can now begin to understand Weston's love of Daguerro-types: a mythic one-ness at the 'birth' of photography. We should not underestimate the language which photography has adopted. If we pursue the metaphor of the natural birth then Fox Talbot's paper negative marks the break-up of the dyadic relationship. And we can also understand Weston's favoured method of printing, what is referred to as contact printing. It was an attempt to preserve an aura of originality.[15] In this process the negative bonds with the paper, the hard surface of the glass plate with the softness of the paper and from this union the issue of a print. It was Jean Cocteau who coined the idea that art is born of an incestuous union of the male and female elements *within* the male. Weston felt that the role of women in his life was to 'stimulate me, fertilize my work.'[16] Ben Maddow, Weston's biographer, speaking of the Weston/Wilson relationship claims that 'great nudes were born from this childless marriage'.[17] Weston was a prolific photographer having made some 60,000 prints of which, incidentally, nudes make up the largest category.

Honour, power and the love of women

According to Freud, the artist achieves what would otherwise remain phantasies, 'honour, power and the love of women'. It was Weston's work that enabled him to realise such invisible fantasies, brought to light through work done in the dark, under a cloth gazing at a ground glass screen, and work done later in the darkroom. Hollis Frampton has written that the work is of someone compelled to sexualise, even genitalise everything.[18] This makes sense of Freud's symbolic topography of genitalia in *The Interpretation of Dreams*. Landscapes, woods, trees, hills, caves, water and rocks come to 'stand in' although the gender to which they refer is by no means obvious (a cigar, as Freud says. is sometimes just a cigar). Freud names only two objects which are never confused (a box and a weapon); on the whole there is ambiguity. It is the context which provides meaning. Symbols tend to be hybrid, and those images which most satisfied Weston were those invoking the fusion of male and female. Excusado, The Nude Back, Shell and Pepper No. 30 achieve this status. It is worth noting that Pepper No. 30 was the all-time best-seller. The others are not so successful in concealing their origins. Weston described the pepper as 'a hybrid of different contractile forces . . . pulling against each other'. It is clear what this suggests. But Weston also ate these 'models' after he had lovingly polished and photographed them. It was part of the ritual consumption of flesh. He saw it 'not as "cannibalistic". They become part of me . . . enrich my blood.' Weston makes everything which constructs a world – 'girls to fuck. food to eat . . . trivia, oddities . . . earth to walk on . . . skies to put a lid on it all.'[19] This is also reminiscent of the way in which he talked about women, each in turn fertilising his work, but it also suggests another moment of imaginary unity: the phase prior to meaning when for the child separation from the m/other is temporarily suppressed by feeding the infant from the breast.

From voyeurism to fetishism

A similar unity is, of course, met in the single process of the daguerreotype. This marks the fetishistic axis of Weston's oscillation. Those early photographs were thought to have the power to see into the human character. For Weston, the camera 'searches out the actor behind the mask, exposing the contrived and the trivial for what they are', and 'all she wants is sex; all her gestures are directed by sex'. This is tinged with the language of punishment and investigation that is characteristic of voyeurism, Hence the oscillation in the work between the female body as form (pleasurable and complete) and the other axis; the sadistic cutting of the image. This latter aspect is achieved in numerous ways. In many of his photographs there is a literal cutting, the implication of cutting, the cutting of the frame, and the more subtle cutting produced by shadow. Enjoyment of the nudes is ensured through the erasure of the threatening gaze of the woman, either through a literal beheading, aversion or covering of the eyes, as if she did not know that she was the object of your gaze. She does not look, pretends she is not being looked at, and at the same moment we know very well that she knows. She is the one to be looked *at* without looking herself. The denial to look is also, by implication the denial of woman's access to the production of knowledge. One of Weston's friends touches upon the importance of photographic *work*, of instruments when he asks for 'spectacles to see as you do, scissors such as you use to cut prints'.[20]

At work in all this is the story of the Medusa, and the implication for the protective, fetishistic print are clear. Like the Medusa herself, the camera has the power to suspend movement, to arrest life, to cause a sort of death by freezing a moment in time.

The woman must not return the gaze, and Weston cannot turn the camera's gaze upon himself. It is hardly surprising to find that there are *no* self portraits. Weston keeps the symbolic register for himself. The Nude as a category is reserved solely for women (there are some of his sons but crucially before puberty.) We provide evidence of body, that natural, raw material which he will fashion into culture. Women are kept in the imaginary. How then can we begin to speak of the historically invisible, inaudible, the powerless; the position of women within patriarchal discourse? In psychoanalytic terms we are the 'nothing to be seen', or at best 'not all.' And yet the puzzle is not simply our exclusion from discourse but our very inclusion as both marginal (out of sight) and central (on display). As Mulvey states 'the paradox of phallocentrism is that the idea of (the) castrated woman stands as lynch-pin to the system.'[21]

There have been several feminist strategies in response to this problem. The first and the least interesting is the attempt to fill in some of the holes in the discourse; to paper over the cracks by inserting more women into the existing structure as phallic mothers who do not lack (honorary men). Such moves are largely a denial of sexual difference: a plea for access to the patriarchal structure: the most common result is to tack on a few more exhibitions or lectures on women photographers.

A second strategy is the refusal to contribute to patriarchal discourse: a rejection of the structure altogether as an attempt to build a specifically feminine discourse in opposition to patriarchy. This also poses problems. How can one know what that might be?

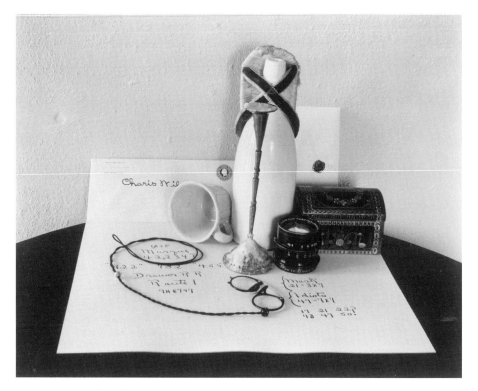

Figure 30.3 Edward Weston, *Valentine,* 1935. Courtesy of the Centre for Creative Photography. 'Like the Medusa the camera has the power to arrest life by 'freezing' a moment in time. Weston is therefore unable to turn the camera eye on himself. Only a symbolic self-portrait exists.'

The feminine is not the same as feminist. How can we be certain that it will not simply construct a parallel ideology where 'men' has been replaced by 'women'? The recent Barbara Kruger poster suggests to us that 'we don't need another hero', but it could equally have read 'we don't need another heroine'. The task at hand is to understand first and foremost how 'woman' (as a sign) functions within patriarchal discourse, and this task is one of dismantling. While we can hardly claim that the edifice of patriarchal (photographic) discourse lies in ruins, the 'cracks' are starting to appear. Structurally, its foundations can no longer be said to be sound.

Notes

1 Unless otherwise stated, all quotes are Weston's from N. Newhall (ed.), *The Day Books of Edward Weston,* vols. I & II, Aperture, 1973.
2 C. Beaton and G. Buckland, *The Magic Image,* Weidenfeld and Nicolson, 1975, p. 159.
3 C. Duncan, 'Virility and Domination in Early Twentieth Century Avant-garde Art', *Art Forum,* December 1973, p. 36.
4 E. Marks and I. De Courtivron (eds.), *New French Feminisms,* Harvester, 1980, p. 152.

5 S. Freud, 'Femininity', *New Introductory Lectures on Psychoanalysis*, Pelican Freud Library, vol. II, 1972 p. 149,

6 H. Frampton, 'Impromptus on Edward Weston, Everything in Its Place', *October no. 5*, 1978, p. 49.

7 N. Newhall (ed) op. cit., p. x.

8 C. Wilson, *Edward Weston Nudes; Aperture, 1977,* p. 115,

9 R. Coward, *Patriarchal Precedents*, Routledge and Kegan Paul, 1983, p. 1.

10 C. Metz, *Psychoanalysis and Cinema*, Macmillan, 1982, pp. 58–60.

11 F. Reyher (ed.), 'Stieglitz-Weston Correspondence', *Creative Camera*, October, 1975, p. 334.

12 C. Wilson, op. cit., p. 8.

13 F. Reyher (ed.), op, cit., p. 335. (It is also well known that it was Stieglitz who stressed the importance of 'straight' photography to Weston in 1922. '. . . a maximum of detail with a maximum of simplification, so Stieglitz talked to me and Jo (Hagemeyer) for hours', Weston File, MOMA, NY.

14 B. Newball, *Supreme Instants: The Photography of Edward Weston*, Thames and Hudson, 1986.

15 'Photography has long been considered a mass-production medium from the standpoint of unlimited duplication of prints . . . not the mass-production of duplicates, but the possibility for the mass-production of original work', Weston File, MOMA, NY.

16 For Weston, woman was still in the realm of the imaginary. 'I was meant to fulfil a *need* in many a woman's life as each in turn fertilises etc.', N. Newhall.

17 B. Maddow, 'Venus Beheaded: Weston and His Women', *New York Magazine*, February 24th, 1975.

18 H. Frampton, op. cit., p. 62.

19 ibid., p. 68.

20 N. Newhall (ed.), op. cit., vol. 1, p. 151.

21 L. Mulvey, 'Visual Pleasure and Narrative Cinema', *Screen*, vol. 16, no. 3, 1975, p. 6.

Jan Avgikos

CINDY SHERMAN
Burning down the house

CONSIDER THE MANY GENRES Cindy Sherman has developed in her photographs – film stills, fashion photos, fairy tales, art-historical portraiture, scenes of dummies deployed in sex acts. Consider, too, the critical discourses engaged in her work – deconstructive post-Modernism, the photograph's dialectic of absence and presence, theories of representation. Consistently, Sherman's photography is positioned in the convergence of discourses, rather than squarely in any one of them; and in that convergence, the feminist content of her work emerges. Like her rehearsal and performance of permutations (her)/self, of the many feminisms that have been read into her work mirror both shifts in feminist thinking over the years and the current, internecine struggles over sexuality and representation that are erupting within our communities.

Skirting the fray of clashing feminisms, many critics still disclose an entrenched resistance to the idea that Sherman's motifs and thematics are embedded in feminist theory rather than incidental to it – they still recast her gender polemics as a grand concert of 'human' (and 'human' always. means 'male') desire. But the cleansing of feminist commentary from Sherman's photography is symptomatic of the very problematics that her work addresses. For example, if we acknowledge femininity as a discursive construction, how can we authentically construe a feminine esthetics and identity apart from the patriarchal framework upon which they are grounded? Rather than assuming a given femininity, Sherman dislodges the operations that have historically defined and imposed the feminine as a social category. Indeed her latest schlock-shock images displaying the broken-down merchandise of a medical-supply house – plastic mannequins endowed with anatomically correct genitalia macabrely animated in pantomimes of sexual fantasy – are emphatically interventional. Hardly indemnified by political correctness, these grimly humorous vignettes deep-throat the politics of pornographic representation. Yet despite their fun-house horrors of freakish hermaphrodites, postmenopausal Medusas, and decapitated Herculeses, these peep show pictures never stay put as clever carnal cartoons,

or even as allegories of alienation. Instead, the seemingly minor questions they raise – Can photos be porn if they don't pass the 'wet test,' if, indeed, the bodies are plastic? – are inseparable from larger, more urgent ones: is the social economy of pornography different from that of art? Is porn antithetical to feminism? Do women see 'differently'?

By framing such questions as dependent on distinctions between artifice and the real (distinctions on which she has long staged her investigations), and by inscribing them within the pornographic, Sherman integrates female identity, representation, contamination, and taboo. By presenting images that ask what's OK, and what's not, in picture-making, fantasy, and sexual practice, she opens wide the Pandora's box that polarizes contemporary feminism. The women crouching as if in fear of discovery, and the plundered female bodies abandoned to vacant lots, in the earlier series, and now the titillating p.o.v. shots of dry, cold sex can only partially be explained by moralizings on the victimization of women in society. For the problems of oppression and objectification that surround pornography do not reside exclusively in the image, but in the very act of looking, in which we ascribe sexual difference.

When we look at photographs, it is through the eyes of the photographer, understood as occupying a masculine position, that we see. The implicit aggression of the photographic act – *aiming* the camera, *shooting* the picture – is literalized when the image examines the female body. In Sherman's photographs, however, active looking is through a woman's eyes, and this ambiguity makes them both seductive and confrontational. Sherman demarcates no privileged space for the female spectator per se, yet the role in which she casts us, as both viewer and subject, parallels the defamiliarizing effects of plastic dummies having real sex. Automatic scopophilic consumption, whether narcissistic or voyeuristic, is interrupted. By rendering the body problematic, and exposing what is conventionally hidden, Sherman infuses the desirous look with a sense of dread and dis-ease.

Sherman heightens the spectacle of the sexual act by isolating genital parts and coding them with fantasies of desire, possession, and imaginary knowledge. The instrumentality of these photographs lies in their tantalizing paradox: offering for scrutiny what is usually forbidden to sight, they appear to produce a knowledge of what sex looks like (hence Sherman's subtle humor in using medical dummies), but simultaneously are not real. The dummies diminish the sense of pliant flesh, distancing the spectator from the body, yet props such as luxurious fabrics focus sensuality. Positioned close to the picture plane, the models invite an intimate viewing relationship. And their placement in splayed, supine, or kneeling positions elicits a fantasy of sexual penetration, even though they are not real.

Many women feel that there is literally no place for them within the frame of porn. Perhaps the most extreme case against pornography is made by Andrea Dworkin, who holds 'pornographers' responsible for 'eroticizing inequality in a way that materially promotes rape, battery, maiming, and bondage' and for making a product 'that they know dehumanizes, degrades and exploits women.'[1] Would Sherman's photographs of dummies qualify as pornographic, even though they aren't 'real'? Actually, the 1986 report of the Meese Commission specifically links porn to what is unreal: it is 'representation' of sex that is the problem, not sex itself. To the writers of the report, as soon as sex is inscribed, as soon as it is made public rather than private, it changes in character, regardless of what variety of sex is portrayed.

The underlying logic, as Avital Ronell has remarked, is one of contagion, of 'exposing' people to a contaminant.[2] This is another way of stating the problem with mimesis: an imitation of reality produces the desire to imitate. It is 'representation' that contaminates, and from which women must be protected. The irony is that woman herself has long been identified with the problems of mimesis, representation, and contamination. And when it comes down to it, we know that what censorship really protects is the so-called majority's self-image of normalcy, and that woman, as Ronell observes, is merely a symptom of the law. We know, too, in Pat Califia's words, that within the narrow range of acceptable sexual behavior, nobody comes out looking normal once you know how they fuck and what they think about when they're doing it, and that the totalitarian insistence on sexual uniformity does hidden violence to all us dissidents and perverts, making us ugly before we have even seen ourselves.[3] Still, even for us, Sherman's images have enormous disruptive power.

Although strident compared to the docile female stereotypes of the 'Film Stills,' 1977–80, the deranged female creatures of the earlier fairy tales and mutilation series of the mid-to-late 1980s, while sometimes intimating the possession of secret powers, are nonetheless the offspring of earlier Sherman women suspended in passive states of waiting, longing, and abandonment. The current series shows what those women have gotten up to, so to speak, when left to their own dark fantasies. One mannequin willingly lifts her rear end, presumably for a spanking with the nearby hairbrush. Another spreads her cunt wide open to some form of penetration – wide enough for a fist. The implication of S/M practice, sex with inanimate objects, fascination with the perverse, and transgression of the 'nice girls don't – and feminists certainly don't' injunction are all personified by a glowering Medusa/whore/Venus/Olympia, who menacingly displays her startling red-foam vagina, the invitation promising pleasure for herself alone.

In the 1960s and 1970s, women using their bodies as subject and site of their art tended to explore feminine identity in relation to nature. Carolee Schneemann, Mary Beth Edelson, Ana Mendieta, and others displayed their sexuality as both natural and empowering. The problem, then as now, is the assumption that we were ever goddesses in the Garden, or, for that matter, that there is a pure state of nature to get back to, a state prior to our contamination by language, or representation, or law. The desire for an 'uncontaminated' expression of female sexuality appears in other guises today, particularly by women who seek to make 'sex-positive' pornographic images that in effect project backward to nature and purity. In adapting pornography for female audiences, this clean-up operation rejects the 'demoralizing' impurity of the excremental, the improper, the dangerous and disgusting.

Sherman's representation of female sexuality, in contrast, indulges the desire to see, to make sure of the private and the forbidden, but withholds both narcissistic identification with the female body and that body's objectification as the basis for erotic pleasure. Her mechanisms of arousal – rubbery tits, plastic pussies, assorted asses, dicks, and dildos – may deceive momentarily, but finally defeat the proprietary gaze of the spectator, whose desire can only partially be satisfied by the spectacle of artificial flesh. The convergence that Sherman establishes between female identity and artifice, desire, and disgust has been widely interpreted. Some

see her sullying of the female form as an argument against the clichés of traditional feminine glamour. Others see it as a pedagogy against violent masculine sexuality, and against images that may incite male aggression. And the idea of the instability of female identity – long a fascination of psychoanalytic theory – has been invoked to suggest that Sherman is ambivalent about her own womanhood.

All of these readings are too simple in isolation; the last of them misinterprets the function of the frame as one that absorbs Sherman herself. From this it is construed that because woman ('Cindy Sherman') is distinguished only by her lack, she can only abhor herself. This argument fails to take into account Sherman's control as director and producer of her own visual dramas. Fantasies of sexual perversion are forever getting confused with real life, but rarely so simplistically. Sherman's porn pictures express no blanket female self-hatred; rather, they engage the age-old designation of woman as essentially monstrous. More specifically, it is not just woman's identity (which, insofar as it is taken to be artificial and unstable, is sensed as antithetical to the rule of law) that is alarming, but her genitals, which emit the smell of death.

Look again at Sherman's images: the 'diseased' cunt, alarmingly red, flayed, unsavory; the severed female torso 'contaminated' by menstrual blood; the frightening Medusa/Olympia whose vagina excretes intestinal or phallic sausages; the doll whose vagina and anus merge into a dark, yawning emptiness. And look, too, at the photographer's enthusiasm for framing female perversity – at her will to disrupt. Sherman portrays no naive notion of pleasurability or purity: her images luxuriate in desire and disgust, which, as Georges Bataille reminds us, are inextricably linked. Marking her bodies as monstrous, she kills all nostalgia for an original state of things – whether the 'original' is identified with respect to distinctions between female and male desire, or is symptomatic of woman's fundamental and a priori 'lack.'

An interlocking network of fetishism and mutilation (a figure of castration) constellates around the body, multiplying the terror and situating the work more insistently in the locale of horror than of erotica. If the images evoke castration anxiety, what is their effect on the woman spectator, who, presumably, cannot lose what she never had? Metaphorically, they represent what is typically displaced, sublimated, or repressed. Sherman's pictures, in fact, flaunt accoutrements immediately suggestive of fetishism. An eroticism ridden with menace is her lure, and artifice her entrapment and dis-ease. In the register of nightmare, the impulse to debase and violate parallels the impulse to worship and adore.

Hélène Cixous insists that women should mobilize the force of hysteria to break up continuities and create horror. This is not to hark back to some 'natural' state – an effort that masks woman's censored hysteria as though it were an unwelcome disease – or to fall into some other form of 'political correctness,' and the guilt and repressed desire that it triggers. For some, Sherman's displacement of sex to a cartoon level may signal an area in which issues can be investigated from a position of safety. Yet the ugliness and hard-core explicitness of her pictures, part of a politics of demasking, also function on a political level – particularly with respect to feminism. Rather than making a 'sex-positive,' Edenic retreat from that which we think we should not think or do, Sherman complicates libidinal desire. There is nothing fake at all about her vision.

Notes

1 Andrea Dworkin, letter to the editor, *The New York Times Book Review*, 3 May 1992, p. 15.
2 See Avital Ronell, interviewed by Andrea Juno, *Angry Women*, San Francisco: Re/Search Publications, 1991, pp. 127–53
3 Pat Califia, *Macho Sluts*, Boston: Alyson Publications, Inc., 1988, p. 16.

Lucy R. Lippard

DOUBLETAKE
The diary of a relationship with an image

First take

> Sam[p]son Beaver and his Family. This lovely photograph of Stoney
> Indian Sam[p]son Beaver was taken by Mary Schäffer in 1906. She was
> a writer, naturalist, photographer and explorer who lived and worked
> in the Rockies for many years. Mary Schäffer is one of several notable
> women who visited the area early in the century and fell captive to the
> charm of the mountains.
>
> <div align="right">(Postcard caption)</div>

I AM SURPRISED BY THIS PHOTOGRAPH (Fig. 32.1), which seems so
unlike the conventional images I've seen of Native people *taken* by white people.
It is simple enough – a man and woman are smiling warmly at the photographer,
while their little girl smirks proudly. The parents are seated comfortably on the
ground, the man with his legs crossed, the woman perhaps kneeling. The child
stands between them, closer to her father, holding a bouquet of leaves. Behind them
are signs of early spring – a tree in leaf, others still bare-branched.

I'm trying to deconstruct my deep attraction to this quiet little picture. I have
been mesmerized by these faces since the postcard was sent to me last month by a
friend, a Native Canadian painter and curator, who found it in a taxidermy and
Indian shop (he was bemused by that conjunction). Or maybe I am mesmerized by
the three cultural spaces that exist between the Beaver family and Mary Schäffer
and me.

They are not vast spaces, although we are separated at the moment by a conti-
nent, national borders, and eighty-some years. They consist of the then-present space
of the subjects, the then-present but perhaps very different space of the photog-
rapher, and the now-present space of the writer, in retrospect, as a surrogate for
contemporary viewers. Or perhaps there are only two spaces: the relationship

between photographer and subjects then, and between me and us – and the photograph – now. I wonder where these spaces converge. Maybe only on this page.

Good photography can *embody* what has been seen. As I scrutinize it, this photograph becomes the people photographed – not 'flat death' as Roland Barthes would have it, but flat life. This one-way (and admittedly romantic) relationship is mediated by the presence and absence of Mary Schäffer, who haunts the threshold of the encounter. I am borrowing her space, that diminished space between her and the Beaver family. She has made a frontal (though not a confrontational) image, bringing her subjects visually to the foreground, into the area of potential intimacy. The effect is heightened by the photograph's remarkable contemporaneity, the crisp presentness that delivers this image from the blatant anthropological distancing evident in most photographs of the period. The Beavers' relaxed poses and friendly, unself-conscious expressions might be those of a contemporary snapshot, except for the high quality of the print. At the same time they have been freed from the ethnographic present – the patronizing frame that freezes personal and social specifics into generalization, and is usually described from a neutral and anonymous third-person perspective. They are present in part because of their impressive personal presence. A certain synchronism is suggested, the 'extended present' or eternal present cited by, among others, N. Scott Momaday.

What would happen to the West, Johannes Fabian has mused, 'if its temporal fortress were suddenly invaded by the Time of its Other.'[1] I think I have been invaded: I feel as though I know these people. Sampson Beaver and his wife seem more familiar than the stiff-backed, blank-faced pictures of my own great grandparents, the two pairs who went West in the 1870s, among those pushing their way into others' centers from the eastern margins of the continent.[2] Two years ago, while I was despairing of ever finding the structure for a book about the cross-cultural process, I dreamed I was climbing a vast grassy hill toward a weather-beaten wooden cabin at the top; on the steps sat a row of Native people who were silently encouraging me to keep going. Although they were elderly, the expressions on their faces were those of the Beaver family in this photograph.

As I begin, I'm also looking at this triple portrait cut loose from all knowledge of the people involved – an aspect that normally would have informed much of my own position. With only the postcard caption to go on, my response is not neutral but wholly subjective. I'm aware that writing about a white woman photographing Native people is a kind of metaphor for my own position as an Anglo critic trying to write about contemporary Native North American art. I'd rather be Mary Schäffer, a courageous woman in long skirts, who seems to be trusted by this attractive couple and their sweetly sassy child. How did she find her way past the barriers of turn-of-the-century barbarism to receive these serene smiles? And I want to be Sampson Beaver and his (unnamed) wife, who are so at home where they are, who appear content, at least in this spring moment.

Second take

I showed the picture and my diary to a friend, who said she was convinced that the real relationship portrayed was between the photographer and the child, that the

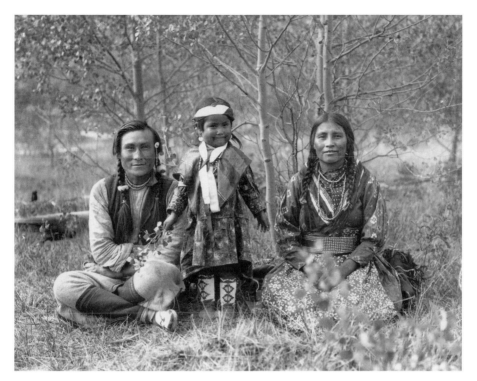

Figure 32.1 Mary Schäffer, *Sampson Beaver, Leah Beaver, and baby Frances Louise*, postcard, 1906. Photo courtesy of the Whyte Museum of the Canadian Rockies, Banff, Alberta.

parents liked Schäffer because she had made friends with their little girl. Certainly the photograph implies a dialogue, an exchange, an I/eye (the photographer) and a You (her subjects, and we the viewers, if the photographer would emerge from beneath her black cloth and turn to look back at us). At the same time, the invisible (unknowable) autobiographical component, the viewpoint provided by the invisible photographer, the 'writer, naturalist, explorer, who lived and worked in the Rockies for many years,' is another factor that shaped what is visible here. I have written to the Whyte Museum of the Canadian Rockies in Banff for information about her.

The cultural abyss that had to exist in 1906 between the Beaver family and Mary Schäffer was (though burdened by political circumstances and colonial conditioning) at least intellectually unself-conscious. It may have been further diminished by what I perceive (or project) as the friendly relationship between them. The time and cultural space that usually distances me – self-consciously, but involuntarily – from historic representations of Another also is lessened here. Schäffer's photograph lacks the rhetorical exposure of authenticity. But neither are the Beavers universalized into oblivion as just folks. Their portrait is devoid of cuteness, and yet it has great charm – in the magical sense. It is only secondarily quaint, despite the inevitable but thin veneer of picturesqueness (totally aside from the subject matter: exotic Native people) imposed by the passage of historical time and the interval implied by the dress of almost ninety years ago. This is not, however, the Edward Curtis

view of the Noble Savage, staring moodily into the misty past or facing the camera forced upon him or her with the wariness and hostility that has been appropriated by the cliché of 'dignity.'

It is now common knowledge that one of the hegemonic devices of colonialism (postcolonialism is hardly free of it either) has been to isolate the Other in another time, a time that also becomes another place – The Past – even when the chronological time is the present. Like racism, this is a habit hard to kick even when it is recognized. Schäffer's photograph is a microcosmic triumph for social equality as expressed through representation. The discontinuity and disjunctiveness that usually characterize cross-cultural experience are translated here into a certain harmony – or the illusion thereof. This is a sympathetic photograph, but it is not, nor could it be, empathetic. (Is it possible to honestly perceive such a scene as idyllic, within the knowledge of such a dystopian social context?) The three figures, despite their smiles and amicable, knowing expressions, remain the objects of our eyes. We are simply lucky that this open, intelligent gaze has passed into history as alternative evidence of the encounter between Native and European, of the maintenance of some human interaction in the midst or aftermath of exploitation and genocide.

The Beavers' portrait seems a classic visualization of what anthropologists call 'intersubjective time.' It commemorates a reciprocal moment (rather than a cannibalistic one) where the emphasis is on interaction and communication, a moment in which subject and object are caught in exchange within shared time rather than shouting across history from their respective peaks. The enculturated distance between photographer and photographed, between white and Native, has somehow been momentarily bridged to such an extent that the bridge extends over time to me, to us, almost a century later.

This is the kind of photograph I often have used as an example of the difference between images taken by someone from within a community and by an outsider. I would have put it in the former category. However, it was not taken by a Stoney, but by an adventurous white lady passing through the Northern Rockies, possibly on the quest for self (or loss of self) in relation to Other and Nature that has been a major theme in North American culture.

The Beaver family (I wish I knew the woman's and child's names) is clearly among friends, but the picture might still have been very different if taken by a Native insider. Of course we have no way to know what that image might have been. Photography, loaded with historical stigmas, has only recently become an accepted art form among Indian peoples; there are not many Native photographers working as artists even today. This has been explained from within the communities as a response to past abuses. Photography has been a tool by which to exploit and disarm, to document the disappearance of Indian nations, keep them in their place in the past, and make them objects of study and contemplation: 'Government surveyors, priests, tourists, and white photographers were all yearning for the "noble savage" dressed in full regalia, looking stoic and posing like Cybis statues. . . . We cannot identify with these images;' wrote Flathead Jaune Quick-to-See Smith, in her text for the first national Native American photography exhibition in 1984.[3] The press release from the American Indian Community House Gallery in New York also set out some distinctions between works of nonIndian and these Indian photographers, among them: 'These photos are not the universal images of

Indians. They are not heroic, noble, stoic or romantic. What they do show is human warmth and an intimacy with their subject. . . .' This is the feeling I get from the Beavers' portrait. Am I just kidding myself or overidentifying with Mary Schäffer?

Another explanation for the avoidance of photography raises old taboos – the photos-steal-your-spirit-syndrome, which is not, in fact, so far off in this situation. The more we know about representation, the more obvious it becomes that photography *is* often a spirit snatcher. I *own* a postcard that permits me to have the Beaver family *living* in my house. The Oglala warrior, Crazy Horse, never allowed his photograph to be taken, and it was said of those leaders who did that 'they let their spirits be captured in a box' and lost the impetus to resistance. Contemporary American Indian Movement leader Russell Means has described the introduction of writing into oral traditions as a destructive 'abstraction over the spoken relationship of a people?'[4] The camera was another weapon in the wars of domination. As Dennis Grady observes,

> . . . how fitting it must have seemed to the victims of that process – the natives of North America, whose idea of 'vision' is as spiritual as it is physical – when the white man produced from his baggage a box that had the power to transcribe the world onto a flat paper plane. Here was a machine that could make of this landscape a surface; of this territory, a map; of this man, this woman, this living child, a framed, hand-held, negotiable object to be looked at, traded, possessed; the perfect tool for the work of the 'wasi'chu,' the greedy one who takes the fat.[5]

Our communal memory of Native people on this continent has been projected through the above-mentioned stoic (numb is a better term), wary, pained, resigned, belligerent, and occasionally pathetic faces shot by nineteenth- and early-twentieth-century photographers like Edward Curtis, Edward Vroman, and Roland W. Reed – all men. Looking through a group of portraits of Indians from that period, I found one (*Indian with Feather Bonnet,* c. 1898) in which the expression was less grim, more eye-to-eye – the photographer was Gertrude Käsebier. The photographs by Kate Cory, a 'midwestern spinster' who came to Arizona at age 44, taken in the Hopi village where she lived from 1905 to 1912, also diverge from the general pattern, as do some of Laura Gilpin's works.[6] All of this suggests an empathetic relationship between race and gender lurking in this subject, though I can't explore it here.

Of course Mary Schäffer, although a woman and thereby also, though divergently, disenfranchised, was at least indirectly allied with the oppressors. She may have been an innocent vehicle of her culture and her times. She may have been a rebel and independent of some of its crueler manifestations. Although it is more likely that she was oblivious to anthropological scholarship, she might have known about the then-new comparative method, which permitted the *equal* treatment of human culture in all times and in all places (but failed to overturn the edifice of Otherness built by previous disciplines). She may have been an enthusiastic perpetrator of expansionism.

Perhaps this photograph was already tinged with propaganda even at the time it was taken. Perhaps Mary Schäffer herself had an axe to grind. She may have been concerned to show her audience (and who were *they?*) that the only good Indian

was not a dead Indian. Perhaps this portrait is the kind of advocacy image we find in the production of Leftist photographers working in Nicaragua. The knowledgeable, sympathetic tourist is not always immune to cultural imperialism. I wonder if Mary Schäffer, like so many progressive photographers working in poorer neighborhoods and countries, gave her subjects a print of this photograph. Was it their first, their only image of themselves? Or the first that had not disappeared with the photographer? Is a curling copy of this picture given a place of honor in some family photo album or on the wall of some descendant's house?

I'm overpersonalizing the depicted encounter. To offset my emotional attraction to this image, let me imagine that Schäffer was a flag-waving imperialist and try to read this image – or my responses to this image – in a mirror, as though I had taken an immediate dislike to it. Can I avoid that warm gaze and see in these three figures an illustration of all the colonial perfidy that provides its historical backdrop? Do Sampson Beaver and his family look helpless and victimized? They are handsome, healthy people, perhaps chosen to demonstrate that Indians were being treated well. They are seated on the ground, perhaps placed there because the photographer was influenced by stereotypical representations of the 'primitive's' closeness to the earth, to nature. The woman is placed at a small distance from her husband and child, like a servant. They are smiling; perhaps Schäffer has offered the child a treat, or the adults some favor. Nevertheless, it is hard to see these smiles as solely money-bought.

A virtual class system exists among the common representations of an Indian family from this period: the lost, miserable, huddled group outside a hut; the businesslike document of a neutrally ordinary family next to a tepee; or the proud, noble holdouts in a grand landscape, highlighted by giant trees or dramatic mesas. For all the separations inherent in such images, there is no such thing as objectivity or neutrality in portrait photography. Personal interaction of *some* kind is necessary to create the context within the larger frame of historical events. The Schäffer photo too is posed. And the pose is an imposition since Native people had no traditional way of sitting for a portrait or a photograph; self-representation in that sense was not part of the culture. But at least the Beaver family is not sitting bolt upright in wooden chairs; Sampson Beaver is not standing patriarchally with his hand on his wife's shoulder while the child is properly subdued below. Man and wife are comfortable and equal as they smile at the black box confronting them, and the little girl's expression is familiar to anyone who has spent time with little girls.

Today I received some scraps of information about the Stoney Indians (an anglicization of the word Assine, meaning stone), who were Assiniboine, offshoots of the Sioux. They called themselves Nakodah, and reached the foothills of the Rockies in the eighteenth century, fleeing smallpox epidemics. With the arrival of settlers and the founding of Banff, the Stoneys were forced into a life of relatively peaceful interaction with townspeople. In the late-nineteenth century, Banff was already a flourishing tourist town, boasting a spa and the annual 'Indian Days' powwow, begun in 1889. The Whyte Museum there has a massive archive of photographs of the Native people of the Rockies, (including this one and one of Ginger Rogers, on vacation, sketching Chief Jacob Twoyoungman in a Plains headdress). Eventually forced to live off of tourism, the Stoneys were exploited but not embattled. And Mary Schäffer, for all her credentials, was a tourist herself.

Indians were the photogenic turn-of-the century counterparts of today's look-outs – roadside scenic vistas: ready-made views; nature viewed from a static culture. The role of photography in tourism (or as tourism) started early. 'What looks to us today like a serious documentary photograph may just be the equivalent of *National Geographic* voyeurism, or a color print of a New York City homeless person taken for the folks at home. The egalitarianism (intentional or not) of Schäffer's photograph may have irritated her audience, at least those Back East, where exaggeration and idealization of the *savage* reigned unchecked. Even today, when Indians wear rubber boots or sneakers at ceremonial dances, or an Apache puberty ritual includes six-packs of soda among the offerings, tourists and purists tend to be offended. Such anachronisms destroy the time-honored distance between Them and Us, the illusion that They live in different times than We do. Anachronisms also may be somewhat threatening to Our peace of mind, recalling how They got there, were put there, in a space that is separated from Us by the barbed wire of what has been called 'absentee colonialism?'

But how did *we* get There – off-center – to the places where we are face to face with those who do not apparently resemble us? Johannes Fabian distinguishes between historic religious travel '*to* the centers of religion or *to* the souls to be saved' and today's secular travel '*from* the centers of learning and power to places where man was to find nothing but himself.'[7] The Sioux visionary, Black Elk, like the Irish, says that anywhere can be the center of the world. We the conquerors have not thought so. We travel to the margins to fulfill some part of us that is marginal to our own culture but is becoming increasingly, embarrassingly, central.

Once at the margins, we are not welcomed with open arms. At dances we gawk or smile shyly at the Indian people hurrying by, and they ignore us, or are politely aloof when spoken to, so long as we behave ourselves. They don't need us, but we, somehow, paradoxically, need them. We need to take images away from these encounters, to take Them with Us. According to Dean MacCannell, tourists are trying to 'discover or reconstruct a cultural heritage or a social identity. . . . Sightseeing is a ritual performed to the differentiations of society.'[8] The same might be said of photography itself. As the ultimate invasion of social, religious, and individual privacy, it is still banned by many pueblos and reservations.

Last take

The books I'd ordered from Banff have finally arrived. I dove into them and of course had to revise some of my notions.

The Beaver family photograph was taken in 1907, not 1906; not in early spring, but in late September, as Schäffer was completing a four-month expedition to the sources of the Saskatchewan River. Having just crossed two turbulent rivers, she and her companions reached the 'Golden Kootenai Plains' (the Katoonda or Windy Plains), and weaving in and out of yellowing poplars, they:

> spied two tepees nestled deep among the trees. . . . I have seen not one but many of their camps and seldom or never have they failed to be artistic in their setting, and this one was no exception. Knowing they

must be Silas Abraham's and Sampson Beaver's families, acquaintances of a year's standing, I could not resist a hurried call. The children spied us first, and tumbling head over heels, ran to cover like rabbits. . . . above the din and excitement I called, 'Frances Louise!' She had been my little favorite when last we were among the Indians, accepting my advances with a sweet baby womanliness quite unlike the other children, for which I had rewarded her by presenting her with a doll I had constructed . . . love blinded the little mother's eyes to any imperfections, and the gift gave me a spot of my own in the memory of the forest baby. . . . In an instant her little face appeared at the tepee-flap, just as solemn, just as sweet, and just as dirty as ever.[9]

It was this group of Stoneys, members of the Wesley Band, who the previous year had given Schäffer her Indian name – Yahe-Weha, Mountain Woman. Banned from hunting in the National Parks, they were still able to hunt, trap, and live beyond their boundaries. In 1907 she remained with them for four days. 'When I hear those "who know" speak of the sullen, stupid Indian,' she wrote,

I wish they could have been on hand the afternoon the white squaws visited the red ones with their cameras. There were no men to disturb the peace, the women quickly caught our ideas, entered the spirit of the game, and with musical laughter and little giggles, allowed themselves to be hauled about and pushed and posed in a fashion to turn an artist green with envy. . . . Yahe-Weha might photograph to her heart's content. She had promised pictures the year before, she had kept the promise, and she might have as many photographs now as she wanted.'[10]

Sampson Beaver's wife, Leah, was no doubt among the women that afternoon. He was thirty years old at the time, and she looks around the same age. In the language of the tourist, Schäffer described him crouching to light his pipe at a campfire:

his swarthy face lighted up by the bright glow, his brass earrings and nail-studded belt catching the glare, with long black plaits of glossy hair and his blanket breeches . . .[11]

It was Sampson Beaver who then gave Schäffer one of the great gifts of her life – a map of how to reach the legendary Maligne Lake, which she had hitherto sought unsuccessfully – thereby repaying his daughter's friend many times over. He drew it from memory of a trip sixteen years before – in symbols, 'mountains, streams, and passes all included.' The next year Schäffer, her friend Mollie Adams, 'Chief' Warren, her young guide whom she later married, and 'K' Unwin followed the accurate map and became the first white people to document the shores of Chaba Imne (Beaver Lake), ungratefully renamed Maligne for the dangerous river it feeds. In 1911 she returned to survey the lake and its environs, which lie in what is now Jasper National Park.

Mary Sharples Schäffer Warren (1861–1939) was not a Canadian but a Philadelphian, from a wealthy Quaker family. Her father was a businessman and

gentleman farmer as well as an avid mineralogist. She became an amateur naturalist as a child and studied botany as a painter. In 1894 she married Dr. Charles Schäffer, a respected, and much older, doctor whose passion was botany and with whom she worked as an illustrator and photographer until his death in 1903. After completing and publishing his *Alpine Flora of the Canadian Rocky Mountains,* she conquered her fear of horses, bears, and the wilderness, and began her lengthy exploring expeditions, going on horseback with pack train deep into the then-mostly uncharted wilderness for months at a time.

Schäffer's interest in Indians and the West had been awakened when as a small child she overheard her Cousin Jim, an army officer, telling her parents about the destruction of an Indian village in which women and children were massacred; afterwards, he had found a live baby sheltered by the mother's dead body. This story made a profound impression on Mary, and she became obsessed with Indians. In her mid-teens she took her first trip west, met Native people for the first time, and became an inveterate traveler. The Canadian Rockies were her husband's botanical turf, and for the rest of her life Schäffer spent summers on the trails there, photographing, writing, and exploring. She finally moved to Banff and died there.

When Schäffer and Mollie Adams decided to take their plunge into the wilderness, it was unprecedented, and improper, for women to encroach on this steadfastly male territory. However, as Schäffer recalled,

> . . . there are times when the horizon seems restricted, and we seemed to have reached that horizon, and the limit of all endurance – to sit with folded hands and listen calmly to the stories of the hills we so longed to see, the hills which had lured and beckoned us for years before this long list of men had ever set foot in the country. Our cups splashed over. We looked into each other's eyes and said: 'Why not? We can starve as well as they; the muskeg will be no softer for us than for them . . . the waters no deeper to swim, nor the bath colder if we fall in,' – so – we planned a trip.[12]

These and many other hardships and exhilarations they did endure, loving almost every minute of it, and documenting their experiences with their (often ineptly hand-colored) photographs of giant peaks, vast rivers, glaciers, and fields of wildflowers. When they were returning from the 1907 expedition, they passed a stranger on the trail near Lake Louise who later wrote:

> As we drove along the narrow hill road a piebald pack-pony with a china-blue eye came round a bend, followed by two women, blackhaired, bare-headed, wearing beadwork squaw jackets and riding straddle. A string of pack-ponies trotted through the pines behind them.
> 'Indians on the move?' said I. 'How characteristic!'
> As the women jolted by, one of them very slightly turned her eyes and they were, past any doubt, the comprehending equal eyes of the civilized white woman which moved in that berry-brown face. . . .
> The same evening, in a hotel of all the luxuries, a slight woman in a very pretty evening frock was turning over photographs, and the eyes

beneath the strictly arranged hair were the eyes of the woman in the beadwork who had quirted the piebald pack-pony past our buggy.[13]

The author of this photographic colonial encounter was, ironically, Rudyard Kipling.

As Claude Lévi-Strauss has pointed out, the notion of travel is thoroughly corrupted by power. Mary Schäffer, for all her love of the wilderness, which she constantly called her 'playground,' was not free from the sense of power that came with being a prosperous modern person at play in the fields of the conquered. At the same time, she also expressed a very modern sense of melancholy and loss as she watched the railroad, which she called a 'python,' and ensuing civilization inching its way into her beloved landscape. More than her photographs, her journals betray a colonial lens. She is condescendingly fond but not very respectful of the 'savages,' bemoaning their unpleasantly crude and hard traditional life. In 1911 for instance, her party passed 'a Cree village where, when we tried to photograph the untidy spot, the inhabitants scuttled like rabbits to their holes.' In 1907 on the same golden Kootenai Plains where she took the Beavers' portrait, their camp was visited by 'old Paul Beaver' (presumably a relative of her darling Frances Louise). He eyed their simmering supper 'greedily,' but

> our provisions were reaching that point where it was dangerous to invite any guests, especially Indians, to a meal, so we downed all hospitable inclinations and without a qualm watched him ride away on his handsome buckskin just as darkness was falling.[14]

Despite years of critical analysis, seeing is still believing to some extent – as those who control the dominant culture (and those who ban it from Native contexts) know all too well. In works like this one, some of the barriers are down, or invisible, and we have the illusion of seeing for ourselves, the way we never *would* see for ourselves, which is what communication is about.

For all its socially enforced static quality, and for all I've read into it, Mary Schäffer's photograph of Sampson, Leah, and Frances Louise Beaver is merely the image of an ephemeral moment. I am first and foremost touched by its peace and freshness. I can feel the ground and grass warm and damp beneath the people sitting here in an Indian Summer, after disaster had struck but before almost all was lost. As viewers of this image eighty-four years later, on the verge of the quincentennial of Columbus's accidental invasion of the Americas, we can only relate our responses in terms of what we know. And as a nation we don't know enough.

Notes

1 Johannes Fabian, *Time and the Other: How Anthropology Makes Its Object* (New York: Columbia University Press, 1983), 35.
2 Frank Isham – teacher, businessman, dairy farmer, mining engineer, ranch foreman, and my great grandfather – built a little wooden schoolhouse in Dakota Territory. I have a photograph of it – bleak, unpeopled, rising from the plains as a rude reminder

of all the unholy teaching to come. Frank and Mary Rowland Isham had their sod house burned out from under them by a 'half breed' who didn't like the way they treated him.

3 Jaune Quick-To-See Smith, (Introduction), *Contemporary Native American Photography*, traveling exhibition by the U.S. Department of the Interior and Indian Arts and Crafts Board, 1984. Originated at the Southern Plains Indian Museum and Crafts Center, January 29 to March 23,1984.

4 Russell Means, 'The Same Old Song,' in Ward Churchill, ed., *Marxism and Native Americans* (Boston: South End Press, 1983), 19.

5 Dennis Grady, 'The Devolutionary Image: Toward a Photography of Liberation,' *San Francisco Camerawork*, 16, (Summer and Fall 1989), 28.

6 In 1989, Lilly and Grant Benally, members of the Navajo Nation, won a suit against the Amon Carter Museum in Texas for the frequent public (and publicity) use of a Laura Gilpin photograph called *Navaho Madonna*, taken in 1932. The court recognized that public use of a personal photograph could be offensive and the Navajos believe that 'bad effects' could result from being photographed. *The New Mexican*, June 10, 1989.

7 Fabian, *Time and the Other*, 6.

8 Dean MacCannell, *The Tourist: A New Theory of the Leisure Class* (New York: Schocken Books, 1989), 13.

9 E.J. Hart, ed., *Hunter of Peace: Mary T.S. Schäffer's Old Indian Trials of the Canadian Rockies* (Banff: Whyte Museum, 1980), 70.

10 Ibid., 71.

11 Ibid., 72.

12 Ibid., 17.

13 Ibid., 2.

14 Ibid., 69.

Catherine Lutz and Jane Collins

THE PHOTOGRAPH AS AN INTERSECTION OF GAZES
The example of *National Geographic*

ALL PHOTOGRAPHS TELL STORIES about looking. As part of a larger project to examine the *National Geographic* magazine's photographs as cultural artifacts from a changing twentieth century American scene, we have been struck by the variety of looks and looking relations that swirl in and around them.[1] These looks – whether from the photographer, the reader, or the person photographed – are ambiguous, charged with feeling and power, and are central to the stories (sometimes several and conflicting) that the photo can be said to tell. By examining the 'lines of sight' evident in the *Geographic* photograph of the 'non-Westerner,' we can see that it is not simply a captured view of the other, but rather a dynamic site at which many gazes or viewpoints intersect. This intersection creates a complex and multi-dimensional object; it allows viewers of the photo to negotiate a number of different identities both for themselves and for those pictured; and it is one route by which the photograph threatens to break frame and reveal its social context. Some of the issues raised in this chapter are particular to this specific genre of photograph while many others illuminate photographic interpretation more generally.

We aim here to explore the significance of 'gaze' for intercultural relations in the photograph and to present a typology of seven kinds of gaze that can be found in the photograph and its social context. These include (1) the photographer's gaze (the actual look through the viewfinder), (2) the institutional, magazine gaze (evident in cropping picture choice, captioning, etc.), (3) the readers' gaze, (4) the non-Western subjects' gaze, (5) the explicit looking done by Westerners who are often framed together with locals in the picture, (6) the gaze returned or refracted by the mirrors or cameras that are shown, in a surprising number of photographs, in local hands, and (7) our own, academic gaze.

[. . .]

A multitude of gazes

Many gazes can be found in any photograph in the *National Geographic*. This is true whether the picture shows a landscape devoid of people; a single person looking straight at the camera; a large group of people, each looking in a different direction but none at the camera; or a person in the distance whose eyes are tiny or out of focus. In other words, the gaze is not simply the look given by or to a photographed subject. It includes seven types of gaze.[2]

The photographer's gaze

This gaze, represented by the camera's eye, leaves its clear mark on the structure and content of the photograph. Independently or constrained by others, the photographer takes a position on a rooftop overlooking Khartoum or inside a Ulithian menstrual hut or in front of a funeral parade in Vietnam. Photo subject matter, composition, vantage point (angle or point of view), sharpness and depth of focus, color balance, framing and other elements of style are the result of the viewing choices made by the photographer or by the invitations or exclusions of those being photographed (Geary 1988).

Sontag argues that photographers are usually profoundly alienated from the people they photograph and may 'feel compelled to put the camera between themselves and whatever is remarkable that they encounter' (1977: 10). *Geographic* photographers, despite an often expressed and fundamental sympathy with the third world people they meet, confront them across the distances of class, race, and sometimes gender. Whether from a fear of these differences or the more primordial (per Lacan) insecurity of the gaze itself, the photographer can often make the choice to insert technique between self and his or her subjects, as can the social scientist (Devereux 1967).

Under most circumstances, the photographer's gaze and the viewer's gaze overlap. The photographer may treat the camera as simply a conduit for the reader's look, the 'searchlight' (Metz 1985) of his/her vision. Though these two looks can be disentangled, the technology and conventions of photography force the reader to follow that eye and see the world from its position.[3] The implications of this fact can be illustrated with a photo that shows a Venezuelan miner selling the diamonds he has just prospected to a middleman (August 1976; see Fig. 33.1). To take his picture, the photographer has stood inside the broker's place of business, shooting out over his back and shoulder to capture the face and hands of the miner as he exchanges his diamonds for cash. The viewer is strongly encouraged to share the photographer's interest in the miner, rather than the broker (whose absent gaze may be more available for substitution with the viewer's than is the miner's), and to in fact identify with the broker from whose relative position the shot has been taken and received. The broker, like the North American reader, stands outside the frontier mining world. Alternative readings of this photograph are, of course, possible; the visibility of the miner's gaze may make identification with him and his precarious position more likely. Ultimately what is important here is the question of how a diverse set of readers respond to such points-of-view in a photograph.

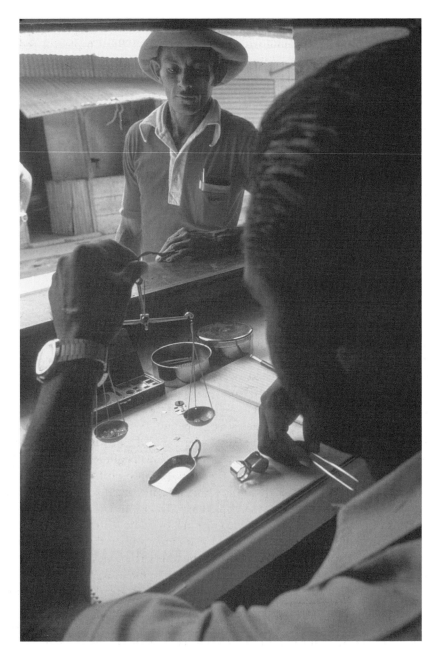

Figure 33.1 Photo: Robert Madden © National Geographic Society

The gaze of the camera is not always exactly the same as the gaze of the viewer, but in most *National Geographic* photographs the former structures the latter in powerful ways. In this August 1976 photograph of a Venezuelan diamond transaction, the viewer is strongly encouraged to share the photographer's interest in the miner rather than in the broker.

The magazine's gaze

This is the whole institutional process by which some portion of the photographer's gaze is chosen for use and emphasis (Lutz and Collins 1993: Chapters 2 and 3). It includes (1) the editor's decision to commission articles on particular locations or issues; (2) the editor's choice of a small number of pictures from the voluminous number (11,000 on an average assignment) the photographer has taken; and, (3) the editor's and layout designer's decisions about cropping the picture, arranging it with other photos on the page to bring out the desired meanings, reproducing it in a certain size format to emphasize or downplay its importance, or even altering the picture. The reader, of course, cannot determine whether decisions relating to the last two choices are made by editor or photographer. The magazine's gaze is more evident and accessible in (4) the caption writer's verbal fixing of a vantage on the picture's meaning. This gaze is also multiple and sometimes controversial, given the diverse perspectives and politics of those who work for the *Geographic*.

The magazine reader's gazes

As Barthes has pointed out, the 'photograph is not only perceived, received, it is *read*, connected more or less consciously by the public that consumes it to a traditional stock of signs' (1977: 19). Independently of what the photographer or the caption writer may intend as the message(s) of the photo, the reader can imagine something else or in addition. The reader, in other words, is 'invited to dream in the ideological space of the photograph' (Tagg 1988: 183). Certain elements of composition or content may make it more likely that the reader will resist the photographic gaze and its ideological messages or potentials. These include whatever indicates that a camera (rather than the reader's eye alone) has been at work – jarring, unnatural colors, off center angles, and obvious photo retouching.

What *National Geographic* subscribers see is not simply what they each get (the physical object, the photograph), but what they imagine the world is about before the magazine arrives, what imagining the picture provokes, and what they remember afterwards of the story they make the picture tell or allow it to tell. The reader's gaze, then, has a history and a future, and it is structured by the mental work of inference and imagination, provoked by the picture's inherent ambiguity (Is that woman smiling or smirking? What are those people in the background doing?) and its tunnel vision (What is going on outside the picture frame? What is it, outside the picture, that she looks at?). Beyond that, the photo permits fantasy ('Those two are in love, in love like I am with Stuart, but they're bored there on that bench, bored like I have been in love.' or 'That child. How beautiful. She should be mine to hold and feed.'). Such differences between the reader's gaze and that of the magazine led us to investigate the former directly by asking a number of people to interpret the pictures (Lutz and Collins 1993).

The reader's gaze is structured by a large number of cultural elements or models, many more than those used to reason about racial or cultural difference. Cultural models that we have learned help us interpret gestures such as the thrown back shoulders of an Argentinean cowboy as indicative of confidence, strength and

bravery. Models of gender lead to a reading of a picture of a mother with a child as a natural scenario, and of the pictured relationship as one of loving, relaxed nurturance; alternatively, the scene might have been read as underlaid with tensions and emotional distance, an interpretation that might be more common in societies with high infant mortality. There is, however, not one reader's gaze; each individual looks with his or her own personal, cultural, and political background or set of interests. It has been possible for people to speak of 'the [singular] reader' only so long as 'the text' is treated as an entity with a single determinate meaning that is simply consumed (Radway 1984) and only so long as the agency, enculturated nature, and diversity of experience of readers are denied.

The gaze of the *National Geographic* reader is also structured by photography's technological form, including a central paradox. On the one hand, photographs allow participation in the non-Western scene through vicarious viewing. On the other, they may also alienate the reader by way of the fact that they create or require a passive viewer and that they frame out much of what an actual viewer of the scene would see, smell, and hear, thereby atomizing and impoverishing experience (Sontag 1977). From another perspective, the photograph has been said (Metz 1985) to necessarily distance the viewer by changing the person photographed into an object – we know our gaze falls on a two dimensional object – and promoting fantasy. Still, the presumed consent of the person to be photographed can give the viewer the illusion of having some relationship with him or her,

Finally, this gaze is also structured by the context of reading. Where and how does the reader go through the magazine – quickly or carefully, alone or with a child? In a less literal sense, the context of reading includes cultural notions about the magazine itself – as high middlebrow, scientific, and pleasurable. The *National Geographic* sits near the top of a socially constructed hierarchy of popular magazine types (e.g., highbrow, lowbrow) that runs parallel to a hierarchy of taste in cultural products more generally (Levine 1988). Readers' views of what the photograph says about the subject must have something to do with the elevated class position they can assume their reading of *National Geographic* indicates. If I the reader am educated and highbrow in contrast to the reader of *People* magazine or the local newspaper, my gaze may take the seriousness and appreciative stance a high-class cultural product requires.

The non-Western subject's gaze

There is perhaps no more significant gaze in the photograph than that of its subject. How and where the photographed subject looks shapes the differences in the message a photograph can give about intercultural relations. The gaze of the non-Westerner found in *National Geographic* can be classified into at least four types; she or he can confront the camera, look at something or someone within the picture frame, look off into the distance, or not look at anything at all.

The gaze confronting the camera and reader comprises nearly a quarter of the photos that have at least some non-Western locals in them.[4] What does the look into the camera's eye suggest to readers about the photographic subject? A number of possibilities suggest themselves.

The look into the camera must at least suggest acknowledgement of photographer and reader. Film theorists have disagreed about what this look does, some arguing that it short circuits the voyeurism identified as an important component of most photography: there can be no peeping if the subject meets our gaze. The gaze can be confrontational: 'I see you looking at me, so you cannot steal that look.' Others, however, have argued that this look, while acknowledging the viewer, simply implies more open voyeurism: the return gaze does not contest the right of the viewer to look and may in fact be read as the subject's assent to being watched (Metz 1985: 800–801).

This disagreement hinges on ignoring how the look is returned and on discounting the effects of context inside the frame and in the reader's historically and culturally variable interpretive work. Facial expression is obviously crucial. The local person looks back with a number of different faces, including friendly smiling, hostile glaring, a vacant or indifferent glance, curiosity, or an ambiguous look. Some of these looks, from various ethnic others, are unsettling, disorganizing and perhaps avoided. In *National Geographic*'s photos, the return look is, however, usually not a confrontational or challenging one. The smile plays an important role in muting the potentially disruptive, confrontational role of this return gaze. If the Other looks back at the camera and smiles, the combination can be read by viewers as the subject's assent to being surveyed. In 38 per cent of the pictures of locals where facial expressions are visible (N = 436) someone is smiling (although not all who smile are looking into the camera), while a higher 55 per cent of all pictures in which someone looks back at the camera include one or more smiling figures.

The camera gaze can also establish at least the illusion of intimacy and communication. To the extent that *National Geographic* presents itself as bringing together the corners of the world, the portrait and camera gaze are important routes to those ends. The non-Westerner is not distanced, but characterized as approachable; the reader can imagine someone is about to speak to him or her. The photographers commonly view the frontal shot as a device for cutting across language barriers and allowing for intercultural communication. The portrait is, in the words of one early *Geographic* photographer 'a collaboration between subject and photographer' (National Geographic Society 1981: 22). In published form, of course, the photographed person is still 'subjected to an unreturnable gaze' (Tagg 1988: 64), in no position to speak.

The magazine's goal of creating intimacy between subject and reader contradicts to some extent its official goal of presenting an unmanipulated truthful slice of life from another country. Virtually all the photographers and picture editors we spoke with at the *National Geographic* saw the return gaze as problematic and believed that such pictures ought to be used sparingly because they are clearly not candid, and potentially influenced by the photographer. They might also be 'almost faking intimacy' one editor said. Another mentioned that the use of direct gaze is also a question of styles suggesting more commercial and less 'gritty' values. The photographer can achieve both the goals of intimacy and invisibility by taking portraits which are not directly frontal, but in which the gaze angles off to the side of the camera.

To face the camera is to permit close examination of the photographed subject, including scrutiny of the face and eyes which are in common sense parlance the seat

of soul, personality or character. Frontality is a central technique of a 'documentary rhetoric' in photography (Tagg 1988: 189); it sets the stage for either critique or celebration, but in either case evaluation of the other as a person or type. Editors at the magazine talked about their search for the 'compelling face' in selecting photos for the magazine.

Racial, age, and gender differences appear in how often and how exactly the gaze is returned and lend substance to each of these perspectives on the camera gaze. To a statistically significant degree, women look into the camera more than men, children and older people look into the camera more often than other adults, those who appear poor more than those who appear wealthy, those whose skin is very dark more than those who are bronze, those who are bronze more than those whose skin is white, those in native dress more than those in Western garb, those without any tools more than those using machinery.[5] Those who are culturally defined by the West as weak – women, children, people of color, the poor, the tribal rather than the modern, those without technology – are more likely to face the camera, the more powerful to be represented looking elsewhere. There is also an intriguing (but not statistically significant) trend towards higher rates of looking at the camera to occur in pictures taken in countries that were perceived as friendly towards the United States)[6]

To look out at the viewer, then, would appear to represent not a confrontation between the West and the rest, but the accessibility of the latter. This interpretation is supported by the fact that historically the frontal portrait has been associated with the 'rougher' classes, [. . .] Tagg (1988), in a social history of photography, argues that this earlier class-based styling was passed on from portraiture to the emerging use of photography for the documentation and surveillance of the criminal and the insane. Camera gaze is often associated with full frontal posture in the *National Geographic;* as such, it is also part of frontality's work as a 'code of social inferiority' (Tagg 1988: 37). The 'civilized' classes, at least since the nineteenth century, have traditionally been depicted in Western art turning away from the camera and so making themselves less available.[7] The higher status person may thus be characterized as too absorbed in weighty matters to attend to the photographer's agenda. Facing the camera, in Tagg's terms, 'signified the bluntness and "naturalness" of a culturally unsophisticated class [and had a history which predated photography]' (1988: 36).

These class coded styles of approach and gaze before the camera in gestures have continued to have force and utility in renderings of the ethnic other. The twist here is that the more civilized quality imparted to the lighter skinned male in Western dress and to adult exotics who turn away from the camera is only a relative quality. Full civilization still belongs, ideologically, to the Euro-American.

Whether these categories of people have actually looked at the camera more readily and openly is another matter. If the gaze toward the camera reflected only a lack of familiarity with it, then one would expect rural people to look at the camera more than urban people. This is not the case. One might also expect some change over time, as cameras became more common everywhere, but there is no difference in rate of gaze when the period from 1950 to 1970 is compared with the later period. The heavy editorial hand at the *Geographic* argues that what is at work is a set of unarticulated perceptions about the kinds of non-Westerners who make

comfortable and interesting subjects for the magazine. *National Geographic* editors select from a vast array of possible pictures on the basis of some notion about what the social/power relations are between the reader and the particular ethnic subject being photographed. These aesthetic choices are outside explicit politics but encode politics nonetheless. A 'good picture' is a picture which makes sense in terms of prevailing ideas about the other, including ideas about both accessibility and difference.

In a second form of gaze by the photographed subject, the non-Westerner looks at someone or something evident within the frame. The ideas readers get about who the Other is are often read off from this gaze which is taken as an index of interest, attention, or goals. The Venezuelan prospector who looks at the diamonds as they are being weighed by the buyer is interested in selling, in making money, rather than in the Western viewer or other compatriots. The caption supplies details: 'the hard-won money usually flies fast in gambling and merry-making at primitive diamond camps where, riches-to-rags tales abound.' And in a 1966 picture showing Ferdinand and Imelda Marcos happily staring at their children, the audience is thereby assured of their family-oriented character.

A potential point of interest in many photographs is a Western traveler. In 10 per cent of these latter pictures at least one local looks into the camera. Yet in 22 per cent of the pictures in which only locals appear, someone looks into the camera. To a statistically significant degree, then, the Westerner in the frame draws a look away from those Westerners beyond the camera, suggesting both that these two kinds of Westerners might stand in for each other, as well as indexing the interest they are believed to have for locals.

Third, the Other's gaze can run off into the distance beyond the frame. This behavior can suggest radically different things about the character of the subject. It might portray either a dreamy, vacant, absent-minded person or a forward looking future-oriented, and determined one. Compare the October 1980 photo of three Argentinean gauchos as they dress for a rodeo with the November 1980 shot of a group of six Australian Aborigines as they stand and sit in a road to block a government mining survey team. Two of the gauchos, looking out the window at a point in the far distance, come across as thoughtful, pensive, and sharply focused on the heroic tasks in front of them. The Aboriginal group includes seven gazes, each heading off in a different direction and only one clearly focused on something within the frame, thus giving the group a disconnected and unfocused look. It becomes harder to imagine this group of seven engaged in coordinated or successful action; that coordination would require mutual planning and, as a corollary, at least some mutual gaze during planning discussions. Character connotations aside, the out-of-frame look may also have implications for viewer identification with the subject, in some sense connecting with the reader outside the frame (Metz 1985: 795).

Finally, in many pictures, no gaze at all is visible, either because the individuals in them are tiny figures lost in a landscape or in a sea of others, or because the scene is dark or the person's face is covered by a mask or veil. We might read this kind of picture (14 per cent of the whole sample) as being about the landscape or activity rather than the people or as communicating a sense of nameless others or group members rather than individuals. While these pictures do not increase in number over the period, there has been a spate of recent covers in which the face

or eyes of a non-Western person photographed are partly hidden (November 1979, February 1983, October 1985, August 1987, October 1987, November 1987, July 1988, February 1991, December 1991). Stylistically, *National Geographic* photographers may now have license to experiment with elements of the classical portrait with its full-face view, but the absence of any such shots before 1979 can also be read as a sign of a changing attitude about the possibilities of cross-cultural communication. The covered face can tell a story of a boundary erected, contact broken.

A direct Western gaze

In its articles on the non-Western world, the *National Geographic* has frequently included photographs that show a Western traveler in the local setting covered in the piece. During the post-war period, these Western travelers have included adventurers, mountain climbers, and explorers; anthropologists, geographers, botanists, and archaeologists; U.S. military personnel; tourists; and government officials or functionaries from the U.S. and Europe from Prince Philip and Dwight Eisenhower to members of the Peace Corps. These photographs show the Westerners viewing the local landscape from atop a hill, studying an artifact, showing a local tribal person some wonder of Western technology (a photograph, mirror or the camera itself), or interacting with a native in conversation, work or play. The Westerner may stand alone or with associates, but more often is framed together with one or more locals.

These pictures can have complex effects on viewers for they represent more explicitly than most the intercultural relations it is thought or hoped obtain between the West and its global neighbors. They may allow identification with the Westerner in the photo and, through that, more interaction with, or imaginary participation in, the photo. Before exploring these possibilities, however, we will speculate on some of the functions these photographs serve in the magazine.

Most obviously, the pictures of Westerners can serve a validating function by proving that the author was there, that the account is a first-hand one, brought from the field rather than from the library or photographic archives. In this respect, the photography sequences in *National Geographic* articles resemble traditional ethnographic accounts, which are written predominantly in the third person but often include at least one story in the first person that portrays the anthropologist in the field (Marcus and Cushman 1982). For this purpose, it does not matter whether the Westerner stands alone with locals.

To serve the function of dramatizing intercultural relations, however, it is helpful to have a local person in the frame. When the Westerner and the other are positioned face-to-face, we can read their relationship and natures from such features as Goffman (1979) has identified in his study of advertising photography's representation of women and men – their relative height, the leading and guying behaviors found more often in pictured males, the greater emotional expressiveness of the women and the like.[8] What the Westerners and non-Westerners are doing, the relative vantage points from which they are photographed, and their facial expressions give other cues to their moral and social characters.

The mutuality or non-mutuality of the gaze of the two parties can also tell us who has the right and/or need to look at whom. When the reader looks out at the

Figure 33.2 Photo: Lowell Thomas, Jr. © National Geographic Society

Photographs in which Western travelers are present encode complete messages about intercultural relations. The nonreciprocal gazes in this February 1960 picture encode distinctly colonial social relations.

world through this proxy Westerner, does the other look back? Here we can look at the February 1960 issue showing two female travelers looking at an Ituri Forest man in central Africa (see Fig. 33.2). Standing in the upper left hand corner, the two women smile down at the native figure in the lower right foreground. He looks towards the ground in front of them, an ambiguous expression on his face. The lines of their gaze have crossed but do not meet; because of this lack of reciprocity, the women's smiles appear bemused and patronizing. Their smiles are neither returned friendly greetings nor can we discern any reason for their smiles in the man's behavior. In its lack of reciprocity, the gaze is *distinctly colonial*. The Westerners do not seek a relationship but are content, even pleased, to view the other as an ethnic object. The composition of the picture, structured by an oblique line running from the women down to the man, shows the Westerners standing over the African; the slope itself can suggest, as Maquet (1986) has pointed out for other visual forms, the idea of *descent* or decline from one (the Western women) to the other.

A related function of this type of photo lies in the way it prompts the viewer to become self-aware, not just in relation to others, but as a viewer, as one who looks or surveys. Mulvey (1985) argues that the gaze in cinema takes three forms – in the camera, the audience, and the characters as they look at each other or out at the audience. She says that the first two forms have to be invisible or obscured if the film is to follow realist conventions and bestow on itself the qualities of 'reality, obviousness, and truth.' The viewer who becomes aware of his or her own eye or that of the camera will develop a 'distancing awareness' rather than an

immediate unconscious involvement. Transferring this insight to the *National Geographic* photograph, Mulvey might say that bringing the Western eye into the frame promotes distancing rather than immersion. Alvarado (1979/80) has also argued that such intrusion can reveal contradictions in the social relations of the West and the rest that are otherwise less visible, undermining the authority of the photographer by showing the photo being produced, showing it to be an artifact rather than an unmediated fact.[9] Whether or not Westerners appear in the picture we *are* there, but in pictures that include a Westerner, we may see ourselves being viewed by the Other, and we become aware of ourselves as actors in the world. The act of seeing the self being seen is antithetical to the voyeurism which many art critics have identified as intrinsic to most photography and film (Alloula 1986; Burgin 1982; Metz 1985).

This factor might best account for the finding that Westerners retreat from the photographs after 1969. Staffers in the photography department said that pictures including the article's author came to he seen as outdated and so they were eliminated. Photographer and writer were no longer to be the stars of the story, we were told, although text continued to be written in the first person. As more and more readers had traveled to the exotic locales of their articles, the *Geographic* staff saw that the picture of the intrepid traveler no longer looked so intrepid. While the rise in international tourism may have had this effect, other social changes of the late 1960s contributed as well. In 1968, popular American protest against participation in the Vietnam War reached a critical point. Massive anti-war demonstrations, the police riot at the Democratic Convention, and especially the Viet Cong's success in the Tet Offensive convinced many that the American role in Vietnam and, by extension, the Third World, would have to be radically reconceptualized. The withdrawal or retreat of American forces came to be seen as inevitable, even though there were many more years of conflict over how, when and why. American power had come into question for the first time since the end of World War II. Moreover, the assassinations of Malcolm X and Martin Luther King, and the fire of revolt in urban ghettoes, gave many white people a sense of changing and more threatening relations with people of color within the boundaries of the United States.

Most of the non-*Geographic* photos now considered iconic representations of the Vietnam War do not include American soldiers or civilians. The girl who, napalmed, runs down a road towards the camera; the Saigon police chief executing a Viet Cong soldier; the Buddhist monk in process of self-immolation — each of these photographs, frequently reproduced, erases American involvement.

The withdrawal of Americans and other Westerners from photographs of *National Geographic* may involve a historically similar process. The decolonization process accelerated in 1968 and led Americans (including, one must assume, the editors of *National Geographic*) to see the Third World as a more dangerous place, a place where they were no longer welcome to walk and survey as they pleased. The decreasing visibility of Westerners signaled a retreat from a Third World seen as a less valuable site for Western achievement and as a place of more difficult access and control. The decolonization process was and is received as a threat to an American view of itself. In Lacan's terms, the Other's look could threaten an American sense of self-coherence and so in this historical moment the Westerner

– whose presence in the picture makes it possible for us to see ourselves being seen by that Other – withdraws to look from a safer distance, behind the camera.

The refracted gaze of the Other: to see themselves as others see them

In a small but nonetheless striking number of *National Geographic* photographs, a native is shown with a camera, a mirror or mirror equivalent in his or her hands. Take the photograph in which two Aivilik men in northern Canada sit on a rock in animal skin parkas, one smiling and the other pointing a camera out at the landscape (November, 1956). Or the picture that shows two Indian women dancing, as they watch their image in a large wall mirror. Or the picture from March of 1968 that shows Governor Brown of California on Tonga showing a group of children Polaroid snapshots he has just taken of them (March, 1968).

Mirror and camera are tools of self-reflection and surveillance. Each creates a double of the self, a second figure who can be examined more closely than the original – a double that can also be alienated from the self, taken away, as a photograph can be, to another place. Psychoanalytic theory notes that the infant's look into the mirror is a significant step in ego formation because it permits the child to see itself for the first time as an other. The central role of these two tools in American society (for example, its millions of bathrooms have mirrors as fixtures nearly as important as their toilet) stems at least in part from their self-reflective capacities. For many Americans, self-knowledge is a central life goal; the injunction to 'know thyself' is taken seriously.

The mirror most directly suggests the possibility of self-awareness, and Western folktales and literature provide many examples of characters (often animals like Bambi or wild children like Kipling's Mowgli) who come upon the mirrored surface of a lake or stream and see themselves for the first time in a kind of epiphany of newly acquired self-knowledge. Placing the mirror in non-Western hands makes an interesting picture for Western viewers because this theme can interact with the common perception that the non-Western native remains at least somewhat child-like and cognitively immature. Lack of self-awareness implies a lack of history (Wolf 1982); he or she is not without consciousness but is relatively without self-consciousness. The myth is that history and change are primarily characteristic of the West and that historical self-awareness was brought to the rest of the world with 'discovery' and colonization.[10]

In the article 'Into the Heart of Africa' (August 1956), a magazine staff member on expedition is shown sitting in his Land-Rover holding open a *National Geographic* magazine to show a native woman a photograph of a woman of her tribe (see Fig. 33.3). Here the magazine serves the role of reflecting glass, as the caption tells us: 'Platter-lipped woman peers at her look-alike in the mirror of *National Geographic*.' The *Geographic* artist smiles as he watches the woman's face closely for signs of self-recognition; the fascination evident in his gaze is in the response of the woman, perhaps the question of how she 'likes' her image, her own self. An early version of this type of photo a quarter of a century earlier shows an explorer in pith helmet who, with a triumphant smile, holds up a mirror to a taller, native man. He dips his head down to peer into it and we, the viewers, see not his expression but a

Figure 33.3 Photo: Volkmar Kurt Wentzel © National Geographic Society

A surprising number of *Geographic* photographers feature mirrors and cameras with Westerners offering third-world peoples glimpses of themselves. In this August 1956 picture a staff artist in what was then French Equatorial Africa shows a woman 'her look-alike'.

redundant caption: 'His first mirror: Porter's boy seeing himself as others see him.' By contrast with the later photo, the explorer's gaze is not at the African but out towards the camera, indicating more interest in the camera's reception of this amusing scene than in searching the man's face for clues to his thinking. It also demonstrates the importance of manipulating relative height between races to communicate dominance. In the same genre, a Westerner in safari clothes holds a mirror up to a baboon (May 1955). Here as well, the *Geographic* plays with the boundary between nature and culture. The baboon, like Third-World peoples, occupies that boundary in the popular culture of white Westerners (see Haraway 1989); its response to the mirror can only seem humorously inadequate when engaged in the ultimately human and most adult of activities, self-reflection.

 The mirror sometimes serves as a device to tell a story about the process of forming national identity. National self-reflection is presumed to accompany

development, with the latter term suggesting a process that is both technological and psychosocial. The caption to a 1980 picture of a Tunisian woman looking into a mirror plays with this confusion between the individual and the nation, between the developing self awareness of mature adults and historically emergent national identity:

> A moment for reflection: Mahbouba Sassi glances in the mirror to tie her headband. A wife and mother in the village of Takrouna, she wears garb still typical of rural women in the region. Step by step. Tunisia has, by any standards, quietly but steadily brought herself into the front rank of developing nations.
>
> <div align="right">(National Geographic 1980)</div>

Cameras break into the frame of many *National Geographic* photographs. In some, a Westerner is holding the camera and showing a local group the photograph he has just taken of them. Here the camera, like the mirror, shows the native to himself. Frequently the picture is shown to children crowding happily around the Western cameraman, Historically it was first the mirror and then the camera that were thought to prove the superiority of the Westerner who invented and controls them (Adas 1989). In many pictures of natives holding a mirror or camera, the magazine plays with what McGrane (1989) identifies with the nineteenth-century European mind that is, the notion 'of a low threshold of the miraculous [in the non-Western native], of a seemingly childish lack of restraint' (1989: 50).

In other pictures, the native holds the camera. In one sense, this violates the prerogative of the Western surveyor to control the camera as well as other means of knowledge. From an early point in the history of photography: its users recognized that the camera was a form of power. In an analysis of photographs of Middle-Eastern women, Graham-Brown (1988) provides evidence that colonial photographers were motivated to keep local subjects 'at the lens-end of the camera' (61), and quotes one who, in 1890, complained. 'It was a mistake for the first photographer in the Pathan [Afghanistan] country to allow the natives to look at the ground glass screen of the camera. He forgot that a little learning is a dangerous thing' (1988: 61). The camera could be given to native subjects only at risk of giving away that power.

Suggesting little peril, however, the pictures in *National Geographic* which place the camera in other hands create an amusing or quaint scene. A broad smile graces the face of the Aivilik man above who uses the camera lens to view the landscape with a companion November 1956). At least one caption suggests that, although the subject goes behind the camera – in 1952 a young African boy looking through the viewfinder – what he looks out at is the imagined self at whom the Western photographer has been looking moments before: 'Young Lemba sees others as the photographer sees him.'

Such pictures were more common in the 1950s. We can detect a change, as decolonization proceeded, in the simple terms with which the problem is depicted in an amazing photograph August 1982 (see Fig. 33.4). It sits on the right hand side of the page in an article entitled 'Paraguay Paradox of South America.' The frame is nearly filled with three foreground figures – white female tourist standing between

Figure 33.4 Photo: O. Louis Mazzatenta © National Geographic Society

A rare picture from August 1982 draws attention to the presence of the camera by photographing people being photographed for pay.

an Amerindian woman and man, both in indigenous dress, both bare-chested. The three stand close together in a line, the tourist smiling with her arm on the shoulder of the sober-faced native woman. The tourist and the man, also unsmiling, face off slightly towards the left where a second camera (in addition to the one snapping the photo that appears in the magazine) takes their picture. The poses and the caption ask us to look at the natives as photographic subjects: 'Portraits for pay: A tourist poses with members of the Maca Indian tribe on Colonia Juan Belaieff Island in the Paraguay River near Asunción. The Indians charge 80 cents a person each time they pose in a photograph . . .'

This rare photograph invites us into a contradictory, ambiguous, but in any case, highly charged scene. It is not a pleasant picture, in contrast with more typical *Geographic* style, because it depicts the act of looking at unwilling subjects, suggesting two things in the process. The first is the voyeurism of the photograph of the exotic. The camera gaze is *doubled* in this picture, not the native subject as in the photos above where the camera enters the frame in some explicit sense, and this doubling underlines that Western gaze. The picture's ambiguity lies in its suggestion that we are seeing a candid shot of a posed shot, and that we are looking at the subject look at us though in fact the Indian gaze is diverted 20 degrees from ours. This unusual structure of gaze draws attention to the commodified nature of the relationship between looker and looked-at. The Indians appear unhappy, even coerced; the tourist satisfied, presumably with her catch. Here too an apparent contradiction – the diverted gaze and its candid appearance suggest that the *National Geographic*

photographer took this picture without paying, unlike the tourists; the caption suggests otherwise.

The photograph's potentially disturbing message for *National Geographic* readers is muted when one considers that the camera has not succeeded so much in representing the returned gaze of indigenous people as it has in taking the distance between Western viewer and non-Western subject one step farther, and in drawing attention to the photographer (and the artifice) between them. A symptom of alienation from the act of looking even while attention is drawn to it, this photo may exemplify a principle which Sontag says operates in all photography:

> The photographer is supertourist, an extension of the anthropologist, visiting natives and bringing back news of their exotic doings and strange gear. The photographer is always trying to colonize new experiences, to find new ways to look at familiar subjects – to fight against boredom. For boredom is just the reverse side of fascination: both depend on being outside rather than inside a situation, and one leads to the other.
>
> (Sontag 1977: 42)

Avoiding boredom is crucial to retaining readers' interest and membership as well.

One could also look at the photograph from a 1990 issue on Botswana showing a French television crew – in full camera and sound gear and from a distance of a few feet – filming two Dzu men in hunting gear and 'authentic' dress. The Frenchmen enthusiastically instruct the hunters in stalking posture, and the caption critiques them, noting that they have dressed up the natives (who otherwise wear Western clothing) for the benefit of European consumers. While this photograph is valuable in letting the reader see how images are constructed rather than found, its postmodern peek behind the scenes may also do what Gitlin notes contemporary journalism has done: engaged in a demystifying look at how image-makers control the face political candidates put forward, they encourage viewers to be 'cognoscenti of their own bamboozlement' (1990).

Ultimately the magazine itself is a mirror for the historical, cultural, and political economic contexts of its production and use. That context is reflected in the magazine's images themselves, but not in a simple reflective way, as either the objectivist myth of the nature of cameras and mirrors or as the Althusserian notion of a 'specular,' or mirror-like ideology (in which the subject simply recognizes him or herself) would have it. It is perhaps more in the form of a rippled lake whose many intersecting lines present a constantly changing and emergent image.

The academic spectator

In one sense, this gaze is simply a sub-type of the reader's gaze. It emerges out of the same American middle class experiential matrix with its family of other cultural representations, its formal and informal schooling in techniques for interpreting both photograph and cultural difference, and its social relations. We read the *National Geographic* with a sense of astonishment, absorption, and wonder, both as children

and, in a way that is different only some of the time, as adults. All of the looks embedded in the pictures are ultimately being filtered for you the reader through this, our own gaze. At times during this project, we have looked at an American magazine reader who is looking at a photographer's looking at a Western explorer who is looking at a Polynesian child who is looking at the explorer's photographed snapshot of herself moments earlier. While this framing of the seventh look might suggest that it is simply a more convoluted and distanced voyeurism, it can be distinguished from other kinds of readers' gazes including the voyeuristic and the hierarchic by both its distinctive intent and the sociological position (white, middle class, female, academic) from which it comes. Its intent is not aesthetic appreciation or formal description, but critique of the images in spite of, because of, and in terms of their pleasures. We aim to make the pictures tell a different story than they were originally meant to tell, one about their makers and readers rather than their subjects.[11] The critique arises out of a desire 'to anthropologize the West,' as Rabinow (1986) suggests we might, and to denaturalize the images of difference in the magazine in part because those images and the institution which has produced them have historically articulated too easily with the shifting interests and positions of the state. The strong impact of the magazine on popular attitudes suggests that anthropological teaching or writing purveys images which, even if intended as oppositional (certainly not always the case), may simply be subsumed or bypassed by the *National Geographic* view of the world.

In addition, a suspicion of the power of images is here, as they exist in a field more populated with advertising photography than anything else. The image is experienced daily as a sales technique or as a trace of the commodity. That experience is, at least for us, and perhaps for other readers, transferred to some degree to the experience of seeing *National Geographic* images. Even if we are simply 'invited to dream' in the photograph, we are also invited to forget and to be lost in it.

Our reading of theory has also tutored our gaze at the photographs in distinctive ways, told us how to understand the techniques by which they work, how to find our way to something other than an aesthetic or literal reading, suggesting that we view them as cultural artifacts. It also suggested that we avoid immersion in the many pleasures of the richly colored and exotically peopled photographs, as in Alloula's reading of Algerian colonial period postcards. He notes his analytic need to resist the 'aestheticizing temptation' (1986: 116) to see beauty in those cards, a position predicated in part on a highly deterministic view of their hegemonic effect.[12] Alternatively, more positive views of the political implications of visual pleasure exist, a view which Jameson (1983) and others argue is achieved in part by unlinking a prevalent disdain for popular culture products from the issue of pleasure. Validating both seemingly contradictory views, however, would seem to be the fact that the seductiveness of the pictures both captures and instructs us. We are captured by the temptation to view the photographs as more real than the world or at least as a comfortable substitute for it – to imagine at some level a world of basically happy, classless, even noble, people in conflict neither with themselves nor with 'us.' These and other illusions of the images we have found in part through our own vulnerability to them. The pleasures are also instructive, however. They come from being given views, without having to make our own efforts to get them, of a world different, however slightly, from the American middle class norm. The

considerable beauty with which those lives are portrayed can potentially challenge the latter, as well.

Concluding remarks

The many relations of looking represented in all photographs are at the very foundation of the kinds of meaning that can be found or made in them. The multiplicity of looks is at the root of a photo's ambiguity, each gaze potentially suggesting a different way of viewing the scene. Moreover, a visual 'illiteracy' leaves most of us with few resources for understanding or integrating the diverse messages these looks can produce. Multiple gaze is the source of many of the photograph's contradictions, highlighting the gaps (as when some gazes are literally interrupted) and multiple perspectives of each person involved in the complex scene. It is the root of much of the photograph's dynamism as a cultural object, and the place where the analyst can perhaps most productively begin to trace its connections to the wider social world of which it is a part. Through attention to the dynamic nature of these intersecting gazes, the photograph becomes less vulnerable to the charge or illusion that it masks or stuffs and mounts the world, freezes the life out of a scene, or violently slices into time. While the gaze of the subject of the photograph may be difficult to find in the heavy crisscrossing traffic of the more privileged gazes of producers and consumers, contemporary stories of contestable power are told there nonetheless.

Notes

1 This essay. which appeared originally in *V.A.R.*, is drawn substantially from a book (Lutz and Collins 1993) that examines the production and consumption of *National Geographic* photographs of the 'non-Western' world in the post World War II period. That book and this essay is in part based on an analysis of 600 photographs from that period; on several visits to the Washington headquarters where the magazine is produced and interviews conducted there with a number of photographers, picture editors, caption writers, layout and design people, and others; and on interviews with 55 individuals from upstate New York and Hawaii who 'read' a set of *Geographic* photographs for us. The present essay benefits extensively from the coding and analytic help of Tammy Bennington, and from the stimulating comments on earlier drafts by Lila Abu-Lughod, Tamara Bray, Phoebe Ellsworth, John Kirkpatrick, Daniel Rosenberg, Lucien Taylor and anonymous reviewers for *V.A.R.*

 The term 'non-Western' which bounds the project is awkward but represents our focus on the world outside the boundaries of the United States and Europe and our interest in how these powerful world areas (which include almost all of the magazine's readers) have constructed and construed other peoples. Our analysis here and elsewhere suggests that, despite some important distinctions which these readers can and do make within the category of the 'non-Western,' there is a fundamental process of identity formation at work in which all 'exotics' play the primary role of being not Western, not a white, middle class reader.

2 An early typology of the gaze from a colonial and racist perspective is found in Sir Richard Burton's accounts of his African expeditions, during which he felt himself to be the victim of 'an ecstasy of curiosity'. Wrote Burton:

At last my experience in staring enabled me to categorize the infliction as follows. Firstly is the stare furtive, when the starer would peep and peer under the tent, and its reverse, the open stare. Thirdly, is the stare curious or intelligent, which generally was accompanied with irreverent laughter regarding our appearance. Fourthly is the stare stupid, which denoted the hebete incurious savage. The stare discreet is that of Sultans and great men; the stare indiscreet at unusual seasons is affected by women and children . . . Sixthly is the stare flattering – it was exceedingly rare, and equally so was the stare contemptuous. Eighthly is the stare greedy; it was denoted by the eyes restlessly bounding from one object to another, never tired, never satisfied. Ninthly is the stare peremptory and pertinacious, peculiar to crabbed age. The dozen concludes with the stare drunken, the stare fierce or pugnacious, and finally the stare cannibal, which apparently considered us as articles of diet.

(Burton in Moorhead 1960: 33)

One can imagine a similarly hostile categorization of white Westerners staring at 'exotics' over the past centuries.

3 Some contemporary photographers are experimenting with these conventions (in point of view or framing) in an effort to undermine this equation. Victor Burgin, for example, intentionally attempts to break this down by making photographs that are '"occasions for interpretation" rather than . . . "the objects of consumption"' and that thereby require a gaze which more actively produces itself rather than simply accepting the photographer's gaze as its own. While one can question whether any *National Geographic* photograph is ever purely an object of consumption the distinction is an important one and alerts us to the possibility that the photographer can encourage or discourage, through technique, the relative independence of the viewer's gaze.

4 This figure is based on 438 photographs coded in this way 24 per cent of which had a subject looking at the camera.

5 These analyses were based on those photos where gaze was visible, and excluded pictures with a Westerner in the photo. The results were, for gender ($N = 360$) $x^2 = 3.835$, df = 1, p $<.05$; for age ($N = 501$) $x^2 = 13.745$, df = 4, p $<.01$; for wealth ($N = 507$) $x^2 = 12.950$, df = 2, p $<.01$; for skin color ($N = 417$) $x^2 = 8.704$, df = 3, p $<.05$; for dress style ($N = 452$) $x^2 = 12.702$, df = 1, p $<.001$; and for technology ($N = 287$) $x^2 = 4.172$, df = 1, p $<.05$. Discussing these findings in the Photography Department, we were given the pragmatic explanation that children generally are more fearless in approaching photographers, while men often seem more wary of the camera than women, especially when it is wielded by a male photographer.

6 In the sample of pictures from Asia in which gaze is ascertainable ($N = 179$), 'friendly' countries (including the PRC after 1975, Taiwan, Hong Kong, South Korea, Japan, and the Philippines) had higher rates of smiling than 'unfriendly' or neutral countries ($x^2 = 2.101$, df = 1, p $=.147$). Excluding Japan, which may have had a more ambiguous status in American eyes, the relationship between gaze and 'friendliness' reaches significance ($x^2 = 4.14$, df = 1, p $<.05$).

7 Tagg notes that the pose was initially the pragmatic outcome of the technique of the Physionotrace, a popular mechanism used to trace a person's profile from shadow onto a copper plate. When photography took the place of the Physionotrace, no longer requiring profiles, the conventions of associating class with non-frontality continued to have force.

8 For example, Goffman (1979) draws on ethological insights into height and dominance relations when he explains why women are almost always represented as

shorter than men in print advertisements. He notes that 'so thoroughly is it assumed that differences in size will correlate with differences in social weight that relative size can he routinely used as a means of ensuring that the picture's story will be understandable at a glance' (*ibid.*: 28).

9 The documentary filmmaker Dennis O'Rourke, whose films *Cannibal Tours* and *Half Life: A Parable for the Nuclear Age* explore Third World settings, develops a related argument for the role of reflexivity for the imagemaker (Lutkehaus 1989). He consistently includes himself in the scene, but distinguishes between simple self-revelation on the part of the filmmaker and rendering the social relations between him and his subjects, including capturing the subject's gaze in such a way as to show his or her 'complicity' with the filmmaker, O'Rourke appears to view the reader's gaze more deterministically (for example, as 'naturally' seeing the complicity in a subject's gaze) than do the theorists considered above.

10 Compare the pictures of natives looking into a mirror with that of an American woman looking into the shiny surface of the airplane she is riveting in the August 1944 issue, It is captioned. 'No time to prink [primp] in the mirror-like tail assembly of a Liberator.' The issue raised by this caption is not self-knowledge (Western women have this), but female vanity, or rather its transcendence by a woman who, man-like, works in heavy industry during the male labor shortage period of World War II. Many of these mirror pictures evoke a tradition of painting in Western art in which Venus or some other female figure gazes into a mirror in a moment of self-absorption. Like those paintings, this photo operates 'within the convention that justifies male voyeuristic desire by aligning it with female narcissistic self-involvement' (Snow 1989: 38).

11 Our interviews with readers show that they do not always ignore the frame, but also sometimes see the photograph as an object produced by someone in a concrete social context.

12 Alloula seems not to broach the possibility of alternative kinds of pleasure (or, more broadly, positive effects or readings) in the viewing because the photos are seen to have more singular ends and because of his fear of what he terms an 'intoxication, a loss of oneself in the other through sight' (1986: 49).

References

Adas, Michael, 1989. *Machines as the Measure of Men*. Ithaca: Cornell University Press.

Alloula, Malek. 1986. *The Colonial Harem*. Minneapolis: University of Minnesota Press.

Alvarado, Manuel. 1979/80. 'Photographs and narrativity.' *Screen Education* (Autumn/Winter): 5–17.

Barthes, Roland. 1977. 'The Photographic Message.' In *Image-Music-Text*, trans. Stephen Heath. Glasgow: Fontana/Collins.

Burgin, Victor, ed. 1982. *Thinking Photography*. London: Macmillan.

Devereux, George. 1967. *From Anxiety to Method in the Behavioral Sciences*. The Hague: Mouton.

Ellsworth, Phoebe. 1975. 'Direct Gaze as Social Stimulus: The Example of Aggression.' In *Nonverbal Communication of Aggression*, ed. P. Pliner, L. Krames, and T. Alloway. New York: Plenum.

Geary, Christraud M. 1988. *Images from Bamum: German Colonial Photography at the Court of King Njoya, Cameroon, West Africa*. 1902–1915. Washington, D.C.: Smithsonian Institution Press.

Gitlin, Todd. 1990. 'Blips, bites and savvy talk.' *Dissent* 37: 18–26.

Goffman, Erving. 1979. *Gender Advertisements*. New York: Harper and Row.

Graham-Brown, Sarah. 1988. *Images of Women: The Portrayal of Women in Photography of the Middle East, 1860–1950*. London: Quartet Books.

Haraway, Donna J. 1989. *Primate Visions: Gender, Race, and Nature in the World of Modern Science*. London: Routledge.

Lacan, Jacques. 1981. *The Four Fundamental Concepts of Psychoanalysis*. New York: Norton.

Levine, Lawrence W. 1988. *Highbrow/Lowbrow: The Emergence of Cultural Hierarchy in America*. Cambridge: Harvard University Press.

Lutkehaus, Nancy C. 1989. '"Excuse me, Everything is Not Alright": On Ethnography, Film, and Representation. An Interview with Filmmaker Dennis O'Rourke.' *Cultural Anthropology* 4: 422–437.

Lutz, Catherine and Jane Collins. 1993. *Reading National Geographic*. Chicago: University of Chicago Press.

Marcus, George E. and Dick Cushman. 1982. 'Ethnographies as Text.' *Annual Review of Anthropology*. 11: 25–69.

Maquet, Jacques. 1986. *The Aesthetic Experience*. New Haven: Yale University Press.

McGrane, Bernard. 1989. *Beyond Anthropology: Society and the Other*. New York: Columbia University Press.

Metz, Christian. 1985. 'From The Imaginary Signifier.' In *Film Theory and Criticism: Introductory Readings*, 3rd ed., eds Gerald Mast and Marshall Cohen, 782–302. New York: Oxford University Press.

Moorehead, Alan. 1960. *The White Nile*. New York: Harper & Brothers.

National Geographic Society. 1981. *Images of the World: Photography at the National Geographic*. Washington, D.C.: National Geographic Society.

Rabinow, Paul. 1986. 'Representations are Social Facts: Modernity and Post-Modernity in Anthropology.' In *Writing Culture*, ed. J. Clifford and G. Marcus, 234–61. Berkeley: University of North Carolina Press.

Radway, Janice. 1984. *Reading the Romance*. Chapel Hill: University of North Carolina Press.

Sider, Gerald. 1987. 'When parrots learn to talk, and why they can't: domination, deception, and self-deception in Indian-White relations.' *Comparative Studies in Society and History* 29: 3–23.

Snow, Edward. 1989. 'Theorizing the Male Gaze: Some problems.' *Representations* 25: 30–41.

Sontag, Susan. 1977. *On Photography*. New York: Dell/Delta.

Tagg, John. 1988. *The Burden of Representation*. Amherst: The University of Massachusetts Press.

Wolf, Eric. 1982. *Europe and the People Without History*. Berkeley: University of California Press.

PART EIGHT

Image and identity

Joy Gregory, 'Eiffel Tower, Paris', 2001, from *Cinderella Stories*. Courtesy of the artist.

Introduction

THE RELATION BETWEEN IMAGE AND IDENTITY has been discussed in terms of photography in general, and, more specifically, domestic photography. The initial focus was upon photographs and the politics of representation. Representation simultaneously depicts and symbolises. Stuart Hall, in his extensive writings on the subject, defines systems of representation as referring both to ways of organising and categorising concepts, and to understanding relations between them. In this formulation, concepts are material in the sense that they are related to objects or experiences; but they are intrinsically ideological in that systems of ideas are brought into play in order to place and comprehend the significance of material experience. Language performs a mediating role; it does not simply reference objects, events, experiences; rather, language operates as a link between experience and what it means to us. The politics of representation was concerned with stereotyping (for instance, of women) and with marginalisation (for instance, of ethnic minorities). In analysing the play of ideological discourses, the still image has to been seen as inter-related to other media forms (television advertising, radio soaps, newspaper features . . .) as sites within which particular ideas tend to be reinforced.

One result of interrogating representation was a burgeoning of photographic projects whereby people were encouraged to envisage aspects of their own experience, thereby challenging marginalisation or stereotypes. Working class people, women, gays, people of colour, were empowered through taking control of the means of picturing their own lives. Simultaneously, the family album, as a site of personal histories, attracted analysis. Representational processes became understood as oscillating complexly between visible stereotyping and more invisible subjective processes of accommodation within social and domestic hierarchies. As the 1970s feminist slogan proclaimed, 'the personal is political'. Thus the family, viewed as a complex and potentially repressive institution, came into focus. Personal memory and photography is inextricably intertwined. It may be difficult to distinguish between that which is remembered 'directly' and that which is remembered due to the continuing existence of a photograph which acts as an aide-memoire. Furthermore, an event, or set of circumstances, may have been experienced differently by different family participants (or groups of friends), so the photograph as token may provoke diverse recollections. Indeed, a particular image may belie family relations.

Investigating uses of photography in the 1960s, French sociologist, Pierre Bourdieu found that more than two-thirds of photographers are 'seasonal conformists', taking photos at family and social events or in the summer holidays. Whether taken by a professional photographer or by a participant, the photograph symbolises significant moments within a family or community context and becomes 'an object of regulated exchange' within group history (Bourdieu 1965: 19–20). Historically, men may have been the principal picture takers, but in general women have been the keepers of the family album, in charge of creating a wall of images, or of choosing pictures for framing and display. Domestic histories are inflected

through the selection and centring (on the page or on the mantelpiece) of certain relatives or events – to the exclusion of others. Photographic coding is also significant: who is most clearly in focus, central within the social group? Who is relegated to the edge of the frame?

Psychoanalysis, developed in the early years of the twentieth century, is premised on the formative influence of childhood experience. We are not born into the world as fully formed or patterned potential adults; rather we *become* who we are. Subjectivity develops and changes as a consequence of myriad encounters within the world of experience, including response to ways in which ideas, people and places are represented to us. We are thus subjectified within ideological processes which operate complexly at both conscious and unconscious levels of psychic patterning. For Freud, the sexual, which is biologically rooted, and the symbolic, are key forces, experienced individually, but consequent upon cultural formations. Psychoanalysis as a therapeutic model is premised on the centrality of memory and on dreams as spaces wherein difficult (traumatic) experiences, or unconscious fantasies, are handled through displacement or through condensation. In effect, experience or fantasy is put aside or masked through a substitute image, memory or reference; or diluted through being condensed into something less complexly disagreeable and therefore more manageable. Freud himself does not discuss photography. But clearly photographs, especially personal photography, relate to individual experience and may operate, like dreams, to condense or to displace, in effect offering a stand-in for actual experience. Photography, more generally, in selective reproduction of images of people, places and events, operates forcefully, in ideological terms, within specific cultural formations.

The first essay included here raises broad questions pertaining to cultural processes and shifting senses of identity. Bailey and Hall trace developments in black cultural theory and practices, arguing that changing times and circumstances should provoke shifts in analytical approaches and in tactics for counteracting stereotyping in representation. Although anchored through reference to then contemporary photography by black British photographers, and first published in an issue of *Ten.8* devoted to Black British Photography in the 1980s, the essay offers something of a hallmark in theorising identity-producing processes and the operations of the image.

The following two essays included here directly interrogate questions of memory and identity. Taking an image of her father as starting point, bell hooks considers the operations of the family snapshot and of the 'gallery' wall within the home. She notes fluidities of meaning and interpretation as each family member positions themselves with the patriarchal family network of relationships. She argues that the picture histories formed on the domestic wall of images functioned as a site of empowerment within the struggle over representation. Likewise, taking a snapshot of herself as a starting point, Annette Kuhn investigates the family photo as a site of conflicting memories and as an emblem within the construction of personal historical narratives.

French linguist and psychoanalyst, Jacques Lacan has indicated ways in which experience – especially, but not exclusively, within the family – contributes to

structuring unconscious subjective patterns of feelings. Interrogation of personal photography, the snapshot and the family album, drew upon such psychoanalytic models in order to read beyond the image. The photograph masks family relations which obtain 'behind the image' as it were. It has long been noted that family albums record particular highlights of family history: births, weddings, parties, festival celebrations, holidays – but not death, divorce, arguments when travelling or, indeed, the everyday banal. Social conventions dictate that people group together, pose and smile when photographed. Often it is a detail – of posture or refusal to look at the camera – which indicates that all is not quite as it at first appears. Hence it was argued that personal photographs can be read sympto-matically, through observation of detail, perhaps in conjunction with reading diaries and notebooks, or with interviews. The photograph thus becomes viewed as an indicator of malaise.

This view of the photograph as indicative and as a token operating to enhance particular memories, led to the proposal developed by Jo Spence, in particular with Rosy Martin, that photographs could contribute to 're-modelling' history. Their first joint essay, 'New portraits for old: the use of the camera in therapy' was published in 1985. Photo-therapy is a process, which draws upon co-counselling techniques, and involves time, trust, confidentiality and therapeutic objectives. Individuals re-view their personal histories analytically, bringing forward particular feelings and memories for exploration through performance in which key personal moments are re-enacted and photographed by the collaborator. Their later essay, included in abridged form here, indicates a breadth of possibilities including permission to explore feelings through 'play'. The process opens up a theatre of memory, and the resulting photographs may become bearers of new meanings which contribute to pointing to further subjective issues for examination. Here the interaction of (photographic) image and subjective sense of identity is utilised proactively, as a way of unlocking previous self-limitations.

What happens when the photographer turns the camera on herself? The self-portrait has been seen as an act of introspection and subjective interrogation. It has also been seen as an act of vanity whereby a particular self-image and status is claimed by the artist. The final piece included here, first published in *Camera-work*, London, in 1979, is intended not only as an example of the sorts of issues associated with gender and stereotyping which were being questioned from femi-nist perspectives but also as a direct example for photographers interested in questioning image, identity and self-portraiture. Here Angela Kelly emphasises the performative dimension, interrogating questions of realism, representation and sexist stereotyping.

Questions of image, identity and representation resonate between public and private, commercial and domestic. Furthermore, methods of visual communication shift, for instance, snapshots may be emailed to distant relatives; the 'family album', in the form of digi-video, may be played back on the TV screen. In this respect, the spaces of the photo album, television and the computer are increasingly convergent and interactive. The 'confusion' of messages, whereby personal experi-ences may be in effect inter-cut with, for instance, 'reality TV' – which aesthetically,

may not look very different – emphasises the interplay of personal imagery and the general circulation of images.

Selected references and further reading

Adams, P. (1996) *The Emptiness of the Image*. London: Routledge.
 On psychoanalytic theory, sexual difference, and representation.
Bourdieu, P. (1965) 'Photographic Practice as an Index and an Instrument of Integration' in his (1990) *Photography: A Middle-brow Art*. London. Polity Press.
 Original French publication, 1965.
Groover, J.Z. (1990) 'Photo Therapy: Shame and the Minefields of Memory' *Afterimage* 18/1, Summer.
 A discussion of photo-therapy, its principles and processes.
Hall, S. (1997) 'Representation' in Hall (ed.) *Representation*. London: Sage and The Open University.
Martin, R. and Spence, J. (1985) 'New portraits for old: the use of the camera in therapy', *Feminist Review*, No. 19, March.
Reprinted in Rosemary Betterton (ed.) (1987) *Looking on – images of femininity in the visual arts and media*. London: Pandora.
Martin, R. (1991) 'Don't say cheese, say lesbian' in Jean Fraser and Tessa Boffin (eds) *Stolen glances – lesbians take photographs*. London. Pandora.
Spence, J. (1986) *Putting Myself in the Picture*. London: Camden Press.
 An account of critical models and practice; includes section on photo-therapy.
Spence, J. and Holland, P. (eds) (1991) *Family Snaps: The Meanings of Domestic Photography*. London: Virago.
 Collection of essays by twenty-five photography critics/curators.
Willis, D. (ed.) (1994) *Picturing Us, African American Identity in Photography*. NY: The New Press.
 Seventeen varied accounts drawing upon personal histories.

Bibliography of essays in Part Eight

Bailey, D.A. and Hall, S. (1990) 'The Vertigo of Displacement' in Bailey and Hall (eds) *Critical Decade*, *Ten.8* Vol. 2/3. Birmingham: Ten.8.
bell hooks (1994) 'In Our Glory: Photography and Black Life' in Deborah Willis (ed.) (1994) *Picturing Us, African American Identity in Photography*. NY: The New Press.
Kelly, A. (1979) 'Self Image: Personal is Political', *Camerawork* 12, January.
Kuhn, A. (1991) 'Remembrance' in Jo Spence and Patricia Holland (eds) *Family Snaps*. London: Virago.
Martin, R. and Spence, J. (1988) 'Photo therapy: psychic realism as a healing art?' in *Spellbound*, *Ten.8* 30, Autumn.

Chapter 34

David A. Bailey
and Stuart Hall

THE VERTIGO OF DISPLACEMENT

[. . .]

A MAJOR SHIFT TOOK PLACE in the 1980s when a significant body of
work from black photographers challenged, explored and pushed back the
parameters of photographic practices. A range of influences, many derived from
film, performing and visual arts, came into play. But perhaps the most crucial shifts
occurred within documentary genres. The development of theories which called
into question documentary photography's claims to some form of objective truth,
the growing critique of the classic realist text, and the reappropriation of the avant-
garde and surrealism were important. At the same time, the development of
post-structuralist theory introduced new concepts of identification, plural identities,
and encouraged the move away from the essential subject towards the development
of the decentered subject. There were also campaigns orchestrated by a range of
constituencies within the black communities to create and circulate positive images.
All of these had a significant influence on the content and form of black photographic
practices in the 1980s. This article explores these shifts and influences in order to
map out how a particular moment in black photography developed.

Documentary truth and guaranteed knowledge

The history of black photographic image-making has been obsessed with opening up
the apparently fixed meanings of images. One of the key sites for this struggle is
documentary. Documentary photography carries a claim to truth, with the meta
message of *this is how it really was*. This stems from its close relationship with clas-
sical realism and the classic realist text – exemplified most powerfully by the
nineteenth century novel – which places the spectator in a position of absolute
knowledge and truth. In a similar way, documentary claims to reveal the truth,

because realism as a narrative form places the spectator in the position of guaranteed knowledge.

The use of the documentary form by many black photographers in the 1970s and early 1980s has, therefore, to be seen within a wider political framework – as part of the attempt to reposition the guaranteed centres of knowledge of realism and the classic realist text, and the struggle to contest negative images with positive ones. For example, both Armet Francis in *The Black Triangle* and Vanley Burke in his portraits of Handsworth used the documentary form to articulate a political statement about making visible black images and black image-makers. Linked to this was the issue of access for black people to the discourse of photography so that they could represent and reflect on their own experience – which has been a major theme throughout the 1980s. There was a general campaign to give black photographers the opportunity to do work that would be seen, gain some kind of credibility, and work against the negative or eurocentric representations of the dominant regime.

This contestation by black photographers was not done in isolation, but was linked to a larger campaign which had support from institutions, academic bodies and a wide range of black individuals and organisations. Within the GLC (Greater London Council), for example, there was a campaign against negative imagery and the way in which certain communities were disenfranchised, discriminated against and marginalised. A key element in the campaign was to give access to these groups by way of finance, infrastructure, lobbying and distribution. At the same time, the GLC created a platform for debate through conferences, seminars, workshops and publications.

Cultural studies and the shift to avant-gardism

A further key element in the development of this debate came from the body of writing and teaching known as cultural studies, which developed ideas from Gramsci as well as from black and feminist movements, and addressed the notion of hegemony. It was argued that the question of power has important cultural and ideological aspects. In *The Empire Strikes Back* and *Policing The Crisis* – both published in the early 1980s – the notion of popular cultural resistance is explored as a form of political resistance. Cultural studies work on race opened up what was going on at the base of English society around race and authoritarian populism, locating new forms of racism articulated around forms of national identification, a sense of Englishness, and the crisis facing a society going through post imperial trauma.

Against this background, a number of black photographers began to explore questions of identification, the issue of how best to contest dominant regimes of representation and their institutionalisation, and the question of opening up fixed positions of spectatorship. This was a move away from documentary, away from the image as something which referred beyond itself to an objective truth, to a concern with representation as such. This mode of contestation goes against the grain of realism: indeed, it opens up realism and exposes it as a particular genre and privileges instead, non-realist modes such as formalism, modernism and surrealism, which can be grouped together under the rubric of avant-gardism.

This anti-realism was developed at a theoretical level in *Screen* magazine which argued that the way in which the realist text places the reader/spectator in the position of guaranteed knowledge serves to conceal and naturalise ideology. In order to disrupt this naturalistic ideology of truth it becomes necessary to disrupt the very thing which positions the spectator so securely – the form of realism. Hence, the importance of avant-gardism which breaks up the realist relationship between work and spectator, thereby preventing the spectator from settling back into an empiricist and secure relationship to knowledge.

It would be misleading, however, to view the shift from documentary to avant-gardism in black photographic practice as simply one visual discourse replacing another. The shift needs to be contextualised within a wider field where a variety of questions – both new and old – were being addressed around black imagery. We need to look again at the earlier documentary forms which were supposedly being superseded in the mid 1980s and recognise that they continue to offer something of value. It would be as absurd to consider documentary a reactionary form *per se* as it would be to assume that a deconstructive avant-garde practice must be progressive. Clearly, there is a need for a more refined critical apparatus for seeing what someone who is practising in the documentary genre can and can't do, how the genre limits them and how the genre allows them to refer to certain things which those who are working in the avant-garde genres cannot, as well as how avant-garde genres open up connections which realism blocks out.

Exploring the kaleidoscopic conditions of blackness

By the mid 1980s, the campaign to contest negative images with positive ones had moved on to an enquiry into the politics of the image itself. It was here that the black photography movement produced its most innovative and exciting work in a range of work that explores complex debates on fine art practices, gender, sexuality, and being black and British.

It was at this stage also that many black practitioners began to articulate the view that black is something which is only partly represented by skin colour – a conceptual shift which owed much to post-structuralist discourses on identity and decentering the subject. Post structuralist thinking opposes the notion that a person is born with a fixed identity – that all black people, for example, have an essential, underlying black identity which is the same and unchanging. It suggests instead that identities are floating, that meaning is not fixed and universally true at all times for all people, and that the subject is constructed through the unconscious in desire, fantasy and memory. This theory helps explain why for example an individual might shift from feeling black in one way when they are young, to black in another way when they are older – and not only black but male/female, and not only black but gay/heterosexual, and so on.

The notion that there is no essential blackness – that black is a cultural term, a political term, that it is a choice of identity – also forced the recognition that the fact of a photographer being black did not guarantee an anti-racist image, any more than the fact of being black guarantees right-on politics.

Black photography therefore moved towards the need to represent plural

identities which are never fixed and never settle into a fixed pattern – which, in a nutshell, is what decentering the subject means. Instead of concentrating on representing an essential black (as opposed to white) identity, the emphasis shifted to the process of identification. A black male, for example, might in some situations identify with being black and in other situations identify with being male – and sometimes these two forces do not pull in the same way. Identities can, therefore, be contradictory and are always situational. Being black does not override the fact that along another axis such as class, gender or sexuality a person may come out in a different position. Identities are then permanently decentered, and there is no master identity such as class or nationality that can gather all these strands into a single weave. In short, we are all involved in a series of political games around fractured or decentered identities.

This means that there is no one thing that is black – black is connected to all these different categories – some blacks are sexist, some blacks are not, some blacks are heterosexuals, some blacks are gay and some blacks are middle class. Identities are positional in relation to the discourses around us. That is why the notion of representation is so important – identity can only be articulated as a set of representations. And, perhaps more importantly, since black signifies a range of experiences, the act of representation becomes not just about decentering the subject but actually exploring the kaleidoscopic conditions of blackness.

In such a situation, it became clear that the individual black artist could not represent the whole of the black experience. How could all of those experiences be spoken of through one photograph, one voice? An aspect of the black experience can be represented, but this representation has to be seen as more tentative and partial.

The 1980s therefore signalled the end of the essential black subject and the kind of essentialism which assumes that the progressive, creative character of black representation is guaranteed by the fact that it is made by a black subject.

This in turn demanded a climate where it was possible to say: 'Black this may be, black you may be, well-intentioned the work may be, but it doesn't come off.' And, by implication, it also required the acknowledgement that it is equally possible that a white photographer, with only limited understanding of the black experience, might be able to say something of significance to a black audience. Unquestionably, this is a much harder form of political practice to take on because the sides are not neatly drawn up: the goodies and baddies aren't given for you neatly nor are they any longer inscribed as to who they are and what their position is. So, the struggle ceased to be simply a binary opposition, replacing one bad photographic practice with an oppositional good photographic practice. It shifted into the arenas of criticism: the politics and the ethics of criticism.

This was highlighted in critical responses to the work of Robert Mapplethorpe and Rotimi Fani-Kayode.

Black and white: towards a new critical response

The essentialist position was effectively saying that as a white photographer photographing a black body, Mapplethorpe could by definition only appropriate and

fetishise it. This body of criticism is underpinned by the belief that a white photographer photographing a black subject is photographing across the line of domination and subordination and that this determines the nature of the image.

Against this, the 1980s produced a fresh body of criticism which said: Yes. Mapplethorpe does fetishise, abstract, formalise, and appropriate the black body. But, on the other hand, we can see that Mapplethorpe is contesting the dominant representation of black masculinity in a lot of black photography – he lets loose his desire for the black male form which many black male photographers suppress. So on the one hand Mapplethorpe is contesting a one-dimensional representation of black masculinity, while on the other expropriating the black male form in a fetishistic way. Both things are true.

If you say only the first thing, you feel comfortable: but you haven't yet given yourself up to that extraordinary play of desire which is why black photographers can't leave Mapplethorpe's work alone.

In Rotimi Fani-Kayode's work we can see many of the same forms of desire and contestation about black masculinity that we find in Mapplethorpe's work.

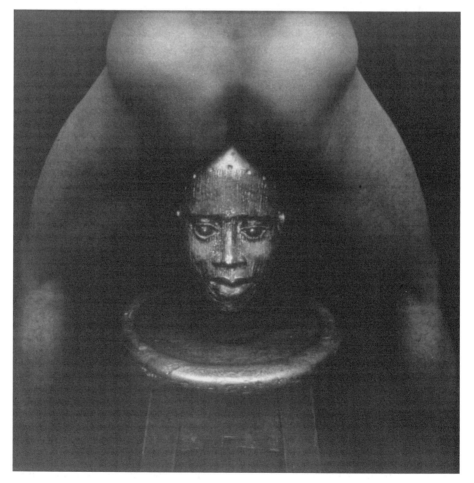

Figure 34.1 Rotimi Fani-Kayode, *Bronze Head*, 1987. Courtesy Autograph © Kayode/Hirst

Figure 34.2 Rotimi Fani-Kayode, *Sonpponnoi*, 1987. Courtesy Autograph © Kayode/Hirst

Rotimi Fani Kayode's work operates alongside Mapplethorpe's critique of dominant representational regimes of black masculinity, and it does not really contest Mapplethorpe's fetishism of the body. So, you have to say both things about Mapplethorpe and both things about Rotimi Fani-Kayode.

However, one of the ways in which Rotimi's work does differ is in the way that Mapplethorpe artificially constructs the forms of the body – black and white, male and female – in an iconographic way, turning them into icons but suppressing

the real forms of ritualism in which the construction of iconography forms part of a social practice. Mapplethorpe's ritualisation is tied only to an aesthetic, whereas Rotimi Fani Kayode's ritualisation seems to reach back to a longer tradition. When he uses a mask it connotes generations of masks used in different spiritual, social, figurative traditions. We don't feel that kind of tradition in Mapplethorpe. The only thing behind Mapplethorpe's work is fashion, the ritualisation of fashion, the iconography of fashion.

It is also important to recognise that there are many things in Rotimi's work which are not in Mapplethorpe's – in other words, we have to get to the stage of refusing to talk about Mapplethorpe as only a fetishtistic, gay, white, male photographer, and Rotimi's work as either limited and restricted because it is influenced by Mapplethorpe or entirely encapsulated and appropriated by Mapplethorpe. Rotimi has both learned from him, fought him off and brought another tradition of representation into his own work.

To get some kind of genuine comparative assessment you have to get inside the contradictory modes and forms and practices of representation operating across both these photographers' work.

Black photography in the 1990s: a struggle on two fronts

The blurring of the old oppositions of black/white, good/bad, documentary/avant-garde does not remove us from earlier struggles to open up more space for black photographers. Simply because the game has got more complicated it does not mean that you lose sight of the struggle. Although a second front has been opened the first front must not be neglected. Questions of access to the means of representation, the relationship of black photographers to the institutions, visibility and exclusion – these are still as important.

If you don't have the means of representation at your disposal then you do not have the access to the places where photographic work can be exhibited, discussed and criticised. You are not even in the game, and you are not part of the photographic discourse. The struggle for entry is a struggle for all black photographers, but once the door has been opened then the name of the game changes. It is then necessary to ask what these photographers are doing with the space that has opened, and what are they doing in relation to discursive practices to which they now have access. Both have to go on. It is very dangerous to talk about the second and not talk about the first because that would be a way of closing the door after a small elite has gone through.

Ultimately, there has to be a wide, active diologic community which is interrogating, evaluating, reconstructing histories, putting back in place the invisible discursive conditions which make new texts possible. All that scholarship, criticism and political and cultural interrogation is part and parcel of the development of a well articulated theory and practice of black representation – doing it, writing about it, arguing about it, theorising it, writing its history and so on – it is all crucial work.

bell hooks

IN OUR GLORY
Photography and black life

ALWAYS A DADDY'S GIRL, I was not surprised that my sister V. became a lesbian, or that her lovers were always white women. Her worship of daddy and her passion for whiteness appeared to affirm a movement away from black womanhood, and of course, that image of the woman we did not want to become – our mother. The only family photograph V. displays in her house is a picture of our dad, looking young with a mustache. His dark skin mingling with the shadows in the photograph. All of which is highlighted by the white T-shirt he wears.

In this snapshot he is standing by a pool table. The look on his face confident, seductive, cool – a look we rarely saw growing up. I have no idea who took the picture, only that it pleases me to imagine that he cared for them – deeply. There is such boldness, such fierce openness in the way he faces the camera. This snapshot was taken before marriage, before us, his seven children, before our presence in his life forced him to leave behind the carefree masculine identity this pose conveys.

The fact that my sister V. possesses this image of our dad, one that I had never seen before, merely affirms their romance, the bond between the two of them. They had the dreamed-about closeness between father and daughter, or so it seemed. Her possession of the snapshot confirms this, is an acknowledgment that she is allowed to know – yes, even to possess – that private life he had always kept to himself. When we were children, he refused to answer our questions about who he was, how did he act, what did he do and feel before us? It was as though he did not want to remember or share that part of himself, that remembering hurt. Standing before this snapshot, I come closer to the cold, distant, dark man who is my father, closer than I can ever come in real life. Not always able to love him there, I am sure I can love this version of him, the snapshot. I give it a title: *in his glory*.

Before leaving my sister's place, I plead with her to make a copy of this picture for my birthday. It does not come, even though she says she will. For Christmas, then. It's on the way. I surmise that my passion for it surprises her, makes her

hesitate. Always rivals in childhood – she winning, the possessor of Dad's affection – she wonders whether to give that up, whether she is ready to share. She hesitates to give me the man in the snapshot. After all, had he wanted me to see him this way, 'in his glory,' he would have given me a picture.

My younger sister G. calls. For Christmas, V. has sent her a 'horrible photograph' of Dad. There is outrage in her voice as she says, 'It's disgusting. He's not even wearing a shirt, just an old white undershirt.' G. keeps repeating, 'I don't know why she has sent this picture to me.' She has no difficulty promising to give me her copy if mine does not arrive. Her lack of interest in the photograph saddens me. When she was the age our dad is in the picture she looked just like him. She had his beauty then – that same shine of glory and pride. Is this the face of herself that she has forgotten, does not want to be reminded of, because time has taken such glory away? Unable to fathom how she cannot be drawn to this picture, I ponder what this image suggests to her that she cannot tolerate: a grown black man having a good time, playing a game, having a drink maybe, enjoying himself without the company of women.

Although my sisters and I look at this snapshot and see the same man, we do not see him in the same way. Our 'reading' and experience of this image is shaped by our relationship to him, to the world of childhood and the images that make our life what it is now. I want to rescue and preserve this image of our father, not let it be forgotten. It allows me to understand him, provides a way for me to know him that makes it possible to love him again and against past all the other images, the ones that stand in the way of love.

Such is the power of the photograph, of the image, that it can give back and take away, that it can bind. This snapshot of Veodis Watkins, our father, sometimes called Ned or Leakey in his younger days, gives me a space for intimacy between the image and myself, between me and Dad. I am captivated, seduced by it, the way other images have caught and held me, embraced me like arms that would not let go.

Struggling in childhood with the image of myself as unworthy of love, I could not see myself beyond all the received images, which simply reinforced my sense of unworthiness. Those ways of seeing myself came from voices of authority. The place where I could see myself, beyond the imposed image, was in the realm of the snapshot. I am most real to myself in snapshots – there I see an image I can love.

My favorite childhood snapshot then and now shows me in costume, masquerading. And long after it had disappeared I continued to long for it and to grieve. I loved this snapshot of myself because it was the only image available to me that gave me a sense of presence, of girlhood beauty and capacity for pleasure. It was an image of myself I could genuinely like. At that stage of my life I was crazy about Westerns, about cowboys and Indians. The camera captures me in my cowgirl outfit, white ruffled blouse, vest, fringed skirt, my one gun and my boots. In this image, I became all that I wanted to be in my imagination.

For a moment suspended in this image: I am a cowgirl. There is a look of heavenly joy on my face. I grew up needing this image, cherishing it – my one reminder that there was a precious little girl inside me able to know and express joy. I took this photograph with me on a visit to the house of my father's cousin, Schuyler.

His was a home where art and the image mattered. No wonder, then, that I wanted to share my 'best' image. Making my first big journey away from home, from a small town to my first big city, I needed the security of this image. I packed it carefully. I wanted Lovie, cousin Schuyler's wife, to see me 'in my glory.' I remember giving her the snapshot for safekeeping; only, when it was time for me to return home it could not be found. This was for me a terrible loss, an irreconcilable grief. Gone was the image of myself I could love. Losing that snapshot, I lost the proof of my worthiness – that I had ever been a bright-eyed child capable of wonder, the proof that there was a 'me of me.'

The image in this snapshot has lingered in my mind's eye for years. It has lingered there to remind of the power of snapshots, of the image. As I slowly work on a book of essays titled *Art on My Mind,* I think about the place of art in black life, connections between the social construction of black identity, the impact of race and class, and the presence in black life of an inarticulate but ever-present visual aesthetic governing our relationship to images, to the process of image making. I return to the snapshot as a starting point to consider the place of the visual in black life – the importance of photography.

Cameras gave to black folks, irrespective of our class, a means by which we could participate fully in the production of images. Hence it is essential that any theoretical discussion of the relationship of black life to the visual, to art making, make photography central. Access and mass appeal have historically made photography a powerful location for the construction of an oppositional black aesthetic. In the world before racial integration, there was a constant struggle on the part of black folks to create a counter-hegemonic world of images that would stand as visual resistance, challenging racist images. All colonized and subjugated people who, by way of resistance, create an oppositional subculture within the framework of domination, recognize that the field of representation (how we see ourselves, how others see us) is a site of ongoing struggle.

The history of black liberation movements in the United States could be characterized as a struggle over images as much as it has also been a struggle for rights, for equal access. To many reformist black civil rights activists, who believed that desegregation would offer the humanizing context that would challenge and change white supremacy, the issue of representation – control over images – was never as important as equal access. As time has progressed, and the face of white supremacy has not changed, reformist and radical blacks alike are more likely to agree that the field of representation remains a crucial realm of struggle, as important as the question of equal access, if not more so. Significantly, Roger Wilkins emphasizes this point in his recent essay 'White Out' (published in the November 1992 issue of *Mother Jones*). Wilkins comments:

> In those innocent days, before desegregation had really been tried, before the New Frontier and the Great Society, many of us blacks had lovely, naïve hopes for integration. . . . In our naïveté, we believed that the power to segregate was the greatest power that had been wielded against us. It turned out that our expectations were wrong. The greatest power turned out to be what it had always been: the power to define

reality where blacks are concerned and to manage perceptions and there-
fore arrange politics and culture to reinforce those definitions.

Though our politics differ, Wilkins' observations mirror my insistence, in the
opening essay of *Black Looks: Race and Representation*, that black people have made
few, if any, revolutionary interventions in the arena of representations.

In part, racial desegregation, equal access, offered a vision of racial progress
that, however limited, led many black people to be less vigilant about the question
of representation. Concurrently, contemporary commodification of blackness
creates a market context wherein conventional, even stereotypical, modes of repre-
senting blackness may receive the greatest reward. This leads to a cultural context
in which images that would subvert the status quo are harder to produce. There is
no 'perceived market' for them. Nor should it surprise us that the erosion of oppo-
sitional black subcultures (many of which have been destroyed in the desegregation
process) has deprived us of those sites of radical resistance where we have had
primary control over representation. Significantly, nationalist black freedom move-
ments were often only concerned with questions of 'good' and 'bad' imagery and
did not promote a more expansive cultural understanding of the *politics* of repre-
sentation. Instead they promoted notions of essence and identity that ultimately
restricted and confined black image production.

No wonder, then, that racial integration has created a crisis in black life, signaled
by the utter loss of critical vigilance in the arena of image making – by our being
stuck in endless debate over good and bad imagery. The aftermath of this crisis has
been devastating in that it has led to a relinquishment of collective black interest in
the production of images. Photography began to have less significance in black life
as a means – private or public – by which an oppositional standpoint could be
asserted, a mode of seeing different from that of the dominant culture. Everyday
black folks began to see themselves as not having a major role to play in the
production of images.

To reverse this trend we must begin to talk about the significance of black image
production in daily life prior to racial integration. When we concentrate on photog-
raphy, then, we make it possible to see the walls of photographs in black homes as
a critical intervention, a disruption of white control of black images.

Most southern black folks grew up in a context where snapshots and the more
stylized photographs taken by professional photographers were the easiest images
to produce. Significantly, displaying those images in everyday life was as central as
making them. The walls and walls of images in southern black homes were sites of
resistance. They constituted private, black-owned and -operated, gallery space
where images could be displayed, shown to friends and strangers. These walls were
a space where, in the midst of segregation, the hardship of apartheid, dehumaniza-
tion could be countered. Images could be critically considered, subjects positioned
according to individual desire.

Growing up inside these walls, many of us did not, at the time, regard them
as important or valuable. Increasingly, as black folks live in a world so technologi-
cally advanced that it is possible for images to be produced and reproduced instantly,
it is even harder for some of us to emotionally contextualize the significance of the
camera in black life during the years of racial apartheid. The sites of contestation

were not *out there*, in the world of white power, they were *within* segregated black life. Since no 'white' galleries displayed images of black people created by black folks, spaces had to be made within diverse black communities. Across class, black folks struggled with the issue of representation. Significantly, issues of representation were linked with the issue of documentation, hence the importance of photography. The camera was the central instrument by which blacks could disprove representations of us created by white folks. The degrading images of blackness that emerged from racist white imaginations and circulated widely in the dominant culture (on salt shakers, cookie jars, pancake boxes) could be countered by 'true-to-life' images. When the psychohistory of a people is marked by ongoing loss, when entire histories are denied, hidden, erased, documentation may become an obsession. The camera must have seemed a magical instrument to many of the displaced and marginalized groups trying to create new destinies in the Americas. More than any other image-making tool, it offered African Americans disempowered in white culture a way to empower ourselves through representation. For black folks, the camera provided a means to document a reality that could, if necessary, be packed, stored, moved from place to place. It was documentation that could be shared, passed around. And ultimately, these images, the worlds they recorded, could be hidden, to be discovered at another time. Had the camera been there when slavery ended, it could have provided images that would have helped folks searching for lost kin and loved ones. It would have been a powerful tool of cultural recovery. Half a century later, the generations of black folks emerging from such a history of loss became passionately obsessed with cameras. Elderly black people developed a cultural passion for the camera, for the images it produced, because it offered a way to contain memories, to overcome loss, to keep history.

Though rarely articulated as such, the camera became in black life a political instrument, a way to resist misrepresentation as well as a means by which alternative images could be produced. Photography was more fascinating to masses of black folks than other forms of image making because it offered the possibility of immediate intervention, useful in the production of counter-hegemonic representations even as it was also an instrument of pleasure. Producing images with the camera allowed black folks to combine image making in resistance struggle with a pleasurable experience. Taking pictures was fun!

Growing up in the fifties, I was somewhat awed and frightened at times by our extended family's emphasis on picture taking. Whether it was the images of the dead as they lay serene, beautiful, and still in open caskets, or the endless portraits of newborns, every wall and corner of my grandparents' (and most everybody else's) home was lined with photographs. When I was younger I never linked this obsession with images of self-representation to our history as a domestically colonized and subjugated people.

My perspective on picture taking was more informed by the way the process was tied to patriarchy in our household. Our father was definitely the 'picture takin' man.' For a long time cameras were both mysterious and off-limits for the rest of us. As the only one in the family who had access to the equipment, who could learn how to make the process work, he exerted control over our image. In charge of capturing our family history with the camera, he called and took the shots. We constantly were lined up for picture taking, and it was years before our household

could experience this as an enjoyable activity, before anyone else could be behind the camera. Before then, picture taking was serious business. I hated it. I hated posing. I hated cameras. I hated the images they produced. When I stopped living at home, I refused to be captured by anyone's camera. I did not long to document my life, the changes, the presence of different places, people, and so on. I wanted to leave no trace. I wanted there to be no walls in my life that would, like gigantic maps, chart my journey. I wanted to stand outside history.

That was twenty years ago. Now that I am passionately involved with thinking critically about black people and representation, I can confess that those walls of photographs empowered me and that I feel their absence in my life. Right now, I long for those walls, those curatorial spaces in the home that express our will to make and display images.

Sarah Oldham, my mother's mother, was a keeper of walls. Throughout our childhood, visits to her house were like trips to a gallery or museum – experiences we did not have because of racial segregation. We would stand before the walls of images and learn the importance of the arrangement, why a certain photo was placed here and not there. The walls were fundamentally different from photo albums. Rather than shutting images away, where they could be seen only by request, the walls were a public announcement of the primacy of the image, the joy of image making. To enter black homes in my childhood was to enter a world that valued the visual, that asserted our collective will to participate in a noninstitutionalized curatorial process.

For black folks constructing our identities within the culture of apartheid, these walls were essential to the process of decolonization. Contrary to colonizing social-ization, internalized racism, they announced our visual complexity. We saw ourselves represented in these images not as caricatures, cartoon-like figures; we were there in full diversity of body, being, and expression, multidimensional. Reflecting the way black folks looked at themselves in those private spaces, where those ways of looking were not being overseen by a white colonizing eye, a white supremacist gaze, these images created ruptures in our experience of the visual. They challenged both white perceptions of blackness and that realm of black-produced image making that reflected internalized racism. Many of these images demanded that we look at ourselves with new eyes, that we create oppositional standards of evaluation. As we looked at black skin in snapshots, the techniques for lightening skin which professional photographers often used when shooting black images were suddenly exposed as a colonizing aesthetic. Photographs taken in everyday life, snapshots in particular, rebelled against all of those photographic prac-tices that reinscribed colonial ways of looking and capturing the images of the black 'other.' Shot spontaneously, without any notion of remaking black bodies in the image of whiteness, snapshots posed a challenge to black viewers. Unlike photo-graphs constructed so that black images would appear as the embodiment of colonizing fantasies, these snapshots gave us a way to see ourselves, a sense of how we looked when we were not 'wearing the mask', when we were not attempting to perfect the image for a white supremacist gaze.

Although most black folks did not articulate a desire to look at images of them-selves that did not resemble or please white folks' ideas about us, or that did not frame us within an image of racial hierarchies, that need was expressed through our

passionate engagement with informal photographic practices. Creating pictorial genealogies was the means by which one could ensure against the losses of the past. They were a way to sustain ties. As children, we learned who our ancestors were by endless narratives told to us as we stood in front of pictures.

In many black homes, photographs – particularly snapshots – were also central to the creation of 'altars.' These commemorative places paid homage to absent loved ones. Snapshots or professional portraits were placed in specific settings so that a relationship with the dead could be continued. Poignantly describing this use of the image in her most recent novel, *Jazz*, Toni Morrison writes:

> . . . a dead girl's face has become a necessary thing for their nights. They each take turns to throw off the bedcovers, rise up from the sagging mattress and tiptoe over cold linoleum into the parlor to gaze at what seems like the only living presence in the house: the photograph of a bold, unsmiling girl staring from the mantelpiece. If the tiptoer is Joe Trace, driven by loneliness from his wife's side, then the face stares at him without hope or regret and it is the absence of accusation that wakes him from his sleep hungry for her company. No finger points. Her lips don't turn down in judgement. Her face is calm, generous and sweet. But if the tiptoer is Violet the photograph is not that at all. The girl's face looks greedy, haughty and very lazy. The cream-at-the-top-of-the-milkpail face of someone who will never work for anything, someone who picks up things lying on other people's dressers and is not embarrassed when found out. It is the face of a sneak who glides over to your sink to rinse the fork you have laid by your place. An inward face – whatever it sees is its own self. You are there, it says, because I am looking at you.

I quote this passage at length because it describes the kind of relationship to photographic images that has not been acknowledged in critical discussions of black folks' relationship to the visual. When I first read these sentences I was reminded of the passionate way we related to photographs when I was a child. Fictively dramatizing the way a photograph can have a 'living presence,' Morrison offers a description that mirrors the way many black folks rooted in southern traditions used, and use, pictures. They were and remain a mediation between the living and the dead.

To create a palimpsest of black folks' relation to the visual in segregated black life, we need to follow each trace, not fall into the trap of thinking that if something was not openly discussed, or if talked about and not recorded, that it lacks significance and meaning. Those pictorial genealogies that Sarah Oldham, my mother's mother, constructed on her walls were essential to our sense of self and identity as a family. They provided a necessary narrative, a way for us to enter history without words. When words entered, they did so in order to make the images live. Many older black folks who cherished pictures were not literate. The images were crucial documentation, there to sustain and affirm oral memory. This was especially true for my grandmother, who did not read or write. I focus especially on her walls because I know that, as an artist (she was an excellent quiltmaker), she positioned the photos with the same care that she laid out her quilts.

The walls of pictures were indeed maps guiding us through diverse journeys. Seeking to recover strands of oppositional worldviews that were a part of black folks' historical relationship to the visual, to the process of image making, many black folks are once again looking to photography to make the connection. Contemporary African American artist Emma Amos also maps our journeys when she mixes photographs with painting to make connections between past and present. Amos uses snapshots inherited from an elder uncle who took pictures for a living. In one piece, Amos paints a map of the United States and identifies diasporic African presences as well as particular Native American communities with black kin, using a family image to mark each spot.

Drawing from the past, from those walls of images I grew up with, I gather snapshots and lay them out, to see what narratives the images tell, what they say without words. I search these images to see if there are imprints waiting to be seen, recognized, and read. Together, a black male friend and I lay out the snapshots of his boyhood, to see when he began to lose a certain openness, to discern at what age he began to shut down, to close himself away. Through these images, he hopes to find a way back to the self he once was. We are awed by what our snapshots reveal, what they enable us to remember.

The word *remember* (*re-member*) evokes the coming together of severed parts, fragments becoming a whole. Photography has been, and is, central to that aspect of decolonization that calls us back to the past and offers a way to reclaim and renew life-affirming bonds. Using these images, we connect ourselves to a recuperative, redemptive memory that enables us to construct radical identities, images of ourselves that transcend the limits of the colonizing eye.

Annette Kuhn

REMEMBRANCE
The child I never was

THIS IS A STORY ABOUT A PHOTOGRAPH; or rather several stories of a sort that could be told about many photographs, yours as well as mine. The six-year-old girl in the picture is seated in a fireside chair in the sitting-room of the flat in Chiswick, London, where she lives with her parents, Harry and Betty. It is the early 1950s. Perched on the child's hand, apparently claiming her entire attention, is her pet budgerigar, Greeny. It might be a winter's evening, for the curtains are drawn and the child is dressed in hand-knitted jumper and cardigan, and woollen skirt.

Much, but not all of this, the reader may observe for herself, though the details of time and place are not in the picture: these are supplied from elsewhere, let us say from a store of childhood memories which might be anybody's, for they are commonplace enough. The description of the photograph could be read as the scene-setting for some subsequent action: one of those plays, perhaps, where the protagonists (already we have four, which ought to be enough) will in a moment animate themselves into the toils of some quite ordinary, yet possibly quite riveting, family melodrama.

All this is true, up to a point. Photographs are evidence, after all. Not that they are to be taken at face value, necessarily, nor that they mirror the real, nor even that a photograph offers any self-evident relationship between itself and what it shows. Simply that a photograph can be material for interpretation – evidence, in that sense: to be solved, like a riddle; read and decoded, like clues left behind at the scene of a crime. Evidence of this sort, though, can conceal, even as it purports to reveal, what it is evidence of. A photograph can certainly throw you off the scent. You will get nowhere, for instance, by taking a magnifying glass to it to get a closer look: you will see only patches of light and dark, an unreadable mesh of grains. The image yields nothing to that sort of scrutiny; it simply disappears.

In order to show what it is evidence of, a photograph must always point you away from itself. Family photographs are supposed to show not so much that we were once there, as how we once were: to evoke memories which might have little

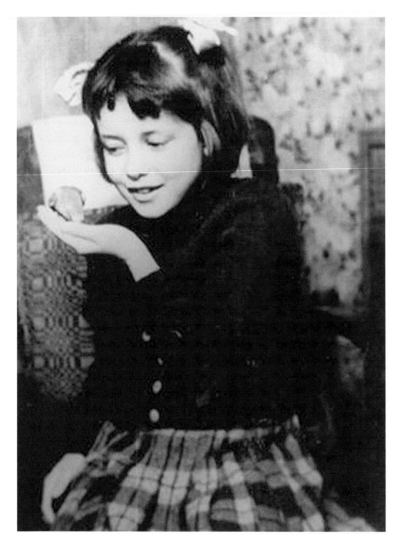

Figure 36.1 Annette Kuhn, *As a Child*. Courtesy Annette Kuhn archive.

or nothing to do with what is actually in the picture. The photograph is a prop, a prompt, a pre-text: it sets the scene for recollection. But if a photograph is somewhat contingent in the process of memory-production, what is the status of the memories actually produced?

Prompted by the photograph, I might recall, say, that the budgie was a gift from Harry to his little girl, Annette; that underneath two layers of knitted wool, the child is probably wearing a liberty bodice; that the room in which the photo was taken was referred to not as the sitting-room but as the lounge, or perhaps occasionally as the drawing-room. Make what you will of these bits of information, true or not. What you make of them will be guided by certain knowledges, though: of child-rearing practices in the 1950s, of fashions in underwear, of the English class system, amongst other things.

What I am saying is: memories evoked by a photo do not simply spring out of the image itself, but are generated in an intertext of discourses that shift between past and present, spectator and image, and between all these and cultural contexts, historical moments. In all this, the image figures largely as a trace, a clue: necessary, but not sufficient, to the activity of meaning-making; always signalling somewhere else. Cultural theory tells us there is little that is really personal or private about either family photographs or the memories they evoke: they can mean only culturally. But the fact that we experience our memories as peculiarly our own sets up a tension between the 'personal' moment of memory and the social moment of making memory, or memorising; and indicates that the processes of making meaning and making memories are characterised by a certain fluidity. Meanings and memories may change with time, be mutually contradictory, may even be an occasion for or an expression of conflict.

On the back of this photograph is written, in my mother's hand: 'Just back from Bournemouth (Convelescent) [sic]'. In my own handwriting 'Bournemouth' has been crossed out and replaced with 'Broadstairs', and a note added: 'but I suspect the photo is earlier than this'.

If, as this suggests, a photograph can be the site of conflicting memories, whose memory is to prevail in the family archive? This little dispute between a mother and a daughter points not only to the contingency of memories not attached to, but occasioned by, an image, but also to a scenario of power relations within the family itself. My mother's inscription may be read as a bid to anchor the meaning of a wayward image, and her meaning at some point conflicted with my own reading of the photograph and also irritated me enough to provoke a (somewhat restrained) retort. As it turns out, my mother and I might well both have been 'off' in our memories, but in a way this doesn't matter. The disagreement is symptomatic in itself, in that it foregrounds a mother–daughter relationship to the exclusion of something else. The photograph and the inscriptions point to this 'something else' only in what they leave out. What happens, then, if we take absences, silences, as evidence?

The absent presence in this little drama of remembering is my father. He is not in the picture, you cannot see him. Nor can you see my mother, except in so far as you have been told that she sought to fix the meaning of the image in a particular way, to a particular end. In another sense, however, my father is very much 'in' the picture; so much so that my mother's intervention might be read as a bid to exorcise a presence that disturbed her. The child in the photograph is absorbed with her pet bird, a gift from her father, who also took the picture. The relay of looks – father/daughter/father's gift to daughter – has a trajectory and an endpoint that miss the mother entirely. The picture has nothing to do with her.

Here is another story: about taking a photograph indoors at night in the 1950s, on (probably slow) black-and-white film in a 35mm camera. My father knew how to do this and get good results because photography was his job: he was working at the time as, if you like, an itinerant family photographer; canvassing work by knocking on likely-looking (that is to say, 'respectable' working-class) doors, taking pictures of children in the parents' homes or gardens, and developing and printing them in a rented darkroom. This must have been the last moment of an era when, if people wanted something better than a blurred snapshot from a Box Brownie,

they would still commission photographs of their children. The photo of me, no doubt, is the sort of picture Harry Kuhn might have made for any one of his clients.

Stylistically speaking, that is: for at this level the picture eschews the conventions of the family photograph to key, perhaps, into professional codes of studio portraiture; or into the cute-kiddie-with-pet subgenre of amateur photography. The peculiar context of this picture's production lends it very different cultural meanings, however, and imbues it with a kind and an intensity of feeling a professional or hobbyist piece of work would scarcely evoke. In this image, Harry's professional, his worldly, achievements are brought home, into a space where such achievements were contested, or at best irrelevant. In this photograph, my father puts himself there, staking a claim: not just to his own skills, to respect, to autonomy; but to the child herself. In this picture, then, Harry makes the child his own daughter. Later on, my mother would assert that this was not so, that Harry Kuhn was not my father.

Thus can a simple photograph figure in, and its showing set the scene for the telling of, a family drama – each of whose protagonists might tell a different tale, or change their own story at every retelling. What I am telling you – 'my own story' – about this picture is itself changeable. In each re-enactment, each re-staging of this family drama, details get added and dropped, the story fleshes out, new connections are made, emotional tones – puzzlement, anger, sadness – fluctuate.

Take my mother's caption to the picture – I don't know when it was written – and my own alteration and footnote, added because I believed she had misremembered a key event of my childhood. At eight years old (two years, that is, after the picture was taken) I was sent off to a convalescent home in Broadstairs, Kent, after a bad bout of pneumonia and a spell in hospital. The adult Annette took the apparent errors of time and place in her mother's caption (by no means an isolated instance) as yet another manifestation of obsessive (and usually 'bad') remembering; as an attempt by her mother to force others' memories into line with her own, however off-the-wall these might be. A capricious piece of power-play, if you like, but – given the transparent inaccuracy of the details – easily enough seen through.

Another, and more disturbing, reading of my mother's inscription is available, however: possibly the biographical details are correct after all, but refer not to me, the ostensible subject of the picture, but to my mother herself. Around the time the photograph was taken, she had suffered an injury at her job as a bus conductor, and been sent by London Transport to convalesce at the seaside. Is this perhaps the event to which the caption refers? If so, my mother is pinning the moment of a photograph of her daughter to an event in her own life.

In the first reading, my mother writes herself into the picture by claiming the right to define the memories evoked by it; and by omission and commission negates my father's involvement in both the photograph and the family. In the second reading, my own involvement as well as my father's is negated, as the caption constitutes a central place for the writer herself in a scenario from which she is so clearly excluded: my mother thereby sets herself up as both enunciator of, and main character in, the family drama.

The intensity of feeling attaching to these stories greatly exceeds the overt content of the tales of dissension and deception in the family I seem to have

unearthed: utter rage at my mother's egomaniac powermongering; sadness at the nullification of my father's stake in the picture/the family; joy in the possibility of remembering his nurturing me; grief over his loss of power and over my loss of him, for I was soon to become, in effect, my mother's property. My use of this photograph as a piece of evidence, a clue – as material for interpretation – is an attempt, then, to instate and enact if not exactly a father's, then certainly a daughter's, version of a family drama.

A photograph bearing a huge burden of meaning and of feeling, this one – to use Roland Barthes's term – *pierces* me. It seems to utter a truth that goes beyond the *studium*, the evidential, however intricately coded. My desire is that the little girl in the picture be the child as she is looked at, as she is seen, by her father. A friend who has not heard these stories looks at the picture, and says: There is a poignancy about her absorption with her pet; she looks lovable with her floppy hair ribbons and warm woollen clothing. Perhaps Harry Kuhn, in giving the child the gift of a living creature, and even more so in the act of making this photograph, affirms not merely a dubious paternity, but also that he loves this child. This photograph, I want to believe, is speaking a relation that excludes her, resists – perhaps finally transcends – my mother's attempt to colonise its meaning.

The stories, the memories, shift. There is a struggle over who is to have the last word – me; my father, the father who figures in my desire; my mother, the monstrous mother of my fantasy. With only one of the characters still alive to tell the tale, there is unlikely ever to be a last word, as the struggle over the past continues in the present. The struggle is now, the past is made in the present. Family photographs may affect to show us our past, but what we do with them – how we use them – is really about today, not yesterday. These traces of our former lives are pressed into service in a never-ending process of making, remaking, making sense of, our selves – now. There can be no last word about my photograph, about any photograph.

Here, then, is one more story: about a family album; about the kinds of tales (and the kinds of families) family albums construct; and about how my photograph was put to use once upon a time, and still survives to be used today, again and again.

Family photographs are quite often deployed – shown, talked about – in series: pictures get displayed one after another, their selection and ordering as meaningful as the pictures themselves. The whole, the series, constructs a family story in some respects like a classical narrative – linear, chronological; though the cyclical repetition of climactic moments – births, christenings, weddings, holidays (if not deaths) – is more characteristic of the open-ended narrative form of soap opera than of the closure of classical narrative. In the process of using – producing, selecting, ordering, displaying – photographs, the family is actually in process of making itself.

The family album is one moment in the cultural construction of family; and it is no coincidence that the conventions of the family album – what goes in and how it is arranged – are, culturally speaking, rather circumscribed. However, if the family album produces the family, produces particular forms of family in particular ways, there is always room for manoeuvre within this, as within any other, genre. People will make use of the 'rules' of the family album in their own ways.

The one and only family album in my family is a case in point. It was made by me at the age of eight, when I collected together some snapshots with a few studio

portraits and some of my father's relatively professional efforts, stuck them in an album (whose cover, significantly, sports the legend: 'Memory Lane'), and captioned them. Even at such an early age, I obviously knew all about the proper conventions of the family album: photos of myself, my parents, and a few of other relatives and of friends are all set out in chronological order – starting with a picture of me at six months old in the classic tummy-on-the-rug pose.

The eight-year-old Annette clearly 'knew', too, what a family album is for. If she was putting together her 'own' history, this sought to be a history of a family as much as of an individual; or rather, of an individual in a family. The history constructed is also an expression of a lack, and of a desire to put things right. What is being made, made up for, by the work of the album is the 'real' family that the child's parents could not make: this particular family story starts not with a wedding, but with a baby. The album's project is to position that baby, that child, the maker, within a family: to provide itself/herself with a family. Giving herself the central role in the story told by the album, the child also gives herself a family: not only positioning herself within a family, but actually bringing it into being – authoring it, parenting it.

Now, as I tell this story, I can set an interpretation of an eight-year-old girl's preoccupation with photographs alongside a reading, today, of a picture that figures in the collection she put together – a portrait of the same child, a couple of years younger, raptly involved with the pet bird perched in her hand. My mother's reading of that portrait is at odds not only with my present understanding(s) of it but also with the little girl's account, in the photograph album she made, of herself and of the family she wanted.

Whilst my 'Memory Lane' album contains a number of photographs of me as a baby and a toddler with my father, there are few early pictures of me with my mother. There is no way of knowing whether this is because no pictures of me with my mother were actually made; or whether it is because certain images were selected for the album in preference over others. Whatever the explanation, the outcome is that, in a child's first years, a father–daughter relationship is fore-grounded at the expense of that between a mother and daughter. Just as Harry's photograph of Annette excludes Betty, so too does the family album marginalise her. Or at least seems to try to: my mother does make more frequent appearances in its later pages, though still not often with me. Both these observations speak of conflict: between my father and my mother over me; between my mother and me over the 'truth' of the past. In all these struggles, my project was to make myself into my father's daughter. My mother's project – in an ironic twist of the oedipal triangle – was to cast herself as my only begetter. Not, however, with complete success: had her story carried the day, you would not now be reading mine.

My stories are made in a tension between past and present. I have said that a child's making a family album was an expression of, and an attempt to come to terms with, fears and desires; to deal with a knowledge that could not be spoken. These silences, these repressions, are written into the album, into the process of its making, and into actual photographs. All the evidence points in the same direction: some-thing in the family was not right, conflicts were afoot, conflicts a little girl could not really understand, but at some level knew about and wanted to resolve. Solving

the puzzle and acknowledging *in the present* the effects *in the past* of a disturbance in the family must be the necessary conditions of a retelling of the family story in its proper order.

As clues are scrutinised and pieces fitted together, a coherent story starts to emerge from the seeming contingency and chaos of a past hinted at by these fragments – a photograph, a photograph album, some memories. A coherent story not only absorbs the listener, but – being a moment in the production of self – satisfies the teller as well, for the moment at least.

Family photographs are about memory and memories: that is, they are about stories of a past, shared (both stories and past) by a group of people that in the moment of sharing produces itself as a family. But family photography is an industry, too, and the makers of the various paraphernalia of family photography – cameras, film, processing, albums to keep the pictures in – all have a stake in our memories. The memories promised by the family photography industry are characterised by pleasure and held-off closure – happy beginnings, happy middles, and no endings to all the family stories. In the way of these things, the promises point towards the future: our memories, our stories, *will* be. They *will* be shared, they *will* be happy – the tone of the seduction is quite imperious. With the right equipment to hand, we will make our own memories, capture all those moments we will some day want to treasure, call to mind, tell stories about.

The promise is of a brighter past in the future, if we only seize the chance today to consume the raw materials of our tomorrow's memories. This past-in-the-future, this nostalgia-in-prospect, always hooks into, seeks to produce, desires hingeing on a particular kind of story – a family story with its own forms of plenitude. The subject position publicly offered is, if not quite personal (consumption is, after all, a social activity), always in the 'private' realm of household and family. All this is familiar enough to the cultural commentator. But the discourses of consumerism form just one part of a bigger picture, one moment in a longer – and probably more interesting – story about the uses of family photography.

Desire is an odd thing. If it can be called upon, even if it can be harnessed to consumption, it can also be unruly and many-sided. It can run behind, or ahead of, the better past tomorrow promised by the family photography industry; it can run somewhere else entirely; it can, perhaps, not run at all. When we look at how family photographs may be used – at what people can do with them once they have them – past and present and the tension between them insert themselves into an equation weighted a little too much towards a certain sort of future. This can stir things up, confuse matters – possibly productively. Just as there is more than one way of making photographs, so there is more than one way of using them. If, however commonplace, my pictures and my stories are not everybody's, my uses of the one, and my method of arriving at the other, could well be.

Rosy Martin and Jo Spence

PHOTO-THERAPY

Psychic realism as a healing art?

The victim who is able to articulate the situation of the victim has ceased to be a victim; he, or she, has become a threat.'

James Baldwin

S INCE THE 1950S THERE HAS BEEN a massive development in private sector counselling and therapy in this country. This is a response to the overwhelming unmet needs of people, and is often in opposition to the official agencies of medicine, psychiatry and social welfare work which, however benevolent they may appear, still aim to confine and control. Institutionally, and particularly if we are women, (especially working class and/or Black women) we are encouraged to accept situations which we should resist. Women's working and domestic situations are often awful, but the resultant depression or anger is often so well contained, that eventually many of us become silenced or ill. Rather, we need forms of assertiveness training to assess our needs better and to try to get them met, individually and collectively. Our work is an intervention into the field of (and redefinition of) 'health education', since it engages with the institutionalised mind and body split of western culture.

[. . .]

An imag(in)ed identity?

It has been argued by such differing theoreticians as Winnicott and Foucault that there are various 'gazes' which help to control, objectify, define and mirror identities to us. Sometimes these gazes are loving or benevolent, but often they are more intrusive and surveilling. Out of the myriad fragments thus mirrored to us, first unconsciously as babies, then as we are growing into language and culture, aspects of our identities are constructed. Through the internalisation and synthesis

of these powerful gazes we learn to see and differentiate ourselves from others, in terms of our class, gender, race and sexuality, thence into other sub-groups. We learn the complexity of the shifting hierarchies within which we are positioned.

The mother represents the primary gaze, which is then transformed into the gaze of mother/father, within their conflicting power relationship. Yet the 'family' is itself positioned within the various discourses of society, which each set up their own gaze of definition, power and control. (For example when the powerful-to-the-child mother takes the child to the doctors she introduces the child to, and mediates between, the child and the discourses of medicine, in which situation she herself is relatively powerless.)

We discovered that we can re-enact these discursive gazes, which are not separate but overlap and reinforce each other. In particular we have reconstructed the gazes of mother and father (family); aspects of the communications industry; and various institutional discourses – for example medicine, fashion, education, law. Revisiting each of these has made it clear that they could be described as 'mirrors' in which we as individual children or adults saw, experienced, internalized (often in a self oppressive way) what those who were/are doing the mirroring or surveillancing were offering, constructing or defining from within their belief systems.

Our work has centred on family relationships, memory and history, so of particular interest has been the writings of the Austrian psychoanalyst Alice Miller.[1] Crucially, she has argued that within the family it is often the unmet narcissistic needs of parents, interlinked with the wider discourses of a given culture, that are basic to how a child is mirrored and 'sees' herself. We have found this of particular interest because in our photo-therapy work we have been criticised for being 'narcissistic' (always used as a pejorative term). Given that most of our work relates to the multifaceted concept of 'resistance', and that we are trying to unearth, make safe, and analyse the working through of such resistances, we would argue that, what we have unmasked through the re-enactment and mapping out of these gazes is a validation of our anger and discontent at our inability to come to terms with these fragmented selves constructed out of the needs, views, attributions of others and our powerlessness in relation to them.

What photo-therapy engages with is primarily the 'needy child' within us all which still needs to be seen and heard. The therapist has to become the advocate of this 'child' and to encourage her to recreate and witness her own history, to feel safe enough to protest, and then learn to become her own inner nurturer. Such work is not about 'parent blaming' but enables us to move beyond that dead end. Instead we re-invent and assert ourselves by becoming the subject rather than the object of our own histories.

[. . .]

A cultural context?

The images in circulation in a particular culture act to mould and set limits upon how each of us will 'see ourselves' and 'others'. Although we are never totally fixed by these images, they do shape our sense of reality. They are a major constituent of the dominant culture as well as being used continually to construct official histories.

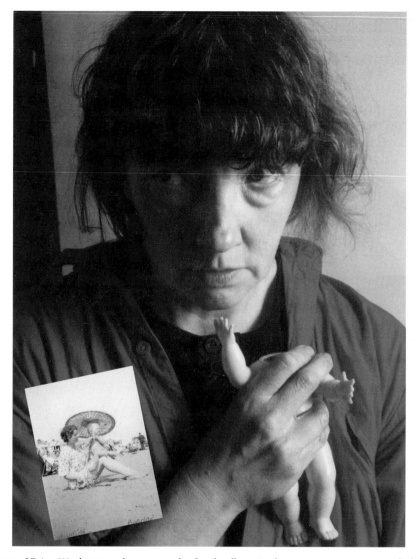

Figure 37.1 Working on absences in the family album I take as a starting point my feelings of abandonment when as an evacuee I was sent away from my family. Later I find a snapshot in a box of old pictures which shows my mother with the much loved new baby of the same period, circa 1940.

Sitter/director: Jo Spence. Photographer/therapist: Rosy Martin.

Courtesy of the Jo Spence Memorial Archive.

For some people, who are positioned by and identify with such all-pervasive imagery unproblematically, photo-therapy would seem to be a superfluous activity. If however, you are not acquiescent with the positions assigned to you, if you are constructed or labelled as one of the various 'Others' *vis à vis* your sexuality, disability, age, gender, race and class in this society, and in receipt of the negative projections of those with power, then you might wish to engage in work on identity to redefine yourself. You then become the active subject of your own dissonant

history. Photography seems to be an ideal tool since in contradistinction to the rest of the communications industry – most of us already have personal practices with our own cameras in the form of snapshotting and the *family album*. All we need to do is to re-define and re-invent such practices.

Our earliest photographs in family 'archives' have invariably been taken by adults who are themselves caught up within a set of aesthetic expectations, culled (whether they know it or not) from the discourses of popular photography. As examples, we cite the world-wide advertising of Kodak with its universalizing regime of images. Then there are the popular and amateur photographic magazines which fetishise technology, offering a voyeuristic gaze of the personally owned camera as a way of experiencing pseudo control in the world. Within the uneven power dynamics of the family, adults also have a vested interest in what is represented and what is not. It is hardly surprising therefore that the stories about ourselves which we can common-sensically construct from family albums probably say more about the histories of amateur and popular photography and their conventions than they do about the history of any given family or its individual members.

We can now understand, with hindsight, that the privately owned (though industrially produced) images of the family (pleasurable as they undoubtedly are) should not be seen as sources of information. Better perhaps that they be viewed as visual indices of the unconscious desires of parents (and those with institutional power, for example schooling) to provide evidence of their own 'good parenting'. 'It was in your own interests' said over a bland school photograph, or 'We did the best we could' and 'Look what a happy family we were', are phrases we recollect from looking at the album with our parents.

Family snaps hardly give any indication of the contradictions, power struggles or desires inherent at all levels of family life, or in the intersection of that life with the structures which make up a patriarchal society with sexual, racial and class divisions. On the other hand, taken as a genre, they give us infinite pleasure. Family albums if taken outside the family and viewed collectively can also contain valuable resource materials for social historians who are compiling dissenting histories of oppressed or minority groups. When the various histories of childhood come to be rewritten perhaps family albums will prove to be useful tools there.

Reinventing the family album?

We can conceive of three overlapping spheres of activity with which individuals and families can engage in order to become more aware of the contradictory workings of their own subjectivity and of their histories. These can best be described as follows:

1. By using existing family album photographs as a basis for telling stories, and beginning to unmask memories with a sympathetic listener or in a workshop or collective situation. The agenda for this is always set by the context, the degree of trust and the underlying goal of the process. Whilst the oral historian may be attempting to retrieve, record and give back a dissenting history to the speaker/s and their subject positions *vis à vis* class, race, gender or a range of institutions, the therapist is more concerned with the psychic interpretations of individuals.

2. Taking things further by creating a *new family album* through snapshotting and documenting that which is absent or customarily ignored. If we train ourselves to 'see' differently, visual markers of various rites of passage which are socially tabooed within the family album can be made. For example, divorce, illness and death; undervalued everyday events such as signing on for the dole, child care, schooling, housework, visiting the doctor. (The experience of those who have tried to take snapshots within institutional contexts immediately foregrounds the problem of the institutional gaze, as permission is often hard to obtain, or limited access only is offered. This in itself offers a useful learning process in relation to forms of external censorship and self censorship).

Events which could not be photographed at the time can be remembered through the photography of objects or places which 'stand in' for the person/s or objects involved. In this way it is possible to break down ideas of universalized experience and to provide a spectrum of markers of race, class and gender through the photography of work, conflict and 'less-than-ideal' aspects of self and family. These areas of life are often photographed by 'professionals' who make a living out of the misery of others, while they help to label and position people as 'victims'. By recording such events ourselves, particularly by those people who are powerless and marginalised by the dominant stories in circulation (e.g. in contradiction to the 'happy family') a new form of social autobiographical documentation can be put together.

3. By the creation and use of images of 'the theatre of the self as practised within photo-therapy. This practice can be especially useful for exploring the contradictory visual markers of sexuality, of power relationships, and expressing *our own* desires.

Photo therapy – 'Theatre of the Self'

Fundamental to our approach is that of ideally being non-judgmental, active, viewers and listeners. As Patrick Casement has noted, 'The therapist's presence therefore has to remain a transitional or potential presence (like that of a mother who is non-intrusively present with her playing child). The therapist can then be evoked by the patient as a presence, or can be used by the patient as representing an absence. This is the world of potential space which is part real and part illusory . . . The patient needs to be allowed opportunities for optimal experience without interference from the therapist . . . The therapist has to discover how to be psychologically intimate with a patient and yet separate, separate and yet still intimate.'[2]

Section 28 of the Local Government Act of 1988 in Britain states that: A Local Authority shall not:

a) Promote homosexuality or produce material for the promotion of homosexuality.
b) Promote the teaching in any maintained school of the acceptability of homosexuality as a pretended family relationship by the publication of such material or otherwise.
c) Give financial or other assistance to any person for either of the purposes referred to in paragraphs (a) or (b). Nothing of the above shall be taken to prohibit the doing of anything for the purpose of treating or preventing disease.

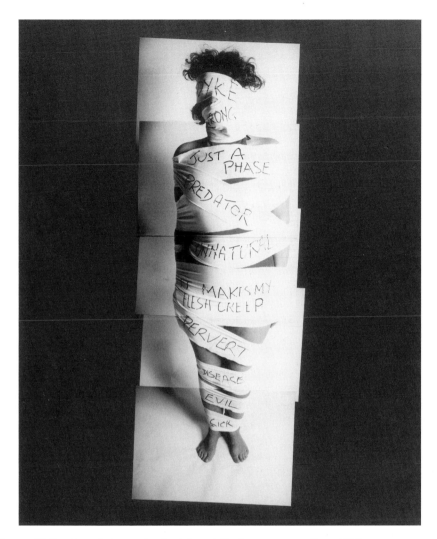

Figure 37.2 *Unwind the Lies that Bind.* Internalised oppressions. Circa 1988.

How does it feel to have the negative projections of others stuck upon me? To internalise their oppressive stereotypes? To be bound, contained and silenced by their hatred and their fear? What do they hate so forcibly? What do they fear so passionately? Why do they choose to scape-goat lesbians and gays? Easy targets?

There are a series of pejorative myths as to what a lesbian could and should be: myths arising from fear, ridicule and contempt, and perpetrated as a means of social control of all women.

Our susceptibility to absorbing oppressive ideas and theories has one major root cause, which is institutionalised in society, but not always recognised as such – the oppression of children and young people and the resultant sense of powerlessness instilled at an early age. Alice Miller has uncovered the 'poison' in universally accepted adult behaviour. Children are silenced. But the more suppressed the expression of any outrage, the more split off the hurt becomes. Hatred for the perpetrator is not allowed, so it is repressed, stored and internalised until it has some outlet in a socially sanctioned form such as racism, classism, misogyny and homophobia.

Sitter/director: Rosy Martin. Photographer/therapist: Jo Spence.

Photo: Courtesy of Rosy Martin.

Our own practice has always been client-centred and client-directed, and unlike most other therapies, has been done mostly on a reciprocal basis, exchanging the power positions of therapist and client. We have also drawn on a range of therapies; for example in psychodrama the sitter/client can act out with others past scenarios or patterns; in gestalt the sitter/client can role play or take up different positions within a family scenario or any other power dynamic, try them out, be heard and seen; in Neuro Linguistic Programming the sitter/client can 'reframe' past experience and examine the present limiting factors arising from it; and as in psychosynthesis, the sitter/client can work on various sub-personalities, personal or archetypal symbols, or visualizations. What photo-therapy enables is visual markers of such work, and is a form of self documentation unlike anything possible via snapshotting or naturalistic documentary modes of photography.

[. . .]

Why are photographs of value in therapy?

Apart from the inter-active process of photo-therapy itself, we have found that the photographs which result from sessions greatly enrich the ongoing therapeutic dynamic for the following reasons.

a) Whilst we know, intellectually, that photographs are not 'real', do not 'tell the truth', but are specific choices, constructions, frozen moments, edited out of time – yet we invest them with meaning. Still, most people believe that photographs have the power to signify 'truth'. It is this contradiction and tension that is so productive in the therapeutic process. As we view the images and witness their mutability it becomes apparent that 'truth' is a construct, and that identity is fragmented across many 'truths'. An understanding of this frees up the individual from the constant search for the fixity of an 'ideal self' and allows an enjoyment of self as process and becoming.

b) They act as a record, a mapping out, of the process gone through in a session, and the making visible of psychic reality. They act as a tangible marker of something which could otherwise go back into the unconscious and remain dormant for a long time.

c) They offer us the possibility to objectify and see a separate part of oneself which can then be integrated back into the overall subjectivity, or core self, as and when we are ready for it, as in psychosynthesis. Although photography objectifies, because photo-therapy is process-based, photographs can act as 'transitional objects' (as theorised by Winnicott) towards another reality. In this sense they can be seen as stepping stones.

d) Photographs can potentially provide unfiltered contact with the unconscious, transcending talking and making possible the direct use of images and symbols. For example, as Assagioli has said of psychosynthesis, symbols are seen as 'accumulators', in the electrical sense, as containers and preservers of a dynamic psychological charge.[3] This 'charge' or psychological energy can be transformed by the use of the symbol, channelled by it, or integrated by it. Symbols are especially powerful for transforming the unconscious which does not operate with the language of logic but with images.

e) They can prompt a cathartic release in that they are able to work directly on gut feelings without the interception of the intellect.

f) Transcending the single image, it is possible to order and re-order the photographs into a variety of mini-narratives, which in themselves can be moved around, providing an infinity of matrixes or montages. There is never a fixed story being told, no narrative closure. Transformation of fixed or screen memories thus become possible through such forms of visual montaging. By adding actual objects, or aspects of other media to photographs, we can make collages. These are effective methods of taking things to pieces and putting them together again differently.

g) Photo-therapy can make visible different 'parts' or 'sub personalities' of our subjectivity, as well as enabling us to explore different positions within a dynamic. Thus we can play cyclically with positions of authority and victimization, power and powerlessness and so on.

h) They can be used as a tool within other therapeutic practices – for example, as a starting point for further sessions.

i) Photographs can help us to 'unfreeze', acknowledge what has previously been resisted and repressed, then let go and move on from the material being worked through.

j) As well as enabling a coming to terms with 'negativity', photographs can be markers of triumph, a celebration of integration, and the successful exploration of an issue or pattern.

[. . .]

> Psychotherapy takes place in the overlap of two ' areas of playing, that of the patient and that of the therapist. Psychotherapy has to do with two people playing together The corollary of this is that where playing is not possible then the work done by the therapist is directed towards bringing the patient from a state of not being able to play into a state of being able to play Playing implies trust, and belongs to the potential space between (what was at first) baby and mother figure . . . It is in playing and only in playing that the individual child or adult is able to be creative and to use the whole personality, and it is only in being creative that the individual discovers the self.[4]

Notes

1 See in particular *Thou Shalt Not be Aware – Society's Betrayal of the Child*, Alice Miller, 1985, Pluto Press, and *The Drama of Being a Child*, Alice Miller, 1981. Virago (see also *Prisoners of Childhood*, *For Your Own Good*).

2 *On Learning from the Patient* by Patrick Casement, Tavistock Publications, 1985.

3 From D.W. Winnicott, *Playing and Reality*, Tavistock Publications, 1471.

4 *Psychosynthesis* by R. Assagioli, Turnstone Books, London, 1975. See also: *Putting Myself in the Picture*, by Jo Spence, Camden Press, 1986.

Angela Kelly

SELF IMAGE
Personal is political

THIS ARTICLE PROVIDES AN OPPORTUNITY to dispel a few myths and raise a few questions about photographic self-portraiture. The challenge I have presented to myself is to examine the use and misuse of self-portraiture, and to determine what relevance a seemingly private practice has to a public audience. It is important to look at and review what self-portraiture there is available for public consumption, and to attempt to analyse it from a critical position – that of a photographic self-portraitist.

Photographic self-portraiture has not been seriously analysed. As with most photography, assumptions are made and essential questions rarely asked. Pictures cannot be considered simple. Photographers need to be more aware of who they are communicating to and how the original intent of their work is affected by the context in which it is viewed. In passively accepting visual statements as works that 'speak' for themselves there is a danger that the underlying ideas are also accepted without question.

One idea that needs to be challenged is the basic notion that an individual artist is creating from her/his 'unique' experience; one should acknowledge art as a language of form within definite cultural parameters.

It seems from my observations that the terms 'self-expression' and 'self-portraiture' have become synonymous. This concept of self-expression also needs to be examined. Traditionally the activity and the term 'self-portrait' came from easel painting. From Rembrandt to Warhol self-portraiture has been freely accepted as a valid activity for artists. Whilst it was considered acceptable for the artist to produce a self-portrait, photographers never had the same licence. To record one's own image by means of a camera involved unwritten rules. The photographer usually presented her/himself in the role of artist or suggested status through objects of her/his particular profession. The association between self-portraiture and self-indulgence or vanity still prevails. The relationship that can exist between self-portraiture and self-awareness is rarely understood.

One simple definition of a self-portrait is that the artist/photographer makes an image purporting to reveal the 'inner' character of the sitter as opposed to a likeness. Both Steichen and Coburn depicted themselves, brush or printing press at hand, as artists revealing theft aspirations and demonstrating their equally dual talents at a time when Stieglitz was leading the debate over photography as an art.

Rembrandt, with his self-portraits, demonstrated not only his skill in his craft and art but that the creator of the work was also the subject. Early twentieth-century photographers, sensitive about their own artistic credibility, appropriated the painters' approach, making the content of their art the expression of the artist, missing the point that work such as Rembrandt's was also showing the inventory of a changing self-image.

Artist photographers also borrowed the idea that they could use nature as a metaphor for self. In photographing a 'nature' that they are a part of, they purport to reveal a world hitherto hidden that only creative insight can show. The end result, the image, then is left to speak for itself, telling us how the artist's 'soul' and 'psyche' has somehow processed nature.

> What lives in pictures is very difficult to define . . . it finally becomes a thing beyond the thing portrayed . . . some sort of section of the soul of an artist that gets detached and comes out to one from the picture. . . .
>
> Francis Brugiere, *Photographers on Photography* (ed. N. Lyons).

Pictures will always be ambiguous if photographers rely on Brugiere's methodology. The assumption again is that photographers are expressing aspects of their own unique vision when ideas are essentially part of a collective experience, one we all share. Personal experience should be seen in relation to a wider context. As Doris Lessing states at the beginning of the *Golden Notebook*:

> There is no way in not being intensely subjective. At last I understood that the way over or through this dilemma, the unease of writing about petty personal problems was to recognise that nothing is personal in the sense that it is uniquely one's own. Writing about oneself is writing about others.

The more isolated we are as individuals the less chance we have of developing trust and working together and the more precious individual contributions become.

However, the position of the 'self-expressive individual artist' is an ironic one. The illusion is that the artist is expressing her/himself. The reality is that any attempt at critically examining a concept of self in a wider social context is treated as taboo, as self-indulgence. We may look in the mirror only to check our appearance, not to see through it.

The use of self-expression in practice has also become synonymous with photographic 'seeing' – ways of ordering, selecting, and fragmenting the world through a camera. Holding up views as singular realities, an individualist view without any wider perspective. This approach tells us less about the actual world and more about a photographically viewed world. The subject of photographs becomes photography.

It is not sufficient to cultivate unconventional ways of photographing, as Friedlander has done in his book of self-portraits, and ascribe their uniqueness to an individual vision. This formulated approach can be mimicked by anyone. However, photographs about photography help make the point that the camera view is not a universal window on the world and this knowledge should be part of the content of the work. Photographers who formulate 'original' ways of photographing are considered to be self-expressive in their approach; in fact, there is a belief among photographers who use self-expression that every photograph is a self-portrait. The assertion allows photographers license to be 'self-expressive' without dealing with any concept of self at all.

It seems that this notion of self-expression should not be the only criteria for self-portraiture. What other uses then can self-portraiture be put to?

[. . .]

Self-portrait and self-image

One photographer and writer whose work functions on a more political level is Jo Spence. A feminist, Jo has been involved with a group of photographers, the *Hackney Flashers,* working in the East End, documenting aspects of working-class culture. She refers to her work as 'visual life-line' and in an article in *Spare Rib,* March 1978, discussed her way of working through extracts from her photographic album. The article, called 'Facing up to myself,' is an attempt to examine how she appears to 'the world' through photographs taken of her from eight months old up to the present day. She carefully juxtaposes images from the past and present to point out how a complete image is built up through stages. Her pictures show us how we have conventionally stereotyped poses for the camera which are encouraged and reinforced by the media. Her pictures and text work together to challenge the viewers' perception of themselves. Jo Spence points out the gap between how women are presented in the media and the more positive and active images of women produced by women themselves. Her pictures attempt to bridge that gap. Without the text the pictures in the article would be just another set of photographs from an album; the text is essential to the understanding of the idea. Because the pictures are not ends in themselves but serve as illustrations to the text, the overall photography is often banal, making literal rather than visual statements.

Photography is used to show 'life' as a literal record, ignoring the problem of distortion inherent within the medium itself in using photography to make statements of facts, 'objective truths'.

The photographs entitled 'feminist portrait' pose a number of problems regarding what constitutes a feminist approach. The fact that a feminist shot the pictures of another feminist hardly makes the content a feminist one. They can be seen as feminist, insofar as both the pose and expression of Jo Spence is a neutral one, the very opposite to the glamour poses of the media. More than one picture is provided which argues against an isolated static image, and finally an active dialogue between the sitter and the photographer is suggested through gesture, the sitter as much in control as the photographer.

The problem of dealing with self-portraiture for me is whether I can now make

feminism the central issue, and how to put that across. Using sexist imagery or stereotyped images can be misread as perpetuating sexist ideology. It is very difficult to articulate our oppression as women through a medium that is misused daily to exploit us. Male/female role reversal through photographs helps to show that women need not be defined by media stereotypes – getting a man to pose provocatively soon shows the ridiculousness of such gestures.

The meanings of the role become denaturalised and the separation of sex and roles begins to take place. Because woman's role is so tied up with her sexual identity and vice versa, many women have begun to challenge the notions of female sensibility.

Many women, as Lucy Lippard points out in *From the Centre*, (feminist essays on women's art), deal with sexual imagery in their work:

> When women use their own bodies in their art work they are using themselves: a significant psychological factor converts these bodies or faces from object to subject. However, there are ways and ways of using one's own body and women artists have not always avoided self-exploitation.
>
> There is a subtle abyss that separates men's use of women for sexual titillation from women's use of women to expose that insult.

It is taken for granted that a woman who uses herself in a photograph is being narcissistic. Women are using themselves in photography to very different ends to men. They are reclaiming back what is theirs, a right to self-defined sexuality.

In my work, which at first may not appear to look any different from other photographs, I am suggesting a new practice – the radical nature exists:

a) in the relationship between individual images
b) in the value and information that is extracted from them
c) in the context in which they are presented and viewed.

The issues are feminist in a wide sense in that they deal with aspects of my woman's experience. They begin to deal with a set of appearances, women's self-image, and involve all the complexities of doing that. The earliest self-portraits I made show more of a concern with photography than with a changing self-image. It was only in retrospect when I placed the pictures next to each other and combined them with text that I could see a developing consciousness of self. When I began the series, which is a continuous work, I tended to avoid the camera rather than confront it, until I could find some way of expressing myself from a feminist perspective. The problems I am concerned with are how women see themselves and how much that self-image defines their behaviour and limits their role. Women tend to model their own image on what is socially acceptable, generally a distorted male concept of femininity. There are few images of women which express typically 'male'-associated feelings of assertion, aggression, activity, self-confidence, etc. Yet positive images of women (although helpful for other women) do not point out the discrepancies between how women actually are and how they are reflected in the media. Congenial active images of ourselves are good role models which women badly need but it is not enough to present more idealistic images of ourselves. What

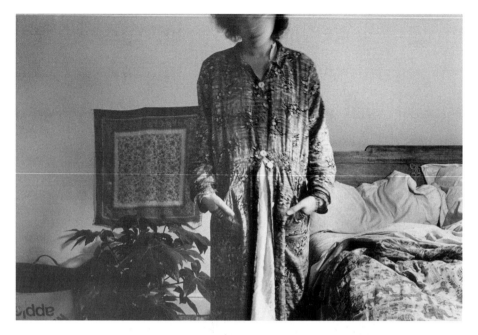

Woman's Identity 1

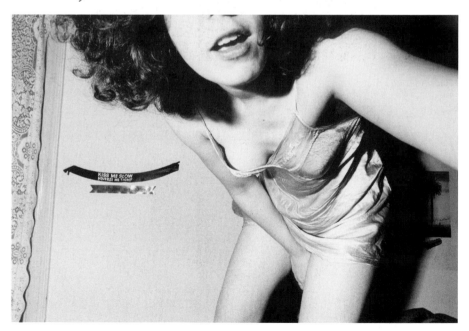

Woman's Identity 2

Figure 38.1 Taking self-portraits creates all sorts of problems and raises questions both practical and psychological which don't exist within the ordinary reference of portraiture. Although taking portraits of others is a socially acceptable activity, self-portraiture has been considered self-indulgent. The self-analysis, within a social context, that I am attempting is a challenge to that assumption and directs the viewer to challenge his/her self-image. Angela Kelly.

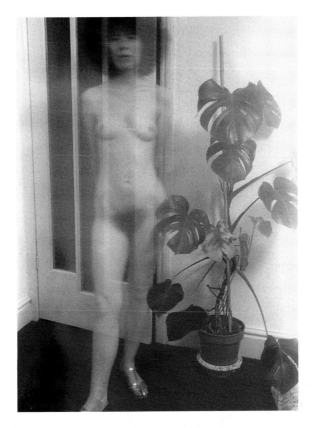

Woman's Identity 3

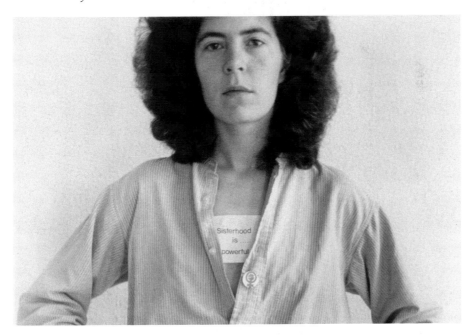

Woman's Identity 4

need to be challenged are the images and role stereotypes that are reinforced daily through the media. My photographs are an attempt to challenge that and can be seen as a positive step towards defining my own sexuality, redefining my role for myself from a feminist perspective.

Turning the camera on to the photographer involves problems that do not exist within the ordinary reference of portraiture – the photographer becomes her/his own sitter and, unless a mirror is used to check the pose, the moment recorded is only 'felt' rather than seen through the camera. The final result is only seen at the contact stage and often the results can be surprising as there is a greater element of chance involved in the unmediated process. To photograph oneself, one has to stand in front of the camera and not behind it. The camera confronts the photographer rather than separates the photographer from the subject. One learns to accept 'unflattering images.' We do tend to carry around a static view of ourselves in our head, catching ourselves in a mirror unawares, we are often shocked at our own self-image. We get some idea how we appear to others.

There is a risk and fear of self-exploitation when making self-portraits. The photographer is in the very vulnerable position of opening up and stating how she/he is, but it is a position that is continually developing and evolving.

Women have been particularly dealing with this area of women's identity through photography because we live in a society where women are assigned a negative place. The very language we speak is male-dominated and women's identity is constricted around this negative role. Woman's identity is tied up with her need to be a person but, in our society, person automatically stands for male. It is contradictory for women to see themselves as persons before women. My work is an attempt to challenge that negative role and I think it also indicates how a personal experience can have a wider social purpose.

Contexts: gallery, museum, education, archive

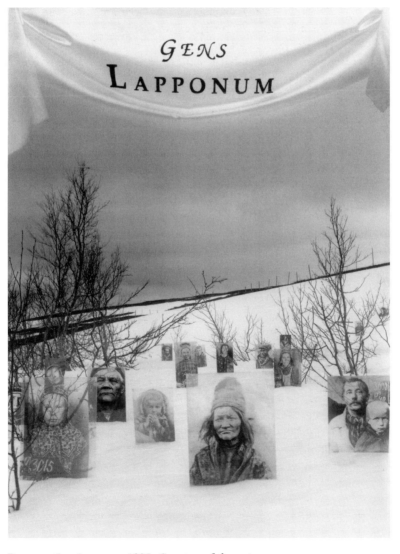

Jorma Puranen, *Gens Lapponum*, 1995. Courtesy of the artist.

Introduction

IN HIS SERIES, *IMAGINARY HOMECOMING*, Finnish photographer, Jorma Puranen, rephotographed portraits of Sami people found in the Musée de L'Homme in Paris, printed them onto Plexiglas sheets, which he placed and photographed in Lapland, metaphorically returning a people to their homeland landscape. Central to the concept for this series was the re-locating of images; the work both operates through and encourages us to reflect upon change of context.

Within sociology, institutions are generally viewed as the point of intersection between the economic and the cultural. Thus the family, the media, the art gallery, and so on, can be seen to be simultaneously economic organisations and sites of sociopolitical interaction. Such institutions become contexts within which meaning is complexly negotiated, with photographic imagery contributing centrally within the ebb and flow of the knowledge economy. John Tagg has used the terms 'circulation' and 'currency', more normally associated with finance, to refer to the trajectory of the photograph as it moves with fluidity through time and space, from one context to another, used for different purposes by different groups of people (Tagg 1988).

Photographic meaning is partly determined at the moment of production, through choice of subject-matter, technical and photographic codings, and so on. But it is also extensively influenced by particular situations of reception. Contrast, for example, the school photograph displayed on the family mantelpiece, where it honours a particular child, with the inclusion of the same photograph within the photographer's portfolio, where the stress is on professionalism, or in the school's annual report, wherein the emphasis may be on student achievement. In effect, there is a negotiation between content and context, within which the viewer's interest in, or use of, the photograph plays a key role. A photograph may be included in a newspaper report or exhibited as part of a series on the gallery wall or within a website, but what we look for in each of these contexts, and how we see the image, differs. Shifts in ways of seeing are influenced, consciously and unconsciously, by contemporary presumptions and concerns. This may lead, for instance, to the viewer reading 'against the grain' of an image or artifact. Art theorist, John A. Walker, gives the example of a statue unveiled in Warsaw in 1933 commemorating fallen war heroes: 'it represented a gladiator struck to death in the arena raising himself on his elbow to draw his last breath. The populace of Warsaw understood its official meaning perfectly well but they proposed an unofficial meaning by declaring that it represented the Polish people expiring under the burden of taxation!' (Walker 1980: 61) This oppositional reading reflected the particular economic context.

Simon Watney, then working in photography education, noted the inter-relation of the political and the ideological, but distinguished between political struggles relating to institutions of employment, the state, education and healthcare, on the one hand, and, on the other hand, ideological struggles within the field of representation:

> Whilst photography may engage with the established practices of polit-
> ical struggle, through the use of the camera on demonstrations, at
> pickets and so on, it should be clear that this does not mean that the
> resulting images are in themselves 'intrinsically' political. They can only
> become so in relation to other institutions such as Law Courts,
> Industrial Tribunals, and so on, where they can 'take on' political values.
>
> (Watney 1986:189)

Taking issue with crude Marxist notions of class determinism – over which debates
were raging in Britain within the cultural studies movement and in response to
feminist critiques of patriarchy – he adds, that this does not mean that the cultural
is somehow secondary to struggles in the economic sphere. This echoes the
emphasis by French philosopher, Michel Foucault, on the inextricable inter-rela-
tion of knowledge, power and individual subjectivity (Foucault, 1974).

The range of contexts implicated in photographic meaning and interpretation
is potentially all-encompassing. Here, this section – itself a sub-section within the
broader context of a collection of writings on photography – emphasises the art
gallery, museum and archive as contexts. Art institutions reflect particular contem-
porary preoccupations, indeed, may seem overly subject to shifts in aesthetic
sensibilities or in social concerns (consider what sorts of themes or types of work
predominate in museums and galleries local to you). Trends can be traced through
exhibition themes, the fashionability of certain artists, in art market price structures
or in museum acquisition policies (all of which are inter-connected). Trends may
also be discerned through shifts in installation design (for instance, the exit of the
modernist 'white cube'), or in types of accompanying publications and events.
Specific tendencies and priorities may not always seem evident at the time;
however, the archives of exhibition catalogues, press reviews and academic essays
together indicate, retrospectively, characteristics of particular eras. For instance,
in the mid-1990s, Women's Art (UK) was re-launched as MAKE in effect
distancing the magazine from the no longer fashionable feminist debates of the
1970s and 1980s which had informed its original purpose and rationale.

In the first essay included in the section, written at a time of initial attempts
to account for the end of modernism and to define the 'postmodern', Douglas
Crimp dryly remarks on the ambiguous position of photography, newly espoused
and recontextualised as art by the institutions of modern art precisely at the point
of loss of confidence in the tenets of modernism. First published in *Parachute*, the
critical journal of art and literature, Ontario, Canada, this section is extracted from
his book *On the Museum's Ruins* in which he critically examines the role and
status of art institutions in contemporary culture.

In Britain, at the end of the 1980s, although photography workshops and a
number of regional galleries were well established as was the photography
section at the V & A in London (the national collection of the 'art of photography'),
photography – as opposed to fine art practices utilising photographic means –
was still treated as something of a 'lesser art' by art critics. Liz Wells' discussion
of the role and influence of the reviewer is an extended version of a piece first

commissioned for *LightReading* (then a photography newsletter for South West England).

David Bate sketches relations between art, theory and photography indicating their fluid overlapping discursive presence, and muses on the situation of photography in education, the relation of photographic practice and theory to the new institutionalisation of photography as art, and implications of the rise of a domestic styled 'snapshot' aesthetic. The context for the paper, commissioned for the Norwegian journal *Hyperfoto* in 1997, was that, in the early 1990s, Bate was a guest lecturer at the art school in Bergen which offered the first photography (as opposed to fine art) course in Norway which considered photography as an art.

Finally, Allan Sekula draws attention to the constitution of archives. This much reproduced essay was originally written as the introduction to a longer three-part essay for a book of mining and other photographs from the Shedden Studio, Cape Breton, Canada, published in 1983, in which the focus was upon work, industry and everyday life. The book was intended not only to reproduce images from that archive but also as a critique of other picture books and an opportunity to encourage the reader to consider the density of meaning of pictures, and ways in which events, past and present, are represented through images. The essay was first published in Britain as a part of a collection of critical papers and photo projects on politics and photography selected to reflect then current debates around photography education and practice. In that particular context the emphasis seemed more upon interrogating archives than upon the particular Canadian example – as, indeed, remains the case given its inclusion here.

References and selected further reading

Boltanski, L. and Chamboredon, J-C. (1965) 'The Expectation of the Profession and the Expectations of the Professionals' in Pierre Bourdieu (1990) *Photography: A Middle-brow Art*. London: Polity Press.
Original French publication 1965.
Foucault, M. (1974) *The Archaeology of Knowledge*. London: Tavistock.
Original French publication, 1969.
Tagg, J. (1988) *The Burden of Representation*. London: Macmillan.
Walker, J.A. (1980) 'Context as a Determinant of Photographic Meaning' in Jessica Evans (ed.) (1997) *The Camerawork Essays*. London: Rivers Oram Press.
Watney, S. (1986) 'On the Institutions of Photography' in Holland *et al. Photography/Politics Two*. London: Comedia.

Bibliography of essays in Part Nine

Bate, D. (1997) 'Art, Education, Photography' first published in *Hyperfoto*. Norway.
Crimp, D. (1993) 'The Museum's Old, the Library's New Subject' in *On The Museum's Ruins*. Cambridge, Mass: MIT Press.

Sekula, A. (1983) 'Reading an Archive: Photography between Labour and Capital' in Patricia Holland, Jo Spence and Simon Watney (eds) (1986) *Photography/Politics Two*. London: Comedia.

Wells, L. (2002) 'On Reviewing Photography' in *The Photography Reader*. London: Routledge.

Original version published in *LightReading* 2, May 1992, Somerset: South West Independent Photographers Association.

Douglas Crimp

THE MUSEUM'S OLD, THE LIBRARY'S NEW SUBJECT

[. . .]

S EVERAL YEARS AGO, JULIA VAN HAAFTEN, a librarian in the Art and Architecture Division of the New York Public Library, became interested in photography. As she studied what was then known about this vast subject, she discovered that the library itself owned many books containing vintage photographic prints, especially from the nineteenth century, and she hit on the idea of organizing an exhibition of this material culled from the library's collections. She gathered books illustrated with photographs from throughout the library's many different divisions, books about archeology in the Holy Lands and Central America, about ruined castles in England and Islamic ornament in Spain; illustrated newspapers of Paris and London; books of ethnography and geology; technical and medical manuals.[1] In preparing this exhibition the library realized for the first time that it owned an extraordinarily large and valuable collection of photographs – for the first time, because no one had previously inventoried these materials under the single category of photography. Until then, the photographs had been so thoroughly dispersed throughout the library's extensive resources that it was only through patient research that van Haaften was able to track them down. And furthermore, it was only at the time she installed her exhibition that photography's prices were beginning to skyrocket. So although books with original plates by Maxime Du Camp or Francis Frith might now be worth a small fortune, ten or fifteen years ago they weren't even worth enough to merit placing them in the library's Rare Books Division.

Julia van Haaften now has a new job. She is director of the New York Public Library's Photographic Collections Documentation Project, an interim step on the way to the creation of a new division to be called Art, Prints, and Photographs, which will consolidate the old Art and Architecture Division with the Prints Division, adding to them photographic materials culled from all other library departments)[2]. These materials are thus to be reclassified according to their newly acquired

value, the value that is now attached to the 'artists' who made the photographs. Thus, what was once housed in the Jewish Division under the classification 'Jerusalem' will eventually be found in Art, Prints, and Photographs under the classification 'Auguste Salzmann.' What was Egypt will become Beato, or Du Camp, or Frith; Pre-Columbian Middle America will be Désiré Charnay; the American Civil War, Alexander Gardner and Timothy O'Sullivan; the cathedrals of France will be Henri LeSecq; the Swiss Alps, the Bisson Frères; the horse in motion is now Muybridge; the flight of birds, Marey; and the expression of emotions forgets Darwin to become Guillaume Duchenne de Boulogne.

What Julia van Haaften is doing at the New York Public Library is just one example of what is occurring throughout our culture on a massive scale. And thus the list goes on, as urban poverty becomes Jacob Riis and Lewis Hine, portraits *of* Delacroix and Manet become portraits *by* Nadar and Carjat, Dior's New Look becomes Irving Penn, and World War II becomes Robert Capa. For if photography was invented in 1839, it was only *discovered* in the 1960s and 1970s – photography, that is, as an essence, photography *itself*. Szarkowski can again be counted on to put it simply:

> The pictures reproduced in this book [*The Photographer's Eye*] were made over almost a century and a quarter. They were made for various reasons by men of different concerns and varying talent. They have in fact little in common except their success, and a shared vocabulary: these pictures are unmistakably photographs. The vision they share belongs to no school or aesthetic theory, but to photography itself.[3]

It is in this text that Szarkowski attempts to specify the particulars of 'photographic vision,' to define those things that are specific to photography and to no other medium. In other words, Szarkowski's ontology of photography makes photography a *modernist* medium in Clement Greenberg's sense of the term – an art form that can distinguish itself in its essential qualities from all other art forms. And it is according to this view that photography is now being redefined and redistributed. Photography will hereafter be found in departments of photography or divisions of art and photography. Thus ghettoized, it will no longer primarily be *useful* within other discursive practices; it will no longer serve the purposes of information, documentation, evidence, illustration, reportage. The formerly plural field of photography will henceforth be reduced to the single, all-encompassing *aesthetic*. Just as paintings and sculptures acquired a new-found autonomy, relieved of their earlier functions, when they were wrested from the churches and palaces of Europe and consigned to museums in the late eighteenth and early nineteenth centuries, so now photography acquires *its* autonomy as it too enters the museum. But we must recognize that in order for this new aesthetic understanding to occur, other ways of understanding photography must be dismantled and destroyed. Books about Egypt will literally be torn apart in order that photographs by Francis Frith may be framed and placed on the walls of museums. Once there, photographs will never look the same. Whereas we may formerly have looked at Cartier-Bresson's photographs for the information they conveyed about the revolution in China or the Civil War in Spain, we will now look at them for what they tell us about the artist's style of expression.

* * *

This consolidation of photography's formerly multiple practices, this formation of a new epistemological construct in order that we may now *see* photography, is only part of a much more complex redistribution of knowledge taking place throughout our culture. This redistribution is associated with the term *postmodernism,* although most people who employ the word have very little idea what, exactly, they're naming or why they even need a new descriptive category. In spite of the currency of its use, *postmodernism* has thus far acquired no agreed-upon meaning at all. For the most part, it is used in only a negative sense, to say that modernism is over. And where it is used in a positive sense, it is used as a catch-all, to characterize anything and everything that is happening in the present. So, for example, Douglas Davis, who uses the term very loosely, and relentlessly, says of it,

> 'Post-modern' is a negative term, failing to name a 'positive' replace- ment, but this permits pluralism to flourish (in a word, it permits *freedom,* even in the marketplace). . . . 'Post-modern' has a reactionary taint – because 'Modern' has come to be acquainted with 'now' – but the 'Tradition of the New' requires a strong counter-revolution, not one more forward move.[4]

Indeed, counterrevolution, pluralism, the fantasy of artistic freedom – all of these are, for many, synonymous with postmodernism. And they are right to the extent that in conjunction with the end of modernism all kinds of regressive symptoms are appearing. But rather than characterizing these symptoms as postmodernist, I think we should see them as the forms of a retrenched, a petrified, reductive modernism. They are, I think, the morbid symptoms of modernism's demise.

Photography's entrance into the museum on a vast scale, its reevaluation accord- ing to the epistemology of modernism, its new status as an autonomous art – this is what I mean by the symptoms of modernism's demise. For photography is not autonomous, and it is not, in the modernist sense, an art. When modernism was a fully operative paradigm of artistic practice, photography was necessarily seen as too contingent – too constrained by the world that was photographed, too dependent upon the discursive structures in which it was embedded – to achieve the self-reflex- ive, entirely conventionalized form of modernist art. This is not to say that no photo- graph could ever be a modernist artwork; the photographs in MOMA's *Art of the Twenties* show were ample proof that certain photographs could be as self-consciously about photographic language as any modernist painting was about painting's partic- ular conventions. That is why MOMA's photography department was established in the first place. Szarkowski is the inheritor of a department that reflected the mod- ernist aesthetic of Alfred Stieglitz and his followers. But it has taken Szarkowski and *his* followers to bestow retrospectively upon *photography itself* what Stieglitz had thought was achieved by only a very few photographs.[5] For photography to be under- stood and reorganized in such a way entails a drastic revision of the paradigm of modernism, and it can happen only because that paradigm has indeed become dysfunctional. Postmodernism may be said to be founded in part on this paradox: it is photography's reevaluation as a modernist medium that signals the end of mod- ernism. Postmodernism begins when photography comes to pervert modernism.

* * *

If this entry of photography into the museum and the library's art division is one means of photography's perversion of modernism – the negative one – then there is another form of that perversion that may be seen as positive, in that it establishes a wholly new and radicalized artistic practice that truly deserves to be called post-modernist. For at a certain moment photography enters the practice of art in such a way that it contaminates the purity of modernism's separate categories, the categories of painting and sculpture. These categories are subsequently divested of their fictive autonomy, their idealism, and thus their power. The first positive instances

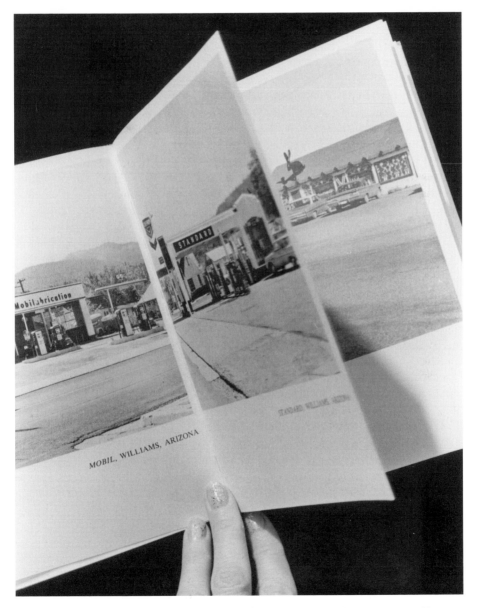

Figure 39.1 Louise Lawler, photo of Ed Ruscha, *Standard, Amarillo, Texas*. From *Twentysix Gasoline Stations*, 1962. Courtesy of the Gagosian gallery.

of this contamination occurred in the early 1960s, when Robert Rauschenberg and Andy Warhol began to silkscreen photographic images onto their canvases. From that moment forward, the guarded autonomy of modernist art was under constant threat from the incursions of the real world that photography readmitted to the purview of art. After over a century of art's imprisonment in the discourse of modernism and the institution of the museum, hermetically sealed off from the rest of culture and society, the art of postmodernism begins to make inroads back into the world. It is photography, in part, that makes this possible, while still guaranteeing against the compromising atavism of traditional realism.

Another story about the library will perhaps illustrate my point: I was once hired to do picture research for an industrial film about the history of transportation, a film that was to be made largely by shooting footage of still photographs; it was my job to find appropriate photographs. Browsing through the stacks of the New York Public Library where books on the general subject of transportation were shelved, I came across the book by Ed Ruscha entitled *Twentysix Gasoline Stations*, first published in 1963 and consisting of photographs of just that: twenty-six gasoline stations. I remember thinking how funny it was that the book had been mis-catalogued and placed alongside books about automobiles, highways, and so forth. I knew, as the librarians evidently did not, that Ruscha's book was a work of art and therefore belonged in the art division. But now, because of the reconfigurations brought about by postmodernism, I've changed my mind; I now know that Ed Ruscha's books make no sense in relation to the categories of art according to which art books are catalogued in the library, and that that is part of their achievement. The fact that there is nowhere for *Twentysix Gasoline Stations* within the present system of classification is an index of the book's radicalism with respect to established modes of thought.

The problem with the view of postmodernism that refuses to theorize it and thereby confuses it with pluralism is that this view lumps together under the same rubric the symptoms of modernism's demise with what has positively replaced modernism. Such a view has it that the paintings of Elizabeth Murray and Bruce Boice – clearly academic extensions of a petrified modernism – are as much manifestations of postmodernism as Ed Ruscha's books, which are just as clearly replacements of that modernism. For Ruscha's photographic books have escaped the categories through which modernism is understood just as they have escaped the art museum, which arose simultaneously with modernism and came to be its inevitable resting place. Such a pluralist view of postmodernism would be like saying of modernism at its founding moment that it was signaled by both Manet *and* Gérôme (and it is surely another symptom of modernism's demise that revisionist art historians are saying just that), or, better yet, that modernism is both Manet and Disdéri, that hack entrepreneur who made a fortune peddling photographic visiting cards, who is credited with the first extensive commercialization of photography, and whose utterly uninteresting photographs hang, as I write this essay, in the Metropolitan Museum of Art in an exhibition whose title is *After Daguerre: Masterworks from the Bibliothèque Nationale*.

Notes

1 See Julia van Haaften, '"Original Sun Pictures": A Check List of the New York Public Library's Holdings of Early Works Illustrated with Photographs, 1844–1900,' *Bulletin of the New York Public Library* 80, no. 3 (Spring 1977), pp. 355–415.

2 See Anne M. McGrath, 'Photographic Treasures at the N.Y.P.L.,' *AB Bookmans Weekly*, January 25, 1982, pp. 550–560. As of 1982, the photography collection, of which Julia van Haaften is the *curator*, was integrated into what is now called the Miriam and Ira D. Wallach Division of Art, Prints, and Photographs.

3 Szarkowski, 'Introduction,' p. 206.

4 Douglas Davis, 'Post-Everything,' *Art in America* 68, no. 2 (February 1980), p. 14. Davis's notion of freedom, like that of Picasso's fans, is the thoroughly mythological one that recognizes no social differences determined by class, ethnicity, race, gender, or sexuality. It is therefore highly telling that when Davis thinks of freedom, the first thing that springs to his mind is 'the marketplace.' Indeed, his notion of freedom appears to be the Reagan-era version of it – as in 'free' enterprise.

5 For a history of MOMA's Department of Photography, see Christopher Phillips, 'The Judgment Seat of Photography, *October*, no. 22 (Fall 1982), pp. 27–63.

Liz Wells

WORDS AND PICTURES
On reviewing photography

Art is an interpreter of the inexpressible, and therefore it seems a folly
to try to convey its meaning afresh by means of words.

Edward Weston, 1930[1]

THE ORIGINS OF THIS ESSAY lie in a contribution, in 1992, on review-
ing photography, commissioned by *LightReading* a newsletter whose target
readership was photo practitioners in the south-west of Britain. The newsletter was
one of a number of initiatives throughout Britain which, variously, stressed regional
networks, thereby, amongst other things, tacitly resisting the hegemony of the
metropolitan. I had spent some years writing for national photography magazines,
including editing two issues of the London-based, *Camerawork*. Living in the south-
west I was often called upon to cover events in the region; hence the invitation to
write about reviewing. The immediate context was regional, but nationally, photog-
raphy exhibitions and publications seemed to attract relatively little critical
coverage.[2] My concern here is to reflect upon the role of the critic in relation to
photography exhibitions taking some account of changing understandings both of
photography and of aesthetic judgment.

Words and pictures

One of the most difficult tasks in writing about photographs, indeed, all visual arts,
is to find words which in any way adequately describe the visual object. This is an
issue whatever the context of publication. Books have limited budgets for repro-
duction and exhibition catalogues may not detail all that is included in a show. For
reviewers (of photography books, or exhibitions) this difficulty is compounded if a
commissioning magazine or journal only include one illustration. This is particularly
impossible with group shows, where work may be very varied in form and style.

But no body of work can be adequately summed up in a single picture. If it could be, why make more than one image?! So the writer ends up using words to describe work. Photographic works have scale, tonal texture, colour intensity, and they may be framed and inter-relate within particular environments within which they are encountered. Illustrations in catalogues, reviews or essays are usually poor substitutes, as are publicity images in press releases or on event websites. Pictures do not necessarily speak louder than words, but they speak differently, with visual language sensitive to context. As Magritte remarked, a painting of a pipe is not a pipe! Likewise, words may be used to describe images and their import, but they cannot convey the affective impact of objectness – scale, physicality and presence within the space of the gallery, website or publication. It follows that words, when used to speak about pictures, seem inadequate. Photography books are something of an exception here as they are in themselves bookart, although reviewers may still have difficulty conveying the full import of a particular publication.

Where exhibitions are concerned, critics take responsibility for feedback to artists and for mediation with audiences. As Mary Kelly has noted, the catalogue outlives the exhibition itself and, as such, comes to be its key marker in history.[3] The way in which work is 'framed' by catalogue essays crucially contributes to characterising status and significance. Reviews and other published critical responses also outlive exhibitions and, along with the catalogue, contribute to marking an event. Descriptions and viewpoints become material for archivists and cultural archaeologists. Ultimately books and archives, reviews and critical essays, along with pictures and other artifacts, conglomerate as testament to the broader intellectual parameters, priorities and academic currencies of particular eras and contexts.

Contexts

Debates about the nature, place and contribution of photography reflect differing cultural understandings and priorities. For instance, British documentary is supported by and feeds into particular kinds of realist writing. But photography tended not to figure within the modernist experimental agenda in Britain which was more associated with early twentieth century literature. This contrasted with elsewhere in Europe, for instance, France, where photography, along with film, became integral to art movements of the 1920s,[4] or Germany where it played a central role in Bauhaus debates and experiments.[5] In Britain, photography, remained relatively overlooked in art historical and critical terms, and had little place in the art institution until the 1980s witnessed a steadily developing network of photography galleries, several major shows, the consolidation and expansion of photography studies (at university level and elsewhere) and enhanced interest in photo-archives.

That photography has not always been viewed as an art form equal in status – albeit different to – painting and sculpture contributes to accounting for the relatively undeveloped state of photography theory and criticism in terms of photo-images, form and subject-matter, and contexts of production and consumption. Nonetheless, foundations for serious study of the medium, taking into account the inter-play of the social and the aesthetic, were laid throughout the twentieth century.

The 1970s and 1980s witnessed an acceleration here as modern certainties and hier-archies came under scrutiny. Semiology engaged the visual and, after a pause, key semiological texts were translated into English causing a flurry of excitement in Anglo-American circles.[6] Photo-historical research and analysis broadened to include more vernacular modes such as social archives and family albums; the canon of great 'masters' of photography which institutions such as MOMA had sought to foster through exhibitions and publications, came up for debate; simultaneously, historical and critical studies acquired a place within the university curriculum.

Thus, paradoxically, in Britain, as in North America, just as photography had acquired a degree of acceptance as art – and photographers as artists – the modernist critical agenda was hijacked, initially by post-modern theoretical misgivings and subsequently by the onslaught of the digital. Debates and understandings about the act of photography, about photographs as semiotic artifacts, and the everydayness of photo-aesthetics undermined any illusory sense of security about the space of photography as art, whilst, simultaneously, photo-video media became incorporated within a wide range of new postmodernist arts practices. Within the museum and the university one response was a new seriousness of academic intent in relation to photography history and culture, both as academic discipline and in terms of archiving and conservation. Fuller emphasis was laid upon proactive policies for enhancing photo-collections as well as exhibition programming. This overlaid and inter-acted with more conservative interest in specific photographers. In promoting photography as art the Museum of Modern Art in New York opened space for photographs to figure increasingly forcefully within the international art market. This all variously contributed to the everyday circulation of ideas and debates about photography which forms the critical context within which writers operate.

Reviewing photography now

Artists, galleries, agents, museums, publishers, all seek coverage of their work. In part there is genuine interest in critical feedback or debate; in part this acts as publicity for the work, the artist and the gallery. But the reviewer is not a press agent. The relationship between the critic and photographers or institutions can be an uneasy one. Typically, the gallery public relations officer is young, pleasant and helpful. At openings she – for it is often a woman – plies the reviewer with press pictures and alcohol (usually in reverse order); she will make a point of introducing the photographer(s) and exhibition curator(s). This is a part of her job. From the point of view of the gallery, the aim is to get free publicity as, regardless of what is written – to paraphrase Oscar Wilde rather freely – the most important thing from the gallery point of view is to be talked about. Some writers never go to opening nights, preferring to seek calmer moments for engagement with the work.[7] Nonetheless, as Abigail Solomon-Godeau has emphasised, criticism remains inte-grally caught up in the commodification of 'art' with the critic functioning 'as a kind of intermediary between the frenzied pluralism of the marketplace and the sacralised judgment seat that is the museum'.[8] Criticism contributes to celebrating the status of artists and *oeuvres,* assuring significance in terms of the gallery and museum; by extension, artworks become viewed as collectible, thus economic status within the

art market is assured. Frequency of citation may come to seem as important as seriousness of critical intent!

For critics there is intellectual pleasure in reflecting upon the affect and import of particular artworks, engaging in current debates about developments within photography as a field of rather varying practices, and gearing discussion towards particular types of readership (academic, arts practitioners, daily press). But, there may be a tension between the needs of the gallery for immediate publication as publicity, and artists' aspirations for a considered response published in a serious context. Self-doubt, and desire for acclaim and support, means that photographers (also curators, editors, publishers) are sensitive to preliminary responses at exhibition openings, archive open events, or book launches. However, in my experience, photographers seek serious consideration and perceptive feedback. Likewise, most critics are driven primarily by fascination with their subject. Some are journalists with regular arts columns; a number are also practitioners. Others are based in academic institutions wherein stress is laid upon their publication profile as academic researchers engaged with contemporary ideas and debates.

But which ideas and debates? In challenging the experiments, pre-occupations and hierarchies of modernism, post-modern debates also, implicitly, undermined criticism. Bill Jay has commented:

> Ideally, photographic criticism should provide one or more of the following services: introduce you to photographers of whom you were unaware; expand your appreciation of a photographer's work; place the images in the context of photography's history; place the images in the context of the artist's culture; and, while accomplishing these services, throw light upon the creative/artistic process. These services demand that the critic demonstrates superior knowledge and insight. The result will be photographic writing which is informative, elevating and, above all else, *useful*.[9]

Useful for what? This menu implies support for art and artists and suggests that the authority of the critic should rest on familiarity with ideas and artworks in a particular field. But it seems outdated. What is assumed in the reference to 'artist's culture' or to 'superior knowledge and insight'? The modernist agenda, with its search for a uniform value system and knowledge hierarchy, continues to resonate! Indeed, Jay reveals the conservatism of his position as he continues with an attack on political correctness which thinly masks an attack on feminist reappraisal: '. . . when critics tell you that all nudes are political in meaning, what they are really saying is this: in order to be accepted and liked by our peers we have decided that all nudes should be considered political. In this sense, critics are telling you more about themselves than about the photographs'.[10] Is it not useful to review photohistories through varying lenses? The value of more recent critical theory is, precisely, that criticism has ceased to purport to be neutral, the critic is invited to acknowledge their position and preoccupations, and multiplicity of voices within debates about the import of particular bodies of work is understood to lend philosophic depth. Contemporary placing of images in the context of the 'artist's culture' has acquired a critical edge which is intended to counter *status quo* agendas.

Theory informs practice, and vice versa; the role of the serious critic may be seen as one of mediating between the two. Feminist criticism proposed a constructive role for the critic: that the critic should engage with the art object, raising new questions and pursuing new lines of enquiry; it also, in principle, expected that the critic should be aware of her audience and develop ways of writing which do not alienate her readers. Elitist forms of writing contribute to perpetuating a hierarchical intellectual order. For critics to be constructive, they need also to be self-analytical, paying attention to the implications of what they are saying and consciously working in ways designed not simply to reproduce established assumptions and hierarchies. The reviewer's subjective response, political tendencies, assumptions about readers, and even mood on the particular day, are inevitably in some way reflected. This can be acknowledged.

Taste

A. D. Coleman reminds us that the term, connoisseurship, originally 'simply distinguished between those who had actually laid eyes on particular works of art, thereby truly "becoming acquainted with" them (the original definition of the term's Latinate root, *cognoscere*) and those who knew them only second-hand, through written descriptions or etched and engraved renditions' – and later, of course, through photographic reproduction (slides, book illustrations, postcards).[11] The elitist connotations which came to adhere to the term are a consequence in part of social class privilege associated with, for instance, the 'Grand Tour' (viewed as an essential finishing education for the sons of the British eighteenth and nineteenth-century aristocracy). Hence, for instance, Walter Benjamin's welcome for photography's wider circulation of images through which visual culture became less exclusive.[12] In addition, in taking on the tenets of High Modernism, connoisseurship became even more associated with hierarchies of critical values – connoisseurs being viewed as steeped in knowledge and therefore able to exercise discrimination within particular fields of expertise. Such notions clearly support power infrastructures within national and international economic and institutional art networks. In addition, characterisations of European Modernism, especially the various avant garde art movements, often rested on dialectic notions of historical change whereby, as Poggioli suggested, 'sons' [sic] rebelled against their father figures.[13] This implies a singular historical trajectory within which younger generations of artists and critics act as a vanguard challenging the previously established.

So what is at stake for the critic now? First, as always, criticism involves taste, judgment and a degree of independence of opinion. Good writing, by which I mean work which is well-informed, purposeful and engaging, involves critics knowing what they value and why they value it. Second, the contemporary critic operates in circumstances where norms and value systems are complex and contested. Postmodern art is considerably more dispersed in issues and concerns, sources of influence and inspiration, and modes of audience address. Within this, the contemporary critic has to locate appropriate spaces of response: intellectual contexts and places of publication. Informed and informative judgment is still expected, but the cultural currencies begging negotiation are markedly multiple. Previous knowledge

assumptions and hierarchies may continue to obtain (especially in the major galleries, museums and auction houses) but are cut across by new 'post-everything' uncertainties. Audiences have been extended through new global means of communication with materials written for email or website spaces wherein the reader, although immediate in time, may seem increasingly anonymous and far removed in location. Increasingly, it seems impossible for any single place that would like to see itself as a centre, to hold sway. Whilst any undermining of the metropolitan may be welcome, the task for the writer becomes increasingly demanding. The setting up of websites in association with exhibition and events is no substitute for direct engagement with photographic artworks, just as words cannot do justice to the affects of photographs. But websites, along with bookworks, catalogues and reviews, offer points of mediation which enable a broad audience to engage with aspects of images and ideas, All such mediations resonate discursively within the capricious complexity of contemporary imagery.

Postmodern theory insisted that things are fluid, things fall apart, there is no centre. Nonetheless, in so far as authorial hierarchies of influence persist, the fashionability of the metropolitan and the sense of superiority of the academic remain marked, as does the inter-relation between the functions of criticism and the economics of the art market. More positively, artists still seek responses, which may be more varied and interesting now, when unconstrained by the dictates of Modernist criticism. Critics' responsibilities continue to include feedback to the artist, the historical marking of particular exhibitions or events, and engagement within debates about ideas and practices, all of which also contribute to mediating work to a broader public. That critical publication is caught up in relation to the politics of the art market, and also contributes to the commodification of art, is not in itself reason to desist from comment, although it may influence choice of sites of publication and certainly lends further complexity in terms of the purpose and responsibilities of more radical writing. Fluidities heralded through the digital era should support the dismantling of legacies of hierarchical attitudes, and open space for more discursive, creative engagement with artifacts and ideas and for enjoying dissonances between words and pictures.

Notes

1 Edward Weston on pictorial photography after Goethe. This quote headed up the earlier version of this essay. I have kept it as it formed my starting point – although now I cannot find its source.

2 At the time, in Britain, coverage of photography exhibitions and events in the major national papers was still relatively rare, excepting occasional high profile retrospectives of work by particular practitioners. Professional photography magazines, such as *The British Journal of Photography*, sometimes featured gallery-based events, again largely in terms of famous names; but more usually exhibitions were covered only in brief reviews. Serious critical discussion of gallery-based work was left to small circulation magazines such as *Portfolio* (Edinburgh) and *Creative Camera* (London – now defunct). In Britain, major exhibitions may pass unremarked – except if hosted in the metropolitan centres of London and Edinburgh.

3 Mary Kelly (1981) 'Re-viewing Modernist Criticism' *Screen* 22:3.

4 This, despite having been dismissed by influential nineteenth-century critics such as Baudelaire who viewed photography as mechanical reportage rather than artistic expression.

5 See John Willett (1978) *The New Sobriety*, London: Thames and Hudson for an introductory overview.

6 Roland Barthes *Mythologies,* first published in French in 1957 was not translated until 1972.

7 Openings at key galleries may be good parties, but not good for looking at work! For instance, openings at The Photographers Gallery, London, are invariably sweaty experiences characterised by occasional glimpses of work on walls spotted between the heads of people networking energetically.

8 Abigail Solomon-Godeau (1991) 'Living with Contradictions: Critical Practices in the Age of Supply-Side Aesthetics' in *Photography at the Dock*, Minneapolis: University of Minnesota Press, p. 124.

9 Bill Jay (1992) *Occam's Razor*, Munich: Nazraeli Press. p. 46.

10 Loc. cit.

11 A.D. Coleman (2000) 'Connoisseurship in the digital era' in *Photo Americas 2000*, Portland, Oregon: Photo Americas, p. 2.

12 Walter Benjamin (1936) 'The Work of Art in the Age of Mechanical Reproduction' in Hannah Arendt ed. (1970) *Illuminations*, London: Jonathan Cape.

13 Renato Poggioli (1981) *Theory of the Avant-Garde*, Cambridge, Mass: Belknap Press.

David Bate

ART, EDUCATION, PHOTOGRAPHY

> . . . the age of Photography corresponds precisely to the irruption of the private into the public, or rather, to the creation of a new social value, which is the publicity of the private: the private is consumed as such, publicly . . .
>
> Roland Barthes, *Camera Lucida*

WHAT IS THE MODERN FUNCTION OF ART and photography today? Photography as a practice is both in and out of art. Photography is a social thing encountered everywhere. It cuts across every type of discourse, every division and boundary (institutional, political, geographic, ethnic, age, sex, economic, psychic, and so on). This is not to somehow say that photography is the same object or has the same purpose and meanings across each of them. Actually, what I am speaking about is not a property of photography at all, it is rather a property of the discourse upon things – like photography or art – which issue from particular institutional sites. Art is one such cultural site, education is another. They both interact with notions of the private, and photography takes place across all three. It must follow, that any discussion of photography that acknowledges these things is not necessarily going to be a simple or easy one. Nor should such debates be regarded as merely 'academic'.

Raymond Williams once remarked 'There are clear and obvious connections between the quality of a culture and the quality of its system of education.'[1] The relationship is also a complex one. In education institutions – art schools, colleges, universities – the cultural values and beliefs about art are established amongst its new recruits. Introduced to those discourses that constitute various objects and practices as 'art', students and staff alike read the same cultural magazines and catalogues that artists, curators, critics, dealers and sponsors also read. These practices, together with the exhibition system (a complex of interwoven and linked 'independent' artist-run, private and state funded institutions), are where the discourses of art are to be found. This is how it functions.

When it comes to art as a component aspect of culture, it has, since the nineteenth century, been 'regarded as one of a number of specialized kinds of production'.[2] The particular, perhaps peculiar function of art according to the dominant common-sense consensus of industrial societies is to provide new ideas rooted in the artist's autonomous creative being. (The fact that twentieth-century art has been about so many other things has not dislodged this view as common-sense belief.) That is, ideas to do with feelings, the senses, personal and apparently private 'experiences'. These have to be translated into the moulded material forms of cultural objects and images which constitute art practice. Obviously, art is not the only sector of culture engaged in this process, but the belief in art as a privileged realm remains, partly, because it *appears* to maintain an economic distance from the capitalism of 'mass culture'. But, patently, art is not impermeable to popular culture. It is saturated with it. This is not, nor should it be, a value judgement in itself. What should be judged is what relationship art has *as* culture.

How does art as an institution and set of discourses constantly renew and re-invent itself? One example is pop art in the 1950s, which like much contemporary art today, reversed the value of things: art, seen as a defence against mass culture was made to face it and in the process 'destroys' what went before, thus renewing the question 'what is art?'. This, to coin the phrase of Jean-François Lyotard's concept of 'postmodernism', is 'not modernism at its end but in the nascent state, and this state is constant'.[3] Thus, to state the obvious, the preoccupation of pop art with popular culture did not collapse the distinction between art and culture. It was just that 'popular culture' was of interest to some artists as the culture of art. It is as though one function of modern art in the twentieth century was to rummage through the junk of industrialized societies and re-value it. (The Surrealists started it.) Invariably, pop art identified, or rather, 'expressed' in its form and content, the common traits of an industrialized culture: banal repetition, series of models, stereotypes, 'Americanism', trademark icons, etc. It is the gap or distance produced by the 'reprocessing' of these representations which made pop art signify as a 'commentary' on – as critique or celebration of – popular culture. In pop art, photography was not 'art photography', it was 'popular culture' as art.[4] This was something very different from previous 'art photography'.

Art photography at the beginning of this century was treated more or less as a haven from the 'nasty' world of industrialized popular culture, war and capitalism. Today it is easy to forget, whilst looking at the pictures, how much early 'modernist' art photography was actually anti-modern. Technically and aesthetically opposed to the sort of mass production photography encouraged and made popular by the major photographic companies like Kodak, they argued – at least by their own production methods – for the photographer's control over the *process* of image making and the conditions of its consumption. A real purity of process, no enlargements of negatives, no cropping of the 'original idea'. The strain of this purity of form on the repression of content in modernist criticism and theory is well known. Also opposed to the content of image production by the dominant picture industries, (even though figures like Edward Steichen, Paul Strand and Edward Weston were involved in them) the legacy of this modernism is a technical fetishism and a craft excellence – values not necessarily to be rejected – coupled with mythologies about the act of creativity.

Peter Wollen has traced the strands of art photography that filtered down from turn-of-the-century debates.[5] Paul Strand's call for the 'integration of science and expression' (machine and human vision) is most famously consolidated in Edward Weston: 'Sharp focus and full light were to be combined with the new post-cubist principles of composition' (and paralleled in Europe by the 'new objectivity' photography of Albert Renger-Patsch, etc.). This was made popular through the work of Walker Evans, Henri Cartier-Bresson and later – but differently – Diane Arbus. Despite the modernist emphasis on the single print, it was the series or suite of pictures that showed the constancy of vision of the photographic seer as 'genius'.

In Britain, which like other European countries suffered an art, aesthetic and intellectual collapse through the impact of the Second World War, a supposed 'indigenous' tradition of documentary-reportage and fine art landscape photography (cannibalized from English landscape painting) inherited those modernist craft values. But the critique of these photographic values of modernism as the horizon of thought in art and education came through conceptual art rather than from photographers. Conceptual art, to put it somewhat simply, was concerned with the issue (politically and philosophically) of art as knowledge. It questioned the conditions and possibility of art as a practice: the production of its own enunciation and the status of the discourses and the institutions in which it took place. It also engaged with 'everyday life': sex, class, politics *and* photography. A new use of photography in art emerged (pregnant with the legacy of 1970s' reformulated notions of conceptual art) and broke with the tendencies of the older 'fine art' photography that had veered towards craft printing. Something happened again during the 1980s, with a renewed interest in popular culture and 'new' forms of colour photography, 'installation' and video. No longer interested in looking for, or 'evolving', a specific genre of fine art photography, the use of photography was opened up to 'refer to' (quote, copy, mimic, parody) those modes and codes of photography that already existed elsewhere in other institutional practices.[6] This new 'postmodern' range of concerns had a particular consequence for the theory and use of photography in some sectors of art and education.

Once upon a time, 'photography theory' used to only designate a technical theory, a study of chemistry and the structures of photographic paper, films, a theory of optics and (if you were lucky) the characteristics of light and the effects of perspective. The consequences of its value judgements were, however, mostly limited to choices of photographic materials, cameras, lenses, etc., and their use in relation to a set of given 'correct' norms. The works of Michael Langford in *Basic Photography* and the various versions of the American 'zone system' exemplify the starting points for this sort of study. These contributions to the study of photography are, needless to say, important components – the technical means of production of the photographic image is certainly relevant, not only to those making photographs, but also as part of the technological history of photography. But again to state the obvious, the notion that 'technique' is all there is to say in a theory of photography is severely limited. (Modernist art photography with its emphasis on the 'purely visual' effectively condemned itself to being dumb, despite the fact that the modernist values were established in reams of writings by Alfred Stieglitz *et al.*) The word theory, I take to mean critical theory. In the distinction of theory/practice, the activity of thinking about photography, what is called theory, is of course,

itself a type of practice. It has its own agenda, just as picture making does. Equally, the practical activity of making photographs (of whatever means or form and no matter how conscious it is or not of 'theory') implicitly or explicitly presupposes theoretical propositions. (To pick up a camera is already to start determining the meanings that a photograph will denote.) Theory involves a practice and practice involves theory. This is not some tautological slogan, masquerading as a 'deconstruction' of the binary opposition of theory/ practice. Nor is it intended to point out the futility of any distinction between them. 'Theory' and 'practice' are, like it or not, the terms of one of the fundamental distinctions that anyone dealing with representations has to negotiate.

Victor Burgin pointed out in the 'Introduction' to the 1982 book, *Thinking Photography*: 'the primary feature of photography, considered as an omnipresence in everyday social life, is its contribution to the production and dissemination of *meaning*.'[7] The meanings of photographs and the issue of how, what and why meanings are derived from photographs by their audiences, is the one thing that technical theory had taken for granted and was forgotten or suppressed in modernism. Photography theory put the production of meaning of the photographic image – in any discourse – at the centre of its aim. In addition, Victor Burgin had argued: 'photography theory will either develop through attention to its own specificity or it will not develop at all'. Arguably, it has not developed, but for different reasons.

Today, a whole range of books are available on photography, with critical and methodological analyses available on advertising, art, etc. There are no excuses for the uninitiated. Semiotics, rhetoric, theories of ideology, psychoanalysis, cultural studies and sociology are all deployed now as 'text book' models for image analysis. It was – and is – a means, a set of methods to demonstrate and improve our understanding of the structures that operate in the production of meanings of pictures. But, for example, the rhetorical analysis of images was not only intended to 'decode' or 'criticize' advertising images, it was also a means to 'demystify' and displace the notions of art photography 'genius' and 'seer' that floated around art photography. The theory was also, implicitly, a critique of the 'methods' in the writings of the history of photography, which had set itself up as a master discourse in which to construct the narratives for those photographs that get held up as masterful pictures. The rise of photography as a taught subject of study in education – with more than forty new courses established in Britain during the 1990s – might be judged as a decisive social choice and cultural shift. But this would be a hasty conclusion. Even today this 'discipline' remains barely touched by, even, the 'new art history' of the 1980s.[8]

Four years on in 1986, Victor Burgin, in the concluding sentence of his essay 'The End of Art Theory' (in the book of the same name) concludes:

> In our present so-called 'postmodern' era the *end* of art theory *now is* identical with the objectives of *theories of representation* in general: a critical understanding of the modes and means of symbolic articulation of our *critical* forms of sociality and subjectivity.[9]

This shift, a response to problems of representation in the eighties, is from 'photography theory' in *Thinking Photography* to '*theories of representation* in general', and

their 'modes and means of symbolic articulation' in *The End of Art Theory*. In other words, a move away from the problems of specific forms of signification towards the general cultural theory field of visual representations. Art theory, or photography theory should give way to theories of representation in general and the inter-textual reference across the domains of visual significations – even though photography theory was already interdisciplinary, like the object of its discourse: the photograph. Whereas photography theory put the photograph at the core of critical analysis, in cultural theory the photograph is one component element in a set of overlapping and interweaving 'visual cultural practices'. This shift in position coincided with the increased traffic of images between institutions and increased rapidly in the 1980s. (For example, the 'genre switching' in Benetton's use of image codes of photo-journalist pictures as their advertising; art photographers using the 'slick' lighting of advertising, etc.). In art, the 'anti-aesthetic' work of the 1970s gave over to the 'commodity pleasure' (artifice, colour,) art work of the 1980s, even though the issues of sexual difference, ethnicity, pleasure, identity politics and desire initiated in the 1970s (conceptual art, film theory, feminism, Marxism and psychoanalysis) were still the main focus. The use value of photographs had changed. This is not surprising. Not only has the photograph permeated every corner of the earth, but the experience of the photographic image has in turn transformed our sense of identity and the social. It is hard, impossible, to think about the modern world without the photographic image. . . .

At its origin, photography emerged in the context of mediums like painting and lithography and the national art academies and scientific research institutions. Industrial entrepreneurs competed to receive capital support for their inventions. Photography supplied the needs of an industrial culture, the mass reproduction of images. Needless to say, at the end of the twentieth century, the cultural and institutional frameworks in which we live are vastly different from those of the nineteenth century when photography first appeared. All the institutions that took up photography in the nineteenth century were themselves transformed in the twentieth century: art, science, medical, psychiatry, police, tourism, etc. The newer twentieth-century photo-image based institutions of advertising, fashion, news, cinema, television, (and the world wide web) have come to dominate the production and distribution of the representations of the world we live in. The consequences of this on photography are, of course, not merely technological. . . .

As computer data images also begin to aid art directors, editors and photographers to construct high resolution image fantasies, the public image world (most obviously, advertising) is increasingly populated by a kind of arbitrary 'surreal' game of impossible logic images. In art, uncanny images and 'baroque spaces' are pitched as a dissident practice against the new 'electronic modernism', where (Clement Greenberg's) 'specificity to the materials' means finding the 'essence' of a computer aesthetic (the computer produced image on the computer screen?).

As a means of apprehending visual knowledge of the world, photography is paralleled and met in the second half of the twentieth century by the dominance of the televisual screen located in most homes in the West. Since the 1950s, Paul Virilio argues, television has been like an 'introverted window' in our homes. We do not look out as we would a window onto a view that is fixed (even if the objects within it move). The images on television, however, are constantly changing

(between different shots, edits, and programmes, across video tapes and channel hopping) resulting in a 'deterioration of stability'.[10]

One recent tendency in British television at peak viewing hours has been to show 'replays' of amateur videos, cctv (close circuit television) camera recordings, video diaries and video tape recordings from police cars and helicopter cameras. These are played for various levels of entertainment, at main viewing hours, and range from serious documentaries to cats and babies falling over, and accidents and drunken drivers shown 'captured' on film. Networked computer users can receive information on their monitor screens from camera (video and still) images that people have installed in their homes and put out on 'the net'. These examples illustrate the problematic changing relationship towards our notions of the public and private. Public space is turned inside out, with private display in the public as public culture, while public culture is also privately displayed in homes on television and computer screens. As a teenager, I frequently heard television being condemned as an 'escape from the world'; to me it was a means of engaging with it beyond the familial setting.

As terrestrial television stations, located in particular national cultures go extra-terrestrial, with digital transmission, the opening up of new channels and satellite projections, the question of what is transmitted into our homes becomes an increasingly important question – about what 'our' paranational culture in the various 'imaginary communities' of viewers actually is. As the visual culture world expands, shedding ever more images each day which pile up around our bodies, the indexical trace value of the photograph is relativized by the digital print, video tape and computer data image. In this context, the aesthetics of a 'lived experience' takes on a new meaning.

Walter Benjamin, like Charles Baudelaire before him, noted that the photograph, despite its reproducibility, was not exempt from the cult value affect of the 'aura', the 'presence of the original':

> In photography, exhibition value begins to displace cult value all along the line. But cult value does not give way without resistance. It retires into an ultimate retrenchment: the human countenance. It is no accident that the portrait was the focal point of early photography.[11]

The idea of the authentic picture (the denotation of 'aura') has not been effaced by the reproductive qualities of the photograph. Indeed, the potential capacity for reproduction of the photograph so often quoted from Walter Benjamin is only actually fulfilled by the publicity and print industries to enable their wide distribution. There the aura is sustained, not by any uniqueness of a material object, (the photograph) but by the production values of the picture and the objects depicted. In contrast, the 'private' photograph the domestic snapshot, is the sort of image that is more likely to be unique, or at least, singular and valued *as an object*. Even where the photograph has been reprinted more than once, the single print is rarely *experienced* as merely a reproduction. It is the opposite. Private photographs are more frequently treasured as authentic objects and given a kind of naturalized function as fetish object.

In his 1978 essay 'Photography and Aesthetics' Peter Wollen argues that painting turned to a (Kantian) subjective, intuitive mode of seeing after the appearance

of photography in the nineteenth century.[12] The graphic mark of the painting (the trace of the human hand) was contrasted with the mechanical tool, the camera. Photographers attempted to imitate the subjective impulse (through hand made papers, home made cameras, refusal of optics and perspective, soft 'impressionist' focus, etc.), but these techniques (often regarded by modernists as 'gimmicks') never really became fully established in art and remained marginal. (Some of them became accepted as amateur rules for 'creative photography'.) The acceptance of photography into modern art is a recognition of an aesthetics of 'lived experience' (now characterized by its 'badness') returning to haunt a modern art that had tried to evacuate it. However, this return does not *in itself* guarantee any change, development or 'progress' in art or photography. One way that photography can emphasize the equivalent of the gesture of the human hand is by turning the camera towards 'private life', especially the private life of the artist. Here it is not the camera as instrument that is subjective (or even objective), but the intuition of the objects supposed within its field of vision.

We can begin to see here how a turn towards the private and especially the aesthetics of the snapshot look of 'immediacy', functions so readily as art. It is as though the 1970s feminist slogan 'the personal is political' has been re-interpreted, skewed and inverted. Originally intended to draw attention to the personal and private sphere as not exempt from an ethical politics of behaviour of the public sphere, 'the personal' has been construed as the expression of politics. The political is now 'the private' when it is made public. It is striking, when you think about it, how a good deal of contemporary work – some more critically aware than others – is structured by this aesthetic claim of actual 'lived experience'. One manifestation is the so-called 'amateur' coded aesthetic of the snapshot as the latest and seemingly last frontier of the photograph as 'authentic', or 'real experience'. This position in its various representational strategies appears to attempt to reveal a 'real me', recalling the strategy of early feminist art, where, as Mary Kelly argues 'the "enigma of femininity" is formulated as the problem of representation (images of women, how to change them) and then resolved by the discovery of a true identity behind the patriarchal facade.'[13] It is as though the public 'facade' of the 'individual' is now only a seething mass of privacy, whose 'true identity' is to be endlessly displayed but cannot be found. What Roland Barthes called 'the creation of a new social value, which is the *publicity* of the private' has begun to appear as more than a residual practice.[14] Indeed this practice in art relates to (I do not say 'reflects') the popular forms of televisual drama and their fascination with the lives of 'ordinary individuals'.

What does all this mean for the study of photography today? The lesson must be that the institutional divisions which were once identifiable with certain codes and styles of images have become far more slippery. The traffic between institutions, pictorial values, styles, codings and ideologies is more conventional rather than the exception, more inter-textual than institutional. To maintain the photograph as a central object in education remains a crucial objective, not so as to fetishize it, as what is now becoming the old rather than the new, but to specify its discourses, its differences (and continuities) with newer digital manifestations. After all, is not the function of education to develop an understanding and knowledge of the role of images within culture? In that respect we have still not escaped the

techno-ideological project of renaissance picturing systems that has governed Western thought ever since. Perspective remains the order of Photoshop as much as it does the camera obscura, discovered so long before photography. Education then, should retain a critical distance to, and awareness of these functions and fluctuations in image culture.

Notes

1 Raymond Williams, *The Long Revolution*, London: Hogarth Press, 1992, p. 125.
2 'Culture' for Williams means the 'whole way of life'. See his *Culture and Society*, Penguin, 1979.
3 This is Lyotard's definition of postmodernism in *The Postmodern Condition*, Manchester University Press, 1986, p. 79.
4 See Roland Barthes, 'That Old Thing, Art . . .' *The Responsibility of Forms*, translated by Richard Howard, University of California Press, 1991.
5 Peter Wollen, 'Photography and Aesthetics', *Screen*, vol. 19, no. 4, winter 1978–79.
6 The internal differences within conceptual art and between artists is here less important than their collective distinction from 'art photography' and photographers. The anathema directed towards the 'fine print' of the former was only equalled by the hostility to the 'anti-aesthetic' by the latter.
7 Victor Burgin (ed.) *Thinking Photography*, Macmillan, 1982, p. 2.
8 A.L. Rees and F. Borzollo, (eds) *The New Art History*, Camden Press, 1986.
9 Victor Burgin, *The End of Art Theory*, Macmillan, 1986, p. 204. Author's emphasis.
10 Paul Virilio, *The Lost Dimension*, Semiotext(e), 1991.
11 Walter Benjamin, 'The Work of Art in the Age of Mechanical Reproduction', *Illuminations*, Fontana, 1980, pp. 227–8.
12 Wollen, 'Photography and Aesthetics' *Screen,* vol. 19, no. 4, winter 1978–79, p. 17.
13 Mary Kelly, 'Re-Viewing Modernist Criticism' *Art after Modernism*, ed. B. Wallis, New Museum of Contemporary Art, 1984, p. 97.
14 Roland Barthes, *La Chambre claire*, Paris: Gallimard, 1980, p. 98. (My emphasis.)

Allan Sekula

READING AN ARCHIVE
Photography between labour and capital

Every image of the past that is not recognised by the present as one of
its own threatens to disappear irretrievably.

Walter Benjamin[1]

The invention of photography. For whom? Against whom?

Jean-Luc Godard and Jean-Pierre Gorin[2]

HERE IS YET ANOTHER BOOK OF PHOTOGRAPHS. All were made
in the industrial and coal-mining regions of Cape Breton in the two decades
between 1948 and 1968. All were made by one man, a commercial photographer
named Leslie Shedden. At first glance, the economics of this work seem simple and
common enough: proprietor of the biggest and only successful photographic studio
in the town of Glace Bay, Shedden produced pictures on demand for a variety of
clients. Thus in the range of his commissions we discover the limits of economic rela-
tions in a coal town. His largest single customer was the coal company. And promi-
nent among the less official customers who walked in the door of Shedden Studio
were the coal miners and their families. Somewhere in between the company and
the workers were local shopkeepers who, like Shedden himself, depended on the
miners' income for their own livelihood and who saw photography as a sensible
means of local promotion.

Why stress these economic realities at the outset, as if to flaunt the 'crude
thinking' often called for by Bertolt Brecht? Surely our understandings of these
photographs cannot be reduced to a knowledge of economic conditions. This latter
knowledge is necessary but insufficient; we also need to grasp the way in which
photography constructs an imaginary world and passes it off as reality. The aim of
this essay, then, is to try to understand something of the relationship between photo-
graphic culture and economic life. How does photography serve to legitimate and
normalise existing power relationships? How does it serve as the voice of authority,

while simultaneously claiming to constitute a token of exchange between equal part-
ners? What havens and temporary escapes from the realm of necessity are provided
by photographic means? What resistances are encouraged and strengthened? How
is historical and social memory preserved, transformed, restricted and obliterated
by photographs? What futures are promised; what futures are forgotten? In the
broadest sense, these questions concern the ways in which photography constructs
an *imaginary economy*. From a materialist perspective, these are reasonable questions,
well worth pursuing. Certainly they would seem to he unavoidable for an archive
such as this one, assembled in answer to commercial and industrial demands in a
region persistently suffering from economic troubles.[3]

Nonetheless. such questions are easily eclipsed, or simply left unasked. To
understand this denial of politics, this depoliticisation of photographic meaning, we
need to examine some of the underlying problems of photographic culture. Before
we can answer the questions just posed, we need to briefly consider what a photo-
graphic archive is, and how it might he interpreted, sampled, or reconstructed in
a book. The model of the archive, of the quantitative ensemble of images, is a
powerful one in photographic discourse. This model exerts a basic influence on the
character of the truths and pleasures experienced in looking at photographs, espe-
cially today, when photographic books and exhibitions are being assembled from
archives at an unprecedented rate. We might even argue that archival ambitions and
procedures are intrinsic to photographic practice.

There are all sorts or photographic archives: commercial archives like Shedden's,
corporate archives, government archives, museum archives, historical society
archives, amateur archives, family archives, artists' archives, private collectors'
archives and so on. Archives are property either of individuals or institutions, and
their ownership may or may not coincide with authorship. One characteristic of
photography is that authorship of individual images and the control and ownership
of archives do not commonly reside in the same individual. Photographers are
detail workers when they are not artists or leisure-time amateurs, and thus it is not
unreasonable for the legal theorist Bernard Edelman to label photographers the 'pro-
letarians of creation.'[4] Leslie Shedden, for his part, was a combination artisan and
small entrepreneur. He contributed to company and family archives while retaining
his own file of negatives. As is common with commercial photographers, he included
these negatives in the sale of his studio to a younger photographer upon retiring
in 1977.

Archives, then, constitute a *territory of images*: the unity of an archive is first and
foremost that imposed by ownership. Whether or not the photographs in a partic-
ular archive are offered for sale, the general condition of archives involves the
subordination of' use to the logic of exchange. Thus not only are the pictures in
archives often *literally* for sale, but their meanings are up for grabs. New owners
are invited, new interpretations are promised. The purchase of reproduction rights
under copyright law is also the purchase of a certain semantic licence. This *semantic
availability* of pictures in archives exhibits the same abstract logic as that which
characterizes goods in the marketplace.

In an archive, the possibility of meaning is 'liberated' from the actual contin-
gencies of use. But this liberation is also a loss, an *abstraction* from the complexity
and richness of use, a loss of context. Thus the specificity of 'original' uses and

meanings can he avoided and even made invisible, when photographs are selected from an archive and reproduced in a book. (In reverse fashion, photographs can he removed from books and entered into archives, with a similar loss of specificity.) So new meanings come to supplant old ones, with the archive serving as a kind of 'clearing house' of meaning.

Consider this example: some of the photographs in this book were originally reproduced in the annual reports of the Dominion Steel and Coal Company, others were carried in miners' wallets or framed on the mantelpieces of working-class homes. Imagine two different gazes. Imagine the gaze of a stockholder (who may or may not have ever visited a coal mine) thumbing his way to the table of earnings and lingering for a moment on the picture of a mining machine, presumably the concrete source of the abstract wealth being accounted for in those pages. Imagine the gaze of a miner, or of a miner's spouse, child, parent, sibling, lover or friend drifting to a portrait during breaks or odd moments during the working day. Most mine workers would agree that the investments behind these looks – financial on the one hand, emotional on the other – are not compatible. But in an archive, the difference, the *radical antagonism between* these looks is eclipsed. Instead we have two carefully made negatives available for reproduction in a book in which all their similarities and differences could easily be reduced to 'purely visual' concerns. (And even visual differences can be homogenized out of existence when negatives first printed as industrial glossies and others printed on flat paper and tinted by hand are subjected to a uniform standard of printing for reproduction in a book. Thus the difference between a mode of pictorial address which is primarily 'informational' and one which is 'sentimental' is obscured.) In this sense, archives establish a relation of *abstract visual equivalence* between pictures. Within this regime of the sovereign image, the underlying currents of power are hard to detect, except through the shock of montage, when pictures from antagonistic categories are juxtaposed in a polemical and disorienting way,

Conventional wisdom would have it that photographs transmit immutable truths. But although the very notion of photographic reproduction would seem to suggest that very little is lost in translation, it is clear that photographic meaning depends largely on context. Despite the powerful impression of reality (imparted by the mechanical registration of a moment of reflected light according to the rules of normal perspective), photographs, in themselves, are fragmentary and incomplete utterances. Meaning is always directed by layout, captions, text, and site and mode of presentation. [. . .] Thus, since photographic archives tend to suspend meaning and use, within the archive meaning exists in a state that is both residual and potential. The suggestion of past uses coexists with a plenitude of possibilities. In functional terms, an active archive is like a toolshed, a dormant archive like an abandoned toolshed. (Archives are not like coal mines: meaning is not extracted from nature, but from culture.)

In terms borrowed from linguistics, the archive constitutes the paradigm or iconic system from which photographic 'statements' are constructed. Archival potentials change over time; the keys are appropriated by different disciplines, discourses, 'specialties.' For example, the pictures in photo agency files become available to history when they are no longer useful to topical journalism. Similarly, the new art history of photography at its too prevalent worst rummages through archives of every sort in search of masterpieces to celebrate and sell.

Clearly archives are not neutral: they embody the power inherent in accumulation, collection, and hoarding as well as that power inherent in the command of the lexicon and rules of a language. Within bourgeois culture, the photographic project itself has been identified from the very beginning not only with the dream of a universal language, but also with the establishment of global archives and repositories according to models offered by libraries, encyclopedias, zoological and botanical gardens, museums, police files, and banks. (Reciprocally, photography contributed to the modernization of information flows within most of these institutions.) Any photographic archive, no matter how small, appeals indirectly to these institutions for its authority. Not only the truths, but also the pleasures of photographic archives are linked to those enjoyed in these other sites. As for the truths, their philosophical basis lies in an aggressive empiricism, bent on achieving a universal inventory of appearance. Archival projects typically manifest a compulsive desire for completeness, a faith in an ultimate coherence imposed by the sheer quantity of acquisitions. In practice, knowledge of this sort can only be organized according to bureaucratic means. Thus the archival perspective is closer to that of the capitalist, the professional positivist, the bureaucrat and the engineer – not to mention the connoisseur – than it is to that of the working class. Generally speaking, working-class culture is not built on such high ground.

And so archives are contradictory in character. Within their confines meaning is liberated from use, and yet at a more general level an empiricist model of truth prevails. Pictures are atomized, isolated in one way and homogenized in another. (Alphabet soup comes to mind.) But any archive that is not a complete mess establishes an order of some sort among its contents. Normal orders are either taxonomic or diachronic (sequential); in most archives both methods are used, but at different, often alternating, levels of organization. Taxonomic orders might be based on sponsorship, authorship, genre, technique, iconography, subject matter, and so on, depending on the range of the archive. Diachronic orders follow a chronology of production or acquisition. Anyone who has sorted or simply sifted through a box of family snapshots understands the dilemmas (and perhaps the folly) inherent in these procedures. One is torn between narration and categorization, between chronology and inventory.

What should be recognized here is that photographic books (and exhibitions), frequently cannot help but reproduce these rudimentary ordering schemes, and in so doing implicitly claim a share in both the authority and the illusory neutrality of the archive. Herein lies the 'primitivism' of still photography in relation to the cinema. Unlike a film, a photographic book or exhibition can almost always be dissolved back into its component parts, back into the archive. The ensemble can seem to be both provisional and artless. Thus, within the dominant culture of photography, we find a chain of dodges and denials: at any stage of photographic production the apparatus of selection and interpretation is liable to render itself invisible (or conversely to celebrate its own workings as a kind of moral crusade or creative magic). Photographer, archivist, editor and curator can all claim, when challenged about their interpretations, to be merely passing along a neutral reflection of an already established state of affairs. Underlying this process of professional denial is a commonsensical empiricism. The photograph reflects reality. The archive accurately catalogues the ensemble of reflections, and so on.

Even if one admits — as is common enough nowadays — that the photograph *interprets* reality, it might still follow that the archive accurately catalogues the ensemble of interpretations, and so on again. Songs of the innocence of discovery can be sung at any point. Thus the 'naturalization of the cultural,' seen by Roland Barthes as an essential characteristic of photographic discourse, is repeated and reinforced at virtually every level of the cultural apparatus — unless it is interrupted by criticism.[5]

In short, photographic archives by their very structure maintain a hidden connection between knowledge and power. Any discourse that appeals without scepticism to archival standards of truth might well be viewed with suspicion. But what narratives and inventories might be constructed, were we to interpret an archive such as this one in a normal fashion?

I can imagine two different sorts of books being made from Shedden's photographs, or for that matter from any similar archive of functional photographs. On the one hand, we might regard these pictures as 'historical documents.' We might, on the other hand, treat these photographs as 'aesthetic objects.' Two more or less contradictory choices emerge. Are these photographs to be taken as a transparent means to a knowledge — intimate and detailed even if incomplete — of industrial Cape Breton in the postwar decades? Or are we to look at these pictures 'for their own sake,' as opaque ends-in-themselves? This second question has a corollary. Are these pictures products of an unexpected vernacular authorship: is Leslie Shedden a 'discovery' worthy of a minor seat in an expanding pantheon of photographic artists?

Consider the first option. From the first decade of this century, popular histories and especially schoolbook histories have increasingly relied on photographic reproductions. Mass culture and mass education lean heavily on photographic realism, mixing pedagogy and entertainment in an avalanche of images. The look of the past can be retrieved, preserved and disseminated in an unprecedented fashion. But awareness of history as an *interpretation* of the past succumbs to a faith in history as *representation*. The viewer is confronted, not by *historical-writing*, but by the appearance of *history itself*. Photography would seem to gratify the often quoted desire of that 'master of modern historical scholarship,' Leopold von Ranke, to 'show what actually happened.'[6] Historical narration becomes a matter of appealing to the silent authority of the archive, of unobtrusively linking incontestable documents in a seamless account. (The very term 'document' entails a notion of legal or official truth, as well as a notion of *proximity to* and verification of an original event.) Historical narratives that rely primarily on photography almost invariably are both positivist and historicist in character. For positivism, the camera provides mechanical and thus 'scientifically' objective evidence or 'data.' Photographs are seen as sources of factual, positive knowledge, and thus are appropriate documents for a history that claims a place among the supposedly objective sciences of human behaviour. For historicism, the archive confirms the existence of a linear progression from past to present, and offers the possibility of an easy and unproblematic retrieval of the past from the transcendent position offered by the present. At their worst, pictorial histories offer an extraordinarily reductive view of historical causality: the First World War 'begins' with a glimpse of an assassination in Sarajevo: the entry of the United States into the Second World War 'begins' with a view of wrecked battleships.

Thus, most visual and pictorial histories reproduce the established patterns of historical thought in bourgeois culture. By doing so in a 'popular' fashion, they extend the hegemony of that culture, while exhibiting a thinly-veiled contempt and disregard for popular literacy. The idea that photography is a 'universal language' contains a persistent element of condescension as well as pedagogical zeal.

The widespread use of photographs as historical illustrations suggests that significant events are those which can be pictured, and thus history takes on the character of *spectacle*.[7] But this pictorial spectacle is a kind of rerun, since it depends on prior spectacles for its supposedly 'raw' material.[8] Since the 1920s, the picture press, along with the apparatuses of corporate public relations, publicity, advertising and government propaganda have contributed to a regularized flow of images: of disasters, wars, revolutions, new products, celebrities, political leaders, official ceremonies, public appearances, and so on. For a historian to use such pictures without remarking on these initial uses is naive at best, and cynical at worst. What would it mean to construct a pictorial history of postwar coal mining in Cape Breton by using pictures from a company public relations archive without calling attention to the bias inherent in that source? What present interests might be served by such an oversight?

The viewer of standard pictorial histories loses any ground in the present from which to make critical evaluations. In retrieving a loose succession of fragmentary glimpses of the past, the spectator is flung into a condition of imaginary temporal and geographical mobility. In this dislocated and disoriented state, the only coherence offered is that provided by the constantly shifting position of the camera, which provides the spectator with a kind of powerless omniscience. Thus the spectator comes to identify with the technical apparatus, with the authoritative institution of photography. In the face of this authority, all other forms of telling and remembering begin to fade. But the machine establishes its truth, not by logical argument, but by providing an *experience*. This experience characteristically veers between nostalgia, horror, and an overriding sense of the exoticism of the past, of its irretrievable otherness for the viewer in the present. Ultimately then, when photographs are uncritically presented as historical documents, they are transformed into aesthetic objects. Accordingly, the pretence to historical understanding remains, although that understanding has been replaced by aesthetic experience.[9]

But what of our second option? Suppose we abandoned all pretence to historical explanation, and treated these photographs as artworks of one sort or another. This book would then be an inventory of aesthetic achievement and/or an offering for disinterested aesthetic perusal. The reader may well have been prepared for these likelihoods by the simple fact that this book has been published by a press with a history of exclusive concern with the contemporary vanguard art of the United States and Western Europe (and to a lesser extent, Canada). Further, as I've already suggested, in a more fundamental way the very removal of these photographs from their initial contexts invites aestheticism.

I can imagine two ways of converting these photographs into 'works of art,' both a bit absurd, but neither without ample precedent in the current fever to assimilate photography into the discourse and market of the fine arts. The first path follows the traditional logic of romanticism, in its incessant search for aesthetic origins in a coherent and controlling authorial 'voice.' The second path might be

labelled 'post-romantic' and privileges the subjectivity of the collector, connoisseur, and viewer over that of any specific author. This latter mode of reception treats photographs as 'found objects.' Both strategies can be found in current photographic discourse; often they are intertwined in a single book, exhibition, magazine or journal article. The former tends to predominate, largely because of the continuing need to validate photography as a fine art, which requires an incessant appeal to the myth of authorship in order to wrest photography away from its reputation as a servile and mechanical medium. Photography needs to be won and rewon repeatedly for the ideology of romanticism to take hold.[10]

The very fact that this book reproduces photographs by a single author might seem to be an implicit concession to a neo-romantic *auteurism*, But it would be difficult to make a credible argument for Shedden's autonomy as a maker of photographs. Like all commercial photographers, his work involved a negotiation between his own craft and the demands and expectations of his clients. Further, the presentation of his work was entirely beyond his control. One might hypothetically argue that Shedden was a hidden artist, producing an original *oeuvre* under unfavourable conditions. ('Originality' is the essential qualifying condition of genuine art under the terms dictated by romanticism. To the extent that photography was regarded as a copyist's medium by romantic art critics in the nineteenth century, it failed to achieve the status of the fine arts.) The problem with auteurism, as with so much else in photographic discourse, lies in its frequent misunderstanding of actual photographic practice. In the wish-fulfilling isolation of the 'author,' one loses sight of the social institutions – corporation, school, family – that are speaking by means of the commercial photographer's craft. One can still respect the craft work of the photographer, the skill inherent in work within a set of formal conventions and economic constraints, while refusing to indulge in romantic hyperbole.

The possible 'post-romantic' or 'post-modern' reception of these photographs is perhaps even more disturbing and more likely. To the extent that photography still occupies an uncertain and problematic position within the fine arts, it becomes possible to displace subjectivity, to find refined aesthetic sensibility not in the maker of images, but in the viewer. Photographs such as these then become the objects of a secondary voyeurism, which preys upon, and claims superiority to, a more naive primary act of looking. The strategy here is akin to that initiated and established by Pop Art in the early nineteen-sixties. The aesthetically informed viewer examines the artifacts of mass or 'popular' culture with a detached, ironic, and even contemptuous air. For Pop Art and its derivatives, the look of the sophisticated viewer is always constructed in relation to the inferior look which preceded it. What disturbs me about this mode of reception is its covert elitism, its implicit claim to the status of 'superior' spectatorship. A patronizing, touristic, and mock-critical attitude toward 'kitsch' serves to authenticate a high culture that is increasingly indistinguishable from mass culture in many of its aspects, especially in its dependence on marketing and publicity and its fascination with stardom. The possibility of this kind of intellectual and aesthetic arrogance needs to be avoided, especially when a book of photographs by a small-town commercial photographer is published by a press that regularly represents the culture of an international and metropolitan avant-garde.

In general, then, the hidden imperatives of photographic culture drag us in two contradictory directions: toward 'science' and a myth of 'objective truth' on the

one hand, and toward 'art' and a cult of 'subjective experience' on the other. This dualism haunts photography, lending a certain goofy inconsistency to most commonplace assertions about the medium. We repeatedly hear the following refrain. Photography is an art. Photography is a science (or at least constitutes a 'scientific' way of seeing). Photography is both an art and a science. In response to these claims, it becomes important to argue that photography is neither art nor science, but is suspended between both the *discourse* of science and that of art, staking its claims to cultural value on both the model of truth upheld by empirical science and the model of pleasure and expressiveness offered by romantic aesthetics. In its own erratic way, photographic discourse has attempted to bridge the extreme philosophical and institutional separation of scientific and artistic practice that has characterized bourgeois society since the late eighteenth century. As a mechanical medium which radically transformed and displaced earlier artisanal and manual modes of visual representation, photography is implicated in a sustained crisis at the very centre of bourgeois culture, a crisis rooted in the emergence of science and technology as seemingly autonomous productive forces. At the heart of this crisis lies the question of the survival and deformation of human creative energies under the impact of mechanization. The institutional promotion of photography as a fine art serves to redeem technology by suggesting that subjectivity and the machine are easily compatible. Especially today, photography contributes to the illusion of a humanized technology, open both to 'democratic' self expression and to the mysterious workings of genius. In this sense, the camera seems the exemplar of the benign machine, preserving a moment of creative autonomy that is systematically denied in the rest of most people's lives. The one-sided lyricism of this view is apparent when we consider the myriad ways in which photography has served as a tool of industrial and bureaucratic power.[11]

If the position of photography within bourgeois culture is as problematic as I am suggesting here, then we might want to move away from the art-historicist bias that governs most contemporary discussions of the medium. We need to understand how photography works within everyday life in advanced industrial societies: the problem is one of materialist cultural history rather than art history. This is a matter of beginning to figure out how to read the making and reception of ordinary pictures. Leslie Shedden's photographs would seem to allow for an exemplary insight into the diverse and contradictory ways in which photography affects the lives of working people.

Let's begin again by recognizing that we are confronting a curious archive – divided and yet connected elements of an imaginary social mechanism. Pictures that depict fixed moments in an interconnected economy of flows: of coal, money, machines, consumer goods, men, women, children. Pictures that are themselves elements in a unified symbolic economy – a traffic in photographs – a traffic made up of memories, commemorations, celebrations, testimonials, evidence, facts, fantasies. Here are official pictures, matter-of-factly committed to the charting and celebration of progress. A mechanical conveyor replaces a herd of ponies. A mechanical miner replaces ten human miners. A diesel engine replaces a locomotive. Here also are private pictures, personal pictures, family pictures: weddings, graduations, family groups. One is tempted at the outset to distinguish two distinct realisms, the *instrumental realism* of the industrial photograph and the *sentimental realism* of the

family photograph. And yet it would seem clear that these are not mutually exclusive categories. Industrial photographs may well be commissioned, executed, displayed, and viewed in a spirit of calculation and rationality. Such pictures seem to offer unambiguous truths, the useful truths of applied science. But a zone of virtually unacknowledged *affects* can also be reached by photographs such as these, touching on an aesthetics of power, mastery, and control. The public *optimism* that suffuses these pictures is merely a respectable, *sentimentally-acceptable,* and ideologically necessary substitute for deeper feelings – the cloak for an aesthetics of exploitation. In other words, even the blandest pronouncement in words and pictures from an office of corporate public relations has a subtext marked by threats and fear. (After all, under capitalism everyone's job is on the line.) Similarly, no family photograph succeeds in creating a haven of pure sentiment. This is especially true for people who feel the persistent pressures of economic distress, and for whom even the making of a photograph has to be carefully counted as an expense. Granted, there are moments in which the photograph overcomes separation and loss, therein lies much of the emotional power of photography. Especially in a mining community, the life of the emotions is persistently tied to the instrumental workings underground. More than elsewhere, a photograph can become without warning a tragic memento.

One aim of this essay, then, is to provide certain conceptual tools for a unified understanding of the social workings of photography in an industrial environment. This project might take heed of some of Walter Benjamin's last advice, from his argument for a historical materialist alternative to a historicism that inevitably empathized 'with the victors':

> There is no document of civilization which is not at the same time a document of barbarism. And just as such a document is not free of barbarism, barbarism taints also the manner in which it was transmitted from one owner to another. A historical materialist therefore dissociates himself from it as far as possible. He regards it as his task to brush history against the grain.[12]

Benjamin's wording here is careful. Neither the contents, nor the forms, nor the many receptions and interpretations of the archive of human achievements can be assumed to be innocent. And further, even the concept of 'human achievements' has to be used with critical emphasis in an age of automation. The archive has to be read from below, from a position of solidarity with those displaced, deformed, silenced or made invisible by the machineries of profit and progress.

Notes

1 Walter Benjamin, 'Theses on the Philosophy of History' (1940), in *Illuminations*, ed. Hannah Arendt, trans. Harry Zohn (New York. 1969), p.255.

2 Jean-Luc Godard and Jean-Pierre Gorin, *Vent d'Est* (Rome, Paris, Berlin, 1969), film-script published in Jean-Luc Godard, *Weekend/Wind from the East* (New York, 1972), p.179.

3 'What is represented in ideology is therefore not the system of the real relations which govern the existence of individuals, but the imaginary relation of those

individuals to the real relations its which they live.' Louis Althusser, 'Ideology and Ideological State Apparatuses' (1969), in *Lenin and Philosophy and Other Essays*, trans. Ben Brewster (New York, 1971), p. 165. Althusser's model of ideology is based in part on Marx and in part on the work of the psychoanalyst Jacques Lacan. Without belabouring this lineage, or explaining it further, I would like to refer the Canadian reader especially to a work by Lacan's first English translator and critical interpreter. Anthony Wilden: *The Imaginary Canadian: An Examination for Discovery* (Vancouver. 1980).

4 Bernard Edelman, *Le Droit saisi par la photographic* (Paris, 1973), trans. Elizabeth Kingdom. *Ownership of the Image: Elements for a Marxist Theory of Law* (London. 1979), p.45.

5 Roland Barthes, 'Rhétorique de l'image,' *Communications* 4 (1964). in *Image, Music, Text*, trans. Stephen Heath New York. 1977), p.51.

6 Leopold von Ranke, preface to *Histories of the Latin and Germanic Nations from 1494–1514*, in *The Varieties of History*, ed. Fritz Stern (New York, 1972), p.57.

7 See Guy DeBord. *La Société du spectacle* (Paris, 1967), unauthorized translation. *Society of the Spectacle* (Detroit, 1970, revised edition, 1977).

8 We might think here of the reliance by the executive branch of the United States government on 'photo opportunities.' For a discussion of an unrelated example see Susan Sontag's dissection of Leni Riefenstahl's alibi that *Triumph of the Will* was merely an innocent documentary of the orchestrated-for-cinema 1934 Nuremberg Rally of the National Socialists. Sontag quotes Riefenstahl: 'Everything is genuine . . . It is history – pure history.' Susan Sontag, 'Fascinating Fascism,' *New York Review of Books*, Vol. XXII, No. 1 February 1975), reprinted in *Under the Sign of Saturn*. (New York 1980). p.82.

9 Two recent books counter this prevailing tendency in 'visual history' by directing attention to the power relationships behind the making of pictures: C. Herron. S. Hoffmitz, W. Roberts, R. Storey, *All That Our Hands Have Done: A Pictorial History of the Hamilton Workers* (Oaksille, Ontario, 1981): and Sarah Graham-Brown *Palestinians and Their Society 1880–1946* (London, 1980).

10 In the first category are books which discover unsung commercial photographers: e.g., Mike Disfarmer, *Disfarmer: The Heber Springs Portraits*, text by Julia Scully (Danbury. New Hampshire. 1976). In the second category are books which testify to the aesthetic sense of the collector: e.g., Sam Wagstaff, *A Book of Photographs from the Collection of Sam Wagstaff* (New York, 1978).

11 This passage restates an argument made in my essay, 'The Traffic in Photographs' *The Art Journal*, Vol. 41, No. I (Spring 1981), pp.15–16.

12 Walter Benjamin. 'Theses on the Philosophy of History,' pp.256–57.

Index